TREASURES OF HEAVEN

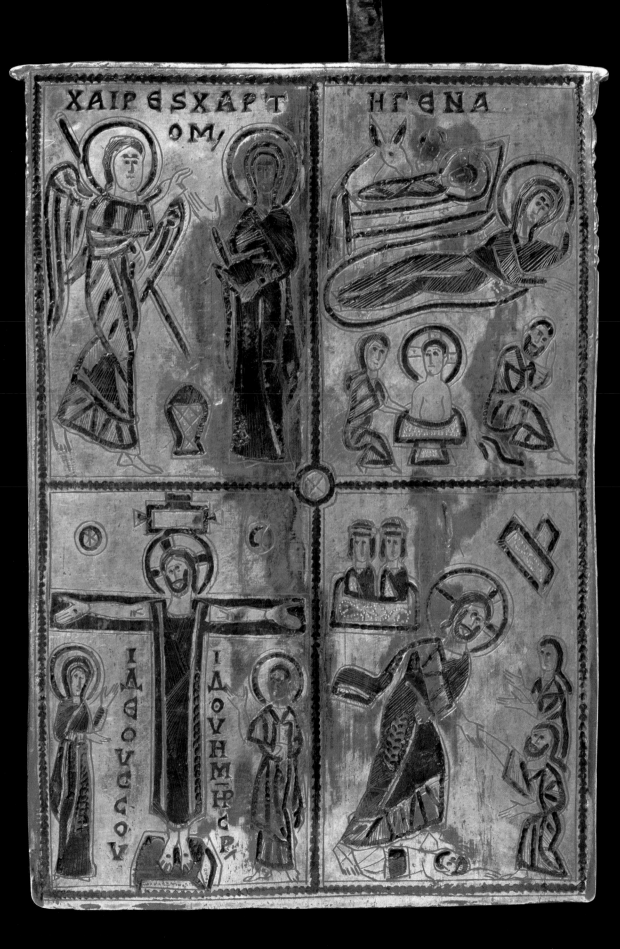

TREASURES OF HEAVEN

SAINTS, RELICS, AND DEVOTION IN MEDIEVAL EUROPE

EDITED BY MARTINA BAGNOLI, HOLGER A. KLEIN, C. GRIFFITH MANN, AND JAMES ROBINSON

THE CLEVELAND MUSEUM OF ART • THE WALTERS ART MUSEUM, BALTIMORE • THE BRITISH MUSEUM, LONDON

DISTRIBUTED BY YALE UNIVERSITY PRESS, NEW HAVEN AND LONDON

The exhibition catalogue has been supported by
Paul Ruddock and an anonymous donor.

This publication accompanies the exhibition *Treasures
of Heaven: Saints, Relics, and Devotion in Medieval Europe*,
organized by the Cleveland Museum of Art, the Walters
Art Museum, Baltimore, and the British Museum, London.

EXHIBITION DATES

The Cleveland Museum of Art
17 October 2010–17 January 2011

The Walters Art Museum, Baltimore
13 February 2011–15 May 2011

The British Museum, London
23 June 2011–9 October 2011

This exhibition is supported by an indemnity from the Federal
Council on the Arts and Humanities

Library of Congress Cataloging-in-Publication Data
Treasures of heaven : saints, relics, and devotion in medieval
Europe / edited by Martina Bagnoli ... [et al.].
p. cm.
Issued in connection with an exhibition held
Oct. 17, 2010–Jan. 17, 2011, the Cleveland Museum of Art,
Cleveland, Feb. 13–May 15, 2011, the Walters Art Museum,
Baltimore, and June 23–Oct. 9, 2011, the British Museum,
London. Includes bibliographical references and index.
ISBN 978-0-911886-74-0 (pbk.)
ISBN 978-0-300-16827-3 (hardback)
1. Reliquaries, Medieval—Exhibitions. 2. Christian art and
symbolism—Medieval, 500–1500—Exhibitions. 3. Relics—
Europe—Exhibitions. 4. Christian saints—Cult—Europe—
Exhibitions. I. Bagnoli, Martina. II. Cleveland Museum of Art.
III. Walters Art Museum (Baltimore, Md.) IV. British Museum.
V. Title: Saints, relics, and devotion in medieval Europe.
NK1652.2.T73 2010
704.9'482094074—dc22

2010026446

The Walters Art Museum
600 North Charles Street
Baltimore, Maryland 21201
thewalters.org

Distributed by
Yale University Press
P.O. Box 209040
302 Temple Street
New Haven, Connecticut 06520-9040
yalebooks.com

Dimensions are given in centimeters; unless otherwise
indicated, height precedes width precedes depth.

Biblical passages are quoted from the Revised
Standard Version.

Translations from the Italian by Martina Bagnoli and Riccardo
Pizzinato, from the French by Charles Dibble, and from the
German by John Heins

Maps by Jennifer A. Corr and Nathan Dennis

The Walters Art Museum, Baltimore
Manager of Curatorial Publications: Charles Dibble
Curatorial Publications Coordinator: Jennifer A. Corr

Front cover: Reliquary with the Man of Sorrows,
detail (cat no. 122)

Back cover: Panel-Shaped Reliquary of the True Cross,
detail (cat. no. 49)

Contents

Director's Foreword

Treasures of Heaven brings together for the first time this collection of objects of unequivocal beauty that express the rich tradition of relic veneration in the Christian church. It looks closely at the period between AD 300 and the rise of Christianity in the late Roman Empire to about 1540, the time of the northern European Reformation. This was an age that witnessed the emergence of saints as exemplars of faith and saw the evolution of Christian art as a material expression of the sacred. During this time churches, chapels, and monasteries served as repositories for relics that might comprise the bodily remains of the saints or other physical evidence of their existence, such as items once owned by them. Enshrined in precious containers studded with jewels, these sacred treasures rapidly became the focus of pilgrimage.

Pilgrimage and relic veneration are, of course, not confined to one particular time and place and in many of the world's religions; they remain inextricably linked. The overwhelming desire to feel close to the events recounted by sacred texts propels vast numbers of Jewish, Christian, and Muslim pilgrims each year to the Holy Land, while Mecca, the most revered site for Muslims the world over, constitutes the largest annual pilgrimage in the world. In a similar fashion, Hindus will converge on Varanasi, while Buddhists might select one of eight holy places for pilgrimage. Each religion has an extensive network of other destinations that allow that sense of intimate contact with the divine for which the pilgrim longs. In a world of increasing secularism, the spiritual quality that defines these journeys has to some extent found expression in tourism, where similar feelings of anticipation and fulfilment might be attached to landscapes, cities, or other attractions. The universal impulse to be absorbed in a spiritual or mystical atmosphere and to feel a connection with past peoples and places remains essentially the same.

One of the guiding impulses of medieval Christian devotional thought was that spiritual understanding might be conveyed through the man-made beauty of the material world. Architectural monuments throughout Europe stand today as witnesses to this conviction, their soaring structures and expansive stained glass testifying to a system of belief that sought to express in physical form something of the spiritual riches of Heaven. This belief was in many ways at its most potent when applied to the production of reliquaries, designed to hold the relics of Christ and his saints. It is this intimate relationship between precious materials and sacred matter that is investigated so comprehensively by the exhibition and its catalogue. Yet for all its centrality to European belief and practice at the time, the dazzling beauty of the reliquary could also be a stumbling-block for some medieval Christians. In a famous tirade against the Cluniac Benedictine monks, whom he considered extravagant, St. Bernard of Clairvaux, who belonged to the more austere Cistercian order, wrote in his *Apologia* (ca. 1122) "Eyes are fixed on relics covered in gold and purses are opened. . . . People rush to kiss [the image of the saint], they are invited to donate, and they admire the beautiful more than they venerate the sacred." Sentiments such as these would become widespread in the sixteenth century during the Reformation when so much sacred art was destroyed on the grounds that it was nothing more than a distraction from the true worship of God.

At about the time that St. Bernard was writing, a Benedictine monk named Theophilus was compiling the most influential manual on crafts to have survived from the Middle Ages, *De diversis artibus* (On the Various Arts). Because of the fluency and detail that characterize the section on metalworking, Theophilus is universally considered to have been a goldsmith himself. In striking contrast to the views of St. Bernard, Theophilus argues that *only* rich and beautiful art is appropriate to the worship of God, and his view seems by and large to have prevailed in medieval religious taste and discourse. It is not surprising, then, given the divine power attributed to relics, that extravagantly sumptuous vessels were fashioned to contain them, nor that goldsmiths were held in such high esteem and were among the first artists of any sort to sign their works.

The international list of contributors to this catalogue includes many of the greatest authorities in their field. They have written a range of essays that reflects the vastness and lavishness of both the subject matter and the objects themselves. They encompass matters such as ritual and liturgy, civil protection, commission, patronage, production, use and reinvention. Integrated object entries amplify the themes of the essays in each section to create a publication that will continue to reward the attention of scholars

and delight the curious or the devout in equal measure as a lasting legacy of a truly remarkable exhibition.

This exhibition springs organically from the collections and the traditions of the partnering institutions, and many generous donors have stepped forward in its support. Grants from the National Endowment for the Humanities and the Samuel H. Kress Foundation gave the project early seals of approval, and we are grateful to Paul Ruddock and our anonymous donor for generous support of the exhibition catalogue. The Cleveland Museum of Art is generously funded by Cuyahoga County residents through Cuyahoga Arts and Culture. The Ohio Arts Council helped fund this exhibition with state tax dollars to encourage economic growth, educational excellence, and cultural enrichment for all Ohioans. At the Walters, we are deeply grateful to Marilyn and George Pedersen and to the Trustees of the Sheridan Foundation for their lead gifts, and to the many other individuals who delight in the adventure of bringing such an ambitious exhibition to our community. The British Museum too has benefited enormously from the great generosity and informed interest of its sponsors: William and Judith Bollinger, Singapore; The Hintze Family Charitable Foundation, and John Studzinski. We are all indeed fortunate to have such friends.

Deborah Gribbon, The Cleveland Museum of Art
Gary Vikan, The Walters Art Museum
Neil MacGregor, The British Museum

Acknowledgments

The presentation of *Treasures of Heaven* would not have been possible without the help and wise counsel of many colleagues across the United States and Europe. International exhibitions such as this rely on the belief that through the exchange of objects we can gain a shared understanding of our common cultural heritage. Cooperation among many institutions is essential to the success of such endeavors, and we are humbled by the level of collaboration and support we have received.

We extend our profound thanks to the Pontifical Commission for the Cultural Heritage of the Church for extending its patronage to the exhibition; in particular, we would like to acknowledge His Excellency Monsignor Mauro Piacenza, former president of the Commission. In Baltimore, we were fortunate to profit from the guidance of His Eminence Cardinal William T. Keeler and his successor as Archbishop of Baltimore, the Most Reverend Edwin O'Brien; we are grateful also for the support of the Bishop of Cleveland, the Most Reverend Richard Lennon. Planning grants from the Kress Foundation and the National Endowment for the Arts allowed extensive study trips abroad and made it possible to convene the scholars who helped us shape the content of the exhibition: Barbara Drake Boehm, Guido Cornini, Cynthia Hahn, Herbert L. Kessler, Derek Krueger, Alice-Mary Talbot, and Gerhard Wolf. We are grateful to all of them for donating their time and expertise.

To the staff of institutions that graciously allowed their objects to travel to the exhibition go our heartfelt thanks.

In Belgium, we acknowledge the assistance of Sophie Balace of the Musées royaux d'Art et d'Histoire, Brussels; in Namur, Sister Suzanne Vandecan graciously opened the door of the Treasury of Oignies in the convent of the Soeurs de Notre-Dame.

In Bulgaria, we thank Dr. Margarita Vaklinova, director, and archeologist Dr. Katya Melamed of the National Institute of Archaeology and Museum in Sofia for their grace and understanding, and Dr. Elka Bakalova at the Bulgarian Academy of Sciences

We are greatly indebted to French colleagues for their kind support of the exhibition. In Paris, we are grateful to Mme Elisabeth Taburet-Delahaye, director of the Musée national du Moyen Âge—thermes et hotel de Cluny,

for her hospitality and generosity, and to Christine Descatoire, curator, for her expertise. At the Musée du Louvre, we thank Elisabeth Antoine and Jannic Durand for their consistent support, and at the Musée Carnavalet—Histoire de Paris, we are grateful to Director Jean-Marc Léri. For their hospitality in Toulouse we would like to thank Evelyne Ugaglia , curator of the Musée de Saint Raymond, Père Lizier de Bardies, curé of Saint-Sernin, and Bernard Ducoureau, conservateur des monuments historiques of the Direction regionale des Affaires Culturelles of the Midi-Pyrenées. For a lovely day in Saint-Nectaire and the kindness with which we were received, we thank mayor M. Alphonse Dellonte; the mayor of Maurs, M. Christian Rouzières, was an enthusiastic advocate on our behalf. To Veronique Breuil Martinez, Chargé de mission patrimoine at the Conseil Général du Cantal and Guillaume Kientz, conservateur des monuments historiques of the Department Regional des Affaires Culturelles of Auvergne goes our gratitude for shepherding a complex loan.

Colleagues in Germany have been extraordinarily generous in their support of the exhibition; we extend our profound thanks to the following colleagues in Aachen: Dr. Georg Minkenberg, Domschatzkammer; in Berlin: Dr. Lothar Lambacher, SMPK—Kunstgewerbemuseum, and Dr. Gabriele Mietke and Dr. Julien Chapuis, SMPK—Skulpturensammlung und Museum für Byzantinische Kunst; in Cologne: Dr. Leonie Becks at the Domschatz and Dr. Hiltrud Westermann-Angerhausen of the Museum Schnütgen; in Frankfurt: Dr. August Heuser of the Dom- und Diözesanmuseum; in Halberstadt: Dr. Jörg Richter of the Dommuseum Halberstadt; in Hamburg: Dr. Christine Kitzlinger, curator, Museum für Kunst und Gewerbe; in Münster: Dr. Reinhard Karrenbrock, Diözese Münster; in Paderborn: Dr. Christoph Stiegemann, Director of the Dom- und Diözesanmuseum Paderborn; in Trier: Dr. Winfried Weber, director of the Bischöfliches Dom- und Diözesanmuseum; Dr. Eckart Köhne, director, and Lothar Schwinden, curator, of the Rheinisches Landesmuseum, and, for his advice and counsel, Prälat Dr. Franz Ronig; and, in Zwiefalten: Pfarrer Paul Zeller.

In Italy, we acknowledge the assistance provided in Rome by Dottoressa Simonetta Antellini and Giorgio Leone at the Soprintendenza of Rome;

Dottoressa Testa at the Direzione Generale per l'Amministrazione del Fondo Edifici di Culto of the Ministry of Interior; Dottoressa Caterina Bon Valsassina and Vittorio Sgarbi in the Ministero per i Beni e le Attività Culturali; and for help forging new contacts and tracing photographs, Valentino Pace at the University of Udine. Gerhard Wolf, Max-Planck-Institut—Kunsthistorisches Institut, Florence provided invaluable advice and counsel, as did Dr. Nicolò Zorzi at the Università di Padova. In the Commune of Sassoferrato, we thank Marino Ruzziconi, Dottoressa Vittoria Garibaldi, and Mayor Ugo Pesciarelli; in Venice: Cristina Dossi, director of the Museo Archeologico Nazionale; Roberto Fontanari at the Soprintendenza; Giandomenico Romanelli, Fondazione Musei Civici Venezia; Monsignore Antonio Meneguolo, Patri-arcato di Venezia; Dr. Maria Da Villa Urbani and Dr. Irene Favaretto, of the Procuratoria di San Marco.

In the United Kingdom, we are grateful to Paul Ruddock for opening the doors of his collection to us and for his generosity, and to Christopher de Hamel at the Parker Library of Corpus Christi College, Cambridge, for the generous loan of an extraordinary manuscript. A number of ex-catalogue loans were negotiated for the British Museum, and we would like to acknowledge the help and support of staff at the British Library, particularly Scot McKendrick, Claire Breay, and Barbara O'Connor for the inclusion of three superlative manuscripts in the London exhibition. Others who were equally sympathetic in their consideration of loans for the British Museum include Paul Willamson at the Victoria and Albert Museum, Luke Syson at the National Gallery, Hazel Forsyth at the Museum of London and Jan Graffius at Stonyhurst College, Lancashire. We are indebted too to Sophia Dicks who gave the British Museum the benefit of her expertise and advice on the relics of King Charles I.

At the Vatican, we are grateful to Monsignore Guido Marini, Maestro delle Celebrazioni Liturgiche Ponteficie. This exhibition could not have happened without the cooperation, expertise, and generosity of the Vatican Museums. In particular we would like to acknowledge the unqualified support of the former director, Francesco Buranelli, and the present director, Antonio Paolucci. To Guido Cornini, head of the department of decorative arts, Umberto Utro, head of the department of Christian Antiquities, and Andrea Carignani, head of exhibitions, we remain grateful for their generosity in time, expertise, and loans.

In the United States, we extend our profound thanks to the many individuals and institutions who have assisted with the exhibition: in Annapolis, the Reverend John Kingsbury of St. Mary's Parish; in Chicago: Christina M. Nielsen, assistant curator for medieval art at the Art Institute of Chicago; in Emmitsburg, Maryland: Sister Betty Ann McNeil, D.C., provincial archivist of the Daughters of Charity Emmitsburg Province; in Los Angeles: Thomas Kren, interim associate director for collections at the J. Paul Getty Museum; in New York: Peter Barnet, Michael David-Weill Curator in Charge, and Barbara Drake Boehm, curator of medieval art at the Metropolitan Museum of Art; William M. Griswold, director, and Roger Wieck, curator of manuscripts at the Morgan Library and Museum; and Samuel Merrin of the Merrin Gallery; in Oberlin: Stephanie Wiles, John G. W. Cowles Director, and Andria Derstine, curator of Western art, at the Allen Memorial Art Museum of Oberlin College; in Washington: Jan Ziolkowski, director, Gudrun Bühl, curator and museum director, and Stephen Zwirn, assistant curator of the Byzantine Collection, Dumbarton Oaks Research Library and Collection; Earl A. Powell, director, and David Allan Brown, curator of Italian paintings, National Gallery of Art; and Daniel de Simone, curator of the Rosenwald Collection at the Library of Congress.

The staff of the three organizing institutions have enthusiastically supported the exhibition since its inception. In Cleveland, we are grateful to Timothy Rub, director 2006–2009, who initially encouraged the project at the CMA and who supported the show during his tenure, and Deborah Gribbon, the museum's interim director, who guided the project through its final stages. Heidi Strean, director of Exhibitions, shepherded the exhibition and managed the venue negotiations, while Mary Suzor and the staff of Collections Management organized the application for indemnity and coordinated and facilitated the loans together with Elizabeth Saluk, who also managed rights and reproductions. We appreciate Jeffrey Strean and Jim Engelmann in Architecture and Design for the installation in Cleveland; Marjorie Williams, Alicia Hudson Garr, and Caroline Goeser in Education and Public Programs for organizing educational programming;

and Betsy Lantz, Louis Adrean, and the staff of Ingalls Library, for facilitating library programming.

A group of staff members from the Cleveland Museum of Art also deserve mention for their time and talents they devoted to the project: Bridget Weber, in curatorial; Thomas Anderson and the Development and External Affairs staff; Howard Agriesti, Gary Kirchenbauer, and Bruce Shewitz in Photographic and Imaging Services; Marcia Steele and Shelley Paine in Conservation; Mary Thomas, Terra Blue, and Alex Jung in Design; Marty Ackley, Barry Austin, Arthur Beukemann, John Beukemann, Joseph Blaser, Todd Hoak, Kim Cook, and Lauren Turner in Collections Management; Cindy Fink and Marketing and Communications staff members; Publications staff Barbara Bradley, Jane Takac Panza, and Amy Sparks; and Emily Marshall and Sheri Walter in the Exhibitions Office.

The Walters Art Museum's director, Gary Vikan, has been an enthusiastic advocate for the exhibition since its earliest stages. The extraordinary talents of the Walters Art Museum staff have immeasurably contributed to the presentation of the exhibition and associated programs: in Exhibitions: Nancy E. Zinn, Annie Lundsten, Laura Yoder, Susan Wallace, and Michael McKee; in the Registrar's office: Joan Elisabeth Reid and Barbara Fegley; in Development: Joy P. Heyrman, Joan Ruch, and Sarah Walton; in Conservation: Terry Draymann-Weisser, Eric Gordon, Julie Lauffenburger, Meg Craft, and Karen French; in Marketing: Mindy Riesenberg, Johanna Biehler, Dylan Kinnett, and Amy Mannarino; in Education: Kathy Nusbaum, Amanda Kodeck, and Lisa Lewenz; in Information Technology: Jim Maza, Susan Tobin, and Ruth Bowler; in the Curatorial Division: Joaneath Spicer, William Noel, Kathryn Gerry, Chiara Valle, Riccardo Pizzinato, and Nathan Dennis.

At the British Museum, the director Neil MacGregor offered insightful advice and unstinting support to the project. An equal measure of thanks is due to Jonathan Williams, keeper of Prehistory and Europe for his benevolent guidance and to Carolyn Marsden-Smith, head of Exhibitions for steering the exhibition along its complicated course. Within the department of Exhibitions, Rachel Dagnall exercised enviable calm, control and cheerfulness as project manager and Chloe Luxford provided sensitivity,

understanding and charm in her development of the 2-d design. From Learning and Audiences, Iona Keene infused the interpretation process with elegance and lucidity. Matt Weaver of Collections Services expertly managed an ever expanding and contracting list of lenders. Curatorial colleagues around the museum were enormously generous in their time. Giulia Bartram of Prints and Drawings was especially helpful along with Venetia Porter of the Department of Middle East, Lesley Fitton, keeper of Greece and Rome and her colleagues Judith Swaddling and Paul Roberts. From the department of Prehistory and Europe, thanks are extended to Chris Entwistle, Richard Hobbs, Ralph Jackson, Sonja Marzinzik and Dora Thornton. Special thanks are due to Anna Harnden, project curator of *Treasures of Heaven* for her energetic involvement in every aspect of the exhibition's conception and delivery at the British Museum and to Naomi Speakman, the John Rassweiler Project Curator, for her skilful authorship of complex catalogue entries. A large number of conservators and scientists were involved in the exhibition and we are enormously appreciative of the contributions of David Saunders, keeper of Conservation and Scientific Research, Catherine Higgitt, Fleur Shearman, Marilyn Hockey, Maickel van Bellegem, Sherry Doyal, Philip Kevin, Clare Ward, Susan La Niece, Caroline Cartwright and Philip Fletcher. The visibility of the exhibition was ensured by colleagues in Marketing, particularly Rosie Folkes, Ann Lumley and by the outstanding art work of Constanza Gaggero. The appearance of the catalogue was further enriched by the superlative photography of John Williams, Saul Peckham and Dudley Hubbard. The exhibition was reliant on the hard work of the department of Development; Maria Muller, Director of Development and her colleagues Tania Hutt and Heather Williamson. Additional thanks are gratefully given to Leslie Webster, Xerxes Mazda, Caroline Ingham, Stuart Frost, Laura Philips, Emma Poulter, James Peters, Lindsey Breaks, Liz Gatti, Sam Wyles, Emma Lunn, Haneesha Melwani, Petra Rae, James Baker and Alex Garrett. The exhibition designers at the British Museum were Alan Fairlie, Debby Kuypers and Catriona Hill of RFK Architects.

For the elegant design of the catalogue, we are grateful to Antonio Alcalá and Leslie Badani of Studio A in Alexandria, Virginia, and for the

catalogue's expert printing, Christian Ghin and the staff of Editoriale
Bortolazzi Stei S.R.L. In Baltimore, Charles Dibble and Jennifer A. Corr
shepherded the catalogue from manuscript to book, and we are grateful
to colleagues at the British Museum Press, Rosemary Bradley and Coralie
Hepburn, for their enthusiastic support of the publication. Elizabeth
Saluk at the Cleveland Museum of Art obtained images and cleared rights
for catalogue photography with extraordinary diligence and efficiency.
A number of individuals graciously provided assistance in locating photo-
graphs for the essays; we thank Christine Brennan and Neil Stimler at
the Metropolitan Museum of Art; Dottoressa Antonella di Marzo, Soprint-
endenza per i Beni Storici Artistici ed Etnoantropologici della Puglia and
Monsignore Vito Domenico Fusillo; Franz Wenhart, Librarian of Kloster
Gars am Inn, Bavaria; Anton Legner. emeritus director of the Museum
Schnütgen, Cologne; György Horváth of Foszékesegyházi Kincstár Eszter-
gom; and Marta Negro Cobo, director of the Museo de Burgos.

Martina Bagnoli
Holger A. Klein
C. Griffith Mann
James Robinson

Lenders

BELGIUM
Couvent des Soeurs de Notre-Dame, Namur
Musée Diocesain et Trésor de la Cathédrale, Namur
Musées royaux d'Art et d'Histoire, Brussels

BULGARIA
Museum of Archaeology, Varna
National Institute of Archaeology and Museum–Bulgarian Academy
of Sciences, Sofia

FRANCE
Basilique Saint-Sernin, Toulouse
L'abbatiale Saint-Césaire, Maurs
Mairie de Saint-Nectaire, Puy-de-Dôme, Auvergne
Musée Carnavalet—Histoire de Paris
Musée du Louvre, Paris
Musée de Cluny—musée national du Moyen Âge, Paris
Palais de Tau, Cathédrale de Notre-Dame, Reims

GERMANY
Aachener Dom, Schatzkammer, Aachen
Erzbischöfliches Diözesanmuseum und Domschatzkammer
Paderborn / Leihgabe Franziskanerkloster Paderborn
Metropolitankapitel der Hohen Domkirche Köln
Museum für Kunst und Gewerbe, Hamburg
Pfarrgemeinde St. Nikomedes, Steinfurt-Borghorst
Rheinisches Landesmuseum, Trier
Staatliche Museen zu Berlin, Kunstgewerbemuseum
Staatliche Museen zu Berlin, Skulpturensammlung und Museum
für Byzantinische Kunst
Trierer Dom, Domschatz

ITALY
Ministero dell'Interno, Direzione Centrale per l'Amministrazione
del Fondo Edifici di Culto, Roma
Basilica di Santa Croce in Gerusalemme, Rome
Museo Archeologico Nazionale, Venice

Museo Civico, Sassoferrato
Museo Correr, Fondazione Musei Civici Venezia
Procuratoria della Basilica di San Marco, Venice

UNITED KINGDOM
The British Library, London
The British Museum, London
The British Province of the Society of Jesus, London
Corpus Christi College, Cambridge
Durham Cathedral and Chapter, County Durham
Private Collections, London
The Museum of London
The National Gallery, London
National Museums Scotland
The National Portrait Gallery, London
The Society of King Charles Martyr, London
Stonyhurst College, Clitheroe
The Victoria and Albert Museum, London

UNITED STATES
Allen Memorial Art Museum, Oberlin College, Oberlin, Ohio
The Cleveland Museum of Art
The Art Institute of Chicago
Dumbarton Oaks, Byzantine Collection, Washington, DC
The J. Paul Getty Museum, Los Angeles
Library of Congress, Washington, DC
The Metropolitan Museum of Art, New York
National Gallery of Art, Washington, DC
The National Shrine of Saint Elizabeth Ann Seton, Emmitsburg, Maryland
The Pierpont Morgan Library, New York
St. Mary of the Assumption Church, Annapolis, Maryland
Virginia Museum of Fine Arts, Richmond
The Walters Art Museum, Baltimore

VATICAN
Musei Vaticani
Ufficio delle Celebrazioni Liturgiche del Sommo Pontefice

Contributors

ESSAYS / VOLUME EDITORS

Arnold Angenendt
Emeritus professor of Medieval and Modern Church History,
Wilhelms-Universität Münster

Barbara Drake Boehm
Curator, Department of Medieval Art and the Cloisters,
The Metropolitan Museum of Art, New York

Martina Bagnoli
Robert and Nancy Hall Associate Curator and Head of the Department
of Medieval Art, The Walters Art Museum, Baltimore

Guido Cornini
Curator of Decorative Arts, Musei Vaticani

Cynthia Hahn
Professor of Art History/Medieval Art, Hunter College, CUNY, New York

Holger A. Klein
Associate professor of Art History and Archaeology, Columbia
University, New York

Derek Krueger
Joseph Rosenthal Excellence Professor in the Department of Religious
Studies, University of North Carolina, Greensboro

C. Griffith Mann
Chief Curator, The Cleveland Museum of Art

Alexander Nagel
Professor of Fine Arts, The Institute of Fine Arts, New York University

Éric Palazzo
Professor of Medieval Art History, University of Poitiers

James Robinson
Curator of Late Medieval Europe, The British Museum, London

CATALOGUE

Elisabeth Antoine (EA), Musée du Louvre, département des
 Objets d'art, Paris
Martina Bagnoli (MB), The Walters Art Museum, Baltimore
Barbara Drake Boehm (BDB), The Metropolitan Museum of Art,
 New York
Virginia Brilliant (VB), The John and Mable Ringling Museum of Art,
 Sarasota, Florida
Gudrun Bühl (GB), Dumbarton Oaks, Washington, DC
Maria Da Villa Urbani (MDVA), Procuratoria di San Marco
Christine Descatoire (CD), Musée de Cluny—musée national
 du Moyen Âge, Paris
Tamara Durn (TD), Case Western Reserve University, Cleveland
Kathryn B. Gerry (KBG), The Walters Art Museum, Baltimore
Herbert L. Kessler (HLK), The Johns Hopkins University, Baltimore
Holger A. Klein (HAK), Columbia University, New York
Claudia Lega (CL), Musei Vaticani
C. Griffith Mann (CGM), The Cleveland Museum of Art
Christina M. Nielsen (CN), The Art Institute of Chicago
Cristina Pantanella (CP), Musei Vaticani
Georgi R. Parpulov (GRP), University of Oxford
James Robinson (JR), The British Museum, London
Lothar Schwinden (LS), Rheinisches Landesmuseum Trier
Christine Sciacca (CS), The J. Paul Getty Museum, Los Angeles
Naomi C. Speakman (NCS), The British Museum, London
Joaneath Spicer (JS), The Walters Art Museum, Baltimore
Gabriella K. Szalay (GS), Columbia University, New York
Dora Thornton (DT), The British Museum, London
Umberto Utro (UU), Musei Vaticani
Chiara Valle (CV), The Johns Hopkins University, Baltimore
Stephen R. Zwirn (SRZ), Dumbarton Oaks, Washington, DC

Europe and the Mediterranean Basin

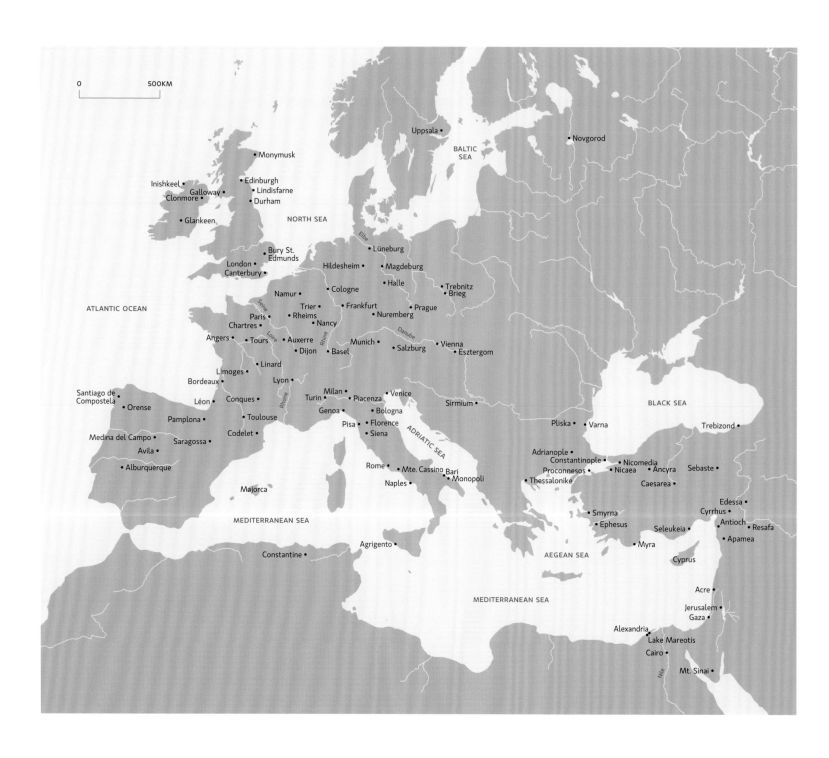

0 500KM

Uppsala •
BALTIC SEA

• Novgorod

• Monymusk

Inishkeel •
• Edinburgh
• Lindisfarne
Galloway •
Clonmore •
• Durham

• Glankeen

NORTH SEA

Elbe
• Lüneburg

Bury St. Edmunds •
London •
Canterbury •

Hildesheim •
• Magdeburg

• Halle
• Trebnitz
• Brieg

Namur •
• Cologne

Trier •
Paris •
• Rheims
Chartres •
Nancy •

• Frankfurt
• Prague
• Nuremberg

Seine

Danube

Angers •
• Tours
• Auxerre
• Dijon
• Basel

Munich •
• Salzburg
• Vienna
• Esztergom

Rhine

• Linard

Limoges •
Bordeaux •
Lyon •

Rhône

ATLANTIC OCEAN

Santiago de Compostela •
• Orense
Léon •
Conques •
Pamplona •
• Toulouse

Milan •
Turin •
• Piacenza
• Venice
Genoa •
• Bologna
Pisa •
• Florence
• Siena

Sirmium •

BLACK SEA

Pliska •
• Varna
• Trebizond

ADRIATIC SEA

Medina del Campo •
Avila •
Saragossa •
Codelet •

Rome •
• Mte. Cassino
Bari •
• Monopoli

Adrianople •
Constantinople •
Proconnesos •
Thessalonike •
• Nicomedia
• Nicaea
• Ancyra
Sebaste •

• Alburquerque

Naples •

Caesarea •

Majorca

Smyrna •
Ephesus •

Edessa •
Cyrrhus •
Seleukeia •
• Antioch
• Resafa
• Apamea

MEDITERRANEAN SEA

• Myra

AEGEAN SEA

Cyprus

Constantine •

Agrigento •

Acre •

MEDITERRANEAN SEA

Jerusalem •
Gaza •

Alexandria •
Lake Mareotis •
Cairo •

Nile

Mt. Sinai •

Western Europe

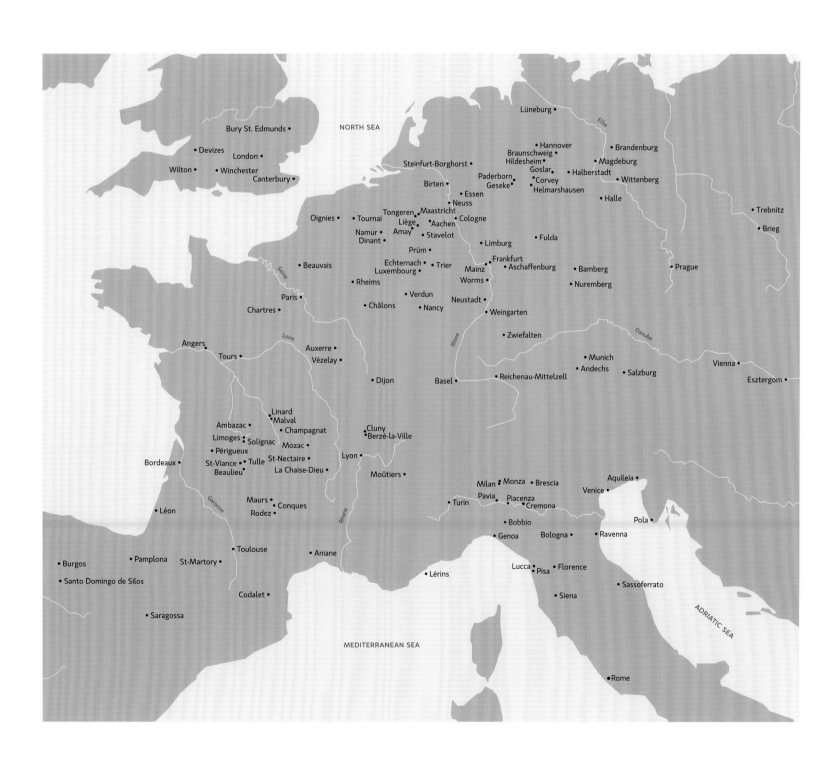

Shrines in Medieval Western European Pilgrimage Itineraries

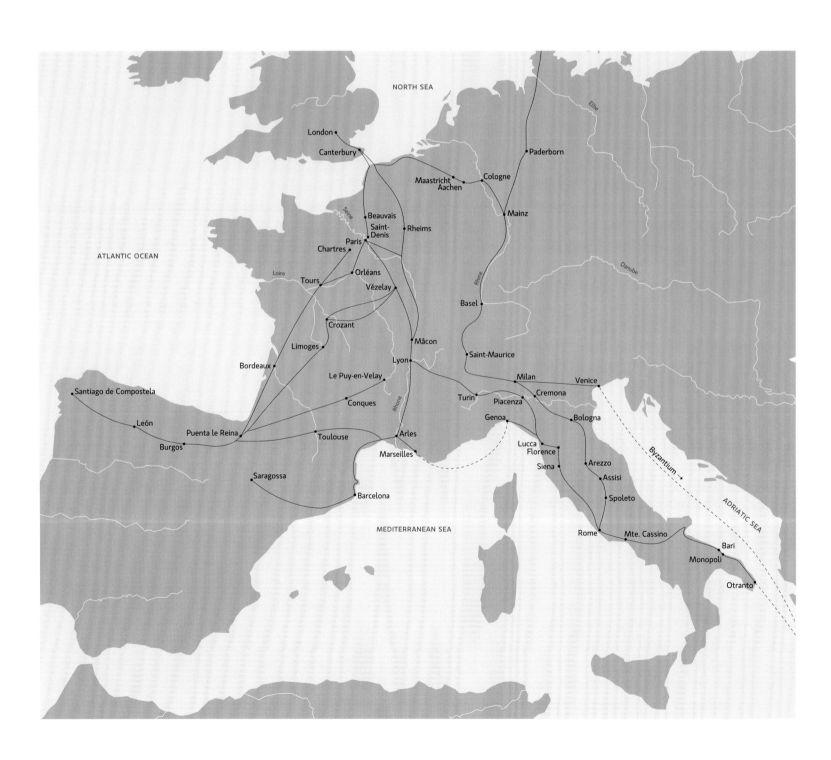

Chronology

31 BC
Battle of Actium marks the end of the Roman
Republic and the start of the Roman Empire

ca. AD 30
Crucifixion of Christ

ca. 35
Martyrdom of St. Stephen

64
Beginning of persecutions of Nero (37–68);
martyrdom of St. Peter (?)

ca. 67
Martyrdom of St. Paul

ca. 155
Martyrdom of St. Polycarp, bishop of Smyrna

ca. 285
St. Anthony of Egypt (ca. 251–356) takes up
the anchoritic life

303
Beginning of persecutions of Diocletian
(245–313)

313
Constantine I (ca. 272–337) issues the Edict
of Milan, instituting a policy of toleration of
Christianity and all other religions

325
First Council of Nicaea; condemnation
of Arian heresy

ca. 326
Alleged rediscovery of the True Cross by
St. Helena

330
Constantinople inaugurated as the New Rome

374
St. Ambrose (340–397) appointed bishop
of Milan

395
St. Augustine (354–430) appointed bishop
of Hippo

ca. 379
Gregory of Nyssa (ca. 335–after 394) records
the use of a relic of the True Cross by his
sister Makrina

ca. 384
Egeria travels in the Holy Land

391
Translation of the Head of John the Baptist to
Constantinople

415
Translation of relics of Zachariah (father of
John the Baptist) to Constantinople

421
Translation of relics of St. Stephen to
Constantinople

ca. 440
St. Symeon the Stylite and other desert saints
flourish in northwestern Syria

527
Justinian I (483–565) named Emperor

ca. 529
Monte Cassino, the first Benedictine
monastery, is founded by St. Benedict
of Nursia (ca. 480–547)

532
Rebuilding of Hagia Sophia (Church of the
Holy Wisdom), Constantinople

573
St. Gregory (538–594) named bishop of Tours

590
St. Gregory the Great (ca. 540–604) named pope

622
Muhammad's Hegira; beginning of the
Muslim calendar

638
Arab conquest of Jerusalem

ca. 726
Beginning of the Iconoclast controversy in the
Byzantine Empire

787
Second Council of Nicaea endorses the
veneration of icons

800
Charlemagne (742–814) is crowned Holy
Roman Emperor

827
Arab conquest of Sicily

815–842
Second period of Byzantine Iconoclasm

944
Mandylion arrives in Constantinople

1066
Norman conquest of England

1099
Crusaders capture Jerusalem

ca. 1100
Theofrid of Echternach (d. 1110) composes the
Flores epytaphii sanctorum

1114–20
Guibert of Nogent (ca. 1053–ca. 1124) composes
De sanctis et eorum pigneribus

1170
Murder of Thomas Becket (b. 1118), archbishop
of Canterbury

1173
Canonization of St. Thomas Becket

1187
Saladin (ca. 1138–1193) captures Jerusalem

1204
Crusaders taking part in the Fourth Crusade
conquer and sack Constantinople

1215
Fourth Lateran Council proclaims that relics
should not be exhibited outside of reliquaries

1226
Louis IX (1214–1270) crowned King of France

1239
Louis IX acquires relics of the Passion

1248
Completion of the Sainte-Chapelle, Paris,
to house relics of the Passion

1261
Michael VIII Palaiologos (1223–1282) recovers
Constantinople

1274
Second Council of Lyon decrees union of Eastern
and Western Churches, condemns punishment
of saints' relics

1348–1349
The Black Death

1378
The Great Schism

1453
Fall of Constantinople to the Ottoman Empire

ca. 1455
First printed Bible is published by Johannes
Gutenberg (ca. 1398–1468)

1492
Christopher Columbus (ca. 1451–1506) crosses
the Atlantic

1519
Beginning of the Protestant Reformation

1529
Martin Luther (1483–1546) attacks the cult
of relics

1536
Henry VIII (1491–1547) begins the dissolution
of British monasteries

1564
Council of Trent

1789
French Revolution

1905
Crypt of the Sancta Sanctorum is opened

1962–1965
Second Vatican Council

FROM TOMB
TO ALTAR

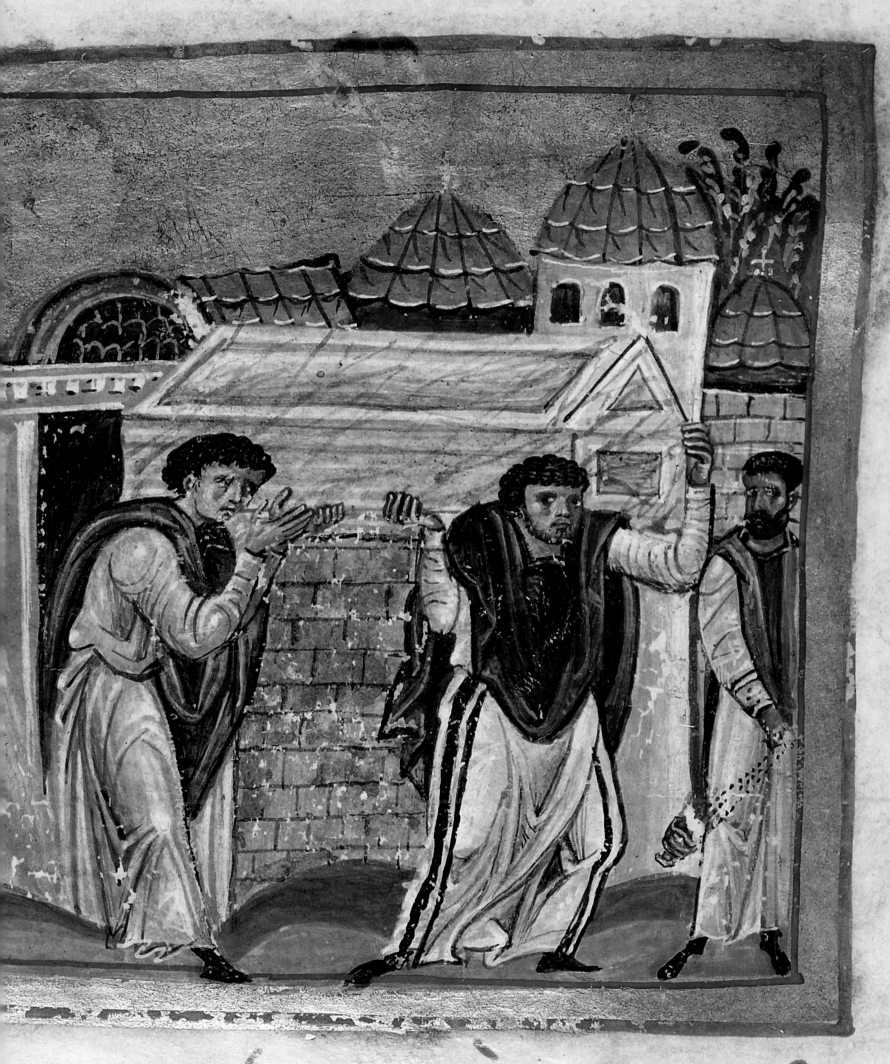

ϲ̄τρομ̄ϲ̄τομβρ̄γὰρ ἀϲτρῶ

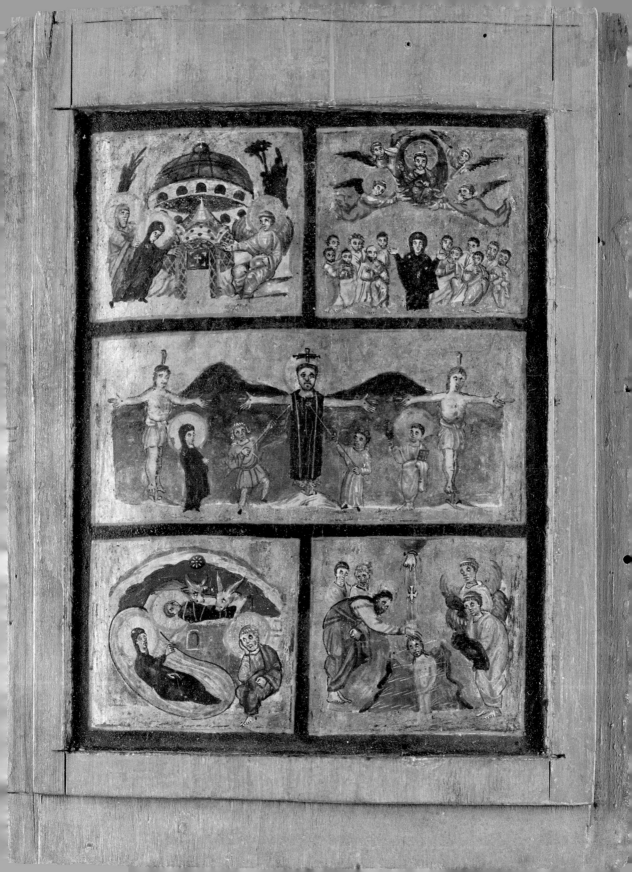

The Religion of Relics in Late Antiquity and Byzantium

DEREK KRUEGER

Christian relics and reliquaries from Antiquity and the Middle Ages provide material evidence for religion. The religion of relics was in fact quite various, involving a system of interrelated practices with respect to holy people and places, together with the popular theories and theological reflection that explained and justified those practices. At the center of the practices lay a basic confidence that matter—fragments of bodies, oil, water, even bits of stone and dust—could contain and convey spiritual power. The word "relics" (Greek: λείψανα; Latin: *reliquiae*) indicates things "left behind." These could be the saint's physical remains, but they could also be personal effects or things that had come into contact with the saint's body. Matter gained holiness through contact with other holy matter, like a sacred contagion. Such matter might, in fact, gain its holiness through mere proximity to holy places where holy events had occurred. And all of this matter might provide access to healing or divine protection, guarding against uncertainty both in this life and the next.

Many of these forms of devotional life—ritual, pageantry, veneration— had already coalesced by the end of the fourth century and spread quickly throughout the Christian world over the following centuries. In late fourth-century Asia Minor, on the night before the anniversary of a martyr's death, people would travel from afar to gather at the tomb for an all-night vigil. Maintaining a strict fast, they participated in a candlelight service with prayers for intercession and the chanting of psalms; they listened to sermons praising the martyrs. The following day, there would be a celebration of the Eucharist and a procession with the martyr's relics on a richly decorated bier.[1] In an oration celebrating St. Theodore the Recruit, Gregory of Nyssa (335/40–ca. 395) expresses his congregation's strong desire for contact with the holy man's physical remains. "For, as if it is the same body, still alive and flourishing, those beholding it embrace it with the eyes, the mouth, the ears. And when they have approached it with all the senses, they pour tears out over it from piety and emotion."[2] This experience of the holy bodies of Christian saints—touching, seeing, kissing—was itself sensory and tactile, conveying holiness from the body of the saint to the body of the worshiper. Gregory's brother, Basil of Caesarea (330–379), wrote, "Those who touch the bones of the martyrs participate in their sanctity."[3] Moreover, this contact with holiness did not require the entirety of the saint's body; as their friend Gregory of Nazianzos (ca. 329–90), later patriarch of Constantinople, explained, "The bodies of the martyrs have the same power as their holy souls, whether one touches them or just venerates them. Just a few drops of their blood, the signs of their sufferings, can effect the same as their bodies."[4] The bodies of the saints differed from those of ordinary people, for they maintained a connection to their holy souls, even after death, and in many cases they remained uncorrupted. When the body of St. Hilarion (d. 371) was exhumed ten months after his initial burial so that his remains could be moved from Cyprus to Gaza, Jerome (ca. 347–420) reports, "his whole body remained perfect, as if he were still alive, giving off such a fragrance that you would think it had been anointed with perfumed oils."[5] Such special bodies mediated between humanity and the divine.

From the Cult of the Dead to the Cult of the Martyrs

Early Christian attitudes toward the bodies of their dead derived from ancient funerary practices. While burial practices varied throughout the Roman Empire, informed by religious affiliation and location, the proper deposition of the bodies of the dead remained among the chief duties of households.[6] Jews, for example, formed burial societies to cover the costs of funerary rites and interment, as did guilds of pagan artisans and soldiers. Although some groups in the ancient world practiced cremation, most practiced inhumation, the intact burial of a properly prepared corpse. Wealthy families commissioned luxuriously carved monuments to their dead, including sarcophagi adorned with religious images (see cat. no. 1). Because the bodies of the dead were regarded as impure or defiling, cemeteries tended to lie on the outskirts of cities and towns, beyond the boundaries of habitation, often in vast necropolises. Monumental tombs lay along the roads leading out of many cities, such as at Rome, along the Via Appia. At the cemetery of Hibis (now Bagawat) in the Kharga Oasis in Egypt, the fourth- and fifth-century "city of the dead" was laid out along streets, with each structure containing tombs and chapels where mourners could gather (fig. 1). Paintings on the walls depicted biblical scenes and images of paradise.[7] At Rome, Naples, and Alexandria, many dead were laid to rest in underground chambers called catacombs. Here the poor were interred in loculi, or shelves, lining long underground hallways. The prominent might lie in sarcophagi in hollowed-out niches (arcosolia), often grouped in private family burial chambers, or cubicula (fig. 2). The fourth century saw the rise of distinct Christian funerary art in Rome, where early Christian sarcophagi often depict biblical scenes associated with hope for resurrection or with physical healing. One exquisitely carved example depicts Christ standing confidently in an architectural setting, flanked by six of his apostles (cat. no. 2). Common themes included the stories of

Jonah and the whale and Daniel in the lion's den, both associated with Christ's resurrection, and the miracles of Jesus, such as the raising of Lazarus and the healing of the blind and lame. An epitaph depicts a pious Roman matron and the three Magi approaching Mary and the Christ Child and bears the inscription "Severa, may you live in God" (cat. no. 6). The slab that covered the grave of a Roman child named Asellus bears images of Peter and Paul, who will intercede on the six-year-old's behalf, together with the *chi-rho,* the monogram of Christ, marking the dead boy as Christ's possession (cat. no. 5).

Religious groups in many parts of the empire marked the anniversaries of the dead with a visit to the burial site, to celebrate their memory with food and drink. During such observances in the catacombs of Rome in the second half of the fourth century, loved ones might place glass medallions at the tomb, or the bottoms of glass bowls depicting in gold leaf biblical scenes or Christian saints, such as Peter and Paul together, or the martyr Agnes (cat. nos. 8–10). This memorial feast, known as a *refregerium,* was a common theme in funerary art, depicted on grave markers or stelae, on sarcophagi, in paintings in *arcosolia,* or on mosaic pavements (fig. 3).[8] Annual festivals at the tombs of Christian martyrs had their origin in such observances. In the late fourth century, as the Roman masses abandoned worship at the pagan temples in the center of the city for visits to Christian martyrs' shrines beyond the city's walls, Jerome famously remarked that "the city has changed address."[9]

Christian martyrs were the first Christian holy people and the first source of relics. At various times from the late first through the early fourth century, Roman officials arrested leaders of Christian communities for practicing a religion that threatened the authority of the Roman state. Standing before magistrates, these Christians refused to renounce their faith in Jesus Christ and offer pagan sacrifice on behalf of the emperor; for their refusal they were condemned to death, often in public arenas.

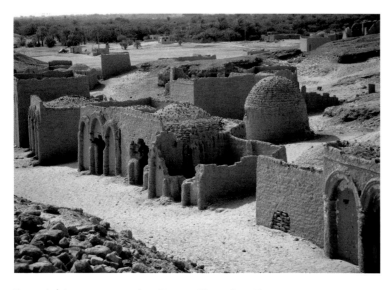

Fig. 1. 4th-/5th-century necropolis at Bagawat, Kharga Oasis, Egypt.
Photo Elizabeth Bolman

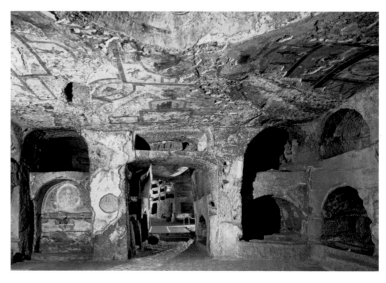

Fig. 2. The catacomb of San Gennaro, Naples, 2nd century

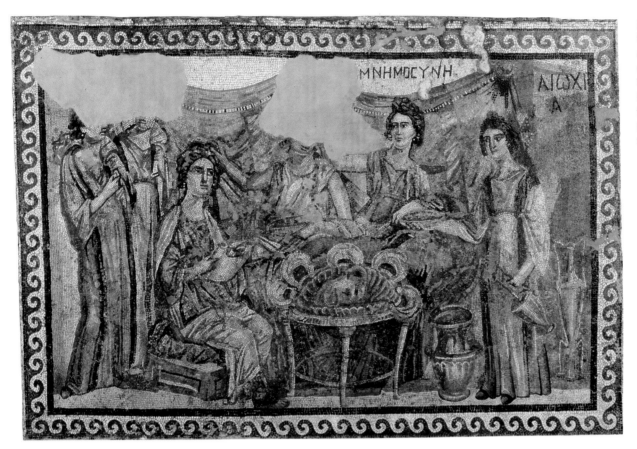

Fig. 3. Funerary symposium, mosaic from the necropolis at Antioch on the Orontes. Roman, 2nd century. Worcester Art Museum, Worcester, Massachusetts, Excavation of Antioch and Vicinity funded by the bequest of the Reverend Dr. Austin S. Garver and Sarah C. Garver (1936.26)

Only a small number of Christians actually died during these persecutions as "witnesses to the faith," but the experience of having their leaders tortured and executed traumatized local Christian communities.[10] The martyrs' endurance and faithful persistence rendered them heroes. Christians believed that the martyrs had been rewarded with salvation—eternal life in heaven—and that they were able to intercede with God on behalf of those who addressed their prayers through them. After the martyrdom and cremation of Polycarp, bishop of Smyrna, around 156, his followers "took up his bones, which are more valuable than precious stones and finer than refined gold, and deposited them in a suitable place. There gathering together, as we are able, with joy and gladness, the Lord will permit us to celebrate the birthday of his martyrdom in commemoration of those who have already fought in the contest."[11] The anniversaries of martyrs' deaths were among the first holy days celebrated by Christian communities; written accounts of martyrdom circulated as the first Christian saints' Lives; and the martyrs' bodies, often brutally mangled, dismembered, and burned, became objects of reverence and hope.

Christian attitudes toward the disinterment, fragmentation, and even display of holy bodies marked a significant departure from Jewish and Greco-Roman pagan practice, which had tended to keep bodies intact and buried. Initially, Christian burial practices differed little from those of the Jews or pagans among whom they lived; Christians did not even necessarily seek to be buried in places different or separate from non-Christians.[12] At Jewish shrines of biblical patriarchs and prophets, or, later, of prominent

rabbis, or at the pagan shrines associated with the cult of heroes, visitors had access only to tombs, not to the remains themselves. Christians, on the other hand, began to dig up the remains of the martyrs and other holy people. They moved them to other locations, reburying some in new tombs so that they could visit them more easily. They divided some remains, so that parts of the same corpse could reside in different places. Some bodies or parts of bodies remained on display, unburied or unentombed.

Scholars have ventured a variety of theories to explain the change in attitude. That the bodies of the martyrs had already been sundered perhaps licensed further fragmentation. For a short while, from the later first century until sometime in the second century, some Jews exhumed the dead a few years after their burial and placed their remains in special boxes for bones called ossuaries, but the evidence is thin that this influenced early Christian practice. Christians in Egypt continued to use techniques of mummification into the fourth century, but this practice was slowly eclipsed by conventional burial. St. Antony, the fourth-century ascetic credited as the founder of monasticism, specifically forbade his closest followers from revealing the location of his grave lest the faithful seek to gather up his body and keep it in their houses.[13] Popular piety about the holiness and efficacy of the bodies of the saints surely preceded attempts to provide a theological explanation, and already in the fourth century the idea that the corpses of Christian holy men and women were infused with spiritual power— that they were able to perform miracles or could function as conduits for God's power to heal—had become a matter of common sense.

The idea that the fragmentation of these holy bodies retained the entirety of the saints' power in each part likely formed in analogy to Christian conceptions of the Eucharist, which contained the body of Christ in each division. Relics contained the real presence of the saint just as the bread and the wine contained the real presence of God. The saint's identity and presence persisted in each division and distribution. In the late sixth century, theologians such as Pope Gregory the Great (ca. 540–604) worried about how the powers of the saint, which one might expect resided in their holy souls, might still be available in their bodies, even after the separation of the soul and body after death. Nevertheless, it seemed sufficient that the holy soul, now residing with God in heaven, had been in contact with the saintly body and maintained a connection with it.[14] The saints' power also resided in items of a personal nature, especially the saint's clothing, and could be transmitted to substances like oil and water that came into contact with the saint's remains.

After the conversion of Constantine and during the rapid Christianization of the Roman Empire over the course of the fourth century, the graves of the previous centuries' martyrs received increased attention. Churches were constructed to house their relics, their bodies lending their holiness to the new building, and the churches were often named for the martyrs whose bones they contained. In order to meet the demand for relics, new legends of martyrs were generated and additional remains discovered. Without a body, it was difficult, although not impossible, to have a cult. In the city of Rome, papal authority and prestige depended in part on the possession and control of the relics of Christ's apostles, particularly Peter and Paul. It is difficult to separate legend from history, but the *Liber Pontificalis (Book of the Pontiffs)*, a sixth-century compilation of biographies of the popes and leading bishops, recounts how during the reign of Pope Cornelius (251–53), the relics of Peter were moved to the Vatican Hill from a tomb along the Via Appia.[15] Aristocratic families also acquired relics both for private devotion and to demonstrate their own power. Numerous legends cite the efforts of pious Roman matrons in gathering the bones of the holy dead; the *Liber Pontificalis* credits a woman named Lucina with moving the bones of Paul from the same tomb where Peter had lain to her own property along the Via Ostiensis.[16] Indeed, in the later fourth century, elite families controlled much of the trade in relics.[17] Wealthy Christians were eager to be buried near the bodies of saints, in cemeteries, catacombs, or private tombs. Preaching for the feast of the Forty Martyrs of Sebaste, Christian soldiers who had frozen to death on an icy lake in northeastern Asia Minor, Gregory of Nyssa declaimed, "I will share a part of the gift by placing my parents' bodies beside the remains of these soldiers, in order that they may rise at the time of the resurrection with those who are filled with greater confidence."[18] People sought burial *ad sanctos* ("among the saints") in urban churches, close to the bodies of holy men, despite various legislative attempts to prevent burials within city walls near saints and martyrs.[19]

The Rise of the Cult of Saints

After the legalization of Christianity and the end of the era of the martyrs, new Christian heroes emerged in monastics who had renounced the world, living a sort of "daily martyrdom." Practicing strict self-discipline and combating demons, these spiritual athletes abandoned their homes, families, and possessions, abstained from sex, controlled their diet, and devoted themselves to prayer and the study of scripture. These holy men—and sometimes women—left the cities and villages to live in deserted places, beyond the edges of habitation. Some formed or joined monastic communities; others lived as hermits. The most accomplished among them were believed to attain the power to heal and to cast out demons. Pious Christians, from near and far, came to them for help.

The late fourth and early fifth century saw the rise of pilgrimage to living saints.[20] Writing around 440, Theodoret, the bishop of Cyrrhus in northwestern Syria, described how the landscape around his small city was dotted with miracle-working holy men and women: Julian Saba lived in a cave, eating barley bread only once a week; Eusebios of Teleda walled himself into a windowless cell for forty years and wore an iron collar and belt; James of Cyrrhestica lived exposed to the elements on a nearby mountaintop. The most famous of all was Symeon the Stylite, who lived for forty years perched upon successively higher pillars on a hill above the road between Cyrrhus and Antioch.[21] People flocked to these ascetic celebrities, who performed miracles modeled after those of Jesus himself: curing paralysis and lameness, restoring vision, exorcizing demons, and raising the dead.[22] Theodoret collected many items from these men as material *eulogiai,* or blessings, that he kept in his household. In his *Religious History,* Theodoret recounts that during his childhood, his mother made weekly visits to Peter the Galatian, who once divided his linen girdle and tied one half around Theodoret to cure an illness. Peter's girdle continued to work like a charm for family and friends alike until it was stolen (9.15). In adulthood, over his bed, Theodoret hung a flask with "oil of the martyrs," while under his head "lay an old cloak of the great James [of Cyrrhestica]" (21.16). People throughout the region collected water that James had blessed, which both cured and prevented disease (21.14). A local noblewoman anointed herself with oil blessed by the ascetic Aphrahat to divert her husband from infidelity. Far away in Rome, artisans positioned images of Symeon the Stylite at their thresholds to ward off evil (26.11). Closer to home, the saints' blessings of water and oil protected livestock and crops (8.11, 14). Before his death, the holy man James himself assembled relics of "many prophets, many apostles, and as many martyrs as possible" in his own coffin, "to dwell with the assembly of saints . . . and share with them both the resurrection and the privilege of the vision of God" (21.30). Saint's relics had become an integral part of everyday religion.[23]

When such holy men and women died, their corpses were treasured, like those of the martyrs before them. Many who had the power to perform miracles during their lifetime became even more potent after their death.

From the fifth century onward, the Mediterranean basin saw the rise of the saint's shrine. The ailing and the possessed traveled to visit the saints' tombs in search of a cure. In Egypt, the shrine of St. Menas, probably a legendary martyr, sprung up across Lake Mareotis from the city of Alexandria. By the reign of Justinian (527–65), visitors encountered a whole pilgrims' city here at Abu Mina, an elaborate complex of hostels, shops, storehouses, and bathhouses. The site included a baptistery and a huge basilica—the largest in Egypt at the time. Between the two lay the Martyr Church, built over the crypt that contained the saint's coffin. Here as at other shrines, the sick would practice "incubation," sleeping near the saint's remains in hopes of a cure. At the site, pilgrims obtained clay flasks or *ampullae* to carry home the saint's miracle-working waters collected from the shrine's cisterns. The flasks, which were manufactured on-site, depicted St. Menas praying with outstretched arms between two camels; pilgrims transported these flasks throughout the Byzantine Empire and beyond in the course of the sixth century (cat. nos. 21, 22).[24] A roughly contemporaneous round ivory container, or pyxis (cat. no. 20) may have held and transported some of the saint's relics. The pyxis's iconography connects the saint's martyrdom and his intercessory power. One scene depicts Menas's trial and judgment, another his beheading attended by an angel ready to transport his soul to heaven; a final scene shows St. Menas at prayer on behalf of male and female pilgrims who approach him for intercession. Reliquaries thus reinforced the memory of the saint's story—the life that had rendered the relics holy.

Similar shrines, such as the shrine of St. Thekla at Seleukeia on the southern coast of Asia Minor and the shrine of Sts. Cyrus and John on the outskirts of Alexandria, are known from their archaeological remains, their widely distributed pilgrim flasks, and the literary texts that

described saints' miracles.[25] A large pilgrims' village arose near the site where Symeon the Stylite had stood upon a pillar. The shrine of Sts. Cosmas and Damian, just outside the city of Constantinople, received the patronage of the emperor Justinian after these doctor-saints cured him of a grave illness.[26] The shrine's attendants collected a salve made of wax and oil that they distributed to suppliants at the weekly vigil on Saturday nights. A century later, at the shrine of St. Artemios within the city, suppliants collected a similar concoction from the lamps above the martyr's coffin and slathered it on their afflictions, especially hernias and genital ailments.[27] The faithful gathered miraculous dust that exuded from the tomb of St. John the Evangelist on the edge of Ephesus and carried it away in small clay ampullae.[28] Further west, the shrine of St. Martin at Tours had become by the late sixth century one of the holiest sites in western Christendom, where the saint's tomb served as a conduit for the divine power to heal, especially diseases of the eye.[29] And further east, on the frontier between the eastern Roman empire and Persia, the garrison at Resafa in the Syrian desert, which protected key trade routes, became a walled city (named Sergiopolis) under the protection of the martyr-saint Sergios (fig. 4). Pilgrims and traders carried away flasks with the image of Sergios, containing oil or water that had been poured over the martyr's bones and collected at the bottom of his sarcophagus. A base-metal flask in the Walters Art Museum depicts St. Sergios on horseback carrying a cross, with the inscription "Blessing [*eulogia*] of the lord St. Sergios" (cat. no. 24).[30]

A large reliquary sarcophagus from Apamea in Syria shows that the practice of infusing water or especially oil with the curative power of the saint was fairly common in that region during the fifth and sixth centuries. Pilgrims or perhaps clerics poured liquid into the top of the sarcophagus,

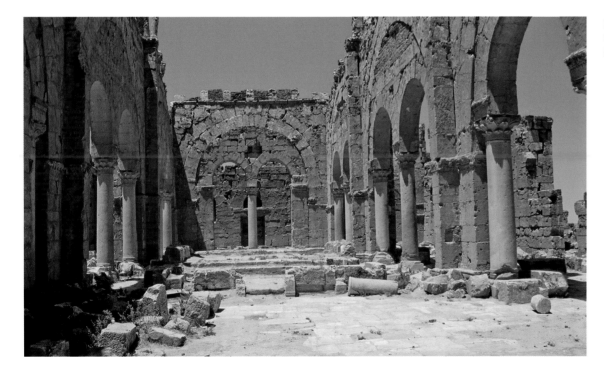

Fig. 4. The Church of St. Sergios at Resafa (Sergiopolis), Syria, 6th century. Photo Elizabeth Bolman

which could then be collected from an opening below, after it had passed over the saint's bones, thus generating a secondary relic from primary ones (fig. 5). Much smaller reliquaries in the form of caskets survive from the sixth century in Asia Minor and the Balkans. One from a church near Varna, Bulgaria, had within it two smaller reliquary boxes, the smallest containing bone fragments and splinters of wood (cat. no. 15). The hole at the top of the outer miniature casket enabled one to pour in oil or water to receive the relics' blessings. Upon the receipt of a miracle, the faithful often presented votive plaques made of clay or pressed metal to mark their gratitude and attest the saint's powers. A small silver plaque from sixth-century Syria depicts a holy woman (possibly St. Thekla) with hands raised in prayer and the inscription "Lord, help!" either to call upon or to thank the saint for her assistance (cat. no. 11).

The images on reliquaries obtained at saints' shrines served not only to identify their contents, but also to provide visual access to these saints. The faithful could address their prayers to the saints while looking at their pictures. Some scholars have suggested that the veneration of images, which would become so prominent in Orthodox Christianity, particularly after the eighth century, grew out of the cult of relics. The holiness of the relics transferred to the saint's images on their containers, and eventually this holiness adhered to the image independent of any relics.[31] The holiness of icons came to function similarly to the holiness of relics, and both used materiality, as well as practices of visual veneration and touch, to mediate holiness to the devotee.

Already in the fourth century, altars in many Christian churches were furnished with relics; by the eighth century, relics had become indispensable (see Robinson herein, p. 112). Sometimes a saint's relics resided in the crypt beneath the altar; in other cases they were deposited into a socket within the altar's plinth. Particularly in the West, the saint's relics might be visible under the altar through a small window, or *confessio,* as in the case of a sixth-century altar from Ravenna (cat. no. 17); and in time, it often

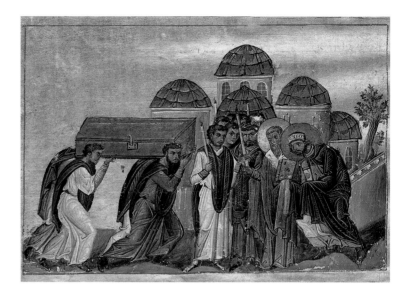

Fig. 6. The translation of the relics of John Chrysostom in 438. Miniature in the Menologion of Basil II. Biblioteca Apostolica Vaticana, ms Vaticanus gr. 1613, fol. 353, entry for 27 January. © 2010 Biblioteca Apostolica Vaticana

became possible to see the entirety of the saint's body entombed behind glass beneath the altar table. The deposition of relics within a church rendered it holy space and required elaborate rites, which in the Greek East are called *enkainia,* or "dedication," and included the washing, anointing, and covering of the altar in preparation to receive the relics, and a procession bringing the relics to the church.[32] The relocation, or translation, of relics from one region to another or even within the same city was celebrated with great pomp and solemnity (fig. 6, cat. no. 14). In some cases, the anniversary of the translation of the saint's relics became a feast in the liturgical calendar, in addition to the anniversary of the saint's death.

Holy Land Relics and the True Cross

The bodies of saints were not the only source of relics. The rise of pilgrimage to places associated with the life of Christ provided additional holy matter. While touring the Holy Land and venerating sites that had featured prominently in the Gospels, pilgrims collected a variety of ordinary substances infused with spiritual and curative power. The fourth-century ascetic Egeria collected fruit, twigs, and a copy of Jesus's legendary correspondence with Abgar, king of Edessa, while she traveled through Palestine, Syria, and Egypt in 384. By the sixth century, the repertoire of holy souvenirs had become more standardized; a pilgrim from Piacenza in Italy traveling in 570 acquired—among other items—oil, earth, rocks, and water.[33] More than ordinary souvenirs, these items conveyed and contained the blessings of the holy places where they were gathered. Pilgrims could easily touch and carry with them these *eulogiae,* or blessings. The Piacenza pilgrim reports that ship-owners from Alexandria dumped

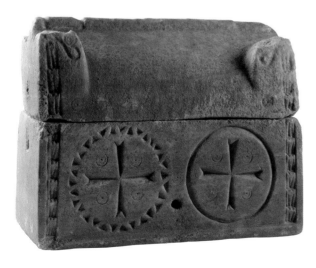

Fig. 5. Reliquary sarcophagus from the region of Apamea, Syria, 5th/6th century. Skulpturensammlung und Museum für Byzantinische Kunst, Staatliche Museen zu Berlin (10/87)

out jars of precious spices and balsam to collect water at the Jordan River. He describes how at the Lord's tomb, where Christ had been buried and rose from the dead, pilgrims collected oil from a lamp as well as dirt from the ground, which needed to be replenished daily to meet demand. Near Golgotha, he describes how pilgrims offered oil in flasks before the wood of the Cross. "When the mouth of one of the little flasks touches the wood of the Cross, the oil instantly bubbles over, and unless it is closed very quickly it all spills out."[34] These substances acquired their holiness, and their status as relics, by contact with holy sites and with holy objects.

Pilgrim flasks from the second half of the sixth century bore images that would indicate and certify the origins of the substances within. An example in the Cleveland Museum of Art made of an alloy of tin and lead bears images on both sides, indicating that its liquid contents had been obtained in Jerusalem (cat. no. 23). One side shows Christ crucified between the two thieves; two figures kneel on either side of the cross in adoration. The opposite side shows Christ's ascension into Heaven, borne aloft by angels; Mary and the apostles witness the event. The scenes thus connect events in the life of Christ with the pilgrim's itinerary in the Holy Land. The kneeling figures and the watchful Mary and the apostles provide models for the pilgrim's own religious response to the narrative. The flask preserves fragments of the leather strap by which it was originally suspended. This object is similar to a trove of flasks now in the treasury of the cathedral of Monza, near Milan. On one of the Monza flasks, Mary sits enthroned with the Christ Child flanked by the three Magi on the right and three shepherds on the left, recalling events at Bethlehem after Christ's birth. On the reverse, the Holy Women arrive at Christ's tomb to find an angel who tells them that Christ has risen. The tomb depicts the circular Shrine of the Anastasis at the Holy Sepulcher, not as it would have appeared in the first century but rather as it appeared in the pilgrim's own day. The images thus invited the viewer to identify with the Magi, shepherds, and the Marys, all of whom had visited the holy places (fig. 7).[35]

The Monza flask became part of a trove of Holy Land reliquaries in the collection of the Lombard queen Theodelinda (d. 626), demonstrating keen interest, even far afield, in possessing images and substances from the places sacred to the life of Christ.[36]

One reliquary box, dating from around the year 600 and now in the collection of the Vatican Museums (cat. no. 13), contains within it a virtual pilgrimage through the Holy Land. The top of the box bears a cross upon a little mound, indicating the place on Golgotha where Christ was crucified. The lid slides off to reveal numerous stones and fragments of wood that bear simple Greek inscriptions indicating the places where the box's first owner had collected them: "From Bethlehem," "From Zion," "From the place of the Resurrection," "From the Mount of Olives." The five scenes painted on the underside of the lid trace the pilgrim's itinerary through the events of the Gospel narrative. Reading from lower left to upper right, the lid depicts Christ's Nativity at Bethlehem, his Baptism at the Jordan River, his Crucifixion at Golgotha, the women arriving at his empty tomb (again shown as the Shrine of the Anastasis), and Christ's Ascension into heaven on the Mount of Olives. The pilgrim thus journeyed through the events of Christ's life, collecting tokens at each sacred site.[37] Together with the Monza treasure, the Vatican reliquary box attests the efforts of the wealthy and powerful to assemble collections of relics from throughout the Holy Land (the box became part of the pope's private collection in Rome). Pilgrimage to distant places tapered off with the rise of Islam and the passing of the Holy Land to Muslim rule after 638. The production of new pilgrim flasks beginning in the eleventh century, together with literary accounts of pilgrimage, signals a revival of religious travel within the Byzantine Empire during this later period of prosperity.[38]

Perhaps the most precious relic was the wood of the Cross on which Christ was crucified, the material remains attesting God's suffering for the salvation of humanity. According to legendary accounts, Helena, the mother of Constantine, discovered the wood of the Cross during a visit

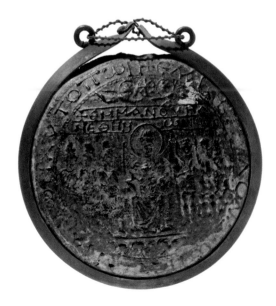
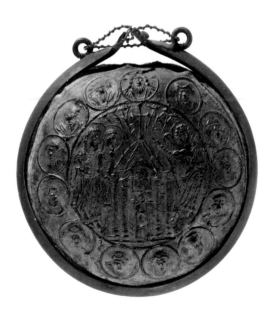

Fig. 7. Tin-lead pilgrim flask depicting Mary enthroned with the Christ Child visited by Magi and shepherds (left) and the Anastasis Rotunda with the Marys and an angel (right). Byzantine, 6th–7th century. Museo e Tesoro del Duomo Monza (3)

to the Holy Land in 326. Egeria describes how on the morning of Good Friday, 384, worshipers lined up at the church at Golgotha:

> A table is placed before [the bishop] with a cloth on it, the deacons stand round, and there is brought to him a gold and silver box containing the Wood of the Cross. It is opened, and the Wood of the Cross and the Title [bearing the inscription "Jesus Christ, King of the Jews"] are taken out and placed on the table. As long as the holy Wood is on the table, the bishop sits with his hands resting on either end of it and holds it down, and the deacons round him keep watch over it. They guard it like this because what happens now is that all the people, catechumens as well as faithful, come up one by one to the table. . . . They stoop down, touch the holy Wood first with their forehead and then with their eyes, and then kiss it, but no one puts out his hand to touch it.[39]

Despite these efforts to keep worshipers from taking slivers of the wood, pieces of the Cross began to appear elsewhere in the empire around the same time. According to Gregory of Nyssa, his sister Makrina, who died in 379, wore a ring with a cross engraved on its surface that contained within it a fragment of the "wood of life."[40] In a letter composed in 402/3, Paulinus, bishop of Nola, near Naples, described how the altar in his new basilica contained within it a fragment of the True Cross that he had received from his friend Melania the Elder.[41] The main relic of the Cross remained in Jerusalem until the Persians captured it in 614. The emperor Heraklios returned the Cross in triumph to Jerusalem in 631.[42] The cult of the Cross gained in significance in Constantinople around the same time. The earliest recorded celebration of the rite of the Exaltation of the Cross in the Church of Hagia Sophia occurred on 14 September 614; this observance became a major festival of the Orthodox Church.[43]

After the Byzantine iconoclasm of the eighth and ninth centuries, workshops in Constantinople produced exquisite reliquaries to contain, transport, and display relics of the True Cross, most often under imperial patronage. These composite works, known as *staurothekai,* or "cross containers," demonstrate a complex relationship between image and relic. Most include a depiction of the Crucifixion that invites the viewer to reflect on this sacred event. A silver-gilt box, known as the Fieschi Morgan Staurotheke (cat. no. 37), is clad on its lid and sides with cloisonné enamels and dates from the early ninth century. The busts of twenty-seven saints surround the Crucifixion on the outside of the box, associating their holiness with that of their savior. Like the Vatican reliquary box crafted two hundred years earlier, the reliquary's lid slides open to reveal its contents, and the underside of the lid depicts scenes from the Life of Christ: the Annunciation, the Nativity, the Crucifixion, and the Resurrection. The reliquary thus teaches the significance of the relic by recounting the sacred narrative and presents the saints as participants in the life of salvation. Dated to the second half of the twelfth century, a panel now in the treasury

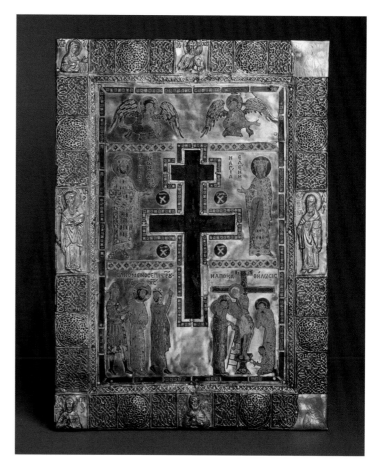

Fig. 8. The Esztergom Staurotheke. Byzantine (Constantinople), ca. 1150–1200. Cathedral Treasury, Esztergom (64.3.1)

of the cathedral in Esztergom, Hungary, embeds pieces of the True Cross between images of Constantine and Helena, as well as depictions of Christ being led to the Cross and taken down from it (fig. 8). Thus, in addition to placing the wood within the narrative sequence of Christ's death, the reliquary also recalls Helena's discovery of the True Cross and the beginnings of its veneration as a relic of the Passion.[44]

Over time, the triptych became more popular as a form to adorn and display relics of the Cross. In one beautiful example from the late tenth or early eleventh century, now in the treasury of the cathedral in Monopoli, near Bari, the wings of the triptych bear images of the apostles Paul and Peter in cloisonné enamel on gold. The center panel depicts the Crucifixion with Mary and John the Theologian (that is, the Evangelist) flanking the crucified Christ. This panel then slides down to reveal the relic in the interior cavity (fig. 9).[45] Noble and aristocratic pilgrims and Crusaders from the West obtained relics of the True Cross in their Byzantine reliquaries during visits to Constantinople and took these home to such places as Germany and France, where the settings influenced Western reliquary production. These Byzantine reliquaries were sometimes disassembled and reincorporated into larger and more elaborate works. The mid-twelfth-century Stavelot Triptych (see p. 168, fig. 7) contains within it two smaller triptychs with Byzantine enamels that were produced around 1100.[46]

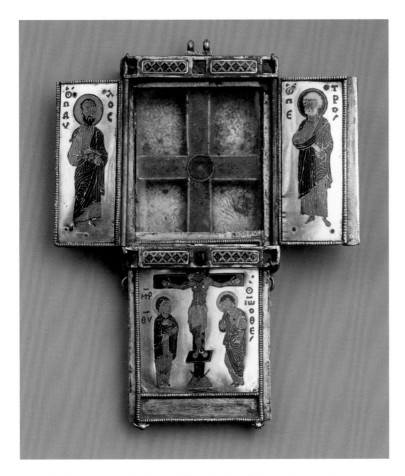

Fig. 9. The Monopoli Triptych. Byzantine (Constantinople), late 10th–early 11th century. Museo Diocesano di Monopoli

Relics and the City of Constantinople

In the Middle Byzantine period—that is, from the beginning of the ninth century until the Fourth Crusade in 1204—Constantinople amassed the largest and most extensive collection of relics in the Christian world. Foreign travelers from France, England, Scandinavia, and Russia devoted significant portions of their accounts of visits to the imperial capital to lists and descriptions of the various relics housed throughout the city's churches, monasteries, and chapels. Traveling in 1200, the Russian pilgrim Antony of Novgorod visited seventy-six shrines in the city and another twenty-one in its environs.[47] One scholar estimated that the city held 3,600 relics of 476 different saints.[48] The city itself became the focus of pilgrimage, its holiness the result of the bodily remains, bone fragments, personal effects, and miraculous icons within its walls.

The most important collection of relics belonged to the imperial household and was kept in the Pharos, or "Lighthouse," a church of the Mother of God within the Great Palace, built in the eighth century. This private collection contained relics of Christ's Passion: pieces of the True Cross; the Mandylion, or "Holy Towel" of Edessa that retained his image when Christ wiped his face on it and which arrived in 944 (cat. no. 113); and a group of objects that arrived in 614 (or perhaps 629): the Crown of Thorns;

the lance that had pierced Christ's side; and the reed and sponge that had been used to give Christ vinegar and gall to drink while he was dying on the Cross.[49] These items were not generally available for viewing or veneration by the public, but images of the Mandylion and the instruments of the Passion commonly adorned the walls of churches, ensuring their significance in the Byzantine religious imagination. In the thirteenth-century dome of the Church of St. Themonianos at Lysi, Cyprus, now in the Menil Collection in Houston, heavenly angels flank the throne prepared for Christ's second coming where a dove, representing the Holy Spirit, alights upon a Gospel book (fig. 10). Behind the throne are the relics of Christ's Passion: the Crown of Thorns hanging upon the Cross, the lance (left) and the rod and sponge (right).[50] Most of these relics had arrived in the capital from further east in the course of Byzantium's wars with Persia and the Arabs. In 1204, Western Crusaders plundered these relics, and by the middle of the thirteenth century many were housed in the Sainte-Chapelle in Paris, where they remained until the French Revolution.[51] Constantinople thus served as an important node in the movement of relics, receiving relics from the East that later traveled to the West.

Relics of the Virgin Mary, including her robe or veil, had begun to arrive in the capital during the fifth century and were venerated at various shrines in the city, the most important of which was the reliquary chapel at Blachernai, on the western edge of the city. Over the centuries, these objects, together with a celebrated icon of the Virgin, solidified her reputation as the city's protector. According to Byzantine accounts, the Virgin's robe fended off an attack by the Avars in 623 and an attack by the Rus' of Kiev in 860.[52] The Virgin's belt arrived in 942 and was housed at the Church of the Virgin at Chalkoprateia near Hagia Sophia.

The Church of the Holy Apostles, which contained mausoleums of the Byzantine emperors, housed the relics of the apostles Andrew, Timothy, and Luke. Brought to the church in 356–57, they remained under the altar in subsequent rebuildings and remodelings. The body of John Chrysostom lay nearby, its arrival in the capital in 438 having been celebrated with a great procession (see fig. 6).[53] By the early eleventh century, the Stoudios Monastery, dedicated to St. John the Baptist, had acquired one of his several extant heads.[54] Small churches throughout the city contained relics of their patron saints.

Perhaps surprisingly, Constantinople's most important and impressive edifice, the Church of Hagia Sophia, contained few relics, and these were mostly housed in the *skeuophylakion*, or sacristy, a separate structure to the northeast of the church. This may have been because the church was dedicated to Holy Wisdom, a theological concept, and not a specific saint. Nevertheless, when new relics arrived in the city, it was customary for them to be taken with elaborate rites and processions first to Hagia Sophia, where they remained for a period before being installed in churches elsewhere in the city, usually in a church dedicated to the saint whose relics it received.[55]

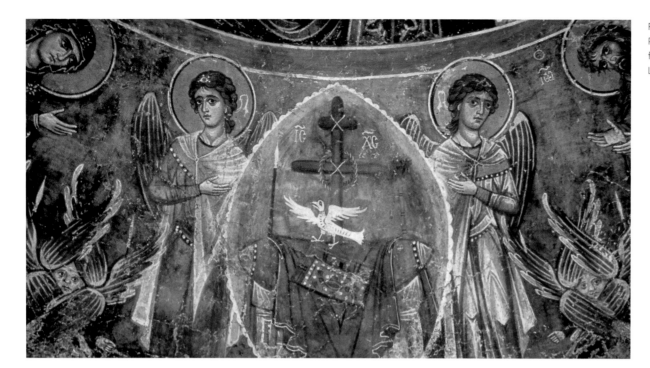

Fig. 10. The Instruments of the
Passion. Detail of the Hetoimasia
from the dome of the church at
Lysi, Cyprus, 13th century

Cult, Shrine, and Reliquary in Byzantium

The veneration of saints remained a central feature of Byzantine piety and
practice. Christians received saints' names at birth or baptism; they
entrusted themselves to their patron saint's care. Saints' images adorned
their churches, homes, and bodies, and sealed the contents of their per-
sonal correspondence. The liturgical calendar was filled with celebrations
of the saints' festivals. Relics constituted a major element of this religious
system. Many Byzantine Christians expressed their personal piety by
wearing crosses or other religious jewelry around their neck. Such adorn-
ment called on divine assistance and protection. While most of these
enkolpia were simple and flat, others were hollow and contained small relics.
Some were made of base metal, but others were luxurious. A sixth-century
necklace includes a pectoral cross and small phylacteries to contain
either relics or magical scrolls (cat. no. 27). Other jewelry, combining icon
and relic in small scale, bore images of Christ, the Virgin Mary, or a
saint (cat. nos. 25, 26, 28–30). The ninth- or tenth-century Pliska cross
includes miniature scenes from the life of Christ, so that the entire
Gospel narrative works with the relic to protect the wearer (cat. no. 32).[56]

In addition to maintaining the cults of earlier saints, Byzantium
continued to generate new ones. The *Translation of the Relics of St. Theodora of
Thessalonike* describes the beginnings of a new saint's cult. During the
year after her death in 892, Theodora appeared in dreams to the nuns with
whom she had lived, demanding that her remains be moved. One morning,
"one of the marble slabs covering her relics . . . suddenly broke."[57] Imme-
diately one woman was cured of paralysis, and a deaf-mute woman began
to hear and speak. After the marble slab broke three times, the superior of
the women's monastery understood that she should commission a new

marble casket with a small hole near the saint's feet, so that "when they
cleaned it out with water, the water could flow out through the hole. . . . For
through that hole, as can still be seen, pours the healing and sweet-scented
oil that exudes from the relics."[58] Many people attended a three-night vigil
in the nearby public squares in the days preceding the exhumation. Seven
priests in sacred vestments, carrying candles while singing hymns and
chanting psalms, accompanied the transfer of the saint's remains, which had
been preserved intact, "almost uncorrupted." After her relics had been
placed in the shrine, "fragrant oil began to pour forth in streams from the . . .
hole in the sarcophagus . . . and it flooded the entire floor of the church."[59]

While some cult shrines flourished in a single era, others were popular
from Late Antiquity through the end of the Byzantine era and beyond.
The veneration of Demetrios in Thessalonike proved particularly endur-
ing. According to his legend, Demetrios was martyred during the final
Roman persecution of the Church in the early fourth century. Some say
that his cult arrived in Thessalonike from the Balkan city of Sirmium
during the fifth century, but others contend Demetrios was a local martyr,
initially revered among non-elites in the city. At first, there were no relics,
and veneration focused on an empty six-sided silver domed structure,
called a ciborium, in the nave of a large basilica in the midst of the city.[60]
A sixth-century mosaic, destroyed by fire in 1917, depicts St. Demetrios
standing in front of his ciborium accepting the donation of an infant named
Maria (fig. 11), emphasizing the importance of Demetrios's shrine in the
spiritual exchange between the inhabitants of Thessalonike and God. By
the early seventh century, the shrine housed remains said to be those of
the saint, although the city's archbishop John expressed some skepticism
about whether the relics were genuine. John of Thessalonike promoted
Demetrios as the city's patron by composing an account of miracles that

the saint had wrought, including healings and the protection of the city from attack by Slavs.

The cult of St. Demetrios continued to thrive into the later Byzantine period, and a variety of objects allows us to consider personal devotion to this saint. Two small circular reliquary *enkolpia* incorporate relics collected from the saint's shrine. The owner of one now in the British Museum, dated to the twelfth or thirteenth century (cat. no. 30), could open the reliquary to see the saint's body lying in repose within his ciborium, beneath the oil lamp where pilgrims collected his scented oil, or *myron*. The inscription around the side indicates that the enkolpion contained the saint's blood and *myron* that exuded from his relics. The obverse of a similar thirteenth-century object, now at Dumbarton Oaks, presents an icon of St. Demetrios with his lance (cat. no. 29). A verse inscription encircles the saint, indicating that this "venerable receptacle" contains "Demetrios's blood together with the scented oil./He asks to have you [Demetrios] as protector, both in life and in death." Thus the owner, whose name was Sergios, not only wore this phylactery but expected to be buried with it. The back of Sergios's reliquary depicts his namesake, St. Sergios, with the saint's companion, Bakchos. By opening small doors within the interior of the box, Sergios would find a depiction of St. Demetrios within his tomb, and could thus re-create for himself the experience of visiting the shrine and obtaining the relics.[61]

A remarkable composite object, combining a mosaic icon, a pilgrim flask, and an inscribed silver frame reinforces the relationship between image, relic, and reliquary (cat. no. 115). The early fourteenth-century miniature mosaic, a work of excellent craftsmanship, depicts St. Demetrios in military dress with a lance and shield. At the top of the mosaic's frame, the wood panel has been hollowed out to affix a lead ampulla of slightly earlier date and much humbler manufacture. One side of the lead ampulla bears the image of St. Demetrios, while the other depicts St. Theodora, who, as we have seen, was also famous for her oil-gushing shrine. The silver-gilt revetment, possibly contemporaneous with the mosaic, contains a Greek inscription on the right-hand side, arranged in four interconnecting diamonds: "This ampulla bears holy oil drawn from the well in which the body of the divine Demetrios reposes, which gushes *here* and accomplishes miracles for the entire universe and for the faithful."[62] Together, the ampulla, icon, and inscription reveal how successive owners of relics and reliquaries might elaborate their settings and display. By the time it had reached the West, a gift from Cardinal Bessarion to his secretary, Niccolò Perroti, this reliquary functioned as a substitute for a visit to the distant shrine; St. Demetrios and his miracle-working power were present and available *here* in the icon and the flask.

Two additional late Byzantine reliquaries confirm the vibrant artistic energies that might be directed toward the cults of Christian holy men and women right up to the end of the empire in 1453. A fourteenth-century wooden box painted with scenes from the life of John the Baptist, including his baptism of Christ and his beheading, emphasizes the relationship between the holiness of a saint's relics and the holy manner of his life and death (cat. no. 52). A beautiful fifteenth-century silver gilt casket from Trebizond, on the other hand, emphasizes the saints' ability to intercede on behalf of sinners (cat. no. 53). The casket depicts St. Eugenios and three other early Christian martyrs of Trebizond in an arcade with hands outstretched in supplication toward an enthroned Christ, who is awarding them crowns of martyrdom. Around the sides, a metrical inscription lauds the martyrs, who "did not fear to shed [their] blood," and bids them to become "intercessors for my salvation / in my desire to escape condemnation." Reading the poem aloud revoiced the owner's prayer for the saints' assistance.[63]

Relics were a matter of faith; Christians invested them with confidence in their efficacy. The religion of relics provided material solutions to Late Ancient and Byzantine Christians' practical concerns. The faithful approached holy people, places, and things seeking divine assistance for health and prosperity in this world and salvation in the next. From their origins in the cult of the martyred dead and the rise of pilgrimage, to the end of Byzantium, Christian relics worked to make divine things present. Reliquaries, meanwhile, served to indicate and celebrate their contents, rendering relics portable and enhancing their meaning though a variety of visual means. Through their relics, the saints interceded for humanity as Christ interceded for humanity before God the Father. Through collection and division, the parts of holiness summoned the power of the whole. Through contact with holy remains or holy places, even the smallest fragments and the basest substances could work miracles.

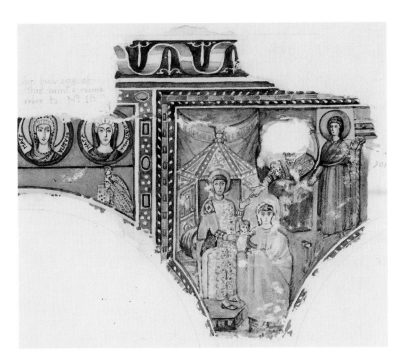

Fig. 11. The infant Maria being presented by her mother to St. Demetrios in front of his octagonal shrine. 6th-century mosaic (destroyed), from the Shrine of St. Demetrios, Thessalonike. Detail from a watercolor illustration by W. S. George

Notes

1. V. Limberis, "The Cult of the Martyrs and the Cappadocian Fathers," in *Byzantine Christianity*, ed. D. Krueger (Minneapolis, 2006), 39–58.

2. Gregory of Nyssa, *Homily on St. Theodore*, trans. in J. Leemans et al., *"Let Us Die that We May Live": Greek Homilies on Christian Martyrs from Asia Minor, Palestine and Syria (c. AD 350–AD 450)* (London, 2003), 85.

3. Basil of Caesarea, *Homily on Psalm 115*, PG 30:112.

4. Gregory of Nazianzos, *Against Julian 1 (Oration 4)* 69.

5. Jerome, *Life of Hilarion* 46, trans. in C. White, *Early Christian Lives* (London, 1998), 115.

6. J.M.C. Toynbee, *Death and Burial in the Roman World* (London, 1971); É. Rebillard, *The Care of the Dead in Late Antiquity* (Ithaca, 2009).

7. A. Fakhry, *The Necropolis of el-Bagawat in Kharga Oasis* (Cairo, 1951); M. Zibawi, *Bagawat: Peintures paléochrétiennes d'Égypte* (Paris, 2005).

8. K.M.D. Dunbabin, *The Roman Banquet: Images of Conviviality* (Cambridge, 2003), esp. 103–40 and 175–202.

9. Jerome, *Epistle* 107.1; P. Brown, *The Cult of the Saints: Its Rise and Function in Latin Christianity* (Chicago, 1981), 42.

10. W.H.C. Frend, *Martyrdom and Persecution in the Early Church: A Study of a Conflict from the Maccabees to Donatus* (Oxford, 1965).

11. *The Martyrdom of Polycarp* 18.2–3; trans. in *The Apostolic Fathers*, II,3, ed. J.B. Lightfoot and J.R. Harmer, 2nd ed., ed. Michael W. Holmes (Grand Rapids, Mich., 1992).

12. É. Rebillard, "Conversion and Burial in the Late Roman Empire," in *Conversion in Late Antiquity and the Early Middle Ages*, ed. K. Mills and A. Grafton (Rochester, 2003), 61–83.

13. J. Wortley, "The Origins of Christian Veneration of Body-Parts," *Revue de l'histoire des religions* 223 (2006): 5–28; Athanasios, *Life of Antony* 91, in R.C. Gregg, *The Life of Antony and the Letter to Marcellinus* (New York, 1980), 96–97.

14. M. Dal Santo, "Gregory the Great and Eustratius of Constantinople: The *Dialogues of the Miracles of the Italian Fathers* as an Apology for the Cult of the Saints," *Journal of Early Christian Studies* 17 (2009): 421–57.

15. *Liber Pontificalis*, 1.66–67, ed. L. Duchesne, 2 vols. (Paris, 1886–92; repr. Paris, 1981), 1:312–15. H. Chadwick, "St. Peter and St. Paul in Rome: The Problem of the Memoria Apostolorum ad Catacumbas," *Journal of Theological Studies* n. s. 8 (1957): 31–52; K. Cooper, "The Martyr, the *Matrona*, and the Bishop: The Matron Lucina and the Politics of Martyr Cult in Fifth- and Sixth-Century Rome," *Early Medieval Europe* 8 (1999): 297–317.

16. N. Denzay, *The Bone Gatherers: The Lost Worlds of Early Christian Women* (Boston, 2007).

17. K. Bowes, *Private Worship, Public Values, and Religious Change in Late Antiquity* (New York, 2008), 84–96.

18. Gregory of Nyssa, *Homily 2, On the Forty Martyrs*, PG 46:784B.

19. *Theodosian Code* 9.17.6 (381); *Justinianic Code* 1.2.2 (sixth century); *Basilika* 5.1.2 (ninth century), in. H. J. Scheltema and Nicolaas van der Wal, eds., *Basilicorum Libri LX* (Groningen: Wolters, 1953–), 1:125. See V. Marinis, "Tombs and Burials in the Monastery *tou Libos* in Constantinople," *Dumbarton Oaks Papers* 63 (2009).

20. G. Frank, *The Memory of the Eyes: Pilgrims to Living Saints in Christian Late Antiquity* (Berkeley, 2000).

21. Theodoret of Cyrrhus, *Religious History* 2, 4, 20, 26, in Theodoret of Cyrrhus, *A History of the Monks of Syria*, trans. R.M. Price (Kalamazoo, Mich., 1985). See also R. Doran, *The Lives of Simeon Stylites* (Kalamazoo, Mich., 1992).

22. D. Krueger, *Writing and Holiness: The Practice of Authorship in the Early Christian East* (Philadelphia, 2004), 21.

23. B. Leyerle, "Pilgrim *Eulogiae* and Domestic Rituals," *Archiv für Religionsgeschichte* 10 (2008): 223–37.

24. P. Grossman, "The Pilgrimage Center of Abû Mînâ," in *Pilgrimage and Holy Space in Late Antique Egypt*, ed. D. Frankfurter (Leiden, 1998), 281–302.

25. C. Lambert and P. Pedemonte Demeglio, "Ampolle devozionali ed itinerari di pellegrinaggio tra IV e VII secolo," *Antiquité Tardive* 2 (1994): 205–31.

26. Prokopios, *On Buildings* 1.6.5–8, in *Procopii Caesariensis opera omnia*, ed. J. Haury, rev. G. Wirth, 4 vols. (Leipzig, 1962–64), 4:30.

27. *The Miracles of St. Artemios*, ed. and trans. V.S. Crisafulli and J.W. Nesbitt (Leiden, 1997); Krueger, *Writing and Holiness* (2005, cited in n. 22), 64–70.

28. J.C. Skedros, "Shrines, Festivals, and the 'Undistinguished Mob,'" in *Byzantine Christianity*, ed. Krueger (2004, cited in n. 1), 81–101.

29. R. Van Dam, *Leadership and Community in Late Antique Gaul* (Berkeley, 1985), 230–55; idem, *Saints and their Miracles in Late Antique Gaul* (Princeton, 1993).

30. E.K. Fowden, *The Barbarian Plain: Saint Sergius between Rome and Iran* (Berkeley, 1999), 77–91.

31. A. Grabar, *Martyrium: Recherches sur le culte des reliques et l'art chrétien antique*, 3 vols. (Paris, 1943–46), 2:343–57; E. Kitzinger, "The Cult of Images in the Age before Iconoclasm," *Dumbarton Oaks Papers* 8 (1954): 83–150.

32. See *Oxford Dictionary of Byzantium*, s.vv. "altar" and "enkainia".

33. Egeria, *Travels*, 3.6, 11.1, 15.6, 21.3 (fruit); 8.3 (twigs); 19.19 (text), *Itinerarium Egeriae*, ed. P. Geyer, CCSL 175 (Turnhout, 1965), 27–90, trans. in J. Wilkinson, *Egeria's Travels* (Warminster, 1981); Piacenza Pilgrim, in *Antonini Placentini Itinerarium*, ed. P. Geyer, CSEL 175 (Turnhout, 1965), 42 (oil); 18, 46 (earth); 3 (rocks); 4, 7, 20, 24, 28 (water), trans. in J. Wilkinson, *Jerusalem Pilgrims before the Crusades* (Warminster, 2002), 142–49, 138–39, 150–51, 131–33, 139–42; Leyerle, "Pilgrim *Eulogiae* and Domestic Rituals" (2008, cited in n. 23).

34. Piacenza Pilgrim, *Travels* 11, 18, 20 (trans. Wilkinson, 136, 138–40). See G. Vikan, "Byzantine Pilgrims' Art," in *Heaven on Earth: Art and the Church in Byzantium*, ed. L. Safran (University Park, Pa., 2002), 229–66; D. Krueger, "Christian Piety and Practice in the Sixth Century," in *The Cambridge Companion to the Age of Justinian*, ed. M. Maas (New York, 2005), 291–315, esp. 302–10.

35. A. Grabar, *Ampoules de Terre Sainte (Monza-Bobbio)* (Paris, 1958), 34 (no. 3). See also G. Vikan, *Byzantine Pilgrimage Art* (Washington, D.C., 1982); idem, "Pilgrims in Magi's Clothing: The Impact of Mimesis on Early Byzantine Pilgrimage Art," in *The Blessings of Pilgrimage*, ed. R. Ousterhout (Urbana, 1990), 97–107.

36. J. Elsner, "Replicating Palestine and Reversing the Reformation: Pilgrimage and Collecting at Bobbio, Monza, and Walsingham," *Journal of the History of Collections* 9 (1997): 117–30.

37. B. Reudenbach, "Reliquien von Orten: Ein frühchristliches Reliquiar als Gedächtnisort," in *Reliquiare im Mittelalter*, ed. B. Reudenbach and G. Toussaint (Berlin, 2005), 21–42.

38. S.E.J. Gerstel and A.-M. Talbot, "The Culture of Lay Piety in Medieval Byzantium, 1054–1453," in *Eastern Christianity*, ed. M. Angold, The Cambridge History of Christianity 5 (Cambridge, 2006), 79–100, at 88–90.

39. Egeria, *Travels* 36.5, 37.1–3 (trans. Wilkinson, 155).

40. Gregory of Nyssa, *Life of Makrina* 30.19, ed. Pierre Maraval, *Vie de sainte Macrine* (Paris, 1971).

41. Paulinus of Nola, *Epistle* 31.1, in D.E. Trout, *Paulinus of Nola: Life, Letters, and Poems* (Berkeley, 1999), 151.

42. On the early history of the cult of the True Cross, see H.A. Klein, *Byzanz, der Westen und das 'wahre' Kreuz: Die Geschichte einer Reliquie und ihrer künstlerischen Fassung in Byzanz und im Abendland* (Wiesbaden, 2004), 19–31.

43. *Chronicon Paschale*, ad annum 614, p. 705, trans. M. Whitby and M. Whitby (Liverpool, 1989), 157. On the date and its problems, see H.A. Klein, "Niketas und das wahre Kreuz: Kritische Anmerkungen zum Chronicon Paschalis ad annum 614," *Byzantinische Zeitschrift* 94 (2001): 580–87.

44. Klein, *Byzanz, der Westen und das 'wahre' Kreuz* (2004, cited in n. 42), 134–37.

45. *The Glory of Byzantium: Art and Culture of the Middle Byzantine Era, A.D. 843–1261*, ed. H.C. Evans and W.D. Wixom (New York, 1997), 162–63.

46. Klein, *Byzanz, der Westen und das 'wahre' Kreuz* (2004, cited in n. 42), 206–19; Evans and Wixom, *Glory of Byzantium* (1997, cited in n. 45), 461–63.

47. K.N. Ciggaar, "Une description de Constantinople traduite par un pèlerin anglais," *Revue des Études Byzantines* 34 (1976): 211–67; G. Majeska, "Russian Pilgrims in Constantinople," *Dumbarton Oaks Papers* 56 (2002): 93–108.

48. O. Meinardus, "A Study of the Relics of Saints of the Greek Church," *Oriens Christianus* 54 (1970): 130–278, at 130–33.

49. P. Magdalino, "L'église du Phare et les reliques de la Passion à Constantinople (VIIe/VIIIe-XIIIe siècle), in *Byzance et les Reliques du Christ,* ed. J. Durand and B. Flusin (Paris, 2004), 15–30; I. Kalavrezou, "Helping Hands for the Empire: Imperial Ceremonies and the Cult of Relics at the Byzantine Court," in *Byzantine Court Culture from 829 to 1204,* ed. H. Maguire (Washington, DC, 2004), 53–79. H. A. Klein, "Sacred Relics and Imperial Ceremonies at the Great Palace of Constantinople," in *Visualisierungen von Herrschaft,* ed. F. A. Bauer, *BYZAS* 5 (2006): 79–99.

50. A. W. Carr and L. J. Morrocco, *A Byzantine Masterpiece Recovered: The Thirteenth Century Murals of Lysi, Cyprus* (Austin, 1991).

51. B. Flusin, "Les reliques de la Sainte-Chapelle et leur passé impériale à Constantinople," in *Le Trésor de la Sainte-Chapelle,* ed. J. Durand and M.-P. Laffitte (Paris, 2001), 20–31.

52. A. Cameron, "The Theotokos in Sixth-Century Constantinople: A City Finds Its Symbol," *Journal of Theological Studies* n.s. 19 (1978): 79–108; eadem, "The Virgin's Robe: An Episode in the History of Early Seventh-Century Constantinople," *Byzantion* 49 (1979): 42–56; M. van Esbroeck, "Le culte de la Vierge de Jérusalem à Constantinople aux VIe–VIIe siècles," in *Aux origines de la Dormition de la Vierge* (Aldershot, 1995), no. x.

53. G. Downey, "The Tombs of the Byzantine Emperors in the Church of the Holy Apostles in Constantinople," *Journal of Hellenic Studies* 79 (1959): 27–51.

54. John Skylitzes, *Synopsis historiarum* 47, ed. H. Thurn, CFHB (Berlin and New York 1973).

55. J. Wortley, "Relics and the Great Church," *Byzantinische Zeitschrift* 99 (2006): 631–47.

56. B. Pitarakis, "Objects of Devotion and Protection," in *Byzantine Christianity,* ed. Krueger (2006, cited in n. 1), 164–81; eadem, "Female Piety in Context: Understanding Developments in Private Devotional Practices," in *Images of the Mother of God: Perceptions of the Theotokos in Byzantium,* ed. M. Vassilaki (London, 2005), 153–66. Gerstel and Talbot, "The Culture of Lay Piety in Medieval Byzantium" (2006, cited in n. 38), 92–93.

57. George the Cleric, *The Translation of the Relics of Saint Theodora* 2, trans. A.-M. Talbot, in *Holy Women of Byzantium: Ten Saints' Lives in English Translation,* ed. A.-M. Talbot (Washington, DC, 1996), 219.

58. Ibid. 3 (trans. Talbot, 221).

59. Ibid. 9 (trans. Talbot, 225).

60. R. Krautheimer [with S. Ćurčić], *Early Christian and Byzantine Architecture,* 4th ed. (Harmondsworth, 1984), 124–28; P. Lemerle, "Saint Démétrius de Thessalonique et les problèmes du martyrion et du transept," *Bulletin de correspondance hellénique* 77 (1953): 660-94; J. C. Skedros, *Saint Demetrios of Thessaloniki: Civic Patron and Divine Protector, 4th–7th Centuries CE* (Harrisburg, 1999).

61. Evans and Wixom, *Glory of Byzantium* (1997, cited in n. 45), 168; A.-M. Talbot, "Epigrams in Context: Metrical Inscriptions on Art and Architecture in the Palaiologan Era," *Dumbarton Oaks Papers* 53 (1999): 75–90, at 84–85.

62. *Byzantium: Faith and Power* (1261–1557), ed. H.C. Evans (New York, 2004), 231–33 (emphasis added); A. Nagel and C.S. Wood, "What Counted as an 'Antiquity' in the Renaissance?" in *Renaissance Medievalisms,* ed. K. Eisenbichler (Toronto, 2009), 53–74, at 59, esp. n. 20.

63. Evans, *Byzantium: Faith and Power* (2003, cited in n. 62), 138–39; Talbot, "Epigrams in Context" (1999, cited in n. 61), 83–84.

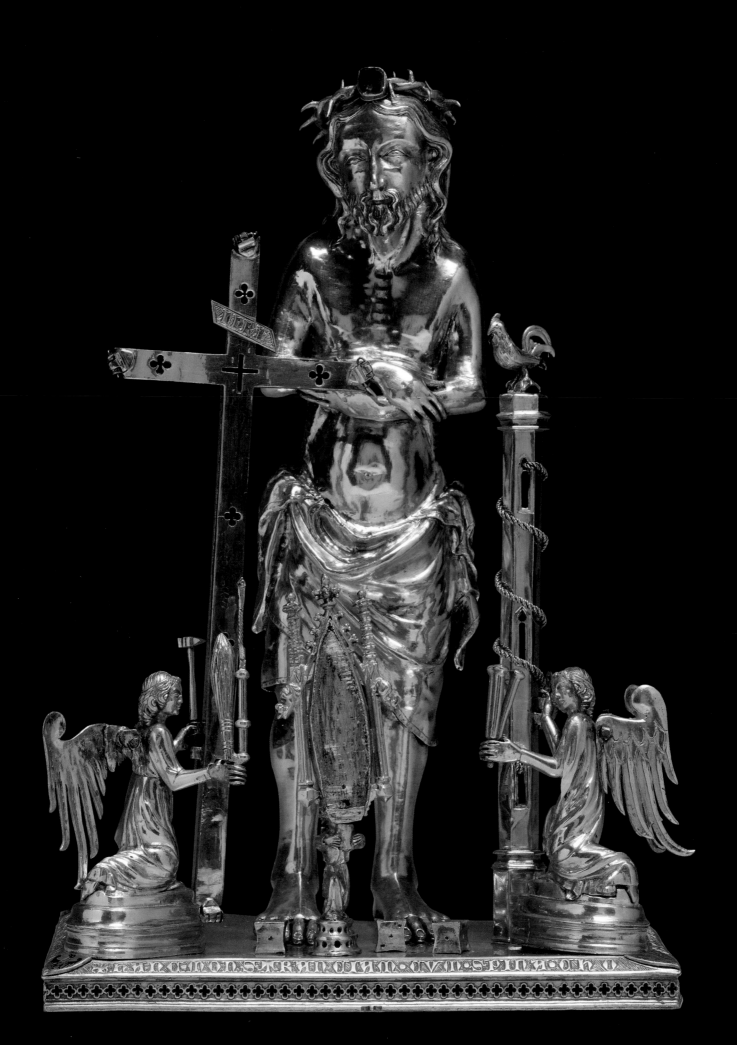

Relics and Their Veneration

ARNOLD ANGENENDT

Religious-Historical Background

To understand the Christian veneration of relics, we must look far back into the history of religion,[1] where it is consistently clear that the dead are not actually dead. Of course the soul travels to the other side, but the corpse retains a second soul with which the dead live on in their graves. The dead are actually able to reanimate themselves through the use of their skeletons, which must remain unscathed.[2] This was especially true for one's ancestors, among whom the primal ancestor was worshiped as "the very first man."[3] Ancestral graves remain the constant center of life, because there one's forebears are present, guaranteeing the line of descent and the dispensation of justice. Accordingly, this is where the hearth fires are located, where sacred community celebrations are held, where altars stand with their requisite cult objects, the bones, the idols, the magic stones, and medicines.[4] Just as the life-force of the ancestors lives on in their graves, so it lives on in their legacies, including their garments, symbols of office, staffs, or ceremonial weapons, as well as the dishes and bowls out of which they ate and drank, and of course especially in the elements of their bodies themselves, their nails and hair, their teeth, and above all their skulls. "These things form . . . in a sense small 'accumulators,' from which power may constantly be drawn, particularly in crisis situations."[5]

"On Earth as it is in Heaven"

In early Christianity, the religious and theological presuppositions required for the veneration of relics were absent at first. The community of Christians preserved Jesus's words but no relics. According to Paul, the earthly body is the "body of death" (Romans 7:24), "perishable" and "physical" (1 Cor. 15:42, 44). Not that Christianity would have favored a bodiless soul; rather, one hoped for a body at the Resurrection that would be "imperishable" and "heavenly" (1 Cor. 15:44, Vulgate: *corpus spiritale*).[6] The Evangelist Luke, however, describes the death of Jesus as an exhalation, giving the Spirit to the Father (Luke 23:46), according to which the Resurrection would be interpreted as a reunion of this spiritual soul with the body.[7] In fact, Jesus's body lying in the tomb did not decay (Acts 2:31, 13:37; cf. Ps. 16:10), and so the dead body gained a special meaning. To oppose the emerging gnosis that despised the body, the incorporation of the earthly body into the transfigured body was emphasized, relying on the Pauline "putting on": "For this perishable nature must put on the imperishable, and this mortal nature must put on immortality" (1 Cor. 15:53). According to Job (but only in the Vulgate), "And I shall be clothed again with my skin, and in my flesh I shall see my God" (Job 19:26).[8]

Although no relics were kept of the first Christians worthy of commemoration, like Stephen, Mary, Peter, or Paul,[9] we are told that after the martyrdom of Polycarp (d. 156), his bones, "more valuable to us than precious stones and finer than refined gold," were gathered and stored.[10]

Fig. 12. Sketch by Johan Baptist Straub (d. 1784) for the high altar in the Church of St. Rasso of Grafrath. Staatliche Graphische Sammlung, Munich (30493 z, trans. 2000/173)

Fig. 13. The Cry of the Martyrs (Rev. 6:9–11). From the *Facundus Beatus*, ca. 1047. Biblioteca nacional de España, Madrid, MS Vitr. 14-2, fol. 138v

Thus began the veneration of martyrs, applicable to the grave as well as to the corpse, to bones as well as blood. Its basis was an interpretive framework that would remain definitive from this point forward: the soul in heaven remains in contact with the earthly body, which shall renew itself at the Resurrection, but which is already filled with a heavenly *dynamis/virtus*, with a manna-like power. It was a miraculous double existence: the sacred power that the soul in heaven sends to the earthly body is transmitted through touching the body.[11]

This sacred power manifests itself as "glory"—a light effect like that of the sun, moon, and stars (1 Cor. 15:40–).[12] For Jesus Christ shall, according to the letter to the Philippians (3:21), "change our lowly body to be like his glorious body." Jesus himself had announced this expected glorification at the transfiguration on Mount Tabor: "And he was transfigured before them, and his face shone like the sun, and his garments became white as light" (Matt. 17:2). Similarly, one day "the righteous will shine like the sun in the kingdom of their Father" (Matt. 13:43). The most exhaustive theorist of the medieval cult of relics, Thiofrid of Echternach (d. 1110), abbot of an abbey in what is now Luxembourg and author of the most important medieval tract on relics,[13] wrote: "Because the saints have been transformed from earthly to heavenly clarity, they are able to emit celestial light and cause their earthly remains to shine. They illuminate their dead bodies from above."[14] A pillar of light may form between earth and heaven, just as lights tend to appear over the forgotten grave of a saint.[15] The name

of one of the most important pilgrimage sites, Compostela in Spain where the grave of the apostle James is located, means "field of stars" (*campus stellarum*), because flashes of light appeared there. Medieval piety maintained these images but not their theology; Thomas Aquinas (ca. 1225–74) doubted that there was a special light in mortal remains.[16]

The sacred power present in the bodies of the saints made their graves holy places. A common religious idea is that a holy place is situated where the earth "opens upward."[17] The classic example is Jacob's Ladder, the vision of the biblical patriarch Jacob, who, while spending the night in the desert, saw heaven open and the angels of God ascending and descending: "This is none other than the house of God, and this is the gate of heaven" (Gen. 28:17). In this sense a holy place is a very specific location, because only here can there be an opening toward the world above (fig. 12). In the New Testament the holiness of a place changes to the holiness of a person. Jesus refers to himself as the Son of Man, above whom we will see "heaven open and the angels of God ascending and descending." Accordingly, a holy place is always the place where Jesus Christ is and where one follows him. This is no longer local, but personal. Stephen, the first Christian martyr, could exclaim "I see the heavens opened" (Acts 7:56), because he had devoted himself entirely to Jesus Christ. With the veneration of relics that began in the second century, there once again emerged a localized sacred space, in Christianity this time: namely, above the grave of the martyr's body. Here, heaven stood open.

Elevation and Solemn Translation

St. Ambrose, bishop of Milan (d. 397), played a key role in the development of the veneration of relics.[18] He was the first within the Western Church to open the graves of martyrs, specifically, Gervasius and Protasius, on 17 June 386, moving their remains to a church altar.[19] By so doing he intended to establish a correspondence between heaven and earth: as the souls of the martyrs are located "under the heavenly altar" (Rev. 6:9), so their bodies should correspondingly have their place under the earthly altar (fig. 13). This "solemn translation" to the altar meant sanctification, precisely like that expressed in papal canonization beginning in the high Middle Ages. The connection between altar and relic tomb became common. Soon no altar was without relics; at the very least fragments were laid in a specially chiseled-out altar grave *(sepulchrum)*. In Carolingian times, as altars in churches were increasing in number, a special hierarchy resulted: the main altar was devoted to the Savior Jesus Christ, and the side altars to the saints.[20]

Papal Rome maintained the pre-Christian principle that a grave is sacrosanct, and therefore that any breach of the casket or transfer of the body was forbidden.[21] Nonetheless, Pope Gregory the Great (r. 590–604), to establish the correspondence between heaven and earth, had the choir space of Saint Peter's Basilica raised so that the upper part of the monument erected by Constantine over the grave of St. Peter could serve as the altar: Mass could be celebrated directly over the grave (fig. 14). Under the raised space Gregory constructed a crypt with a passageway leading to the tomb, so that visitors could touch it.[22]

In Gaul, on the other hand, translations were done in the manner of St. Ambrose. As soon as a miracle occurred at the grave of a Christian considered saintly, the body was raised and reburied inside the church, under the altar or as close to it as possible.[23] Soon there followed an inten-

sification of the practice in all of Western Christianity, finally accepted in Rome: the "elevation to the honor of the altars." The casket was placed at an elevation behind the altar and at a right angle to it, with the head of the saint lying to the west, so that he could look toward Christ returning from the east (fig. 15).[24] The elevation to the honor of the altars dissolved the correspondence between heaven and earth, according to which the soul as well as the body was to be located at the foot of both heavenly and earthly altars. According to an admonition in the Gospel, the light of a saint should not be concealed, but rather should shine before all (cf. Matt. 5:15),[25] and so the elevation was carried out. Although Rome had originally deemed the opening of tombs and especially the translation of relics to be sacrilegious, from the Carolingian period onward popes yielded to the universal desire for Roman saints' bodies, and allowed elevations as well as translations of saints' relics to the north.[26]

The "Complete" and "Incorrupt" Body

The presence of the saint's *virtus* in the relics was confirmed particularly in the "complete" and "incorrupt" body. Here an idea common to many religions was revived: that a life-force remained in the bodies of the dead and that its maintenance was the condition for the afterlife. In ancient Egypt mummification of the corpse was considered necessary for life after death.[27] In the Christian context two psalms were used as support for this idea: "He [the Lord] keeps all his [the righteous one's] bones, not one of them is broken" (Ps. 34 [33]:20), and further: "For thou does not . . . let they godly one see the Pit [Vulgate: *corruptio*/Corruption]" (Ps. 16 [15]:10). From this emerged the "legend of indestructible life,"[28] according to which the bodies of the martyrs were miraculously reconstituted and the bodies of specific saints remained undecayed.[29] St. Ambrose reported that the bodies

Fig. 14. The ring crypt of St. Peter. From B.M. Apollonj Ghetti and A. Ferrua, *Esplorazioni sotto la confessione di San Pietro in Vaticano* (Vatican City, 1951), vol. 1, 186, fig. 141.

Fig. 15. The high altar and reliquary chasse of St. Ursula (12th century), Church of St. Ursula, Cologne (unknown photographer, 1889)

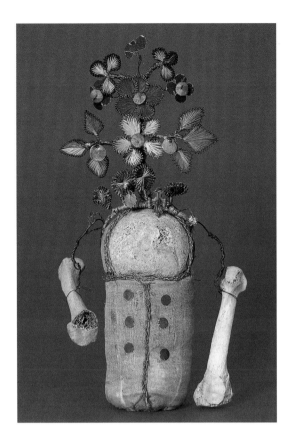

Fig. 16. Decorated bones from the Bentlager Reliquiengarten (1499), Museum Kloster Bentlage, Rheine.

of the martyrs Gervasius and Protasius that he had raised were "all complete,"[30] and St. Augustine (354–430) describes these as "incorrupt bodies."[31]

The phenomenon of the "complete" and "incorrupt" body came to have a special meaning in Christianity: uncorruptedness was interpreted as an early gift of grace, in anticipation of the imperishability hoped for at the Resurrection (1 Cor. 15:42). Thiofrid of Echternach provides the most comprehensive interpretation: the sanctified flesh, which is naturally subject to decay and falls to dust, is given a miraculous heavenly power thanks to divine mercy and the saint's own merits.[32] The corruptible flesh has acquired this new power through a transfer from Jesus Christ, who has made the saints members of his own body and thereby transmitted his own incorruptibility to their dead flesh.[33] Even the garments of the saints, as well as all their trappings, are implicated: as the favor of incorruptibility and holiness is poured from the incorruptible flesh of the Lord onto all flesh of the saints, so also from his merciful and miraculous clothing onto all implements of the saints.[34] Finally, Thiofrid refers to the pleasant aroma emitted by the relics and of course also by the uncorrupted bodies; he attributes this religious phenomenon of the divine aroma, known also in Antiquity, to the saints exuding the scent of their future incorruptibility rather than the odor of the corpse:[35] their corruptible flesh does not pollute the air, but rather fills the people with the sweet aroma of paradise.[36]

Thanks to the unscathed nature transferred to them from the glorified Jesus Christ, at the opening of their graves the bodies of the saints often emerge as "complete," "as if untouched," "as if still living," "only sleeping," with "fresh blood" and looking "rose-colored or lily-colored," and also filled with "heavenly aroma" and the "scent of paradise" (fig. 16).[37] To take just one example: the body of St. Hubert (d. 727), bishop of Liège (still venerated today as the patron saint of hunters), was found "complete and uninjured," and in fact "emitting a wonderful scent" and with "preserved garments." Karlmann (d. 754), son of Karl Martell (d. 741), arrived quickly for the elevation, along with the family and members of the court. They kissed the hands and feet of the dead saint, carried his body to the altar and made donations of cult objects as well as land.[38]

Sexual purity was especially important for the uncorrupted nature of the saints. The cultic conception of impurity *(pollutio)* reemerging in the early Middle Ages focused on the sexual stain,[39] leading to the notion that the celibate in particular maintained uncorrupted bodies. In Anglo-Saxon Christianity an early example was cited throughout the Middle Ages: the abbess Æthelthryth,[40] an East Anglian princess and founder of the monastery at Ely. Her body, which was found "uncorrupted,"[41] had experienced the "the divine miracle whereby her flesh would not corrupt after she was buried"; this was proof "that she had remained uncorrupted by contact with any man."[42] According to Ælred of Rievaulx (1110–67), chastity exceeds the other virtues because it is not only a quality of the soul, but "brings the corruptible flesh to a certain incorruptibility and facilitates a foretaste of the sweetness of the future resurrection."[43] Ælred referred to the sanctified King Edward the Confessor (r. 1042–66; canonized 1161), whose uncorruptedness he had seen himself.[44] Of the many saints' bodies that are still shown uncorrupted today, we need only refer to St. Clare of Assisi (1194–1253; canonized 1255).

Division of Relics

The division of relics is a relatively late phenomenon. No relic divisions are cited, "not even among the many solemn translations in the sixth century," in the writings of Gregory of Tours, who was the first to provide an extensive description of the cult of saints and relics.[45] The same holds true for Pope Gregory the Great: "Neither Gregory's dialogues nor his correspondence ledgers contain any hint of identifiable parts divided from the corpse of a saint."[46] In fact, anyone who took away part of a saint's body or sought to divide his bones suffered the saint's punishment.

Early on, however, it was permissible to take away superfluous parts or parts that continued growing after death, such as blood, hair, teeth, and fingernails. The fact that these were at first the only bodily relics allowed to be taken was supported on theological grounds. St. Augustine raised the issue, with reference to the resurrection of the body: "Thus if hair which had been cut and nails which have been trimmed would constitute a deformity if they were restored to the same places [at the Resurrection], they will not be restored."[47] Hair and nails were in a sense superfluous for the immortal body, and so one could remove them, which became the general practice. Concerning the elevation of St. Amandus (d. 676), the patron

saint of Belgium, we have the following report from the year 809: with a daring hand the abbot of the Monastery of St. Amandus took some of the undecayed parts; specifically, he cut the nails, for these had continued growing vigorously, "against nature," after the saint's death, even through the sleeves of the winding-sheet. The abbot also shaved off the saint's beard, which had similarly continued to grow after death. Finally he took out two teeth with a strong pair of tongs, miraculously causing blood to flow.[48] The reports of the opening of Charlemagne's tomb by Emperor Otto III (r. 983–1102) are dramatic: Charlemagne was found enthroned in his grave, no part of him decayed, missing only part of the tip of his nose, which Otto ordered remade. Otto also had the fingernails cut that were growing through Charlemagne's gloves, and removed a tooth from his mouth.[49] Now we can understand the exceptional status of the relics of Jesus and Mary. Only the hair and teeth of Jesus and Mary, both taken up bodily into heaven, remained, supplemented in Jesus's case by his umbilical cord (see cat. no. 124), the foreskin removed at his circumcision, and the blood spilled on the Cross,[50] and in Mary's case by her milk as well as her belt and shirt.[51] With martyrs, separated body parts were preserved; for instance, in decapitations the head was separately preserved, as were the heads of Peter and Paul in the Basilica of St. John at the Lateran in Rome.[52] Special head-reliquaries were made for these heads, the most numerous of which date to the high and late Middle Ages for the many companions of St. Ursula of Cologne.[53] In addition, the heads of non-martyrs were sometimes separated from their bodies in the Middle Ages, as was that of St. Elizabeth of Hungary in Marburg.[54]

The reluctance to divide up saints' bones faded in the ninth and tenth centuries. This was alluded to by Charlemagne's biographer Einhard (d. 840) and by Rabanus Maurus (d. 856), abbot of Fulda and archbishop of Mainz.[55] Einhard sent to Archbishop Hetti of Trier some of the relics of St. Marcellinus and St. Peter that he had arranged to have surreptitiously taken in Rome: "A part of the remains (cineribus) of the holy martyrs is coming to you, and this should be treated with the same honor that we are obligated to accord to their whole bodies."[56] It was thought permissible to take such parts, since the bones transported from Rome were mixed up with one another anyway. Still, a certain degree of reluctance persisted; Einhard reports that a heavenly intervention caused him to call back the relics of St. Marcellinus that he had given to the emperor's court: "So with great respect I returned those holy relic parts to the body from which they had been taken."[57] In the years following, however, the dispersal of bones became common practice. Whereas originally the saint and his sacred power could be manifested only in a complete body, they could now be manifested in individual parts as well. Veneration was accorded to them as to the whole body, and so we can speak of a "real presence of the saints in their relics."[58]

The majority of the relics were "contact" relics: objects of use such as garments, sandals, beds, or books, as well as grave objects, such as oil from the lamps burning there or dust from the gravestone. To guard against the constant risk of deception, the usual criteria were applied, especially certificates of authenticity, finger-wide strips of parchment with the saint's name, or even the fire test, since relics were considered not to be flammable.[59]

Tomb, Pilgrimage, and Miracle

Saints preferred to work their miracles at their earthly graves, with which their souls in heaven remained in contact.[60] St. Augustine had instructed that miracles occurring at tombs and in the presence of relics should be recorded, and this was done throughout the Middle Ages.[61] An examination of 5,000 reports of miracles in the eleventh and twelfth centuries has established that of 1,102 miracles where the location is mentioned, roughly 40 percent occurred directly upon uttering an invocation at the saints' shrines or upon touching their relics. There was also a temporal concentration, on the saint's feast day;[62] this was the anniversary of the saint's death,[63] or the day of his translation, as the moment of cultic sanctification. Of the 216 miracles for which there is evidence of what day the event occurred, 68—almost a third—occurred on the saint's feast day, 37 during Holy Week or Easter Week, and finally 32 during the Octave of Pentecost.[64] The best approach was to combine place and time, and to be at the saint's grave on his feast day.

The relic bodies and feast days of the great saints functioned as places and times of salvation and healing. The most important European pilgrimage sites of the Middle Ages were the tombs of the apostles Peter and Paul in Rome, as well as the grave of James in Compostela, that of Thomas Becket in Canterbury, St. Mary's cloak in Aachen, the Shrine of the Three Kings in Cologne, and the many places and festivals of innumerable other saints. In the late Middle Ages a veritable pilgrimage fever broke out; young and old suddenly left home, some even naked, to go on pilgrimages.[65] The relics that by then were plentiful everywhere were not only considered carriers of virtus, but were associated with indulgences, which were considered even more valuable. The relics that were brought together at All Saints' Church in Wittenberg by Frederick the Wise, Elector of Saxony (r. 1486–1525) and patron of Martin Luther, and in Halle by Cardinal Albrecht of Brandenburg (r. 1514–45), Luther's Catholic antagonist, were associated with indulgences representing a million years.[66] The late medieval theology of piety, however, which sought to connect theological knowledge with popular piety,[67] called for calm and restraint, and pushed for spiritual reflection.[68]

The saints' graves were not only the place where the saints worked miracles; they were also the source of spiritual authority. The most powerful grave of Christendom, that of St. Peter in Rome, demonstrated the insurmountable preeminence of the Roman Church. If the medieval popes, obviously lacking external power in the modern sense, nonetheless were able to exercise an all-encompassing authority, this was dependent on the presumption that "Peter was not just a biblical figure from long ago or high up in heaven, but rather remained present in his church."[69]

Relics and Patronage

Ambrose was the first person in the West to call a saint a patron. With the use of this designation he adopted an ancient legal concept.[70] In Roman law, *patrocinium* designated a patron's duty to protect a client, such as a landowner's duty to his tenants and a slaveholder's to his freedmen.[71] Correspondingly, the patron saint now had to protect his charges on earth from his position in heaven. St. Ambrose saw this duty of protection especially in the saint's intercession for the forgiveness of sins at the heavenly judgment, that is, for achieving eternal salvation.[72] According to Peter Brown, one of the overlooked strengths of Christianity in Late Antiquity was the subtle sense with which the ideal measures developed for patron saints were applied to and transformed social reality: the heavenly patron functioned as a model for all earthly patrons.[73]

Gregory of Tours demonstrates how the Middle Ages imagined a patron saint with the example of his own patron, St. Martin: at the judgment, the saint was supposed to hide him behind his back, protecting him from the angry gaze of God, even covering him, Bishop Gregory, with his cloak. St. Martin's cloak, the most famous relic of the early Middle Ages, takes on a special meaning on the basis of ancient legal symbolism: taking someone under one's coat *(pallio cooperire)* had long expressed an act of protection.[74] In the case of Gregory, the heavenly patron covers the earthly follower with his coat to save him from condemnation. In the high and late Middle Ages, Mary hides those who ask for protection under her cloak.[75]

The patronage of saints had a legal effect, with emphasis on the element of care. In ninth-century monastic documents, for instance, the older classification of peasants into free, half-free, and unfree disappears; instead, they now appear as "persons" *(homines)* of the corresponding saint. "Belonging" to a saint no longer meant being a free person or a slave, but becoming "his person," to be bound to the saint.[76] Noble donors, just like abbots or bishops, often released the unfree from bondage because doing so was considered worthy before God, and those who were freed in this way were subject to the saint for whose honor they had been freed.

There were also patrons of particular countries. Alcuin of York (d. 804) celebrated the great saints as protectors of the provinces of Charlemagne's realm: Peter and Paul in Rome, Ambrose in Milan, the Theban Legion in Agaunum (St. Moritz, Switzerland), Hilary in Poitiers, Martin in Tours, Denis in Paris, and Remigius in Champagne.[77] In the Middle Ages each country had its own patron, its "national saint": in France, St. Denis; in England, Edward the Confessor and St. Edmund; in Norway, King Olaf, and so on.[78] Beyond this, every profession had its own saint, just as there was a special patron saint for every matter of concern.

The patron saint was duty-bound to provide both earthly and heavenly protection. In return, however, he demanded loyalty of his followers, which was promised in a vow *(votum)* consummated in the form of a commendation. A number of Latin expressions were used convey the notion of giving oneself over to a saint: *se mancipare, se tradere, se devovere, se obligare, se offere,* and *se commendare.*[79] This commitment was similar to a vassal's commendation, and the corresponding ritual act was the vassal's hand gesture, putting one's hands together while the lord takes them between his own hands. If throwing oneself upon the ground or holding one's hands in the ancient orant gesture had been common earlier,[80] folded hands become the usual way to approach God and one's patron saint during the late Middle Ages. The vow made to the saint on this occasion was often spontaneous, especially in the late period. The young Luther made this kind of a spontaneous vow in June 1505 when, upon being almost struck by lightning, he cried, "Help me, St. Anna, I will become a monk."[81]

In general, a gift of thanks for being saved was recommended, at least the gift of a candle, with the utterance of certain prayers or the celebration of masses, at most a pilgrimage, but occasionally also, as with Luther, entering a monastery. The formula for this was: *votum fecit—gratiam accepit*—the one who was saved has made a vow, and the saint has accepted it.[82] Often one also made votive offerings: an image of the person saved or of a healed body part, then objects associated with the rescue or images of them. In the ancient church, votive offerings had been forbidden; instead, a gift to the poor was expected.[83] In the Middle Ages it had to be an offering to the saint. Thomas de Cantilupe, who left the position of chancellor of Oxford University to become bishop of Hereford, died in 1282, and was canonized in 1320, provides a good example. According to the documents of his canonization, the following thank offerings were placed on his grave: 170 silver vessels and 41 of wax, 129 human figures or parts in silver and 1,424 in wax, 77 animal figures, 108 crutches, and finally three wooden wagons.[84] The figures of persons and their parts not only illustrated their healing, but also represented a "speaking" gift of thanks. Votive images that had come into use in the late Middle Ages illustrate the circumstances of a miraculous salvation: the emergency situation, above this in the heavens the saint who has been called upon, and beneath, on earth, the person who has been saved.

Loyal followers understood the absence of help as their patron's lack of caring, and for this reason a saint who had evidently failed was punished.[85] For centuries there were rituals for this. The liturgy would be celebrated in a minimal way, with a lower voice, without special clothing, and with few lights, with a cross and relics lying on a penance mat before the altar, and the saint's tomb covered with thorns. The Second Council of Lyon (1274) condemned the humiliation of saints: "We strongly forbid doing this in the future."[86]

Relics and Art

The effects of the veneration of relics on art were many and varied. The halo and the mandorla are good examples, to start with.[87] In Antiquity there was the nimbus, the light surrounding the gods that shone around Apollo and also around heroic mortals.[88] In the New Testament a light effect was associated with the "golden crowns of glory" (cf. Rev. 4:4), or the "crown

of life" (James 1:12, Rev. 2:10). Scholastic theology concerned itself especially with the *aureola*, the diminutive form of the "golden crown" (*corona aurea*), which was now understood as a supplementary crown of virgins.[89]

Particular effects on figural sculpture should be noted. The practice of making an artistic totality, a "speaking reliquary," for relic parts began in the ninth century. Hans Belting observed that "the plastic image often gives a bodily relic the human appearance that it has lost in decay and division."[90] The oldest surviving example of such a figural reliquary is the tenth-century statue of St. Foy of Conques (fig. 17, and 140, fig. 48). The head had been preserved as a relic; this was completed with an artificial body, and, as Belting notes, "the statue presents this body in its three-dimensionality."[91] In the high and late Middle Ages, statues of saints often held relics within them and in this way "brought about" the bodily presence of the represented saint.[92] Moreover, the saint's effigy could be formed in such a way that it showed the immortal body. The archbishop of Cologne, Konrad von Hochstaden (d. 1261), who laid the cornerstone for the Cologne Cathedral, appears on his grave at his "perfected age" of 30, although he died at 60 (fig. 18). Michelangelo (d. 1564) understood his statue of Moses in the Church of San Pietro in Vincoli in Rome as a projected image of the great prophet's immortal body.

Similarly, the "elevation to the honor of the altars" had an effect on art. Whereas Christians had first placed the bones in a new casket after raising them, soon there was also talk of a "house" for these bones. In the history of religion, the grave is considered the "house of the dead" and therefore

was given a corresponding form, whether as an underground crypt or in the form of a tomb above ground.[93] Christians, however, hoped for a dwelling in heaven, according to Jesus's promise, "In my Father's house are many mansions (*mansiones*)" (John 14:2).[94] While old Church theology imagined only the martyrs and the great ascetics to be already in the mansions of heaven, the innumerable throng of the good were believed to be in a pre-heavenly paradise, in golden houses.[95] Pope Gregory the Great was able to report, on information obtained from a visionary on the other side, the presence of sweet-smelling, flower-covered fields with people dressed in white, and "for all the deceased there are individual houses in an abundance of light."[96] It is from this vantage that we may understand the fashioning of medieval reliquaries in the form of houses, churches, and temples: they represent the house on the other side.[97] The Anglo-Saxon church historian Bede (d. 735) described the relic shrine as a "small house" (*domuncula*).[98] The Shrine of the Three Kings in Cologne (see p. 157, fig. 61), the "most important of the medieval relic shrines,"[99] should be understood as a three-part house.[100]

In the high Middle Ages relics were no longer just set up on high, but now were specifically placed on view, which was justified by their light-effects. Originally relics always had to be veiled, and so they were covered in precious fabrics. Thiofrid of Echternach again has the explanation: as the Eucharist, the true flesh and blood of Jesus Christ, was fittingly surrounded by the external form of the bread and wine, so the relics also had to be externally enveloped.[101] The Fourth Lateran Council (1215) continued

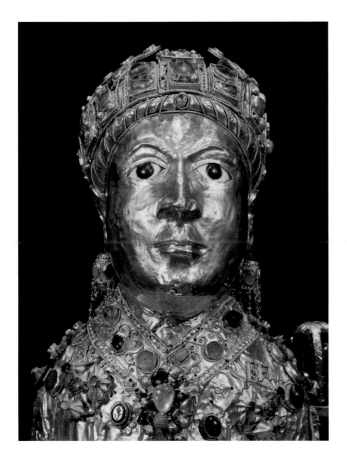

Fig. 17. Reliquary of St. Foy (detail). Conques, 9th century. L'abbatiale Sainte-Foy de Conques

Fig. 18. The tomb of Archbishop Konrad von Hochstaden (detail). 1261. Cathedral of Sts. Peter and Maria, Cologne

Fig. 19. The altar of St. Felix (d. ca. 350), 1752, in the Felix-Capelle, Kloster Gars am Inn, Bavaria. Photo Anton Legner

The most serious incursion came with the Enlightenment. In the Middle Ages, as in all time before, the dead were considered persons in a legal sense, legal subjects as well as subjects of relationships. That is, "they are present among the living."[107] Only in modernity have the dead lost their agency and legal status. Whereas Thomas More's Utopians continued to believe that the dead "are actually present among us, and hear what we say about them,"[108] for the Enlightenment all that remained was the memory. For now the dead were really dead. In his *Elective Affinities* (1809), Goethe describes villagers protesting the moving of gravestones, since that act wiped out the actual location of the dead: "But for all that, there were some parishioners who had already expressed disapproval that the place where their ancestors reposed was no longer marked, and that their memory had thus been so to speak obliterated. There were many who said that although the preserved gravestones showed who was buried there, they did not show where they were buried, and it was where they were buried that really mattered."[109] The villagers knew that their dead—despite the Enlightenment—were somehow there in the grave. But scientific medicine was stronger, and it declared the corpse finally and permanently lifeless. The question of whether the corpse might still have a life-force *(vis vegetativa)* within it, still a subject of intense discussion in the eighteenth century, ended with the irrefutable conclusion that it is dead, and even dangerous because of its poisons. Thus, instead of kissing the bones, a warning about poisoning; instead of a pleasant aroma, now the stench of decay. A religious form that had been central in human history ended at once, now appearing so absurd that it grew to epitomize the "dark" Middle Ages, cited as the prime example of priestly deception, as the article "Relique" in Diderot's *Encyclopédie* demonstrates. The church reform of Emperor Joseph II (r. 1764–90) removed all images and relics for which there was no verified evidence. The violence of the French Revolution wrought destruction in blind anger.[110] The ultramontane piety of the nineteenth century brought about a renewal, even believing it possible to establish through further research in the catacombs that saints and relics were venerated there by the early Christians, and to find new material for an affirmation of Catholic veneration of saints.[111] It is striking that the ersatz religions of the modern era created their own relics, in the case of the Nazis the monument for the "blood heroes" on the Königsplatz in Munich, or the embalmed Lenin near the wall of the Kremlin in Moscow.[112]

The veneration of relics provides a noteworthy example of the relationship of Christianity to archaic religion, the respect for the corpse as well as the concept of saints' graves belonging to the oldest marks of humanity. The early Christians remembered and preserved only Jesus's words and miracles, keeping no bodily relics. Similarly, they did not at first tend the graves and relics of the apostles and martyrs. Only in a second phase did the ancient religious practice of venerating relics return, producing an incomparable effect: the fathers and mothers of the faith personally present, caring for the faithful.

to maintain that, "old honorable relics should not be shown outside a reliquary."[102] Nonetheless, the practice of putting relics on show established itself. They were enclosed in glass boxes that made the contents visible—indeed, enabled the unveiled relics to shine out. On special feast days or in specific years the relics were publicly displayed, in the so-called *Heiltumsschau* (presentations of relics).[103]

The Reformers' Protest

Luther, who praised the model character of witnesses of the faith but rejected praying through saints, accepted images but not relics, which were for him "all dead things" *(alles tot Ding)*.[104] The Calvinists congratulated themselves that no saints had resisted when they destroyed the images of the saints or when they burned their relics. On the Catholic side, the Council of Trent affirmed the veneration of saints as well as relics, but sought to curb abuses.[105] The rediscovery of the Roman catacombs had an invigorating effect on the discipline of Christian archeology, but even more so on the translation of relics. "Catacomb saints" were conveyed as "complete bodies" from Rome to Switzerland, southern Germany, and Austria. They were placed on altars, decorated with the heavenly adornment of white garments and pearls, and presented for veneration (fig. 19).[106]

Notes

1. A. Angenendt, *Heilige und Reliquien: Die Geschichte ihres Kultes von den Anfängen bis zur Gegenwart*, 3rd ed. (Munich, 2007), 102–22.

2. K. E. Müller, *Das magische Universum der Identität: Elementarformen sozialen Verhaltens. Ein ethnologischer Grundriß* (Frankfurt am Main and New York, 1987), 174.

3. Ibid., 95.

4. Ibid., 124.

5. Ibid., 177.

6. P. Hoffmann, *Die Toten in Christus: Eine religionsgeschichtliche und exegetische Untersuchung zur paulinischen Eschatologie*, Neutestamentliche Abhandlungen, NF 2 (Münster 1966), 247.

7. P. Hoffmann, "Auferstehung II.1" (Auferstehung Jesu. Neues Testament), in *Theologische Realenzyklopädie* 4 (1979): 478–513, at 505.

8. A. Kehl, " Gewand (der Seele)," *RAC* 10 (1978): cols. 945–1025, at 987–97.

9. B. Kötting, "Grab," *RAC* 12 (1983), cols. 366–97, at 383–91.

10. *The Martyrdom of Polycarp* 18.2–3; trans. in *The Apostolic Fathers*, II.3, ed. J. B. Lightfoot and J. R. Harmer, 2nd ed., ed. Michael W. Holmes (Grand Rapids, Mich., 1992).

11. Angenendt, *Heilige und Reliquien* (2007, cited in n. 1), 102–22.

12. G. de Nie, *Views from a Many-Windowed Tower: Studies of Imagination in the Works of Gregory of Tours* (Amsterdam 1987), 133–211.

13. M. C. Ferrari, introduction to Thiofrid of Echternach, *Flores epytaphii sanctorum*, CCCM 133 (Turnhout 1996), VIII–XCII, at XXXV.

14. Thiofrid of Echternach, *Flores epytaphii sanctorum* 2.7, CCCM 133, p. 53, l. 133.

15. A. Angenendt, "Der Leib ist klar, klar wie Kristall," in K. Schreiner, ed., *Frömmigkeit im Mittelalter: Politisch-soziale Kontexte, visuelle Praxis, körperliche Ausdrucksformen* (Munich, 2002), 387–98.

16. Thomas Aquinas, *Summa Theologica* III, Suppl., Question 79.3.

17. M. Eliade, *Das Heilige und das Profane: Vom Wesen des Religiösen* (Frankfurt am Main, 1990), 81.

18. B. Kötting, "Der frühchristliche Reliquienkult und die Bestattung im Kirchengebäude," in his *Ecclesia peregrinans: Das Gottesvolk unterwegs*, Gesammelte Aufsätze, vol. 2, Münsterische Beiträge zur Theologie 54.2, (Münster, 1988), 90–119, at 109; also T. Baumeister, "Heiligenverehrung I," *RAC* 14 (1988): cols. 98–150, at 128–35.

19. E. Dassmann, "Ambrosius und die Märtyrer," *JAC* 18 (1975), 49–68; V. Zangara, "L'inventio dei corpi dei martiri Gervasio e Protasio: Testimonianze di Agostino su un fenomeno di religiosità popolare," *Augustinianum Roma* 21 (1981): 119–33.

20. A. Angenendt, "In honore salvatoris—Vom Sinn und Unsinn der Patrozinienkunde," *Revue d'Histoire Ecclésiastique* 97 (2002): 431–56, 791–823.

21. J. M. McCulloh, "From Antiquity to the Middle Ages: Continuity and Change in Papal Relic Policy from the Sixth to the Eighth Century," in E. Dassmann and K. S. Frank, eds., *Pietas: Festschrift für Bernhard Kötting*, JAC Supp. 8 (Münster, 1980), 313–24.

22. E. Kirschbaum, *Die Gräber der Apostelfürsten* (Frankfurt am Main, 1957), 156–65.

23. A. Angenendt, "In porticu ecclesiae sepultus: Ein Beispiel von himmlisch-irdischer Spiegelung," in N. Staubach and H. Keller, eds., *Iconologia sacra: Mythos, Bildkunst und Dichtung in der Religions- und Sozialgeschichte Alteuropas (Festschrift für Karl Hauck)* (Berlin and New York, 1994), 68–80.

24. A. Angenendt, "Zur Ehre der Altäre erhoben: Zugleich ein Beitrag zur Reliquienverehrung," *RQ* 89 (1994): 221–44.

25. A. Angenendt, "Der Leib ist klar, klar wie Kristall," in K. Schreiner, ed., *Frömmigkeit im Mittelalter: Politisch-soziale Kontexte, visuelle Praxis, körperliche Ausdrucksformen* (Munich, 2002), 387–98.

26. H. Röckelein, *Reliquientranslationen nach Sachsen im 9. Jahrhundert: Über Kommunikation, Mobilität und Öffentlichkeit im Frühmittelalte*, Beihefte der Francia 48 (Stuttgart, 2002); K. Herbers, "Rom in Frankreich—Rombeziehungen durch Heilige in der Mitte des 9. Jahrhunderts," in D. R. Bauer et al., eds., *Mönchtum—Kirche—Herrschaft: 750–1000* (Sigmaringen, 1998), 133–69.

27. E. Brunner-Traut, *Gelebte Mythen: Beiträge zum altägyptischen Mythos*, 3rd ed. (Darmstadt, 1988).

28. T. Baumeister, *Martyr invictus: Der Martyrer als Sinnbild der Erlösung in der Legende und im Kult der frühen koptischen Kirche. Zur Kontinuität des ägyptischen Denken*, Forschungen zur Volkskunde 46 (Münster, 1970).

29. A. Angenendt, "Corpus incorruptum: Eine Leitidee der mittelalterlichen Reliquienverehrung," *Saeculum* 42 (1991): 320–46.

30. Ambrosius, *Epistula* 77.2, CSEL 82.3, p. 128, l. 17.

31. Augustinus, *Confessiones* 9.7, CSEL 33, p. 208, l. 23.

32. Thiofrid of Echternach, *Flores epytaphii sanctorum* 1.3, CCCM 133, p. 16, l. 23.

33. Ibid., 1.4, CCCM 133, p. 20, l. 80.

34. Ibid., 3.4, CCCM 133, p. 67, l. 43.

35. Kötting, "Wohlgeruch der Heiligkeit," in his *Ecclesia peregrinans* (as cited in n. 18), 23–33.

36. Thiofrid of Echternach, *Flores epytaphii sanctorum* 1.5, CCCM 133 p. 21, l. 1.

37. Angenendt, "Corpus incorruptum" (1991, cited in n. 29), 322.

38. *Vita Hugberti* 20, MGH ScriptRerMerov 6, p. 495, l. 24.

39. H. Lutterbach, *Sexualität im Mittelalter: Eine Kulturstudie anhand von Bußbüchern des 6. bis 12. Jahrhunderts*, Beihefte zum Archiv für Kulturgeschichte 43 (Cologne and Weimar 1999).

40. D. Rollason, *Saints and Relics in Anglo-Saxon England* (Oxford 1989), 34.

41. Beda Venerabilis, *Historia ecclesiastica gentis Anglorum* 4.19, ed. and trans. B. Colgrave (Latin-English edition) (Oxford, 1969), 293

42. "Nam etiam signum diuini miraculi, quo eiusdem feminae sepulta caro corrumpi non potuit, indicio est quia a uirili contactu incorrupta durauerit." Ibid., 4.19, ed. and trans. B. Colgrave, 293.

43. Ælred von Rievaulx, *Sermo* 14.21, CCCM 2A, p. 119, l. 181; cf. *Sermo* 45.11, CCCM 2A, p. 355, l. 119.

44. Ælred von Rievaulx, *Vita Sancti Edwardi Regis I*, PL 195:782 B–D.

45. M. Weidemann, "Reliquie und Eulogie: Zur Begriffsbestimmung geweihter Gegenstände in der fränkischen Kirchenlehre des 6. Jahrhunderts," in Joachim Werner, ed., *Die Ausgrabungen in St. Ulrich und Afra in Augsburg, 1961–1968*, text volume, Münchner Beiträge zur Vor- und Frühgeschichte 23 (Munich, 1977), 353–73, at 371f.; see also M. Vieillard-Troiekouroff, *Les monuments religieux de la Gaule d'après les oeuvres de Grégoire de Tours* (Paris, 1976), 377f.: "On ne semble pas encore en Gaule avoir mutilé les corps des saints pour en distribuer des reliques."

46. J. M. McCulloh, "The Cult of Relics in the Letters and 'Dialogues' of Pope Gregory the Great: A Lexiographical Study," *Traditio* 32 (1976): 153; idem, "From Antiquity to the Middle Ages" (1980, cited in n. 21), 313.

47. Augustinus, *De civitate Dei* 22.19, CCSL 48, p. 837, l. 44.

48. *Vita Amandi* 7, MGH ScriptRerMov 5, p. 479, l. 1.

49. K. Görich, "Otto III. öffnet das Karlsgrab in Aachen: Überlegungen zu Heiligenverehrung, Heiligsprechung und Traditionsbildung," in G. Althoff and E. Schubert, eds., *Herrschaftsrepräsentation im ottonischen Sachsen*, Vorträge und Forschungen des Konstanzer Arbeitskreises für mittelalterliche Geschichte 46 (Sigmaringen, 1998), 381–430.

50. A. Angenendt, "Praeputium Domini," *LThK* 8, 3rd ed. (1999): col. 485.

51. Angenendt, *Heilige und Reliquien* (2007, cited in n. 1), 214–29.

52. Kirschbaum, *Die Gräber der Apostelfürsten* (1957, cited in n. 22), 208–11.

53. F. G. Zehnder, *Sankt Ursula: Legende—Verehrung—Bilderwelt* (Cologne, 1985).

54. J. Petersohn, "Kaisertum und Kultakt in der Stauferzeit," in Petersohn, ed., *Politik und Heiligenverehrung im Hochmittelalter*, Vorträge und Forschungen, Konstanzer Arbeitskreis für Mittelalterliche Geschichte 42 (Sigmaringen, 1994), 101–46, at 117–23.

55. Angenendt, "Zur Ehre der Altäre erhoben" (1994, cited in n. 24), 237–44; H. R. Seeliger, "Einhards römische Reliquien: Zur Übertragung der Heiligen Marzellinus und Petrus ins Frankenreich," *RQ* 83 (1988): 58–75.

56. Einhard, *Epistula* 45, MGH Ep 5, p. 132, l. 27,

57. Einhard, *Translatio et miraculi SS. Marcellini et Petri* II.11, MGH SS 15, p. 248, l. 30.

58. P. Dinzelbacher, "Die 'Realpräsenz' der Heiligen in ihren Reliquien und Gräbern nach mittelalterlichen Quellen," in P. Dinzelbacher and D. R. Bauer, eds., *Heiligenverehrung in Geschichte und Gegenwart* (Ostfildern, 1990), 115–74.

59. K. Schreiner, "'Discrimen veri ac falsi': Ansätze und Formen der Kritik in der Heiligen- und Reliquienverehrung des Mittelalters" *Archiv für Kulturgeschichte* 48 (1966): 1–53.

60. F. Graus, *Volk, Herrscher und Heiliger im Reich der Merowinger: Studien zur Hagiographie der Merowingerzeit* (Prague, 1965), 62–88.

61. C. Gnilka, "Der neue Sinn der Worte," *Frühmittelalterliche Studien* 26 (1992): 32–64; A. Angenendt, "Grab und Schrift," in H. Keller, C. Meier, and T. Scharff, eds., *Schriftlichkeit und Lebenspraxis im Mittelalter: Erfassen, Bewahren, Verändern* (Akten des Internationalen Kolloquiums 8.–10.6.1995) (Munich, 1999), 9–23.

62. P.-A. Sigal, *L'homme et miracle dans la France medievale (XIe–XIIe siècle)* (Paris, 1985), 188–96.

63. A. Stuiber, "Geburtstag," *RAC* 9 (1976), cols. 217–43.

64. Sigal, *L'homme et miracle* (1985, cited in n. 62), 68–73.

65. K. Arnold, *Niklashausen 1476: Quellen und Untersuchungen zur sozialreligiösen Bewegung des Hans Behem und zur Agrarstruktur eines spätmittelalterlichen Dorfes*, Saecula spiritalia 3 (Baden-Baden, 1980).

66. Angenendt, *Heilige und Reliquien* (2007, cited in n. 1), 161f.

67. B. Hamm, "Frömmigkeit als Gegenstand theologiegeschichtlicher Forschung: Methodisch-historische Überlegungen am Beispiel von Spätmittelalter und Reformation," *Zeitschrift für Theologie und Kirche* 74 (1977): 464–97.

68. K. Schreiner, "'Peregrinatio laudabilis' und 'peregrinatio vituperabilis': Zur religiösen Ambivalenz des Wallens und Laufens in der Frömmigkeitstheologie des späten Mittelalters," in *Wallfahrt und Alltag in Mittelalter und früher Neuzeit*, Veröffentlichungen des Instituts für Realienkunde des Mittelalters und der frühen Neuzeit 14 (Vienna, 1992), 133–63, at 133.

69. R. Schieffer, "Papsttum und mittelalterliche Welt," in R. Hiestand, ed., *Hundert Jahre Papsturkundenforschung: Bilanz—Methoden— Perspektiven. Akten eines Kolloquiums zum hundertjährigen Bestehen der Regesta Pontificum Romanorum vom 9.–11. Oktober 1996 in Göttingen*, Abhandlungen der Akademie der Wissenschaften zu Göttingen. Philologisch-Historische Klasse, 3rd ser., vol. 261 (Göttingen, 2003), 373–90, at 388 (quotation), 382.

70. E. Dassmann, "Ambrosius und die Märtyrer," *JAC* 18 (1975): 49–68, at 59 n. 83 with examples; A. M. Orselli, *L'idea e il cuto del santo patrono cittadino nella letteratura latina cristiana*, Studi e ricerche, n.s. 12 (Bologna, 1965), 332–66.

71. H.-J. Becker, " Patrozinium," *Handwörterbuch zur Deutschen Rechtsgeschichte* 3 (1984): cols. 1564–68, at col. 1564.

72. Dassmann, "Ambrosius und die Märtyrer" (1975, cited in n. 70), 60.

73. P. Brown, *The Cult of the Saints: Its Rise and Function in Latin Christianity* (Chicago, 1981), 67.

74. A. Erler, "Mantelkinder," *Handwörterbuch zur Deutschen Rechtsgeschichte* 3 (1984): cols. 255–58; R. Kahsnitz, *Die Gründer von Laach und Seyn: Fürstenbildnisse des 13. Jahrhunderts*, Germanisches Nationalmuseum Nürnberg 4. Juni bis 4. Oktober 1992, ed. G. Bott (Nuremberg, 1992), 59–65.

75. K. Schreiner, *Maria: Jungfrau, Mutter, Herrscherin* (Vienna, 1994), 333–66, 373.

76. L. Kuchenbuch, *Bäuerliche Gesellschaft und Klosterherrschaft im 9. Jahrhundert: Studien zur Sozialstruktur der Familia der Abtei Prüm*, Vierteljahresschrift für Sozial- und Wirtschaftsgeschichte, Supp. 66 (Wiesbaden, 1978), 360f.

77. *Vita Willibrodri* 32, MGH ScriptRerMerov 7, p. 139, ll. 7–24.

78. Petersohn, ed., *Politik und Heiligenverehrung im Hochmittelalter* (1994, cited in n. 54).

79. M. Matheus, "Adlige als Zinser von Heiligen: Studien zu Zinsverhältnissen geistlicher Institutionen im hohen Mittelalter" (masch., Habilitationsschrift) (Trier 1989).

80. Sigal, *L'homme et le miracle* (as cited in n. 62), 126f.

81. M. Brecht, *Martin Luther*, vol. 1 (Stuttgart, 1981), 57.

82. L. Kriss-Rettenbeck, *Ex-voto: Zeichen, Bild und Abbild im christlichen Votivbrauchtum* (Zürich, 1972), 155–227.

83. *Synodus Dioecesana Autissiodorensis* (561/605), chap. 3; ed. C. Clercq, CCSL 148A (Turnhout, 1963), 265, l. 7

84. A. Vauchez, *La sainteté en Occident aux derniers siècles du moyen âge: D'après les procès de canonisation et les documents hagiographiques*, 2nd. ed. (Rome, 1988), 534.

85. P. Geary, "Humiliation of Saints," in S. Wilson, ed., *Saints and Their Cults: Studies in Religious Sociology, Folklore and History* (Cambridge, 1983), 123–40.

86. Concilium Lugdunense II, can. 17, ed. C.J. Hefele and H. Leclercq, *Histoire des conciles d'après les documents originaux*, vol. 6 (Paris, 1914), 195.

87. W. Messerer, "Mandorla," *LCI* 3 (1971): cols. 147–49; H.P. L'Orange, *Studies on the Iconography of Cosmic Kingship in the Ancient World*, Institutet for sammenlignende kulturforskning A 23 (Oslo, 1953).

88. W. Weidlé, "Nimbus," *LCI* 3 (1971): cols. 323–32.

89. N. Wicki, *Die Lehre von der himmlischen Seligkeit in der mittelalterlichen Scholastik von Petrus Lombardus bis Thomas von Aquin*, Studia Friburgensia 9 (Freiburg [Switzerland], 1954), 298–318.

90. H. Belting, *Bild und Kult: Eine Geschichte des Bildes vor dem Zeitalter der Kunst* (Munich, 1990), 331.

91. Ibid., 333.

92. A. Legner, *Reliquien in Kunst und Kultur: Zwischen Antike und Aufklärung* (Darmstadt, 1995), 232–55.

93. B. Kötting, "Grab," *RAC* 12 (1983): cols. 366–97; K. Stähler, "Grabbau" *RAC* 12 (1983): cols. 397–429.

94. E. Stommel, "Domus aeterna" *RAC* 4 (1959): cols. 109–28.

95. A. Angenendt, *Geschichte der Religiosität im Mittelalter*, 4th ed. (Darmstadt, 2009), 685–89.

96. Gregory the Great, *Dialogi* 4.37.9, Sources chrétiennes 265 (Paris, 1980), 130, l. 69.

97. E. Stommel, "Domus aeterna" *RAC* 4 (1959): col. 125.

98. Beda Venerabilis, *Historia ecclesiastica gentis Angelorum* 3.19, 4.3, ed. and trans. B. Colgrave (Latin-English edition) (Oxford, 1969), 277, 347.

99. R. Lauer, "Dreikönigenschrein," *LM* 3 (1986): col. 1389f.

100. R. Lauer, "Dreikönigenschrein," in A. Legner, ed., *Ornamenta ecclesiae: Kunst und Künstler der Romantik*, exh. cat., Schnutgen Museums, vol. 2 (Cologne, 1985), 216–24.

101. M.C. Ferrari, introduction to Thiofrid of Echternach, *Flores epytaphii sanctorum*, CCCM 133, XLIX–LI.

102. Concilium Lateranense 4, can. 62, ed. R. Foreville, Lateran I–IV, Geschichte der ökumenischen Konzilien 6 (Mainz, 1971), 439.

103. H. Kühne, *Ostensio reliquiarum: Untersuchungen über Entstehung, Ausbreitung, Gestalt und Funktion der Heiltumsweisungen im römisch-deutschen Regnum*, Arbeiten Zur Kirchengeschichte 75 (Berlin and New York, 2000).

104. Luther, *Deutsch Catechismus* 1529, Weimarer Ausgabe 30, 123–238, 145 l. 19.

105. H. Jedin, "Die Entstehung und Tragweite des Trienter Dekrets über die Bilderverehrung," in his *Kirche des Glaubens, Kirche der Geschichte: Ausgewählte Aufsätze und Vorträge* (Freiburg, Basel, and Vienna, 1966), 460–98.

106. H. Achermann, *Die Katakombenheiligen und ihre Translationen in der schweizerischen Quart des Bistums Konstanz*, Beiträge zur Geschichte Nidwaldens 38 (Stans, 1979).

107. O.G. Oexle, "Die Gegenwart der Toten," in H. Braet and W. Verbeke, eds., *Death in the Middle Ages*, Mediaevalia Lovaniensia, Studia 9 (Leuven, 1983), 19–77.

108. Thomas More, *Utopia*, II: *De religionibus utopiensum*, ed. and trans. G.M. Logan, R.M. Adams, and C.H. Miller (Cambridge, 1995), 227, ll. 16–17.

109. Johann Wolfgang von Goethe, *Die Wahlverwandtschaften*, ed. E. Trunz, *Werke* 6 (Hamburger Ausgabe), 10th ed. (Munich, 1981), 361; [= *Elective Affinities*, trans R. J. Hollingdale (London, 1971), 156].

110. Angenendt, *Heilige und Reliquien* (2007, cited in n. 1), 261–73.

111. V. Saxer, "Zwei christliche Archäologen in Rom: Das Werk von Giovanni Battista de Rossi und Joseph Wilpert," *RQ* 89 (1994): 163–72.

112. Angenendt, *Heilige und Reliquien* (2007, cited in n. 1), 316–30.

1
Garland Sarcophagus

Roman (Asia Minor), ca. 150–80
Dokimeion marble; 83.5 × 143.4 × 69.9 cm
The Walters Art Museum, Baltimore (23.29)
Cleveland and Baltimore

PROVENANCE: So-called Licinian tomb, Rome, 1885; Don Marcello Massarenti Collection, Rome; Henry Walters, Baltimore, 1902, by purchase; Walters Art Museum, 1931, by bequest

BIBLIOGRAPHY: Lehmann-Hartleben and Olsen 1942, 15, 19, 21, 67–70; Ward-Perkins 1975/76; Bentz 1997/98, 63, 88; Van Keuren 2002, 121, 122

Starting in the second century, Romans began to favor inhumation, or burial, rather than cremation, and the upper strata of Roman society could afford finely carved marble sarcophagi for their tombs. This sarcophagus, festooned with carved garlands, was likely made in Phrygia, a region of present-day Turkey, and then shipped to Rome, where it was used in the tomb of a wealthy Roman family. Scientific analysis of the marble places it in the Dokimeion quarries, and the artistic style is similar to other works known to be from that region. This example has several incomplete areas across all four faces of the exterior, suggesting that work was interrupted at an intermediary stage and that it might have been needed at shorter notice than expected; many other known examples have also been left unfinished, and it is often impossible to determine the reason. Many of the sarcophagi produced in the Roman Empire, and particularly those made in Asia Minor, have a lid shaped like a gabled roof. This architectural appearance might have been considered appropriate to house the dead, or it might have been intended to suggest a temple, presenting the deceased as a hero worthy of veneration. The garlands carved in stone represent the real swags of leaves and fruit that were used to adorn altars and tombs. Roman tombs often housed the remains of several generations and could be visited by family members, who would hold ceremonial meals and perform other rituals in the tombs at certain times of the year. The tomb complex in which the Garland Sarcophagus was found included large carved sarcophagi, small altars with cremated remains, and a number of carved portrait busts. / KBG

2
Column Sarcophagus with Christ and the Apostles

Roman, mid-4th century
White marble; 62 × 207 × 110 cm
Museo Cristiano, Musei Vaticani (31475)

PROVENANCE: Vatican, site of the Vannutelli quarry, 1841

BIBLIOGRAPHY: Garrucci 1872–80, 5:33, pl. 317.1; Ficker 1890, 82, no. 138; Marucchi 1910, 17, pl. 21.3; Wilpert 1929, 124, pl. 124.2; Deichmann, Bovini, and Brandenburg 1967, 52–53, no. 53, pl. 18 (with previous bibliography); Liverani 1999, 152–53; U. Utro in Vatican 2006, 244, 250, no. 13

This sarcophagus was excavated from an area behind the Vatican basilica that once was likely occupied by an extension of the necropolis to the east. Another sarcophagus with columns and biblical scenes also comes from this area (Museo Cristiano, 31489, 31490), as does a funerary stele inscribed LICINIAE AMIATI BE/NE MERENTI VIXIT (to the well-deserving Licinia Amias who lived . . .), famous for its reference to Christ as ΙΧΘΥC ΖΩΝΤΩΝ (fish of the living), today in the Museo Nazionale Romano (67646).

The mid-fourth-century workshop responsible for this sarcophagus reused a block from an entablature (the molding is still visible at the back of the sarcophagus). The front is decorated with seven figures each dressed in a tunic and a pallium and holding a roll, the attribute of philosophers. Each occupies a niche formed by fluted columns with Corinthian capitals that support alternating round and pointed arches. Above each capital, in the spandrels of the arches, are small male busts inserted among shells. A beardless Christ occupies the center of the composition, turning to engage the neighbor on his right: Christ is warning Peter, recognizable by his beard, of his imminent betrayal. The gesture of Christ, which corresponds to that used in Antiquity to signal the number eight (an allusion to the eighth day of Resurrection) identifies the scene, as does the rooster perched on the tree next to Peter and the apostle's gesture of doubt. The other figures on each side (the faces of three are plaster reconstructions) should also be identified as apostles. In early Christian art the number of six was often used as a reduction of twelve to represent the entire apostolic college. The identification of the eight busts is more difficult. They are likely generic images of saints (biblical figures, martyrs, or other personages venerated by the emerging Christian Church, such as famous popes, etc.); their number was probably dictated by the available space, but their meaning should be related to similar groups of unidentified figures in fourth-

century catacomb wall paintings, gold glass tomb decorations (see cat. nos. 8–10), and sarcophagi. The front of this sarcophagus is thus occupied by images dear to the imagination of the early Christian faithful: Christ, the apostles, and the saints, invoked as protectors of the deceased buried within.

The sarcophagus is exhibited here for the first time after an extensive cleaning and restoration executed by Massimo Bernacchi of the Vatican Museums' stone conservation laboratory (directed by Guy Devreux) under the direction of the author. The treatment has completely reinstated the object's legibility. / UU

3
Tree Sarcophagus with the Anastasis

Roman, ca. 340–50
Fine-grained white marble; 62 × 206 × 73 cm
Museo Cristiano, Musei Vaticani (28591)

PROVENANCE: Rome, Basilica of St. Paul's Outside the Walls

BIBLIOGRAPHY: Garrucci 1872–80, 5:75, pl. 350.2; Ficker 1890, 109, no. 164; Marucchi 1910, 20, pl. 27.1; Wilpert 1929, 125, 164, pl. 142.3; Deichmann, Bovini, and Brandenburg 1967, 57–58, no. 61, fig. 19 (with earlier titles); G. Spinola in Rome 2000b, 207–8, no. 48; Koch 2000, 45, 85–86, 362 (updated bibliography on p. 294); U. Utro in Vatican 2009, 122–24, no. 10

This fine and unusually well-preserved sarcophagus comes from the Roman basilica of St. Paul Outside the Walls and is one of several mid-fourth-century Roman sarcophagi with identical iconography and composition. Like the others, it is dominated by the central image of the Anastasis (Greek for "resurrection"). Modeled on Roman triumphal banners, this is one of the earliest depictions of Christ's victory over death. Here, the Cross is stripped of its associations with abject humiliation and becomes a symbol of triumph: a standard, with Christ's name inscribed in a *chi-rho* monogram at the top, framed within a crown bearing fruit with a gem at the center, flanked by two doves. The two ineffectual soldiers on each side of the Cross allude to the Gospel of Matthew, which recounts how at the Resurrection, the soldiers posted at the sepulcher of Christ "trembled, and became as dead men" (Matt. 28:4).

The four scenes flanking the central image refer to the idea of Resurrection. The two at the extreme left and right are taken from the Old Testament. On the left, Abel and Cain present their offerings to God; on the right, Job sits on the dung heap before his wife and a friend. Abel and Job, as just and faithful

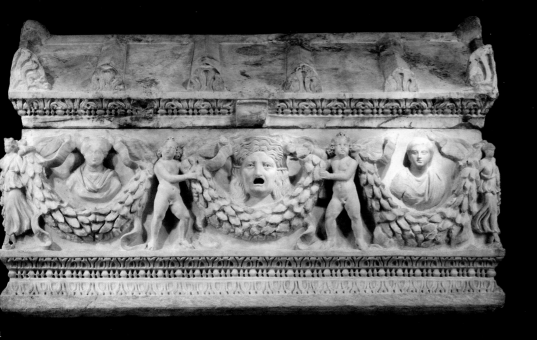

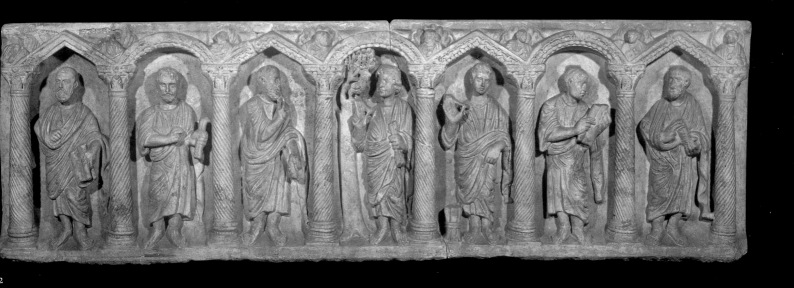

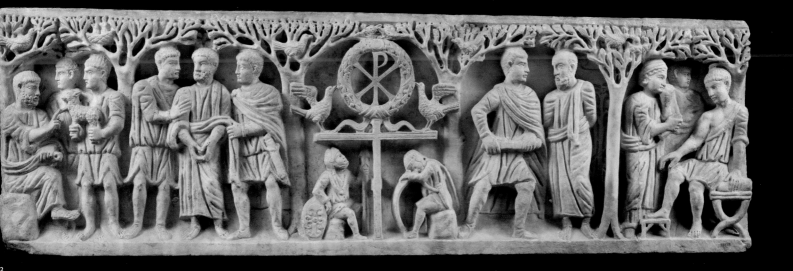

men unjustly tested to try their faith, prefigure Christ's martyrdom. The lamb that Abel offers carries sacrificial associations, anticipating the sacrifice of "the Lamb of God, who takes away the sins of the world" (John 1:29) and Jesus as "mediator of the new covenant," whose purifying blood "speaks a better word than that of Abel" (Heb. 12:24). Job is tested by his sufferings, while his wife covers her nose ("my breath is strange to my wife" [Job 19:17]) and one of his friends comes forward to offer consolation (Job 2:11). Job is a prototype of Christ: despite his unjust suffering, he does not abandon his faith in God's power of salvation (Job 19:25–27).

While the two outermost scenes portray the distant past before the crucial historical event of salvation (the martyrdom and the glorification of Christ), the two scenes framing the Anastasis illustrate the Christian community's future. They are, on the left, the arrest of Peter and, on the right, the martyrdom of Paul with the soldier pulling out his sword. The apostles were the first to follow Christ's example and commit to martyrdom. They stand for the entire Church, which is founded on their witness. The apostles, the martyrs of Christ, the entire community of the faithful are reflected in the martyrdom of their Redeemer and stand in contemplation of the Anastasis—that is, his triumphant Resurrection. The theological program and the stylistic characteristics of this work, compared with a group of mid-fourth-century sarcophagi, suggests a dating at the end of the first half of the fourth century and its identification as the prototype for the entire group. / UU

4
Reliquary Sarcophagus with Libation Opening

Byzantine (Syria), 5th/6th century
Gypseous stone; 36 × 38 × 23 cm
Skulpturensammlung und Museum für Byzantinische Kunst
Staatliche Museen zu Berlin (1/88)
Cleveland and Baltimore

PROVENANCE: Acquired on the international art market

BIBLIOGRAPHY: Jahresbericht 1988, *Jahrbuch der Berliner Museen* 31 (1989): 318; Mietke 1998, 48; Engemann 2001, 47; Mietke 2006, 30

This roughly carved reliquary is shaped like a small sarcophagus, representing a type of object common in Syria-Palestine and other parts of the eastern Mediterranean during the early Byzantine period. The reliquary's gabled lid, worked separately, is

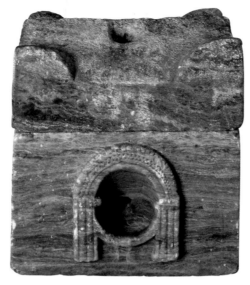

4

sparsely decorated with four geometric *acroteria*, or corner ornaments. On one of its sides, close to the crest of the roof, a drilled hole allowed for oil or water to be poured into the trough, which was thus brought into contact with the relics of the saint contained within. Framed by an aedicule that consists of an arch with zigzag ornament supported by pilasters, a round opening with a small exit hole and a shallow reservoir is visible on the reliquary's front. It gave pilgrims access to the liquids that had just been sanctified through direct physical contact with the saint's holy body.

Contemporary literary accounts and archaeological evidence suggests that the practice of collecting holy oil from a martyr's shrine was already well established by the late fourth century and that it was particularly widespread in Syria-Palestine and its neighboring regions. At major pilgrimage centers such as the shrine of St. Sergios at Resafa in the Syrian desert, or at churches with a popular local martyr's cult, reliquaries such as this one were often installed on stone pedestals and placed in dedicated martyr's chapels to give pilgrims an opportunity for pious veneration and allow them to collect holy oil or water from the martyr's tomb. Surviving terracotta and tin- and lead-alloy flasks (see cat. nos. 21–24) further attest how such substances were collected at a martyr's tomb and taken away by pilgrims for future use as protective tokens or as ointments to cure all kinds of maladies. Bishops such as John Chrysostom and Theodoret of Cyrrhus recommended that sanctified oil thus acquired be used to heal drunkenness and protect against nocturnal visits by demons. / HAK

5
Epitaph of Asellus, with the Portraits of Peter and Paul

Roman, end of the 4th century
Fine-grained white marble with gray veins with modern rubrication; 18.5 × 86.5 × 3.2 cm
Museo Cristiano, Musei Vaticani (28596)
Cleveland and Baltimore

INSCRIBED: (Chrismon) / PETRVS // PAV/LVS // ASELLV BENEM{B}ERE / NTI QVI VI{C}XIT ANNV / SEX MESIS OCTO DIES / XXÇII (Christ / Peter / Paul / To beloved Asellus, who lived six years, eight months, and twenty-eight days)

PROVENANCE: Rome, Cemetery of St. Hippolytus, excavated before 1720

BIBLIOGRAPHY: Boldetti 1720, 193; Silvagni et al. 1922 1:1513, 7:20018; C. Lega and D. Mazzoleni in Di Stefano Manzella 1997, 304, no. 3.8.5; G. Spinola in Rome 2000a, 233–34, no 112 (with previous bibliography); L. Acampora in Vatican 2009, 195, no. 66

This rectangular slab, broken in two and reassembled, once sealed a tomb in the Roman cemetery of St. Hippolytus on the Via Tiburtina, where it was excavated at the beginning of the eighteenth century (Boldetti 1720, 193).

The text follows a common formula in funerary epitaphs: the name of the deceased in the dative, followed by a praising attribute *(elogium)*, and the deceased's age, expressed here in a combination of letters and numbers. Noteworthy is also the composition of the number 28 with the *episemon* (Ç, which corresponds to the number VI, that is, 6) instead of the more usual XXVIII. The name of the deceased ("little donkey") is one of the so-called "names of humiliation" often used by the Christian community; it might also allude to Jesus's ride in the Entry into Jerusalem (John 12:14–15).

There are numerous spelling errors. The insertion of the labial *b* after the nasal *m* in *benemerenti*; the change of the long vowel (*u* instead of *o*) in *Asellu* and in *annu(s)* where the final *s* is also dropped. These, as well as the guttural doubling in *vicxit*; the loss of the nasal *n* and the transposition of the terminal vowel in *mesis* (instead of *menses*) are linguistic phenomena originating in the spoken language.

The epitaph is decorated on the left with an interesting image of the apostles Peter and Paul, identified by captions, with Christ's monogram between them. Their faces are skillfully rendered and quite detailed. Peter's head is round and has thick and short hair and beard, while Paul's hair is thinner and his beard is pointed. Their foreheads are creased with wrinkles, and their gaze is fixed and solemn, the pupils dilated. The two apostles wear tunics and pallia. The presence of Peter and Paul identified by

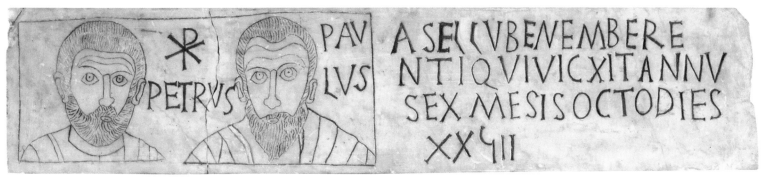

5

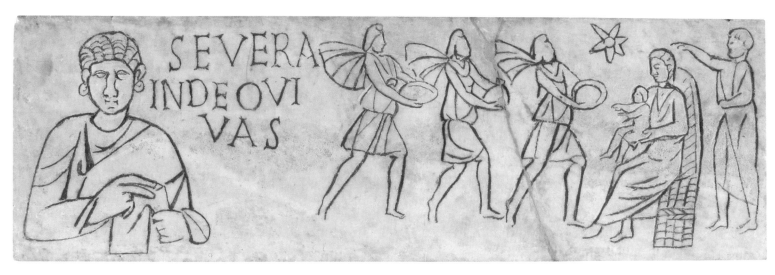

6

name suggests that the intercession of the two apostles, much venerated in fourth-century Rome, was invoked by his parents for the young Asellus. / UU

BIBLIOGRAPHY: Bianchini 1752, 205, no. 28, pl. 1; Marucchi 1910, 57, pl. 57.1; Silvagni et al. 1922, 8:23279; Kirschbaum 1954, 149; Testini 1972, 281–83; Calcagnini 1988, 67–69, 79–80; G. Spinola in Rimini 1996, 221, no. 70; C. Lega and F. Bisconti in Di Stefano Manzella 1997, 302, no. 3.8.2; Singapore 2005, 56; U. Utro in Trier 2007, no. II.4.13

6
Epitaph of Severa, with the Adoration of the Magi

Roman, second half of 3rd century–beginning of 4th century
White marble with modern rubrication; 32 × 102.3 × 2.5 cm
Museo Lapidario Cristiano, Musei Vaticani (28594)
London only

INSCRIBED: SEVERA / IN DEO VI / VAS (Severa, may you live in God)

PROVENANCE: Rome, Catacomb of Priscilla, 1751; then in the Church of Sta. Maria in Trastevere; from 1854 in the Lateran Christian Lapidary (moved to the Vatican in 1963)

This marble slab, used to seal a tomb (perhaps that of a child if the dimensions of the slab correspond to those of the tomb) contains one of the oldest known depictions of the Adoration of the Magi, represented next to the portrait of the deceased, Severa, and the acclamation wishing her eternal life (in Deo vivas). The three Magi are shown in adoration before the Christ Child, after their journey from the east following the star (Matt. 2:1–12). Sketched with few simple lines, they are dressed in oriental costumes with flowing cloaks and bring the gifts described in the Gospels—gold, frankincense, and myrrh, depicted with a few stylized strokes. Mary sits on a wicker chair and holds the Christ Child on her lap, while he stretches out his arms toward the first gift: a crown of gold, symbol of the regal status

of the Messiah. The star announcing the birth of the "world's light" (John 8:12) shines above. The prophet Balaam stands behind Mary and gestures toward the star. He foresaw the birth of the Messiah, which he interpreted as a star that would shine over the Hebrew people (Num. 24:11). This figure is sometimes erroneously identified as Joseph (Testini 1972), who, however, is not mentioned in the Gospel's text of the Epiphany.

The Severa epitaph comes from a tomb in the Catacomb of Priscilla and dates to after the mid-third century. It is contemporary with a wall painting of the Adoration of the Magi on an arch in the so-called Greek Chapel (probably a hall for funerary banquets [refregeria]) from the same catacombs. The remarkable similarity of the two scenes suggests that the maker of the slab may have used the wall painting as a model. / UU

7
Epitaph of the Subdeacon Ursinianus

Frankish/Merovingian (Trier), early 6th century
Marble; 26 × 70 × 4 cm
Rheinisches Landesmuseum, Trier (G 121)

INSCRIBED: URSINIANO SUBDIACONO SUB HOC TUMULO OSSA
QUIESCUNT QUI MERUIT SANCTORUM SOCIARI SEPULCRA [sic]
QUEM NEC TARTARUS FURENS NEC POENA SAEVA NOCEBI[T]
HUNC TITULUM POSUIT LUDULA DULCISSIMA CONIUX
R(ECESSIT) V K(ALENDAS) D(ECEMBRES). VIXIT ANNIS XXXIII

The bones of the subdeacon Ursinianus lie in this grave.
It is fitting that he be buried in the company of saints.
Neither Tartarus's fury nor cruel pains shall harm him.
Ludula, his dearest wife, commissioned the grave.
He died on 27 November, having lived thirty-three years.

PROVENANCE: Found in 1823 near the Church of St. Paulinus, Trier

BIBLIOGRAPHY: Gose 1958, 70, no. 466; Heinen 1996, 162–68;
Trier 2007, no. II.4.35

The epitaph for the cleric Ursinianus is evidence for
the early Christian cult of relics in Gaul. Other
inscriptions from Trier (Gose 1958, 76ff, nos. 481, 481a,
482) attest to a similar desire to be buried near the
tombs of saints. While the similarity of their formulas
distinguishes them from Ursianus's inscription
(and may in fact date them to a later period than the
subdeacon's gravestone), all clearly testify to the
veneration of saints, as demonstrated archaeologically
for earlier periods by the cemeteries of the imperial
residence at Augusta Treverorum (Trier).

Medieval sources describe a church and some
bishops' graves not far from the Oratory of St. Maxi-
mian of Trier, where the body of Bishop Paulinus
(r. 347–58) was transferred by a Bishop Felix (r. 386–98).
In addition to several bishops' tombs, the unnamed
Trier martyrs, and martyrs of the Theban Legion

were venerated at the Church of St. Paulinus.
Bishop Marus (d. ca. 480), a later successor of Bishop
Felix, devoted particular attention to the grave of
St. Paulinus.

The first four verses of the inscription for
Ursinianus were composed as a poem in hexameters.
Naming the deceased in the first verse, however,
like the formulation in the second, caused difficulties
for the author. The first verse, which extends into
the second line of the inscription, is separated from
the latter by an ivy leaf. The scribal errors in the
inscription attest to the limitations of the stonema-
sons. The notion that saints' relics offered protection
from the vengeance of Tartarus (Hell) is explicitly
expressed, in language similar to that of the inscrip-
tion, in a famous homily of Maximus of Turin
(d. ca. 465). / LS

8
Gold Glass with St. Agnes between Sts. Peter and Paul

Roman, ca. 390
Greenish colorless glass, gold leaf
Height 0.8 cm, diameter 8.7–8.8 cm, diameter of foot 8.4–8.5 cm,
thickness of upper layer 0.1 cm, thickness of lower layer 0.15 cm
Museo Cristiano, Musei Vaticani (60757)
Cleveland and Baltimore

INSCRIBED: ANNES / PAULUS / ZESES / PETRUS

PROVENANCE: Rome, from an unknown catacomb

BIBLIOGRAPHY: Rossi 1878–94, fols. 73v–74r, no. 305; Morey and
Ferrari 1959, 18, no. 75, pl. 12; Faedo 1978, 1031, 1059–60, 1063,
pl. 49; L. Vattuone in Rome 2000a, 223–24, no. 91 (with further
bibliography); U. Utro in Milan 2003, 393, no. 176; U. Utro in
Catania 2008, 361–62, no. 125

The present object is the remnant of the bottom
of a cup whose walls were purposely broken off along
the line of the circular base. It composed of layers
of colorless greenish glass sandwiching gold leaf.
Although the find spot is unknown, the distinctive
breakage suggests that it comes from the catacombs.
Indeed, the bottoms of glass plates and bowls of
this type were reused in Antiquity to decorate grave
sites, inserted into the plaster that sealed loculi in
Roman catacombs.

The lower layer of glass, over which gold leaf
was applied, is bent so as to form a ring-shaped foot.
The figural decoration was engraved on the gold
and consists of three saints, identified by captions,
within a square frame. Agnes (*Annes* is a corruption of
Hagne, the Latin transliteration of the Greek name
ʽΑγνή) stands in an orant posture in the middle. She
wears a tunic and *palla* fixed by a circular fibula and
a veil over her head, which falls onto her shoulders.
Peter and Paul in profile flank the young martyr and
turn toward her. Their stylized hair resembles hel-
mets; they are beardless and are dressed with tunic
and pallium. The left hand of each is wrapped in
the pallium. Peter's right hand gestures toward Agnes;
Paul's holds a roll.

Agnes was a Roman girl, probably a victim of
Decius's persecutions (250–51). She is the only female
saint, aside from the Virgin Mary, represented on
Christian gold glasses; she sometimes appears next
to Mary (Morey 1959, no. 265), and is one of the first
saints to be represented with a nimbus on gold
glasses. Her cult is attested since the fourth century,
particularly in Rome, where she was the focus of
special veneration and where the martyr had a cem-
etery dedicated to her on the Via Nomentana.

The image on this glass—in which the young
martyr Agnes, in preeminent position, is associated
with the two patron saints of the Roman Church,

7

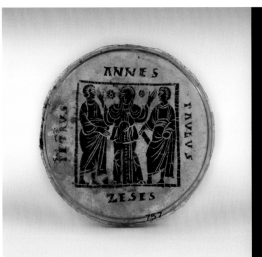

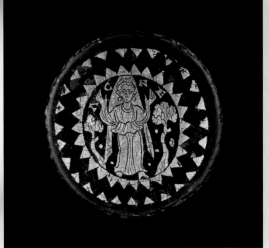

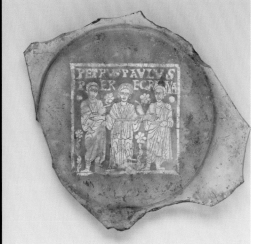

8

9

10

Peter and Paul—confirms the hagiographical information. The image corresponds to other examples of gold glasses with portraits of Agnes between the princes of the apostles (Morey 1959, no. 83) or between Christ and the other important Roman patron saint, Lawrence (Morey 1959, no. 283).

The arrangement of the inscription on the exergue conforms with other gold glass from the same workshop (Morey 1959, nos. 71, 292, and 451 although the association of the latter with this workshop is doubtful), active in Rome during the reign of Theodosius ("workshop 7": Faedo 1978, 1059–63). The Greek verb *zezes* (to live) transliterated in Latin in the lower part of the image, directly relates to *Annes* on the upper register, thus introducing a possible reference to the saint's feast day on 21 January. The gold glass might have been offered as a precious gift on this occasion. / CL

9
Gold Glass with St. Agnes in Orans Posture

Roman, second half of the 4th century
Greenish colorless glass, gold leaf
Height 0.6 cm, diameter 8.8–9 cm, diameter of foot 8.8–8.9 cm, thickness of upper and lower layers each 0.15 cm
Museo Cristiano, Musei Vaticani (60774)
London only

INSCRIBED: ACNE

PROVENANCE: Rome, from an unknown catacomb; collection of Cardinal Gaspare Carpegna (1625–1714)

BIBLIOGRAPHY: Buonarroti 1716, pl. 21 no. 1; *Arch. Bibl.* 70, fol. 21v, no. 137; *Arch. Bibl.* 72, fol. 22v, no. 137; *Arch. Bibl.* 73, fol. 7r; Perret 1851–55, vol. 4, pl. 26, no. 41; Garrucci 1858, 49, fig. 21, no. 5; Garrucci 1864, pl. 21, no. 5; Garrucci 1872–80, 3:170, pl. 190, no. 5; Rossi 1878–94, fols. 74v–75r, no. 307; Vopel 1899, 9, 11, 57, 85, 109, no. 391=190,5; Leclercq 1907–53, vol. 5.2, col. 1839, no. 232; Morey and Ferrari 1959, 20, no. 82, pl. 14; G. Daltrop in Matt 1969, 30, 169, no. 51, fig. 51; Zanchi Roppo 1969, 191–92, no. 226, pl. 51; Faedo 1978, 1032–39, esp. 1037 workshop 1, no. l; U. Utro in Ravenna 2001, 107 fig. 50, 214 no. 50

Like no. 8, this object must have come from one of the Roman catacombs and shows the characteristic fragmentation of the rim intended to transform a glass vessel into a tomb ornament. Like other works of this kind, the original cup or plate of which this is a fragment was probably a gift offered on the occasion of a public or private celebration. The decoration, in gold leaf between two layers of glass, one of which originally formed the ring-shaped foot of a cup, consists of a double circle of triangles framing a female figure. She stands between two trees and opens her arms in the *orans* posture. Her hair, dressed into a tall bun, is covered by a veil that falls around her body; she wears a tunic and a palla tied with a belt. Heavy jewelry adorns her ears and neck. The inscription ("Acne," another corruption of Hagne) identifies the figure as St. Agnes. The saint, widely venerated in Rome, is portrayed with her usual iconography, derived from a common prototype, which is probably to be identified with the representations on the very pluteus associated with the decoration around her burial area refurbished by Pope Liberius (r. 352–66).

Agnes is represented on more than fifteen surviving gold glasses, either alone and flanked by trees (as here), by doves (symbols of purity, handing the woman her crown of martyrdom), or by other saints. In the context of representations of saints, martyrs, and even the ordinary deceased, the *orans* posture indicates that the person is a blessed dweller in paradise, which in early Christian iconography was depicted as a lush garden and is here symbolized by trees. The style, the rendering of the design and of the saint's features, the typology of the frame, and the pattern of the decoration suggest that the glass is the work of a Roman workshop active in the second half of the fourth century ("workshop 1": Faedo 1978, 1032–39, esp. 1037). / CL

10
Gold Glass with Peregrina between Sts. Peter and Paul

Roman, mid-4th century
Glass, gold leaf; 11.5 × 13.3 × 1.2 cm
The Metropolitan Museum of Art, New York, Rogers Fund, 1918 (18.145.2)
Cleveland and Baltimore

INSCRIBED: PETRUS PAULUS / PEREGRINA

PROVENANCE: From Rome; acquired 1918.

BIBLIOGRAPHY: New York 1979, 572, no. 510

None of the figures is labeled as a saint and none has a distinguishing halo. Yet the two men surely represent Sts. Peter and Paul, who are often paired in Christian imagery, are honored on the same feast day, and are commonly depicted on surviving gold glasses. The identity of "Peregrina" is less certain. Her position between the figures of Peter and Paul corresponds to that of figures labeled "Maria" and "Agnes" on other, contemporary gold glass, presumably the Virgin Mary and St. Agnes. Whether this female figure represents an obscure saint named Peregrina or simply a Roman Christian by that name is not clear. / BDB

11
Votive Plaque with a Female Saint

Syria, 6th or 7th century
Silver alloy; 3 × 2.5 cm
The Walters Art Museum, Baltimore (57.1826)

INSCRIBED: κ[γ]ριε ΒοΗθι (Lord, help)

PROVENANCE: Found near Ma'aret en-Noman, Syria, prior to
1945; Joseph Brummer, New York (date of acquisition unknown),
by purchase; Walters Art Museum, 1949, by purchase

BIBLIOGRAPHY: Jalabert and Mourterde 1959, 5:39–40; Baltimore
1986, 242–45, nos. 72a, 72j; Vikan 1998, 252–53

11

12

12
Votive Plaque with Eyes

Syria, 6th or 7th century
Silver alloy; 2.9 × 3.8 cm
The Walters Art Museum, Baltimore, gift of M. Henri Seyrig,
Institut Français d'Archéologie de Beyrouth, 1956 (57.1865.563)

INSCRIBED: γ πєρ [ε]γxHc (in fulfillment of a vow)

PROVENANCE: Found near Ma'aret en-Noman, Syria, prior to
1945; Henri Seyrig, Beirut (date of acquisition unknown), by
purchase; Walters Art Museum, 1956, by gift

BIBLIOGRAPHY: Jalabert and Mourterde 1959, 5:39–40; Baltimore
1986, 242–45, nos. 72a, 72j; Vikan 1998, 252–53

Pilgrims could take home tokens from the shrines
they had visited (see cat. nos. 21–24), but they could
also purchase small votive offerings to be left at
the shrines, prolonging their spiritual devotion long
after they had left. The practice of leaving *ex-votos*
continues to the present day in some regions. In the
early medieval period, such offerings could take
the form of small objects left at the shrine, paintings
or mosaics commissioned by the faithful, or even
words of thanks scratched into the fabric of the
church building. They could be left either in antici-
pation of a successful visit or in gratitude after the
suppliant had been healed or forgiven or had other
requests satisfied. A number of votive plaques
were found outside Ma'aret en-Noman, in present-
day Syria. These thin sheets of silver, stamped with
images and inscriptions, were probably produced
near the shrine and sold at a relatively low cost to
pilgrims. Several of these feature depictions of eyes,
perhaps related to an affliction that the saint was
asked to heal. The group also included figures of
unidentified female saints shown standing, facing
forward, with arms raised in the *orans* posture of
prayer. This stance presents the saint as an intercessor
between the faithful suppliant and God, bridging
the divide between earthly need and divine power.
It is possible that these plaques were offered at
a smaller church, rather than a major shrine, and
small holes in the plaques might indicate that they
were nailed to a wall inside the church, or sus-
pended from above. / KBG

13
Reliquary Box with Stones from the Holy Land

Syria or Palestine, 6th century
Painted wood, stones, wood fragments, plaster
Box: 24 × 18.4 × 3 cm; lid: 1 cm thick
Museo Sacro, Musei Vaticani (61883.2.1 [lid], 61883.2.2 [box])
Cleveland and Baltimore

PROVENANCE: Treasury of the Sancta Sanctorum; transferred in
1905 to the Museo Cristiano of the Vatican Library; transferred
to the Vatican Museums pursuant to the rescript of Pope John
Paul II, 1999

BIBLIOGRAPHY: Lauer 1906, 97–99; Grisar 1908, 113; Morey 1926,
151; Volbach 1941; Matt 1969, 171; Weitzmann 1974; M. Della
Valle in Ravenna 1990, 140–41, no. 52; Morello 1991; Cleveland
1998, 31–33; G. Curzi in Naples 2000, 71; U. Utro in Ravenna
2001, 216–17, no. 63; Trier 2007, 27, no. II.2

This wooden box with a sliding lid, containing
fragments of stones and wood from the Holy Land,
is one of the oldest objects attesting the custom
of collecting souvenirs from pilgrimages to the Holy
Land. The top of the lid is painted with an image
of the Golgotha Cross and the monogram of Christ
enclosed in a mandorla. The lid's interior is painted
with five scenes from the life of Christ: the Nativity,
Christ's Baptism, his Crucifixion, the Holy Women
at the Tomb, and the Ascension. The fragments
contained in the box, each of which relate to the
scenes painted on the lid's interior, are labeled and
encased in a layer of plaster. The box was part of
the treasure of the Sancta Sanctorum (see Cornini
herein, pp. 69–78), whose relics were accessible
only to the popes for many centuries, which accounts
for their extraordinary state of preservation.

The content and the style of the painted
decoration suggest Palestine as a place of origin for
this reliquary. In particular, the iconography of
the Crucifixion, with the crucified Christ dressed in
colobium (a long tunic decorated with lateral bands
on both sides), has rightly been associated with the
style of the Rabbula Gospels (Biblioteca Medicea
Laurenziana, Florence) made in Syria in 586. The
artist's knowledge of the holy sites of Palestine is
attested by the representation of Christ's sepulcher
in the scene of the Holy Women, which depicts
the monument as it was before its modification in the
seventh century. The reliquary box must therefore
date to before this period. It is a reminder both of the
vitality of the Christian faith at this time and of
how widely objects and images of the holiest places
in Christianity were circulated. / CP

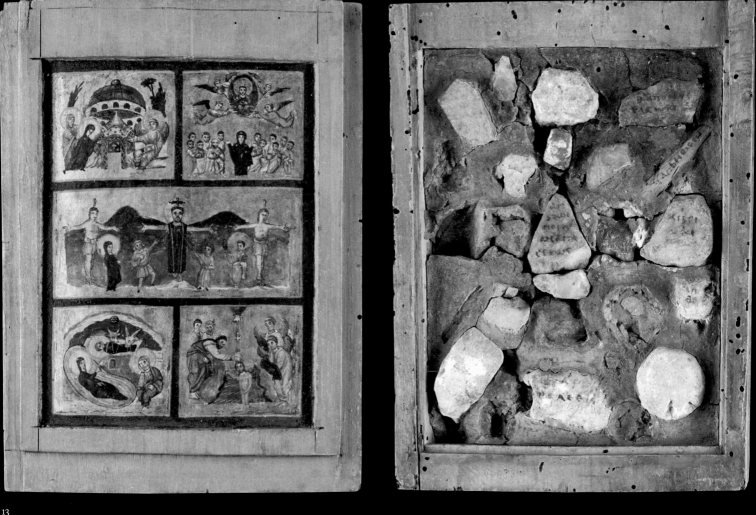

14
The Trier Ivory

Byzantine (Constantinople), first half of the 6th century (?)
Ivory; 13.1 × 26.1 × 2.3 cm
Trierer Dom, Domschatz
London only

PROVENANCE: Purportedly in the Treasury of Trier Cathedral until 1792; Count Klemens Wenzeslaus Renesse-Breitbach, Antwerp, by 1826; Johann Jacob Reichel, St. Petersburg, 1836; acquired by the Chapter of Trier Cathedral, 1845

BIBLIOGRAPHY: Delbrueck 1929, 261–74; Fischer 1969; Spain 1977; Holum and Vikan 1979; Wortley 1980; Brussels 1982, 96, no. IV. 5; Wilson 1984; Speck 1987; Brubaker 1999

This extraordinary ivory plaque likely formed part of a small reliquary box carved by a Byzantine master craftsman working in Constantinople during the first half of the sixth century. It represents the ceremonial arrival, or *adventus*, and the solemn reception of the relics of a saint or prophet in the Byzantine capital, as it is described in various literary accounts of the early and middle Byzantine periods. On the left, passing by an archway decorated in its tympanum with a bust-portrait of Christ, two bishops, dressed in traditional ecclesiastical garb, are seated high on a lavishly decorated horse-drawn wagon, holding between them a small gabled box that contains the precious cargo. They are preceded by a group of imperial officials wearing court costumes and carrying burning candles. The person leading the festive procession is the emperor himself, clearly distinguished by his diadem and richly embroidered tunic. The imperial escort is received on the right by a slightly smaller female figure wearing imperial dress and regalia and carrying a cross staff over her shoulder. Behind her rises a church, identifiable as a basilica by its apse, aisles, and clerestory windows. Four workmen climbing about the building are seemingly busy putting the finishing touches on its roof. In the background, a large arcaded structure is filled with more than two dozen people, some swinging censers and chanting acclamations while others are watching the procession pass by.

On the basis of surviving literary sources and iconographic details such as the bust-length portrait of Christ in the lunette on the left, the spectator-lined arcades in the background, and the depiction of an imperial procession toward a newly constructed church on the right, some scholars have identified the scene as the *adventus* of the relics of St. Stephen in Constantinople, an event recorded to have taken place in 421. Others have identified it as the translation of the relics of Zacharias, father of John the Baptist, whose body arrived in the capital together with that of Joseph, son of the Old Testament patriarch Jacob in 415. While the identity of the saint honored in the *adventus* remains uncertain, the Trier Ivory clearly conveys a sense of the atmosphere, excitement, and visual splendor of a ceremonial reception of saintly relics as is frequently attested for the capital during the early and middle Byzantine periods. / HAK

15a–c
Set of Reliquary Boxes

Byzantine, ca. 350–450
Marble; 22.4 × 15.5 × 15.6 cm
Silver; 9.3 × 5.6 × 11 cm
Gold, garnets, and precious stones; 6.1 × 4.7 × 3.8 cm
Museum of Archaeology, Varna (III.766–68)
Cleveland and Baltimore

PROVENANCE: Archaeological excavations conducted by K. Škorpil at Canavar (Djanavar, Dzhanavar) Hill near Varna (1919)

BIBLIOGRAPHY: Buschhausen 1971, 253–56, no. C1; New York 1979, 631f, no. 569; Bojadjiev 1995; Rome 2000b, 115f, no. 5; Sankt Pölten 2001, 358, no. I/14.1; Minchev 2003, 15–18, nos. 1–3

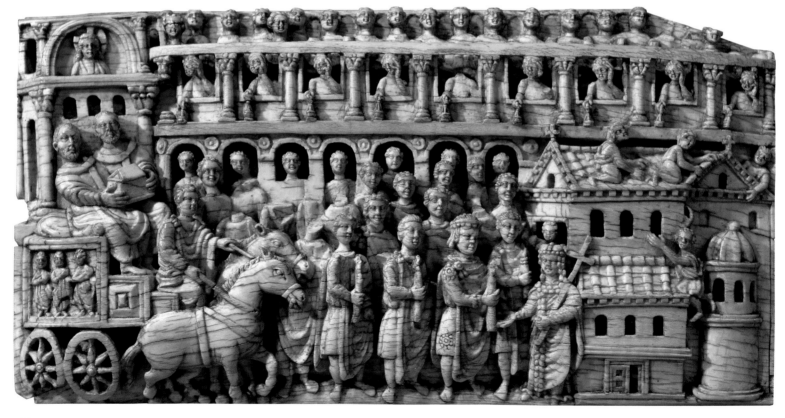

Byzantine liturgical manuscripts explain that consecrating an altar requires "three particles of holy relics to be placed inside a container that the mason has made beneath the holy table" (Trempelas 1950–55, 2:120; cf. Tanner 1990, 145). The officiating bishop prays: "Our God, having bestowed upon the saints who struggled for Thy sake the honor that their relics be sown throughout the earth in Thy holy churches and bear healing fruit, as the giver of all good things grant us through the prayers of those saints whose relics Thou vouchsafed to be deposited in this venerable church that in it we should offer Thee bloodless sacrifice without condemnation. . . ." (Ruggieri 1988, 93).

This ritual has many archaeological witnesses (Yasin 2009, 151–85; Peschlow 2006; Kourkoutidou-Nikolaïdou 1981), including the present boxes. When unearthed and opened, the first and largest one was found to contain a silken handkerchief and something enveloped in black cloth. This turned out to be a second, silver box that held a third, golden one wrapped in silk. Inside were a finger phalanx, a fragment from a shoulder blade and a small piece of wood (Škorpil 1921, 59f).

The marble box imitates the shape of sarcophagi from ca. 330–450 (Koch 2000, 427–29; cf. Piatnitsky 2006). Mosaic-like garnet inlays similar to those on the golden reliquary are first attested in the fourth century (Venice 2008, 290–93). The excavators found a coin of Emperor Constantine (d. 337) beneath the floor close to the altar (Beliaev 1929, 122). Due west of it, in the center of the nave, was an underground barrel-vaulted tomb. It contained a pair of wooden coffins with two skeletons in them (Škorpil 1921, 60). The buried must have been of high social rank (Yasin 2009, 69–100).

The church lies on a hill (known by the later, Turkish name Canavar Tepe) outside the Greco-Roman town of Odessos (modern Varna). Its four side chambers have ornamented floor mosaics (Minchev 2001) that may be much later than the building. Its peculiar ground plan (Bojadjiev 1995) and thick walls have been compared to those of churches in Syria (Georgiev 2006).

Archaeological work started in 1915, ceased because of World War I (when German troops stationed in Varna quarried building material from the ruins [Škorpil 1921, 20f]), and was completed in 1919. The site is currently being re-excavated, and further structures have been discovered beside the church. Treasure-hunters damaged it by illegal digging in July 2008. / GRP

15c

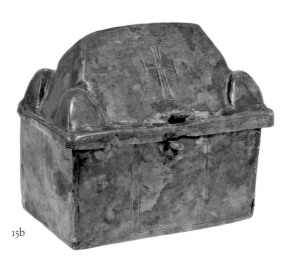

15b

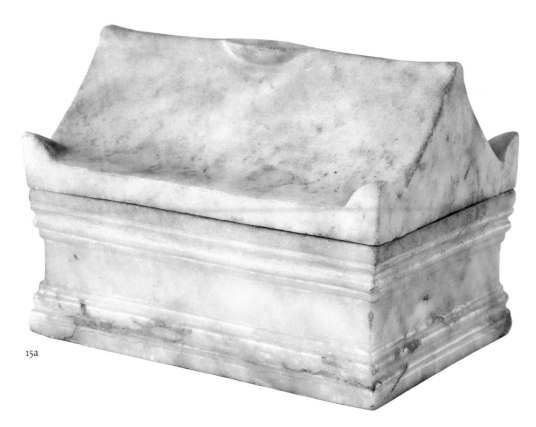

15a

16

The Pola Casket

Roman, first half of the 5th century
Ivory and silver over a wood core; 19 × 20 × 16 cm
Museo Archeologico Nazionale, Venice (1952-279)
Cleveland and Baltimore

PROVENANCE: Found in the ruins of the Church of
Sant'Ermagora at Samagher near Pola in Istria, 1906; Museo
Civico di Pola, until the Second World War; transferred to the
Museo Archeologica Nazionale, Venice, 1960

BIBLIOGRAPHY: Gnirs 1908; Buddensieg 1959; Angiolini 1970;
Künzle 1976; Guarducci 1978; Rimini 1996, 327, no 251; Longhi
1997; Paderborn 1999, 615–16, no. IX.5; Rome 1999, 436, no. 256

This precious ivory chest was discovered in 1906 in
the sanctuary area of an early Christian church
dedicated to St. Hermagoras near Pola in Istria, Italy.
Reportedly found in a somewhat larger stone
container below the floor level, the chest may be con-
sidered a reliquary shrine that was deposited, as
was customary during the early Byzantine period,
below the main altar of the church. Because it was
submerged for some time in water, the ivory decora-
tion of the chest has suffered considerable damage.
However, enough of it survives for its iconographic
program to remain legible.

Both chest and lid consist of a wooden core,
clad on the exterior walls with ivory plaques. Silver
brackets on the corners reinforce the reliquary's
structure. A lock and two hinges, likewise made of
silver, determine the chest's overall orientation and
hierarchy of its figural program. Organized in four
registers, the ivory plaques decorating the sides
of the lid represent pairs of birds flanking a central
gem-studded cross. The narrow strips below show
a central wreath inscribed with a *staurogram* and the
flanking Greek letters *alpha* and *omega*. Issuing
from city gates at the ends of each plaque and walking
toward the wreath in the center are pairs of lambs—
two pairs on the long sides and one on the short
sides—thus completing the symbolic representation
of the Twelve Apostles.

The four relief panels below, flanked at the bottom
by an ornamental band with leaf motifs with central
crosses, and the panel at the top of the lid fall into
two distinct groups. Two symbolic images on the
reliquary's front and lid represent the *Acclamatio sedis*
(two pairs of apostles flanking the empty throne
prepared for Christ's Second Coming) and the *Traditio
legis* (Christ handing the Law to St. Peter with St. Paul
in attendance). The three remaining scenes likely
show pilgrims venerating at three major saints' shrines
in the city of Rome. However, only the representa-
tion on the reliquary's back can be identified with
certainty as the sanctuary of St. Peter's on the basis
of its architectural setting, which features a colonnade
supported by twisted columns. Flanked by pairs
of male and female figures, a man and a woman
approach the shrine of St. Peter, possibly to obtain
a contact relic of the apostle by lowering a piece of
cloth *(palliolum)* onto his tomb. This practice is first
described in the writings of Gregory of Tours, who
states that the piece of cloth would soak up the
sanctity from the apostle's tomb if the faithful prayed,
fasted, and held vigil during the process. / HAK

17

Front Panel of a Box-shaped Altar

Byzantine (Constantinople or Ravenna), early 6th century
Proconnesian marble, Rosso di Verona (inlaid cross);
101 × 169.5 × 25.5 cm
The Cleveland Museum of Art, John L. Severance Fund (1948.25)

PROVENANCE: Oratory of San Carlino (SS. Fabiano e Sebastiano),
Ravenna; Villa Lovatelli dal Corno near Ravenna; Villa Landau
near Florence; Jenny Ellenberger-Finaly (by bequest); Horace
Finaly (by bequest); Adolph Loewi, Los Angeles

BIBLIOGRAPHY: Cappi 1846, 98–99; Ricci 1909, 265, fig. 13, 275;
Lawrence 1954, 134, fig. 100, 138–42; Brandenburg 1972, 126–27,
133; Kollwitz and Herdejürgen 1979, 164–65; Deichmann 1989,
329–30; Peschlow 2006, 183

This large relief panel is cut from the fine, gray-
veined marble typical of the island of Proconnesos
in the Marmara Sea near Constantinople. It was
long considered to be the front of an early Byzantine
sarcophagus, sliced off and reused as an altar
frontal in the Church of San Carlino in Ravenna in
the later Middle Ages. Indeed, the panel's design—
four columns supporting a central gable and two
conch-filled arches—and its decoration—crosses
under *aediculae*, lambs flanking the central gable,
and palm trees next to the framing arches—are remi-
niscent of the decorative vocabulary of fifth- and
sixth-century sarcophagi in Ravenna and Constanti-
nople. However, the panel's overall dimensions and
its unusual proportions seem to indicate that the
relief never formed part of a sarcophagus but that it
was instead made to serve as the front panel of a
box-shaped altar from the outset. Several altars
of this kind or fragments thereof have survived in the
churches of Rome (Sant' Alessandro) and Ravenna
(San Giovanni Evangelista, Sant' Apollinare Nuovo,
and San Francesco), documenting an important
stage in the development of the Christian cult of
saints and their relics.

Already by the mid-fourth century, a close con-
nection had started to develop between the Eucharistic
altar and the tombs of Christian martyrs. In the
cemeteries outside of Rome, Constantine the Great
built large basilicas to honor the memory of the
most important Roman martyrs. As written sources
and archaeological evidence indicate, altars were
often set up directly above or in front of a martyr's

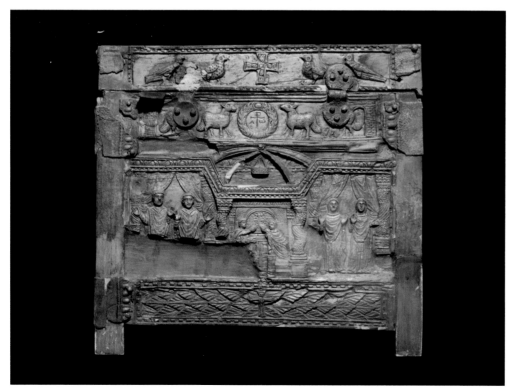

16

17

tomb, linking the commemoration of Christ's suffering, death, and Resurrection closely with that of the holy martyr. Where martyrs' tombs did not exist, relics were often brought from elsewhere and deposited in a small shrine inside or underneath the altar. The Cleveland relief panel was not only designed to make the altar/tomb connection palpable, but also granted visual and physical access to the saint's shrine and relics by means of a *fenestella*, or small window. Small pieces of cloth could thus be lowered down to the shrine to literally soak up the miracle-working and salvific properties associated with the saint's bodily remains. / HAK

18
Capsella Africana

North Africa (?), late 5th–early 6th century
Silver, embossed and chiseled; 8.5 × 16.6 × 7.7 cm, thickness of metal foil 1 mm
Museo Cristiano, Musei Vaticani (60859)
London only

PROVENANCE: Excavation of the early Christian basilica of Henchir Zirara, Algeria, 1884; gift of Charles Lavigerie, archbishop of Carthage, to Pope Leo XIII, 1888

BIBLIOGRAPHY: Rossi 1887, 118–29, pls. viii, ix; Lassus 1958, 42–44; Frend 1996, 67–73, 76–81, 127–29; U. Utro in Rimini 1996, 253–54, no. 127; Bisconti 1997, 335, figs. 23, 24; A. Effenberger in Paderborn 1999, 646–47, no. IX.29; Leader-Newby 2004, 105 fig. 106; C. Lega in Vicenza 2008, 130–37, no. 12, with further bibliography; Noga-Banai 2008, 64–95

The "capsella Africana" is a silver reliquary found in 1884 at the site of Henchir Zirara, Algeria, near Constantine in an early Christian (probably sixth-century) basilica (see Frend 1996) in a structure identified as a reliquary tomb.

Oval in form, with a domed lid, the little silver box is decorated with Christian scenes framed by a simple twisted-cord motif (the bottom and lower cords are restorations). On one of the sides, eight sheep (an allegorical synthesis of the apostolic college) exit from two basilica-like buildings. The procession alludes to the Hebrew and pagan people, recipients of the word of God, progressing from the heavenly cities of Jerusalem and Bethlehem toward Christ, who is represented in the box's center, as a lamb surmounted by a gemmed cross. The other side presents an iconographic motif common in early Christian art: the image of a deer as a symbol of rebirth through baptism, evoking Psalm 42:1: "As a hart longs for flowing streams, so longs my soul for thee, O God." Between two palm trees, a deer and a doe, representing the faithful, drink from the four rivers of Paradise flowing from the heavenly mountain, crowned by Christ's gemmed monogram.

On the lid, a man dressed in a tunic and pallium stands on a mountain from which four rivers flow. He is flanked by two lighted candles (an allusion to heaven) and holds a crown in his hands. Above the man, the hand of God emerges from clouds to place a crown of leaves on his head. He is the martyr whose relics were once preserved in this little box. Some scholars (e.g., Paderborn 1999) identify the figure as St. Stephen; others (Leader-Newby 2004, 105, 121 n. 142) interpret the figure as a more generalized allusion to the rewards of martyrdom. The location at the top of the mountain of Paradise, however,

seems to imply an assimilation of the martyr into the figure of Christ: a bold iconographic and theological synthesis whose explication lies in the martyr's own sacrifice in witness of his faith in God. The sacrifice transforms the figure of the martyr into an icon of Christ, the model for all martyrs. It is also possible that the iconography of the box reflects a tradition of the cult of the martyrs peculiar to North Africa. Such a tradition could have been shaped in part by the Donatist heresy—attested from the fourth century and reinvigorated after the Vandals' conquest of the region (Lassus 1958).

The allusion to this specific form of devotion, together with the motif of the candlesticks, seems to suggest that the silver reliquary was made in Africa and perhaps in Numidia (present-day Algeria), where it was found, during the period between the end of the fifth century and the beginning of the sixth (that chronology is supported by recent scholarship, with the exception of Leader-Newby 2004). Nonetheless, recently Galit Noga-Banai (2008, 64–95), without excluding the possibility of a North African manufacture of the silver box, drew parallels between the capsella's iconography and the decorations of the catacomb of San Gennaro in Naples, proposing a Campanian origin for the reliquary and dating it somewhat earlier—to the second quarter of the fifth century. It should be noted, however, that Bisconti had already pointed out the iconographic relationship between the capsella and the decorations of the Catacomb of San Gennaro (Bisconti 1997; id. 1998, 253–82). / CL

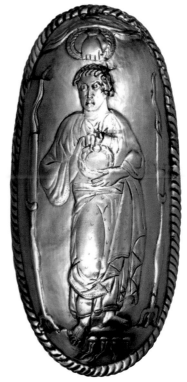

18

19
Reliquary of the Head of St. Sebastian

Roman (?), refashioned second quarter of the 9th century
Partially gilded silver, niello; 19.5 × 22.5 × 20.5 cm, thickness of silver 3 mm
Musei Sacro, Museo Vaticani (60864)
Cleveland and Baltimore

INSCRIBED: AD DECORE[M] CAPITIS BEATI SEBASTIANI GREG[ORIUS] IIII EPIS[COPUS] OPT[VLIT] (Bishop Gregory conceived the work in order to decorate the head of Saint Sebastian)

PROVENANCE: Attested in the Basilica of Saint Peter in the oratory of Gregory the Great during the pontificate of Pope Gregory IV (827–44); in the Basilica of the SS. Quattro Coronati, Rome, during the pontificate of Pope Leo IV (847–55); moved to the Museo Sacro early in the twentieth century; transferred to the Vatican Museums pursuant to the rescript of Pope John Paul II, 1999

BIBLIOGRAPHY: Muñoz 1913, 196ff; Liebaert 1913; Volbach 1937; Matt, Daltrop, and Prandi n.d. [1970], 170; New York 1983, 99; Brisbane 1988, 100; Morello 1991; Vatican 1998, 103–4, no. 2

This Antique silver vessel, decorated in niello on both its interior and the exterior of its lid, was transformed into a reliquary of St. Sebastian during the Middle Ages. The "Bishop Gregory" named as the reliquary's patron in the inscription is likely Pope Gregory IV (r. 827–44). Documentary evidence attests that the latter built an oratory dedicated to Pope Gregory the Great (r. 590–604) in the Basilica of St. Peter as a repository for a group of relics, including those of the martyr-saint Sebastian, found in a cemetery dedicated to the saint on the Appian Way.

Gregory IV's successor, Leo IV (r. 847–55), transferred the reliquary from St. Peter's to the Basilica of the SS. Quattro Coronati in Rome, where it was

discovered in the seventeenth century in pristine condition in a leather pouch under the altar dedicated to the martyr. The precious reliquary was brought back to the Vatican early in the twentieth century and displayed in the Vatican Museums.

The external niello decoration consists of a motif of double palms with leaves joined at the stems, enhanced by parcel gilding; the alternating empty and decorated spaces create an elegant effect on the domed lid. The decoration is reprised, more deeply incised and hammered out with great skill, on the lower part of the lid, that corresponding to the body of the vessel. The interior of both the base and the lid are engraved with concentric and geometrical designs, forming rosette and a Latin monogram, which can be read either as *Adeodatus* or *Pantaleon*, probably the vessel's original patron.

The vessel's date is disputed. Some scholars date it to the sixth or seventh century, but others argue that the rhythmical decoration and the chromatic play of the niello, gold, and silver point to a date around the eighth century, if not to the time of its refashioning in the ninth century. / CP

20
Pyxis

Roman (Alexandria), 6th century
Ivory; height 7.9 cm, diameter 11.9 cm
The British Museum, London (PE 1879,1220.1)

PROVENANCE: Alexander Nesbit; The British Museum, London, 1879, by purchase

BIBLIOGRAPHY: Dalton 1909, no. 12; New York 1999 [1977], no. 514; Buckton 1994b, no. 65; London 2007, 206

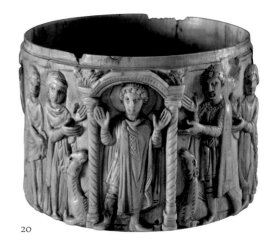

20

This sixth-century ivory pyxis, originally from Alexandria, was reportedly discovered in Rome, in a chapel dedicated to St. Menas in the Church of St. Paul Outside the Walls. Pyxides—lidded, circular boxes made to store medicines or cosmetics—were also used as reliquaries.

Menas, born in Egypt, was a soldier in the Roman army who deserted to follow his Christian calling; he was martyred under the Roman emperor Diocletian (245–313) for declaring his faith. Menas is traditionally represented with hands raised in *orans* posture, flanked by kneeling camels. The iconography alludes to Menas's burial: Athanasios, patriarch of Alexandria, had a vision commanding him to take the saint's body into the desert, and the spot where the camel carrying the body stopped marked the site of his entombment. Following his death and burial, Menas's shrine, southwest of Alexandria near Lake Mareotis, became famous for providing miraculous cures.

One side of this pyxis shows Menas's dramatic martyrdom: a Roman official, seated behind a table with an ink pot, delivers his judgment. Menas kneels before him, hands bound, as a Roman soldier holds him by the hair, raising his sword in readiness to strike the saint's bare neck. An angel waits between the two to catch his soul. The other side shows Menas with his traditional iconography: he stands under an arch supported by spiralled columns, flanked by pilgrims who gesture toward him and two camels that kneel at his feet. A relief of a basket covers the space where the lock once was, suggesting that the box was adapted for another use at a later date. / NCS

19

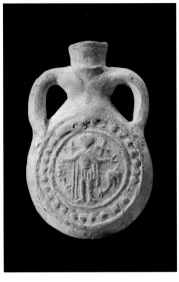
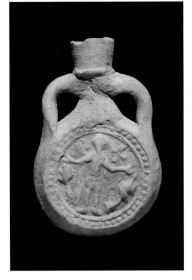
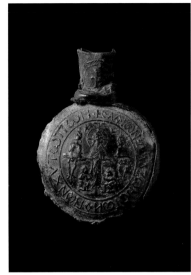
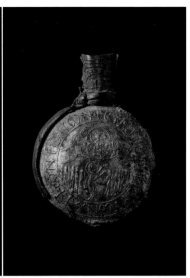

21 22 23

21
Pilgrim Flask of St. Menas

Roman (Egypt), ca. 6th–7th century
Terracotta; 10 × 6.7 × 2.4 cm
The Walters Art Museum, Baltimore (48.2541)
Cleveland and Baltimore

PROVENANCE: Pete N. Nickolas (Helios Old World Antiquities),
Westminster, Maryland; Walters Art Museum, 1987, by purchase

BIBLIOGRAPHY: Vikan 1998, 239–40, fig. 8.13; Skedros 2006, 92,
fig. 4.4; Woodfin 2006, 111–17

22
Pilgrim Flask of St. Menas

Roman (Egypt), ca. 6th–7th century
Terracotta; 10.2 × 6.6 × 2.3 cm
The Cleveland Museum of Art, gift of Bruce Ferrini in memory
of Robert P. Bergman (1999.230)
Cleveland and Baltimore

PROVENANCE: Bruce Ferrini, Akron, Ohio

BIBLIOGRAPHY: Unpublished

The widespread popularity of the cult of St. Menas
is attested by the hundreds of pilgrim flasks from his
shrine that have been found throughout the Medi-
terranean region. The flasks most likely contained
holy oil that was kept in a large pot underneath
the altar and distributed to the faithful. This oil, con-
sidered holy because of its proximity to the saint's
grave, allowed pilgrims to carry away the healing
power of the saint. Molds for mass-producing these
flasks have been found at the site of the shrine.

Pilgrim flasks from this shrine depict St. Menas
with his arms raised in prayer, flanked by kneeling
camels. The camels are drawn from the legend
of the saint's burial, but, as many pilgrims to the
desert shrine might have traveled with camels,
the picture would perhaps remind pilgrims of their
own journey. It is also possible that a similar cult
image of some sort was kept at the shrine. / KBG

23
Pilgrim Flask

Byzantine (Palestine), late 6th or early 7th century
Tin-lead alloy, fragments of leather; 6.2 × 4.2 × 1.5 cm
The Cleveland Museum of Art, John L. Severance Fund
(1999.46)
Cleveland and Baltimore

INSCRIBED: +ΕΛΑΙΩΝ ΞΥΛΟΥ ΖΩHC ΤΩΝ ΑΓΙΩΝ ΧΡΙCΤΟΥ ΤΟΠΩΝΩΝ (+ Oil of
the Wood of Life from the Holy Places of Christ); + ΕΥΛΟΓΙΑ ΚΥΡΙΟΥ
ΤΩΝ ΑΓΙΩΝ ΤΟΠΩΝ (+ Blessing of the Lord from the Holy Places)

PROVENANCE: Bernard Manhes, Grenoble and Paris; Bruce Ferrini,
Akron, Ohio

BIBLIOGRAPHY: Los Angeles 2007, 54–55, no. 10. For related
flasks, see Grabar 1958; Engemann 1972; Engemann 1973; Vikan
1982; Kötzsche-Breitenbruch 1984; Engemann 2002

This lead *ampulla*, or flask, is decorated on both
sides with images of central events from the life of
Christ, namely, the Crucifixion and the Ascension.
The inscriptions surrounding these images reveal
that the flask once contained "oil of the wood of life,"
namely, oil that had been brought into contact
with the relic of the True Cross.

Guided by the belief that physical contact
with holy matter would result in the transfer of its

miraculous properties, Christian pilgrims to the
Holy Land not only desired to touch and kiss objects
associated with Christ's Passion at sites such as
Mount Golgotha and Mount Sion; they also sought
to preserve and carry home with them substances
that could claim some physical contact or proximity
to the sites and objects they had seen and venerated.
Frequently referred to as *eulogiai* (blessings) in
contemporary pilgrim accounts, such substances often
included wax from candles or fragrant oil from lamps
that burned at shrines or tombs of holy martyrs.
Depending on the pilgrim's financial resources, these
substances could be collected, brought into contact
with important relics such as the True Cross, and
eventually carried away in small portable *ampullae*
of terracotta, lead, and presumably also more pre-
cious materials such as silver, offered for sale.

While the inscriptions on the "eulogia" flasks
recalled the places from which the sacred substances
derived, the images imprinted on them served as
visual reminders of the very events that endowed these
places with their sacred power, namely, the Passion
and Resurrection of Christ. / HAK

24
Pilgrim Flask of St. Sergios

Byzantine (Syria), ca. 6th or 7th century
Tin-lead alloy; 5.4 × 3.8 × 1.6 cm
The Walters Art Museum, Baltimore (55.105)
Cleveland and Baltimore

INSCRIBED: on both sides: ΕΥΛΟΓΙΑ ΤΟΥ ΑΓΙΩΝ ϹΕΡΓΙΟΥ (Blessings of St. Sergios)

PROVENANCE: Private collection (date and mode of acquisition unknown); Antiquarium, New York, by purchase (date of acquisition unknown); Walters Art Museum, 2000, by purchase

BIBLIOGRAPHY: Engemann 2002, 158–60

Throughout the Middle Ages, small keepsakes were made for the masses of pilgrims who visited shrines across Europe, the Byzantine Empire and the Holy Land. A pilgrim flask, or *ampulla*, was a popular type of this sort of souvenir. These small vials were made to contain holy water or holy oil from a saint's shrine. These were usually made of relatively cheap materials and were cast in reusable molds. This example is typical in shape, having a circular body made of two domical halves, somewhat flattened in the center, with a narrow neck that could be crimped shut, or sealed with a stopper. Such flasks were sometimes carried home to heal a family member who was too ill to make the journey to the shrine, and in some cases they were given to a local church by a returning pilgrim. Pilgrim flasks could be worn around the neck as a pendant, or suspended in the home or over an altar. Examples have been found from shrines across eastern and western Europe and the Holy Land, and they are mentioned in a number of textual accounts of pilgrimage from the early Christian and medieval periods.

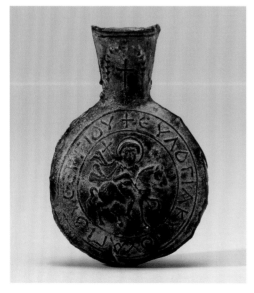

24

This well-preserved example depicts, on both sides, St. Sergios on horseback, encircled by an inscription. St. Sergios, often paired with St. Bakchos, was reputed to be an officer in the Roman army who was martyred in the third century when he was exposed as a Christian. His cult center was located in Sergiopolis (Resafa), in northern Syria, a city near the supposed site of his martyrdom. / KBG

25
Reliquary of St. Zacharias

Byzantine, 6th century
Gold (with the addition of a contemporaneous garnet intaglio from the Dumbarton Oaks collection); 3 × 2.5 × 0.5 cm
Byzantine Collection, Dumbarton Oaks, Washington DC (BZ.1957.53)

INSCRIBED: on the sliding lid: ΤΟΥ ΑΓΙΟΥ / ΖΑ ΧΑΡΙΟΥ (of St. Zacharias)

PROVENANCE: Acquired from George Zacos, 1957; said to have been found in Constantinople

BIBLIOGRAPHY: Ross 1965 [2005], 30–31, no. 31, pl. 27; Kötzsche-Breitenbruch 1991, 296, pl. 38e; Boston 1995, 21, 102, no. 12; Geroulanou 1999, 97, no. 127, fig. 167; Bühl 2008, 88, pl. 89

Several churches in Constantinople were dedicated to Zacharias: a Church of the Prophet (Zechariah) and two to the father of St. John Prodromos (the Baptist); one of the two latter was a monastery church founded about 474. A large *martyrion*-like structure labeled ΤΟ ΤΟΥ ΑΓΙΟΥ ΖΑΧΑΡΙΟΥ (the [sanctuary] of St. Zacharias) is represented on the mid-sixth-century mosaic map of the Holy Land at Madaba (in modern Jordan). It is not known whether the saint is the Old Testament prophet, the high priest mentioned in 2 Chron. 24:20–22, or the father of St. John Prodromos. The same lack of specificity surrounds this gold reliquary or amulet.

The container would have hung from three loops, one attached to the container itself and two to its sliding closure. The opened lid reveals a narrow, pocketlike cavity; neither its shape nor its size indicates what it held. If it was a reliquary, it might have held a piece of cloth *(brandeum)* that had touched the saint; or, if an amulet case, it might have held an inscription—a prayer, an invocation, or possibly a miniature book.

Decorated on all sides, the front of the pendant had an oval element (now replaced) framed by an openwork rinceau surrounded by an *opus interrasile* (finely punched openwork) lattice edged with a beaded frame. On the reverse, an equal-armed cross stands within a wreath surrounded by a single guilloche. Emanating from a circle (depicting a gem-

stone?), at the center of the bottom, branches with short, thick leaves fill the sides. The gold pendant is made like a piece of jewelry of the highest quality; its precious content, though protectively encased, was exposed, or accessible, through the openwork of its obverse side. / SRZ

26
Necklace with Pendants

Byzantine (Constantinople [?]), 5th/6th century
Gold, garnets; cross: 4.5 × 3.1 cm; chain: 56.5 cm
The Cleveland Museum of Art, purchase from the J. H. Wade Fund (1954.3)

PROVENANCE: Marguerite Mallon, New York

BIBLIOGRAPHY: Milliken 1954, 190–92; Frolow 1966, 44; Los Angeles 2007, 64–65, no. 15

This gold necklace consists of a chain and four gold pendants of different shapes and sizes. Attached to the chain with a plain suspension ring, a gold cross with flaring conical arms forms the central ornamental element. It is decorated on the obverse at the intersection of its arms with a dark red garnet set in a high circular collet. Flanking the cross are two hexagonal gold cylinders, which likely contained magical or sacred texts or substances. Each is suspended from two plain rings and has beaded borders and rounded caps on either side. The fourth pendant, outfitted once again with a plain suspension ring, is circular and decorated on its obverse with a central garnet.

Wearing richly ornamented gold necklaces such as this one was a common practice among elite members of society in the late Roman and Byzantine Empire. In the Christianized Roman Empire, necklaces with cross pendants and amuletic capsules functioned as objects of personal adornment and symbols of social status as well as powerful protective devices. While Christian theologians were not always comfortable with the use of protective amulets, especially if they contained undisclosed texts or substances, their existence is well attested. One of the earliest records for the use of Christian relics in necklaces such as this one comes from St. Gregory of Nyssa, who reported that, at the time of her death, his sister Makrina (d. 379) was wearing a relic of the True Cross on a chain around her neck. Bishop Paulinus of Nola in Italy, an early collector of relics and avid impresario of the cult of St. Felix, sent another fragment of the True Cross to his friend Sulpicius Severus in Gaul. It was enclosed "in a small golden tube" that may have resembled the hexagonal containers on this necklace. / HAK

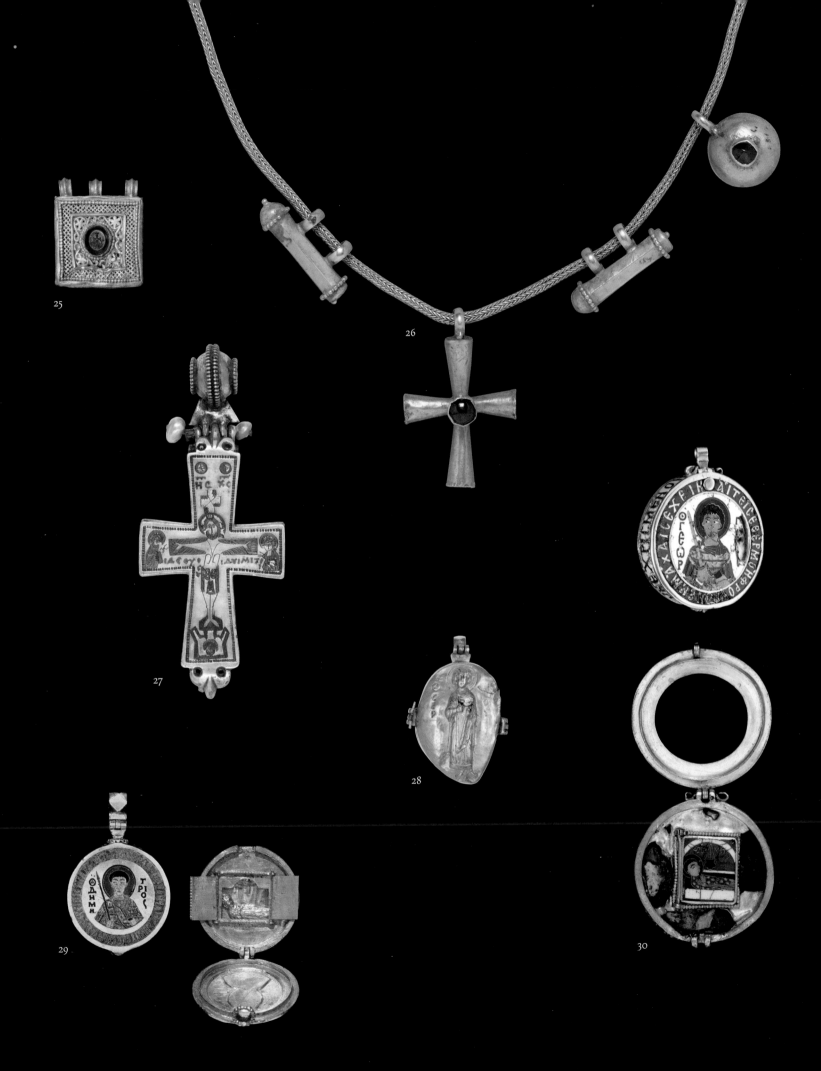

25

26

27

28

29

30

27
Pendant Reliquary Cross

Byzantine, 10th–11th century
Silver, gilding, niello, pearls; 9.3 × 4 × 0.8 cm
Byzantine Collection, Dumbarton Oaks, Washington, DC
(BZ.1965.2.1)
Cleveland and Baltimore

INSCRIBED: obverse: HC XC (Jesus Christ); below the arms of the
cross, to the left, ΙΔΕ Ο ΥΟ [ΥΙΟC] COY (Behold thy son), to the
right, ΙΔΟΥ Ι ΜΙΤΙ Ι (ΙΔΟΥ Η ΜΗΤΗΡ COY [Behold thy mother]); reverse:
M–P ΘΟΥ (Mother of God)
PROVENANCE: Acquired from George Zacos, 1965

BIBLIOGRAPHY: Ross 1965 [2005], 204–7, no. 196, pls. κ and 128;
Bühl 2008, 148, pl. 149

Like a great many Byzantine reliquaries of the True
Cross, this one is made in the shape of a cross,
reflecting its contents; like most examples of this type,
it is an *enkolpion*, made as a pendant to be worn on
the chest. Further reflecting the nature of its relic, the
obverse image is a Crucifixion: Christ is depicted on
the Cross with the sun and moon above his name.
Three-quarter-length figures of Mary and John flank
the Cross and are accompanied by the Gospel words
of Jesus recorded in John 19:26–27. The Cross is set
on Golgotha, the place of the skull, as mentioned in
the Gospels, with the skull of Adam and the three
wedges used to stabilize the Cross. Though usually
a realistic detail, the wedges are exaggerated in size
and perhaps misunderstood in this rendering.

On the reverse Mary is identified as the Mother
of God, her usual epithet in Orthodox Christianity.
She stands on a footstool, a symbol of prestige,
and raises her open hands in prayer. Three arms of
the cross are filled with teardrop-shaped ornaments.

In his letter to the Romans 5:12–21, Paul
contrasted the sin and death caused by Adam's
transgression with the grace and righteousness
brought to mankind through Jesus Christ. And fur-
ther, Paul said in 1 Cor. 15:45, "as it is written,
'The first man Adam became a living being'; the last
Adam became a life-giving spirit." The Byzantines
developed this succinct image of the Crucifixion to
express both their historical and their theological
ideas of redemption. Just as relics held concentrated
spiritual power, fragments of the True Cross were
especially potent because they were suffused with
the dual nature of Christ. Wearing the reliquary
became an act in the pursuit of personal redemption,
also expressed in the metaphorical axiom: "as we
have borne the image of the man of dust [Adam], we
shall also bear the image of the man of heaven"
(1 Cor. 15:49).

Narrow strips of silver form the sides of the cross
reliquary, which is suspended from a large loop with
beading and a trapezoidal plate whose rings interlock
with those on the cross. The hinge is secured by a pin
with a pearl at each end passing through a copper
alloy tube. The extensive gilding, lustrous niello, and
chasing create an enriched Crucifixion image. / SRZ

28
Reliquary Pendant of
St. Sergios

Byzantine (Constantinople?), 11th century
Gold (repoussé); 3.9 × 2.8 × 1.9 cm
Byzantine Collection, Dumbarton Oaks, Washington, DC
(BZ.1953.19)

INSCRIBED: obverse and reverse: Ο Α(ΓΙΟC) CΕΡΓΙΟC (St. Sergios)

PROVENANCE: Acquired in 1953. Said to have been fund in Antioch

BIBLIOGRAPHY: Ross 1965 [2005], 71, no. 94

At first glance, the boxlike container seems to be
distorted, especially at its lower right edge. However,
a closer look confirms that this reliquary pendant
is not damaged but was shaped to contain an object,
most likely a piece of bone or other relic. On the
front, a full-length figure of a young man dressed in
a tunic with a jeweled hem and a mantel is worked
in repoussé. The inscription on both sides identifies
the beardless, youthful saint as Sergios.

The back and sides of the gold container are
undecorated; a three-part hinge on the right corre-
sponds to a clasp on the left side, and a polygonal
ring at the top would have allowed the owner to
wear it as a pendant. Repoussé work is rare in Byz-
antine metalwork from this period; the closest
parallels are found among other reliquary containers.
Among these, the closest in style and iconography
is a rectangular pendant reliquary in the Treasury
of Halberstadt with St. Demetrios on the front in
enamel and St. Nestor of Thessalonike on the
back in very shallow relief which has been dated to
the tenth or eleventh century (see Grabar 1950;
Sevrugian et al. 2001, 30). Whether the workshop was
located in Constantinople or in Thessalonike is
uncertain. / GB

29
Reliquary Pendant of
St. Demetrios with Sts. Sergios
and Bakchos

Byzantine (Constantinople or Thessalonike), 13th or 14th century
Gold (cast and repoussé), enamel (cloisonné); diameter 2.8 cm;
depth 0.6 cm
Byzantine Collection, Dumbarton Oaks, Washington, DC
(BZ.1953.20)

INSCRIBED: obverse: Ο Α ΔΗΜΗΤΡΟC (St. Demetrios)
Encircling portrait on front: CΕΠΤΟΝ ΔΟΧΕΙΟΝ ΑΙΜΑΤΟC ΔΗΜΗΤΡΙΟΥ /
CΥΝ ΜΥΡΩ ΦΕΡΕΙ ΠΙCΤΙC Η ΤΟΥ CΕΡΓΙΟΥ (The faith of Sergios carries
[wears] the venerable receptacle with the blood and myron
of St. Demetrios); around the sides: ΑΙΤΕΙ CΕ ΚΑΙ ΖΩΝ ΚΑΙ ΘΑΝΩΝ
ΡΥCΤΗΝ ΕΧΕΙΝ CΥΝ ΤΟΙC ΔΥCΙΝ ΜΑΡΤΥCΙ ΚΑΙ ΑΘΛΟΦΟΡ[ΟΙ]C (He asks to have
you as protector both in life and in death together with the
two victorious martyrs)

PROVENANCE: Given by an anonymous donor, 1953

BIBLIOGRAPHY: Grabar 1950; Grabar 1954; New York 1997, 168,
no. 117; Buckton 1994b, 186; Athens 2002, 180–83, no. 202;
Taylor et al. 2009, 160–61

When closed, this round pendant and the very similar
one in London (cat. no. 33) look like solid medal-
lions; the "inner nature"—the reliquary function—
remains concealed.

The exterior front and back as well as the shallow
edge all around are covered with cloisonné enamel,
including lavishly set cloisonné lettering on a gold
ground. The bust of Demetrios in military costume,
a spear and a sword in his hands, is shown on the
front; two standing military saints—Sergios and
Bakchos—are depicted on the back, both holding
small crosses. Besides the identifying inscriptions
that flank the saints, a dodecasyllabic verse encircles
the front bust and continues around the edge.

A beaded collar, soldered to the lid, and a long
screw that ends in a faceted suspension ring, make
a very secure lock; in itself, this feature represents
a sophisticated example of ingenious goldsmithing,
but even more elaborate craftsmanship is revealed
when the interior of the *enkolpion* is opened: two tiny
doors with beaded frames are hinged to the gold
ground; they part to show a figure worked in gold
repoussé, reclining under an arch with eyes closed.
The London pendant shows the same design and
concept; the miniature door in the London medallion,
however, repeats the recumbent saint in enamel.

The image refers without doubt to the patron
saint of Thessalonike and the miraculous appear-
ances of Demetrios at his shrine or ciborium in the
church dedicated to him; the inscription implies
that the pendant was created to contain the blood

and *myron*, a sweet-scented substance that purportedly flowed from the venerated site. The pendants in London and Washington share features that distinguish them from the other five extant middle Byzantine reliquary containers of St. Demetrios. First, through their inscriptions, the owners, in the case of the Washington *enkolpion* named Sergios, invoke the saint's protection directly. Second, the profile view of the reclining saint is unique to these reliquaries, and seems to have been established under thirteenth-century Latin influence, probably reflecting Crusader representations of Christ in the Holy Sepulcher as depicted on seals of the Grand Masters of the Knights Hospitallers of Jerusalem. / GB

30
Reliquary Pendant of St. Demetrios with St. George

Byzantine (Thessalonike?), 12th or 13th century
Gold, silver, silver gilt, enamel; diameter 3.8 cm, depth 1.1 cm
The British Museum, London (PE 1926,0409.1)

INSCRIBED: reverse: Ο Α ΓΕΩΡ / ΓΗΟϹ (St. George)
Around the border: ΑΙΤΕΙϹΕ ΘΕΡΜΟΝ ΦΡΟΥΡΟΝ ΕΝ ΜΑΧΑΙϹ ΕΧΕΙΝ (He supplicates you to be his fervent guardian in battles; around the sides: ΑΙΜΑΤΙ ΤΩ ϹΩ ΚΑΙ ΜΥΡΩ ΚΕΧΡΙϹΜΕΝΟΝ (Being anointed by your blood and your myrrh); on the upper ring, a mid-18th-century inscription in Georgian: (trans) St. Kethevan [the] Queen's relic: Cross: True

PROVENANCE: Durlacher Bros, London; The British Museum, London, 1926, purchased with contributions from the Art Fund and O. M. Dalton

BIBLIOGRAPHY: Dalton 1926, 33–35; Grabar 1954; Tait 1986b, no. 504; Buckton 1994a, 47–49; Buckton 1994b, 185–86; New York 1997, 168, no. 116; Robinson 2008, 80–81

A handful of personal reliquaries of St. Demetrios have survived, each incorporating small interior shuttered compartments for relics and depictions of the saint. The relics of Demetrios were not his bones, but oil or *myron* collected from his tomb and blood-soaked earth taken from the site of his martyrdom. The owners of the reliquaries would have had to move through several layers, opening first the lid of the reliquary and then the shutters covering the interior compartments, before finally seeing the relics and the innermost depiction of the saint.

Two of these reliquaries are in the form of circular pendants, meant to be worn around the neck of the owner, with hinged lids allowing access to the reliquary compartments inside. The upper lid of the London reliquary was replaced with an open ring in the eighteenth century, but the inscription on the side of the reliquary refers to Demetrios, and the interior compartment is similar to those of other Demetrios reliquaries, so it is likely that Demetrios was depicted on its lost lid, in a manner similar to the representation on the Washington pendant (cat. no. 29). Demetrios was the patron saint of Thessalonike, and a large festival in his honor was held there every year in October, coinciding with his feast day (26 October). These reliquaries, like many objects associated with Demetrios, have been attributed to workshops in Thessalonike, but given the saint's popularity with members of the imperial family and the aristocracy, and scant evidence of any enamel workshops in Thessalonike, production in the Byzantine capital, Constantinople, should also be considered.

From the eleventh century onward, Demetrios became increasingly popular among the military classes in the Byzantine Empire, and he was often depicted as a soldier and paired with other military saints. St. George, another popular soldier saint, is depicted on the back of the London reliquary. André Grabar, following O.M. Dalton, suggested that the lamp suspended over the tomb of the saint in this reliquary was a reflection of Crusader influence. Similar iconography was used in certain Crusader contexts, but such lamps had long been associated with the tombs of a number of Byzantine saints, including, significantly, St. Theodora, another *myron*-producing saint of Thessalonike with whom Demetrios was often associated. / KBG

31
Menologion with Scenes of Martyrdom

Byzantine (Constantinople), ca. 1025–50
Ink, paint, and gold on parchment; fol. 50v: 30 × 23.1 cm; fol. 203v: 30 × 23.5 cm
The Walters Art Museum, Baltimore (W.521)
Illustrated: fols. 50v, 203v
Cleveland and Baltimore

PROVENANCE: Library of the Greek Patriarchate, Alexandria (no. 32/33), known to be there in 1895 and 1901, but reported lost by 1914; Henry Walters, by purchase (probably from Gruel, Paris), 1930; Walters Art Museum, by bequest, 1931

BIBLIOGRAPHY: Halkin 1985; Ševčenko 1993; Parpulov 2004, 83–88

A menologion (from the Greek word for *month*) is a catalogue of saints arranged in order of their feast days. This example follows the so-called Imperial version, which includes a detailed account of each saint's life, and, at the end of each saint's story, a prayer for the emperor. The menologion covers the month of January, and each entry is prefaced with a picture of the saint whose feast is celebrated on that day. It was produced in Constantinople, and was probably made at the request of either Michael Keroularios, patriarch of Constantinople (r. 1043–59), or the Byzantine emperor Michael IV (r. 1034–41). On folio 50v, the martyrdom of St. Zotikos is shown. Zotikos, according to medieval accounts, was a priest in the city of Constantinople, who dedicated himself to helping the poor; although he enjoyed the favor of Emperor Constantine I (r. 306–37), Constantine's son and successor Constantius II (r. 337–61) did not take such a kindly view and had Zotikos killed by being dragged behind mules. The martyrdom of St Timothy is shown on folio 203v, along with either his funeral procession or the translation of his relics. Timothy, a follower of St. Paul, was buried at Ephesus, but in the fourth century his relics were brought to the Church of the Holy Apostles in Constantinople; that church, which has since been destroyed, may be the building shown in the background of this picture. The Walters' menologion has twenty-four miniatures, but a number of original leaves have been lost (some of the lost text was replaced in the late sixteenth century) and the book probably had at least another eight miniatures when it was complete; a single detached leaf from this manuscript, showing St. Sylvester, is now in Berlin (Staatsbibliothek Preussischer Kulturbesitz, MS gr. fol. 31). / KBG

31 FOLIO 50V (DETAIL)

31 FOLIO 203V (DETAIL)

32
Pectoral Reliquary Cross

Byzantine, 9th century
Gold, niello; 1A: 4.2 × 3.2 × 0.5 cm, 1B: 4 × 3 cm, 2: 3.7 × 2.7 cm
National Institute of Archaeology and Museum–Bulgarian
Academy of Sciences, Sofia (4882)

INSCRIBED: 1A: I(HCOY)C X(PICTO)C (Jesus Christ), ΙΔΕ Ο ΥΟC [sic] [COY]
(Here is your son [John 19:26]), ΙΔΟΥ Η ΜΗ(ΤΗ)Ρ [COY] (Here is your
mother [John 19:27]), ΤΟΠΟC ΚΡΑΝΙΟΥ (The Place of the Skull);
1B: Η ΑΓΙΑ ΘΕΟΤ(ΟΚΟC) (The Holy Mother of God), Ο ΧΡΥCΟCΤΟΜ(ΟC)
(Chrysostom), ΝΙΚΟΛΑ(ΟC) (Nicholas), ΒΑCΛΗ(ΟC) [sic] (Basil),
ΓΡΗΓΟΡ(ΙΟC) (Gregory); 2: ΧΕΡΕ(ΤΙCΜΟC) [sic] (Annunciation), Η ΓΕΝΑ
[sic] (The Nativity)

PROVENANCE: Archaeological excavations conducted by
L. Dončeva-Petkova in Pliska, 1973

BIBLIOGRAPHY: Dončeva-Petkova 1979; Kitzinger 1988, 63–66;
S. Taft in New York 1997, 331–32, no. 225 (with bibliography);
Rome 2000b, 144–45, no. 35 (with bibliography); Pitarakis 2006,
57–68; Henning 2007, 674, no. 55; K. Melamed in London 2008,
102–3, 391, no. 53; K. Melamed in Bonn 2010, 158–59, no. 35

The Bulgarian capital of Pliska was surrounded
with stone fortifications probably ca. 820 (Ziemann
2007, 325). Four oblong buildings were later erected
by its western gate, evidently to serve as soldiers'
barracks. An alley separated them from the city wall.
There, at a depth close to the original street level,
archaeologists unearthed this tiny object (Dončeva-
Petkova 1992, 126). Evidently lost by accident, it
would have been treasured because of a miniscule
piece of wood inside it. The latter (not illustrated
here) is fitted within a hollow golden cross and kept
visible by way of two slits. These slits follow the
body and arms of a crucified Christ, depicted in black
inlay (niello). The content is thus revealed to be
a fragment of the Cross upon which Jesus died.
The other side of the golden cover carries portrayals
of the Virgin and Child, Nicholas of Myra, John
Chrysostom, Basil of Caesarea, and Gregory of
Nazianzos. Specks of bone embedded in the holy
wood probably come from the bodily remains of
these four saints. The whole is encased in a second,
slightly larger cruciform pendant, densely nielloed
with scenes from Christ's life: the Annunciation,
Nativity, Presentation in the Temple, Baptism, and
Transfiguration on one side, the Resurrection and
Ascension on the other.

Similar objects must have been known by
818–20, when Nikephoros, patriarch of Constanti-
nople, wrote:

"we, the faithful, faithfully venerate the original,
as it were, of the cross, [its] honourable, glorious
and life-giving wood. . . . From earliest times
Christians have been fashioning from gold and
silver so-called phylacteries that we hang from
our neck and wear upon the chest for the protection
(from which word the name of such objects is
derived) and safety of our lives, for the salvation
of our souls and bodies, to cure us of passions
and repel the attacks of unclean spirits. . . . These
objects are found in countless number among
Christians; Christ's Passion, Miracles and life-
giving Resurrection are often depicted on them"
(PG 100:433; cf. Kartsonis 1986, 118).

The Pliska cross could have been made soon
after Nikephoros's time. The tunic worn by the cru-
cified Christ and the Virgin's appellation *he hagia
Theotokos* found on it are both attested in ninth-
century works (e.g., New York 1997, cat. nos. 52 and
43). Very similar niello is seen on the so-called
Fieschi Morgan Staurotheke (cat. no. 37), now
unanimously dated to the early 800s. The R-shaped
Greek letter B in the inscription "St. Basil" may,
however, indicate manufacture after 850 or so (Nes-
bitt 2008, 154). The cross must have been brought
to Pliska from Byzantium, whence the Bulgarians
received the Christian faith (Ziemann 2007,
345–64). / GRP

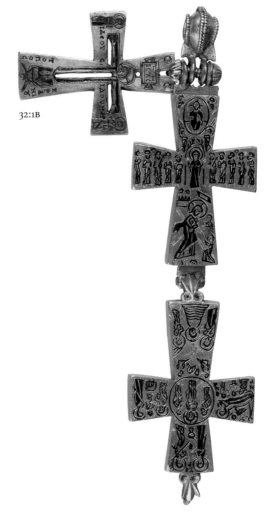

32:1B

32:1A

32:2

33

33
Reliquary Pendant with the Adoration of the Magi

Byzantine (Constantinople), 10th–11th century
Silver, gold, niello; 0.8 × 2.1 × 3.7 cm
The British Museum, London (AF.354)

INSCRIBED: reverse: + Η ΒΕΒΑΙΑ ϹΩΤΗΡΙΑ ΚΑΙ ΑΠΟϹΤΡΟΦΗ ΠΑΝΤΩΝ ΤΩΝ ΚΑΚΩΝ (Secure deliverance and aversion [from] all evil); edge of lid: + ΤΩΝ ΑΓΙΩΝ ΚΩϹΜΑ ΚΑΙ ΔΑΜΙΑΝΟΥ (of Sts. Cosmas and Damian)

PROVENANCE: Augustus Wollaston Franks (date and mode of acquisition unknown); The British Museum, London, 1897, by bequest

BIBLIOGRAPHY: Dalton 1901, no. 284; Mango 1994, 189–92

On its front, this octagonal locket bears scenes of the Nativity and the Adoration of the Magi, divided by a dotted horizontal line. The upper portion shows the Virgin lying on a bed, with Joseph on the left. Above her the Christ Child lies beneath a watchful ox and ass. In the lower section a seated Virgin holding Christ is presented with gifts by the three Magi, who stand one behind the other. This scene is framed by large plants. A symbol is etched in the center: a monogram based on the form of a raised cross. The terminations of the arms have been interpreted as holding magical or numerological significance. The inscription on the rim refers to Cosmas and Damian, twin saints martyred in the third century, known as *anargyroi* (lit. without money), who healed the sick without taking payment. Their cult originated in the region of Cyrrhus (Kyrros) in northern Syria. By the fifth century the popularity of the two saints had expanded throughout Christendom: in Rome a chapel was built in their honor by Pope Symmachus (r. 498–514). Cyril Mango (1994) suggests that the connection of the Marian scenes with these saints might stem from the proximity of shrines dedicated to the Virgin Mary and to Cosmas and Damian around Blachernae, Constantinople. The healing symbolism of the twin saints suggests that this reliquary was a type of medical amulet, intended to protect the wearer from illness. The hinged loop at the top would have been for suspension, so that the locket could have been worn or held. The locket contains a cavity, closed by a sliding pin, that probably contained relics. / NCS

34
Reliquary Cross

Byzantine, late 12th–early 13th century
Gold, cloisonné enamel; 9.7 × 6.2 × 1.3 cm
Byzantine Collection, Dumbarton Oaks, Washington, DC (BZ.1936.20)
Cleveland and Baltimore

INSCRIBED: IC XC (Jesus Christ) and Ο ΒΑϹΙΛΕϹ / ΤΗϹ ΔΟΞΗ / Ϲ (Jesus Christ, the King of Glory)

PROVENANCE: reportedly acquired in Ierissos, Chalkidike by P.I. Sevastyanov, 1860–61; P.I. Sevastyanov, Moscow; M.P. Botkin, St. Petersburg; Mrs. Walter Burns, London; Mr. and Mrs. Robert Woods Bliss, Washington, DC

BIBLIOGRAPHY: Ross 1965 [2005], 109–10, no. 159 (with earlier bibliography); Wessel 1967a, 186, no. 60; Effenberger 1983, 122, 124; New York 1997, 174, no. 125; Bühl 2008, 172, pl. 173

As with most cross-shaped reliquaries, it is believed that this one held a fragment of the True Cross. Its shape and the image of the crucified Christ support such an assumption, while the luxurious medium of cloisonné enamel speaks for the distinctive honor given to the enclosed relic. Traces of a gold hinge or ring on the top suggest use as a box reliquary, while lead(?) solder on all four arm-ends transformed it into a sealed, and perhaps a pendant, reliquary. The enamel is almost intact and its palette provides an undiminished impression of what Byzantine viewers would have seen when it was newly fabricated.

Christ is depicted on a black cross, which is surrounded by a bright blue border with scrolling cloisons. Although the tilted head, the closed eyes, and the stream of blood from Christ's wound signify his death, the flesh-colored body expresses no suffering. In fact, the inscription above the Cross identifies Christ as the King of Glory, alluding to his spiritual triumph over death (cf. Psalm 23 [24]: 7–10), differentiating this image from Crucifixions in which the title King of the Jews (Matt. 27:29 and John 19:19) would appear, with Mary and John the Evangelist as witnesses. The Cross stands on the hill of Golgotha above Adam's skull, the visual allusion to Christ as the new Adam being sacrificed for the remission of humanity's sins (see cat. no. 27).

Although this reliquary is often associated with Thessalonike through comparison with two enamel reliquaries representing St. Demetrios, the patron saint of that city (cat. nos. 29, 30), such a link cannot be maintained on stylistic grounds. This enamel may well be of the later twelfth century or very early thirteenth century from Constantinople just before the sack of the city by Crusaders in 1204. / SRZ

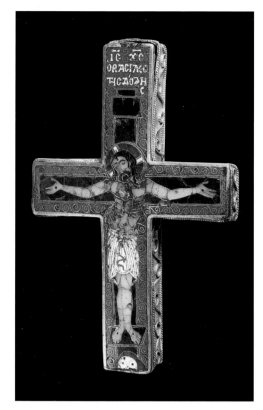

34

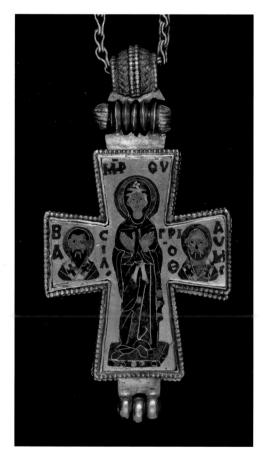

35

35
Pendant Reliquary Cross

Byzantine (Constantinople), early 11th century
Gold, enamel; cross: 6.1 × 3.1 × 0.9 cm; chain: length 62.2 cm
The British Museum, London (PE 1965,0604.1)

INSCRIBED: MP ΘY (Mother of God) BACIΛ (Basil) ΓΡΙ ΘAYM (Gregory Thaum[atourgos])

PROVENANCE: Mme Michele Stoclet; The British Museum, London, purchased through Sotheby's and John Hewett, 30 June 1965, lot 34

BIBLIOGRAPHY: Tait 1986b, no. 503; Buckton 1994a, 165; Buckton 1994b, 47–49; Robinson 2008, 82

This reliquary cross, which preserves its original chain, is made of gold and decorated with multicolored cloisonné enamelwork sunk into a gold background. This technique, known as *Senkschmelz*, is in contrast with the earlier taste for fully enameled crosses, such as the Paschal Cross from around 817–24 (cat. no. 36). The enamel sheeting from the front of the cross is missing; what remains is the reverse, which shows the central standing figure of the Virgin Mary, with hands crossed upon her chest in prayer. She is clad in a blue *chiton* (a type of tunic) and a *maphorion* (a mantle) and stands on a pedestal that resembles a *suppedaneum* used to support the feet in a crucifixion. To the Virgin's left is a bust of St. Gregory Thaumatourgos (a third-century bishop from Asia Minor) and to her right the bust of St. Basil the Great (a fourth-century bishop known as one of the Cappadocian fathers); all three figures are identified by abbreviated inscriptions in Greek. The reliquary is hinged and opens to reveal a space just under a centimeter deep that would have held an important relic, possibly a fragment of the True Cross or a Passion relic given the costly materials and the extraordinary quality of the workmanship. The reliquary is reputed to have been found in the ruins of the Great Palace of Constantinople. / NCS

GATHERING THE SAINTS

hI S·BAPT·PAVLI·AP̄Ł·II·ACO B·HP̄·OA·HE

P̄·Φ·EW·IOHIS·EW·STEPhANI·PTO·O͂·LAVREN

TI·CORNELII·CIPRIANI·FABIANI·SEBASTIANI·BONIFACII·E

I SII·EPI·FELICIS·CRISTOPhORI·COSME·DAMIANI·PA

ATII·ThEODORI·DIONISII·EPI·OARELLINI·PETP

RIANI·IPOLITI·VITALIS·FELICIS·SIONIO·AVRICIIIACINCTI·TO

TI·EELICIS·NARORIS·OR̄O·ETCO͂·CONFESSOR GODEHARI

I·NICOLAI·SERVACIO·ARTINI·BENEDICTI·ABBIS·EG͂IO·RIE

AGDALENE·AGATHE·OORIS·ThIDERICVS·ABBAS·III·DED·IT

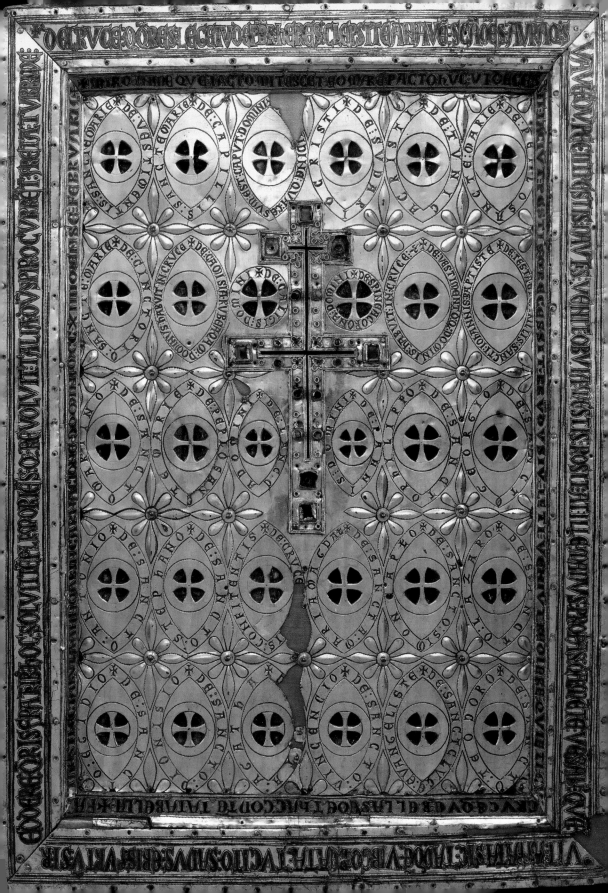

Sacred Things and Holy Bodies
Collecting Relics from Late Antiquity to the Early Renaissance

HOLGER A. KLEIN

The bodies of the martyrs, after having been exposed and insulted in every way for six days, and afterwards burned and turned to ashes, were swept by the wicked into the river Rhône which flows near by, so that not even a relic of them might still appear upon the earth. And this they did as though they could conquer God and take away their rebirth in order, as they said, "that they might not even have any hope of resurrection."[1]

As this passage from an early account of the martyrdom of a group of Christians at Lyon in Roman Gaul around 177 suggests, one of the ways in which Roman authorities tried to discourage Christians from spreading their faith and from seeking martyrdom was to shatter their hopes for resurrection and salvation by burning their bodies and scattering all that was left of their earthly remains. Similar stories of the scattering of holy bodies are known from a number of early saints' *Lives* and *passiones*, or martyrdom accounts, most famously perhaps from the second-century *Martyrdom of St. Polycarp*, whose body was burned in the stadium at Smyrna in 155/56 to prevent his fellow Christians from venerating his earthly remains and worshiping him like Christ.[2] Prudentius's description of the martyrdom of St. Hippolytus, whose body was torn apart and scattered by wild horses, paints an equally vivid picture of the violent dismemberment and scattering of a martyr's body.[3] However, both narratives also stress how

the martyrs' disciples eagerly collected the bones and body parts of their masters. While St. Polycarp's companions "took up his bones which are more valuable than precious stones and finer than refined gold, and laid them in a suitable place,"[4] the disciples of Hippolytus, "stunned with sorrow, went along with searching eyes, and in their garments' folds gathered his mangled flesh."[5]

Intimately tied to concepts of wholeness, corporeal integrity, and the resurrection of the body, the collecting of bones and body parts of holy martyrs was an important aspect of the Christian cult of relics already during Antiquity.[6] While the mangled bodies or ashes of many Christian martyrs of the first centuries were buried by members of local Christian communities in cemeteries or other "suitable places," few burial sites were marked by *tropaia*, or victory monuments, like those of Sts. Peter and Paul at the Vatican Hill and the Via Ostiense, and developed into *memoriae*, places in which Christians gathered to commemorate the life and death of Christ's most distinguished followers and martyrs.[7] More often than not, as was the case with the protomartyr St. Stephen, the resting places of early Christian martyrs remained unrecorded or were forgotten soon after their death.[8] In such cases, the saints themselves had to make their earthly presence known and communicate their wishes for proper burial and veneration to chosen individuals in dream visions or through other forms of divine inspiration.[9]

In 385/86, Bishop Ambrose of Milan was thus inspired to dig in front of the chancel screen of the Basilica of Sts. Felix and Nabor outside Milan, where he promptly discovered the intact bodies of the previously unknown martyrs Sts. Gervasius and Protasius.[10] Despite long-standing prohibitions against disturbing the dead and the enactment, in February 386, of a law stipulating that "no person shall transfer a buried body to another place . . . sell the relics of a martyr . . . or traffic in them,"[11] Ambrose moved the remains of the martyrs to the Basilica of Fausta and on the following day transferred them to his new basilica, commonly known as the Basilica Ambrosiana, where he laid them to rest under the altar.[12] It was not the last time that local martyrs would call Ambrose to action. Less than ten years later, in 395, Ambrose discovered the bodies of Sts. Nazarius and Celsus in a garden outside Milan and transferred them to the Basilica of the Holy Apostles.[13]

Such transgressions of imperial law were not restricted to the bishop and the diocese of Milan. Other bishops were likewise able to channel and obey the wishes of long-forgotten martyrs and become, as Peter Brown has shown, important *impresarios* of their cult: In 392/93, Bishop Eusebius of Bologna, for instance, found the remains of the martyrs Agricola and Vitalis in a Jewish cemetery outside the city, removed them, and honored them with proper burial in a church.[14] More careful in his efforts was Bishop Exuperius of Toulouse, who did not dare to move the body of St. Saturninus to a newly built church until he had received proper permission from both the martyr—who visited him in a dream—and the emperor, who officially sanctioned the removal and reburial of the saint's body in 402/3.[15]

Not every place, however, was blessed in the same way by the presence of holy martyrs' relics. Unlike Rome, which could boast the corporeal remains of numerous high-profile Christian martyrs, Constantinople, the Roman Empire's new administrative center and imperial residence on the Bosphorus, was lacking such mighty presence and protection. In the eyes of Bishop Paulinus of Nola, it was therefore only proper that Emperor Constantine the Great decided to remove the remains of the apostles Andrew from Greece and Timothy from Asia to fortify his new city "with twin towers, vying with the eminence of great Rome, or rather resembling the defenses of Rome in that God has counterbalanced Peter and Paul with a protection as great, since Constantinople has gained the disciples of Paul and the brother of Peter."[16]

Paulinus and his like-minded colleagues could see nothing wrong in the exhumation and translation of holy bodies. On the contrary, it was Christ himself, who they considered to have "graciously decided . . . , both by inspiring princes and by making a revelation to his servants to summon martyrs from their former homes and transfer them to fresh lodgings on earth."[17] Sharing the blood, bones, and ashes of holy martyrs among themselves and with less fortunate colleagues, eager to consecrate the altars of their churches with sacred matter, increased the number of holy bodies at their own local shrines and cult centers, while helping to spread the

martyrs' sacred presence throughout the empire—and thus fortify it.[18] But it was not only bishops who were willing to part with their sacred treasures. When Bishop Gaudentius of Brescia (d. 410) passed through Cappadocia on his way to the Holy Land in 386, the nuns of Caesarea bestowed on him a gift of relics of the Forty Martyrs of Sebaste, which they themselves had previously received as a gift from St. Basil. Upon his return, Gaudentius deposited these and other relics in a new church, which he consecrated in 402 and named *Concilium Sanctorum* in celebration of the precious "gathering of saints" he had been able to assemble.[19]

Sacred Things and Holy Places

Early Christian attempts to gather and preserve the remains of holy men and women were not an isolated phenomenon. Indeed, they formed part of a much broader culture of collecting that focused on bodily remains of *people* as much as on material remains of *things* that could either claim direct physical contact with the body of Christ or were associated with events and places related to his life, ministry, and death through the account of the Gospels.[20]

Already during the first half of the fourth century, Christian pilgrims were drawn to Jerusalem and the Holy Land from faraway regions to see with their own eyes and touch with their own hands and lips the things and places that had witnessed Christ's presence on earth and were known or presumed to have played a role in the story of his Passion and Resurrection. The anonymous pilgrim from Bordeaux, who visited Jerusalem in 333, recorded a detailed list of the objects and places shown to pilgrims: "the column at which they fell on Christ and scourged him . . . the hillock Golgotha where the Lord was crucified, and about a stone's throw from it the vault where they laid his body."[21] Later pilgrims such as the pious Egeria, who visited Jerusalem and the Holy Land in the 380s, and Jerome, who chronicled the Holy Land pilgrimage of Paula and Eustochium, stress the importance of physical contact with such relics, especially those related to Christ's Passion. Before the memorial cross that marked the spot of Christ's Crucifixion on Mount Golgotha, the blessed Paula "fell down and worshipped before the Cross as if she could see the Lord hanging on it. On entering the Tomb of the Resurrection she kissed the stone which the angel removed from the sepulcher door; then like a thirsty man who has waited long, and at last comes to water, she faithfully kissed the very shelf on which the Lord's body had lain."[22] Some pilgrims, however, went even further than kissing the material tokens of Christ's earthly presence. As we know from Egeria, the relic of the True Cross had to be especially guarded at its annual presentation and veneration on Mount Golgotha during Good Friday because on one occasion someone had allegedly dared to bite off a piece of the Holy Wood and thus stole it away.[23] The eagerness of pilgrims to collect and take home with them souvenirs of their visit to the Holy Land and tokens of Christ's Passion is well documented by literary

accounts and surviving objects. As we know from Bishop Cyril of Jerusalem, small fragments of the True Cross had already started to "fill the entire world" by the middle of the fourth century.[24] Like Makrina (d. 379), the sister of Gregory of Nyssa, who is known to have carried a splinter of the True Cross in a ring around her neck, relics of the True Cross were highly desirable collectibles, often procured through a network of trustworthy friends with good connections to the bishop of Jerusalem.[25] Paulinus of Nola, who himself had received such a splinter from a friend in Jerusalem and later "buried" it within the altar of his basilica at Nola, passed on an even smaller splinter of the same relic to his friend Bishop Sulpicius Severus, explaining to him: "Let not your faith shrink because the eyes behold evidence so small; let it look with the inner eye on the whole power of the cross in this tiny segment. Once you think that you behold the wood on which our Salvation, the Lord of Majesty, was hanged with nails whilst the world trembled, you, too, must tremble, but you must also rejoice."[26]

Not everybody was as fortunate or well connected as Sulpicius and Paulinus. Few bishops or pilgrims of later centuries could hope to obtain actual fragments of Christ's Cross. However, from at least the sixth century onward, pilgrims who came to venerate the True Cross in the courtyard of Constantine's basilica on Mount Golgotha could receive a blessing of oil, contained in little flasks, or *ampullae,* and sanctified through direct contact with it (see cat. nos. 23, 24). An anonymous pilgrim from Piacenza, who visited Jerusalem around 570 and witnessed the ritual veneration of the True Cross, described the event as follows: "At the moment when the Cross is brought out of the small room for veneration, and arrives in the court to be venerated, a star appears in the sky. . . . It stays overhead whilst they [the pilgrims] are venerating the Cross, and they offer oil to be blessed in little flasks. When the mouth of one of the little flasks touches the Wood of the Cross, the oil instantly bubbles over, and unless it is closed very quickly it all spills out."[27]

As the remains of leather straps on a number of surviving *ampullae* indicate, pious pilgrims are likely to have worn such objects around their neck in hope that the sanctified oil would grant them health and protection from bodily harm and maladies long after they had left Jerusalem. While the Greek inscriptions identifying the flasks' contents as "Oil from the Wood of Life from the Holy Places" or simply as "Blessing of the Lord from the Holy Places" might not have been understood by every pilgrim, especially those from the western parts of the empire, the images imprinted on the flasks would have kept the memory and desire for Jerusalem's holy places alive in them, visually connecting the sacred substances they carried with the *loca sancta* they once visited and the sacred events that—in a somewhat more distant past—had taken place there.

Flasks filled with sanctified oil, water, or earth from the holy places, however, were appreciated not only for their curative and salvific powers. Their cumulative presence could also serve, as Jaś Elsner has shown, to bolster the authority of new saints. Such was the case with the Irish missionary St. Columban (d. 615). To enhance the status of his newly established

monastery and church at Bobbio in the Apennines, his body was interred among a veritable collection of Holy Land relics that included the fragments of twenty such *ampullae*, earthenware medallions, and other *eulogiai*.[28] Evoking the sacred topography of Palestine through the images imprinted on them as well as through their sacred content, these relics and reliquaries—while buried and thus not visible—made "the Holy Land accessible in Lombardy through its tangible mementos" thus creating a *locus sanctus*, in which "the sacred traditions of early Christian Ireland and Palestine should coincide in the form of a saintly body buried with holy relics."[29]

Similar attempts to enhance the status and authority of churches through the accumulated presence—both visible and invisible—of relics were made at other places as well. The treasury of the Church of St. John the Baptist at Monza in Lombardy preserves not only sixteen tin-alloy pilgrim *ampullae* of the type described above (see p. 11, fig. 7)—the largest cache surviving at any one institution—but also a number of other precious objects donated by the Lombard queen Theodelinda (d. 627) and her husband, King Agilulf (r. 590–616), who founded and richly endowed the basilica in the late sixth century. These include twenty-eight glass *ampullae* filled with oil collected at the tombs of more than sixty saints and martyrs in and outside of Rome.[30] Likely procured with the help of Pope Gregory the Great (r. 590–604) and sent to Monza through a deacon named John, these relics and reliquaries were not buried like their counterparts in Bobbio, but were apparently intended for display and veneration from the outset, thus granting both visual and tangible access to important sacred sites in Italy and beyond.[31]

Evoking the sacred topographies of Rome and Palestine through images and substances sanctified by spatial proximity or direct contact with sacred things and holy bodies, the caches of relics and reliquaries at Bobbio and Monza illuminate two different ways in which secondary relics served to elevate the prestige and status of a recently deceased saint and a newly established church. They also highlight the crucial role played by high-ranking ecclesiastical officials in procuring such sacred treasures, and emphasize the role of prominent aristocratic patrons in assembling them.

Rome and Constantinople

As far as the distribution of relics was concerned, Pope Gregory's presumed involvement in facilitating Queen Theodelinda's request for oil from the tombs of Roman martyrs was not an isolated incident. It formed part of a broader papal attempt to make accessible the remains of the most prominent Roman martyrs—especially those of St. Peter—and to distribute material tokens of their miracle-working presence among the most prominent aristocratic, royal, and even imperial petitioners.[32] Papal munificence, however, had its limits. When Empress Constantina, wife of Emperor Maurice (r. 582–602), requested the head of St. Paul for a new church dedicated to the saint in Constantinople, Gregory responded by invoking

a long-standing Roman tradition prohibiting the dismemberment of saintly bodies and sending her *brandea* instead—textile relics created by bringing pieces of cloth into contact with sacred matter.[33] Only on a few occasions did Gregory feel inclined to part with relics of a higher order. In 599, for instance, he sent a very small key containing iron shavings from the chains of St. Peter, a cross containing "wood from Christ's Cross and hair from the head of St. John the Baptist" to the Visigothic king Reccared I (r. 586–601).[34] A few years later, in 603, another gift of relics, namely, "a crucifix with wood from the Holy Cross of our Lord, and a text from a holy evangelist, enclosed in a Persian case," was sent to Queen Theodelinda on the occasion of the baptism of her son Adaloald (d. 625/26).[35] Both gifts seem to indicate that under Gregory the Great the distribution of relics had become as much an act of papal munificence as a means of papal diplomacy, serving to reaffirm orthodox Catholicism among the newly established dynasties in Italy and Spain.

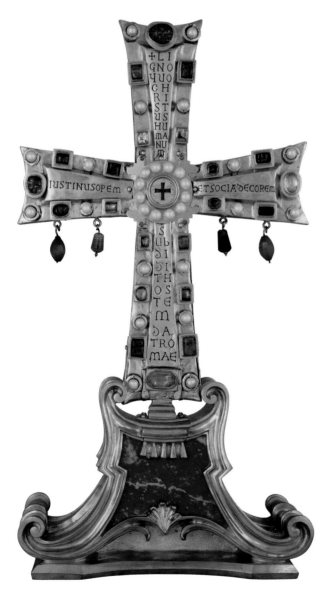

Fig. 20. The Cross of Justin II (*Crux Vaticana*). Byzantine (Constantinople), 6th century, with later additions. Tesoro di Capitolo di San Pietro, Vatican

The papal court in Rome, however, was not only a source of relics for recently converted "barbarian" tribes and their aristocratic elite. It was also the recipient of important gifts of relics from elsewhere, notably from the imperial court in Constantinople and from high-profile Western pilgrims to the Holy Land. The earliest imperial gift of relics that is known—or alleged—to have reached the city of Rome was a sizable portion of the True Cross, sealed "with gold and jewels."[36] According to the so-called *Liber Pontificalis*, or Book of the Pontiffs, the donor was none other than Constantine the Great, who had sent the True Cross to Rome to be kept at the Basilica of the Sessorianum—later named Sta. Croce in Gerusalemme—which his mother Helena is said to have established.[37] Other emperors followed Constantine's example: At some point during his reign, Emperor Justin II (r. 565–78) and his wife, Sophia, likewise donated a precious reliquary cross "to Rome," as the accompanying inscription records (fig. 20). Richly decorated with gold and precious stones and containing a portion of the wood of the True Cross, it is still preserved in the treasury of St. Peter's in Rome, making it one of the earliest surviving True Cross reliquaries.[38] However, the Cross of Justin II is not the only distinguished portion of the relic in Rome. Others have been preserved as part of the famous papal relic chapel at the Lateran Palace: the *Sancta Sanctorum*, or Holy of Holies. Named after the tabernacle of Solomon's temple in Jerusalem, in which the most precious objects of Judaism—the Ark of the Covenant with the Tablets of the Law—were preserved together with other objects, the heart of this chapel—the true *Sancta Sanctorum*—is a cedar chest, made during the pontificate of Leo III (r. 795–816) and locked behind bronze doors cast under Pope Innocent III (r. 1198–1216), underneath the chapel's altar.[39] Successive popes have added to this most sacred treasure chest of Christendom and thus accumulated an ecclesiastical treasure beyond compare.

Until the tragic events that led to the conquest of Constantinople in 1204, however, not even papal Rome could rival the imperial city on the Bosphorus in either the number or the importance of its sacred treasures. If not since the days of Constantine and Helena, as many firmly believed, then at least since the reign of Constantine's son and successor, Constantius (r. 337–61), emperors and their spouses, patriarchs and clerics, patricians and noble women had steadily increased the city's holdings in sacred bodies.[40]

According to the *Chronicon Paschale*, or Easter Chronicle, the prophet Samuel's body arrived in Constantinople in 406 "with Arcadius Augustus leading the way, and Anthemius, pretorian prefect and former consul, Aemilianus, city prefect, and all the senate."[41] Unfortunately, few representations have survived to give us a sense of the atmosphere, excitement, and visual splendor of ceremonies associated with the translation and solemn arrival of relics. A sixth-century ivory panel—presumably a fragment of a reliquary—and now preserved in the cathedral treasury at Trier, Germany, is one of the earliest surviving documents of this kind (cat. no. 14). It shows the solemn reception and deposition of relics in the Byzantine capital,

most likely those of the archdeacon St. Stephen, an event that is recorded as having taken place in 421.

While the transfer of the bodily remains of important New Testament saints and Old Testament prophets was at first a matter of prestige and a means to ensure imperial and ecclesiastical control over substances too important and potent to be left unguarded, the Persian conquest of Syria-Palestine in 614 and the Avar and Persian attacks on the capital in 626 created an even more urgent need to safeguard Christendom's most sacred relics in the capital and to fortify the city through the accumulated presence of the empire's powerful supernatural defenders within its walls.[42]

The Church of the Virgin of the Pharos, or lighthouse, a chapel located "in the midst" of the imperial palace, soon developed into the city's most important repository of sacred relics, containing the Holy Lance, a portion of the True Cross, and other relics of Christ's Passion already by the mid-seventh century.[43] In 944 and 945, respectively, the famous Mandylion, an imprint of Christ's face on a piece of cloth (see cat. no. 113) and the relic of the right arm of John the Baptist were likewise deposited there.[44] Other relics followed as a result of successful military campaigns in the East.[45] By the end of the twelfth century, the Pharos church was renowned as the home of the most important relics of Christendom and praised as "another Sinai, a Bethlehem, a Jordan, a Jerusalem . . ." by virtue of its sacred content—a *locus sanctus* at the very heart of the Byzantine Empire.[46]

While many of the sacred objects in the imperial relic collection survived the Latin conquest of Constantinople in 1204 unscathed, the most important among them were later gifted, pawned, or sold to Western rulers and potentates in an effort to save the Latin Empire from economic and military collapse. Between 1239 and 1241, King Louis IX of France (r. 1226–70) was thus able to acquire twenty-two precious objects—foremost among them the Crown of Thorns, portions of the relic of the True Cross, and other important relics of Christ's Passion—from his cousin Emperor Baldwin II (r. 1240–61) of Constantinople, who found himself hard pressed for money and resources to defend his weakened realm against Bulgars and Greeks.[47]

To create a fitting home for this sacred treasure, Louis commissioned a splendid relic chapel, the Sainte-Chapelle (fig. 21) within the precinct of his royal palace in Paris and inaugurated it in 1248. Inside this larger architectural reliquary, the precious cache of relics was safeguarded in a magnificent shrine known as the *Grande Châsse*. Made in the early 1240s and placed on a platform behind the chapel's altar, the Grande Châsse was decorated on its three principal sides with copper-gilt reliefs depicting the Flagellation, Crucifixion, and Resurrection, while two doors on the rear face, secured with multiple locks, gave access to the shrine's sacred content.[48]

Other important relics from Constantinople, among them, "the gold-mounted, miracle-working cross that Constantine . . . took with him into battle, an ampoule with the miraculous blood of Jesus Christ, the arm of the martyr-saint George, and a fragment of the skull of St. John the Baptist," were allegedly sent to the Church of San Marco in Venice by Doge Enrico

Fig. 21. View of the royal palace and the Sainte-Chapelle, from the *Très Riches Heures du Duc de Berry*, ca. 1411–16. Musée Condé, Chantilly, MS 65, fol. 6v

Dandolo (r. 1192–1205), one of the principal leaders of the Fourth Crusade. Like the arm of St. George, which was later enshrined in a new Venetian container (cat. no. 51), and the hand of St. Marina, whose Byzantine reliquary survives largely intact (cat. no. 50), most relics thus transferred found new homes in the churches and monasteries of Venice, where their cult continued to flourish well beyond the Middle Ages.

The Western Empire

In Western Europe, rulers had long been aware of the Byzantine Empire's distinguished collection of sacred relics, especially its holdings in relics of Christ's Passion. However, similar efforts to concentrate a high-profile collection of relics in a single location were at first limited to the papal court in Rome. In the Carolingian and Ottonian empires, on the other hand,

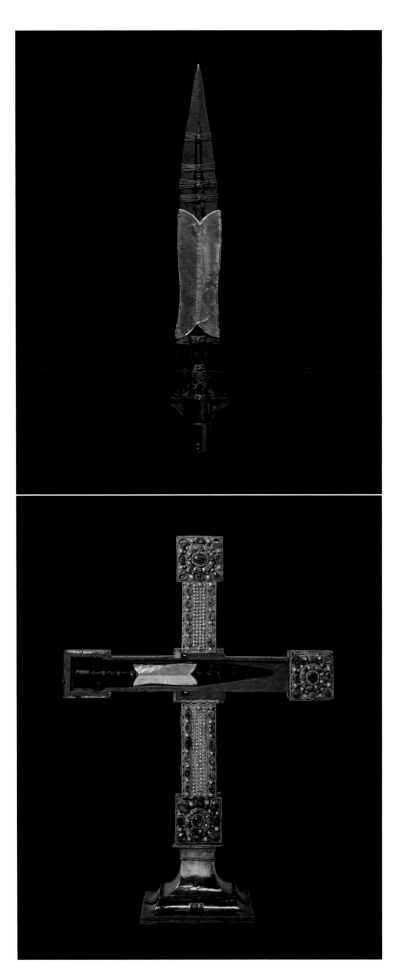

the concept of itinerant rulership resulted in a somewhat different attitude toward the collecting of sacred matter. While Carolingian rulers had inherited the famous *cappa*, or mantle, of St. Martin of Tours, and other important relics from their Merovingian predecessors, these precious objects were not kept in one particular location, but accompanied the ruler on his travels to grant him protection and victory in battle and thus ensure the safety and stability of the entire realm. The name of the Carolingian court's most prominent relic, namely, the *cappa* of St. Martin, was hence transferred to both the court clergy who guarded it and the physical location where it was kept, making the word *cappella*, or small chapel, a synonymous designation for the relic, its guardians, and the architectural reliquary in which it was housed.[49] Other relics, no less important, served a similar function. Like the mantle relic of St. Martin, a relic of the True Cross was carried into battle, and oaths were sworn on it.[50] After Charlemagne's death in 814, his collection of relics—some of which he had received as diplomatic gifts from Pope Hadrian I (r. 772–95) and Leo III, others from the Byzantine court—was divided among his heirs, who later donated them to prominent churches and monasteries, among them the monasteries of Centula and Prüm, and the palatine chapel at Aachen.[51]

While the attitude of Western rulers toward the possession and use of relics, especially those that had proven their efficacy in battle or in moments of political crisis, remained largely unchanged during the following centuries, late Carolingian, Ottonian, and Salian rulers tended to donate important relics they had acquired to institutions connected to them by close personal or familial ties.[52] Religious foundations that functioned as dynastic burial places and/or contained the shrines of important dynastic saints and martyrs—such as the royal abbey of St. Denis, the palatine chapel at Aachen, the collegiate churches of St. Servatius in Quedlinburg and of Sts. Simon and Judas in Goslar, or the cathedrals of Magdeburg and Bamberg, to name only a few prominent examples—were thus able to accumulate very distinguished collections of sacred relics.[53]

Like the pope and the Byzantine emperor, who regularly bestowed gifts of relics to distinguished foreign rulers and their emissaries, Western rulers did not hesitate to use sacred relics as tokens of royal or imperial munificence and as powerful means to further their own political agenda.[54] Of particular political and dynastic importance was Henry's acquisition of the Holy Lance, which, according to Liutprand of Cremona, was granted as a gift only after Henry threatened the relic's owner, King Rudolph II of Burgundy (r. 912–37), with the destruction of his entire kingdom "by fire and sword."[55] It was this important relic of Christ's Passion and the Holy Nails that the later emperor Otto I (r. 939–82) took with him when he faced

Fig. 22. The Holy Lance. Lance: 8th century; silver sleeve: second half of the 11th century; gold sleeve: third quarter of the 14th century. Kunsthistorisches Museum, Vienna, Schatzkammer (SK XIII 19)

Fig. 23. The Imperial Cross (*Reichskreuz*), with the Holy Lance. German, ca. 1024/25, 1325. Kunsthistorisches Museum, Vienna, Schatzkammer (SK XIII 21)

his disaffected brother Henry and Duke Giselbert of Lotharingia at the battle of Birten. Otto's miraculous victory at Birten not only secured his legitimacy as a ruler; it also transformed the Holy Lance—with one of the Holy Nails that was inserted into it already before the year 1000—into one of the Western Empire's most important relics and the first and foremost symbol of imperial rule and power (fig. 22; cat. nos. 128, 129).[56] Together with a large portion of the wood of the True Cross, the Holy Lance was later inserted into the so-called *Reichskreuz* (fig. 23) of Emperor Conrad II (r. 1027–39) and used in imperial coronations from at least the mid-eleventh century on.[57]

Imperial interest in the political and ceremonial use of relics seems to have gradually increased during the course of the eleventh century. Henry IV (r. 1056–1106), for instance, is known not only to have received fragments "of the sudarium, the True Cross, and the Crown of Thorns" as gifts from the Byzantine emperor; he also ordered the transfer of the remains of several martyrs and confessors—including the head of St. Anastasios the Persian (see cat. no. 55)—from Aachen to his castle on the Harzburg to fortify it against Saxon rebels.[58] At the end of the reign of Henry's son and successor, Henry V (r. 1106–25), the imperial collection of relics, regalia, and insignia—commonly known as the *Reichskleinodien*—was moved to Trifels Castle in the Palatinate, which served as the first more permanent "imperial treasury" into the late thirteenth century.[59]

The most avid—some would say, fanatical—imperial collector of sacred relics was undoubtedly Charles IV (r. 1355–78). Educated at the Capetian court in Paris, he had a first-hand knowledge of the cult of the relics of Christ's Passion and their ritual veneration at the Sainte-Chapelle. He had also experienced the cult of the recently canonized (1297) St. Louis—i.e., King Louis IX—and was deeply impressed by the pious king's example. As king of Bohemia, Charles endowed his own palace chapel near Prague

with precious relics—among them, a portion of the Crown of Thorns—and liturgical vessels during the 1340s. When he was elected king of the Romans in 1346, his focus shifted to the hoard of imperial relics. These had been kept at Trifels Castle prior, but given the controversies surrounding Charles's election, the treasure did not arrive in Prague until shortly before Easter 1350, on which occasion it was publicly displayed.[60] Already before the relics' arrival, however, Charles had made preparations to built Karlstein Castle (fig. 24), located about forty kilometers south of the city, as a more permanent home for the imperial collection of relics and insignia.[61] In 1365, when Karlstein was finally completed, the imperial treasure was transferred to its largest and most lavishly decorated chapels: the Chapel of the Holy Cross (fig. 25).[62] Encrusted with more than two thousand pieces of polished semiprecious stones—among them, agate, carnelian, amethyst, and jasper—gilded stucco, and painted panels featuring inlaid fragments of saintly relics, the sacred content and decoration of Charles IV's relic chapel at Karlstein Castle emulates the preciousness of both Louis IX's Sainte-Chapelle in Paris and the Byzantine emperor's Church of the Virgin of the Pharos. It can be considered the culmination of Western attempts to create a worthy permanent setting for the most sacred relics of Christendom and the insignia of imperial rule, which had meanwhile themselves acquired a relic status. The annual display of these treasures, for which Pope Innocent IV granted indulgences in 1354, followed a strictly prescribed liturgical formula, which Charles himself had helped to draft.[63] They continued even after Emperor Sigismund (r. 1433–39), Charles's son and successor on the imperial throne, decided to transfer the imperial treasure of relics, regalia, and insignia to Nuremberg in 1424 and granted the city the right to display them to the faithful in an annual *Heiltumsschau* (cat. no. 125).[64]

Fig. 24. Karlstein Castle, founded 1348

Fig. 25. Karlstein Castle, Chapel of the Holy Cross, founded 1357

Pious Patrons and Princely Collectors

The accumulation of important collections of relics, however, was not exclusively a prerogative of kings and emperors. Distinguished ecclesiastical leaders such as Archbishop Egbert of Trier (r. 977–93), Bishop Bernward of Hildesheim (r. 993–1022), and Abbot Wibald of Stavelot (r. 1130–58), who served as imperial advisors, teachers, and ambassadors, likewise participated in the elite culture of collecting sacred matter, for which they commissioned exquisite containers designed for liturgical use, display, and private devotion (cat. nos. 38, 44).[65] Members of the empire's leading aristocratic families, such as the Saxon margraves Hermann Billung (r. 936–73) and Gero I (r. 937–65), or Countess Gertrude of Braunschweig (d. 1077), were no less active as collectors of holy relics and patrons of luxury objects. The religious foundations they established at Lüneburg, Gernrode, and Braunschweig were designated to serve as family burial places and were thus endowed with land, relics, and precious liturgical objects, which ensured safety and protection for the foundation, eternal prayer on behalf of

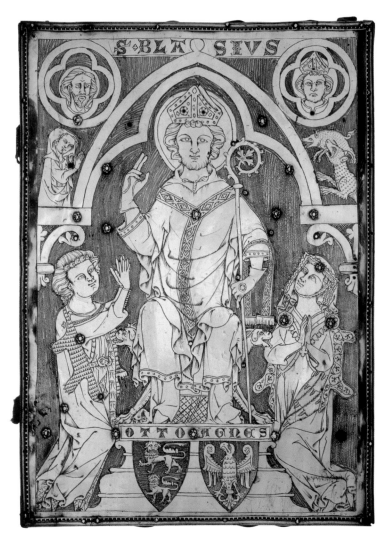

Fig. 26. Plenarium of Duke Otto the Mild, back cover, with representation of Duke Otto of Braunschweig-Goettingen and his wife, Agnes of Brandenburg, flanking St. Blaise enthroned. Braunschweig, 1339. Kunstgewerbemuseum, Staatliche Museen zu Berlin (w32)

the founder, and lasting commemoration of his or her family's name and fame.[66] The later renown of such distinguished ecclesiastical treasures as that of the Monastery of St. Michael in Lüneburg or the collegiate church of St. Blaise in Braunschweig, however, depended as much on the arrangements made by the original founders as it depended on the care, devotion, and patronage received by successive generations of family members, friends, and other benefactors.[67] Countess Gertrude's early donations to the Church of St. Blaise (cat. no. 65), for instance, were augmented considerably a century later by Duke Henry the Proud (r. 1137–39), the first Guelph ruler of Saxony, and his son Henry the Lion (r. 1142–95), who not only rebuilt the church and established it as his family's burial place, but also donated various relics to its treasure, which he had brought from a pilgrimage to Jerusalem in 1172/73 (cat. no. 41). Henry's son, Emperor Otto IV (r. 1209–15), further ensured the prosperity and fame of the Church of St. Blaise and its treasury through a bequest of all but one relic formerly in his and his father's possession.

Following Otto's munificence, it was not until the early fourteenth century that the Church of St. Blaise once again received serious attention from members of the Guelph family, namely, from Duke Otto the Mild (r. 1318–44), who contributed several precious reliquaries to its inventory and had himself and his wife represented on the reverse of the so-called Plenarium (fig. 26). During the fifteenth and sixteenth centuries, however, it was mainly due to the benefactions of individual members of the local nobility and the chapter of St. Blaise that the church and its treasure continued to prosper (cat. nos. 40, 44). The fame of the "Guelph Treasure," as it is now commonly known, is thus the result not of one but many avid relic collectors and pious patrons.

During the late fourteenth and fifteenth centuries, several prominent new collections of relics emerged in Germany as a result of princely ambition and a heightened awareness of the human need for divine grace, forgiveness, and salvation. Accumulated at first to ensure personal safety and protection, such aristocratic relic collections were commonly transferred posthumously—as had also been the case in previous centuries—to religious foundations. In 1379, for instance, the distinguished Palatine Elector Rupert I (r. 1353–90) donated a collection of more than sixty relics and reliquaries in his possession to the collegiate church he had founded at his residence in Neustadt "for the salvation of our soul and those of our forebears, heirs, and descendents."[68] The fact that Rupert had decided to be buried in his church at Neustadt only a few years prior to his donation (namely, in 1371), seems to indicate that personal salvation remained the most pressing concern and ultimate motivation for elite patrons to endow churches with sacred relics.[69]

Concern for his own and his family's salvation was also a prime reason for Rudolph I (r. 1298–1356), Elector of Saxony, to ask Pope Clement VI (r. 1342–52) for permission to deposit a relic of the Crown of Thorns in a chapel he had previously founded and dedicated to All-Saints inside his castle at Wittenberg and to establish a chapter of canons there in 1353.

This precious relic of Christ's Passion, which Rudolph had received from King Philip VI of France (r. 1328–50) during a diplomatic mission in 1341/42, is featured prominently in the *Wittenberger Heiltumsbuch* (fig. 27) an elaborate "relic book" illustrated with woodcuts by Lucas Cranach the Elder and published in two editions in 1509.[70] It reproduces—in word and image—the extensive collection of sacred relics that Prince Frederick the Wise (r. 1488–1525), Elector of Saxony, had assembled at the All-Saints Church in Wittenberg during the last decade of the fifteenth century and the first two decades of the sixteenth. It was displayed there annually on the second Sunday after Easter from 1503 (or 1504) until 1523, granting those who witnessed the *Heiltumsweisung*, or presentation of relics, generous indulgences.[71] While Frederick's interest in collecting sacred relics may have started before his pilgrimage to the Holy Land in 1493, it certainly intensified as a result of it and grew into an outright passion after his return.[72] Thanks to a papal brief of 1507, which asked every bishop and prelate in the empire to share relics with the Elector, Frederick's collection started to grow steadily. By 1509, the *Wittenberger Heiltumsbuch* listed

5,005 relic fragments, a number that increased to 5,262 in 1513. It was over the next five years, however, that Frederick's collection started to grow dramatically, partly through personal requests and interventions with foreign dignitaries, partly through the efforts of a staff of "relic hunters" who combed the courts and churches of Europe for relics to satisfy the Elector's appetite for sacred matter.[73] By 1518, Frederick's collection had reached the staggering number of 17,443 relic fragments, a number that grew to 19,013 in 1520. The enormous increase of Frederick's collection since 1513 can perhaps best be explained as a result of the rise of yet another passionate collector of saintly relics in Frederick's own territory: Albrecht of Brandenburg.

In August 1513, the death of Frederick's brother Ernst had left the archiepiscopal See of Magdeburg vacant, and Albrecht, youngest son of Prince Johann Cicero, Elector of Brandenburg (r. 1486–99), succeeded him as archbishop the following year. Elected archbishop of Mainz a few months later and appointed cardinal by Pope Leo X (r. 1513–21) in 1518, Albrecht started to enlarge the relic collection he had inherited from his

Fig. 27. Lucas Cranach the Elder (German, 1472–1553). Frontispiece double-portrait (1509) of Frederick III (the Wise), Elector of Saxony, and his brother John (the Steadfast), Elector of Saxony, from the *Wittenberger Heiltumsbuch* (Leipzig: Melchior Lotter, 1514). The British Museum, London (PD 1949,0411.4991).

Fig 28. Albrecht Dürer (German, 1471–1528), Portrait of Cardinal Albrecht of Brandenburg, from the *Hallisches Heiltumsbuch* (1525). Herzog August Bibliothek, Wolfenbüttel, Cod. T 24.4 Helmst (3), fol. 1v

predecessor almost immediately.[74] Since the chapel in which Ernst had kept his collection on the Moritzburg in Halle soon proved too small, Albrecht founded a collegiate church in the city and designated it to serve as the new home for his sacred treasure.[75] Both attested public presentations of Albrecht's collection, however, took place before the relics could be moved to the new church in 1523. On 8 September 1520, the Feast of the Nativity of the Blessed Virgin, 8,133 relic fragments, arranged in nine "passages" were presented to the faithful from a window on the north side of the chapel. As was the case at Wittenberg in 1509, a richly illustrated relic-book—the *Hallisches Heiltumsbuch*—was prepared for the occasion, featuring 237 woodcut prints by Wolf Traut and an engraved portrait of the cardinal by Albrecht Dürer (fig. 28).[76] A second, more lavish copy of the *Heiltumsbuch*, with 348 illustrations by several artists, was prepared in 1525/26, likely as a presentation copy for the cardinal's personal use. This book, a small number of artifacts, and several fragments of objects (see cat. no. 131) are all that survives of Albrecht's famous collection of relics and reliquaries, large parts of which had already been pawned or sold during the cardinal's lifetime. When the city of Halle adopted Protestantism in 1541, Albrecht dissolved the collegiate church and left the city for Mainz and Aschaffenburg with the remainder of his sacred treasure.

At Wittenberg, Frederick's collection of relics fared no better. The publication of Martin Luther's *Ninety-Five Theses on the Power and Efficacy of Indulgences* in 1517 had changed the climate for public displays of relics once and for all. In 1520, shortly after Frederick's collection had reached a fantastic 19,013 relics, he ceased collecting altogether.[77] As was the case in Halle, the last *Heiltumsschau* of the Wittenberg relics was held in 1521, but any reference to indulgences was cautiously avoided. While the sacred things and holy bodies Frederick had gathered so passionately from all corners of the world were still displayed annually on the high altar of the Church of All-Saints until the Elector's death in 1525, they were never publicly displayed again. Most of the precious reliquaries that had once been made to enshrine and elevate the bodies of the saints and martyrs are presumed to have found their way to the Electoral mint during the early 1540s. Their sacred content, now considered highly suspect by Frederick's reform-minded successors, was likely scattered, discarded, or destroyed. What remains of Frederick's treasures today is a single beaker of cut glass (fig. 29).[78] Once venerated for its association with Sts. Hedwig and Elizabeth of Thuringia, it is now cherished for its connection with Martin Luther, who is said to have received the glass from Frederick's grandson, Johann Frederick (r. 1532–54) as a gift.

The story of the formation, growth, and eventual dispersal of the relic collections of Frederick the Wise and Albrecht of Brandenburg may be considered to reflect both the deep-rooted religiosity and extreme uncertainty of an age in which Christian religious traditions and practices started to be questioned more radically than ever before. While the cult of relics had its critics since the fourth century—most famously in Vigilantius of Calagurris (modern St. Martory near Toulouse), Claudius of Turin, and

Fig. 29. Hedwig beaker. Syria or Egypt (?), 10th (?) century. Kunstsammlungen der Veste Coburg (A.S. 652)

Guibert of Nogent—it was the rhetorical force of Martin Luther and other reformers that resulted in a permanent split of Christian attitudes toward the cult of saints and the veneration of relics. Unlike the reformers, however, who strictly distanced themselves from what they considered to be superstitious practices, the Catholic Church kept insisting on the validity of the cult of saints and continued to honor their relics.[79] Interestingly, it was the "rediscovery" and scholarly exploration of the Roman catacombs from the mid-sixteenth century onward that provided new impulses for the Christian cult of relics.[80] Still considered "more valuable than precious stones and more precious than refined gold," the bodily remains of the martyrs now served as tangible proof not only for the saints' continued presence and efficacy on earth, but also for the long and unbroken history of the cult and veneration of their relics.

Notes

1. Eusebius, *Ecclesiastical History*, 5.1.62–63, in *Die Kirchengeschichte: Eusebius Werke*, ed. F. Winkelmann, GCS, n.s. 6, 2nd ed., 3 vols. (Berlin 1999), 1:426 trans. adapted from Eusebius, *Ecclesiastical History*, trans. K. Lake, 2 vols. (London, 1965), 1:437.

2. *The Martyrdom of Polycarp*, ed. J. B. Lightfoot, in *The Apostolic Fathers* II,3 (London, 2nd ed., 1889; repr. Hildesheim, 1973; 2nd ed., ed. Michael W. Holmes (Grand Rapids, Mich., 1992), 351–403 and 477–87 (trans.). For a more accessible English translation, see B. Ehrman, ed. and trans., *The Apostolic Fathers*, 1, Loeb Classical Library 24 (Cambridge, Mass., 2003), 355–401.

3. Prudentius, *Carmina*, ed. M.P. Cunningham, CCSL 126 (Turnhout, 1966), book 11, 370–78.

4. *The Martyrdom of Polycarp*, ed. Lightfoot (1889/1973, cited in note 2), chap. 18.2, 396 and 484 (trans.). See also Ehrman, *The Apostolic Fathers* (2003, cited in n. 2), 393.

5. Prudentius, *Carmina*, ed. Cunningham (1966, cited in n. 3), book 11, 135–36, 374; trans. adapted from M. Clement Eagan, *The Poems of Prudentius*, The Fathers of the Church: A New Translation 43 (Washington, DC, 1962), 251, and M. Malamud, *A Poetics of Transformation. Prudentius and Classical Mythology* (Ithaca, 1989), 85. On Prudentius, relics, and rhetoric, see also P. Cox Miller, "The Little Blue Flower Is Red: Relics and the Poetizing of the Body," *Journal of Early Christian Studies* 8, no. 2 (2000): 213–36; eadem, "Visceral Seeing: The Holy Body in Late Ancient Christianity," *Journal of Early Christian Studies* 12, no. 4 (2000): 391–411; eadem, "Relics, Rhetoric, and Mental Spectacles," in *Seeing the Invisible in Late Antiquity and the Early Middle Ages*, ed. G. de Nie, K.F. Morrison, and M. Mostert, Utrecht Studies in Medieval Literacy 14 (Turnhout, 2005), 25–52.

6. See C.W. Bynum, *The Resurrection of the Body in Western Christianity, 200–1336* (New York, 1995), 21–108.

7. Eusebius, *Ecclesiastical History*, 2.25.7, Winkelmann ed., 1:178, trans. Lake (1965, cited in n. 1), 183. That Christian communities were not generally prohibited or hindered from burying the remains of their martyrs is indicated in the Roman *Acts of the Martyrdom of St. Ignatius*, chap. 11, ed. J. B. Lightfoot, in *The Apostolic Fathers*, II,2 (London 1889: repr. Hildesheim, 1973), 496–540, at 537–38 and 587 (translation).

8. For early evidence of the commemoration of martyrs in Rome, compare the so-called *Calendar of 354*, in *Chronica minora*, ed. T. Mommsen, MGH ActAnt 9.1 (Berlin, 1892), 13–148. On the lists of martyrs and bishops, see M.R. Salzmann, *Roman Time: The Codex-Calendar of 354 and the Rhythms of Urban Life in Late Antiquity* (Berkeley, 1990), 44–47.

9. For the relics of the protomartyr St. Stephen and their discovery, see E.D. Hunt, "The Traffic in Relics: Some Late Roman Evidence," in *The Byzantine Saint*, ed. S. Hackel (Birmingham, 1981), 171–80, at 171.

10. Ambrose, *Letter XXII*, PL 16:1019–25. For an English translation, see *Saint Ambrose, Letters*, trans. M.M. Beyenka, The Fathers of the Church: A New Translation 26 (Washington, DC, 1987), 376–84, at 376. On the significance of blood in this context, see G. Clark, "Bodies and Blood: Martyrdom, Virginity, and Resurrection in Late Antiquity," in D. Montserrat, ed., *Changing Bodies, Changing Meanings: Studies on the Human Body in Antiquity* (London, 1997), 99–115.

11. *Codex Theodosius* 9.17.7 (issued at Constantinople, 26 February 386), in *Theodosiani libri XVI cum Constitutionibus Sirmondianis et Leges novellae ad Theodosianum pertinentes*, ed. T. Mommsen with P. Meyer and P. Krüger, 2 vols. (Berlin, 1905; repr. 1967), I, 2:466. For an English translation, see C. Pharr, *The Theodosian Code and Novels, and the Sirmondian Constitutions*, 2d ed. (New York, 1969), 240.

12. Ambrose, *Letter XXII*, PL 16:1020, trans. Beyenka, *Saint Ambrose, Letters* (1987, cited in n. 10), 376.

13. Paulinus of Milan, *Vita di S. Ambrogio: Introduzione, testo critico e note*, ed. M. Pellegrino (Rome, 1961), 98–100. For an English translation, see B. Ramsey, *Ambrose* (London, 1997), 195–218, at 209.

14. Ambrose, present at the occasion, later described the event in one of his sermons. Ambrose, *De exhortatione virginitatis*, PL 16:335–64.

15. The details are spelled out in the *Passio S. Saturnini*, in *Acta Martyrum*, ed. T. Ruinart (Regensburg, 1859), 175–80, composed presumably a few years after the bishop's death in or around 410. For an analysis of the context, see D. Hunter, "Vigilantius of Calagurris and Victricius of Rouen: Ascetics, Relics, and Clerics in Late Roman Gaul," *Journal of Early Christian Studies* 7, no. 3 (1999): 401–30.

16. Paulinus of Nola, *Carmina*, ed. W. von Hartel, CSEL 30 (Vienna, 1894), 19.338–42, trans. after P.G. Walsh, *The Poems of St. Paulinus of Nola* (New York, 1975), 142. The *translatio* of the bodies of Sts. Andrew and Timothy is likely to have occurred on 3 March 357 and also included the remains of the Evangelist Luke. See C. Mango, "Constantine's Mausoleum and the Translation of Holy Relics," *Byzantinische Zeitschrift* 83 (1990): 51–62 with 434.

17. Paulinus of Nola, *Carmina*, ed. von Hartel, 19.320–24, trans. after Mango, "Constantine's Mausoleum" (1990, cited in n. 16), 53.

18. For the views of a vocal opponent of the cult of relics, see Hunter, "Vigilantius of Calagurris" (1999, cited in n. 15).

19. Gaudentius, *Sermon 17*, 35–36, PL 20:962, in *Tractatus*, ed. A. Glueck, CSEL 68 (Vienna, 1936); P. Brown, *The Cult of Saints: Its Rise and Function in Latin Christianity*, 2nd. ed. (Chicago, 1983), 95; G. Noga-Banai, *The Trophies of the Martyrs: An Art Historical Study of Early Christian Silver Reliquaries* (Oxford, 2008), 138.

20. For relics of places, see B. Reudenbach, "Reliquien von Orten: Ein frühchristliches Reliquiar als Gedächtnisort," in *Reliquiare im Mittelalter*, ed. B. Reudenbach and G. Toussaint, Hamburger Forschungen zur Kunstgeschichte 5 (Hamburg, 2005); J. Elsner, "Replicating Palestine and Reversing the Reformation: Pilgrimage and Collecting at Bobbio, Monza, and Walsingham," *Journal of the History of Collecting* 9 (1997): 117–30. See also Angenendt herein, pp. 22–23.

21. *Itinerarium Burdigalense*, ed. P. Geyer and O. Cuntz, CCSL 175 (Turnhout, 1965), 16–17, trans. after J. Wilkinson, *Egeria's Travels*, 3rd ed. (Warminster, 2006), 31.

22. Hieronymus, *Epistulae*, ed. I. Hilberg, CSEL 55, 2nd ed. (Vienna, 1996), Ep. 108.9, 315.4–10, trans. after J. Wilkinson, *Jerusalem Pilgrims before the Crusades*, rev. ed. (Warminster, 2002), 83.

23. *Itinerarium Egeriae*, ed. P. Geyer, CCSL 175 (Turnhout, 1965), 81.16–18. For a translation of the passage, see Wilkinson, *Egeria's Travels* (2006, cited in n. 21), 155.

24. *Cyrilli Hierosolymorum Archiepiscopi opera qui supersunt omnia*, cat. 4.10, ed. W.K. Reischl and J. Rupp, 2 vols. (Munich, 1848–60), 1:100.

25. See Krueger and Robinson herein, pp. 12 and 114, respectively.

26. Paulinus of Nola, *Epistulae*, 31, 268.11–19, ed. von Hartel, CSEL 29, trans. after Walsh, *The Letters of St. Paulinus of Nola* (1975, cited in n. 16), 2:126.

27. *Antonini Placentini Itinerarium*, 20, 139.18–23, ed. P. Geyer, CSEL 175 (Turnhout, 1965), trans. after J. Wilkinson, *Jerusalem Pilgrims before the Crusades*, rev. ed. (Warminster, 2002), 139. See also Krueger herein, pp.11.

28. Elsner, "Replicating Palestine" (1997, cited in n. 20), 119–21. For information on individual objects and the circumstances of their discovery, see G. Celi, "'Cimeli Bobbiesi'," *La Civiltà Cattolica* 74 (1923): 2:504–14; 3:37–45, 124–36, 335–44, 423–39; A. Grabar, *Ampoules de Terre Sainte (Monza–Bobbio)* (Paris, 1958), 32–44.

29. See Elsner, "Replicating Palestine" (1997, cited in n. 20), 121–23. See also A. Sepulcri, "I papyri della basilica di Monza e le reliquie inviate de Roma," *Archivio Storico Lombardo* 19 (1903): 241–62.

30. The content is listed on small labels (*pittacia*) and an accompanying catalogue (*notula*). See *Itineraria Romana*, CCSL 175 (Turnhout, 1965), 286–95.

31. Starting with the apostles Peter and Paul, the *notula* lists the various saints according to the location of their tombs in the cemeteries and shrines outside Rome, thus creating a topographical map of the city's sacred sites. Elsner, "Replicating Palestine" (1997, cited in n. 20), 122.

32. See C. Leyser, "The Temptations of Cult: Roman Martyr Piety in the Age of Gregory the Great," *Early Medieval Europe* 9, no. 3 (2000): 289–307.

33. Gregory the Great, *Registrum Epistularum Libri I–XIV*, ed. D. Norberg, CCSL 140, 2 vols. (Turnhout, 1982), 1:248–250. For an English translation, see J.R.C. Martin, *The Letters of Gregory the Great*, Medieval Sources in Translation 40, 3 vols. (Toronto, 2004), 1:310–12. See also J.M. McCulloh, "The Cult of Relics in the Letters and 'Dialogues' of Pope Gregory the Great. A Lexicographical Study," *Traditio* 32 (1976): 145–84; idem, "From Antiquity to the Middle Ages: Continuity and Change in Papal Relic Policy from the Sixth to the Eighth Centuries," in *Pietas: Festschrift für B. Kötting*, ed. E. Dassmann and K.S. Frank (Münster, 1980), 313–24.

34. Gregory the Great, *Registrum Epistularum*, ed. Norberg (1982, cited in n. 33), 2:810.128–30, trans. after Martin, *The Letters of Gregory the Great* (2004, cited in n. 33), 2:703.

35. Gregory the Great, *Registrum Epistularum*, ed. Norberg (1982, cited in n. 33), 2:1083.35–37, trans. after Martin, *The Letters of Gregory the Great* (2004, cited in n. 33), 3:878.

36. *Liber Pontificalis*, ed. L. Duchesne, 2 vols. (Paris, 1886–1892; repr. Paris, 1981), 1:179, trans. after R. Davis, *The Book of Pontiffs (liber pontificalis): The Ancient Biographies of the First Ninety Roman Bishops to AD 715*, 2nd ed. (Liverpool, 1989), 21. On the circumstances of the gift, see S. De Blaauw, "Jerusalem in Rome and the Cult of the Cross," in *Pratum Romanum: Richard Krautheimer zum 100. Geburtstag*, ed. R. Colella et al. (Wiesbaden, 1997), 55–73; H.A. Klein, *Byzanz, der Westen und das 'wahre' Kreuz: Die Geschichte einer Reliquie und ihrer künstlerischen Fassung in Byzanz und im Abendland* (Wiesbaden, 2004), 70.

37. On this church and its collection of relics, see Nagel herein, pp. 219–20.

38. On the reliquary, see most recently *Picturing the Bible: The Earliest Christian Art*, ed. J. Spier, exh. cat., Fort Worth: Kimbell Art Museum (New Haven, 2007), 283–85 (no. 83). See also Klein, *Byzanz, der Westen und das 'wahre' Kreuz* (2004, cited in n. 36), 70, 96, 177; C. Belting-Ihm, "Das Justinuskreuz in der Schatzkammer der Peterskirche zu Rom," *Jahrbuch des Römisch-Germanischen Zentralmuseums Mainz* 12 (1965): 142–66; V.H. Elbern, "Das Justinuskreuz im Schatz von St. Peter zu Rom," *Jahrbuch der Berliner Museen* n.s. 6 (1964): 24–38.

39. For a summary account of the history of the chapel and its treasure, see H. Grisar, *Die römische Kapelle Sancta Sanctorum und ihr Schatz* (Freiburg im Breisgau, 1908), 11–26. On the chapel's decoration, see the contributions in *Sancta Sanctorum* (Milan). On the Sancta Sanctorum and its treasure, see Cornini herein, pp. 69–78.

40. For a summary account of the history of relic translations into Constantinople, see H.A. Klein, "Sacred Relics and Imperial Ceremonies at the Great Palace of Constantinople," in *Visualisierungen von Herrschaft*, ed. F.A. Bauer, Byzas 5 (Istanbul, 2006), 79–99.

41. *Chronicon Paschale*, ed. L. Dindorf, CFHB (Bonn, 1932), 569.12–18. For an English translation, see *Chronicon Paschale. 284–628 AD*, trans. M. and M. Whitby (Liverpool, 1989), 60.

42. On the "supernatural defenders" of Constantinople, see N. Baynes, "The Supernatural Defenders of Constantinople," *Analecta Bollandiana* 67 (1949): 165–77.

43. Photios, *Homilies*, Hom. X, 100.24, ed. B. Laourdas (Thessalonike, 1959). For an English translation, see C. Mango, *The Homilies of Photius, Patriarch of Constantinople* (Cambridge, Mass., 1958), 185.

44. *Ioannis Scylizae Synopsis historiarum*, ed. H. Thurn (Berlin and New York, 1973), 231.66–232.72 and 245.27–32. For general information on the Mandylion of Christ, see *Mandylion: Intorno al Sacro Volto da Bisanzio a Genova*, exh. cat., Genoa: Museo Diocesano (Genoa, 2004); A. Cameron, "The History of the Image of Edessa: The Telling of the Story," in *Okeanos: Essays Presented to Ihor Ševčenko on His Sixtieth Birthday*, ed. C. Mango and O. Pritsak, Harvard Ukrainian Studies 7 (1984), 80–94; S. Runciman, "Some Remarks on the Image of Edessa," *Cambridge Historical Journal* 3 (1931): 238–52.

45. The Holy Keramion, a miraculous imprint of the Mandylion on a brick, and the sandals of Christ entered the collection in 968 and 975, respectively. Leo the Deacon (*Leonis Diakoni Caloensis historiae libri decem*, ed. C.B. Hase, CSHB [Bonn, 1828], 71 and 166), records that the sandals of Christ were brought from Hierapolis in Syria (Mempetze). Matthew of Edessa, on the other hand, reports that this and other relics were found at the city of Gabala. See A.E. Destourian, *Armenia and the Crusades, Tenth to Twelfth Centuries: The Chronicle of Matthew of Edessa* (Belmont, 1993), 32. On the circumstances of the translation, see N. Adontz, *Notes arméno-byzantines, 2: La lettre de Tzimiscès au roi Ashot (Ašot)*, Études arméno-byzantines 1965 (Lisbon, 1965), 141–47.

46. See Nikolaos Mesarites, *Die Palastrevolution des Johannes Komnenos*, ed. A. Heisenberg (Würzburg, 1907), 30–31.

47. On the treasure of the Sainte-Chapelle, see *Le trésor de la Sainte-Chapelle*, ed. J. Durand and M.-P. Lafitte, exh. cat., Paris: Musée du Louvre (2001). On the circumstances of the acquisition and translation of the relics, see J. Durand, "Les reliques et reliquaires byzantins acquis par saint Louis," and "La translation des reliques impériales de Constantinople à Paris," in ibid., 52–54, 37–41, respectively; H.A. Klein, "Eastern Objects and Western Desires: Relics and Reliquaries between Byzantium and the West," *Dumbarton Oaks Papers* 58 (2004): 283–314, at 306–8. On the display of relics at the Sainte-Chapelle, see M. Cohen, "An Indulgence for the Visitor: The Public at the Sainte-Chapelle of Paris," *Speculum* 83 (2008): 840–83.

48. On the Grand Châsse and its contents, *Le trésor de la Sainte-Chapelle* (2001, cited in n. 47), 107–37; R. Branner, "The Grand Chasse of the Sainte-Chapelle," *Gazette des Beaux-Arts* 77 (1971): 6–18.

49. Walahfrid Strabo, *Libellus*, MGH Capit. 2, 515.29–31. For an English translation, see *Walahfrid Strabo's libellus de exordiis et incrementis quarundam in observationibus ecclesiasticis rerum*, Mittellateinische Studien und Texte 19, trans. (with liturgical commentary) A.L. Harting-Correa (Leiden, 1996), 193. See also P.E. Schramm and F. Mütherich, *Denkmale der deutschen Könige und Kaiser: Ein Beitrag zur Herrschergeschichte von Karl dem Grossen bis Friedrich II. 768–1250*, 2nd ed. (Munich, 1981), 24.

50. For the use of the *cappa* of St. Martin, see J.M. Wallace-Hadrill, *The Long-Haired Kings and Other Topics in Frankish History* (London, 1962), 224, with reference to MGH L Form. Marc., book I, chaps. 38 and 40, 68. For oaths taken on the relic of the True Cross and other relics, see Klein, *Byzanz, der Westen und das 'wahre' Kreuz* (2004, cited in n. 36), 83.

51. On Charlemagne's collection of relics, see H. Schiffers, *Karls des Großen Reliquienschatz und die Anfänge der Aachenfahrt* (Aachen, 1951). On the donations to Centula and Prüm, see Schramm and Mütherich, *Denkmale der deutschen Könige und Kaiser* (1981, cited in n. 50), 25, with bibliographic references.

52. On the emergence and growth of the cult of St. Martin, see R. Van Dam, *Saints and Their Miracles in Late Antique Gaul* (Princeton, 1993), 13–28. For a broader analysis of the cult of relics in the early Middle Ages, see H. Fichtenau, "Zum Reliquienwesen im frühen Mittelalter," *Mitteilungen des Instituts für österreichische Geschichtsforschung* 60 (1952): 60–89.

53. See *Le trésor de Saint-Denis*, ed. D. Alcouffe et al., exh. cat., Paris: Musée du Louvre (1991), and Dom M. Félibien, *Histoire de l'abbaye royale de Saint-Denys en France* (Paris, 1706) (Saint-Denis); E.G. Grimme, *Der Aachener Domschatz*, Aachener Kunstblätter 42 (Aachen, 1972) (Aachen); D. Kötzsche, ed., *Der Quedlinburger Schatz* (Berlin, 1992) (Quedlinburg); E. Bassermann-Jordan and W. Schmid, *Der Bamberger Domschatz* (Munich, 1914), and W. Messerer, *Der Bamberger Domschatz in seinem Bestande bis zum Ende der Hohenstaufenzeit* (Munich, 1952) (Bamberg).

54. When, in 923, the imprisoned Frankish king Charles the Simple (898–923) sent his ambassador Heribert of Vermandois to King Henry I (r. 919–36) to present him with the right hand of St. Dionysius, it was not lost on contemporary observers that this gift marked an important moment of political and dynastic transition. See K.H. Krüger, "Dionysus und Vitus als frühottonische Königsheilige. Zu Widukind I, 33," *Frühmittelalterliche Studien* 8 (1974): 131–54; J. Oberste, "Heilige und ihre Reliquien in der politischen Kultur der frühen Ottonenzeit," *Frühmittelalterliche Studien*, 2003, 73–97.

55. Liutprand of Cremona, *Antapodosis*, book IV, chap. 25, 112.537–38, in *Liudprandi Cremonensis Opera Omnia*, ed. P. Chiesa, CCCM 156 (Turnhout, 1998), 1–150. For the provenance of the relic, see B. Schwineköper, "Christus-Reliquien-Verehrung und Politik. Studien über die Mentalität der Menschen des früheren Mittelalters," *Blätter für deutsche Landesgeschichte* 117 (1981): 183–281, at 204.

56. For the use of the Holy Lance at the Battle of Birten, see Liutprand of Cremona, *Antapodosis*, book IV, chap. 24, 111.498–506, in *Liudprandi Cremonensis Opera Omnia*, ed. Chiesa, (1998, cited in n. 55), 1–150.

57. For the use of the True Cross and Holy Lance in imperial coronations, see Benzo of Alba, *Ad Henricum IV. imperatorem libri VII*, ed. and trans. H. Seyffert, MGH SRG 65 (Hannover, 1996), 124–27.

58. *Lamperti Monachi Hersfeldensis Opera*, ed. O. Holder-Egger, MGH SRG 38 (Hannover, 1894), 135–36 and 183–84. For the circumstances of events, see C.V. Franklin, *The Latin Dossier of Anastasius the Persian: Hagiographic Translations and Transformations*, Studies and Texts 147 (Toronto, 2004), 25–26.

59. D. Leistikow, "Die Aufbewahrungsorte der Reichskleinodien— vom Trifels bis Nürnberg," in *Die Reichskleinodien: Herrschaftzeichen des Heiligen Römischen Reiches, Schriften zur staufischen Geschichte und Kunst* 16 (Göppingen, 1997), 184–213; N. Grass, "Reichskleinodien—Studien aus Rechtshistorischer Sicht," in *Sitzungsberichte der Österreichischen Akademie der Wissenschaften, Philosophisch-historische Klasse* 248/4 (Vienna, 1965), 19–28.

60. K. Otavsky, "Reliquien im Besitz Kaiser Karls IV., ihre Verehrung und ihre Fassungen," in *Court Chapels of the High and Late Middle Ages and Their Artistic Decoration*, ed. J. Fajt, Proceedings from the International Symposium, Convent of St. Agnes 23.9.–25.9.1998 (Prague, 2003), 129–41; H. Kühne, *Ostensio reliquiarum: Untersuchungen über Entstehung, Ausbreitung, Gestalt und Funktion der Heiltumsweisungen im römisch-deutschen Regnum* (Berlin, 2000), 106–32. In 1354, Pope Innocent VI granted Charles permission to display his collection of relics every seventh year on the Feast of the Dormition of the Virgin and allowed him to celebrate a new liturgical feast in his realm: the *festum lanceae et clavorum* (Feast of the Lance and Nails). On the history of the public display of relics, or *Heiltumsschau*, see Kühne, *Ostensio reliquiarum* (2000, this note).

61. On Karlstein Castle and its significance, see F. Seibt, "Karlstein," in *Burg- und Schloßkapellen*, ed. B. Schock-Werner (Stuttgart, 1995), 3–8. On the relic chapel and its decoration, see K. Möseneder, "Lapides vivi: Über die Kreuzkapelle der Burg Karlstein," *Wiener Jahrbuch für Kunstgeschichte* 34 (1981): 39–69; J. Fajt and Jan Royt, *Magister Theodericus. Hofmaler Karls IV: Die künstlerische Ausstattung der Sakralräume auf Burg Karlstein* (Prague, 1997).

62. Charles's collection of relics had meanwhile grown considerably through papal, royal, and imperial gifts. On Charles's acquisition of relics, see F. Machilek, "Privatfrömmigkeit und Staatsfrömmigkeit," in *Kaiser Karl IV: Staatsmann und Mäzen*, ed. F. Seibt (Munich, 1978), 87–101, esp. 93–94; P.E. Schramm, F. Mütherich, and H. Fillitz, *Denkmale der Deutschen Könige und Kaiser: Ein Beitrag zur Herrschergeschichte von Rudolf I. bis Maximilian I., 1273–1519* (Munich, 1978), 18–20, with further bibliographic references. See also B.D. Boehm, "Charles IV: The Realm of Faith," in *Prague: The Crown of Bohemia, 1347–1437*, ed. B.D. Boehm and J. Fajt, exh. cat., New York: The Metropolitan Museum of Art (New York, 2005), 23–45.

63. Details about the public display of Charles's relic collection are known from five surviving "relic lists" in Prague and Munich. See Otavsky, "Reliquien im Besitz Kaiser Karls IV" (2003, cited in n. 60), 135, with references.

64. On the Nuremberger *Heiltumsschau*, see Kühne, *Ostensio reliquiarum* (2000, cited in n. 60), 133–52; J. Schnelbögel, "Die Reichskleinodien in Nürnberg 1424–1523," *Mitteilungen des Vereins für Geschichte der Stadt Nürnberg* 51 (1962): 78–159.

65. On Egbert of Trier, see T. Head, "Art and Artifice in OttonianTrier," *Gesta* 36, no. 1 (1997): 65–82; H. Westermann-Angerhausen, *Die Goldschmiedearbeiten der Trierer Egbertwerkstatt*, Beiheft zum 36, Jahrgang der Trierer Zeitschrift (Trier, 1973). On Bernward of Hildesheim, see *Bernward von Hildesheim und das Zeitalter der Ottonen*, ed. M. Brandt and A. Eggebrecht, exh. cat., Hildesheim: Roemer- und Pelizaeus-Museum, 2 vols. (Hildesheim, 1993). On Wibald of Stavelot, see S. Wittekind, *Altar—Reliquiar—Retabel: Kunst und Liturgie bei Wibald von Stablo* (Cologne, Weimar, and Vienna, 2004).

66. H. Westermann-Angerhausen, "Die Stiftungen der Gräfin Gertrud: Anspruch und Rang," in *Der Welfenschatz und sein Umkreis*, ed. J. Ehlers and D. Kötzsche (Mainz, 1998), 51–76.

67. For an important later donation at St. Michael's in Lüneburg, made by Duke Berhard I of Braunschweig-Lüneburg on 29 June 1432, see W. von Hodenberger, *Archiv des Klosters St. Michaelis zu Lüneburg*, Lüneburger Urkundenbuch 7 (Celle, 1861–70), nos. 1046–47, 641–42. For a comprehensive analysis of the history and inventory of the Treasure of the "Goldene Tafel," see F. Stuttmann, *Der Reliquienschatz der Goldenen Tafel des St. Michaelisklosters in Lüneburg* (Berlin, 1937).

68. Karlsruhe, Generallandesarchiv, no. 67/807 (15 March 1379). See C. Fey, "Reliquienschätze deutscher Fürsten im Spätmittelalter," in *"Ich armer sundiger mensch": Heiligen-und Reliquienkult am Übergang zum konfessionellen Zeitalter*, ed. A Tacke (Halle, 2006), 11–36, at 11. For further information on Rupert's collection of relics and his motivations, see ibid., 19–24.

69. A similar motivation can be cited for the Palatine Elector Ludwig III (r. 1410–36) and his wife, Mechthild, who are known to have donated a number of relics to the church they had chosen as their burial place in Heidelberg. See Fey, "Reliquienschätze deutscher Fürsten im Spätmittelalter" (2006, cited in n. 68), esp. 15–17, 21.

70. For the date and the circumstances of this gift, see G. Wentz, "Das Kollegiatstift Allerheiligen in Wittenberg," in *Das Bistum Brandenburg II*, Germania Sacra I, III/II, ed. F Bünger and G. Wentz (Berlin, 1941), 75–164, at 82–83. For the *Wittenberger Heiltumsbuch*, see L. Cárdenas, *Friedrich der Weise und das Wittenberger Heiltumsbuch. Mediale Repräsentation zwischen Mittelalter und Neuzeit* (Berlin, 2002).

71. On the dates and the amount of indulgences, see H. Kühne, "Heiltumsweisungen: Reliquien—Ablaß—Herrschaft: Neufunde und Problemstellungen," *Jahrbuch für Volkskunde* n.s. 26 (2003): 42–62, at 61; Cárdenas, *Friedrich der Weise* (2002, cited in n. 70), 111; P. Kalkoff, *Ablaß und Reliquienverehrung an der Schloßkirche von Wittenberg unter Friedrich dem Weisen* (Gotha, 1907), 65.

72. From his journey to the Holy Land, Frederick brought back a number of holy souvenirs, including coins that had been brought into contact with holy sites, water from the river Jordan, and a thumb of St. Anne, which he had acquired at Rhodes. In 1502, Frederick received another thumb, that of St. Corona, from his aunt Hedwig, abbess of Quedlinburg. I. Ludolphy, *Friedrich der Weise: Kurfürst von Sachsen 1463–1525* (Göttingen, 1984), 355–56, with further literature.

73. On Frederick's "relic hunters," see S. Laube, "Zwischen Hybris und Hybridität. Kurfürst Friedrich der Weise und seine Reliquiensammlung," in Tacke, ed., *"Ich armer sundiger mensch"* (2006, cited in n. 68), 170–207, at 182, with further literature. See also E. Bünz, "Zur Geschichte des Wittenberger Heiltums: Johannes Nuhn als Reliquienjäger in Helmarshausen und Hersfeld," *Zeitschrift des Vereins für Thüringische Geschichte* 52 (1998): 135–58; E. Bünz, "Die Heiltumssammlung des Degenhart Pfeffinger," in Tacke, ed., *"Ich armer sundiger mensch"* (2006, cited in n. 68), 125–69.

74. U. Timann, "Bemerkungen zum Halleschen Heiltum," in *Der Kardinal: Albrecht von Brandenburg, Renaissancefürst und Mäzen*, ed. T. Schauerte and A. Tacke, exh. cat., Halle: Stiftung Moritzburg, Kunstmuseum des Landes Sachsen-Anhalt, 2 vols. (Regensburg, 2006), 2:255–83.

75. K. Merkel, "Die Reliquien von Halle und Wittenberg. Ihre Heiltumsbücher und Inszenierung" in *Cranach: Meisterwerke auf Vorrat. Die Erlanger Handzeichnungen in der Universitätsbibliothek*, ed. A. Tacke (Erlangen, 1994), 37–50.

76. L. Cárdenas, "Albrecht von Brandenburg—Herrschaft und Heilige. Fürstliche Repräsentation im Medium des Heiltumsbuches," in Tacke, ed., *"Ich armer sundiger mensch"* (2006, cited in n. 68).

77. Ludolphy, *Friedrich der Weise* (1984, cited in n. 72), 454.

78. H. Kohlhaussen, "Fatimidischer Glasschnitt, 11. Jahrhundert. Hedwigsglas," in *Kunstwerke der Welt aus dem öffentlichen bayerischen Kunstbesitz*, 6 vols., ed. R. Netzer (Munich, 1960–66), 2:49-50.

79. See H.J. Schroeder, trans., *Canons and Decrees of the Council of Trent* (Rockford, 1978), 215–17.

80. On the "rediscovery" of the Roman catacombs, see most recently I. Oryshkevich, "The History of the Roman Catacombs from the Age of Constantine to the Renaissance" (Ph.D. diss., New York, Columbia University, 2003). For medieval visitations of the catacombs, see J. Osborne, "The Roman Catacombs in the Middle Ages," *Papers of the British School in Rome* 53 (1985): 278–328. For an overview history, see W.H.C. Frend, *The Archaeology of Early Christianity: A History* (London, 1996), 1–40.

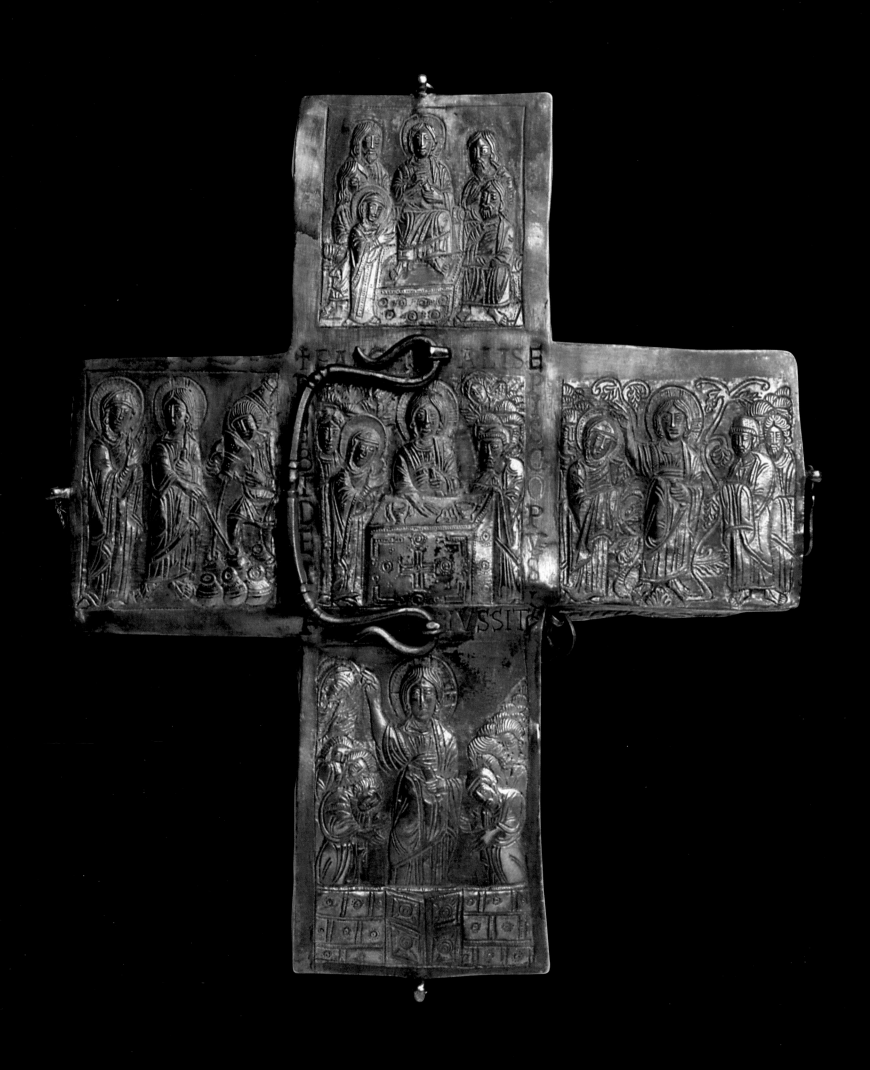

"Non Est in Toto Sanctior Orbe Locus"
Collecting Relics in Early Medieval Rome

GUIDO CORNINI

Since Antiquity, the Palatine chapel of the Sancta Sanctorum, dedicated to the martyr-saint Lawrence, has served as the pontiff's private chapel and has occupied a privileged status within the Lateran, the ancient palace built between the fourth and fifth centuries near the Basilica of Our Savior. Since the reign of Julius I (337–52), the papal chancery was located in the Lateran Palace, which later became the primary residence of the bishop of Rome. Remains of the walls of the *sacratissimum Lateranensis palatii scrinium* described by John the Deacon in his *Life of Gregory the Great* (2:12) have been unearthed in the building's foundations. In the sixteenth century, the old chapel and its groundwork were incorporated into the sanctuary of the new palace (1585–90) designed by Domenico Fontana.[1] During archaeological excavations conducted by Philippe Lauer in 1900, a pit "filled with human bones" and containing "the bone handle of a knife, a terracotta lamp, a small bell, and fragments of a piece of wood with some nails," was found approximately 80 cm from the geometrical center of the room.[2] The entry to the pit is now hidden by the pavement of the thirteenth-century chapel, but the presence of a sixth-century fresco representing St. Augustine in the rooms of the Arciconfraternita, located in the floor below, confirms that this site was the location of the *aedes lateranorum*, part of the ancient imperial donation to the Church that became the core of the *Patriarchium*, the popes' palace, and was used by the clergy to serve the papal court.[3]

The papal oratory of St. Lawrence (or the Lateran Sancta Sanctorum, as it has come to be known) was originally located on the complex's eastern side, southwest of the medieval palace's entry porch. Today it is accessible through the sanctuary of the Scala Santa, and is thus isolated so as to emphasize the aura of sanctity and veneration that it has traditionally come to represent. The inscription NON EST IN TOTO SANCTIOR ORBE LOCUS (There is not a holier place in the whole world), dating to the reign of Sixtus V (1585–90), is prominently displayed on the façade of the apse wall (fig. 30). Indeed, the presence of some of the most sacred relics of Christianity made the chapel the center of an elaborate liturgy that, starting in the late eighth century, shared many characteristics with the ceremonies of the Byzantine court before the period of Iconoclasm (726–843).[4]

A series of corridors that have not survived connected the chapel with the *macrona* (the corridor that runs along the southwestern side of the palace), the reception halls, and the buildings adjacent to the basilica, thus facilitating the transport of the relics during major feasts.[5] The first mention of the oratory is contained in a thirteenth-century chronicle of the Monastery of San Gregorio al Celio, which dates the collection of important relics "intra palatium suum, in ecclesia Sancti Laurentii" (within his palace in the Church of St. Lawrence) to the reign of Pope Pelagius (579–90).[6] Later references to the chapel and its relics treasure appear in the *Liber Pontificalis* in the entries for Sergius I (r. 687–701), Stephen II (r. 752–57),

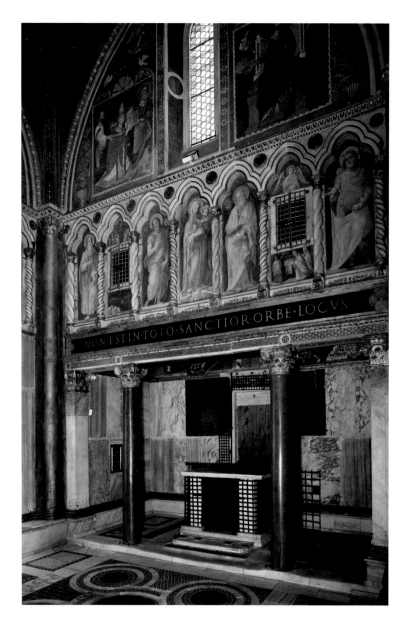

Fig. 30. Holy Stairs Sanctuary, Chapel of the Sancta Sanctorum: General view of the interior looking east

Leo III's chest was subsequently encased in the new altar, shielded by a grate inscribed with the words + HOC OPVS FECIT FIERI DOMINVS INNOCENTIVS PAPA TERTIVS (This work was commissioned by our Lord Pope Innocent III [Count Lotario of Segni, r. 1198–1216]), on the left door, and, on the right + NICOLAVS PAPA III HANC BASILICAM A FVNDAMENTIS RENOVAVIT ET ALTARE FIERI FECIT IPSVMQVE ET EANDEM BASILICAM CONSECRAVIT (Pope Nicholas III renovated this basilica from the foundations, had this altar made, and consecrated it together with the basilica), emphasizing the extent of Nicholas's renovations. According to the historian Tolomeo (Bartholomew or Ptolemy) of Lucca, "in the year 1280 [Nicholas] ordered the Lateran Palace . . . to be renovated, and not only did he repair the chapel of the Sancta Sanctorum, which was in a very ruinous state, from the ground up, but he also ordered the interior to be clad in marble and the ceiling decorated with the most beautiful paintings."[11] In-depth restorations carried out in the years 1992–94 have established that Nicholas's decoration of the chapel's interior extended to the mosaic coating of the altar niche,[12] which had been earlier attributed to Honorius III (Cencio Savelli, r. 1216–27), on the basis of a notice in the *Liber Pontificalis* stating this pope had "renovated" *(renovatum)* the Oratory in the last year of his pontificate.[13]

The complex architectural history of the building, whose loggia was altered again during the pontificate of Sixtus V,[14] attests to the veneration accorded this site and the respect for its liturgical function, which began to be codified during the Carolingian period.[15] The name *Sancta Sanctorum* (Holy of Holies) itself, which came into consistent use only in the thirteenth century, was borrowed from the designation of the inner sanctuary of the Temple of Jerusalem in the Bible.[16] It claimed for the Lateran Chapel the function of repository for the most sacred relics of the Church, to which only the pope and his closest entourage had access. The parallel was underscored by the fact that only the pontiff could celebrate the Easter liturgy inside the Sancta Sanctorum, like the high priest in the Temple of Jerusalem.[17]

In light of the above, the opening of Leo III's chest on 6 June 1905, as well as the study of the relics and liturgical implements guarded therein, ranks among the most sensational archeological discoveries of the last century and confirms the value ascribed to these objects during the medieval period. As it has been rightly observed, the exceptional character of the discovery, with all its liturgical, ideological, and historical implications, was compounded by the extraordinary artistic quality—both technical and iconographic—of the objects and by the "sense of mystery that had always surrounded this sacred repository," which researchers had been unable to access for four centuries.[18] It is precisely for this reason that press accounts in contemporary newspapers made a point of praising the scholars' initiative in securing permission to study the relics and, in so doing, shattering a four-hundred-year-long silence.[19] Indeed, the "experimental" opening of the chest done two years earlier as part of a study of the martyr-saint Agnes had done little to dispel the mystery that surrounded the Lateran collection.[20] Grisar himself describes the emotion he felt when he opened the chest and saw the "precious reliquaries in silver and gold, ivory and rare wood,"

and Stephen III (r. 768–72).[7] Leo III (r. 795–816) endowed the chapel with a chest of cypress wood, inscribed LEO INDIGNVS / TERTIVS EPISCOPVS / D[E]I FAMVLVS / FECIT (Leo III, undeserving bishop and servant of God, made this), which contained artifacts recorded in the ancient catalogues and inventoried centuries later by Hartmann Grisar.[8] The plan of this early oratory is undocumented and unrecorded, although sources suggest that it was a structure larger than the present building, aligned along a north-south axis (as is the present corridor at the entry to the oratory), inside which—according to John the Deacon's *Descriptio Lateranensis Ecclesiae* (Description of the Lateran Church), "tria sanctissima computantur altaria" (three most holy altars can be found).[9] Pope Nicholas III (Giovanni Gaetano Orsini, r. 1277–80) is credited with the decoration of the present chapel, adorned with a cosmatesque-style pavement and frescoes by Umbro-Roman painters, having repaired the building following an earthquake in 1277.[10]

"the miniatures on the boxes painted on glittering gold," "the very ancient textiles with vividly colored scenes. . . . Holy objects, venerated for more than a thousand years by the popes, the Romans, and the numerous generations of pilgrims that came here from the four corners of the world."[21] The treasure was taken to the Vatican to be studied and exhibited. The relics were taken out of their containers and then put back in their original location, whereas the reliquaries were kept at the Vatican and exhibited in the Museo Sacro, "to the admiration of visitors in the Vatican Museums."[22]

It is impossible to discuss at length all the numerous objects transported to the Vatican after the opening of the chest.[23] In his general analysis of this material, Volbach argued that a group of very ancient textile fragments, like the large tunic (inv. 61307) and some *brandea* stained with blood (or at least so reputed to be by their earlier investigators) were associated with the earliest Christian persecutions and therefore must have been part of the original treasure.[24] Many other relics of later date, like the tunic (inv. 61859) and the *mappula* (an ornamental handkerchief used in Roman dress and subsequently adapted to liturgical use as the maniple) with red stripes of Eastern manufacture (inv. 61310) should be related to the arrival of the Greek popes in the eighth and ninth centuries, and their connection to real or alleged episodes of the sacred history must therefore be critically reconsidered. Little is left of the boxes and the textiles that were used to wrap and preserve the relics during the treasury's early history (fifth–seventh centuries): among the ivories, the fourth- or fifth-century pyxis with Bacchic scenes (inv. 61889), as well as the sixth-century relief with the Healing of the Blind (inv. 61895);[25] among the metalwork, the seventh-century oval pyxis with the Adoration of the Cross, the so-called *capsella vaticana* (inv. 61309),[26] and the famous gemmed cross—a sixth- to eighth-century masterpiece of early medieval decorative art, stolen in 1945 from the Museo Sacro of the Vatican Library;[27] among the paintings, the small encaustic diptych with the portraits of Peter and Paul (inv. 61911, 61912),[28] and the wooden reliquary box painted with scenes from the Life of Christ, containing stones from the Holy Land (inv. 61883 [cat. no. 13]).[29] Noteworthy among the textiles of this earlier period are the Sassanian fragment with scenes of a lion hunt, another textile with haloed roosters (inv. 61250 and 61244), and two more ornamental pieces, of probable Byzantine origin, dating to the sixth or seventh century.[30] Because of their age and provenance, most of these objects might have found their way to the Lateran at a comparatively early stage in their history, thus forming a group possibly predating Leo III's donation to the papal oratory in the *Patriarchium*.

The remaining artifacts are of a later date. At the beginning of the ninth century, during the *Renovatio Romani Imperii* under the reign of Carolingian pontiffs, the entire concept of reliquaries changed, and their style and iconography were transformed.[31] Paschal I (r. 817–24) donated to the treasury a marvelous enameled cross (inv. 61881 [cat. no. 36]) and two silver cross reliquaries (inv. 60985 and 61888) (fig. 31),[32] with the silk pillows mentioned by the sources (inv. 61306 for the gemmed cross and inv. 61250 for the enameled cross).[33] Other precious textiles, such a Byzantine specimen decorated

with facing lions (inv. 61251) and another with a design of winged horses (inv. 61275: also Byzantine, but probably derived from a Persian model) date to the same period. There are also textiles of an altogether different style, like the eighth- or ninth-century (possibly Syrian) examples, one decorated with scenes of the Annunciation (inv. 61231) and the other with the Nativity (inv. 61258).[34] Additional items were donated between the ninth and the twelfth century, such as the beautiful painted cross reliquary (inv. 61898) (fig. 32),[35] the oval reliquary box with the Deesis and the Evangelists (inv. 61906)[36], the Byzantine casket for the head of St. Praxedes (inv. 61914) (fig. 33a–b),[37] the orichalcum chasse with the Crucifixion in niello (inv. 61930),[38] and some fragments of Eastern silk textiles. An impressive silver box for the head of St. Agnes, commissioned by Honorius III in honor of the Roman martyr (inv. 61913), was among the last gifts added to the treasury during the medieval period.[39]

Among the objects discussed above, the most interesting for the history of liturgical art are those commissioned by Pope Paschal I. The sources mention a cross "diversis ac pretiosis lapidibus perornata" (decorated with varied and precious stones), discovered by Pope Sergius I (r. 687–701) in the sacristy of St. Peter's and moved sometime in the following centuries to the Lateran for use in liturgical processions during certain feast days. It is still a matter of debate whether that particular cross should be identified with the enameled cross (as proposed by Lauer and Grisar), or with the gemmed one (as proposed by more recent scholarship).[40]

We can be certain that at least since the mid-seventh century the rites preceding Lent and Good Friday included a procession from the Lateran to the Basilica of Sta. Croce in Gerusalemme (where another important relic of the True Cross was kept), during which the pope, holding the archdeacon by the left hand, was followed by a deacon carrying the Lateran relic enshrined in a golden case decorated with gems and containing a vial of scented oil.[41]

The *ordines* of Benedictus Canonicus and of Cencius Camerarius (later Pope Honorius III) describe the ceremonial protocol followed during the Feast of the Exaltation of the Cross (14 September), when the pope, coming from the palace, would enter the Lateran basilica accompanying in procession the sacred objects taken from the oratory, "scilicet de ligno Crucis Domini et sandalia Domini Nostri Jesus Christi et circumcisionem ejus" (the Holy Wood, the sandals of our Lord Jesus Christ, and his foreskin), before restoring them to their hiding place under the altar.[42]

The objects given to the treasury by Paschal I, following the tradition of the *debir* that took place in the Temple of Jerusalem, functioned as liturgical *vasa sacra* or *sanctuaria* for the cult, like those deposited in Antiquity near the Ark of the Covenant.[43] Like the liturgical vessels in the Hebrew temple, the reliquaries offered by the pontiff to the oratory were a sign of unity and religious identity for the community of the faithful.[44] In the same pope's vision, Leo III's old chest, made of cypress wood, like the Ark of the Covenant, and similarly filled with relics, functioned both as an altar and as a repository, thereby linking the ideas of mediation and primacy

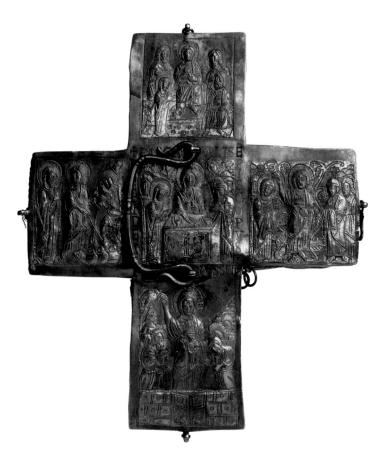

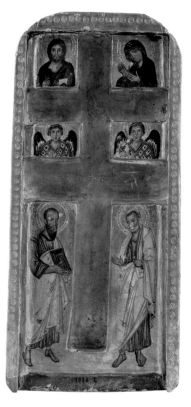

Fig. 31. Staurotheke, Roman, first quarter of the 10th century. Museo Cristiano, Musei Vaticani (60985)

Fig. 32. Reliquary of the True Cross, Byzantine (Constantinople), second half of the 10th century. Museo Cristiano, Musei Vaticani (61898)

(as expressed by the Eucharistic iconography developed at length on the objects commissioned by Pope Paschal I) with the dedication to St. Peter of the first altar of the Lateran basilica.[45]

By emphasizing their importance through the commissioning of special containers, Paschal made the relics of the True Cross the very center of his decorative program, establishing a parallel with the sacrifice of Christ: as with his own Passion, death, and Resurrection, Christ had torn the veil of the Temple, substituting for it his own body by virtue of the blood that he had spilled "for the sins of the world" (Heb. 10: 19–21), the relics of the *lignum crucis,* or Holy Wood, symbolized the victory of the New Covenant entrusted by Christ to the Church, governed by the pope, guarded by Mary, and nourished by faith in the Eucharist.[46] Through the interplay of this complex set of references, Paschal's figurative program stressed the transfer of God's power to the Roman pontiff (and from him to his ministers) and illustrated how this was made possible through the intercession of the Virgin and consecrated by the sacraments administered by the Church.

The most celebrated Lateran relic was the *acheiropoietos* (i.e. "not painted by human hands") image of Our Savior,[47] traditionally identified with the portrait painted by the Evangelist Luke in Jerusalem and later completed by angels.[48] The Lateran's "most sacred icon" of Christ was both the center and the starting point of a complex liturgy. It is an encaustic painting on

linen mounted on a chestnut panel. A gemmed cross, painted in tempera on the panel's back, dates to the reign of John X (914–928). The front of the panel shows a very damaged image of the enthroned Christ with a cruciform halo. Following the Byzantine iconography of the *Majestas Domini,* Christ makes a gesture of blessing with the left hand and holds the Gospels in his right. The rigid frontality of the image recalls the formality of consular portraiture in Late Antique ivory diptychs.[49] The entire surface of the icon, including the frame around the outer borders, is covered by a silver repoussé revetment. Only the face and the feet of Christ are left visible. The revetment is inscribed + INNOCENTIVS . P . P . III . HOC . OPVS . FIERI . FECIT, which dates the commission to the last years of the pontificate of Innocent III. The face, which resembles the features of the Vatican "Veronica,"[50] is painted on silk and it is probably a late addition. Because the Lateran *acheiropoietos* was a miraculous and venerated image, inextricably linked to the civic and religious history of Rome, it was kept in the palace of the popes and protected through a ceremonial protocol that isolated it from the general cult.

As an image of "public salvation" (see below), reportedly generated by divine intervention, the icon profited from the status of a legal imperial portrait (that is to say, a portrait with a specific jurisdictional role, as already acknowledged in the ancient Roman world)[51] and, as a result of Christ's

Fig. 33. Reliquary box for the head of St. Praxedes, Byzantine (Contantinople), first half of the 11th century, and Roman, 11th–12th century. Museo Sacro, Musei Vaticani (61914a–b)

incarnation, it was the visualization of the transcendence of God.[52] Praying before such an image, the faithful would not only have gazed upon that "authorized picture of himself that the Word Incarnate had left on earth after his death and resurrection,"[53] but would also have confronted the immanence of the power—as well as of the moral and dogmatic authority— that had been specifically associated with the model. According to a legend reported by Georgios Hamartolos (d. after 867) and taken up by later authors, the icon came from Constantinople, where it had been venerated during the years of Leo III the Isaurian, right at the beginning of the first phase of Iconoclasm (726–41). To rescue the painting from possible persecutions, the patriarch Germanos (r. 715–30) entrusted it to the sea: the icon floated west toward Italy and traveled up the Tiber to Rome, where Pope Gregory II (r. 715–731), who had been alerted to its arrival in a dream, was waiting for it.[54] Whatever historic circumstances the legend intimates,[55] news of the existence of the Roman *acheiropoietos* must have reached Constantinople as early as beginning of the ninth century: the patriarch Nikephoros (r. 802–11), for instance, mentions the painting as an argument in favor of the veneration of images in his *Antirrhetikos* of 817.[56] Faith in the miraculous powers of icons, on the other hand, was so deeply rooted in Roman religious life that a century before, the Lateran panel had been borne aloft in a procession to protect the city from invasion. The

Liber Pontificalis recounts how Stephen II (r. 752–57), barefoot and his head covered with ashes, walked with the icon on his shoulders in a procession from the Lateran to the Church of Sta. Maria Maggiore to enlist the help of God against the threats of the Longobard king Aistulf, who sought to regain the lands ceded to the pope by his own predecessors.[57]

Faith in the salvific power of images was reasserted in Rome at the precise moment when in Constantinople, the center of Byzantine spirituality and the capital of artistic production for the Christian East, images fell prey to the rapacity of iconoclasts. One might plausibly see in the Roman procession of 752 the transfer of traditional Byzantine cult from the capital of the Eastern Empire to the capital of the Western Church. Certainly, the figure of the pope carrying the image of Our Savior to protect the Church (and particularly the manner in which his trust in the power of the icon was performed) should be associated with pre-iconoclastic Byzantine practice.[58] It should not be forgotten that in Byzantium, as later in Rome, an icon of Christ of similar nature had been exhibited as a *palladium* (an image of public salvation) during the campaigns of Mauritius (586) and Heraklies (622) against the Persians. It is even possible that the procession of 752, the first recorded procession of the Lateran *acheiropoietos*, followed the tradition set by the annual processions of 15 August, when the icon, removed from its habitual dwelling place and paraded through the streets

of Rome, was followed by Church dignitaries and adored by the people, becoming the object of ritual washings.[59]

The liturgy of the Feast of the Assumption, in its turn, can be best explained as a ritual reenactment, through the proxy of an image, of Christ's visit to his mother at the moment of her death.[60] The procession was a performance with a prominent visual content midway between theater and painting, enacted using the city of Rome as a backdrop. At night, the image was taken from the Lateran to the Forum and to the church of "the holy Mother of God" (the Church of Sta. Maria Maggiore), passing through the places where the Christian faith had vanquished its persecutors and thus celebrating the memory of its triumph over the dark forces of paganism. Having reached the Esquiline Hill, the cortege made its solemn entrance into the Church of Sta. Maria Maggiore, where the icon of Christ, which along the way had stopped at all the most important sites of the Marian cult, met that of the *Salus Populi Romani*, Rome's most important Marian image.[61] The meeting of the icons symbolized the mystery of the *dormitio*, the death of the Virgin, and her subsequent assumption to heaven. The High Mass in the cathedral and the vigil before dawn marked the climax of this peculiar ceremony, which ended with the return of the *acheiropoietos* to its "home" in the Sancta Sanctorum. An interesting poem from the time of Otto III (r. 983–1002) records the spectacle of this procession, with Church and city authorities heading the cortege of the pilgrims "amidst the singing of psalms and the scent of candles, while the streets along the route are lit by numerous lamps."[62] The most ancient version of the procession, recorded in the life of Leo IV in the *Liber Pontificalis* (14 August 847) started from the Lateran and went through the Fora, up the Via Sacra to the Church of Sant'Adriano and then to the Church of Sta. Lucia de' Selci.[63] In later times, the course was supplemented with additional stops at which the icon was venerated in different ways, the most famous being the ritual washing with basil oil in commemoration of the meeting between Christ and Mary Magdalene in the house of the Pharisee (Luke 7:36–50).[64] During the reform initiated by Gregory VII (r. 1073–85), the medieval procession of the Assumption acquired new meanings in accordance with the pope's own agenda of emphasizing the centrality of the Church's role in its struggle against the empire. By now the procession stops included the key places of political power (both ancient and present-day), stressed the importance of both major basilicas (Sta. Maria Maggiore and San Giovanni in Laterno), and introduced the dichotomy between Christ and the Virgin as a parallel to the relationship between the pope and his Church. Traversing the most significant sites of Roman religious history, the procession reasserted the shared identity of the civic community, reconciling the city's pagan past with its Christian present and absorbing the inherent contrasts in the doctrine of salvation.[65] The Majesty of Christ and the Majesty of Mary, public intercession and private salvation, collective protection and legitimization of power: these are the main themes of the august liturgy upon which Gregory VII based his ceremonies.[66] It is therefore not surprising that from this time forward, the story of the icon is marked by an increasing desire to make its public dimension more sacred by stressing its supernatural origin and investing it with a quality of inaccessibility, intended to mitigate the risks of an indiscriminate cult. In the second half of the twelfth century, Pope Alexander III (r. 1159–81) had multiple layers of silk applied to the icon so that those who gazed on the image would not be struck by its supernatural look. Gervase of Tilbury argued that the reason for this addition was to avoid scaring people who had stared at it for too long: an action that might induce death.[67] An English pilgrim who visited Rome in those same years, makes the same point, recounting how a predecessor of the reigning pontiff died because he gazed too closely at the icon.[68] Notwithstanding these contemporary accounts, it is possible that Innocent III's decision to cover the icon with a silver revetment was to remove from public view an image that was already much degraded.[69] Since the revetment left the figure's face and feet visible, the ritual washing and oiling of the panel could continue without having to remove the cover. The continuation of these rites well into the sixteenth century attests how deeply rooted the tradition was within popular Roman devotion. It also underscores the extent to which this image was associated with a physical notion of the divine—a notion that Innocent III himself helped to spread, transforming the cult of this image into that of a relic.

Notes

1. M. Delle Rose, "Il Patriarchio: Note storico-topografiche," in C. Pietrangeli, ed., *Il Palazzo Apostolico Lateranense* (Florence, 1991), 19–35. On the transformations of the Campus Lateranensis from Late Antiquity until the early centuries of Christianity, see R. Krautheimer, *Il Laterano e Roma: Topografia e urbanistica nel V/VI secolo* (Rome, 1975), passim; idem, *Rome: Profile of a City, 312–1308* (Princeton, 1980), 311–26 (= *Roma: Profilo di una città, 312–1308* [Rome 1981], 383–402). For the medieval period, see in particular I. Herklotz, "Der Campus Lateranensis im Mittelalter," in *Römisches Jahrbuch für Kunstgeschichte* 22 (1985): 2–43.

2. P. Lauer, "Les fouilles du Sancta Sanctorum au Latran," in *Mélanges d'archéologie et d'histoire* 20 (1900): 274ff; see also idem, "Le trésor du Sancta Sanctorum," in *Monuments et Mémoires publiés par l'Académie des Inscriptions et Belles-Lettres* (Fondation E. Piot, 1906), 8.

3. D. Redig de Campos, "Il 'S.Agostino' della Scala Santa restaurato," in *Festschrift E. Kirschbaum, II: RQ* 58 (1963): 101–4; G. Matthiae, *Pittura romana del Medioevo,* I (Rome 1965, rev. 1987, with scientific update [fourth–tenth centuries] by M. Andaloro): 123, 253; B. Bertani, "La sede dell'Arciconfraternita Lateranense del SS. Sacramento," *Alma Roma* 20 (1979): 15–23, nn. 5–6; idem, "Le fondazioni del Sancta Sanctorum," *Alma Roma* 21 (1980): 29–39, nn. 3–4; idem, "I sotterranei della Sede della Arciconfraternita Lateranense del SS. Sacramento: Forse riemerge una traccia delle 'aedes lateranorum,'" in *Alma Roma* 27 (1986): 79–96, nn. 3–4.

4. M. Andaloro, "L'Acheropita," in Pietrangeli, ed. *Il Palazzo Apostolico Lateranense* (1991, cited in n. 1), 81–89. See P. Verzone, "La distruzione dei palazzi imperiali di Roma e di Ravenna e la ristrutturazione del Palazzo Lateranense nel IX scolo nei rapporti con quello di Costantinopoli," in *Roma e l'età carolingia: Atti delle giornate di studio (Rome, 3–8 May 1976)* (Rome, 1976), 39–54. On Byzantine ceremonial liturgy, see in particular H. A. Klein, "Sacred Relics and Imperial Ceremonies at the Great Palace of Constantinople," in F. A. Bauer, ed., *Visualisierungen von Herrschaft: Frühmittelalterliche Residenzen-Gestalt und Zeremoniell* (Istanbul 2006), 79–99 (with previous bibliography).

5. M.R. Tosti-Croce, "Il Sancta Sanctorum: Architettura," in Pietrangeli, ed. *Il Palazzo Apostolico Lateranense* (1991, cited in n. 1), 51–57; I. Lavin, "The House of the Lord: Aspects of the Role of Palace 'Triclinia' in the Architecture of Late Antiquity and the Early Middle Ages," *Art Bulletin* 44 (1962): 1–27; H. Belting, "Die beiden Palastsäulen Leos III. im Lateran und die Entstehung einer päpstlichen Programmkunst," in *Frühmittelalterliche Studien* 12 (1978): 55–83; M. Luchterhand, "Päpstlicher Palastbau und höfisches Zeremoniell unter Leo III," in C. Stiegmann and M. Wemhoff, eds., *Kunst und Kultur der Karolinger Zeit: Karl der Grosse und Papst Leo III,* 3 vols. (Mainz, 1999): 3:109–22.

6. Biblioteca Apostolica Vaticana, MS Vat. Lat. 60.

7. Sergius I: *Liber Pontificalis,* ed. L. Duchesne, 2 vols. (Paris, 1886, ed. 1955 [repr. 1981]), 1:374; Stephen II: *Liber Pontificalis,* 1:443; Stephen III: *Liber Pontificalis,* 1:469.

8. The earliest mention of the existence of relics in the Lateran chapel is given by John the Deacon, canon of the Basilica of Our Savior during the reign of Pope Alexander III (1159–81), in his *Descriptio Lateranensis Ecclesiae.* For the compilation of the entries in his list, John relied on lost documents from the Archivio Capitolare of the Basilica. The number of relics listed by the clergy in chapter 14 of his description is very close to the actual archeological material found in the twentieth-century survey of the chest. Johannes Diaconus, *De ecclesia Sancti Laurentii in palatio,* ca. 1170, quoted in Lauer, "Le trésor du Sancta Sanctorum" (1906, cited in n. 2), 28–29. For the sources used by the compiler in his treatise, dating back to 1073–1118, see C. Vogel, "La 'Descriptio Ecclesiae Lateranensis' du Diacre Jean," in *Mélanges en honneur du Monsigneur Michel Andrieu* (Strasbourg, 1956), 457–76; B. Galland, *Les authentiques du reliques du Sancta Sanctorum,* Studi e Testi 421 (Vatican City, 2004), 58–68. A second inventory was given in an inscription in Latin hexameters that hung outside the chapel and informed visitors about the nature and number of relics contained therein. See Lauer, "Le trésor du Sancta Sanctorum" (1906, cited in n. 2), 31; H. Grisar, *Il "Sancta Sanctorum" ed il suo Tesoro Sacro: Scoperte e studii dell'autore nella Cappella Palatina Lateranense del Medio Evo* (Rome, 1907), 76. The original text of the inscription is reported in a note added at the beginning of the fourteenth century at the foot of a twelfth-century manuscript now in the library of the Bischöflichen Priestersseminars, Trier. H.V. Sauerland, "Aus Handschriften der Trier Seminarbibliothek," in *Neues Archiv der Gesellschaft für Ältere Deutsche Geschichtskunde* 17 (1892): 608; see Galland, *Les authentiques du reliques du Sancta Sanctorum* (2004, cited above), 71. A third inventory was the one commissioned by Leo X after a visitation held in 1517 (see below) and intended to verify the claims of the *Tabula Magna Lateranensis,* a comprehensive list of the relics once placed near the main altar of the basilica and later copied and published by Panvinio (*De septem ecclesiis . . .* [Rome 1570], 194); on this topic, see also Biblioteca Apostolica Vaticana, *Chigianus* G II 38, discussed by Galland, *Les authentiques du reliques du Sancta Sanctorum* (2004, cited above), 78–81. A marble replica of the *tabula* is now exhibited in the corridor leading to the sacristy, on the left wall of the ambulatory that surrounds the apse of the basilica on the south side. The fourth and last record of these relics, quite inaccurate in their identification and numbering, was made in 1624 by the canon Lorenzo Bonincontri, secretary of the Compagnia of the Sancta Sanctorum. His catalogue was based on documents formerly in the archive of the Confraternita and was compiled in both Latin and Italian. Until not very long ago it was possible to read its text distributed on two panels located in the entry corridor of the chapel: C. Rasponi, *De basilica et patriarchio lateranensi* (Rome, 1656), 368–69; G. Marangoni, *Istoria dell'antichissimo Oratorio o Cappella di San Lorenzo nel Patriarchio Lateranense . . .* (Rome 1747; repr. 1802, 1861), 40–41; see also Grisar, *Il 'Sancta Sanctorum' ed il suo Tesoro Sacro* (1907, cited above), 78–79; Galland, *Les authentiques du reliques du Sancta Sanctorum* (2004, cited above), 81–83.

9. Johannes Diaconus, in PL 78:1390.

10. J. Gardner, "Nicholas III's Oratory of the Sancta Sanctorum," *Burlington Magazine* 115 (1973), no. 842, pp. 283–94; J.T.Wollesen, "Die Fresken in Sancta Sanctorum: Studien zur römischen Malerei zur Zeit Nikolaus' III. (1277–1280)," *Römisches Jahrbuch für Kunstgeschichte* 19 (1981): 35–83; M.D'Onofrio, "Le committenze e il mecenatismo di papa Niccolò III," in A.M. Romanini, ed., *Roma Anno 1300,* Atti della IV Settimana, 1980 (Rome, 1983), 553–56; J.T. Wollesen, "Perduto e ritrovato: una riconsiderazione della pittura romana nell'ambiente del papato di Niccolò III (1277–1280)," in Romanini, ed., *Roma Anno 1300,* 343–53; L. Bellosi, "Il Maestro del Sancta Sanctorum," in *Scritti in onore di Giuliano Briganti* (Milan, 1990), 21–36, repr. in *"I vivi parean vivi": Scritti di Storia dell'Arte Italiana del Duecento e del Trecento* (Florence, 2006), 48–55; A. Tomei, "I mosaici e gli affreschi della Cappella del Sancta Sanctorum," in Pietrangeli, ed., *Il Palazzo Apostolico Lateranense* (1991, cited in n. 1), 59–79; J. Gardner, "L'architettura del Sancta Sanctorum," S. Romano, "Il Sancta Sanctorum: Gli affreschi," and A. Tomei, "Un modello di committenza papale: Niccolò III e Roma," in C. Pietrangeli et al. ed., *Sancta Sanctorum* (Milan, 1995), 19–37, 38–125, 192–201, respectively.

11. "Anno 1280 palatium Lateranense . . . fecit perfeci, necnon et basilicam ad Sancta Sanctorum evidentius ruinosam a solo terrae opere perpetuo intus ipsam per latera vestita marmore ac in superiori parte testudinis picturis pulcherrimis ornata fundare iussit." Tolomeo da Lucca, *Historia Ecclesiastica,* in L.A. Muratori, *Rerum Italicarum Scriptores* (Milan, 1727), col. 1181; for a comprehensive survey of the building's many vicissitudes, see N. Horsch, "Kapelle 'Sancta Sanctorum,'" in C. Strunk, ed., *Rom: Meisterwerke der Baukunst von der Antike bis heute; Festgabe für Elisabeth Kieven* (Petersberg-Imhof, 2007), 152–54.

12. M. Andaloro, "I mosaici del Sancta Sanctorum," in Pietrangeli et al., ed, *Sancta Sanctorum* (1995, cited in n. 10), 126–91; see also J. T. Wollesen, "Eine 'vor-cavallineske' Mosaikdekoration in Sancta Sanctorum," *Römisches Jahrbuch für Kunstgeschichte* 18 (1979): 11–34; A. Tomei, "I mosaici e gli affreschi," in Pietrangeli, ed., *Il Palazzo Apostolco Lateranese* (1991, cited in n. 1), 59–79; A. Tomei, "La pittura e le arti suntuarie: da Alessandro IV a Bonifacio VIII," in A.M. Romanini, ed., *Roma nel Duecento: L'arte nella città dei papi da Innocenzo III a Bonifacio VIII* (Turin, 1991), 323–403.

13. *Liber Pontificalis,* ed. Duchesne (cited in n. 7), 2:453 and n. 4: see M. Righetti Tosti-Croce, "Il Sancta Sanctorum: Architettura," in Pietrangeli, ed., *Il Palazzo Apostolico Lateranense* (1991, cited in n. 1), 51–57; eadem, "L'architettura tra il 1254 e il 1308, in Romanini, ed., *Roma nel Duecento* (1991, cited in n. 12), 73–143, at 112. Before being resumed by Righetti Tosti Croce on the grounds of a compelling stylistic analysis, the attribution of the mosaics to Honorius's own patronage had been strongly argued by G.B. De Rossi (*Musaici cristiani e saggi dei pavimenti delle chiese di Roma anteriori al secolo XV* [Rome, 1899]; Wilpert (*Die römischen Mosaiken und Malereien der kirchlikichen Bauten vom IV. bis XIII. Jahrhundert,* 4 vols. [Freiburg-im-Breisgau, 1917], 1.1: 176–79]; and W. Oakeshott (*The Mosaics of Rome from the Third to the Fourteenth Century* [London 1967], 297–98).

14. P. Tosini, "La loggia dei santi del 'Sancta Sanctorum': Un episodio di pittura sistina," in Pietrangeli et al., *Sancta Sanctorum* (1995, cited in n. 10), 202–23.

15. E. Bozóky, *La politique des relics de Constantine à Saint Louis: Protection collective et légitimation du pouvoir* (Paris, 2007); P. Cordez, "Die Reliquien, ein Forschungsfeld: Traditionslinien und neue Erkundungen," *Kunstchronik* 60, no. 7 (2007): 271–82, opens new avenues of research.

16. The Bible contains numerous references to Moses's tabernacle, which was the predecessor to the space consecrated in the Temple for the safekeeping of the Ark of the Covenant: Exod. 26:31–33, 40:1–33. References to the Sancta Sanctorum in the Temple of Solomon are found in 1 Kings 6:19, and 2 Chron. 3:1–14; to its rebuilding at the time of Zorobabel (520–515 BC), in 1 Esdras 5:1–17, 6:1–22. Further references to the same structure at the time of the Maccabees and Herod the Great, are found in 1 Macc. 4:36–58, and John 2:20, respectively. Flavius Josephus gives a detailed description of the Temple of Jerusalem in his *Bellum Iudaicum* 5.5.4–5.

17. M. Cempanari, *Sancta Sanctorum Lateranense: Il Santuario della Scala Santa dalle origini ai nostri giorni,* 2 vols. (Rome, 2003), 1:169–72.

18. G. Morello, "Il Tesoro del Sancta Sanctorum," in Pietrangeli, ed. *Il Palazzo Apostolico Lateranense* (1991, cited in n. 1), 90–105.

19. As, for example, in the *Kölnische Volkszeitung* of 26 October 1906, and in the *Corriere della Sera* of 18 January 1907.

20. With the exception of the brief inspection executed on 14 April 1903 by the Jesuit Florian Jubaru and limited to the relics of St. Agnes (see F. Jubaru, "Le chef de Sainte Agnès au Trésor du Sancta Sanctorum," in Études 104 [20 September 1905], 721 ff), Leo III's chest and its contents had lain undisturbed for four centuries, since the time Pope Leo X (Giovanni de' Medici, 1513–21) had visited the chapel with members of his retinue and extracted from the treasury the most precious relics, showing each of them to the dignitaries present at the event (See O. Panvinio, De praecipuis [urbis] Romae . . . basilicis [Rome, 1570], 192: "In sacello Sancta Sanctorum, quod Sancti Laurenti appellatur . . . sunt infinitae reliquiae a Leone papa X visae, et multis astantibus ex duabus fenestrellis erutae et ostensae, et iterum in eodem locatae. . . ." (In the chapel of the Sancta Sanctorum, which is called of St. Lawrence . . . there are numerous relics seen by Pope Leo X, who took them out from two small windows, showed to the people present and then put them back . . .): on this topic, see also Paris de Grassis, Diarium Curiae Romanae, in J. Mabillon, Museum Italicum, 2 vols. (Paris, 1724–26), 2:587ff. This episode must have happened during one of the last sessions of the Fifth Lateran Council (Eighteenth Ecumenical Council), which took place at the Lateran between 1512 and 1517.

21. Grisar, Il 'Sancta Sanctorum' ed il suo Tesoro Sacro (1907, cited in n. 8), 4–5.

22. See S. Le Grelle, Guida delle Gallerie di Pittura (Musei e Gallerie Pontificie, V), (Rome, 1925), 54–55 (armadi 16–19, vetrina VI). The relics were furnished with reliquaries only in 1936, when Pope Pius XI commissioned new gold containers from the goldsmith Alfredo Ravasco. A. Lazzarini, "I reliquiari del Ravasco per il "Sancta Sanctorum,'" in L'Illustrazione Vaticana, anno 4, no. 18 (16–30 September 1933) 704–5; Morello, "Il Tesoro del Sancta Sanctorum" (1991, cited in n. 18); see Galland, Les authentiques du reliques du Sancta Sanctorum (2004, cited in n. 8).

23. On the treasury of the Sancta Sanctorum, in addition to Grisar's 1907 monograph (cited in n. 8), see Lauer, "Le trésor du Sancta Sanctorum" (1906, cited in n. 2); H. Grisar, "Note topografiche e storiche sulla più antica residenza dei papi al Laterano," La Civiltà Cattolica 52 (1901), 4:474–85; idem, "Die angebliche Christusreliquien im mittelalterlichen Lateran (Praeputium Domini)," in Römische Quartalschrift 20 (1906): 109–22; idem, "Il 'Sancta Sanctorum' in Roma e il suo tesoro nuovamente aperto," La Civiltà Cattolica 57 (1906), 3:161–76;. idem, Die Römische Kapelle "Sancta Sanctorum" und ihr Schatz (Freiburg, 1908); P. Stanislao Dell'Addolorata, La cappella pontificia del Sancta Sanctorum e i suoi sacri tesori: L'immagine Acheropita e la Scala Santa (Grottaferrata, 1919); C. Cecchelli, "Il Tesoro del Laterano," Dedalo 7 (1926–27): 138–66 (gold- and silverwork, enamels, I), 231–56 (gold- and silverwork, enamels, II), 295–319 (the acheiropoietos), 419–37 (ivories, carved wood); 469–92 (textiles); W. F. Volbach, Il tesoro della Cappella "Sancta Sanctorum," Biblioteca Apostolica Vaticana, Museo Sacro, Guida 4 (Vatican City, 1941); Morello, Il Tesoro del Sancta Sanctorum (1991, cited in n. 18).

24. Volbach, Il tesoro della Cappella "Sancta Sanctorum" (1941, cited in n. 23), 5–21.

25. On the ivories of the Sancta Sanctorum, see the exhaustive discussion found in C.R. Morey, Gli oggetti di avorio e osso del Museo Sacro Vaticano (Vatican City, 1936), passim.

26. On the iconography of this piece, see U. Utro, in Lo Spazio della Sapienza: Santa Sofia a Istanbul, exh. cat., Rimini, 2007, 88–89, no. 2 (with previous bibliography).

27. [W.F. Volbach] Biblioteca Apostolica Vaticana—Museo Sacro, Guide 2: La Croce: Lo sviluppo nell'oreficeria sacra (1938), fig. 1. See also A. Frolow, La reliquie de la Vraie Croix. Recherches sur le dévelopment d'un culte (Paris, 1961), 227–28 (no. 123); T. Jülich, "Gemmenkreuze: Die Farbigkeit ihres Edelsteinbesatzes bis zum 12. Jahrhundert," Aachener Kunstblätter 54/55 (1986–87), 99–258, at 139.

According to John the Deacon (De ecclesia Sancti Laurentii in palatio, ca. 1170, quoted in Lauer, "Le trésor du Sancta Sanctorum" [1906, cited in n. 2], 28–29), the cross contained the relic of Christ's circumcision. Hartmann Grisar ("Die angebliche Christusreliquien" [1906, cited in n. 22]), argued that the belief in the existence of such a relic attests to a later medieval tradition that emerged after the formation of the treasury. For the identification of this relic with the one that later appeared at Calcata (Viterbo), see Franciscus Toletus (Francisco de Toledo), Commentaria in sacrosanctum Jesu Christi D.N. Evangelium secundum Lucam (Venice, 1601), 250; Narrazione critico-storica della reliquia preziosissima del santissimo Prepuzio di N. S. Gesù Cristo che si venera nella chiesa parochiale di Calcata (Rome, 1797), passim.

28. G. Cornini, in U. Utro, ed., San Paolo in Vaticano: La figura e la parola dell'Apostolo delle genti nelle raccolte pontificie, exh. cat., Musei Vaticani (Todi, 2009), 205–6, no. 76 (with previous bibliography).

29. M. Della Valle, in Splendori di Bisanzio, exh. cat., Ravenna, Museo Nazionale (Milan, 1990), 140–41, no. 52; U. Utro, in Dalla terra alle genti: La diffusione del Cristianesimo nei primi secoli, exh. cat., Rimini, Palazzo dell'Arengo e del Podestà, (Milan, 1996), 325–26, no. 250; G. Curzi, in B. Ulianich, ed., La Croce: Dalle origini agli inizi del secolo XVI, exh. cat. Naples, Castel Nuovo (Naples, 2000), 77, no. 1; U. Utro, in A. Donati and G. Gentili, eds., Deomene: L'immagine dell'orante fra Oriente e Occidente, exh. cat., Ravenna, Museo Nazionale (Milan, 2001), 216–17, no. 61.

30. For a catalogue of the textiles in the Vatican collections, see W.F. Volbach, Biblioteca Apostolica Vaticana—Museo Sacro, Cataloghi 3: I tessuti del Museo Sacro Vaticano (Vatican City, 1942).

31. For a discussion of this topic, see V.H. Elbern, s.v. "reliquiari" in Enciclopedia dell'Arte Medievale (Istituto dell'Enciclopedia Italiana, Rome) (Milan, 1998), 892–910, at. 897.

32. Inv. 61881 (reliquary of the True Cross [Enameled Cross of Pope Pascal I]: G. Cornini, in Restituzioni 2004: Tesori d'arte restaurati, exh. cat., Vicenza, Gallerie di Palazzo Leoni Montanari (Cornuda [Treviso], 2004), 92–98, no. 13 (with previous bibliography); idem, in C.G. de Castro Valdés, ed., "Signum Salutis": Cruces de orfebrería de los siglos V al XII, exh. cat., Asturias, Consejería de Cultura y Turismo (Oviedo, 2008), 128–33 (no. 16). Inv. 60985 (silver-gilt staurotheke): Cornini in ibid., 134–38 (no. 17, with previous bibliography). Inv. 61888 (silver-gilt staurotheke): E. Thunø, Image and Relic: Mediating the Sacred in Early Medieval Rome, Analecta Romana Institui Danici, Supp. 32 (Rome, 2002), 53–78 (with previous bibliography).

33. See John the Deacon, De ecclesia Sancti Laurentii in palatio, ca. 1170, quoted in Lauer, "Le trésor du Sancta Sanctorum" (1906, cited in n. 2), 28–29: "In sacro namque palatio est quoddam Sancti Laurentii oratorium, in quo tria sanctissima computantur altaria. Primum in arca cypressina, quam Leo papa III condidit, tres capsae sunt. In una est crux de auro purissimo adornata gemmis et lapidibus pretiosiis, id est hyacintis et smaragdis et prasinis. In media cruce est umbilicus (et preputium Circumcisionis) Domini Nostri Iesu Christi, et desuper est inuncta balsamo, et singulis annis eadem unctio renovatur, quando dominus papa cum cardinalibus facit processionem in Exaltatione Sanctae Crucis, ab ipsa ecclesia Sancti Laurentii in basilicam Salvatoris, quae appellatur constantiniana. Et in alia capsa argentea et deaurata cum historiis est crux de smalto depicta, et infra quam est crux Domini nostri Iesu Christi. Et in tertia capsa, quae est argentea, sunt sandalia, id est calciamenta Domini nostri Iesu Christi" (And in the same holy palace is the oratory of St. Lawrence in which three most holy altars can be found. In the first, a container of cypress commissioned by Leo III, are three caskets. In one of them there is a cross of pure gold adorned with gems and precious stones, i.e., hyacinths and emeralds, and green gemstones; and in the middle of the cross is the navel of the Lord and his foreskin; and above it is anointed with balm, and each year this balm is renewed when the pope with the cardinals makes the procession of the Exaltation of the Cross from the same Church of St. Lawrence to the Basilica of Our Savior, also referred to as 'Constantiniana.' And in the other silver casket, gilded and adorned with scenes, is a cross of enamel, and within it is the Cross of our Lord Jesus Christ. And in the third casket, which is made of silver, are the sandals or footwear of our Lord Jesus Christ.) Further references in the Liber Pontificalis (ed. Duchesne, [cited in n. 7] 1:374 n. 162) mention the silk pillow ("plumacium ex holosirico") attached to one of the crosses.

34. G. Cornini, in F. Bisconti and G. Gentili, ed., La rivoluzione dell'immagine: Arte paleocristiana tra Roma e Bisanzio, exh. cat., Vicenza, Gallerie di Palazzo Montanari (Cinisello Balsamo [Milan], 2007), 186–87, no. 44, 190–91, no. 45; G. Cornini, in R. Cormack and M. Vassilaki, Byzantium, 330–1453, exh. cat., London, Royal Academy of Arts (London, 2008), 389, no. 48 (with previous bibliography).

35. G. Cornini, in Cormack and Vassiliki, Byzantium (cited in n. 34), 441–42, no. 244 (with previous bibliography).

36. U. Utro, in Restituzioni 2004: Tesori d'arte restaurati, exh. cat., Vicenza, Gallerie di Palazzo Leoni Montanari (Cornuda [Treviso], 2004), 107–11, no. 16 (with previous bibliography).

37. G. Cornini in Restituzioni 2004 (cited in n. 36), 102–6, no. 15 (with previous bibliography).

38. U. Utro, in Restituzioni 2004 (cited in n. 36), 112–15, no. 17 (with previous bibliography).

39. G. Cornini in Restituzioni 2004 (cited in n. 36), 136–38, no. 23 (with previous bibliography).

40. Liber Pontificalis, ed. Duchesne (cited in n. 7), 1:374 n. 162.

41. G.B. de Rossi, Inscriptiones Christianae Urbis Romae, 2 (Rome, 1888), 34–35; see Ordo Romanus xxiii, in M. Andrieu, Les Ordines Romain du Haut Moyen-Âge 3: Textes, Ordines xiv–xxxiv (Louvain, 1951), 265–73; S. de Blaauw, Cultus et Decor: Liturgia e architettura nella Roma tardoantica e medievale, Studi e Testi 355, 2 vols. (Vatican City, 1994), 1:186–89; L. van Tongeren, "A Sign of Resurrection on Good Friday. The Role of the People in the Good Friday Liturgy until 1000 AD and the Meaning of the Cross," in C. Caspers and M. Schneiders, eds., Omnes circumadstantes: Contributions towards a History of the Role of the People in the Liturgy (Kampen, 1990), 101–20. Grease residues from the liturgical oiling of the objects have been found on both the gemmed and the enameled crosses. See H. Grisar, Il "Sancta Sanctorum" ed il suo Tesoro Sacro (1907, cited in n. 8), 115–16, 118–22.

42. Benedictus Canonicus, *Ordo Romanus XI*, in J. Mabillon, *Museum Italicum seu collectio veterum scriptorum ex bibliothecis italicis eruta* (1687–89), 2:152; see Cencius Camerarius, *Ordo Romanus XII*, in Mabillon, *Museum Italicum*, 2:209–10; on the topic, see also A. Chavasse, *Le sacramentaire gélasien (Vaticanus Reginensis 316): Sacramentaire présbyterial en usage dans les titres romains au VIIIe siècle* (Tournai, 1958), 358–60; P. Jounel, "Le cult de la croix dans la liturgie romaine," *La Maison-Dieu* 75 (1963): 68–91; Blaauw, *Cultus et Decor* (1994, cited in n. 41) 1:197. For the relationship with Constantinople, see B. Flusin, "Le cérémonies de l'Exaltation de la Croix à Constantinople au XIe siècle d'aprés le 'Dresdensis A 104,'" in J. Durand and B. Flusin, eds., *Byzance et les Reliques du Christ* (Paris, 2004), 61–89.

43. Exod. 26:31–33, 29:37, 30:10, 30:29, 40:10; Lev. 24:9; Num. 4:4, 4:19; 1 Kings 6, 19.

44. O. Nussbaum, "Sancta Sanctorum," *Römische Quartalschrift* 54 (1959): 234–36.

45. The tradition according to which St. Peter himself would have said Mass on the wooden table top encapsulated in the high altar of the Lateran Basilica (so that, in the following centuries, such a privilege would have been retained by his successors), was first established by Bonizo, bishop of Sutri, between 1076 and 1086, but is probably older. Bonizo Sutrinensis [Bonizo di Sutri], *Liber de vita christiana*, in E. Perels, ed., *Texte zur Geschichte des römischen und kanonischen Rechts im Mittelalter* (Berlin, 1930), 164–65; see S. de Blaauw, "The Solitary Celebration of the Supreme Pontiff: The Lateran Basilica as the New Temple in the Medieval Liturgy of Maundy Thursday," in Caspers and Schneiders, *Omnes circumadstantes* (cited in n. 41), 120–28. It is precisely following this tradition that Pope Sylvester I (r. 314–35) had decreed that no altar other than that in the Lateran could be made of wood. J. Braun, *Das christliche Altargerät in seinem Sein und in seiner Entwicklung* (Munich, 1932), 1:58. Since the authority of the Roman cathedral proceeded from its connection with Peter, even Leo III's wooden chest in the treasure might have been regarded as part of this line of tradition. Thunø, *Image and Relic* (2002, cited in n. 32), 160–66; see also U. Peschlow, "Altar und Reliquie: Form und Nutzung des Frühbyzantinischen Reliquienaltars in Konstantinopel," in M. Altripp and C. Nauerth, eds., *Architektur und Liturgie: Akten des Kolloquiums vom 25. bis 27. Juli in Greifswald* (Wiesbaden, 2006), 175–202, tav. 22–29.

46. T.F.X. Noble, "Topography, Celebration and Power: the Making of Papal Rome in the Eighth and Ninth Century," in M. de Jong et al., eds., *Topographies of Power in the Early Middle Ages* (Leiden, 2001), 68–72.

47. *Acheiropoieton*, in its primary meaning of "authentic portrait," was held to be an image "not painted by human hands" and "capable of performing miracles," having come into being "either through divine intervention or by means of direct contact with the body of the archetype." Thunø, *Image and Relic* (2002, cited in n. 32), 15. The first references to *acheiropoieton* images come from the East, where the term was applied to images of Christ such as the Holy Face of Kamuliana or the Mandylion of Edessa, important venerated icons in Byzantine history. E. von Dobschütz, *Christusbilder: Untersuchungen zur christlichen Legende*, Texte und Untersuchungen zur Geschichte der altchristlichen Literatur 18, 3 vols. (Leipzig 1899), 1:61ff; J. Wilpert, "L'Acheropita ossia l'immagine del Salvatore nella Cappella del 'Sancta Sanctorum,'" *L'Arte* 10 (1907): 162–77, 248–62; Dell'Addolorata, *La cappella pontificia del Sancta Sanctorum* (1919, cited in n. 33), 54–55; Cecchelli, "Il Tesoro del Laterano" (1926–27, cited in n. 23), 295–319; M. Andaloro, "Il 'Liber Pontificalis' e la questione delle immagini da Sergio

I a ad Adriano I," in *Roma e l'età carolingia* (Rome, 1976), 69–77. The term *acheiropoieton* could also be used in its broader sense to indicate an image of great veneration and holiness, which was treated as a "heavenly object." Grisar, *Il 'Sancta Sanctorum' ed il suo Tesoro Sacro* (1907, cited in n. 8), 53. Medieval tradition held there were at least five *acheiropoieton* "portraits" of Christ, spread over an area covering Byzantium, its empire, and the ancient Roman world. Dobschütz, *Christusbilder*, 1:40–60 and passim; see also H. Belting, *Bild und Kult: Eine Geschichte des Bildes vor dem Zeitalter der Kunst* (Munich, 1990), 49–87; G. Wolf, *Salus Populi Romani: Die Geschichte römischer Kultbilder im Mittelalter* (Weinheim, 1990), 60–68.

48. "Super hoc altare, [primum] est imago Salvatoris mirabiliter depicta in quadam tabula, quam Luca evangelista designavit sed virtus Domini angelico perfecit officio." John the Deacon, *De ecclesia Sancti Laurentii in palatio*, ca. 1170, quoted in Lauer, "Le trésor du Sancta Sanctorum" (1906, cited in n. 2), 28–29. On the Lateran panel, see in particular, Marangoni, *Istoria dell'antichissimo Oratorio o Cappella* (1747, cited in n. 8), 73–76; Dobschütz, *Christusbilder* (1899, cited in n. 47), 1:61ff ; Wilpert, "L'Acheropita" (1907, cited in n. 52), 162–77, 248–62; Stanislao Dell'Addolorata, *La cappella pontificia del Sancta Sanctorum* (1919, cited in n. 23), 54–55; Cecchelli, "Il Tesoro del Laterano," (1926–27, cited in n. 23), 295–319; Andaloro, "Il 'Liber Pontificalis'" (1976, cited in n. 47); H. Belting, "Icons and Roman Society in the Twelfth Century," in W. Tronzo, ed., *Italian Church Decoration of the Middle Ages and Early Renaissance. Functions, Forms, and Regional Traditions* (Bologna, 1989), 27–41. Belting, *Bild und Kunst* (1990, cited in n. 47), 78–79; Wolf, *Salus Populi Romani* (1990, cited in n. 47), 37–44; Andaloro, "L'Acheropita" (1991, cited in n. 4); S. Romano, "L'acheropita lateranense: Storia e funzione," and M. Andaloro, "L'Acheropita in ombra," in G. Morello and G. Wolf, *Il Volto di Cristo*, exh. cat., Rome, Palazzo delle Esposizioni (Milan, 2000), 39–42, 43–45; M. Bacci, "Vera croce, vero ritratto e vera misura," in J. Durand and B. Flusin, eds., *Byzance et les reliques du Christ: XXe Congrès International des Études Byzantines* (Paris, 2004), 223–38; and K. Noreen, "Revealing the Sacred: The Icon of Christ in the 'Sancta Sanctorum,'" in M. Bagnoli and P.W. Parshall, eds., *The Language of the Object: Essays in Honour of H.L. Kessler* (London, 2006), 228–37. On the legend of St. Luke as a painter, see M. Bacci, "San Luca: il pittore dei pittori," in E. Castelnuovo and M. Bacci, eds., *'Artifex bonus': Il mondo dell'artista medievale* (Rome, 2004), 3–11. (with previous bibliography); on the iconography of this particular theme, A. Eörsi, "The Incarnation of the Word and the Form: Some Thoughts about St. Luke the Painter, and about Some Painters of St. Luke," in *Acta Historiae Artium* 44 (2003): 47–57; C.M. Boeckl, "The Legend of St. Luke: Eastern and Western Iconography," *Wiener Jahrbuch für Kunstgeschichte* 54 (2005 [2007]): 7–37.

49. W. Angelelli, "La diffusione dell'immagine lateranense: Le repliche del Salvatore nel Lazio," in Morello and Wolf, eds., *Il Volto di Cristo* (2000, cited in n. 48), 46–49, at 46. H.L. Kessler and J. Zacharias, *Rome 1300: On the Path of the Pilgrim* (New Haven, 2000). 61–63 (with previous bibliography).

50. The "Veronica" (*Vera Icon* [True Icon] of the Son of God) was another image of alleged supernatural origin, thought to keep a record of Christ's own appearance, as impressed on a cloth handed over to him by a woman with this particular name, yearning for a portrait of her Divine Master (or, in a different version, pressing her handkerchief against Christ's own face to wipe out his sweat on the way to the Calvary). During the first half of the second millennium, the relic became immensely popular among the northern countries of Europe, attracting huge masses of pilgrims to the See

of St. Peter and shaping their own view of Christ's historical appearance, through the influence exerted by the picture on writers and artists. Until as late as 1606, the image was kept in the Vatican, in a tabernacle or ciborium built by John VII (r. 705–7) by the oratory of Sta. Maria ad Praesepe, to the northern entrance of St. Peter's, and enlarged by Celestinus III in 1191. Petrus Mallius, 1160, in von Dobschütz, *Christusbilder* (1899, cited in n. 47), 1:285*; see also G. Grimaldi, *Descrizione della Basilica antica di San Pietro in Vaticano: Cod. Barberini Lat. 2733* [Rome, 1606], ed. R. Niggl (Vatican City, 1972), c. 92r. Mallius calls the chapel *Veronica*, and the relic itself *sudarium Christi* (Christ's shroud). It is not clear whether the picture mentioned by the sources survived the sack of 1527 (when Rome was put to fire by the imperial troops and its religious heritage dispersed) and whether the image presently kept in the loggia of the corresponding pillar, under the dome of the modern basilica, actually coincides with the ancient "reliquia." On the topic, see R. Suckale, "Arma Christi: Überlegungen zur Zeitenhaftigkeit mittelalterlicher Andachtsbilder," *Stadel-Jahrbuch* 6 (1977 [1978]): 107–208; H. Belting, *Das Bild und sein Publikum im Mittelalter* (Berlin, 1981); H. Pfeiffer, "L'immagine simbolica del pellegrinaggio a Roma: la Veronica e il volto di Cristo" and "L'iconografia della Veronica," in M. Fagiolo and M.L. Madonna, eds., *Roma 1300–1875: L'arte degli anni santi*, exh. cat., Rome, Palazzo Venezia (Milan, 1984), 106–12, 113–19; S. Lewis, "The 'Veronica': Image, Legend and Viewer, in England in the Thirteenth Century," in *Proceedings of the 1984 Harlaxton Symposium*, (Nottingham, 1985), 100–106; I. Ragusa, "Mandylion-Sudarium: The Translation of a Byzantine Relic to Rome," *Arte Medievale*, 2nd ser., 5, no. 2 (1989): 97–106; idem, "The Iconography of the Abgar Cycle in Paris. MS. Lat. 2688 and Its Relationship to Byzantine Cycles," *Miniatura* 2 (1989): 35–52; Belting, *Bild und Kult* (1990, cited in n. 47); W. Bulst and H.W. Pfeiffer, *Das Turiner Grabtuch und das Christusbild*, 1: *Das Grabtuch: Forschungen und Untersuchungen*, and 2: *Das Echte Christusbild* (Frankfurt-am-Main 1991); G. Morello, "La Veronica nostra," in *La Storia dei Giubilei*, vol. 1: 1300–1423, ed. G. Fossi (Florence, 1997): 160–67; H.L. Kessler, "Configuring the Invisible by Copying the Holy Face," G. Wolf, "From Mandylion to Veronica: Picturing the 'Disembodied' Face and Disseminating the True Image of Christ in the Latin West," and C. Egger, "Papst Innocenz III. und die Veronika: Geschichte, Theologie, Liturgie und Seelsorge," in H.L. Kessler and G. Wolf, eds., *The Holy Face and the Paradox of Representation*, Villa Spelman Colloquia, 6 (Bologna, 1998), 129–51, 153–179, and 181–203, respectively; M. D'Onofrio, ed., *Romei e Giubilei: Il pellegrinaggio medievale a San Pietro (350–1350)*, exh. cat., Rome: Museo di Palazzo Venezia (Milan, 1999); G. Wolf, "La vedova di re Abgar: Uno sguardo comparatistico al Mandylion e alla Veronica," in J.-M. Sansterre and J.-C. Schmidt, eds., *Les images dans les sociétés médiévales: Pour une histoire comparée*, Bulletin de l'Institut Historique Belge de Rome, 69 (Brussels and Rome, 1999), 215–43; G. Finaldi, ed., *The Image of Christ*, exh. cat., London: National Gallery (London, 2000); G. Morello and G. Wolf, eds., *Il Volto di Cristo*, exh. cat., Rome: Palazzo delle Esposizioni (Milan, 2000); M. Büchsel, *Die Entstehung des Christusporträts* (Mainz, 2003); G. Wolf et al., eds., *Mandylion: Intorno al "Sacro Volto" da Bisanzio a Genova*, exh. cat., Genoa: Museo Diocesano (Milan, 2004), 209–35; R. Krischel et al., eds., *Ansichten Christi: Christusbilder von der Antike bis zum 20. Jahrhundert*, exh. cat., Cologne: Wallraf-Richartz-Museum–Fondation Corboud (Cologne, 2005).

51. In given circumstances and places, emperors could be represented by their own portraits, when *force majeure* prevented their presence or participation in specific events. In all such cases, portraits were given the honors of the sitter himself, thus blurring the line of demarcation between image and archetype.

52. H. Belting, "Gli inizi," in Morello and Wolf, eds., *Il Volto di Cristo* (2000, cited in n. 51), 25–27.

53. Ibid., 27

54. Georgius Hamartolòs (Georgius Monachus), PG 110:381–84, 917–21; see G. Marangoni, *Istoria dell'antichissimo Oratorio o Cappella di San Lorenzo nel Patriarchio Lateranense, comunemente appellato Sancta Sanctorum* (Rome, 1747 [1802, 1861]), 73–75.

55. F. de Mély, "L'image du Christ du 'Sancta Sanctorum' et les reliques chrétiennes apportés par les flots," *Mémoires de la Societé Nationale des Antiquaires de France* 63 (1904): 1–32. The hypothesis of the panel's Byzantine origin is discussed by M. Cempanari, *Sancta Sanctorum Lateranense: Il Santuario della Scala Santa dalle origini ai nostri giorni*, 2 vols. (Rome, 2003), 1:127–43; Andaloro (*L'Acheropita in ombra* [2000, cited in n. 48], 43–45), points to a possible origin from Jerusalem (on which, see also E. Parlato, "Le icone in processione," in M. Andaloro and S. Romano, eds., *Arte e Iconografia a Roma dal Tardoantico alla fine del Medioevo* [Milan, 2002], 64–68). The deteriorated condition of the image makes it impossible to discern the painting's geographical provenance, which Wilpert assigned to the "Latin or, better said, Roman" area, between the end of the fifth and the beginning of the sixth century. Wilpert, "L'Acheropita" (1907, cited in n. 52), 162–77, 248–62; see also F. Persegati, *Relazione [Acheropita: tavola e cornice]*, 1996, Musei Vaticani, Archivio Laboratorio Restauro Pitture: M.Cempanari, *Sancta Sanctorum Lateranense: Il Santuario della Scala Santa dalle origini ai nostri giorni*, 2 vols. (Rome, 2003), 2:718–26. An analysis of the diffusion of similar images in the territory of Latium around Rome argues favorably for a dating between the sixth and seventh centuries (Thunø, *Image and Relic* [2002, cited in n. 33]). On this particular subject, see also W. F. Volbach, "Il Cristo di Sutri e le venerazione del SS. Salvatore nel Lazio," *Rendiconti della Pontificia Accademia Romana di Archeologia* 17 (1940–41): 97–126; Angelelli, "La diffusione dell'immagine lateranense" (2000, cited in n. 49); Parlato, "Le icone in processione" (2002, cited above, this note).

56. Nicephorus Constantinopolitanus (Nikephoros of Constantinople), *Antirrhetikos adv. Eusebium et Epiphanidem*, ed. J. B. Pitra, in *Spicilegium Solesmense*, IV (Paris 1858), 332–34; see also PG 100:200; P. O'Connell, "The Ecclesiology of St. Nicephorus I (758–828)," *Orientalia Christiana Analecta* 194 (1972): 190–93. On the use of images in the iconoclastic controversy, see H. L. Kessler, *Iconoclastia*, in *Enciclopedia dell'Arte Medievale* (Milan, 1996), 7:276–82 (with previous bibliography). On the development of *acheiropieton* images into relics, see L. Brubaker and R. Ousterhout, eds., *The Sacred Image: East and the West* (Urbana and Chicago, 1995); K. C. Innemèe, "Some Notes on Icons and Relics," in D. Mouriki, ed., *Byzantine East, Latin West: Art-Historical Studies in Honor of Kurt Weitzmann* (Princeton, 1995), 519–22; E. Thunø, "The Cult of the Virgin, Icons and Relics in Early Medieval Rome: a Semiotic Approach," in *Rome, AD 300–800: Power and Symbol, Image and Reality*, Acta ad Archeologiam et Artium Historiam Pertinentia, new ser. 3 (Rome, 2003), 79–98; S. J. Cornelison, "When an Image Is a Relic," in S. J. Cornelison and S. B. Montgomery, eds., *Images, Relics, and Devotional Practises in Medieval and Renaissance Italy* (Tempe, Ariz., 2006), 95–113; J. Wirth, "Immagine e reliquia nel Cristianesimo occidentale," in F. Franchi and G. Bottiroli, eds., *L'immaginario degli oggetti* (Milan, 2007), 19–33.

57. See the *Liber Pontificalis*, ed. Duchesne (cited in n. 7), 1:443, describing the icon as the "imago Domini Dei et Salvatoris Nostri Iesu Christi, quae acheropsita nuncupatur" (the image of Our Lord and Saviour Jesus Christ, that is called *acheropsita*).

58. Andaloro, "L'Acheropita" (1991, cited in n. 4), 81. On this topic, see also E. Kitzinger, "The Cult of Images in the Age before Iconoclasm," *DOP* 8 (1954): 83–149, repr. in Kitzinger, *The Art of Byzantium and the Medieval West* (Bloomington, 1976), 90–156); S. Mergiali-Sahas, "Byzantine Emperors and Holy Relics: Use and Misuse of Sanctity and Authority," in *JÖB* 51 (2001): 41–60.

59. The procession was instituted by Sergius I (r. 687–700). during the last years of his pontificate; Leo IV (r. 847–55) perfected its liturgy. The festival took place each year as a renowned midsummer event, attracting crowds from all over Europe, until Pius V (r. 1566–72) had it suppressed in 1566. On the celebration of the feast throughout the Middle Ages, see Parlato, "Le icone in processione" (2002, cited in n. 55) (with previous bibliography); on the subject of its posthumous iconography, see idem, "La storia 'postuma' della processione dell'Acheropita e gli affreschi secentesachi della Confraternita del Salvatore 'ad Sancta Sanctorum,'" in M. A. Visceglia, ed., *Diplomazia e politica dalla Spagna a Roma: Figure di ambasciatori*, Università degli Studi Roma Tre/Roma moderna e contemporanea, 15.2007 (Rome, 2008), 327–55.

60. See E. Parlato, "La processione di Ferragosto e l'Acheropita del 'Sancta Sanctorum,'" in Morello and Wolf, eds., *Il Volto di Cristo* (2000, cited in n. 48), 51.

61. On the Virgin Hodegetria of Sta. Maria Maggiore, also attributed to St. Luke and considered a protector of the city by the Romans, see P. Bombelli, *Raccolta delle Immagini della Beata Vergine ornate della corona d'oro dal Rev. Cap. di San Pietro* (Rome, 1792), 4:81–90; P. Amato, ed., *De vera effigie Mariae: Antiche Icone Romane*, exh. cat., Rome: Basilica di Sta. Maria Maggiore (Milan and Rome, 1988), 51–60; Wolf, *Salus Populi Romani* (1990, cited in n. 47), passim.

62. Grisar, *Il 'Sancta Sanctorum' ed il suo Tesoro Sacro* (1907, cited in n. 8), 56; see J. Mabillon, *Comment. in ord. rom.*, in PL 78:868. The poem has been published by M. Andrieu in *Ordo Romanus* 50 (1961): 358, and by C. Vogel and R. Elze, *Le pontifical romano-germanique du dixième siècle* (Vatican City, 1963–72), 2:138–40.

63. *Liber Pontificalis*, ed. Duchesne (cited in n. 7), 2:110.

64. Basil was the "herb of kings," therefore associated with the Majesty of Christ. Parlato, "La processione di Ferragosto" (2000, cited in n. 60), 51. Wolf (*Salus Populi Romani* [1990, cited in n. 47], 54), relates the use of the plant to the monster (*basiliscus*) that according to legend inhabited the area of the Church of Sta. Lucia in Orphea (later Sta. Maria dei Selci), freed by the passage of the icon in the procession of 847. See M. Armellini and C. Cecchelli, *Le chiese di Roma* (Rome, 1942), 273–74.

65. Romano, "L'acheropita lateranense" (2000, cited in n. 48), 39. Variants of the rites in the procession are reported in the *Ordines romani* by Benedictus Canonicus (ca. 1143) (PL 78:1025–63) and Cencius Camerarius (ca. 1192) (PL 78:1025, 1063–1106).

66. E. Bozóky, *La politique des relics de Constantine à Saint Louis: protection collective et légitimation du pouvoir* (Paris, 2007), passim; see also Parlato, "La processione di Ferragosto" (2000, cited in n. 60), 51–52.

67. Gervasius Tilburiensis (Gervase of Tilbury), *Otia Imperialia* (1212–14), in G. W. Leibnitz, ed., *Scriptores Rerum Brunsvicensium*, 4 vols. (Hannover, 1707–11), 1:881–1004, at 968.

68. Giraldus Cambrensis (Girald of Wales), *Speculum Ecclesiae* (ca. 1220), in J. S. Brewer, ed., *Giraldi Cambrensis Opera* (*Rerum Britannicarum Medi Aevi Scriptores*, 21), 7 vols. (London, 1861–91), 4:3–354, at 278–79.

69. Andaloro, "L'Acheropita" (1990, cited in n. 4).

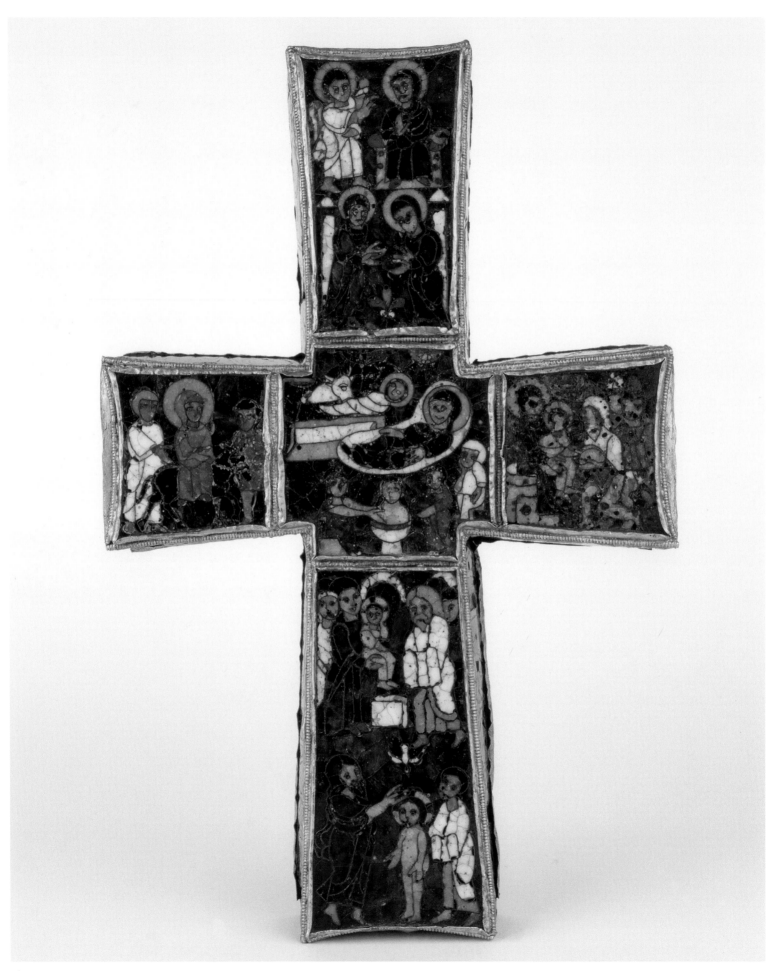

36
Reliquary of the True Cross (Enameled Cross of Pope Paschal I)

Rome or Syria/Palestine, first quarter of the 9th century
Copper gilt (engraved and embossed), enamel (cloisonné);
27 × 17.8 × 3.5
Museo Sacro, Musei Vaticani (61881)
London only

INSCRIBED: (after C.R. Morey 1937): ACCI / PE QUAES / O A DO / MINA MEA R / EGINA MVNDI H / OC VE / XILLUM CRVCIS / QUAOD / TIBI PAS / CHALIS / EPISCOPVS OPTULIT (I beseech you, my sovereign, Queen of the World, to accept this sign of the cross that is offered to you by Bishop Paschal)

PROVENANCE: Treasury of the Sancta Sanctorum; transferred in 1905 to the Museo Cristiano of the Vatican Library; transferred to the Vatican Museums pursuant to the rescript of Pope John Paul II, 1999

BIBLIOGRAPHY: Lauer 1906, 40–49; Grisar 1908, 62–69; Morey 1937; Stohlmann 1939, 47–48; Matt 1969, 172–73; Morello 1991, 90–105; Cleveland 1998, 35–36; Thunø 2002, 25–51; G. Cornini in Vicenza 2004, 92–98, no. 13 (with bibliography); G. Cornini in Asturias 2008, 128–33, no. 16 (with bibliography)

The Cross of Pope Pascal I is part of the relics treasure of the Sancta Sanctorum (see Cornini herein, pp. 69–78). The reliquary is a cross-shaped box; its lid, made of gilded copper, is decorated with five cloisonné enamels: four are trapezoids; the central enamel resembles a cross with short arms. The body of the box is decorated on the sides with enamels bearing Latin inscriptions; the back is decorated with a cross in repoussé. The interior is divided into five compartments.

Cross-shaped reliquaries appear very early in Christian art, but only rarely are they so large. Most often they are small *enkolpia*—portable crosses with relics chambers; occasionally they take the form of large processional or altar crosses. The size of the Santa Sanctorum reliquary suggests an official function, probably for a restricted circle of dignitaries of the pontifical court.

The reliquary's style and date have been the subject of extensive debate, but the enamels have long been one of its more perplexing features. Curiously, the scenes depicted are those of the Infancy of Christ rather than those of the Passion. Starting from the top, these are the Annunciation and the Visitation; on the horizontal arm of the reliquary: the journey to Jerusalem and the Nativity; at the center, the Adoration of the Magi; the Presentation and the Baptism of Christ conclude the cycle in the bottom half of the cross's vertical arm. Some scholars have argued that the enamels have a

Palestinian (specifically, Syrian) origin, while others have suggested that the cross was made by a Roman workshop heavily influenced by near Eastern art, or by an artist from the Near East working in Italy.

The closest stylistic parallel is with the Fieschi Morgan Staurotheke (cat. no. 37). Iconographic features that recall the Apocryphal Gospels would confirm this theory of its origins, although such texts and their iconographical renderings were known in Rome as well.

The enameled inscription, in red on a green background, is in a Latin uncial script. The changes made to the reliquary over the centuries have made the text difficult to read. The *Paschalis episcopus* named in the inscription is very likely Pope Paschal I (r. 817–24), who was an important patron of the arts during his brief reign. Notable among his commissions are the basilicas of Sta. Prassede, Sta. Cecilia, and San Marco in Rome, all lavishly decorated with mosaics, their narrative programs modeled on early Christian examples in Ravenna and Rome.

Paschal's desire to emulate early Christian art might explain the archaizing style of the reliquary's enamels, while dating it to the first quarter of the ninth century. It is also possible, however, that some elements of the cross—notably the enamels—date earlier than the reliquary itself and were purposefully reused (Morello 1991, Vicenza 2004). The use of Late Antique elements would accord with Paschal's artistic agenda and, like the mosaics mentioned above, could be understood as a polemic against Byzantine iconoclasm. / CP

37
Reliquary of the True Cross

Byzantine (Constantinople?), 9th century (possibly second quarter)
Gold, silver, silver gilt, enamel (cloisonné), niello
Overall (with lid) 2.7 × 10.3 × 7.1 cm
The Metropolitan Museum of Art, New York, gift of J. Pierpont Morgan, 1917 (17.190.715a, b)
Cleveland and Baltimore

INSCRIBED: (after T. Matthews in New York 1997) at the center top, in the titulus: IC (Jesus); at either side of Christ's head: ΙΔΙ Ω ΥΟC COY · ΙΔΟΥ Η ΜΙΤΙΡ C (Here is your son. . . . Here is your mother [John 19:26–27]); alongside the Virgin: ΘΕΟΤΩΚC (Mother of God); alongside John: ΗΩΑΝΙC (John); on the border, clockwise from upper left: Ο ΑΓΙΟC ΔΗΜΙΤΡΙΟC · Ο ΑΓΙΟC ΕΥCΤΑΘΙΟC · Ο ΑΓΙΟC ΛΑΥΡΕΝΤΙΟC · ΛΟΥΚΑC · ΜΑΡΚΟC · ΘΩΜΑC · ΙΑΚΟΒΟC · Ο ΑΓΙΟC ΔΑΜΙΑΝΟC · Ο ΑΓΙΟC ΚΟCΜΑC · Ο ΑΓΙΟC ΓΡΙΓΟΡΙΟC ΜΘΑΛ · ΒΑΡΘΟΛΟΜΕΟ · ΙΟΥΔΑC · CΗΜΩΝ (St. Demetrios, St. Eustathios, St. Lawrence, Luke, Mark, Thomas, James, St. Damian, St. Kosmas, St. Gregory the Miracle-Worker, Bartholomew, Matthew, Jude, Simon); around the sides, clockwise from upper left: Ο ΑΓΙΟC ΑΝΑCΤΑCΙΟC · Ο ΑΓΙΟC ΝΙΚΟΛΑΟC · Ο ΑΓΙΟC ΠΛΑΤΩΝ · Ο ΑΓΙΟC ΘΕΟΔΟΡΟC · Ο ΑΓΙΟC ΠΡΟΚΟΠΙΟC · Ο ΑΓΙΟC ΓΕΩΡΓΙΩC · Ο ΑΓΙΟC ΜΕΡΚΟΥΡΙΟC · Ο ΑΓΙΟC ΕΥΤΡΑΤΗΩC · Ο ΑΓΙΟC ΠΑΝΤΕΛΕΣΥΜΩΝ · Ο ΑΓΙΟC ΑΝΔΡΕΑ · Ο ΑΓΙΟC ΙΩΑΝΙC · Ο ΑΓΙΟC ΠΑΥΛΟC · Ο ΑΓΙΟC ΠΕΤΡΟC (St. Anastasios, St. Nicholas, St. Platon, St. Theodore, St. Prokopios, St. George, St. Merkourios, St. Eustratios, St. Panteleimon, St. Andrew, St. John, St. Paul, St. Peter); inside the lid: ΧΑΙΡΕC ΧΑΡΙΤΟΜ (Hail, full of grace [Luke 1:28]), Η ΓΕΝΑ (The Nativity), ΙΔΕ Ο ΥΟC COY · ΙΔΟΥ Η ΜΗΡ CP (Here is your son. . . . Here is your mother [John 19:26–27])

PROVENANCE: purportedly Pope Innocent IV (Sinibaldo Fieschi, wr. 1243–54) and descendants; Baron Albert Oppenheim, Cologne (until 1904); Jacques Seligmann, Paris and New York (until 1906); J. Pierpont Morgan, London and New York (1906–17)

BIBLIOGRAPHY: Bock 1986, 175; Rosenberg 1921, 31–38; Frolow 1961b, 320–27, fig. 3; Palli 1962, 250–67, pls. 17a, 186; Wessel 1967, 44–46, no. 5; New York 1979 [1977], 634–36, no. 574; New York 1997, 74–75, no. 34; Hildesheim 1998, 48–51 figs. 38, 39a–c, 155, no. 18; London 2008, 102, 390–91

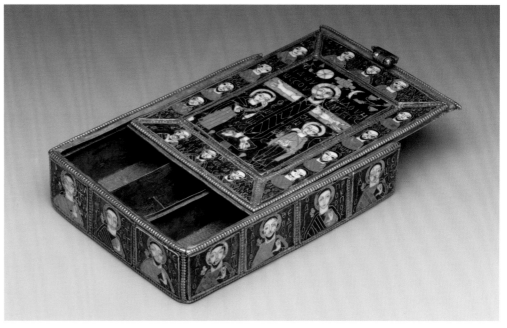

37

According to legend, it was Helena, the mother of the emperor Constantine, the first Christian Roman emperor, who initiated the successful search to find the cross on which Jesus had been crucified. This is one of the earliest ensuing examples of a precious container for relics of the True Cross to have survived. The lid, on which the Crucifixion is represented in cloisonné enamel, slides open to allow access to the gilded interior, which is fitted with compartments in the shape of a double-arm cross.

The underside of the lid presents four scenes from the life of Christ, realized in niello in a style that is surprisingly distinct from the enamel but common to a number of surviving works of art, notably cross pendants (see cat. no. 32). The elongated figures of the Annunciation, the Nativity, the Crucifixion, and the Anastasis have a sketchlike, summary quality. Attempts to localize and date the reliquary have historically focused in particular on the scene of the Anastasis (or Harrowing of Hell). While Marc Rosenberg advocated an early date, a hypothesis followed by M. E. Frazer, Anatole Frolow argued that the subject indicated a date after the end of Iconoclasm, and it has been recognized subsequent to the work of Anna Kartsonis to be an image that developed in Constantinople around 800. A ninth-century date places the reliquary logically in the succession of early enamelwork as well.

Twenty-seven busts of saints frame the lid and the sides. Identified by inscriptions in Greek, they include apostles and saints, predominantly those venerated in the Eastern Church. On the lid, reading clockwise from the upper left, are Demetrios, Eustathios, Lawrence; Luke, Mark, Thomas and James; Damian, Cosmas, Gregory Thaumaturgos (the three healing saints in red); Bartholomew, Matthew, Jude, and Simon. On the sides, moving clockwise from upper left on either side of the lock are Anastasios and Nicholas; then, continuing clockwise to the panel of four: George, Prokopios, Theodore, Platon; then on the opposite short end, Mercurios, Eustratios, Panteleimon; and finally on the fourth side, Andrew, John, Paul, and Peter (the last two in red robes).

At the bottom of the lid are three healers and wonderworkers, in the company of apostles and evangelists: Cosmas, Damian (each of whom has a small pyramidal object at his chest, identified by Frazer as a box for medicines) Gregory Thaumatourgos. All are robed in red, and Gregory wears an *omophorion*. Gregory, as a number of other saints, appears with a small green enameled square at his chest, presumed to represent a book. At the top of the lid are Sts. Demetrios and Eustathios, both soldiers, but not distinguished as such, joined by

St. Lawrence. As the unique deacon saint, his appearance seems anomalous, but perhaps he is to be thought of with the three healers and wonderworkers beneath. Two bishop saints, Anastasios and Nicholas, flank the lock plate. On the opposite short side are Sts. Panteleimon, Eustathios and Mercurios, all military saints.

The program of saints is an issue that has not otherwise garnered much attention. Even if we cannot discern the program that underlies the choice of saints entirely, two other saints' identity may be worth considering: Platon and Theodore. Platon may be the third-century martyr of Ancyra, as Frazer inferred, and among the numerous saints named Theodore, Frazer identified him as a soldier saint. Might Platon and Theodore, represented side by side, be the Platon and his sainted nephew Theodore, both renowned for their defense of icons, who were both resident at the Studion Monastery in Constantinople? St. Platon died in 813; Theodore in 826, with his relics transferred to Constantinople in 845. / BDB

38
Reliquary of the Holy Nail

Ottonian (Trier), before 975
Gold (filigree), enamel, precious stones, engraved gems, glass
Length 21.4 cm
Trierer Dom, Domschatz
London only

PROVENANCE: Attested in the treasury of Trier Cathedral since the tenth century

BIBLIOGRAPHY: Kraus 1868; Westermann-Angerhausen 1973, 32–34; Ronig 1993, 168; Westermann-Angerhausen 1990; Magdeburg 2001, 2:286–88, no. IV.69

Because the form of this small reliquary imitates the shape of the relic it contains, namely one of the nails that was believed to have affixed Christ's body to the Cross, it has often been categorized as one

of the earliest "speaking reliquaries"—that is, a reliquary that visually describes its content; such reliquaries became widespread in Western Europe only during the late eleventh and early twelfth centuries with the rise of body-part reliquaries (see Hahn herein, pp. 163–72, and cat. nos. 104–12).

Made to contain one of the most important relics of Christ's Passion, the reliquary was sumptuously decorated with gold filigree, translucent green and blue cloisonné enamels, precious stones, gems, and cut glass. When exactly the object was executed, however, is difficult to determine. On account of the "effortlessness" of its overall composition and the high quality of its cloisonné enamel decoration, the reliquary was long considered to be the most refined work of the so-called Egbert workshop—an atelier of goldsmiths active in Trier during the last quarter of the tenth century—known to have produced a number of exquisite reliquaries for Archbishop Egbert of Trier (r. 977–93), a powerful ecclesiastical leader and prominent patron of deluxe manuscripts and precious liturgical objects. More recently, however, it has been pointed out that the colors and the internal decorative structure of the reliquary's *Vollschmelz* enamels have more in common with works produced during the Carolingian period than with the most notable products of the Egbert workshop, among them the so-called Egbert shrine, a portable altar and precious container made to hold the relic of the Holy Nail, portions of the beard and chains of St. Peter, a sandal of the apostle Andrew, and other saintly relics. The fact that the reliquary is a few centimeters longer than the relic of the Holy Nail itself may indicate that it was created before a portion of the Holy Nail was cut off and transferred to Wilton Abbey in England by Benna, a former canon of the collegiate church of St. Paulinus at Trier who served as teacher of St. Edith, the illegitimate daughter of King Edgar of Wessex (r. 959–75), an event that can be dated prior to 975 on the basis of of several literary sources. / HAK

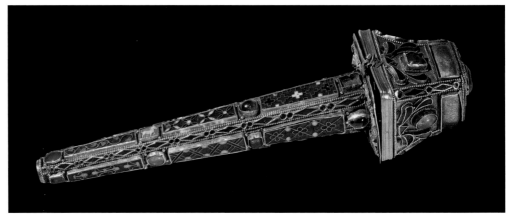

38

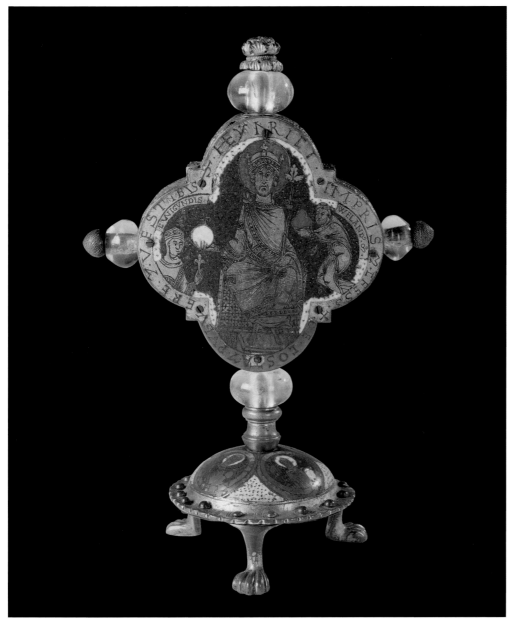

39

1168. Matilda's father was the namesake of the king depicted on the front of the reliquary, and the kings depicted on the back would have had particular resonance for an English recipient of the gift. Oswald was a seventh-century king of Northumbria, Sigismundus was a sixth-century Burgundian king related to the English royal house, while Eugeus might be Eugenius IV, a legendary Scottish king who had given asylum to Oswald when he fled Northumbria in 617. Both Oswald and Eugeus were considered saints.

The shape of the reliquary is significant. The quatrefoil resembles a Greek cross, and the shape is also associated with clover: four-leafed clover (known as *corona Regis* [regal crown] in contemporary English herbiaries [Michael 1994, 38–42]) was thought to symbolized the Cross and Christ's blessing.

Welandus, the donor of the reliquary, was a monk at the Benedictine monastery of St. Michael at Hildesheim, where this reliquary was presumably made. The abbey of Hildesheim had strong political ties with the Holy Roman Emperors and in particular with Henry the Lion, who granted the Benedictine foundation political independence. The reliquary is enameled with a lapis blue background dotted with stars in gold, white and bright green, a typical palette in twelfth-century enamels from Lower Saxony. Goldsmiths' workshop flourished under Henry the Lion's patronage during the Holy Roman Empire. / MB

39
Reliquary of St. Henry

German (Lower Saxony), ca. 1175
Copper over wood, enamel, rock crystal; 23.6 × 16.1 cm
Musée du Louvre, Paris, Département des Objets d'art (OA 49)
Cleveland and Baltimore

INSCRIBED: on front border: DE COSTA Y PULVERE Y VESTIBUS S. HEY(N)RICI. IMP(E)R(ATOR)IS. C(ONFE)SS(ORIS) (Of the rib, dust, and clothes of St. Henry the Emperor); on left lobe: CUNEGUNDIS; on right lobe: WELAND(US) MO(NACHUS); on back border: OSVVALDUS REX

PROVENANCE: Engelke collection; purchased in 1857

BIBLIOGRAPHY: Gauthier 1972, no. 108; Hildesheim 1993, no. IX-11; Michael 1994

This reliquary, one of the earliest known representations of a Holy Roman Emperor, contains relics of Henry II, the last emperor (r. 1002–24) of the Ottonian dynasty, who was canonized in 1142. Henry is portrayed at the center sitting on a throne and holding a scepter and orb—symbols of his imperial power—flanked by his wife, Cunigunde, and the monk Welandus, who offers the reliquary to the saint. On the opposite side, Christ, named REX REGUM (King of Kings), is flanked by three haloed kings: Oswald on the right and Sigismundus and Eugeus on the left. The base is decorated with circular medallions of Sts. Gereon, Mauritius, Eustace, and Sebastian.

The prominent representations of sacred and earthly kings suggests that the reliquary might have been made for the wedding of Matilda, daughter of Henry II, king of England, with Henry the Lion in

40
Arm Reliquary of the Apostles

German (Lower Saxony), ca. 1190
Silver gilt over wood (oak), enamel (champlevé)
51 × 14 × 9.2 cm
The Cleveland Museum of Art, gift of the John Huntington Art and Polytechnic Trust (1930.739)

PROVENANCE: House of Braunschweig-Lüneburg; Treasury of the Cathedral of St. Blaise, Braunschweig; J. & S. Goldschmidt, Frankfurt and New York

BIBLIOGRAPHY: Neumann 1891, 268–69, no. 47; Falke, Schmidt, and Swarzenski 1930, 47–48, no. 30; Milliken 1930, 165–67; Stuttgart 1977, 448–49, no. 578; De Winter 1985, 83–85, fig. 111 and pls. XIV–XVIII; Lasko 1994, 214; Braunschweig 1995, 247, no. D 60; Brandt 1998; Los Angeles 2007, 122–23, no. 38

This reliquary belongs to a class of objects often referred to as body-part, shaped, or "speaking" reliquaries. Imitating the form of a clothed lower arm with an outstretched right hand, it gives visual expression to the very body part it contains, namely, the *ulna* bone—part of the lower arm—of an unidentified saint. Correspondences between the shape of a reliquary and its contents, however,

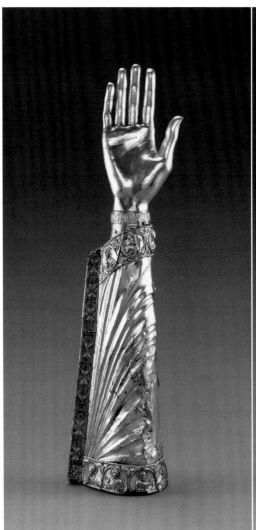
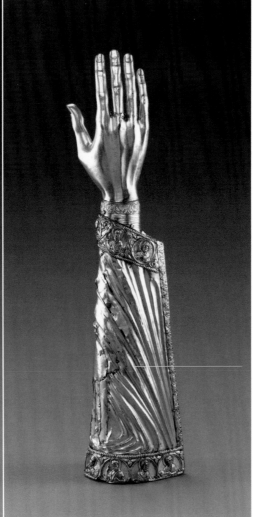

40

are not the rule. Some arm reliquaries contain the remains of not just one, but several saints. Others hold relics from different parts of a saint's body, or contact relics. The popularity of arm reliquaries from the twelfth century onward must be considered a result of their usefulness as liturgical props, which allowed clerics to animate a saint's body during liturgical celebrations and processions. In this way, the saint could literally bless, touch, and heal the faithful with his own hand (see Hahn herein, pp. 166–67).

Named for a series of bust-length figures of apostles that decorate the upper and lower borders of the liturgical vestment, in which the arm is "dressed," the arm is one of the finest reliquaries from the treasury of St. Blaise in Braunschweig. While two arm reliquaries are already recorded in an inventory of 1482—namely, those of Sts. Martin and Eustace—the iconographic program of the Cleveland reliquary may suggest that it was made to contain the relic of an apostle. In fact, Duke Henry the Lion (r. 1142–80), during whose reign the reliquary was

likely made, is known to have received several arm relics of apostles as gifts from Emperor Manuel I (r. 1143–80) in Constantinople in 1173. Since Henry donated at least two arm reliquaries—those of Sts. Theodore and Innocence—to St. Blaise's treasury, his patronage of this arm reliquary seems indeed likely. / HAK

41
Reliquary with Tooth of St. John the Baptist

Reliquary: German (Lower Saxony), 1375/1400
Rock crystal vessel: Egyptian (Fatimid), 10th or 11th century
Silver gilt, rock crystal; 45.5 × 14.6 cm
The Art Institute of Chicago, gift of Mrs. Chauncey McCormick (1962.91)
Cleveland and Baltimore

INSCRIBED: DENS JOHANNES BAPTISTE (tooth of John the Baptist)

PROVENANCE: From the Church of St. Blaise, Braunschweig; given in 1670 by Duke Rudolph August of Braunschweig-Lüneburg

to his cousin, Johann Friedrich of Hannover (d. 1679); Leinenschloss at Hannover until 1803, when it was temporarily transferred to England; moved to King George V's (d. 1878) Guelph Museum in Hannover in 1861; transferred in 1867 to the castle of Cumberland in Gmunden, Austria, and then Penzing Castle near Vienna; in 1869 the former King George, now duke of Cumberland, temporarily entrusted the Treasure to the Österreichisches Museum für Kunst und Industrie, Vienna, before returning it to the ducal castle in Gmunden; by descent to Duke Ernst August I (d. 1923); by descent to Duke Ernst August II (d. 1953) in 1911, who placed it in a bank vault in Switzerland in 1918 for safekeeping; in October 1929, the Treasure was sold to a consortium of dealers: Julius Falk Goldschmidt of the firm J. & S. Goldschmidt, and Zacharias Max Hackenbroch, Isaak Rosenbaum, and Saemy Rosenbaum of the firm J. Rosenbaum; purchased in 1931 by Mrs. Chauncey (Marion Deering) McCormick (d. 1965) from the Goldschmidt Galleries, New York [according to notes in registrar's files]; on loan to the museum as of 24 April 1931; accessioned by the museum in 1962

BIBLIOGRAPHY: Molanus 1697, 30–31; Neumann 1891, 285–86, no. 58; Falke, Schmidt, and Swarzenski 1930, 194, no. 60; De Winter 1985, 141, no. 59; Shalem 1996, 183–84; Leningrad 1990, no. 34; Nielsen 2004, no. 31

Unusual for a reliquary that is now in a museum collection, this monstrance still contains its original content: the Tooth of St. John the Baptist. The brown linen wrapped around the tooth is visible in the middle of the translucent vessel at the center of the reliquary; an inscription on the foot also proclaims its presence. While this artwork was produced by a Saxon goldsmith around 1400, the rock crystal flask that now holds the tooth was carved four hundred years earlier by an artist working in Fatimid Cairo, where it was used to hold perfumed oil. This luxurious secular object from Islamic lands could have been transported to medieval Europe by any number of means: through commerce, through gift exchange, or as a spoil of war. It was clearly deemed worthy to hold the precious relic of one of Christianity's most important saints. Originally housed in the Church of St. Blaise in Braunschweig, Germany, the reliquary, together with cat. nos. 40 and 42–44, was part of the so-called Guelph Treasure, named for the family of Saxon dukes who were great patrons of the church for several hundred years. When the congregation embraced Protestantism during the Reformation in the sixteenth century, the duke of Braunschweig-Lüneburg took possession of the treasure to safeguard the relics. The treasure was sold by his heir, Duke Ernst August II, in 1931 and it was at this time that the reliquary—complete with the Tooth of St. John—entered the collection of a great benefactor of the Art Institute. A dentist has examined the tooth and confirmed that it is indeed that of a thirty-year-old man who ate a coarse diet; however, further scientific dating will be required to determine the tooth's age. / CN

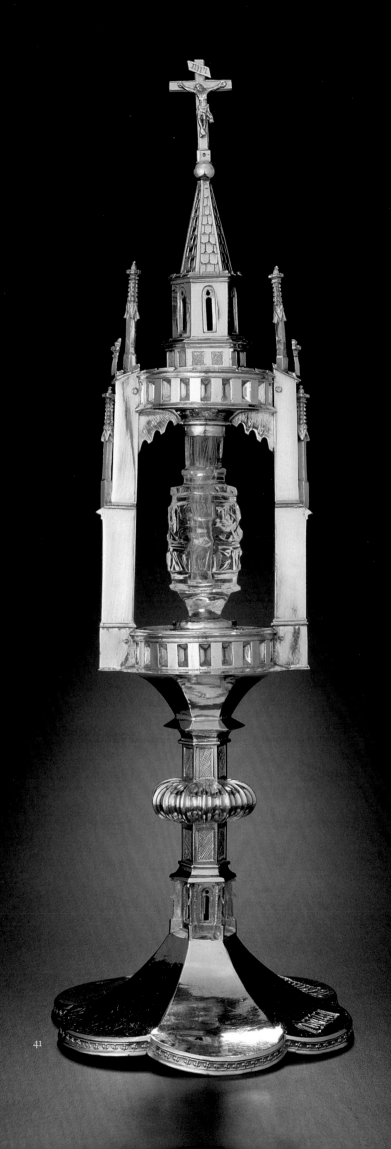

41

42
Portable Altar of Countess Gertrude

German (Lower Saxony), ca. 1045
Gold over wood (oak), enamel (cloisonné), red porphyry, gems, pearls, niello; 10.5 × 27.5 × 21 cm
The Cleveland Museum of Art, gift of the John Huntington Art and Polytechnic Trust (1931.462)

INSCRIBED: around the porphyry stone on top: GERTRVDIS XPO [CHRISTO] FELIX/VT VIVAT IN IPSO/OBTVLIT HVNC LAPIDEM/GEMMIS AVROQ[VE] NITENTEM (Gertrude offers to Christ, to live joyfully in him, this stone that glistens with gems and gold); on the sides: SANCTA CRUX (Holy Cross), CONSTANTI[N]VS, S[AN]C[T]A HELENA, SIGISMVNDVS, S[AN]C[T]A ADALHEIT

PROVENANCE: House of Braunschweig-Lüneburg; Treasury of the Cathedral of St. Blaise, Braunschweig; J. & S. Goldschmidt, Frankfurt and New York

BIBLIOGRAPHY: Neumann 1891, 129–35, no. 13; Falke, Schmid, Swarzenski 1930, 105–6, no. 5; Milliken 1931; Swarzenski 1967, pl. 36, 40; Gosebruch 1979; De Winter 1985, 36–40; Lasko 1994, 214; Westermann-Angerhausen 1998; Peter 2001; Los Angeles 2007, 116–18, no. 36

43
Reliquary Bag from the Gertrude Altar

Spanish (Mudejar), 13th century
Silk (lozenge twill, two-sided, weft-faced); 36.9 × 8 cm
The Cleveland Museum of Art, gift of the John Huntington Art and Polytechnic Trust (1931.462.1)
Cleveland and Baltimore

PROVENANCE: The reliquary bag was removed from the portable altar of Countess Gertrude in 1985. Its relic content was put back inside the altar together with the other relic pouches. They were removed once again in preparation for the exhibition during the fall of 2009

BIBLIOGRAPHY: Neumann 1891, 134–35; De Winter 1985, 37–38; See also Schorta 1998

This portable altar belongs to a group of precious liturgical objects commissioned by Countess Gertrude of Braunschweig shortly after the death of her husband, the powerful Count Liudolf in 1038. It was destined for the collegiate church of St. Blaise, founded in 1030 to serve as the couple's burial place. While a lengthy inscription in metric verse, placed around the porphyry altar stone, prominently records the patron's name and pious intentions, the choice of materials, quality of craftsmanship, and iconographic program spell out her more worldly ambitions.

The altar's front, clearly distinguished as such by its fine cloisonné enamel arcade, shows the full-length figures of Christ in the center with three apostles on either side. The back panel mirrors the arrangement on the front, but here the arcades are worked in repoussé and the apostles flank the Virgin Mary, her hands raised in a gesture of prayer and intercession. Completing the altar's decoration on one side are four scepter-bearing angels under nielloed arcades flanking St. Michael killing the dragon, and an Adoration of the True Cross on the other. Emperor Constantine and his mother, Helena, are placed on either side of the precious enameled cross, with the Burgundian king Sigismund and the Ottonian empress Adelheid following suit, a choice that attests to Gertude's acute sense of dynastic alignment and pious tradition.

According to the prescriptions of the Seventh Ecumenical Council of Nicaea of 787, every consecrated altar was to contain sacred relics. The portable altar of Countess Gertrude was no exception. Of the various relics listed in the inventory of 1482, those of Sts. Hermes, Bartholomew, Vincent, Adelheid, Gertrude, Marcian, and others are still preserved today. They were wrapped in textiles, stuffed into a richly decorated silk pouch (cat. no. 43) and inserted into the altar through a trap door on the altar's underside. This oblong reliquary pouch was sewn together with a few irregular stitches from a single piece of light-green silk. Its woven figural decoration, which consists of pairs of opposing lions arranged in several narrow registers, is reminiscent of Near Eastern designs and Islamic textiles produced by Mudejar

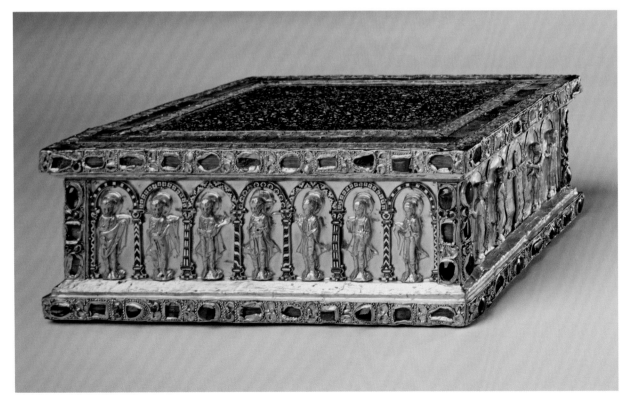

42

43

artists in thirteenth-century Spain. An accompanying *cedula*, or parchment strip with an identifying inscription, suggests that the bag used to contain relics of the arm of one of the Twelve Apostles, namely that of St. Bartholomew. Together with other precious relics, some of which were likewise wrapped in silk and linen textiles, the apostle's remains (multiple fragments of soft tissue rather than bone) were found inside the portable altar of Countess Gertrude of Braunschweig in 1985, when the trap door on the reliquary's underside was opened for the first time since the late nineteenth century. According to early Christian tradition, St. Bartholomew was flayed alive and beheaded, which may explain the presence of soft tissue (rather than bone) and its identification as the "arm" *(brachium)* of the apostle. / HAK

44
Ostensorium with "Paten of St. Bernward"

German (Lower Saxony [Hildesheim?]); paten: ca. 1180–90, monstrance: ca. 1350–1400
Paten: Silver, silver gilt, and niello; diameter 13.4 cm
Monstrance: silver, silver gilt, and rock crystal; 34.5 × 15.9 × 14 cm
The Cleveland Museum of Art, purchase from the J. H. Wade Fund with additional gift from Mrs. R. Henry Norweb (1930.505)

INSCRIBED: on the paten's outer rim: + EST. CORPVS. IN. SE. PANIS. QVI. FRANGITVR. IN. ME: VIVET. IN ETERNVM. QVI. BENE. SVMIT. EVM. (+ The bread which is broken in me is the body [of Christ] itself. He who receives it in good faith shall live in eternity); surrounding the medallion with the enthroned Christ: + HVC. SPECTATE. VIRI. SIC. VOS MORIENDO. REDEMI (+ Behold, O men, I have thus redeemed you with my death); on the scrolls held by the four cardinal virtues: IVSTITITIA (Justice) PRVDENTIA (Prudence) FORTITVDO (Fortitude) TEMP[ER]ANTIA (Temperance)

PROVENANCE: House of Braunschweig-Lüneburg; Treasury of the Cathedral of St. Blaise, Braunschweig; J. & S. Goldschmidt, Frankfurt and New York

BIBLIOGRAPHY: Neumann 1891, 294–97, no. 65; Falke, Schmidt, and Swarzenski 1930, 156–57, no. 32; Milliken 1930, 167–68; Stuttgart 1977, 447–48, no. 577; De Winter 1985, 84–86, fig. 109 and pl. XIII; Hildesheim 1993, 630–32, no. IX-28; Lasko 1994; Hildesheim 2001, 145–47; Los Angeles 2007, 124–25, no. 39

This unusual *ostensorium* (from the Latin *ostendere*: to show) was made to facilitate the display and veneration of ten relics, most prominent among them an elaborate liturgical paten—a shallow plate for the elevation of the Eucharist during Mass—associated with St. Bernward of Hildesheim (d. 1022), and a relic of the True Cross. Eight more relics, wrapped in small silk pouches, are visible on the reliquary's reverse (see p. 142, fig. 51). They are identified as the remains of Sts. Godehard, Nicholas,

Auctor, Silvester, Servatius, John Chrysostom, Alexis, and Lawrence by accompanying inscriptions on parchment.

The "Paten of St. Bernward" is presented vertically on a six-lobed foot and framed by buttresses with turrets and spires. Above it, a rock crystal oculus, set in an openwork gable, enshrines the "Wood of the Lord." The paten itself is richly decorated with a central image of Christ seated on a rainbow and displaying his stigmata. Surrounding him are the symbols of the four Evangelists and personifications of the four cardinal virtues. Two inscriptions in niello allude to the mystery of the Eucharist and Christ's sacrifice on the Cross.

While the paten's form and decoration support a date in the late twelfth century and thus contradict an association with St. Bernward, the object's inclusion in a fourteenth-century *ostensorium* attests to a strong tradition that linked the paten to Hildesheim and its famous bishop. Fragments of the True Cross may have been included to reinforce this association, as Bernward was known to have received a portion of this very relic from Emperor Otto III (r. 985–1002) as a gift. Interestingly, the reliquary is recorded in the first inventory of the Treasury of St. Blaise (1482) as "a large monstrance, containing the paten made by St. Godehard," Bernward's sainted successor as bishop of Hildesheim. / HAK

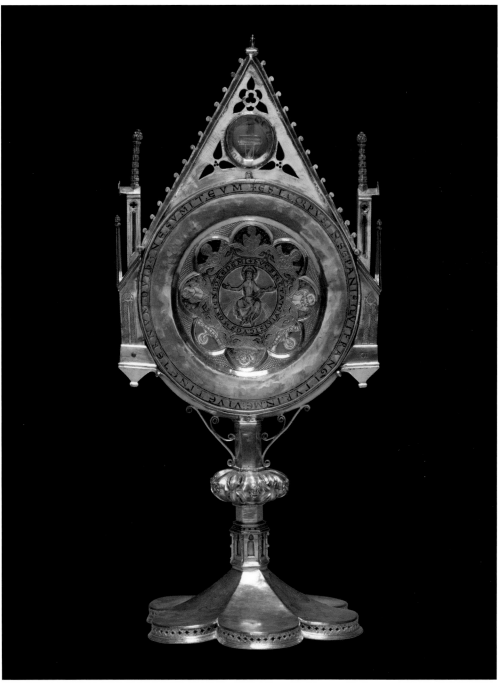

44

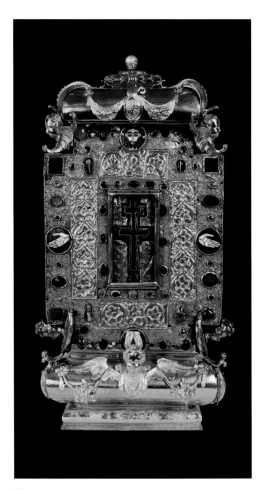

45

45
Reliquary of the True Cross

German (Swabia), before 1135 (with later additions)
Gold, silver gilt (repoussé and filigree) over wood, enamel
(cloisonné), gems; 36.5 × 18.5 cm
Katholisches Münsterpfarramt Zwiefalten, Germany

PROVENANCE: Treasury of the Benedictine Abbey, Zwiefalten

BIBLIOGRAPHY: Wallach, König, and Müller 1978; Spilling 1992;
Braunschweig 1995, 99–101, no. B 16; Mainz 2004, 400–402,
no. 64; Klein 2004; Bregenz 2008, 156–57

In his *Zwiefalten Chronicle*, written around 1138,
the Benedictine monk and later abbot Berthold of
Zwiefalten recounts the history of the monastery's
most sacred treasure: a book-shaped reliquary
containing a portion of the True Cross, a relic of
Christ's manger, and stones from Golgotha, the Holy
Sepulcher, and the mountain of the Lord's Ascen-
sion. According to Berthold, the relics previously
belonged to Abbot Gerhard of Schaffhausen, who
had participated in the First Crusade and subse-
quently become prior of the Church of the Holy
Sepulcher in Jerusalem. Upon Gerhard's death, he
bequeathed the reliquary to his chaplain Zeisolf,
who, upon his untimely death at Jaffa, bequeathed

it to his fellow traveler Berthold of Sperberseck
(d. 1111). Upon his safe return from the Holy Land,
Berthold in turn donated the sacred treasure to the
Monastery of Zwiefalten.

As Berthold further records in his *Chronicle*, the
monastery soon commissioned a local goldsmith
named Ulrich—whether he was a monk or a layperson
remains unknown—to create a new shrine for these
and other important relics in the monastery's posses-
sion. It is this reliquary, "made by Ulrich from
purest gold and with precious stones in the shape of
a book" (*Zwiefalten Chronicle*, 40, 264–65), which
still survives at Zwiefalten today. Set into a rectangular
panel decorated with stars at the center of a larger
cruciform panel, a small double-armed cross lies at
the heart of the entire composition. Like other
reliquary crosses of its kind it is likely the product
of an early twelfth-century workshop in the Latin
Kingdom of Jerusalem. While the True Cross is
made visible, the other relics listed by Berthold are
concealed behind precious stones at the terminal
ends of the vertical and larger horizontal cross bars.
Four decorative strips, possibly reused parts of an
older reliquary container, surround the central panel
with a rinceau pattern reminiscent of Byzantine
repoussé works. Following the outlines of these
ornamental borders is a frame richly decorated with
precious stones, gold filigree, gems, and four
cloisonné enamel medallions. Depicting the head,
hands, and feet of Christ, these enamels constitute
the most unusual and innovative aspect of the
reliquary's design, as the arrangement equates the
body of Christ with the material remains of his
Cross and with relics from places that witnessed his
Nativity, Crucifixion, Entombment/Resurrection,
and Ascension. / HAK

46
Reliquary of the True Cross

Cross: Latin Kingdom of Jerusalem, mid-12th century
Container: Italo-Byzantine (Sicily?), second half of the
12th century
Silver gilt on wood; 15.9 × 9.2 cm
Musée du Louvre, Paris, Département des Objets d'art (OA 3665)
Cleveland and Baltimore

INSCRIBED: box rim: +HOC EST LIGNUM S(AN)C(TA)E CRUCIS IN QUA
XPI PEPE(N)DIT/ QUAM JERUSALE/M +CONSTANTINUS ET HELENA
DETULERUNT (This is the Holy Cross on which Christ hung and
which Constantine and Helen brought from Jerusalem); box
interior, inner edge, bottom left: S(AN)C(TU)S CONSTANTINUS; next
to emperor's head: KO(N)CTA(N)TIN(OC); bottom right: S(AN)C(T)A
HELENA; next to saint's head: H AΓIA EΛENI; top of the lid: ICTAVPOCIC
(Crucifixion); on cross: ICXC; along arm of cross: IHS XPS

PROVENANCE: Acquired in 1894

BIBLIOGRAPHY: Frolow 1965, 108, 127, fig. 55; Folda 1995, 293–94;
New York 1997, 398, no. 264

This reliquary box with a sliding lid opens to reveal
a double-arm cross containing two relics of the
True Cross, visible through cross-shaped openings
along the vertical axis. The cross is decorated with
repoussé roundels of the four Evangelists. Four
quatrefoils around the central relic window would
originally have contained stone fragments of the
Holy Sepulcher, depicted at the foot of the cross as
a domed structure with a hanging lamp surmounted
by a cross. A vegetal scroll and a roundel with the
Agnus Dei grace the back of the cross.

Constantine and Helena are portrayed in the
interior of the box in which the cross is set, standing,
respectively, on the left and right of the cross and
named in both Latin and Greek inscriptions. A Latin
inscription on the box's outer border that identifies

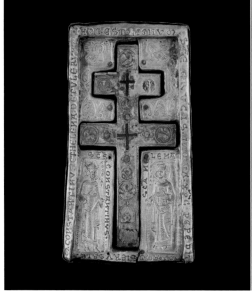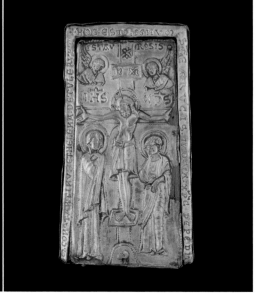

46

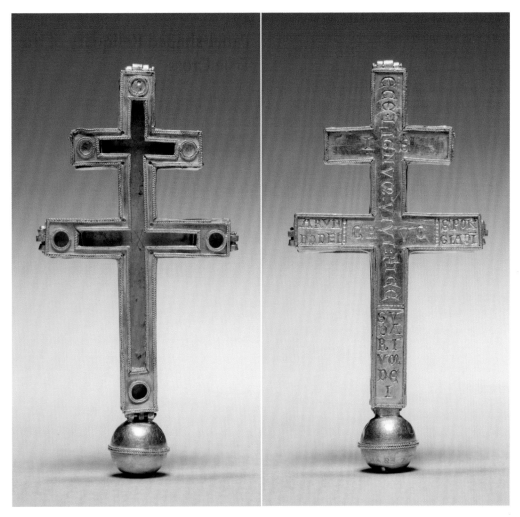

47

the relic and emphasizes the role of Helen and Constantine in its retrieval would have been visible also when the lid was in place. The image on the lid—the crucified Christ flanked by St. John and the Virgin Mary—establishes a visual parallel between the emperor and his mother and the Evangelist and the Mother of Christ. The cartiglio with Jesus's Greek acronym (ICXC) is affixed to the cross, but his name is repeated in the shortened Latin form XPS along the horizontal arm.

The reliquary combines Eastern and Western elements: the shape is that of a Byzantine *staurotheke*, while the prominence of Latin inscriptions indicates that it was made for a Western patron. The punchwork and some of the iconography, such as the representation of the Holy Sepulcher as a domed structure, resemble those on metalwork produced in the Latin Kingdom of Jerusalem between 1153 and 1163, but some scholars have proposed that the use of recessed punched dots indicates a slightly later, probably Sicilian, manufacture. / MB

47
Double-Arm Reliquary Cross

Latin Kingdom of Jerusalem (?), 12th century
Gold; 10.5 × 5.3 × 1.5 cm
The Cleveland Museum of Art, purchase from the J. H. Wade Fund (1983.208)

INSCRIBED: on the reverse: EC(C)E · LIGNVM : VIVI : FIC(A)E CRVCIS; at base: SVDARIVM DEI; at the ends of main cross arm: ARVNDO DEI; SPONGIA D(E)I. (Behold the Wood of the life-giving Cross: sudarium of the Lord: staff of the Lord: sponge of the Lord)

PROVENANCE: Dr. Jacob Hirsch, Lucerne; Thomas J. Flannery, Chicago; Sotheby's, London, 1 December 1983, lot 12

BIBLIOGRAPHY: Adolph Hess AG and William Schwab 1957, 40, lot 118; Sotheby Parke Bernet and Co. 1983, 22, lot 12; Meurer 1985, 70–71

Mounted on a small globe and decorated on its front and back with strips of twisted wire molding, this elegant double-arm gold cross shares a number of decorative features with a group of silver crosses that can be attributed to a leading goldsmith workshop in the Latin Kingdom of Jerusalem during the twelfth century. Robbed of its relic content, the front of this cross now reveals a double-cruciform cavity in the center and three round openings at the bottom end of the vertical and the terminal ends of the larger horizontal cross arm, respectively. These cavities once contained fragments of four of the most important relics of Christ's Passion, namely, a portion of the True Cross, a piece of Christ's *sudarium*, and fragments of the reed staff and sponge used by Christ's tormentors to mock him and give him vinegar for his thirst during the Crucifixion. The identity and the placement of these relics in the cross are confirmed by accompanying inscriptions on the reverse, a practice that can be observed in both East and West from the sixth century onward.

While the distribution of relics of the True Cross and other Holy Land relics is attested for the Latin kings and patriarchs of Jerusalem on various occasions during the twelfth century, the presence of relics of the Holy Sponge, reed, and *sudarium* is somewhat unusual, as these relics of Christ's Passion are known to have been kept among the relic treasures of the Pharos Church, located inside the imperial palace at Constantinople.

If the Cleveland reliquary cross was indeed created before 1204, as art historical evidence indicates, and if its inscription and relic content were not added later, the cross's original owner must have been among the most powerful and influential figures in the Latin Kingdom of Jerusalem. Such an assumption is further supported by the artist's choice of gold as the material for this reliquary cross. / HAK

48
Reliquary Cross

French (Limoges), probably from the Abbey of Grandmont, ca. 1180
Silver gilt on a wood core, rock crystal, glass; 29.8 × 12.5 × 2.5 cm
The Metropolitan Museum of Art, New York, purchase, Michel David-Weill Gift, The Cloisters Collection, and Mme. Robert Gras Gift, in memory of Dr. Robert Gras, 2002 (2002.18)
Cleveland and Baltimore

INSCRIBED: on the proper right side of the shaft, running up: DE SEPVLCRO D(OMI)NI; DE SEPVLCRO BE(ATE)MARIE; on the proper right arm: DE INNOCENTIB(VS); over the proper left arm: S(ANCTI) APOLLINARIS, obscured by a strip of metal engraved: S(ANCTI) VINCENCI; on the proper left side of the shaft, running down: S(ANCTI) HERMITIS M(ARTYR)I; CAPILLI S(ANCT)I STEPH(AN)I. M(ARTIRI); under the proper right arm: DE NATIVITATE D(OMI)NI; under the proper left arm: DE CALVARIE

PROVENANCE: Felix Doistau, Paris; Augustin Gilbert, Paris; Brimo de Laroussilhe, Paris; Withney collection

BIBLIOGRAPHY: Goy 1909; Bertrand 1993, 30–35, no. 3; Boehm 2006

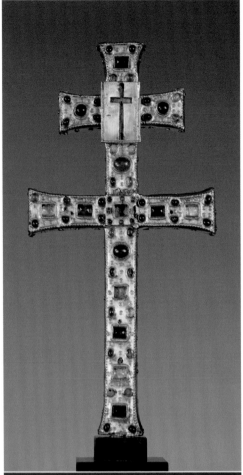

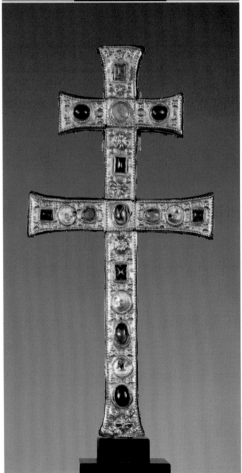

Tiny relics are set like jewels on both sides of this cross, which is studded with more than sixty "gems" of colored glass. The inscriptions that, atypically, run the length of the shaft and arms indicate that they are, above all, associated with sites in the Holy Land that in the twelfth century were under the control of the Western Church: the Holy Sepulcher, the Church of the Nativity at Bethlehem, Notre-Dame at Josaphat in Jerusalem. In their company are relics of early deacons of the church: St. Stephen, the first martyr, St. Vincent, and St. Hermitis (Hermès), a deacon of Adrianople, martyred while trying to protect the liturgical vessels of his church. The ensemble constitutes a virtual tour of key sites, as described, for example, in the *Saint voyage de Jherusalem,* a late fourteenth-century pilgrimage account of the seigneur d'Anglure.

Some twelfth-century reliquary crosses have been convincingly attributed to the Latin Kingdom of Jerusalem, where goldsmiths, like court and church dignitaries, were resident. In this case, the profusion of the glass cabochons and the particular use of faience are consistent with a decidedly Limousin aesthetic as seen on the chasse of Ambazac (1182–89).

This cross, with a similar example preserved in the Musée du Berry, Bourges, is one of the earliest surviving French examples of a double-arm reliquary cross: that form, mimicking Byzantine examples and referred to in contemporary inventories as "à la façon d'outremer," signaled the presence of relics of the Holy Land. Testament to the important tradition of goldsmith's work in central France, the cross also bears witness to the region's strong spiritual, cultural, and political links to the Holy Land in the second half of the twelfth century, prior to the loss of Jerusalem in 1187.

The inventory of the abbey of Grandmont near Limoges, from which the chasse of Ambazac comes, describes a number of double-arm reliquary crosses that were clearly related to this example. Of gilded silver decorated with "pierreries," they contained numerous relics from many of the same holy sites, which were likewise identified by inscriptions on the uprights of the shaft and cross arms—a type not known in other inventories. Compiled in 1666, the inventory is frustratingly confusing as to the total number of such crosses, several of which were in poor condition; nonetheless, it is reasonable to infer that this cross comes from the treasury of Grandmont itself, or possibly from one of its dependencies. Testament to the spiritual, cultural, and political links between central France and the Holy Land, this reliquary cross is the only cross of this type and date to survive outside France. / BDB

49
Panel-shaped Reliquary of the True Cross

Cross: Latin Kingdom of Jerusalem
Panel: Rhine-Meuse region, 1214
Silver, silver gilt over wood (walnut), precious stones, niello
41.6 × 30.2 cm
The Cleveland Museum of Art, purchase from the J.H. Wade Fund (1952.89)

INSCRIBED: +DE VESTIMENTIS SANCT(A)E MARI(A)E (of the vestments of the Virgin Mary); +DE CAPILLIS SANCT(A)E MARI(A)E (of the hair of the Virgin Mary); +(DE SIN)DINE QUA CESVM EST CAPVT DOMINI (of the shroud that covered the head of Christ); +DE SVDARIO CRISTI (of Christ's *sudarium*); +DE TVNICA CRISTI (of Christ's tunic); +DE PEPLO SANCT(A)E MARI(A)E (of the Virgin's *peplos*); +DE CINCTORIO SANCT(A)E MARI(A)E (of the Virgin's belt); +DE CAMISIA RVBEA Q(U)AM DOMINVS HABVIT IN CRVCE (of the red chemise that the Lord wore on the Cross); +DE CALIGIS DOMINI (of the Lord's sandals); +DE SPINEA CORONA DOMINI (of the Lord's crown of thorns); +DE VESTIMENTO Q(UOD) DOMINIS HABVIT IN CRVCE (of the Lord's garment which he wore on the Cross); +DE TESTA ET CARILLIS SANCTI IOHANNIS BAPTISTE (of the head and hair of St. John the Baptist); +DE SANCTO MARTINO (of St. Martin); +DE PEPLO SANCT(A)E MARI(A)E (of the Virgin's *peplos*); +DE LANCEA DOMINI (of the lance of the Lord); +DE PANNIS DOMINIS (of the Lord's swaddling clothes); +DE SANCTO PHILIPPO (of St. Philip); +DE SANCTO GEORGIO (of St. George); +DE SANCTO ANTONIO (of St. Anthony); +DE SANCTO STEPHANO (of St. Stephen); +DE CRVCE (LATRON)IS CONFITENTIS (of the Good Thief's cross); +DE SANCTO MARIA MAGDAL(ENA) (of St. Mary Magdalene); +DE SANCTO SIMON CAPEL(L)O (of St. Simon's hair); +DE SANCTO LAZARO (of St. Lazarus); +DE SANCTO EGIDIO (of St. Giles); +DE SANCTO DIONISIO (of St. Denis); +DE SANCTA AGATHA (of St. Agatha); +DE SANCTO VINCENCIO (of St. Vincent); +DE SANCTE [*sic*] LVC(A)E EVANGELIST(A)E (of St. Luke the Evangelist); +DE SANCTO TEODORO (of St. Theodore)
+ DE CRVCE Q(V)I Q(VE)RES LEGE IVDE P(RES)B(ITE)R HERES / CLEPSIT EA(M) NAVE(M) SCA(N)DE(N)S AVRA(M)Q(VE) SVAVE(M) / DV(M) PECIIT PESTIS NAVTIS VENIT OBVIA MESTIS / ROSIT AT ILLE MANVS PROR(R)IAS Q(V)A ME(N)TE VESAN(VS) / QVE(M) F/VIT AFFATA SIC TANDE(M) VIRGO BEATA / TV CITO SANVS ERIS FVRTV(M) SI R/EDDERE Q(VE)RIS / FRATRIB(VS) HOC SOLVIT TE(M)PLI MORIE(N)SQ(VE) REVOLVIT / TALIA DV(M) SPIRO CVRRE(N)T FRATA TVRBINE + MIRO / IN ME QVE IACTO MITESCET EO MARE PACTO / HV(N)C VT DECESSIT IACIV(N)T PESTISQ(VE) RECESSIT / BRV(N)DVSIV(M) LETI VENIV(N)T REDIERE QVIETI / CV(M) CRVCE QVE BELLA SEDET HAC CONTE(N)TA TABELLA / + FACTA EST H(A)EC TABVLA ANNO AB INCARNATIONE DOMINI MCCXIIII MENSE FABRVARIJ (+You who ask about the cross: read! The heir of Judas the priest / Stole it. But when, after boarding a ship, / He sought a mild breeze, a fierce storm opposed the sorry sailors. / Out of his mind, he gnawed at his own hands. / In the end the blessed Virgin spoke thus to him: / "You shall soon be well, if you seek to return what was stolen." / He pays back this debt to the brothers of the Temple, / And as he was dying, he turned over such [thoughts in his mind]: / "As long as I breathe, the waves shall flow, with a wondrous whirlwind laid against me, / But when this is settled, the sea shall grow calm." / When he died, they cast him overboard, and the storm subsided. / Happy they arrive at Brindisi, quiet they have returned with the cross, / Which resides beautiful in this handsome panel. + This tablet was created in the 1214th year from the Lord's incarnation in the month of February +)

PROVENANCE: purportedly from Cologne Cathedral; Albin Chalandon, Lyon; Georges Chalandon, Paris; Adolph Loewi, Los Angeles

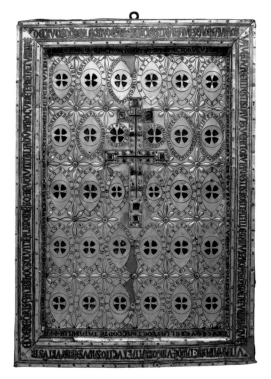

49

BIBLIOGRAPHY: Riant 1879, 140–45; Milliken 1952b, 203–5; Frolow 1961a, 407–8, no. 494; Verdier 1982; Gauthier 1983, 96–97, no. 53; Cologne 1985, 3:130–33, no. H43; Meurer 1985, 71–72; Kötzsche 1994

This panel-shaped reliquary follows a format commonly associated with Byzantine *staurothekai*, or reliquaries of the True Cross. Soon after the Crusader conquest of Constantinople in 1204, which resulted in the transfer of a number of distinguished Byzantine reliquaries of this type, Western artists—especially in the Rhine-Meuse region—started to adopt such Byzantine reliquary formats for their own purposes, thus fusing Eastern and Western metal-working techniques and traditions.

The Cleveland reliquary is one of the most striking examples of such an artistic fusion. A lengthy Latin inscription, executed in niello, frames the reliquary's central panel in two layers on all four sides. It records the colorful history of the translation of the relic of the True Cross, displayed prominently at the reliquary's center. While the inscription itself does not reveal where and under what circumstances the cleric named in the *translatio* account stole the relic, the design of the silver-gilt, double-arm cross—which is, in fact, only the front face of a reliquary cross—points toward the Latin Kingdom of Jerusalem as its place of origin. Likewise unknown is the exact location where the panel-shaped reliquary with its thirty additional relics of Christ, the Virgin, John the Baptist and other important saints and martyrs was manufactured. The overall arrangement

of these additional relics around the double-arm cross relic as well as the placement of the framing inscription seems to indicate a knowledge of the famous Byzantine *staurotheke* that Henry of Ulmen brought back with him to the Rhineland from Constantinople in 1207 (now in the cathedral treasury of Limburg an der Lahn), where it served as a highly influential model for local goldsmiths for several decades. / HAK

50
Reliquary of St. Marina

Byzantine (Constantinople), before 1213
Silver gilt; 10 × 6 × 2.8 cm
Museo Correr, Fondazione Musei Civici Venezia

INSCRIBED: on the sides: ΖΗΤΕΙСΘΕ ΑΥΤΑ ΤΙΝΟС Η ΧΕΙΡ ΤΥΝΧΑΝΕΙ / ΜΑΡΤΥΡΟС ΗΔΕ ΜΑΡΙΝΗС ΤΗС ΑΓΙΑС / ΗС ΤΟ ΚΡΑΤΟС ΕΘΛΑСΕ ΔΡΑΚΟΝΤΟ ΚΑΡΑС / ΑΥΤΗΝ ΜΕ ΠΡΟС ΖΗΤΗСΙΝ ΩΤΡΥΝΕ СΧΙСΙС / ΖΗΤΟΥСΑ Τ ΟΥΝ ΕΤΥΧΟΝ ΑΥΤΗС ΕΚ ΠΟΘΟΥ / ΠΡΟС ΚΟСΜΙ ΟΥΝ ΕСΠΕΝΖΑ ΤΟΝ ΤΗС ΚΟСΜΙΑС (Do you inquire about these things, [asking] to whom the hand belongs? This is [the hand] of the holy martyr Marina, whose power crushed the head of the dragon. Its having been cut off stirred me to seek it, and seeking it I found it, in accordance with my desire, and I made an offering for the seemly adornment of the honored one); on the bottom: ΜΙΚΡΟС ΜΕΝ ΟΥΤΟС ΤΗ ΜΕΓΑΛΗ ΤΥΝΧΑΝΕΙ / ΟΜΩС Δ ΑΠΕΙΡΟС СΥΝ ΠΡΟСΑΙΡΕСΕΙ ΠΟΘΟС / ΤΟΙΝΥΝ ΑΜΑΡΑΝΤΙΝΟΝ ΑΝΘΟС ΜΑΡΤΥΡΩΝ / ΖΑΛΗС ΡΥΟΝ ΜΕ ΤΩΝ ΝΟΗΤΩΝ ΠΝΕΥΜΑΤΩΝ / ΝΙΚΗΝ ΚΑΤ ΑΥΤΩΝ ΤΟ ΚΡΑΤΟС ΤΕ ΠΑΡΕΧΟΙС / ΑΝΑΛΟΓΟΝ ΝΕΜΟΥСΑ ΤΗ СΧΕСΕΙ ΔΟСΙΝ (While this reliquary is a small thing in comparison with the great [martyr], there is nonetheless unbounded devotion to my gift. Now, imperishable flower of the martyrs, save me from the storm of the evil spirits of my mind and give me victory over them, and power, dispensing a gift comparable to your nature)

PROVENANCE: From the Church of Sta. Marina (formerly San Liberale), Venice

BIBLIOGRAPHY: Pastorello 1938, 292; Cornaro 1749, 3:251–60; Cornaro 1758, 45–46; Riant 1875, 198–99; Riant 1877–78, 2:263–64, 266, 296, 298; Ross and Downey 1962; Venice 1974, no. 52; Brussels 1982, 155, no. 0.22; New York 1997, 496, no. 332

This unusually shaped reliquary consists of sheets of gilded silver, decorated on its sides with three bands of twisted wire. A string of pearls, threaded through loops, once framed the reliquary's upper rim. Bottom and sides are engraved with a Greek metric inscription that provides detailed information about the box and its content. According to the poem, the reliquary was made to hold the hand of St. Marina—St. Margaret of Antioch in the Western tradition—an early Christian virgin who allegedly suffered her martyrdom under Emperor Diocletian (r. 284–305). Because the hand had been cut off from the martyr's body—when and under what circumstances remains unclear—the reliquary's patron was able to acquire it and commission a worthy container to house the relic. As a reward, the patron

asks for the martyr's help and protection against evil spirits, an appropriate request considering the saint's legendary defeat of a dragon through a blessing gesture she made with her hand. Unfortunately, the identity of the reliquary's patron remains unknown. It may have been, as some scholars suggested, a Venetian named Giovanni de Bora, who, according to the chronicle of Doge Andrea Dandolo (r. 1343–54), acquired the relics of St. Marina from a monastery outside Constantinople and brought them to Venice in 1213. However, it might be considered unusual for a Venetian patron to commission a reliquary with a Greek rather than a Latin inscription. In Venice, the relics of St. Marina were solemnly received and deposited in the Church of San Liberale, where their cult soon eclipsed that of the church's former patron and led to the rededication of the church to Sta. Marina.

The asymmetrical shape of the reliquary can best be explained as a result of the odd shape of the relic it once contained. It remains ambiguous, however, how the hand of St. Marina was originally displayed. The toothed edges on the reliquary's upper rim clearly hint at a glass or crystal cover under which the relic was formerly presented. At the same time, the repoussé medallion with a bust-portrait of St. Marina on the reliquary's bottom was also meant to remain visible. The orientation of the saint's portrait and the presence of a suspension ring further suggest a vertical display or suspension from a chain. / HAK

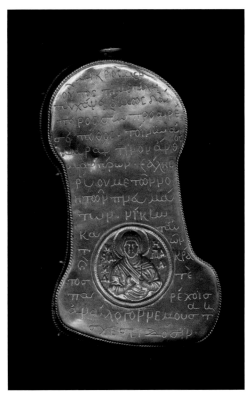

50

51
Reliquary of the Arm of St. George

Interior: Byzantine (before 1204)
Exterior: Venetian (before 1325 and 16th century)
Interior: silver; height 31 cm, maximum width 7.9 cm
Exterior: silver gilt, enamels (basse-taille), glass (modern);
height 51.9 cm, maximum width 11.7 cm
Procuratoria della Basilica di San Marco, Venice (Santuario 159)

INSCRIBED: on both sides of the exterior reliquary: + ISTUT · EST · BRACHIUM · GLORIOXIS IMI · MARTIRIS + SANCTI · GEORGII (this is the arm of the glorious martyr St. George); on interior silver casing: +ΓΕΩΡΓΙΟΥ ΛΙΜΨΑΝΟΝ ΑΘΛΗΤΟΥ ΦΕΡΩΝ / ΠΙCΤΙΝ ΠΑΝΟΠΛΩΝ ΤΟΥC ΕΝΑΝΤΙΟΥC ΤΡΕΠΩ (Bearing the relic of George the warrior; Faith, fully armed, puts the enemy to flight)

PROVENANCE: Constantinople; in the treasury of the Basilica of San Marco after 1204

BIBLIOGRAPHY: Tiepolo 1617, 62; Pasini 1886, 43–44; Gallo 1967, 23; Hahnloser 1971, 162–63; Paris 1984, 282–85; Guillou 1996, 101–2

The arm of St. George, with its interior silver casing, is one of the four precious relics that Doge Enrico Dandolo (r. 1195–1205) allegedly brought to Venice from Constantinople after 1204. The other three are the relics of the blood of Christ, the Cross, and the head of St. John the Baptist. St. George soon became the city's third patron saint after St. Mark and St. Theodore.

While in Venice the Byzantine reliquary acquired a new bejeweled container, which in 1325 was still in the making. In an inventory of the treasury dated 5 September of the same year, Pietro Grimani and Angelo Mudazio, *procuratori*, observed: "We also ascertain that the arm of St. George is being given a gold and silver revetment with enamel appliqués and topped by a figure of St. George riding a horse."

The new Venetian reliquary is shaped like an inverted cone with an oval section. It is supported by large stems decorated with leaves that fan out to form the base. A quadrilobe knot decorated with stars joins the stems at the top. Above, two nielloed plaques carry an inscription identifying the relic. The reliquary vessel is divided into three vertical bands on each side. The one at the center is a lush vegetal scroll with four busts of saints in the round alternating with three partly enameled rosettes. The central bands were hinged at front and back so that they could be opened to show the original reliquary. Two bands of four gothic windows decorated with figures of saints in translucent enamels flank the central opening element.

During the nineteenth century, to compensate for six missing enamels, the plaques were rearranged and were moved to the front, leaving the back void of decoration. The elegant reliquary is enriched with eight stems from which busts of saint and prophets (of which two survive) once "blossomed." During the ninenteenth-century restoration, criticized by Antonio Pasini, amethysts and hyacinths (zircons) were set on the broken stems. A figure of St. George stands atop the lid (formerly rock crystal, now glass). The dragon is original; the saint's figure is a sixteenth-century replacement. / MDVU

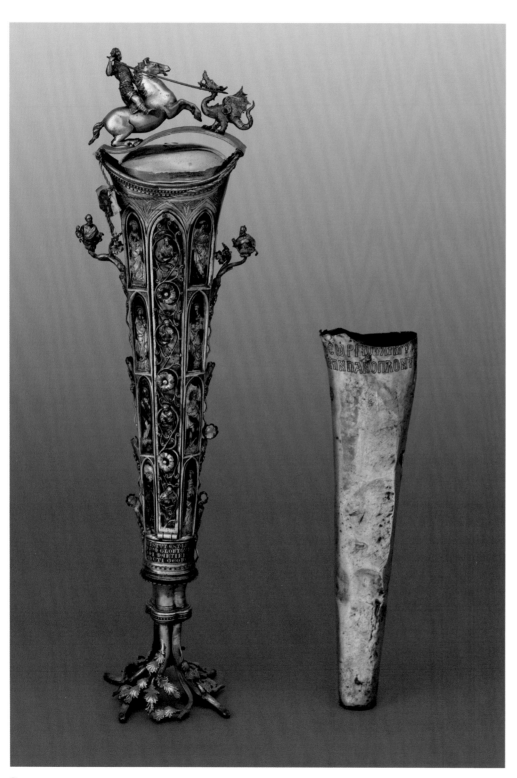

51

52

Reliquary Box with Scenes from the Life of John the Baptist

Byzantine (Constantinople), 14th century
Tempera and gold on wood; 23.5 × 9.9 × 9 cm
The Cleveland Museum of Art, gift of Bruce Ferrini in Memory
of Robert P. Bergman (1999.229 a–b)

PROVENANCE: Bruce Ferrini, Akron, Ohio

BIBLIOGRAPHY: Hess 2002; New York 2004, 137–38, no. 73; Los
Angeles 2007, 90–91, no. 26

This small painted wood box shows on its long sides four scenes illustrating the life and death of St. John the Baptist. Interestingly, the narrative runs from right to left, beginning with a combined scene of the annunciation of John's birth to Zacharias and the visitation of Elizabeth and Mary. Following on the left is a scene depicting John's birth and first bath as well as his father's writing down the name of his son on a small tablet. On the box's opposite side, two further scenes illustrate episodes from John's adult life. A scene on the right shows John baptizing Jesus in the river Jordan while three attending angels hold Christ's garments. The last scene shows John's imprisonment and execution following his denouncement of the adulterous relationship between King Herod Antipas and his brother's wife, Herodias.

The Christian veneration of John the Baptist emerged early as a result of his prominence in the account of the Gospels, which credit him as the first to recognize Christ as the promised Savior. After John's execution at the fortress of Machaerus, his remains were allegedly moved to Sebaste. Despite reports that John's coffin "was opened, his bones burned, and his ashes scattered" during the reign of Julian the Apostate (Theodoret, *Ecclesiastical History* 3.3), Christian pilgrims such as Egeria in the 380s continued to visit his tomb. His head, however, was taken to the capital, where it was solemnly deposited on 18 February 391 in a church richly endowed by Emperor Theodosius I. Over the centuries, at least thirty-six churches were dedicated to St. John the Baptist in Constantinople alone, attesting to his exceptional status among the saints and martyrs venerated in the Byzantine Empire.

The painted wood box likely served as a container for one of the saint's relics. Several such relics—two fragments of his skull, his right arm, and locks of his blood-clotted hair—were kept and venerated in churches and monasteries at Constantinople into the late Byzantine period. / HAK

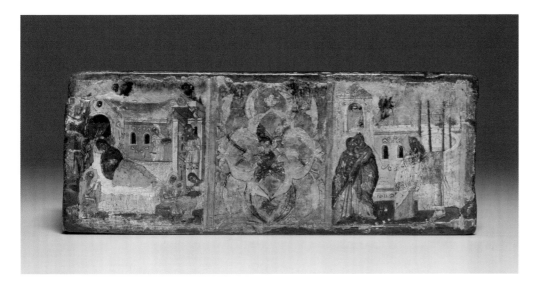

52

53
Reliquary Box

Byzantine (Trebizond), 14th–15th century
Silver gilt (chiseled, repoussé), niello; 9 × 28 × 14 cm
Procuratoria della Basilica di San Marco, Venice (Tesoro 33)

INSCRIBED: on lid: Ο ΑΓ(ΙΟC) ΑΚΥΛΑC | Ο ΑΓ(ΙΟC) ΕΥΓΕΝΙΟC | Ο ΤΡΑΠΕΖΟΥΝΙΤΙΟC | Ο ΑΓ(ΙΟC) ΚΑΝΙΔΙΟC | Ο ΑΓ(ΙΟC) ΟΥΑΛΕΡΙΑΝΟC; on bands on four sides: + ΥΜΕΙC ΜΕΝ ΟΥ ΠΤΗΞΑΝΤΕC ΑΙΜΑΤΩΝ ΧΥCΕΙC ΜΑΡΤΥΡΕC ΗΘΛΗCΑΤΕ ΠΑΝCΘΕΝΕCΤΑΤΟC ΤΟΥC ΤΗC ΕΩΑC ΑΚΛΙΝΕΙC CΤΥΛΟΥC ΛΕΓΩ ΤΟ ΛΑΜΠΡΟΝ ΕΥΤΥΧΗΜΑ ΤΡΑΠΕΖΟΥΝΤΙΩΝ ΠΡΩΤΑΘΛΟΝ ΕΥΓΕΝΙΟΝ ΑΜΑ Δ ΑΚΥΛΑΝ ΟΥΑΛ[Λ]ΕΡΙΑΝΟΝ ΤΕ CΥΝ ΚΑΝΙΔΙΩ ΚΑΙ ΤΗΝ ΑΜΟΙΒΙΝ ΤΩΝ ΑΜΕΤΡΗΤΩΝ ΠΟΝΩΝ Ο Χ(ΡΙCΤΟ)C ΑΥΤΟC ΕCΤΙΝ ΥΜΙΝ ΠΑΡΕΧΩΝ ΚΑΙ ΓΑΡ ΔΙΔΩCΙ ΤΟΥC CΤΕΦΑΝΟΥC ΑΞΙΩC ΕΓΩ Δ Ο ΤΑΛΑC ΠΛΗΜΜΕΛΗΜΑΤΩΝ ΓΕΜΩΝ ΥΜΑC ΜΕCΙΤΑC ΤΗC ΕΜΗC C(ΩΤΗ) ΡΙΑC ΤΙΘΗΜΙ ΦΥΓΕΙΝ ΤΗΝ ΚΑΤΑΔΙΚΗΝ ΘΕΛΩΝ (trans. below)

PROVENANCE: In the Treasury of San Marco from an early date; recorded in 1623

BIBLIOGRAPHY: Pasini 1886, 84–85; Gallo 1967, 314; Frolow 1971, 31–41; Paris 1984, 201–3; Venice 1994, 455–56

Recent scholarship accords in situating the manufacture of this gilded silver reliquary casket in Trebizond (capital of the successor state to the Byzantine Empire, which fell to Ottomans in 1461), between the fourteenth and fifteenth centuries. It probably arrived in Venice as a gift of Cardinal Bessarion (d. 1472), a native of Trebizond.

The lid is secured by three hinges—one at the front and two at the back—and is decorated with five repoussé and chiseled figures standing under arches supported by double twisted columns. At the center of the composition, the enthroned figure of Christ hands the crown of martyrdom to the four martyrs of Trebizond, who turn toward him in prayer: Aquila and Eugene (on Christ's right) and Canidius and Valerian (on his left). The saints are identified by their names, written in Greek characters above their heads.

On the sides of the recently conserved casket, a Greek inscription, engraved and nielloed, runs on two tiers divided by three decorative bands with a palmette motif. It is a poem celebrating the martyrdom of the four saints to whom the author, perhaps Cardinal Bessarion, prays in intercession: "Without fear of spilling your blood, you fought the loftiest battles, O martyrs. I name you the pillars of the East, splendid episode of the race of Trebizond, you Eugene first combatant, and together Aquila and Valerian with Canidius. And Christ himself will compensate you for your incommensurable efforts: rightly he offers you the crown. Whereas, I, miserable sinner, in my desire to escape condemnation, take you as intercessors for my salvation."

The casket is now empty, but a 1623 inventory of the relics of Venice and the Veneto describes the "silver casket with most beautiful decoration in relief, all gilded, with Greek letters and with the images of the saints of Trebizond Eugene, Achilleus, Valerian, and Canidius" as containing "two *ampullae* with the blood of the martyrs and ten other relics of saints and the Virgin." / MDVU

54
The Holy Thorn Reliquary

French (Paris), 1390–97
Gold, enamel, rock crystal, pearls, rubies, sapphires
Height: 30.5 cm; weight: 1404.7 g
The British Museum, London, The Waddesdon Bequest (PE WB.67)
London only

INSCRIBED: in black enamel on a gold label on the stem: ISTA EST UNA SPINEA CORONE DOMINI NOSTRI IHESU RPISTI (This is a thorn from the Crown of Our Lord Jesus Christ)

PROVENANCE: Jean, Duke of Berry, perhaps given away before 1401; Geistliche Schatzkammer (Spiritual Treasury) of the Hapsburg Emperors in Vienna by 1544; sent from there for restoration to Salomon Weininger in 1860; acquired by Baron Anselm von Rothschild by 1873; inherited by Baron Ferdinand de Rothschild in 1874; bequeathed by the latter to the British Museum as part of the Waddesdon Bequest in 1898.

BIBLIOGRAPHY: Vienna 1860, no. 70; Schestag 1872–74, no. 607; Sitte 1901, 140–41, no. 69, figs. 1, 2; Read 1902, no. 67, pl. 16; Hayward 1974, 170ff; Tait 1986a, no. 1; Cherry forthcoming

This reliquary, with its magnificent vision of the Last Judgment, was made to contain a thorn that the Latin inscription asserts, came originally from the Crown of Thorns placed on Christ's head before the Crucifixion. The Crown of Thorns was brought to Paris from Constantinople by Louis IX of France, who constructed the Sainte-Chapelle in Paris to house it. The Crown was closely associated with the French royal family, and individual thorns were used to make jewels of various kinds.

This reliquary of the Holy Thorn was made for Jean, duke of Berry (1340–1416); two panels on the base are enameled with his arms as used before 1397. He was the third son of Charles V of France and exercised almost sovereign powers in the Berry, with Bourges as its capital. There, next to his palace, he constructed a mortuary chapel modeled on the Sainte-Chapelle in Paris, which was consecrated in 1405. The scale of the reliquary and the sumptuous nature of the gold work, enamel, and jewels emphasize the very personal nature of the reliquary. The belief that the Crown of Thorns was merely on deposit to the realm of France until Christ would claim it back on the Day of Judgment may have influenced the choice of subject matter that enshrines the Thorn.

It is thought that Jean may have given away this reliquary before 1401, perhaps as one of his *étrennes*, or New Year's gifts, used to affirm patronage and build ties of allegiance at the Valois court. The reliquary is first recorded in the 1544 inventory of the treasury chapel of the Holy Roman Emperors in Vienna. It remained there until 1860 when it was sent for restoration to Salomon Weininger, who kept the original and returned a replica. The original reliquary was then acquired by Baron Anselm von Rothschild of Vienna before 1873 and passed to his son, Baron Ferdinand de Rothschild, by inheritance. The story of the forgery and substitution was only uncovered in 1925 through the work of Joseph Destrée. / DT

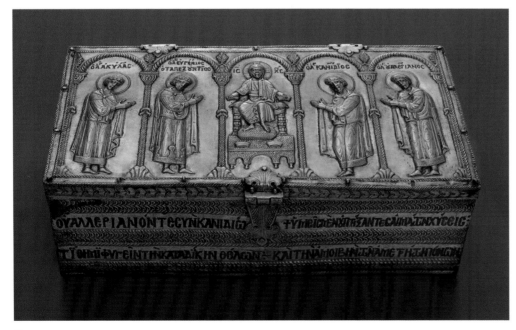

53

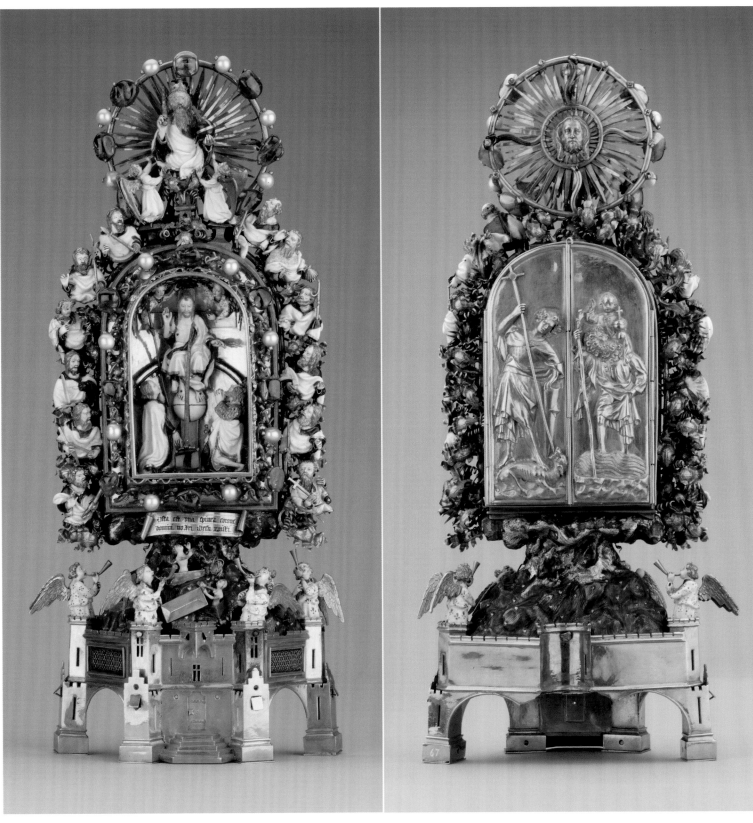

RITUAL AND PERFORMANCE

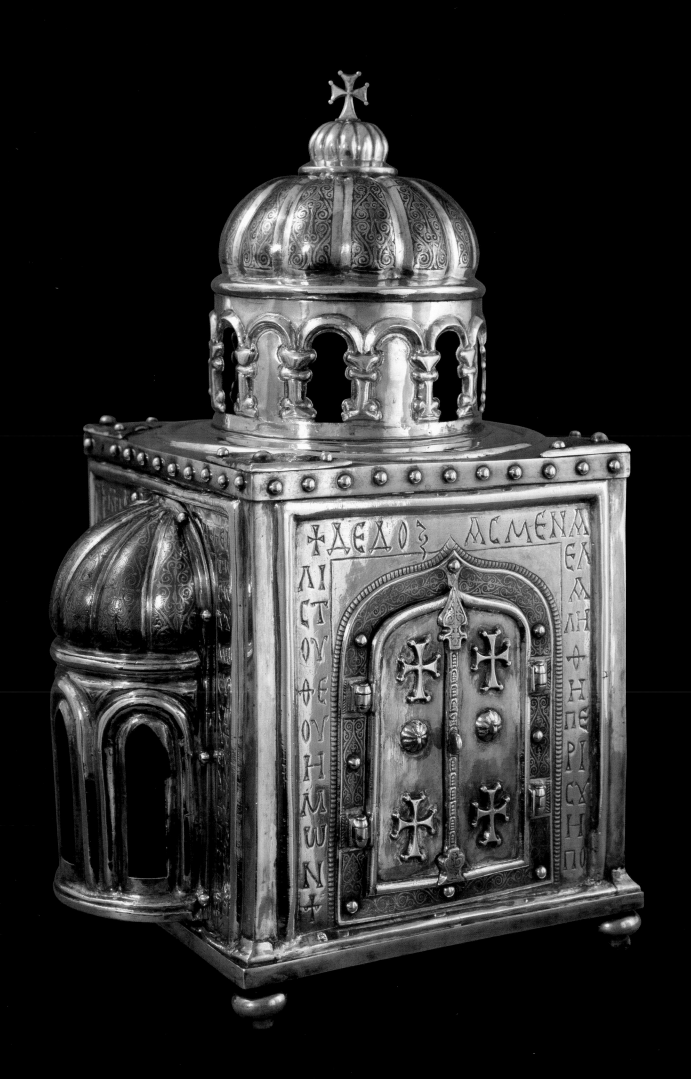

Relics, Liturgical Space, and the Theology of the Church

ÉRIC PALAZZO

In his *Mitralis de officiis*, the great liturgical commentator Sicard of Cremona (1155–1215) devotes a long discussion to the symbolic significance of the building designed for enacting Christian rituals.[1] His exegetical reading is inspired by the church's plan, which takes the form of a cross and its constituent parts. Its length and breadth, for example, symbolize the Christian virtues, disseminated through the world by means of the Church. Crypts, he observes, are the symbols of hermits, who lead a more secluded life than do others, and the building's walls represent the religious, whose prayer and faith constitute the unity of Christians. Sicard is equally interested in the symbolism of various elements of the church, such as the windows, which, he observes, are the Doctors of the Church, enabling the divine light to reach the faithful. A little farther down, Sicard also compares the windows to the five senses, which facilitate the understanding of the Holy Word. He moves on to stress the ecclesiastical significance of the place of worship and all that constitutes it. In other words, for this author the physical structure of the church is a "representation," an "image" of the institutional Church and Catholic theology at its most sophisticated. One finds a similar notion in the symbolic meaning of portable altars (see cat. nos. 42, 65, 66), which, in addition to their actual liturgical function, were also treated in exegetical, liturgical, and canonical literature as miniature representations of the physical church, like the images that came to symbolize the institutional Church.[2] In both instances—the physical church and the portable altar—the presence of relics was essential in defining places of worship and their symbolic significance. Indeed, from the earliest period of Christianity and throughout the Middle Ages, the place where the liturgy was celebrated was defined by the presence of relics, among other elements. The exegesis of the account in Revelation 6:9 that situates the souls of martyrs beneath the altar institutionalized the Late Antique and medieval conception of the church as a monumental reliquary whose primary purpose was to protect the relics of the saints that had been laid within its altars. The placement of relics in column capitals, such as those of two columns erected in the nave of the Church of St. Michael at Hildesheim during the Ottonian period, which bear inscriptions naming the saints whose relics are preserved within,[3] attests to a theological emphasis on the founding of the church (in both its physical and ecclesiastical sense) on the sacred relics of saints. To the same degree, reliquaries crafted in precious metals, which survive in great abundance from the twelfth century onward, should be construed as "miniature" churches, on the model of portable altars conceived as "images" of churches, down to the smallest architectural detail (see cat. nos. 40, 44, 55, 69).

I shall begin by considering, on the basis of the symbolic background treated briefly above, the relationship between the cult of relics and the architecture of medieval churches, using specific examples to outline the possible influence of the cult of relics on architectural design and the evolution of church architecture over the course of the Middle Ages. In the second section I consider the arrangement of liturgical spaces, informed by the cult of relics as well as by various aspects of ritualized performance that directly implicated the presentation of relics in the context of the church.[4]

The Cult of Relics and Their Influence on Architectural Forms

In 1999, Jean-Pierre Caillet outlined current thinking on the relationship between the cult of relics and the forms of Christian architecture during the high Middle Ages and the Romanesque period.[5] Rejecting the notion of the strictly liturgical functionality of Christian buildings, Caillet instead proposed that liturgical practices informed the design of architectural spaces. He usefully surveyed several well-known examples of Carolingian and Romanesque buildings as a means of exploring the impact of ritual imperatives, notably those that implicated relics, on architectural typology. At first glance, the cult of relics might seem to have had scant influence on Carolingian architectural forms—at least with respect to their principal elements. At the same time, during the Carolingian period, as in Late Antiquity, relics were significant objects of devotion and the focal point of liturgical practice; their influence on the design of the interiors of Carolingian churches is unmistakable. One need only consider the configuration of crypts in the apses, the proliferation of altars in the church, or even the need to regulate processions within the cult edifice. For Caillet, the defining element for understanding the influence of relics and their cult on medieval religious architecture is the identification of the church as a reliquary. I would add to that observation the idea that reliquaries, in their capacity as objects, were themselves associated with the "image" of the physical church that at least some reliquaries were intended to represent. In the Romanesque period, the relationship between the liturgy and architectural forms drew even closer than during the Carolingian period; one might posit on this evidence that the cult of relics had a stronger influence than earlier on the architecture of the church and the design of its interior. Such was the case in the architecture of pilgrimage churches (notably the multiple apses), as well as the ritual practices that took place within them (numerous processions directed toward the veneration of relics), although one should not rule out, in this particular case and others, the possibility that architectural innovation might equally have been driven by the development of construction techniques or architectural aesthetics.[6] A brief account of the characteristics of a few monuments of the high Middle Ages and of their relationship with the liturgy and relics may help refine these questions.[7]

At its core, the medieval church was a space intended for performing the liturgical ritual.[8] Its architecture, like the layout of its interior, responded to the needs of the various ceremonies conducted within, many of which implicated the veneration of relics. Following the substantial innovations in Christian architecture of Late Antiquity, the Carolingian period witnessed the birth of most of the new forms that were to have a significant legacy throughout the Middle Ages. The builders of the eighth and ninth centuries proved remarkably ingenious in adapting spaces to the needs of the Roman liturgy that informed the culture of the Carolingian empire.[9] Particularly noteworthy are the unprecedented innovations,

driven by the cult of relics, in the design of altar decoration and the increase in the number of altars in churches. In addition to the cult of relics, the proliferation of altars during the Carolingian period reflects the emergence of new liturgical practices such as votive Masses and paid indulgences as well as the desire to emulate Roman religious topography through altars and their relics, which were conceived as copies of the titular churches of Rome. Collectively, these innovations gave birth to new architectural forms, such as narthexes (at Centula [Saint-Riquier] and Corvey), rotundas (at St. Michael of Fulda), and crypts—especially the annular, or ring, crypts based on the *confessio:* a chamber that contained the relics of a venerated saint. Beginning in the Carolingian period, the architectural typology and the liturgical function of crypts assumed new characteristics that were informed by the cult of saints and their relics. In the late eighth century and throughout the ninth, the cult of relics witnessed an unprecedented fervor, inspiring architects to design crypts expressly

Fig. 34. Plan of St. Gall. Early 9th century. Stiftsbibliothek St. Gallen, Cod. Sang. 1092

intended for the veneration of relics. In addition to a diversity of vaulted spaces that could house relics—such as the narthex of Centula at the end of the eighth century—builders constructed subterranean or half-buried spaces that warrant classification as crypts.[10] Half-buried annular crypts were laid out at church chevets to form a half-circle around the choir. Inspired by the architecture of St. Peter's in Rome, annular crypts were built throughout the Carolingian Empire, as attested by buildings like the abbey of Fulda or even the idealized plan of Saint-Gall (fig. 34). Essentially, their architectural configuration was determined by their principal function: the veneration of a saint's relics. Situated beneath the choir in the church's *confessio*, the relics were visited by pilgrims who circulated around them in great processions, mandating the creation of a space that ensured easy access to the relics. The annular crypt was ideally suited to the purpose. In this architectural and liturgical configuration, the tomb of the saint was the linchpin around which processions circulated in the semicircular, half-buried space of the annular crypt. Architects of the Carolingian period devised other solutions as well to the problem posed by the cult of relics. In Burgundy, for example, architects built crypts with a design different from that of annular crypts.[11] The space that surrounded the saint's tomb was no longer deployed as a semicircular crypt but rather according to a design resembling an apse with radiating chapels. A complex system of internal circulation gave access to the crypt itself from the building's choir. The upper and lower crypts of the abbey of Flavigny, completed around 860, are particularly representative of this type of design.[12] Sheltering the relics of St. Prix (and subsequently those of St. Reine) deposited in the *confessio*, and transforming this space into a monumental reliquary, a vast network of internal circulation that led from the crypt to the upper level facilitated the expression of a dynamic liturgy centered on the cult of relics. The monumental framework of the lower and upper crypts (the latter are in fact at the level of the chevet's chapels) concentrated the liturgical process on the building's eastern side. Transformed over time into the ambulatory— an architectural feature widely used during the Romanesque period—the design had a long posterity. In the Carolingian period, the church of the Abbey of Saint-Germain at Auxerre still incorporated an elaborate network of crypts, situated at the building's apse, intended for the promotion of relics.[13] In the middle of the ninth century, the *confessio* in which the relics of St. Germanus were preserved was extensively reconfigured. A vast crypt, partly separated from the main body of the church, was constructed expressly so that pilgrims flocking to Auxerre could venerate the saint's relics.[14] The crypt at Auxerre (fig. 35), which alternates circulatory passage-ways with spaces for the cult and adoration of relics, constitutes a church in itself. In the *Miracula sancti Germani*, Heiric of Auxerre left eloquent testimony on this architectural complex, innovative for its time and destined for a long posterity. In describing the site's liturgical function, the chronicler particularly emphasizes the cult of relics: "After the construction had been finished and all that enhanced the decoration completed, the very holy body of the blessed Germanus, whom all should venerate, was transferred

Fig. 35. Sectional axonometric of the Church of Saint-Germain, Auxerre

into a crypt entirely worthy of such a treasure with the pomp of a great ceremony and a very special respect The incomparable treasure of his body, which all should adore, translated to the middle of a vast cortege, was laid to rest, with a very great glory and the highest respect, where we now venerate him and give him homage."[15]

In addition to the opportunities presented by narthexes and crypts, the proliferation of altars dependent on the cult of relics in churches of the high Middle Ages provided an occasion for devising and developing other architectural forms, such as chapels; most often these were situated within or directly adjacent to the church, and their essential liturgical function was related to the cult of relics. The church at Reichenau-Mittelzell, for example, contains no fewer than six discrete phases of construction from the eighth century to the beginning of the ninth.[16] At the beginning of the ninth century, the church comprised a short nave with a large transept, a square crossing, and a long choir composed of two twin apses (fig. 36). Between 925 and 946, an axial chapel in the form of a rotunda was built on the eastern side; it was connected to the church by two corridors that gave access to the two apses of the choir. The acquisition of relics of Christ's blood and of the True Cross was the occasion for the construction of a circular chapel at Reichenau-Mittelzell in the middle of the tenth century. These relics were the object of careful handling and special veneration, placed in a cross-reliquary that lay on the altar in the center of the newly built chapel dedicated to the Holy Cross. This liturgical treatment was mainly (but not exclusively) directed at the cult of precious relics

acquired by the German abbey. In effect, the altar of the chapel of the Holy Cross was built in order to enlarge and complete the already highly elaborate design of the church's other altars. The chapel on the building's western side contained an altar dedicated to St. Mark; another dedicated to the Holy Cross stood at the exit to the building's west front; an altar dedicated to the Savior was situated in the middle of the nave, two side-altars in the arms of the transept, the main altar in the choir and dedicated to the Virgin, the monastery's patron; finally, the two altars of the apses were dedicated to the apostles Peter and Paul. The altars dedicated to St. Mark, the Holy Cross, the Savior, and the Virgin defined an east-west axis that terminated in the chapel of the Holy Cross, which housed the relics acquired by Reichenau-Mittelzell in the middle of the tenth century. This layout was little changed by Abbot Witigowo (r. 985–97), who was responsible for significant renovations on the church's westwork that were begun in 988. Clearly, the church's architecture, with the addition of a chapel to the east, was largely determined by the layout of the altars and the liturgical practices related to the cult of relics. The eastern orientation of the liturgical activity of churches in the high Middle Ages endured for several centuries after the Carolingian period, notably in Romanesque structures. In the eleventh century, it was the basis of a new type of architectural space, although initially associated with Carolingian crypts: the rotunda. Altars proliferated in these multistory buildings, thus empha-

sizing the cult of relics to such an extent that it seems entirely plausible to consider rotundas as monumental reliquaries. The most representative example of this architectural form is the rotunda of Saint-Bénigne in Dijon (fig. 37), of which only the lower story survives.[17] Begun in 1001 at the instigation of William of Volpian, this building, of major importance in the history of medieval architecture, was consecrated in 1016; the rotunda to the east of the church was consecrated only two years after the church's dedication. To get an idea of the complexity of its architecture and of the liturgical design, most of which was intended for the cult of relics, we turn to a chronicler of the second half of the eleventh century, who described the monument in some detail, compensating somewhat for its almost complete disappearance. He describes, among other elements, the first floor of the rotunda, which was dedicated to the Virgin and contained other altars dedicated to other saints: John the Evangelist, James, Matthew, Thomas, James the Younger, and Phillip. From this story, stairs gave access to a second story dedicated to the Holy Trinity, and the rotunda was crowned by a third story dedicated to St. Michael the Archangel. A solemn liturgy was conducted in the rotunda, conceived both as a separate church, complementing the nave with its collaterals, and as a reliquary whose function was to protect the relics preserved in the altars and to serve as the setting for enacting the liturgy, which was emphatically based on the cult of relics.[18]

Fig. 36a. Plan of the choir of the Church of Sts. Maria and Marcus, Reichenau-Mittelzell. From W. Erdman and A. Zettler, "Zur karolingischen und ottonische Baugeschichte des Marienmunsters in Reicheanau-Mittelzell," in *Die Abtei Reichenau* (Sigmarigen, 1974), 511

Fig. 36b. Axonometric projection of the Church of Sts. Maria and Marcus, Reichenau-Mittelzell

Fig. 37. Sectional axonometric of the Church of Saint-Bénigne, Dijon. Reconstruction by Carolyn Malone, drawing by G. Monthel

Another important eleventh-century building, the Church of the Abbey of St. Michael of Cuxa (figs. 38, 39), shows close affinities between architectural taste, a liturgy devised expressly for this church, and the cult of relics.[19] The alterations to the church, undertaken in the middle of the eleventh century by the abbot Oliba, which survive in part to this day but are known largely through the description and commentary of the monk Garsias in a treatise dedicated to the abbot of Cuxa, mainly entailed the chevet and the church's westwork. To the east the builders added apses that housed the altars and their relics. Another unusual feature for the period was the presence of two towers situated at the ends of the transept, whose symbolic significance, alluding to the defense of the Church by the angels and recorded in Garsias's text, emphasized affinities between the church of Cuxa and the heavenly Jerusalem.[20] The architectural alterations to the church in the eleventh century included the construction of a rotunda on the church's western side which resembles that of Saint-Bénigne of Dijon, although they are distinguished by their siting. The rotunda of Cuxa comprises two stories dedicated to the Virgin and the Trinity as well as to the church's protector archangels. Altars on both stories contained relics organized to celebrate a sumptuous liturgy, undoubtedly quite similar to that conducted in the rotunda at Dijon, whose essence relied on the cult of relics, suggesting a conception of the rotunda of Cuxa as the monumental "representation" of a reliquary.[21]

Relics and the Liturgical Design of Churches: The Ritual Performances of Relics

In the early twelfth century, Thiofrid, abbot of Echternach (d. 1110) composed the *Flores epytaphii sanctorum* (literally, Flowers Strewn over the Tombs of the Saints) which, together with Guibert de Nogent's *De sanctis et eorum pigneribus* (On the Saints and Their Relics, ca. 1114–20) is one of two medieval treatises devoted to the cult of relics. Thiofrid proposed a typology of the forms of relics based on their physical, sensory qualities rather than on the hierarchy of saints in heaven or on other symbolic categories. In this context, he construed relics (notably the *arma Christi*) above all as objects defined by the senses. Michele Ferrari demonstrated that two of the manuscripts containing the text of the *Flores*, made at the scriptorium of Echternach and containing illuminations, convey this validation of the sensory perceptions of relics, which he convincingly associates with contemporary thought on the actual presence of the divine in the Eucharist.[22] Theofrid's treatise emphasizes that saints' relics are not only "sacred" objects of cult and religious devotion but also objects intended to quicken the senses in the liturgy. In some respects, the liturgical layout of churches in Late Antiquity and the Middle Ages also expressed the sensory element associated with the way in which relics were understood.

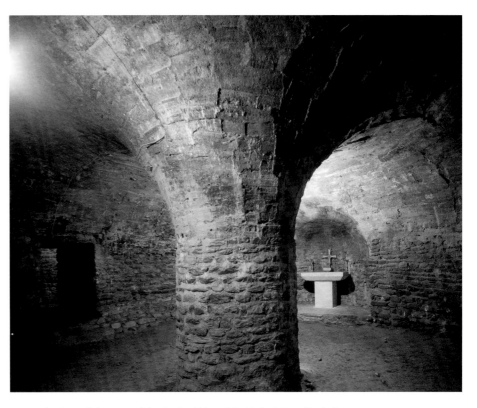

Fig. 38. Plan of the church of the Abbey of St. Michael, Cuxa (Prades). From M. Durliat, *Roussillon Roman* (Paris, 1958), 42

Fig. 39. The Crypt of the Virgin of the Creche, Abbey of St. Michael, Cuxa (Prades)

Already in Late Antiquity, the emphasis on relics—both ritualistically through altars and on a sensory level through reliquaries—played an important role in the liturgical design of churches. We know, for example, that the spatial organization of large Roman churches in Late Antiquity and the high Middle Ages was in large part based on the cult of saints' relics through altars situated according to a strategy that was at once liturgical and political.[23]

These hypotheses regarding relics and their impact on liturgical design in the high Middle Ages are illuminated by a passage from the Life of St. Benedict of Aniane, the Carolingian monastic reformer, composed soon after the saint's death by the monk Ardo Smaragdus. This text, a wealth of information in any number of areas, contains all the characteristics of a biography intended to bring its subject to life as well as to record his historical significance.[24] A passage in the *vita* provides a summary account of the reconstruction of the church at Aniane undertaken in 782 at Benedict's instigation. While Ardo's description of the new building's main elements is not unusual in hagiographies of the high Middle Ages, the passage nonetheless attests a certain originality in its emphasis on the symbolism, related mainly to relics and the cult of saints, of the architecture and of the liturgical design planned for the new building. Ardo focuses on the triune and septiform symbolism of the church's architecture and the organization of its liturgical space, in particular the design of the various altars in the choir intended to evoke the three figures of the Trinity.[25] Elements of the passage lend plausibility to the argument that it prefigures in some ways the symbolism of the liturgical space—particularly the emphasis on the Trinity—as it was developed two centuries later by Abbot Oliba (d. 1046) and recorded in Garsias's biography. Here are some excerpts from Ardo's account:

> In the year 782 . . . Benedict, with dukes and counts aiding him, undertook to construct another large church in honor of our Lord and Savior. . . . [He] adorned the cloisters with as many columns as possible placed in the porches. . . .
>
> Venerable Father Benedict decided upon pious reflection to consecrate the aforesaid church not by the title of one of our saints but in the name of the Holy Trinity. For it to be more clearly recognized, he determined that three small altars should be placed near the main altar so that by them the persons of the Trinity may be figuratively indicated. A marvelous arrangement it is: by the three altars, the undivided Trinity is shown forth, and by the single altar, the true Godhead in essence is shown forth. The great altar is one solid surface on the front but inwardly concave. In figure it suggests what Moses built in the desert. It has a little door behind where on ferial days chests containing various relics of the fathers are enclosed. The foregoing statements suffice concerning the altar. . . .
>
> All the vessels that are kept in the building are consecrated to the number seven. For instance, there are seven candelabra wondrously

wrought by the craftsman's art. . . . In front of the altar hang seven lamps, marvelous and beautiful, cast with inestimable labor, lighted in the manner of Solomon by trained persons eager to tend them.

> In the same way other lamps, silver ones, hang in the choir arranged as a crown; little rings were soldered all around each of the lamps, and on high feast days, it was customary to place goblets filled with oil in the rings and light them. When they were lighted the whole church was aglow at night as if it were day. Lastly, three further altars in the basilica were dedicated, one in honor of Saint Michael the archangel, another in devotion to the blessed apostles Peter and Paul, and a third in honor of good Stephen the protomartyr.
>
> In the church of blessed Mary Mother of God which was first established, there are altars of Saint Martin and the blessed Benedict. But that one that is built in the cemetery is distinguished in honor of Saint John the Baptist, than whom among those born of women none greater has arisen, as the divine oracles testify. . . . It is appropriate to ponder with what profound humility and reverence this place was feared by them, this place protected by so many princes. . . . By the seven altars, by the seven candelabra, and by the seven lamps, the sevenfold grace of the Holy Spirit is understood.[26]

In the fashion of other monastic churches of the high Middle Ages, the dedications of the seven secondary altars of the church at Aniane evoke the beginning of liturgical lists—that is, the long series of names of saints with a liturgical vocation—composed during the Carolingian period and forming a sort of heavenly cohort that protected the place, as relics protected both the building and the institutional Church.

A second text brings us to England in the second half of the tenth century. Several clerics dominated the English ecclesiastical scene during this period. The leading figure among these was St. Æthelwold, bishop of Winchester from 963 to 984, whose impact in the sphere of politics was mirrored in artistic activity of vast scope.[27] Of particular interest in the latter regard is Æthelwold's reconstruction of the cathedral of Winchester; its first dedication is plausibly dated to 20 October 980. On Æthelwold's death in 984, his energetic successor, Ælfeah (984–1005), brought his illustrious predecessor's architectural projects to fruition. The ambitious extent of the work is relatively well known thanks to a group of documents, including several passages in the *Narratio metrica de sancto Swithuno*, composed in the last decade of the tenth century.[28] Wulstan, the text's author, devoted several passages of the hagiography to a description of architectural alterations and liturgical designs realized in the cathedral of Winchester by Æthelwold and Ælfeah. Several of these alterations, including various aspects of their symbolic interpretation provided by the writer, lend themselves to interesting conclusions regarding the importance of relics and their liturgical context. Wulfstan's text, preceded by an *Epistola specialis ad Aelfegum episcopum*, the content of which recalls elements characteristic of dedicatory letters,[29] provides a wide-ranging account of the dedication

of the cathedral by Bishop Æthelwold.[30] The passage abounds with interesting details about the liturgy, calling to mind basic ideas that regularly appear in texts of this sort: a balance of liturgical description and the glorification of the bishop-architect of a building of unprecedented scale. Of greater interest in the present context are descriptions of several specific elements of the new building, beginning with the eastern chapel, built by Æthelwold with the assistance of the Holy Spirit with which he was filled.[31] The passage that immediately follows the account of the eastern chapel describes the crypts; their construction was carried out by Æthelwold's successor, Ælfeah, who had the burden, the text tells us, of completing the work undertaken by his predecessor. Thereafter follows the literal description of this space, which, according to specialists, may correspond to an annular crypt composed of several compartments.[32] The *vita* recounts that each of these compartments had an opening at the top (at roof level); darkness nonetheless prevailed. In two instances, the text's author emphasizes that a pilgrim unfamiliar with this space or visiting these crypts for the first time would have been hard pressed to find his way out. To enable visitors to orient themselves, openings (windows, perhaps) were pierced in these compartments, which introduced sunlight into the dark space. Finally, each compartment of this vast crypt sheltered an altar containing relics that amounted to spiritual illumination, intended to spread light beyond the building itself into the Church and the larger world.[33] In fact, this text, which surely warrants deeper study (in particular, to tie the account to what we know of the architecture of crypts of the high Middle Ages), constitutes a short introductory treatise for Christians. I cannot in the context of this essay treat the *vita*'s theological content or its poetical style in detail (the latter is clearly deeply indebted to the influence of Venantius Fortunatus [530–609]),[34] but for the purposes of this discussion, I would emphasize the strongly symbolic character of the liturgical space described in this passage of Wulfstan's *Narratio*, in which the relics are of primary importance. In effect, the crypts of the cathedral of Winchester, or, more accurately, the crypt and its various compartments, are conceived as a labyrinth seemingly intended to disorient the first-time visitor. The author's emphasis on the prevailing darkness in these spaces, which made it difficult for the visitor to find his way, may be a metaphor for the path of the Christian, who, lost in darkness and unable to find his path, makes his way toward salvation thanks to the light of the sun, which illuminates the space of the crypt in different ways and at different times of day, thus guiding him toward the spiritual light that he will reach as a result of the power of the saints whose relics, contained in the altars situated in each compartment of the crypt, radiate beyond the building's walls. This account of the crypts of the cathedral of Winchester clearly communicates the symbolic dimension of the space as it relates to the spiritual progress of the Christian and the function of relics in this journey. In other words, the architecture of the crypt becomes here a perfect metaphor for Christian theology, stressing the relationship between darkness and light, centered on the path of Man, guided upward by relics, toward the light.

The layout of the great Gothic cathedrals, recorded in the Ordinaries and Ceremonials that describe the ritual performances in great detail, attests the same desire as in the high Middle Ages to situate relics, by means of altars and reliquaries, at the heart of the system of liturgical celebrations.[35] Marie-Pasquine Subes-Picot's analysis of the layout of the apse of the cathedral of Angers and the composition of its thirteenth-century painted cycle is a particularly important study in this regard.[36] Studying the various sources relating to the cathedral's liturgical design in the thirteenth century, Subes-Picot reveals the emphasis placed on the figure of St. Maurille through the main altar, probably built by Bishop Guillaume de Beaumont (1202–40) and the new chasse containing the saint's relics, given to the cathedral by Bishop Guillaume in 1239. She notes the close relationship between the painted images of the choir, dedicated to St. Maurille, and certain images on the saint's shrine, which was in some respects the linchpin of the sanctuary's liturgical design. Subes-Picot makes a persuasive case for the proposition that the paintings are in fact the enlargement, at a monumental scale on the apse's walls, of figural scenes on the shrine's medallions. The parallels between the decoration of the chasse and the monumental images on walls of the cathedral's choir reinforce the hypothesis that, in the symbolic thought of the Middle Ages, the church was a monumental reliquary.

To illustrate the strongly performative aspect of relics in the liturgy and their ties to the church as an architectural structure, consider the centrality of relics in the development of the ritual of church dedications, whose history can be traced back over several centuries from early Christianity through the Middle Ages in their entirety. In Late Antiquity and the Middle Ages, churches were constructed around the altar and the relics that it contained. The decision to erect an altar and then a church in one place or another coincided with the emergence of a saint's cult. The church was erected around the saint's relics, contained in the altar, and it was there that the congregation met to animate the local Church, viewed as a part of the body of Christ. Christian theologians compared the church to a human body, drawing an analogy between the transformation of the human soul through baptism and the sacramental effects of a church's dedication. This explains the body's general importance in the dedication ritual. With respect to relics, the rite, as it is conceived in the *Ordines Romani* 41 (ca. 750–75) and 42 (the Roman text regarding the dedication and disposition of relics, ca. 700–750), provides that the main element of the ceremony be centered around the deposition of the martyrs' relics and the consecration of the altar. Thus, during the evening vigil preceding the day of the dedication, the deposition of the relics begins: contained in a temporary reliquary of sorts, they are placed under a tent outside the church. The next day, they are carried in procession into the building according to the appropriate rite and then deposited in the altar. The Roman ritual emphasized the moment when the bishop seals the mortar of the "sepulcher"—that is, the altar in which the relics are deposited.

Fig. 40. Plans of the Church of Cluny II (left), the Church of Saint-Bénigne at Dijon (center), and the Church of Saint-Philibert at Tournus (right)

Other liturgical rituals envision a diversion of the sacred character of relics; among these, the most widely known is the humiliation of saints.[37] In the Middle Ages, saints were occasionally held responsible for the troubles that befell men on earth, and the invocation of saints in the liturgy was in effect turned on its head. During the medieval period the ritual in which men (particularly monks) humiliated a saint took place when they deemed that he had failed to fulfill his role as protector.[38] Elaborated in the context of the monastic liturgy during the tenth and eleventh centuries, this ritual consisted of insulting the saint for his ineffectuality by hurling complaints and curses against his image or his relics. In certain monasteries, such as Cluny, the humiliation of saints took place during the celebration of the Mass. Between the *Pater noster* and the *Libera nos*, the monks placed a piece of cloth on the ground in front of the altar and laid a crucifix, the Gospels, and the saint's relics on the cloth; these objects were then cursed while the monks prostrated themselves before the altar in a gesture of submission and the choir sang penitential psalms. God's servants—monks and saints—abased themselves so as to implore divine protection when the protection afforded by the relics did not work. The ritual of humiliating saints, particularly through their relics, was generally believed effective, since God, having heard the prayers of his servants, allowed the reparation

of wrongs visited on relics. The conduct of the ritual in the context of the church attests to the continuous expectations that relics evoked: to justify the offerings made to them during the liturgy, relics were obligated to offer man protection. This singular ritual enables us to gauge the central position that relics occupied though the liturgy in the spiritual and social life of the Middle Ages.

Conclusion

Church relics play a crucial role in understanding the symbolic meaning of the place of worship in medieval Christianity, for they were the foundation of both the physical and the institutional church. Liturgical practices evolved in close relation to the cult of relics and the design of churches during Late Antiquity and the Middle Ages, although those developments do not eclipse the importance of architectural ingenuity. The foregoing analysis of the main elements of the liturgical outline of the church and of certain rituals that entailed the use of relics emphasizes the primary importance of relics in the organization of the ritual space of the church, notably through sensory perception. Through relics and their cult, the

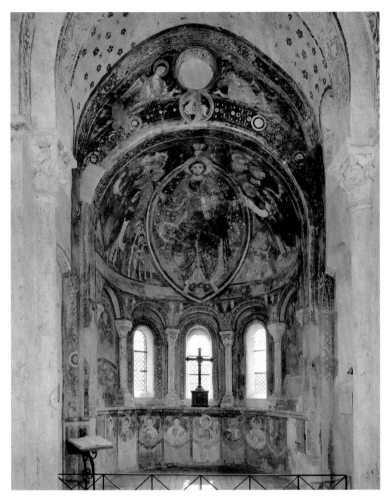

Fig. 41. View of the apse and the early 12th-century wall paintings in the Cluniac chapel of the priory, Berzé-la-Ville

church was transformed into a true monumental reliquary whose ultimate purpose was to express a theological understanding of the liturgy.

This liturgical and theological interpretation must be supplemented with a political reading of the role of relics in the Church. The iconographic program of certain buildings, based largely on hagiographic figures, as well as the spatial organization of relics and reliquaries within the leading churches of the Middle Ages, leads to a conception of the church building as the "image" of the Christian community and its saints.

The church of Cluny II (fig. 40, left), founded in the tenth century during the rule of Abbot Maieul (906–94) and extensively renovated under Abbot Odilon in the eleventh, provides an apt illustration of this idea. This edifice was built above the abbey's first church, that which archaeologists call Cluny A. The originality of Cluny II inheres particularly in the design of its chevet. Whether or not it included crypts, this section of the church was quite sophisticated, comprising several staggered apses. These apses fulfilled several liturgical functions mentioned in the *Liber Tramities* (ca. 1035–40), the Customary of Cluny, which describes the abbey's liturgical and monastic customs during the time of Odilon. Several altars erected in the chevet enabled monk-priests to celebrate votive Masses. The great number of relics inventoried in the customary

of Cluny suggests an equivalent number of small reliquaries that were led in processions in the church on the main feast days of the liturgical year. Alain Guerreau interprets this impressive collection of relics as a kind of geography of the sacred. In a single space—the church of Cluny—all the landmarks of Christianity are represented through relics: Palestine, Rome, St. James of Compostela, and the major cities of Gaul. In this case, the liturgical space intended to celebrate the abbey's various rituals is coupled with a physical character that is at once ecclesiastical and political, making the church the space of Christianity par excellence, in which the saints hold a predominant place.[39] The decoration of the apse of the chapel at Berzé-la-Ville (fig. 41), painted at the beginning of the twelfth century at the instigation of Hugues de Semur, the abbot of Cluny, also falls under Cluny's orbit. The iconography of Berzé-la-Ville astutely joins political themes emphasizing Cluny's support of the Gregorian reforms—embodied in the presence of the *Traditio legis*—with others underscoring the local grounding of the chapel, notably the representation of hagiographical themes centered around the figures of St. Blaise and St. Vincent, the patrons of farmers and wine-growers, respectively, in the region of Berzé.[40] Daniel Russo has convincingly demonstrated that other saints represented in other parts of the wall decoration at Berzé—notably the nine figures represented frontally on the lower register of the wall of the apse—were intended to complete the political and localized decorative program through a message emphasizing "Cluny's apostolic succession to Rome, in a Christianity conceived, experienced, and imagined as a space saturated with relics and on the model of pilgrimage toward God," as the author elegantly phrases it.[41] Jean-Claude Bonne has traced the manner in which the painted program at Berzé and its spatial organization in the apse of the chapel also incorporate a learned discourse on time, whose richness and complexity relative to the reenactment of the *memoria* of the holy during the celebration of the Eucharist, deemed by theologians to constitute the reactualization of Christian mystery, with all of its temporal implications.[42] In several respects, the painted program of Berzé-la-Ville resembled the deployment of relics and reliquaries in the liturgical space of Cluny II during the time of Odilon, which Guerreau interprets as the perfect embodiment of the physical space of Christianity and its saints. Both cases affirm the determinative function of relics, or of images of the saints with which they are associated, in the organization of the church and its rituals and in the definition of ecclesiastical space.

Notes

1. *Sicardi cremonensis episcopi Mitralis de officiis*, ed. G. Sarbak and L. Weinrich, CCCM 228 (Turnhout, 2008), 13–26.

2. É. Palazzo, *L'espace rituel et le sacré dans le christianisme: La liturgie des autels portatifs dans l'Antiquité et au Moyen Age* (Turnhout, 2008).

3. A. Angenendt, "'In meinem Fleisch werde ich Gott sehen': Bernward und die Reliquien," in *Bernward von Hildesheim und das Zeitalter der Ottonen*, ed. M. Brandt and A. Eggebrecht, 2 vols. (Hildesheim, 1993), 1:361–68, esp. 366. Jean-Pierre Caillet recalls that around the year 1000 the chronicler Thietmar of Merseburg reported that Otto I counseled builders to place relics in several capitals of the cathedral of Magdeburg during its construction: "Preciosum quoque marmor cum auro gemmisque cesar precepit ad Magadaburc adduci. In omnibusque columnarum capitibus sanctorum reliquias diligenter includi iussit." Thietmar von Merseburg, *Chronik*, ed. W. Trillmich (Darmstadt, 2002), 52; J-P Caillet, "Reliques et architecture religieuse aux époques carolingienne et romane," in *Les reliques: Objets, cultes, symboles*, actes du colloque international de l'Université du Littoral-Côte d'Opale (Boulogne-sur-Mer), 4–6 septembre 1997 (Turnhout, 1999), 169–97, at 179. Regarding the inscription on the abacus of the capital in the oratory of Germigny-des-Prés, which gives the date of the dedication (806) and names the saints to whom the church was dedicated (Geneviève and Germain), Cécile Treffort (*Paroles inscrites: A la découverte des sources épigraphiques latines du Moyen Age* [Paris, 2008], 79), believes that it is to all appearances an error introduced during the restoration of the building in the nineteenth century.

4. The bibliography on relics is extensive. In this context, four sources are particularly pertinent: P. Geary, *Furta sacra: Thefts of Relics in the Central Middle Ages* (Princeton, 1990); A. Angenendt, *Heilige und Reliquien: Die Geschichte ihres Kultes vom frühen Christentum bis zur Gegenwart* (Munich, 1994); *Les reliques: Objets, cultes, symboles* (1999, cited in n. 3); and E. Bozoky, *La politique des reliques: De Constantin à Saint Louis* (Paris, 2007).

5. Caillet, " Reliques et architecture religieuse" (1999, cited in n. 3).

6. On this subject, see the pertinent (if sometimes overstated) conclusions of B. Brenk, "Les églises de pèlerinages et le concept de prétention," in *Art, cérémonial et liturgie au Moyen Age*, actes du colloque du 3e cycle Romand de Lettres, Lausanne-Friborg, 24–25 mars, 14–15 avril, 12–13 mai 2000 (Rome, 2002), 125–36.

7. For a general survey of these issues, see my chapter "L'espace du monastère," in A. Davril and É. Palazzo, *La vie des moines au temps des grandes abbayes (Xe–XIIIe siècles)* (Paris, 2000), 197–250.

8. H.L. Kessler, *Seeing Medieval Art* (Peterborough, 2004), 107–30.

9. For a survey, see C. Heitz, *L'architecture religieuse carolingienne: Formes et fonctions* (Paris, 1980).

10. C. Sapin, "Archéologie des premières cryptes du haut Moyen Age en France," *Hortus Artium Medievalium* 9 (2003), 303–14.

11. C. Sapin, *La Bourgone préromane* (Paris, 1986), 81–112.

12. C. Sapin, "La crypte de Flavigny: Un 'reliquaire' pour sainte Reine?" in *Reine au Mont Auxois: Le culte et le pèlerinage de sainte Reine des origines à nos jours*, ed. P. Boutry and D. Julia (Paris, 1997), 81–94.

13. C. Sapin, ed., *Archéologie et histoire d'un site monastique, Ve–XXe siècles: Dix ans de recherches à l'abbaye Saint-Germain d'Auxerre* (Paris, 2000), 181–293; and C. Sapin, *Peindre à Auxerre au Moyen Age, IXe-XIVe siècles: Dix ans de recherches à l'abbaye Saint-Germain d'Auxerre et à la cathédrale Saint-Etienne d'Auxerre* (Paris, 1999), 104–54.

14. J.-C. Picard, "Les *Miracula sancti Germani* d'Heiric d'Auxerre et l'architecture des cryptes de Saint-Germain d'Auxerre: Le témoignage des textes," in J.-C. Picard, ed., *Evêques, saints et cités en Italie et en Gaule: Études d'archéologie et d'histoire*, Collection de l'École Française de Rome 242, (Rome, 1998), 321–33.

15. Hericus Antissiodorensis Monachus, *Miracula Sancti Germani Episcopi Antissiodorensis*, PL 124:1207ff.

16. N.K. Rasmussen and É. Palazzo, "Messes privées, livre liturgique et architecture: A propos du ms. Paris, Arsenal 610 et de l'église abbatiale de Reichenau-Mittelzel," *Revue des sciences philosophiques et théologiques* 72 (1988): 77–87.

17. C. Malone, *Saint-Bénigne et sa rotonde: Archéologie d'une église bourguignonne de l'an mil* (Dijon, 2008); and *Saint-Bénigne de Dijon en l'an mil, "totius Gallie basilicis mirabilior": Interprétation politique, liturgique et théologique* (Turnhout 2009).

18. See Malone, *Saint-Bénigne de Dijon en l'an mil* (2009, cited in n. 17).

19. M. Durliat, "L'architecture du XIe siècle à Saint-Michel de Cuxa," in *Études d'art médiéval offertes à Louis Grodecki*, ed. S. McK. Crosby (Paris, 1981), 49–62.

20. T. Lyman, "Les tours de Saint-Michel de Cuxa," *Les Cahiers de Saint-Michel de Cuxa* 11 (1980), 269–87.

21. On all these issues, see most recently, É. Palazzo, "Liturgie et symbolisme de l'espace rituel à Cuxa du temps d'Oliba," *Les Cahiers de Saint-Michel de Cuxa* 40 (2009), 77–89.

22. M.C. Ferrari, "*Lemmata sanctorum*: Thiofrid d'Echternach et le discours des reliques au XIIe siècle," *Cahiers de civilisation médiévale* 38 (1995), 215–25.

23. See the various example studied by S. De Blauuw, *Cultus et décor: Liturgia e archittetura nella Roma tardo antica e medievale*, Studi e Testi 355–56 (Vatican City, 1994); "The Lateran and Vatican Altar Dispositions in Medieval Roman Church Interiors: A Case of Models in Church Planning," *Cinquante années d'études médiévales: A la confluence de nos disciplines*, actes du colloque organisé à l'occasion du cinquantenaire du CESCM, Poitiers, 1–4 septembre 2003 (Turnhout, 2005), 201–17. See also J.J. Emerick, "Altars Personified : The Cult of the Saints and the Chapel System in Pope Paschal I's S. Prassede (817–819)," *Archaeology in Architecture: Studies in Honor of Cecil L. Stiker, ed.* J.J. Emerick and D.M. Deliyannis (Mainz, 2005), 43–63.

24. For all that follows concerning the Life of Saint Benedict of Aniane, see *Vie de Benoît d'Aniane*, introduction and notes by P. Bonnerue, trans. F. Baumes, revised and corrected by A. de Vogüé (Bégrolles en Mauge, 2001).

25. Ibid., 69–72.

26. The translation is that of Allen Cabaniss, with emendations, in Thomas F.X. Noble and Thomas Head, eds. *Soldiers of Christ: Saints and Saints' Lives from Late Antiquity and the Early Middle Ages* (University Park, Pa., 1995), 228–29, after *Ardonis sive Smaragdis Vita Benedicti Abbatis Anianensis et Indensis*, chap. 5.17, ed. G. Waitz, MGH SS 15.1 (Hannover, 1887).

27. *Bishop Aethelwold: His Career*, ed. B. Yorke (Woodbridge, 1988).

28. *The Cult of St. Swithun*, ed. M. Lapidge, Winchester Studies 4.2: The Anglo-Saxon Minsters of Winchester (Oxford, 2003), 372–97.

29. Ibid., 372–76.

30. Ibid., 376–80.

31. Ibid., 380–81.

32. See the commentary on the archeological survey of these crypts in ibid., 381.

33. "On Crypts. Your excellency [i.e., Ælfeah] straightway succeeded him in the episcopacy and with attentive application brought to completion the work thus begun. What is more, you have taken care to add hidden crypts which Daedelian wit had constructed in such a way that, should any unfamiliar visitor enter them he would not know whence he came nor how to retrace his steps. They have unseen recesses which lie hidden on this side and that; their roofs are open, but inside their compartments lie hidden. The entrance and exit is sealed, but someone who does not know these crypts—which seem to subsist in the depth of night and darkness—might think them devoid of light. Nonetheless, they have the light of the unseen sun; at day-break, when the first rays glimmer, the sun enters and scatters its radiance everywhere, and with the brilliance of its light reaches into all the compartments, until it sinks into the western ocean. Their structure is such that they each in turn contain a holy altar and the holy relics of saints; and their structure is useful in many ways supporting what is without, yet covering what is within." Ibid., 380–82.

34. Ibid., 381.

35. On the relevance of liturgical Ordinaries to the study of the liturgical design of cathedrals from the thirteenth to the fifteenth century, see the examples collected in *Heiliger Raum: Architektur, Kunst und Liturgie in mittelalterlichen Kathedralen und Stiftskirchen*, ed. F. Kohlschein and P. Wünsche, Liturgiewissenschaftliche Quellen und Forschungen 82 (Münster, 1998).

36. M.-P. Subes-Picot, "Remarques sur l'aménagement liturgique de l'abside de la cathédrale d'Angers et la disposition des images du cycle peint au XIIIe siècle," *Cahiers archéologiques* 46 (1998), 129–49.

37. P. Geary, "L'humiliation des saints," *Annales ESC* 1979, 27–42.

38. On the rituals associated with the humiliation of the relics of St. Amandus, see B. Abou-el-Haj, *The Medieval Cult of Saints: Formations and Transformations* (Cambridge, 1994), 102–5, 118–19.

39. A. Guerreau, "Espace social, espace symbolique: A Cluny au XIe siècle," *L'ogre historien: Autour de Jacques Le Goff*, ed. J. Revel and M. Augé (Paris, 1998), 171–77.

40. É. Palazzo, "L'iconographie des fresques de Berzé-la-Ville dans le contexte de la réforme grégorienne et de la liturgie clunisienne," *Les Cahiers de Saint-Michel de Cuxa* 19 (1988), 169–86. This political reading of the program of the paintings at Berzé-la-Ville was recently enlarged by E. Lapina, "The Mural Paintings of Berzé-la-Ville in the Context of the First Crusade and the *Reconquista*," *Journal of Medieval History* 31 (2005), 309–26.

41. D. Russo, "Espace peint, espace symbolique, construction ecclésiologique: Les peintures de Berzé-la-Ville (chapelle-des-moines)," *Revue Mabillon*, n.s. 11, vol. 72 (2000), 57–87, quoted from p. 80.

42. J.-C. Bonne, "'*Temporum concordia discors*': Le temps dans les peintures murales romanes de Berzé-la-Ville," in *Metamorphosen der Zeit* ed. E. Alliez, Ursprünge der Moderne 2 (Munich, 1999), 145–75.

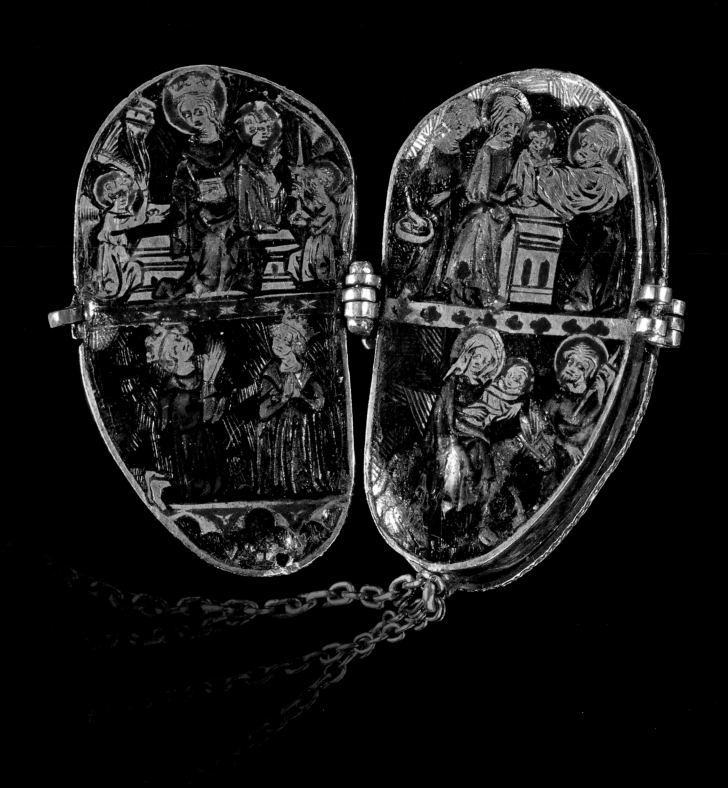

From Altar to Amulet
Relics, Portability, and Devotion

JAMES ROBINSON

As you pray, place a few drops of Holy Water/Holy Oil on your fingers and bless yourself (make the sign of the Cross, put some Water/Oil on your forehead, then on your heart at the center, then on your left chest and on your right chest). Rub the Holy Oil on the body and pray for physical healing. Keep the Holy Earth as a spiritual keepsake.[1]

These directions come not from a medieval medical tract, scientific treatise, or devotional manual but from instructions issued with the purchase of a boxed set of souvenirs offered from one of a multitude of websites specializing in products from the Holy Land. The holy water that is included in the set is taken from the river Jordan, the site of Christ's baptism. Another souvenir available for purchase through the Internet is a collection of Holy Land Blessing Stones.[2] The stones are retailed through a Judaica gift shop in Jerusalem and are valued as both a physical connection with the Holy Land and as an aid to prayer. As in the medieval period, the appeal of this type of souvenir today appears equal among Christians and Jews. The notion that somehow the very ground that Christ or the prophets trod, that the environment they occupied, was imbued entirely with their lasting spiritual presence is central to understanding the power invested in relics. As a modern expression of an ancient tradition, the sale of such souvenirs demonstrates a universal human impulse that seeks closeness to important past events or people through shared physical contact. The merchandising of objects with sacred associations for their healing properties or for the purpose of spiritual renewal was, of course, manifest in the Middle Ages. Then, as now, the success of such ventures depended to a large extent on the portability and availability of material.

The modern taste for simple souvenirs such as olive oil, water, and stones is strikingly close to the collecting instincts of early Christian pilgrims to the Holy Land who went in search of the sacred sites associated with Christ's ministry and the events described in the Old Testament. By the fifth century, a specific pilgrimage route starting at Jerusalem and following a prescribed pattern of holy sites *(loca sancta)* had begun to emerge. The pilgrims might secure for themselves rocks or earth from some of these sites and would sometimes set them into containers, such as painted boxes. A painted box from the sixth or seventh century containing stones collected from various sacred sites survives in the Vatican (cat. no. 13). The box, perhaps the original and most utilitarian means of transporting this ragged assemblage of rocks, amplifies the importance of its contents through painted scenes on the lid. Such precious souvenirs served as keepsakes of the holy places visited by pilgrims, but they also functioned as amulets.

That stones were collected as relics and often set into sumptuous settings is less surprising when seen in the context of scriptural allusion. Christ's assertion to St. Peter "you are Peter, and upon this rock I will build my

church." (Matt. 16:18) gave stone relevance as a symbol of unshakeable faith. Christ too is likened to stone in the Gospels. Paul's First Epistle to the Corinthians (10:4) states, "and all ate the same spiritual food, and all drank the same spiritual drink. For they drank from the spiritual rock that followed them, and the rock was Christ." The association of Christ with stone is reflected in altar construction by the altar stone, the part that alone is consecrated. Writing in the early twelfth century, the Benedictine abbot Rupert of Deutz expressed the relationship in the following terms: "Altare significat Christum."³ Rupert's forthright definition was the product of a long-established understanding of the altar's sacred nature that had its basis in ancient Judaic and classical traditions. The supreme importance of the altar stone ensured that it was the most vital component of portable altars used to celebrate the liturgy in unconsecrated spaces. Only certain stones were considered appropriate for use, and the most usual choices were marble, porphyry, jasper, alabaster, onyx, and serpentine.⁴ A second prerequisite for altar design that was to transform the nature of the portable altar emerged from the Seventh Ecumenical Council of Nicaea in 787, which decreed that relics were to be placed in churches and that no altar was to be consecrated without them. Cavities were made beneath the altar stone to accommodate relics, and although there is evidence to suggest that some portable altars were already equipped with relics,⁵ from this point onward they began officially to serve two functions: that of altar and reliquary.

Éric Palazzo's detailed study of the portable altar in medieval liturgical practice has argued convincingly for the unique part that these objects play in defining ritual space.⁶ To do this, portable altars were charged with the power to convey the spirit of consecration and served as miniature embodiments of the Church and, therefore, the Heavenly Jerusalem. Their construction and embellishment were strongly influenced by Old Testament descriptions of altars furnished with precious materials. The portable altar of Countess Gertrude (cat. no. 42) was originally encrusted with 184 pearls and 92 precious or semiprecious stones.⁷ At its center a porphyry slab encloses a cavity accessed from a trap door on the underneath that contains the multiple relics of saints. The richness of the decoration on the outside appears frequently to have been equaled by the dense storage of relics inside. The British Museum's portable altar from Hildesheim (cat. no. 66) was made to contain the relics of no fewer than forty saints, each of them named on the reverse. Another example from Hildesheim in the Victoria and Albert Museum, London (10-1873), also identifies its relics with an inscription naming thirteen relics, including one relating to the eleven thousand virgins of St. Ursula.⁸

Portable altars by design and definition are mobile. Their principal function was to accommodate the chalice and the paten in the celebration of the Eucharist outside the confines of the consecrated church. The need for this portable liturgical instrument appears to have extended from the early years of Christian persecution, when fixed altars were not feasible, to a variety of contexts ranging from missionary activities, pilgrimage, and the battlefield.⁹ The spiritual power of relics and reliquaries is similarly portable, and relics were used in the same contexts to promote faith. Portability underpins much of the ritual surrounding the veneration of relics. Even large-scale shrines were taken into procession, and the reception of relics into cities was an occasion of great ceremony. Relics were routinely translated or plundered and reestablished in new shrines. The Shrine of the Three Kings at Cologne (see Boehm herein, pp. 156–158) was the result of multiple movements from the time that the relics were discovered by Empress Helena in the fourth century. They were initially kept in Constantinople but were taken to Milan by Bishop Eusebius (d. 462) in the fifth century before finally falling into the hands of Frederick Barbarossa, who took the relics to Cologne in 1164. Cologne became duly celebrated as one of the four most important shrines in Europe. It vied with Canterbury for third place after the great penitential pilgrimages of Rome and Santiago de Compostela.

Canterbury's fame was secured by the murder of its archbishop, Thomas Becket, in the nave of the cathedral in 1170. Becket's renown was partly due to the scandalous nature of the attack that killed him, but it owed something also to the circulation of his relics throughout France, Italy, northern Spain, parts of Germany, and Scandinavia.¹⁰ Plantagenet dynastic marriages and the movement of monks and bishops ensured the steady flow of relics and helped to make him England's only truly international saint. In 1177 when Henry II's daughter Joanna married the king of Sicily, William the Good, they were sent relics of Becket,¹¹ which undoubtedly promoted his cult in Sicily. Their devotion to the saint is shown by a representation of him in the mosaics of the cathedral of Monreale, which was built by William between about 1174 and 1189. A reliquary chasse on loan to the British Museum from the Society of Antiquaries of London, bought in Naples by Sir William Hamilton in the early nineteenth century, may have found its way there in the Middle Ages under the influence of Joanna and William's patronage. Further evidence of a Sicilian-based interest in Becket is provided by the pendant reliquary of Margaret of Navarre, queen of Sicily, now at the Metropolitan Museum of Art, New York (cat. no. 98). It dates from between 1174 and 1177 and was given to Margaret, as the inscription on the reverse indicates, by Reginald Fitz-Jocelyn, bishop of Bath. The miniature scale of the pendant belies the complexity of the politics that produced it. Fitz-Jocelyn and Margaret had displayed unambiguous sympathies with Henry II both before and after Becket's death.¹² It is an eminently personal jewel, made compelling by the Latin inscription on the front, which translates as: "Of the blood of St. Thomas martyr. Of his vestments stained with his blood; of the cloak, the belt, the hood, the shoe, and of the shirt." (De sanguine s[an]c[t]i Thome M[arty]ris de vestibu[s] suis sanguine suo tinctis de pellicia. De cilitio. De cuculla. De calciamento. Et camisia). The inscription most probably refers to blood-stained threads of textile and fragments of leather that were once held within the pendant's cavity, now empty. The depth of the pendant supports this suggestion, since it would accommodate only a relic of the finest dimensions. It seems that the relic was placed behind a panel of crystal or polished horn, now

also lost, and so would appear to constitute an early example of a personal reliquary displaying its relics.[13]

The desire to display relics in personal jewel reliquaries does not necessarily follow the general trend in reliquary design toward visibility. A selection of pendant reliquaries dating from the ninth to the early sixteenth century, discussed below, conceal their contents from view without diminishing the personal engagement of the devotee with the relic. Each uses the symbolic strength of its material structure to communicate the sacred value of the relics it was made to hold—a symbolism often heightened by the magical agency of stones worn close to the skin. The famous "Talisman of Charlemagne" (fig. 42), generally considered to date from the ninth century, takes the traditional form of a pilgrim's ampulla.[14] However, unlike traditional ampullae, which were first made of terracotta or later cast in lead (see cat. nos. 21–24), this example is crafted from gold. Its surface is encrusted with filigree, pearls, garnets, and emeralds, and its reverse is set with a large centrally placed sapphire. The front has suffered some losses as a consequence of changes, probably in the nineteenth century, when the corresponding sapphire was replaced with a blue glass stone to make visible a relic of the True Cross inside. The early history of the pendant is unknown, but from 1620 it was described as one of three jewels found around the neck of Charlemagne when the tomb was opened by Otto III in the year 1000.[15] The pendant, along with a second jewel now at the Cleveland Museum of Art (cat. no. 114), was given to Empress Josephine in 1804.[16] The third, a reliquary cross, remained at Aachen.[17] Of the three jewels, the Talisman is the only one that is conceivably early enough in date to have a convincing connection with Charlemagne. There is little evidence, however, to suggest what the original relic was. Nicholas Vincent has argued a case for it containing a portion of the Holy Blood based on its similarity to written descriptions of the reliquary of the Holy Blood at Hailes Abbey, England.[18] This would admittedly make sense of its ampulla-like form. An inventory of the twelfth or thirteenth century describes it as containing a hair of the Virgin Mary. Its original content was probably replaced by the relic of the True Cross when the alterations were made in the nineteenth century.

The association with Charlemagne held obvious and appropriate appeal for Napoleon and his empress when the gift was made, endowing the reliquary with imperial resonances. The coronation process under Charlemagne acquired a specific ritualistic quality, reinforcing the semi-sacerdotal role of the emperor. This undoubtedly invoked the power of relics, and Nicholas Vincent has suggested that the Talisman may even have played some part in imperial coronations. He very usefully cites the Mainz Ordo for Otto I's crown wearing in the 960s to support this point. Official crown wearings were occasions of great hierarchical ceremony that occurred only on Church festival days, particularly Christmas, Easter, and Pentecost.[19] In this instance two bishops were positioned on either side of the emperor with "sacred relics hanging from their necks."[20] The relics were undoubtedly contained in pendants and suspended from chains. This demonstrates that

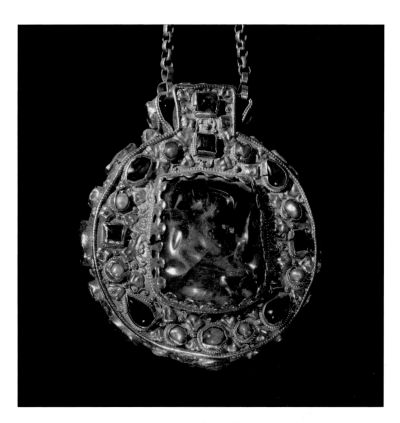

Fig. 42. The Talisman of Charlemagne. German (Aachen), 9th century. Treasury of the Cathedral of Notre-Dame, Palais du Tau, Reims

the clergy, at least, were using pendant reliquaries in a ceremonial context. Might the dominant use of the sapphire at the centre of the Talisman indicate a clerical owner? Sapphires were prized for their celestial connotations but also because they cooled the body and chastened the spirit.[21] They are known to have been chosen for bishops' rings perhaps for that reason.[22]

The choice of stones used for portable, jewel reliquaries is potentially of greater importance than for reliquaries used in public ceremonies, as the wearer is likely to invoke the magical qualities of the gems in a much more direct and personal way. The majority of surviving or documented jewel reliquaries are of small-scale dimensions and were intended to be worn, often close to the skin. Many were handled and gazed at in presumably private contexts and so constitute an intensely personal expression of medieval piety. A reliquary pendant in the British Museum, made in Paris around 1340 (cat. no. 74), requires its user to uncover its mysteries by degrees. It operates in the manner of a miniature book, with narrative scenes of translucent enamel beneath a cover of cool amethyst. Essentially it takes the form of a locket, and when closed there is no outward sign to suggest that it contains a relic. The short chain, a later replacement, may replicate the original arrangement, since the jewel was almost certainly made to be held, not suspended around the neck. Its weight, balance, and shape indicate that it would not sit comfortably on the breast and would be prone to movement and the twisting of the chain. The original chain was probably worn around the wrist, working as a security measure to prevent the reliquary from falling from the hand, rather like a modern camera

strap. It was designed for intimate inspection in the palm of the hand and required the physical interaction of the owner to release its spiritual value. The meaning of the pendant is transmitted through symbolism, iconography, and perhaps even magic.

The amethyst, along with the vast majority of other stones, carried magical properties that were well advertised and commonly understood by the thirteenth century. Amethysts were used to improve the complexion, to prevent drunkenness, gout, and bad dreams and offered protection from treason, deceit, blindness, hair loss, enchantment, choking, and strangulation.[23] Amuletic pendants of amethyst were commonly worn to deploy the power of the stone. Contact with the wearer was essential; occasionally open backs on pendants and rings allowed the stone to touch the skin. But what is the significance of the amethyst for the British Museum pendant? The amethyst seems to have been rather disparaged. It was known and legislated against as a fraudulent substitute for rubies.[24] Marbodus himself, the compiler of the most influential lapidary of the late eleventh century, states that amethysts were not highly prized because they were thought too common.[25] The choice of amethyst appears even more surprising when the contents of the pendant are considered. The first page shows a conventional donor portrait with a king and queen kneeling beneath an image of the Virgin and Child. This, along with the early, fashionable use of translucent enamel helps to establish the jewel as probably a product for the royal court. Stylistically and technologically, the pendant falls to the years around 1340, and the royal couple is most likely to be Philippe VI and Jeanne de Bourgogne.[26] Philippe had an interest in gems and commissioned at least one prose lapidary that combined Christian symbolism with literary descriptions and popular belief.[27] Other stones were clearly at his disposal, and this would suggest that the amethyst was chosen for its specific qualities rather than as a substitute for other, more expensive jewels.

The relevance of the amethyst may lie with the classical Greek legend that recounts the stone's origin. According to mythology, Amethyst was a maiden who incurred the wrath of the god of wine, Dionysos. She was saved from a terrible death by the goddess Diana, who turned her into quartz. The remorseful Dionysos then wept tears of wine upon the stone, staining it purple.[28] The Dionysian connection with wine—and therefore the Eucharist—made the god a logical antitype for Christ in the medieval assimilation of classical mythology. A blood-and-wine association endowed the pendant with symbolic shorthand for the sacrifice of Christ, reinforced by scenes from the infancy and Passion of Christ that unfold when it is open. At its center, in a secret compartment covered by a leaf of painted vellum showing the Nativity, lies a thorn from the Holy Crown of Thorns. The positioning of the Nativity above the relic heightens the emotional tension by juxtaposing an image of the moment of incarnation with the physical evidence of the Crucifixion. The reliquary may have been commissioned by Jeanne de Bourgogne rather than her husband. Documentary references reveal the interest of the female nobility of France in miniature jewel reliquaries.[29] The blood symbolism of the amethyst that is invoked through

its Eucharistic connection with wine and the emphasis placed on the Nativity could mean that the reliquary was created for Jeanne de Bourgogne as a birth amulet. The use of relics in royal birthing rituals is well documented, and stones with color associations with blood, such as red jasper, ruby, garnet, and haematite, were used in Judeo-Christian traditions to prevent haemorrhaging.[30]

The Eucharistic significance of the amethyst seems to have determined its use in other devotional jewels, particularly crucifixes, and reliquaries associated with the Passion. The Thame Ring from the Ashmolean Museum, Oxford (fig. 43), carries the plea: "Memanto [sic] Mei Domine" (Remember me, O Lord).[31] The words that decorate the surface of this exceptional, massive gold ring express the dual nature of relics, which compel the wearer to remember the sacrifice of Christ but also invite Christ to recognize and remember the wearer of the ring at the time of the Last Judgment. This ring dates from the late fourteenth century and is of the highest quality. The hoop is set with five table-cut amethysts, suggestive of the best Parisian gemcutting workshops. The oblong bezel is decorated with a double-arm cross much in use on Byzantine cross reliquaries; it opens to reveal a hollow cavity for the accommodation of a relic, most probably a fragment of the True Cross. On the reverse of the bezel is engraved a representation of the Crucifixion against a background of red enamel, redolent in its own way of the bloody sacrifice of Christ.

Reliquaries such as the Thame ring combine invocation with the symbolic power of materials and the sacred power of the relic. The use of inscriptions on jewel reliquaries may occasionally serve as a personal expression of faith, though most frequently they take the form of charms or incantations that were thought to have healing powers in their own right and might be engraved on other items of jewelery such as rings and brooches. A beautifully engraved pendant, known as the Middleham Jewel (fig. 44) after the spot where it was found in 1985, is now at the Yorkshire Museum in York, England (YORYM 1991.43). It dates from around 1450–75 and shows on the front the Holy Trinity beneath a huge cabochon sapphire. A Latin inscription surrounds the scene, stating "Behold the Lamb of God who takes away the sins of the world, have mercy on us." The words that follow this verse, taken mainly from the Gospel of John (1:29), are *tetragrammaton* and *ananyzapta*. The first is used to describe the unutterable name of God according to Jewish belief and was recited by Christians as a magical charm in the Middle Ages. The second, *ananyzapta*, served a similar purpose preventing the falling sickness (probably epilepsy) and drunkenness.[32] On the reverse of the reliquary is a Nativity surrounded by fifteen saints. At the base is the miniature figure of an *Agnus Dei* that may provide a clue to how the pendant was used. When the reliquary was opened, it was found to contain three and a half roundels of silk thread wound around with gold foil. No substantial evidence of the original relics remained. John Cherry has speculated that among the contents there may have been a wax *Agnus Dei* roundel and that this marvelous jewel operated as an elaborate *Agnus Dei* container.[33] *Agnus Dei* votives were considered effica-

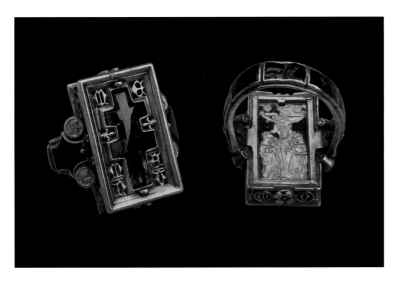

Fig. 43. Reliquary ring from the Thame Hoard. English, 14th century. The Ashmolean Museum, Oxford (AN1940.228)

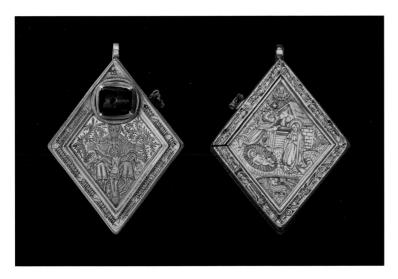

Fig. 44. The Middleham Jewel. English, second half of the 15th century. Yorkshire Museum Collection (1991.43)

Fig. 45. Reliquary pendant found at Hockley, English, early 16th century. Submitted under the Treasure Act. The British Museum, London (2009 T256)

cious in averting thunderbolts and in alleviating the pain of childbirth. The Nativity image combined with the *Agnus Dei* inscription may signify that this exquisitely crafted reliquary pendant was also a birth amulet.[34]

The distinctive lozenge-shaped form of the Middleham jewel may have held further significance in an age where number symbolism and geometry had a supernatural dimension. A recent find of a similarly shaped pendant was made in 2009 at Hockley in Essex, England (fig. 45). Though of inferior quality and smaller in size than its grander cousin, like the Middleham Jewel its meaning is centered not only in the relic it may contain (the contents, if there are any, have not yet been examined), but in the inscription that decorates its sides. The words read IASPAR MELCIOR BALTASAR, the names given to the Three Kings. These words, too, were credited with healing powers as a charm against fever and the falling-down sickness. The epigraphy suggests a sixteenth-century date, which places the pendant close to the turbulent years of the English Reformation. On the front of the pendant is an unusual image showing a female saint, probably the Virgin Mary, supporting the Cross. Another possibility is that this figure, though uncrowned, represents the empress Helena as discoverer of the True Cross. Helena had legendary links with Essex, and the pendant may represent local devotional interests. The beams of the Cross are spattered with spots of blood in a graphic reminder of the horrors of the Crucifixion. This theme is developed on the reverse of the pendant, which is engraved with the blood and wounds of Christ. Christ is not represented figuratively but through the symbols of the Cross and disembodied blood and wounds. The use of images emblematic of the intense suffering of Christ held particular sway in England from the fourteenth century due to the writings of mystics such as Richard Rolle, Walter Hilton, and Julian of Norwich. The Hockley pendant represents the climax of this contemplative impulse on the eve of Reformation. Its diminutive size, so characteristic of this category of reliquary, is evocative of the deeply personal relationship between worshiper and relic.

Pendant and jewel reliquaries, through their physical proximity to the wearer, demonstrate the most intimate aspect of relic veneration. Their effectiveness, like that of the portable altar, relied on their mobility and their use in a variety of locations. Although portable altars were uniquely empowered as agents of consecration, a power dependent on the altar stone as much as on the relics beneath it, relics played an undeniably crucial part in creating sacred space. Their role in imperial and civic ceremony involved a ritual of sanctification that relied on their movement around palace and city. The relics of Christ and St. John were used not only to endorse the building schemes of Michael III and Basil I in Constantinople in the ninth century but to reinvent the palace of the emperor as the house of Christ.[35] Only relics could do this. In both public ritual and private devotion, relics and the reliquaries that enshrined them effected a transformation of experience and understanding that helped form the very fabric of religious life in the Middle Ages.

Notes

1. www.wholesalechristiangifts.com (visited May 2010).

2. www.madelinesgallery.com (visited May 2010).

3. Rupert of Deutz, *Liber de divinis officiis*, 1.5.30, ed. H. Haacke, CCCM 7 (Turnhout, 1977), quoted in E. Palazzo, *L'éspace rituel et le sacré dans le christianisme: La liturgie de l'autel portatif dans l'Antiquité et au Moyen Age* (Turnhout, 2008), 122.

4. R. Favreau, "Les autels portatif et leurs inscriptions," *Cahiers de Civilisation Médiévale* 56 (2003): 327–52.

5. The *Life* of the seventh-century saint Wulfram, composed in the eighth century, tells how the saint uses a portable altar with relics in its center; see Palazzo, *L'éspace ritual* (2008, cited in n. 3), 136.

6. Palazzo, *L'éspace ritual* (2008, cited in n. 3), passim.

7. H. A. Klein, ed., *Sacred Gifts and Worldly Treasures: Medieval Masterworks from the Cleveland Museum of Art* (Cleveland, 2007), 116.

8. See. P. Williamson, ed., *The Medieval Treasury: The Art of the Middle Ages in the Victoria and Albert Museum* (London 1986), 114, 115.

9. Palazzo, *L'éspace ritual* (2008, cited in n. 3), 135–51.

10. S. Caudron, "Thomas Becket et l'oeuvre de Limoges," *Valérie et Thomas Becket: De l'influence des princes Platagenêt dans l'oeuvre de Limoges*, exh. cat., Limoges: Musée municipal de l'Evêche/Musée de l'émail (1999), 2.

11. Ibid., 64.

12. T. P. F. Hoving, "A Newly Discovered Reliquary of St Thomas Becket," *Gesta* 4 (Spring 1965): 28–30; G. Zarnecki, ed., *English Romanesque Art, 1066–1200*, exh. cat., London: Hayward Gallery (London 1984), 283.

13. Hoving, "A Newly Discovered Reliquary" (1965, cited in n. 12), 28; Zarnecki, ed., *English Romanesque Art* (1984, cited in n. 12), 283.

14. The "talisman" passed from the Bonaparte family to the cathedral at Rheims.

15. E. G. Grimme, *Der Aachener Domschatz*, Aachener Kunstblatter 42 (Düsseldorf 1972), 14.

16. Ibid.

17. Ibid., 52.

18. N. Vincent, *The Holy Blood* (Oxford, 2002), 144–45

19. P. Buc, "Political Rituals and Political Imagination," in *The Medieval World,* ed. P Linehan and J. Laughland Nelson (London, 2001), 196.

20. Vincent, *The Holy Blood* (2002, cited in n. 18), 145.

21. J. Evans, *Magical Jewels of the Middle Ages and the Renaissance, particularly in England* (Oxford 1922), 36.

22. O. M. Dalton, *Catalogue of Finger Rings: Early Christian, Byzantine, Teutonic, Mediaeval and Later* (London, 1912), 259.

23. Evans, *Magical Jewels* (1922, cited in n. 20), 35, 40, 60.

24. R. Lightbown, *Medieval European Jewellery: With a Catalogue of the Collection in the Victoria & Albert Museum* (London, 1992), 18.

25. Ibid., 31.

26. F. Baron, *Les Fastes du Gothique*, exh. cat., Paris: Galeries nationales du Grand Palais (Paris 1981), 235–36.

27. Evans, *Magical Jewels* (1922, cited in n. 20), 77.

28. Nonnus, *Dionysiaca XII*, trans. W. H. D. Rouse (London, 1940), 380.

29. Lightbown, *Medieval European Jewellery* (1992, cited in n. 23), 181.

30. E. Baumgarten, *Mothers and Children: Jewish Family Life in Medieval Europe* (Princeton, 2004), 48.

31. D. Scarisbrick and M. Henig, *Finger Rings: From Ancient to Modern* (Oxford, 2003), 40–41.

32. Dalton, *Catalogue of Finger Rings* (1912, cited in n. 21),135–37.

33. J. F. Cherry, *The Middleham Jewel and Ring* (York 1994), 30–31.

34. Ibid., 32.

35. H. A. Klein, "Sacred Relics and Imperial Ceremonies at the Great Palace of Constantinople," in *Visualisierungen von Herrschaft*, ed. F. A. Bauer, Byzas 5 (Istanbul, 2006), 79–99, at 93.

55
Artophorion (Reliquary of St. Anastasios the Persian)

Byzantine (Antioch), ca. 969/70
Silver and silver gilt (repoussé), niello; 39 × 19.6 × 20 cm
Aachener Dom, Schatzkammer (G 31)

INSCRIBED: around the apse: + κ(ΥΡΙ)Ε ΒΟΗΘΕΙ ΤΩ CΩ ΔΟΥΛΩ ΕΥCΤΑΘΕΙΩ ΑΝΘΥΠΑΤΩ ΠΑΤΡΙΚ(ΙΩ) ΚΑΙ CΤΡΑΤΙΓΩ ΑΝΤΙΟΧΙΑC ΚΑΙ ΛΙΚΑΝΔΟΥ (Lord, help your servant Eustathios, the proconsul, patrician, strategos of Antioch and Lykandos); around the portals on the other sides: + ΑΝΑCΤΗΘΙ ΚΥΡΙΕ ΕΙC ΤΗΝ ΑΝΑΠΑΥCΙΝ COY CY ΚΑΙ Η ΚΙΒΩΤΟC ΤΟΥ ΑΠΑCΜΑΤΟC (Rise up, O Lord, and go to your resting place, you and the ark of your might [Ps. 132:8]); + ΕΞΕΛΕΞΑΤΟ ΚΥΡΙΟC ΤΗΝ CΙΩΝ ΗΡΕΤΙCΑΤΟ ΑΨΤΗΝ ΕΙC ΚΑΤΟΙΚΙΑΝ ΕΥ ΑΤΩ (For the Lord has chosen Sion, he has desired it for his habitation [Ps. 132:23]); + ΔΕΔΟΞΑCΜΕΝΑ ΕΛΑΛΗΘΗ ΠΕΡΙ COY Η ΠΟΛΙC ΤΟΥ ΘΕΟΥ ΗΜΩΝ (Glorious things are spoken of you, O city of God [Ps. 87:3])

PROVENANCE: Said to have arrived at Aachen before 1204

BIBLIOGRAPHY: Beissel 1902, 23–25; Schlumberger 1905; Grabar 1957; Saunders 1982; Aachen 1972, 46–47, no. 31; Cologne 1985, 88–90, no. H12; New York 1997, 460–61, no. 300; Paderborn 2006, 450–51, no. 537

This precious silver object with its central dome rising above an arcaded drum, its small apse pierced by long windows and its large portals decorated with applied crosses, is made in the shape of a small but elaborate Byzantine church. A dedicatory inscription framing the apse of the "church" invokes the Lord's help on behalf of a certain Eustathios, a highly decorated Byzantine official, who served as

55

military commander of Antioch, a city in northern Syria, and Lykandos, a district in eastern Asia Minor in 969/70. Three further inscriptions taken from the Book of Psalms surround the ogival doorframes. The Psalm verses chosen may be construed to interpret the precious container as an image of the Heavenly Jerusalem, thus suggesting that it originally functioned as an *Artophorion*, a container for the Eucharist.

Nothing is known about the circumstances under which the object arrived at Aachen, but it seems likely that it was brought there by a German cleric or nobleman, who acquired it in Constantinople or Antioch during the twelfth or thirteenth century. At Aachen, the precious container never served as an *Artophorion*, but was used to enshrine the head of the Persian martyr-saint Anastasios (d. 628). The circumstances of this adaptation are, once again, obscure. The Byzantine object may simply have been appropriated on account of its shape, lavish decoration, and Eastern provenance, shortly after its arrival to serve as a new container for an existing relic of St. Anastasios (see p. 61). It is also possible that the object contained a newly acquired relic of the head of St. Anastasios when it arrived at Aachen. As recorded in the pilgrim's account of Antony of Novgorod of ca. 1200, the body of St. Anastasios (his head having previously been stolen) was venerated in the Church of St. Luke in Constantinople. While it is impossible to prove that the relic described by Antony is in fact the one later venerated at Aachen, the church-shaped container of Eustathios may well have been used as an appropriate means to attest the origin and authenticity of its sacred content at a time when many relics with uncertain provenances arrived in western Europe as sacred commodities or loot from the eastern Mediterranean. / HAK

56
Chrismatory

English or French?, late 8th century; ridge pole late 9th century
Gilded copper alloy (repoussé) on wood core; 15.6 × 13 × 6 cm
Private Collection, London (0808)

INSCRIBED: ΚΑ-Ρ; ΒΑ-Ρ; Κ-C Θ-C; Ι-C Χ-C; C-Ο Τ-Ρ (see below)

PROVENANCE: Probably Moissac Abbey, France, possibly before 1669 (inventory reference); private ownership from 1801; Private Collection, London, 2008

BIBLIOGRAPHY: New York 2007; Camber et al., forthcoming

56

The relationship between reliquaries and other sacred containers is vividly demonstrated by this intriguing chrismatory. In form and size, it resembles surviving house-shaped continental and Insular reliquaries. Its particular locking mechanism, whereby a rod fixed into the wooden base holds the lid shut when manipulated from one of the gable ends, occurs on some reliquaries of Irish type such as those from Monymusk and Clonmore. It also shares an opening mechanism with two Anglo-Saxon containers identified as chrismatories: the Mortain and the Gandersheim caskets. This structural similarity and the explicit deployment of iconography and inscription indicate that this piece was made as a container for sacramental oils. The inscriptions running along the ridge pole have been interpreted by Richard Camber as Latin abbreviations for *kapsa* or *kapsella* (ΚΑ-Ρ) and *baptismalis* (ΒΑ-Ρ) indicating that it was used in the sacrament of baptism. Other letters arranged across the ridge pole on three bands that hold settings for lost gems or pearls are understood to signify the three names of Christ in Greek: Κ-C Θ-C for *Kyrios Theos* (Lord God); Ι-C Χ-C for *Iesos Christos* (Jesus Christ) and C-Ο Τ-Ρ for *Soter* (Savior). The ridge pole seems to be a later adjustment cast from a different alloy from the rest of the casket and rendered in a Franco-Saxon style suggestive of the later ninth century. The iconography of the container, however, indicates that this alteration was in keeping with the chrismatory's original use.

The wooden core is clad in gilded copper alloy panels worked in repoussé. On the front the four

Evangelists are depicted, seated with open books. One is selected for singular treatment; his halo is more ornate, and, unlike the others, he does not write but displays the Word. It has been suggested that this figure represents John. On the lid above stands the risen Christ between vine tendrils. Eucharistic imagery is also developed on the reverse, where a chalice sprouting a vine is placed between two deer on the lower part of the box and shown alone on the lid. The insistence on the Eucharist refers to the Gospel of John, where Christ is described as the true vine (15:1); this endorses the box's function as one closely connected with the celebration of the sacraments. / JR

57
Bell and Bell Shrine of St. Cuileáin

Hibernian (Glankeen, County Tipperary, Ireland)
Bell: 7th or 8th century; shrine: late 11th century
Bell: iron; shrine: copper alloy, silver, copper, niello, enamel
Shrine: 30 × 24 × 9.6 cm
The British Museum, London (PE 1854,0714.6a-b)

PROVENANCE: Burke, Castle Borrisoleigh, early seventeenth century; Mrs. Dunn, Glankeen (date and mode of acquisition unknown); Mr. O'Dwyer, Culiean, 1797 (mode of acquisition unknown); Father David McEneiry, Glankeen, 1797, by reclamation; Father Michael Bohun, Glankeen, 1802, by inheritance; Mr. Cooke, Parsontown, by gift (date unknown); The British Museum, London, 1854, by purchase

BIBLIOGRAPHY: Cooke 1825, 31–46; Cooke 1853, 7; Crawford 1922, 1–4; Kenny 1944, 1–9; Bourke 1980, 59; Paris 1992, 340

The history of this famous shrine (called the Barnaan-Cuilawn) is shrouded in legend: St. Cuileáin (seventh century), the patron saint of Glankeen in County Tipperary, is reputed to have made the bell himself, yet nothing is known about its original use, and it is said to have been discovered in the hollow of a tree in Kilcuilawn in Glankeen. Once "rediscovered," the bell was used within the parish as a truth test: liars who came into contact with the shrine reputedly fell into convulsions. If the bell was tied around the neck of a deceiver it would eventually strangle the wearer. In later years the bell was hired out by a Mrs. Dunn for people to swear upon by touching it with a hazel stick. Possession of the bell was also reputed to bring good luck to the owner. A seventeenth-century narrative concerning "Burke from the Castle of Burrissleigh" recounts how the man lost the bell shrine only to have it returned to him a few nights later, reappearing on his bedside table.

Parts of the iron bell are coated in bronze, and the top portion is decorated with engravings in a Scandinavian animal-interlace decoration. Human heads, which are engraved on either side of the top crown of the object, appear as motifs on other bell shrines: in the National Museum of Ireland, the bell shrine crest of Killua depicts a human face between two monsters. A cross engraved on the bronze sheeting of St. Cuileáin's shrine outlines where a jeweled crucifix was once attached; this was unfortunately removed and stolen in 1802 when the object was stored by Father Michael Bohun in an open stable. / NCS

58
Bell and Bell Shrine of St. Conall Cael

Hibernian (Inishkeel, County Donegal, Ireland)
Bell: 7th–8th century; mount: late 10th–11th century
Shrine: 15th century
Bell: iron, copper alloy; mount: copper alloy; shrine: gold, bronze, silver, rock crystal
Bell and mount: 17 × 12.8 × 8.5 cm; shrine: 21.9 × 15.5 × 12.7 cm
The British Museum, London (PE 1889,0902.22 and PE 1889,0902.23)

PROVENANCE: Connell Mac Michael O'Breslin, Glengesh, in or before 1833 (mode of acquisition unknown); Major Nesbitt, Woodhill, in or before 1833, by purchase; stolen by unknown agent or bequeathed to Mr. Evans (date unknown); Robert Moore, Birmingham, 1858, by purchase; Augustus Wollaston Franks, London, by purchase (date unknown); The British Museum, London, 1889, by donation

BIBLIOGRAPHY: Crawford 1922, 5–9; O'Flanagan 1927, 114–19; Bourke 1980, 65; Ó Floinn 1994, 8, 34; Clayhil and Cherry 1997, 176; Robinson 2008, 94–95

This bell contained within a later shrine casing was reputed to have belonged to St. Conall Cael, the abbot of Inishkeel, County Donegal, in the sixth century. The bell itself is very simple in its design and decoration. It is pyramidal with traces of bronze sheeting, and has a T-shaped bronze mount on the top. The mount is engraved with a large incised cross, and the sections are decorated with animals and ring-chains. The shrine covering the bell, decorated with silver plates incised with figures of God the Father, the Virgin and Child, the Archangel Michael, the crucified Christ, and various saints, was made

57

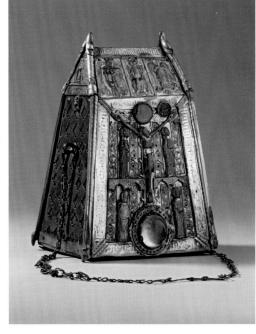

58

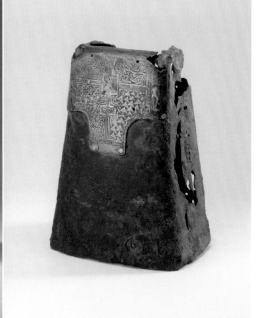

during the fifteenth century and is far more elaborate than the object that it houses. Many Irish shrines were "redecorated" or reenshrined years after their creation: the Stow Missal Shrine and the Shrine of St. Patrick's Tooth were both altered in the fourteenth century. The bell shrine was integral to the celebration of St. Conall's feast day, when pilgrims gathered at his well on the island of Inishkeel. John O'Donovan, writing for the ordnance survey in 1835, describes this local ritual. "This chain O'Breslin threw around his neck, and from it the bell hung down his breast, exhibiting to the enthusiastic pilgrims the glittering gems and the symbol of the bloody sacrifice." The O'Breslin family were the ancestral family of St. Conall and keepers of the shrine until the mid-1800s. There is no known reason why these bell shrines are a particularly Irish custom. The practice of enshrining objects associated with, or owned by holy figures, was encouraged heavily through royal patronage from the twelfth century and was not reserved for bells alone: croziers, clothes, and other items were also encased and venerated. Water, when drunk from a bell shrine, was believed to have healing properties. / NCS

59
The Franks Casket

English, early 8th century
Whale's bone; 13 × 23 × 19 cm
The British Museum, London (PE 1867,0120.1)
London only

INSCRIBED: front: MÆGI (Magi); FISC FLODU AHOF ON FERGENBERIG WARÞ GASRIC GRORN ÞÆR HE ON GREOT GISWOM HRONÆSBAN (The sea cast up the fish onto the mountainous high beach [or: "into a rocky burial mound"]; the king of terror became sad when he swam onto the shingle. Whale's bone); back: HER FEGTAÞ TITUS END GIUÞEASU HIC FUGIANT HIERUSALIM AFITATORES (Here Titus and a Jew fight: here its inhabitants flee from Jerusalem); left: ROMWALUS OND REUMWALUS TWŒGEN GIBROÞÆR AFŒDDÆ HIÆ WYLIF IN ROMÆCÆSTRI OÞLÆ UNNEG (Romulus and Remus, two brothers. A she-wolf nurtured them in Rome city, far from their native land); right: WUDU (wood), RISCI (rushes) and BITA (biter); HER HOS SITIÞ ON HARMBERGA, AGL. DRIGIÞ SWA HIRÆ ERTAE GISGRAF SARDEN SORGA AND SEFA TORNA (Here Hos sits on the sorrow-mound; she suffers distress as Ertae had assigned to her a wretched den of sorrows and of torments of the heart)

PROVENANCE: In the possession of a family at Auzon (France) in the early nineteenth century; Professor P.-P. Mathieu before ca. 1850; Jean Baptiste Joseph Barrois (d. 1855), 1850s; Augustus Wollaston Franks, 1858; The British Museum, London, 1867, by gift

BIBLIOGRAPHY: Napier 1900, 362–81; Marquardt 1961, 10–16; Webster 1982; Wood 1990; Lang 1999; Webster 1999; Neumann de Vegvar 2008; Webster 2010

The Franks Casket was probably intended for use in a royal context. It is now incomplete; the lid lacks its framing inscription, and the right side-panel, separated from it in the early nineteenth century, is in the Museo Nazionale del Bargello in Florence. The casket's carved scenes draw on Roman, Jewish, Christian, and Germanic traditions and are accompanied by commentaries mainly in the runic alphabet (*futhorc*), in Old English and (briefly) Latin. The Adoration of the Magi on the front panel is set alongside the Germanic tale of the exiled Weland. Imprisoned by King Nithhad, Weland exacts a terrible revenge, murdering the king's two sons and raping his daughter. Weland is not an obvious

parallel for Christ but both share the fate of exiles fleeing a tyrannical king and illustrate models of good (Christ) and bad (Nithhad) kingship. The lid depicts a siege from an unidentified episode in the life of the Germanic hero Egil, while the back shows the capture of Jerusalem by the Romans in AD 70. This event was seen to symbolize the triumph of Christianity over Judaism, and the similar siege from the unknown Egil story probably echoes this theme. The left panel shows the legend of Romulus and Remus suckled by the wolf as a symbol of the mother Church offering succor. The enigmatic right panel is a wilderness scene identified by an encoded inscription that relates how Hos suffers at the hands of Ertae. These characters have not been identified, but in juxtaposition with the Romulus and Remus panel, which is representative of Christian salvation and life, this image is suggestive of paganism and death.

The casket resembles some fourth- to fifth-century ivory boxes such as that from Brescia, northern Italy. It served as a reliquary but was probably made to hold a holy text such as a Gospel, or the Psalms, and this may have been the original purpose of the Franks Casket. It has been linked to the cult of St. Julian at Brioude, where it may have served as a reliquary. In 1291, the lord of Mercoeur "made homage and swore loyalty to St. Julian, to the chapter and church of Brioude, and to the aforesaid dean, hand on the holy Gospels, and devoutly kissing a box of ivory filled with relics, as is the barons' custom." It has been suggested that the carved scenes might have been reinterpreted in such a way as to relate to the life of St. Julian, thus making the casket's conversion to a reliquary entirely plausible. / JR

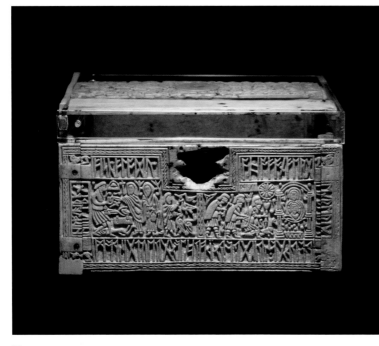
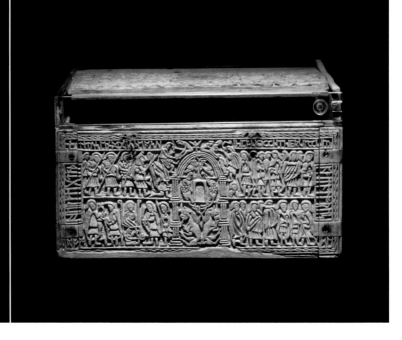

59

60
Reliquary

Ottonian (Germany), ca. 1000
Ivory; 17.4 × 8.8 cm
The British Museum, London (PE 1855,1031.1)

INSCRIBED: upper band: HIC IHM XPM SEPTIS ORA [. . .]S EVANEIST
DOF MASCANENE NT [. . .] EM [. . .] IVG [. . .] ME FIER'IVSS \\\
[. . .] ILLO MGIS; lower band: mostly illegible [. . .]EM [. . . .] IVT
[. . .] MEFIERI IVSS V \\\ LLOD MGIS [. . .]

PROVENANCE: John Josias Conybeare (1779–1824), purchased in
Paris; William Daniel Conybeare (1787–1857), Dean of Llandaff,
by inheritance; The British Museum, London, 1855, by donation

BIBLIOGRAPHY: Smith 1854, 102–4; Franks 1856, 88; Dalton 1909,
no. 47

An expensive commodity, ivory was widely used in the
Middle Ages for reliquaries and smaller sculptures.
Its pure white color was an indication of the holy
status of its contents, and the smooth, unblemished
surface of ivory hinted at the incorruptibility of
sacred human remains. Ivory itself was considered
incorruptible. This cylindrical carving is hollow,
with a pyramid-shaped cavity in which relics may
have been stored. A cover, now missing, would have
sealed the opening on the underside. It is thought
that this reliquary served as the base of a crucifix:
a narrow space at the top is crossed by drilled holes
that could have contained rivets to hold the tang
of a cross. A smaller, pyramid-shaped base for a cross,
decorated with beasts, in the Victoria and Albert
Museum (12-1873) is a similar example.

The piece is divided into three registers. The base
is oval, showing the Crucifixion, the visit of the
three Marys to the tomb, the *Noli me tangere*, and the
Ascension, framed by two inscribed bands inter-
spersed with drilled holes that likely once contained
gems or pastes set in gold. The armor and weapons
of the soldiers guarding the sepulcher are seen in
Carolingian manuscripts, and examples of their
spear heads have been excavated from the Thames.
Above the base is a rectangular structure bearing
a column at each corner containing figures of the
Evangelists, supporting a wreath. Their symbols are
shown in two of the sections between the columns:
the ox, the eagle, the lion, and the man or angel.
A seraph with six wings stands at one end, hands
extended; another seraph would likely have been
located at the other end. The top portion of the reli-
quary is a steep tiled roof, on one side of which
Christ in Majesty is seated on a throne between two
angels. / NCS

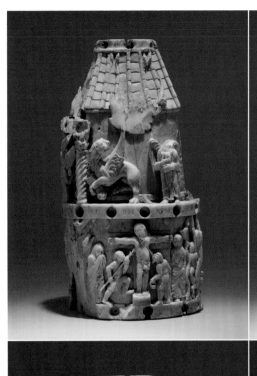
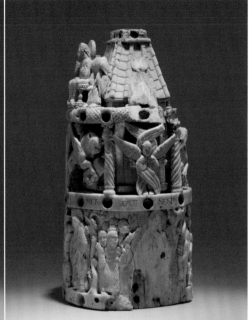
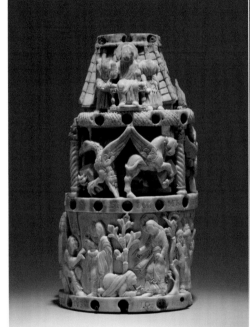
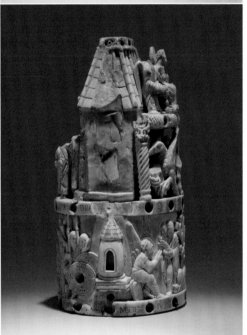

60

61
Treasure Binding of a
Gospel Book

German (Regensburg?), 11th or 12th century with later additions
Silver gilt, copper gilt, gold foil, niello, ivory, rock crystal, ink or
paint, wood, leather, silk; 28.1 × 23.3 × 10.4 cm
The Walters Art Museum, Baltimore (W.8)
Baltimore only

INSCRIBED: around image of Crucifixion: MORS XPI MORS MORTIS
ERAT TUUS INFERE MORSUS (trans. after Kessler 2006: The death
of Christ was the death of death, rendering its sting impotent)
[paraphrase of Hosea 13:14]

PROVENANCE: In the collection of Munich art dealer Jacques
Rosenthal in 1925; purchased from Rosenthal by Henry Walters
before 1931; Walters Art Museum, 1931, by bequest

BIBLIOGRAPHY: Walters Art Gallery 1985, 147, 165, 166, 172, Fillitz
and Pippal 1987, 96–100; Kessler 2006, 244, 309, 310

This manuscript copy of the Gospels, probably
made at Regensburg in the eleventh century, is cov-
ered with a treasure binding, the front cover of which
includes silver, copper gilt, ivory, and rock crystal.
The arrangement of the filigree and ivory panels
suggests a cross teeming with life, a reference to the
everlasting life supposedly offered to humankind

through Christ's Crucifixion, and, as Herbert Kessler has pointed out, this idea had been depicted in a similar fashion on earlier treasure bindings. The central feature of this cover is a large rock crystal set over a depiction on gold leaf of the Crucifixion; a small splinter of wood has been placed across Christ's chest. The inclusion of a relic of the True Cross would have enhanced the devotional properties of the cover, and would also have been suitable for a Gospel book destined for the high altar of an important monastic church. Such a book would have been considered a liturgical implement and housed in the treasury of the monastery, rather than in the library.

This Gospel book, unlike the majority of medieval manuscripts, retains its original twelfth-century binding structure, including a piece of silk damask cloth covering the spine. However, there is some debate about whether portions of the front and back covers might have been produced or added later. The ivory plaque in the lower left corner, depicting the

Evangelist Mark, is certainly a nineteenth-century replacement, as are the corner bosses. Recent examination has demonstrated that the back cover, sometimes claimed to be modern, is indeed a medieval production, though it has not necessarily always been the back cover of this particular book. There has been some suggestion that the rock crystal was removed and reattached at some point, and it is possible that the splinter of wood was placed there at this time. The date of such an alteration might well have been medieval, rather than modern. Although book covers were sometimes heavily reworked in the nineteenth century, many examples were altered in the fifteenth or the sixteenth century, such as the famous Lindau Gospels in the Pierpont Morgan Library (MS M.1), or another Gospel book in that collection (MS M.651), which includes a piece of rock crystal positioned over a painting of a different devotional image: the face of Christ from the Veil of Veronica, believed to have been, like the True Cross, a contact relic of Christ. / KBG

61

62
Reliquary of the True Cross

French (Limoges), ca. 1178–98 (base and consoles 16th century)
Copper (engraved, stippled, and gilt), enamel (champlevé) over wood core; 12.9 × 29.2 × 14 cm
Treasury of the Basilique de Saint-Sernin, Toulouse
London only

INSCRIBED: left side: S[ANCTA] [H]ELE NA / IUD AS; back: [H]IER[USA]L[E]M / ABBAS DE IO SAPHAT DE / CRU CE DAT / OREMUS; RAIMUNDO BOTARDE // LLI HI[C] INTR AT / MA / RE; right side: H[IC] DAT ABBATIS PON CIO; front: HA / NONICI [CUM] ABATE / OFFER[UN]T / CRUCEM / SATURNI / NO TO LOSA; front of roof: A Ω

PROVENANCE: In the church from an early date; first recorded in 1836

BIBLIOGRAPHY: Gauthier 1972, no. 62; Durliat 1986, 139–41; New York 1996, no. 40

The spirited narrative displayed along the sides of this extraordinary reliquary recounts the story of the arrival of a relic of the True Cross to the Church of Saint-Sernin, where presumably this reliquary was commissioned to preserve it. The story begins on the left side: Helena, mother of the emperor Constantine, instructs Judas Cyriacus to dig where the Cross was buried. The narrative continues on the back: John of the Monastery of Josaphat in Jerusalem presents a relic of the Cross to Raymond Botardelli. He embarks on a ship to bring it home, where (on the right side of the shrine) Abbot Poncio receives it. On the front of the casket the abbot blesses Botardelli in the presence of three monks. Botardelli, holding the Cross, kneels before the Abbey of Saint-Sernin. The roof of the casket is occupied by Christological scenes: the three Marys at the tomb on the back and an image of Christ in Majesty flanked by Mary and St. John the Evangelist, each escorted by an angel on the front. The left and right sides of the roof are occupied, respectively, by two standing angels gesturing above, and by the Annunciation.

The identity of the figures represented on the chasse is corroborated by documentary sources: Raymond Botardelli is named as a scribe in late twelfth-century entries in the cartulary of the Abbey of Saint-Sernin of Toulouse; Pons de Montserrat was the abbot from 1176 until approximately 1198, while Jean was abbot of the Monastery of Notre-Dame-de-Josaphat until 1195. The reliquary should thus be dated to the end of the twelfth century. Some scholars have argued that the unusual shape of this True Cross reliquary might have been dictated by the original relic, which probably arrived in Toulouse enshrined inside a cross-shaped reliquary, precisely like that shown on the sides of the chasse.

62

Notwithstanding the plausibility of that obser-
vation, the shape of the Saint-Sernin reliquary recalls
a Merovingian sarcophagus and resembles the
caskets used to contain the Eucharist, such as, for
example, that from the treasury of Grandmont

(formerly Limoges, Musée municipal de l'Evêché).
The Saint-Sernin reliquary thus presents the relic
of the Cross, a contact relic of Christ, as if it were the
body of Christ, making Christ's bodily absence
all the more poignant. The Christological images

on the roof underscore this idea and present scenes
depicting Christ's Incarnation, Resurrection, and
Ascension (as his majesty in heaven). / MB

63
Life and Miracles of
St. Edmund

English (Bury St Edmunds?), ca. 1130
Ink, paint, and gold on parchment, 100 leaves, each
approximately 27.4 × 18.7 cm
The Pierpont Morgan Library, New York, gift of J.P. Morgan
(1867–1943), 1927 (MS M.736)
Illustrated: fol. 16r
Cleveland and Baltimore

PROVENANCE: Probably assembled at the Abbey of Bury St
Edmunds; George Roche (16th-century signature) W. Stonehouse
(17th-century signature); John Towneley; sale, London, R.H.
Evans, 8 June 1814, lot 904, to Booth; Payne & Foss; sold to R.S.
Holford (catalogue 1841, lot 1); Sir George Holford; purchased
by J.P. Morgan (1867–1943) for the Pierpont Morgan Library
from the Holford estate in 1927

BIBLIOGRAPHY: MacLachlan 1965 [1986], 74–119, Kauffmann 1975,
72–74, no. 34, Abou-el-Haj 1983; Hahn 1991

Illustrated copies of saints' *Lives*, usually including
hymns, prayers, and other material to be read on the
saint's feast day, began to appear in Europe in the
tenth century, but they do not appear to have been
made in England until the turn of the twelfth
century. This is one of the earliest English examples,
and it includes Latin texts recounting the miracles
of St. Edmund and his martyrdom, as well as the
office, or ceremonial observance, for the saint's feast
day (20 November). At the start of the manuscript
is a series of thirty-two full-page miniatures depicting
the events leading up to Edmund's death, his mar-
tyrdom and burial, and several miracles that took
place after his death. Edmund was a king of East
Anglia (r. 855–69) who was killed by Vikings. Accord-
ing to medieval accounts, after cutting off Edmund's
head, his attackers threw it into the woods. His
followers eventually found the head, which had been
miraculously guarded by a wolf, and were able to
bury his complete body. Several years later, when the
body was exhumed for reburial in a new church,
it was discovered that Edmund's wounds had been
miraculously healed, his head rejoined to his
body with only a thin red line showing where it had
been severed. Edmund's shrine, located at Bury
St Edmunds in East Anglia, was a popular destina-
tion for pilgrims throughout the Middle Ages,
though Edmund's importance as a saint was some-
what eclipsed by the phenomenal popularity of
Thomas Becket (see cat. nos. 97–101). / KBG

64
Reliquary Casket of
Sts. Adrian and Natalia

Spanish (Kingdom of León, Monastery of St. Adrian de Boñar?),
early 12th century
Silver (repoussé) over a wood (oak) core; 15.9 × 25.4 × 14.5 cm
The Art Institute of Chicago, Kate S. Buckingham Endowment
(1943.65)

INSCRIBED: MARTIRIS EXIMINI SACRUM (sacred [relic] of the
exalted martyr); QUI MARTIR FACTUS SPREVIT EUM ([Adrian] was
made a martyr, [Natalia] removed him); [JA]CET HIC ADRIAN (Here
lies Adrian)

PROVENANCE: Julius Böhler, Munich, by 1914. Harry Fuld (d. 1932),
Frankfurt, by 1918; by descent to his widow, Lucie Mayer-Fuld
(d. 1966), Frankfurt, Berlin, and New York, 1932–42; on loan
to the Art Institute of Chicago starting 17 October 1942; sold,
through Raphael Stora, to the museum, 1942

BIBLIOGRAPHY: Swarzenski 1918 [1978], 88, pl. 90; Rogers and
Goetz 1945, 65, no. 21, pls. 26–28; Donnelly and Smith 1961,
figs. 1–4; Leningrad 1990, no 34; New York 1993, no. 122; Nielsen
2004, 15, and no. 11

This house-shaped reliquary, produced by a northern
Spanish artist in the early twelfth century, once
contained relics of Sts. Adrian and Natalia. Worked
in silver repoussé over a wood core, the imagery

on all four sides of the casket vividly recalls the
martyrdom of Adrian, which took place in the city
of Nicomedia in Asia Minor (now Izmit, Turkey),
in 304. The narrative begins on one of the smaller
side-ends and reads counter-clockwise as follows:
Adrian, a guard at the court of Emperor Galerius
Maximianus (r. 286–305), escorts a condemned
Christian prisoner from the throne room; impressed
by the bravery of the Christian martyrs, Adrian
joins them in their martyrdom—much to the delight
of his wife, Natalia, also a devout Christian, who is
shown holding up her husband's newly severed hand;
Natalia, still holding Adrian's hand, travels by
boat to Constantinople; there, she finally joins Adrian
and his martyred companions in eternal repose.

According to legend, Natalia had kept Adrian's
dismembered hand at the head of her bed for con-
solation until she was forced to flee Nicomedia with
it to escape the advances of a powerful tribune.
Adrian and Natalia were popular saints in medieval
Spain, as attested by the thirty-six religious sites
dedicated to them there. This casket was most likely
made for one of them, the Monastery of St. Adrian
de Boñar, which enjoyed the patronage of the royal
family of León. Two members of this family, Count
Gisvado and his wife, Leuvina, had acquired relics
of Adrian and Natalia on a trip to Rome in 920. / CN

64

65
The Abdinghof Altar

German (Paderborn), first quarter of the 12th century
(with later additions)
Copper gilt, bronze gilt, wood, stone, paint; 11.8 × 31.1 × 18.5 cm
Erzbischöfliches Diözesanmuseum und Domschatzkammer
Paderborn / Leihgabe Franziskanerkloster Paderborn (PR 50)
Cleveland and London

PROVENANCE: In the church at Abdinghof since its manufacture;
transferred to the diocesan museum at an unknown date

BIBLIOGRAPHY: Lasko 1994, 165–66; Lasko 2003, 188–93;
Paderborn 2006, 421–22, no. 508

This is one of two portable altars attributed to the noted monk and artisan Roger of Helmarshausen. Portable altars were small, consecrated versions of he fixed altars found in Christian churches; they allowed priests to say Mass outside of a church building if the need for travel arose, and could also expand the liturgical activities within a given church by increasing the number of altars without the construction of additional chapels. The patron saints of the Abdinghof monastery are depicted on the top of this altar: Peter, Paul, Felix of Aquileia (the figure is a modern replacement), and Blaise of Sebaste in Armenia. Many portable altars depict rows of saints standing under arcades along their sides (see cat. no. 42), but others, like this example, include narrative scenes. In this case, scenes from the lives and martyrdoms of Felix and Blaise are shown on the long sides of the altar. The short sides of the altar depict a martyrdom and a baptism, but the precise identification of the scenes is unclear. Felix and Blaise were not nearly so widely known as Peter and Paul, but their relics had been acquired by Meinwerk (d. 1036), bishop of Paderborn and founder of Abdinghof, who gave them to the monastery in 1031. This portable altar, now empty, probably contained relics of Felix and Blaise, and perhaps of other saints as well. / KBG

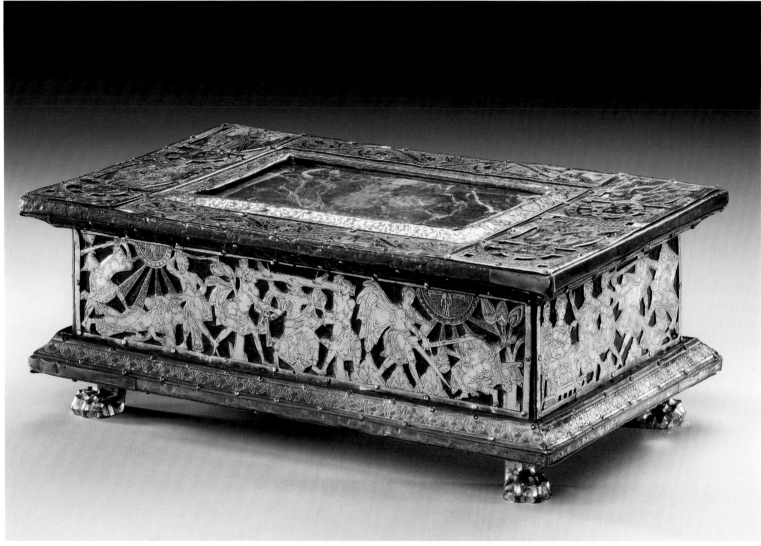

65

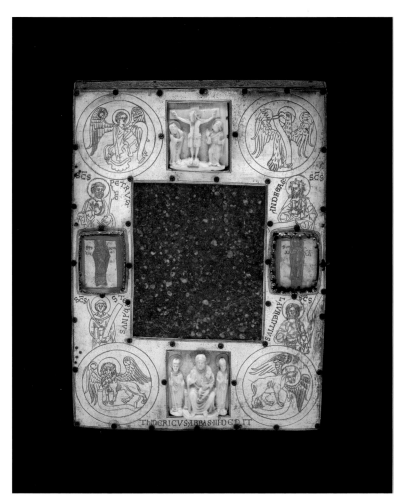

66
Portable altar

German (Hildesheim), 1190–1200
Copper gilt over a wood core, limestone, painted vellum, rock crystal, ivory; 35.4 × 25.1 cm
The British Museum, London (PE 1902,0625.1)

INSCRIBED: obverse: SCS PETRUS (St. Peter); SCS ANDREAS (St. Andrew); SCS STEPHANUS (St. Stephen); SCS LAURENTIUS (St. Lawrence); THIDERICUS ABBAS IIIS DEDIT (given by the Abbot Theodoric III); reverse: JOANNIS BAPTISTE. PAULI APOSTOLI. JACOBI APOSTOLI. MATHEI APOSTOLI ET EVANGELISTE. JOHANNIS EVANGELISTE. STEPHANI PROTOMATIRIS. LAURENTII. VITI. CORNELII. CIPRIANI. FABIANI SEBASTIANI. BONIFACI I EPISCOPI. BLASII EPISCOPI. FELICIS CRISTOPHORI . COSME. DAMIANI. PANCRATTI. THEODORI. DIONISII EPISCOPI. MARCELLINI. PETRI. CIPRIANI. IPOLITI. VITALIS FELICISSIMI. MAURICII. IACINCTI TOTINATI. FELICIS NAEORIS. MARTIRUM ET CONFESSORUM. GODEHARDI EPISCOPI. NICOLAI. SERVACII. MARTINI. BENEDICTI. ABBATIS. EGIDII. MARIE MAGDALENE. AGATHE MARTIRIS. THIDERICUS ABBAS TERTIUS DEDIT

PROVENANCE: Comte C.W. de Renesse-Breidbach (1773–1833); Sellieres; Thomas David Gibson Carmichael (1859–1926); P. Soltykoff; Durlacher Bros., London; The British Museum, London, 1902, by purchase

BIBLIOGRAPHY: Dalton 1909, 59; Brandt 1985; Norwich 2006, 72; Robinson 2008, 68–69

This altar contains the relics of forty saints whose names are inscribed on the reverse. As with the St. Eustace head reliquary (cat. no. 104), the relics within (which include hair identified by its label as that of St. John the Evangelist and semiprecious stones associated with St. Christopher) are wrapped in textiles and labeled. A range of materials has been used in the decoration of the altar, partly for variety and also to show the expense of the object. The central stone is bordered with a sheet of gilt copper, engraved with symbols of the Evangelists (angel, eagle, ox, and lion) and the figures of Sts. Peter, Andrew, Stephen, and Lawrence. This is held in place by silver nails with floral heads. Four compartments are cut out of this panel. The top and bottom hold walrus ivory carvings of the Crucifixion and the Virgin and Child. Painted miniatures on vellum, covered with rock crystal, depict two bishops of Hildesheim: on the left St. Bernward (r. 993–1022) and, on the right, his successor, St. Godehard (r. 1022–38). The rock crystal covers protect the images and magnify them. Detailed portraits such as these were easier to execute on vellum than enamel or ivory. Manuscript illuminations were expensive, prestige

items; these paintings were cut down from larger pages that were recycled for their value.

The multiplicity of relics stored within the altar served to increase its sacredness (see Robinson herein, p. 112). The altar was blessed, so that it became a traveling consecrated space itself. This was also a way of helping those who could not undertake pilgrimages or reach places that housed relics come into contact with this holy material. / NCS

67
The Crippled and Sick Cured at the Tomb of St. Nicholas

Gentile da Fabriano (ca. 1370–1427), 1425
Tempera on wood; panel: 36.4 × 35.9 cm
National Gallery of Art, Washington, Samuel H. Kress
Collection (1939.1.268)
Cleveland and Baltimore

PROVENANCE: Main altar(?) of San Niccolò Oltrarno, Florence;
in the church until the 1780s; Tommaso Puccini (1749–1811),
Villa a Scornia, near Pistoia, by ca. 1803–5; his nephew, Niccolò
Puccini (1799–1852); Niccolò's sister, who married a member
of the Tucci family; Marchese Alessandro Tucci and his co-heirs
from the Spada family, Pistoia, by 1899; possibly art market,
Rome, by 1928. (Count Alessandro Contini-Bonacossi, Florence);
purchased June 1937 by the Samuel H. Kress Foundation, New
York; gift to National Gallery of Art, 1939

BIBLIOGRAPHY: Boskovits and Brown 2003, 293–98 (with earlier
bibliography)

According to his legend, St. Nicholas was buried
in a marble tomb in the city of Myra, in Asia Minor,
where he served as bishop. His body remained in
Myra until it was transferred to the Italian city
of Bari in 1087. In both sites, the holy oil that issued
from his bones cured all illnesses. In this rendering
of the tomb of St. Nicholas, Gentile da Fabriano
imagines the tomb within a basilica-style church
interior, complete with a raised presbytery, central
and side chapels, and a small ambulatory. Altars
with gold-ground altarpieces are visible in the shad-
ows of the flanking side chapels, while the apse is
embellished with glimmering mosaics. The saint's
tomb, elevated on four columns in order to facilitate
close contact between the faithful and his relics,
occupies the focal point of the composition.

The fictive setting of the painting evokes the mul-
timedia environments of saint's shrines, where
architecture connected worshipers with a saint's mor-
tal remains and art proclaimed the saint's broader
relationship to sacred history. In the apse, Christ in
Majesty flanked by the Virgin Mary and St. Nicholas
crowns a narrative cycle featuring the saint's life
and miracles. Beneath the apse, pilgrims converge

upon the saint's shrine. Their crutches and weak-
ened states serve as outward markers of the assistance
they seek. Around the tomb itself, a man and
a woman touch the sarcophagus while a possessed
woman swoons into the arms of her companion.
At left, a man in red hose strides away, no longer need-
ing the crutches with which he arrived.

This painting was once part of a narrative predella
featuring five episodes from the life and miracles
of St. Nicholas. The sequence of paintings behind
the tomb reproduces the narrative images of the
predella, an unusual instance of self-quotation that
would have been easily recognized when the panels
were displayed together. / CGM

68
Fragment of a Relic Shroud

Eastern Mediterranean or Near Eastern, 11th/12th century
Silk and gold (compound twill, brocaded); 46.4 × 54.6 cm
The Cleveland Museum of Art, purchase from the J. H. Wade
Fund (1950.2)
Cleveland and Baltimore

PROVENANCE: St. Peter's Church, Salzburg; Mrs. Paul Mallon, Paris

BIBLIOGRAPHY: Tietze 1913, 96–98; Ackerman 1936; Falke 1936, 27,
fig. 192; Shepherd 1950; Müller-Christensen 1973, Salzburg 1982,
282, no. 187; Wilckens 1987, 71

When the main altar of the Benedictine abbey church
of St. Peter in Salzburg was torn down in 1606 to
make place for a new one, this fragment of a brocaded
silk was among the precious textiles reportedly
found in the *sepulchrum*, or altar tomb, of St. Aman-
dus. According to a local tradition, the relics of
St. Amandus had been brought to Salzburg from
Worms by the city's first bishop and abbot of St.
Peter's, St. Rupert (d. 718). The presence and venera-
tion of the relics of St. Amandus at St. Peter's,
however, can be traced back only to the episcopate
of Archbishop Arno (785–821), who served as abbot
of the Monastery of St. Amandus at Elnon (Flanders)
from 782 until his appointment as bishop of Salz-
burg in 785. It is therefore likely that the relics of the
second-most important saint of the abbey church
of St. Peter's are those of St. Amandus of Maastricht
(d. 679), the "Apostle of Flanders," rather than St.
Amandus of Worms (d. 659).

On which occasion the relics of St. Amandus were
wrapped in the precious silk shroud, found during
the early seventeenth-century renovation of the
main altar, is difficult to determine with certainty.
An opening of the tomb of St. Amandus is first
recorded for 1443. However, it is more likely that the

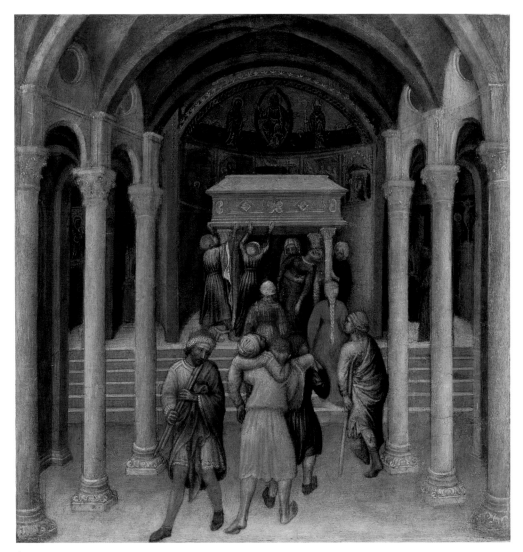

67

shrine was already opened under Abbot Balderich (r. 1125–47), who rebuilt the St. Peter's Church from its foundations after a devastating fire in 1127.

The practice of wrapping the bodily remains of Christian saints in precious textiles, often imported from the eastern Mediterranean, the Near East, Spain, or Sicily, is well attested from at least the eleventh century onward. The decoration of this gold-brocaded reddish pink silk, which consists of an imposing double-headed eagle attacking two white-flecked panthers with dragon-head tails enclosed within two half-circles that terminate in dragon-heads, points toward an origin in the eastern Mediterranean or, more likely, the Islamic Near East. / HAK

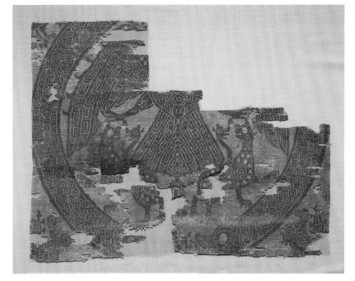

68

69
The Shrine of St. Amandus

Flemish, early 13th century with significant later additions
Copper gilt, silver, and brass over wood (oak), enamel
(champlevé and cloisonné), rock crystal, semiprecious stones;
48.9 × 64.1 × 30.3 cm
The Walters Art Museum, Baltimore (53.9)

INSCRIBED: along the base of the lid (19th century): IN ISTA
CAPSA SVNT SEQVENTES RELIQ(VIA)E B(EATI) AMANDI EP(ISCOPU)S
(In this reliquary are the following relics of the blessed
Bishop Amandus); also along the base of the lid, a fragmentary
inscription: PROESENTIS COMPOSITIVS

PROVENANCE: Brimo de Laroussilhe, Paris; Henri Daguerre, Paris
(date and mode of acquisition unknown); Henry Walters, Baltimore,
1930, by purchase; Walters Art Museum, 1931, by bequest

BIBLIOGRAPHY: Ross 1936

Amandus was the bishop of Maastricht and the founder and abbot of the Monastery of Elnon, near Tournai, where he was buried after his death (ca. 679). Before the end of the seventh century, he was considered a saint, and a pilgrimage cult developed at Elnon, eventually requiring that his bones be housed in a reliquary that could be shown to the faithful. In addition to being visited by pilgrims and carried in procession on feast days, the relics of St. Amandus were taken on a tour of the region around Elnon at least twice: once in 1066 to raise funds to rebuild the monastery after it was destroyed by fire, and again in 1107 to remind ambitious nobles of the monastery's power and privileges. At least one earlier reliquary for St. Amandus must have existed, but it was destroyed or lost prior to the thirteenth century, perhaps in the fire of 1066. The figure at one of the gable-ends is presumably Amandus; the other end, now empty, probably originally contained a figure

69

of Christ (cf. cat. nos. 81, 82). Although many such reliquaries were destroyed or sold to collectors during periods of religious reformation and political revolution, some continued to be used into the modern period: a reliquary similar to that of St. Amandus is still owned by the religious brotherhood of St. Symphorian in Belgium, and carried in public procession on several occasions during the year. Over the centuries, reliquaries such as this were likely to suffer some wear. Extensive scientific testing has shown that this reliquary was made in the early thirteenth century, but that it has been repaired and modified throughout the centuries as it continued to be used in the service of the cult of St. Amandus. The most recent modifications, however, were made by a late nineteenth- or early twentieth-century art dealer hoping to "improve" the piece and make it more marketable. / KBG

70, 71
Panels from a Window Showing the Life and Martyrdom of St. Vincent of Saragossa

French (Paris), ca. 1245
Vitreous paint, colored glass; lancet: 337.2 × 110.5 cm, panel (with supporting frame): 67.4 × 44.5 cm
The Walters Art Museum, Baltimore (46.65 [lancet], 46.69 [panel])
Lancet: Baltimore only
Panel: Cleveland and Baltimore

PROVENANCE: Lady Chapel of the Abbey of Saint-Germain-des-Prés, Paris; Abbey of Saint-Denis, 1840 (as described by Baron François de Guilhermy); Charles Tollin, Paris (date and mode of acquisition unknown); Jacques Seligmann, Paris (date and mode of acquisition unknown); Henry Walters, Baltimore, 1918, by purchase; Walters Art Museum, 1931, by bequest

BIBLIOGRAPHY: Shepard 1998; Hayward 2003, 163–85

The Abbey of Saint-Germain-des-Prés, in Paris, was founded in the sixth century when Germain, or Germanus, the bishop of Paris (d. 576), persuaded King Childebert (r. 511–58) to build a monastery to protect the relic of the tunic of St. Vincent of Saragossa. Eventually, the abbey came to be dedicated to Germain himself, rather than Vincent, but the tunic continued to be an important relic, and in 1215 another relic of Vincent, his jawbone, was given to the abbey by the future king Louis VIII (r. 1223–26). When a new chapel dedicated to the Virgin was built in the 1240s, windows depicting the lives and relics of Sts. Vincent and Germain were installed; fragments of the Vincent windows, dispersed after the French Revolution, have survived in the Walters Art Museum, Baltimore, the Metropolitan Museum of Art, New York, the Victoria and Albert Museum, London, and the parish church of Wilton, Wiltshire, England. The bright colors of these panels are typical of stained glass produced in the twelfth and thirteenth centuries, and the geometric arrangement of the scenes was also common in windows from this period. Although only fragments have survived, the complete program of the Vincent windows has been reconstructed. It is likely that two windows existed: one recounted his martyrdom, while the other displayed scenes related to his relics. Many medieval stained glass windows depicted the lives and miracles of individual saints, but the relics themselves were an unusual topic; perhaps this choice at Saint-Germain-des-Prés was related to the near-contemporary Sainte-Chapelle in Paris, a royal chapel that housed several relics from the Passion of Christ, and included stained glass windows that depicted the purchase of those relics and their arrival in Paris.

The panels in Baltimore, although now displayed as a reconstructed lancet and a separate panel, were probably parts of a single large window showing the life and martyrdom of St. Vincent. As it stands today, the reconstructed lancet reads from bottom to top, a common arrangement for medieval windows with narrative stories. In the lowest panels, Vincent, dressed in red, preaches to a crowd, accompanied by his mentor, Bishop Valerius, dressed in yellow. Above this, Vincent is tortured over fire at the command of the provincial governor, Dacian (the right-hand portion of this scene is a modern replacement; the original panel is in the Victoria and Albert Museum). Above this, the panel on the left is a modern, abstract replacement of a lost episode in the story, and on the right, Vincent is imprisoned in a tower. According to a medieval account of the saint's life, the floor of the tower was covered with sharp pieces of broken pottery, but these miraculously changed to flower petals when Vincent was imprisoned. In the next set of panels, Vincent is shown on his deathbed on the left, his soul carried

71

70

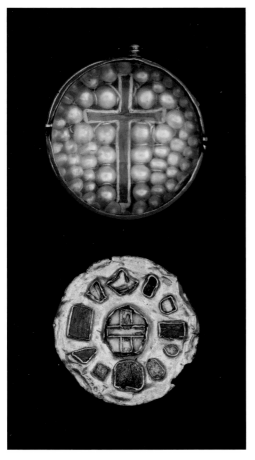

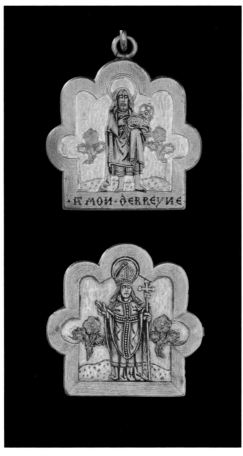

72

73

to heaven by angels, while on the right his body is left out in the wilderness, where it is protected from wild animals by an angel and a raven. In the upper-most panels, the saint's body is thrown into the sea, weighed down with a millstone to ensure that it will sink. Not depicted in these panels, the body was later miraculously washed to shore, where Vincent's faithful friends could bury him.

The separate panel shows one of the tortures endured by Vincent before he was martyred: the saint is being broken on a rack while two men tear his flesh with iron hooks. The extended hand of the governor Dacian, commanding the two torturers in their work, can be seen at the far left. / KBG

72
Reliquary Pendant

Scottish, ca. 1200
Gold, wood, rock crystal, pearls; 5.5 × 5.2 × 2.8 cm
The British Museum, London (PE 1946,0407.1)

INSCRIBED: + SEXPSTI: NINIAN / ANDREEX MAVRIS: GEORGII: MERG: D (?) NOR: F (?) ERG: B (?) O / NEF (?) SE: MARIE (Of Jesus Christ, of Ninian, of Andrew of the Moors, of George, of Margaret (?), of Norbert (?), of Fergus (?), of Boniface (?), of St Mary)

PROVENANCE: Maurice Elestein; National Art Collections Fund; The British Museum, London, by donation, 1946

BIBLIOGRAPHY: Tonnochy 1952, 77; Radford 1955, 119–23; Jones 1990, no. 64; London 1984, 289; Robinson 2008, 76

The saints referred to in the abbreviated Latin inscrip-tion around its cover suggest that this reliquary is Scottish in origin. St. Andrew is the patron saint of Scotland; Fergus, lord of Galloway, was a benefactor of Holyrood Abbey, Edinburgh; St. Margaret was the queen consort to the Scottish king Malcolm III; St. Ninian founded the Whithorn priory, Galloway, in 397. St. Norbert of Xanten, also named in the inscription, was the founder of the Order of Regular Canons of Prémonstré. Considering that Whithorn priory was a Premonstratensian order, this reliquary probably belonged to a bishop of Galloway in the late twelfth or thirteenth century, and reflects patterns of local devotion and religious affiliation.

The pendant is formed of a circular gold box with a base plate into which a number of different relics are set. A central setting for lost fragments of the True Cross sits at the center of the plate. The cover of the reliquary is decorated with a paving of pearls sewn with gold wire around a miniature wooden cross. A dome of rock crystal covers this setting, and the whole pendant was locked together by a nut

screwed down from the top. The relics themselves would have been hidden from view, but the wooden cross on the front indicates the holy fragments held within. Two rings on either side of the pendant suggest that it was originally suspended by a chain. Although it was not necessarily worn, it may have been hung above a shrine or an altar. / NCS

73
Reliquary Pendant

English, 15th century
Gold, enamel; 5 × 4.2 × 0.8 cm
The British Museum, London (AF.2765)

INSCRIBED: A MON DERREYN (at my death)

PROVENANCE: Rev. William Maskell, 1848 (date and mode of acquisition unknown); Augustus Wollaston Franks (date and mode of acquisition unknown); The British Museum, London, 1897, by bequest

BIBLIOGRAPHY: Archaeological Institute of Great Britain and Ireland 1848, 156–57; Tait 1986b, no. 521; Robinson 2008, 78

The front of this double-sided gold pendant shows John the Baptist, with long hair and a beard, dressed in a short tunic and cloak. Standing on a hillock and flanked by two flowers in white enamel, he holds the Lamb of God, gesturing toward it with his other hand. The reverse shows a bishop, set in a similar background, who holds a long cross in one hand and raises the other in a two-fingered blessing. The bishop is unnamed; commentators have suggested that he may be St. Thomas Becket or St. Germanus.

Much of the enamel that decorated this piece is now lost; traces can be seen in white on the flowers, and in black on the costumes and etching detail. The pendant is hollow to allow items to be stored within; we do not know what relics it once held. There has been speculation that, based on the iconography of St. John, rather than holding a relic, the pendant was an *Agnus Dei* container (see Robinson herein, pp. 114–15). A loop on the top suggests that it was originally hung from a chain. The pendant may have been used by the owner as a talisman against ill and to protect against sudden death. The hidden relics and the inscription beneath John the Baptist show this to be a personal object. Etched tears, surrounding the sides of the pendant, might relate to the somber sentiment of the inscription. / NCS

74
Reliquary Pendant for the Holy Thorn

French (Paris), ca. 1340
Gold, enamel (basse-taille), amethyst, glass, vellum
4 × 2.65 × 2.5 cm
The British Museum, London (PE 1902,0210.1)

PROVENANCE: George Salting, London (date and mode of acquisition unknown); The British Museum, London, 1902, by donation

BIBLIOGRAPHY: Paris 1981, 235–36; Tait 1986b, 209; Robinson 2008, 84–85

The Holy Thorn, from the Crown of Thorns worn by Christ before and during the Crucifixion (Matt. 27:29), was a celebrated relic during the Middle Ages. The thorn in this reliquary may have come from the Crown of Thorns that was purchased by King Louis IX of France in 1238 from the Latin Emperor of Constantinople, Baldwin II. Consecrated in 1248, the Saint-Chapelle was built to store the crown itself. Louis detached the thorns from the main band and sent many in reliquaries as gifts. This practice continued under successive kings (see cat. no. 54).

The outer cover of this pendant is backed with amethyst. The interior is enameled using a technique known as *basse-taille,* in which shallow wells are cut for the enamel. The enamel is laid in such thin sheets that it is translucent and the metal shines through; this differs from the champlevé technique where the enamel is opaque. The pendant is composed of three leaves, each divided into two registers, that depict scenes from the life of Christ: the Nativity, the Annunciation to the Shepherds, the Presentation in the Temple, the Flight into Egypt, the Virgin and Child enthroned, the Crucifixion, and the Descent from the Cross. The lower register of the first leaf shows a secular scene: a queen with a barefoot kneeling king, who look up toward the sacred scene above them, their hands pressed together in prayer. The presumed date of the object and its Parisian manufacture suggest that the scene depicts the French king Philippe VI and his wife, Jeanne de Bourgogne. The central leaf showing the Nativity and Annunciation to the Shepherds is a painted piece of vellum covered by glass that conceals the relic of the Holy Thorn, topped with a small gold crown. / NCS

75
Reliquary Jewel

Bohemian (Prague), middle or third quarter of the 14th century
Silver (engraved, openwork) partially gilded; enamel (champlevé, opaque red, black, and white enamel, translucent green); rubies, garnets, sapphires, amethysts, rock crystal, pearls, glass; 18.5 × 18.5 cm
Musée de Cluny—musée national du Moyen Âge, Paris (Cl. 3292)
London only

INSCRIBED: on eight phylacteries contained in the receptacles: MARTINE (Martin), AND(R)E (Andrew), MARGARITE (Margaret), NICOLA (Nicholas), SC PETRI (St. Peter), YPOLIT . . . (Hippolytus), CONSTANTIN (Constantine), LAURENTI (Lawrence)

PROVENANCE: Louis-Fidel Debruge-Duménil, Paris (sale, 22 January 1850); Prince Petr Soltykoff, Paris, 1850–1861 (sale, 8 April–1 May 1861, no. 211); acquired by the Musée de Cluny at the Soltykoff sale

BIBLIOGRAPHY: Shaw 1843, pl. 88; Du Sommerard 1838–46, 5:277, 406; Labarte 1847, no. 981; Jacob 1848–51, 3: *Orfèvrerie* fol. 14; Labarte 1864–66, 1: pl. 54, no. 4, 2:381–82; Corblet 1868, 500; Viollet-le-Duc 1871–75, 3:14; Champeaux 1888–98, 2: pl. 131; Evans 1953, 66; Kraft 1971, 105; Nuremberg 1978, no. 96; Taburet-Delahaye 1989, 248–51; Lightbown 1992, 227–28; New York 2005, no. 16

This sumptuous work—an octolobe framing a square plaque—is both a jewel and a reliquary. Its perimeter, covered in champlevé enamel, is punctuated with eight small receptacles that contain parchment phylacteries, each inscribed in a fourteenth-century uncial script with the names of the saints whose relics were formerly housed within it. On the plaque at the center, against an engraved background of stylized tongues of flame, is a crowned eagle with its wings outspread, studded with stones and pearls. This object was likely a clasp or buckle, designed to secure the folds of a formal secular or religious garment. It was probably commissioned by one of the kings of Bohemia. The single-headed eagle, an attribute of Wenceslas, the patron saint of Bohemia, has long been associated with the arms of Bohemia, and often appears on a background of flames, as in the tombs of Duke Bretislav I and his son Spytihnev II in the cathedral of Prague. The gem mounts date the work to the middle of the fourteenth century or slightly later, which would suggest that it was commissioned either by Charles IV of Luxembourg, king of Bohemia and a great patron of relics (see Klein herein, p. 61), who took the single-headed eagle as his insignia at his coronation as king of Bohemia in 1347 and used it until his coronation as Holy Roman Emperor in 1355 or by his son Wenceslas, who used the emblem beginning in 1363. This reliquary jewel might have been made in Prague, which under Charles's reign drew artists from all over Europe. / CD

76
Reliquary Pendant

Post-Byzantine (Serres, Greece), mid-16th century
Gold, amethyst, emeralds, rubies, pearls, semiprecious stones, niello; lid: 6.5 × 6.2 × 1 cm; backplate: 8.6 × 7.1 × 1.6 cm
cross: 5.2 × 3.2 × 0.6 cm
The Walters Art Museum, Baltimore (57.1511)

INSCRIBED: (after Ross and Laourdas 1951) on amethyst: MP ΘY / IC XC (Mother of God; Jesus Christ); outer rim of inside face: Arsenios, the most holy metropolitan of Serres and Hypertimos [and] substituting for [the metropolitan of] Caesarea-Cappadocia, God be helper; cross, top: Jesus Christ / The king of the Jews; below Christ's arms: You redeemed us with your holy blood, being crucified; on sides (a later inscription): Dedicated by the most holy metropolitan of Serres, Arsenios, to the Monastery of the Holy Trinity called Esoptron on the island of Chalke

PROVENANCE: Metropolitan Arsenios, Serres, Greece; Monastery of the Holy Trinity called Esopotron, Chalke; Henry Walters, Baltimore (date and mode of acquisition unknown); Walters Art Museum, Baltimore, 1931, by bequest

BIBLIOGRAPHY: Ross and Laourdas 1951; Johnston 1984, 151

The Byzantine Empire collapsed when the capital city, Constantinople, fell to the Ottomans in the spring of 1453. Byzantine artistic traditions, however, have continued to influence the production of Orthodox Christian art. This pendant reliquary, meant to be worn around the neck of its owner, is an excellent example of the continuing tradition of Byzantine art, and shares a number of features with earlier *enkolpia,* or reliquary pendants. The reliquary consists of a hinged outer case with a smaller reliquary inside. The central feature of the outer cover, an amethyst carved with a depiction of the Virgin and Child, has many parallels in the Byzantine world, building on a tradition that carried over from Antiquity; the carved gem may in fact be an earlier piece reset in a sixteenth-century reliquary. The outer cover opens to reveal a small reliquary cross, set into a compartment of the back cover, and flanked by six small compartments for other relics. Thus, while the gem-encrusted outer cover provided a suitably brilliant housing for the relics, the owner of this pendant could choose to reveal the relics themselves. A similar arrangement of layered access can be seen in two earlier reliquary pendants of St. Demetrios (cat. nos. 29, 30). Another feature shared with these two earlier pendants is the inclusion of an inscription. In the case of the Walters' pendant, the inscription names the original owner, Arsenios, metropolitan of Serres in northeastern Greece. Serres was a center of art production in the sixteenth century, so it is likely that the pendant was made there. A later inscription relates that Arsenios gave the pendant to the Monastery of the Holy Trinity on the island of Chalke (present-day Heybeliada), near Istanbul. / KBG

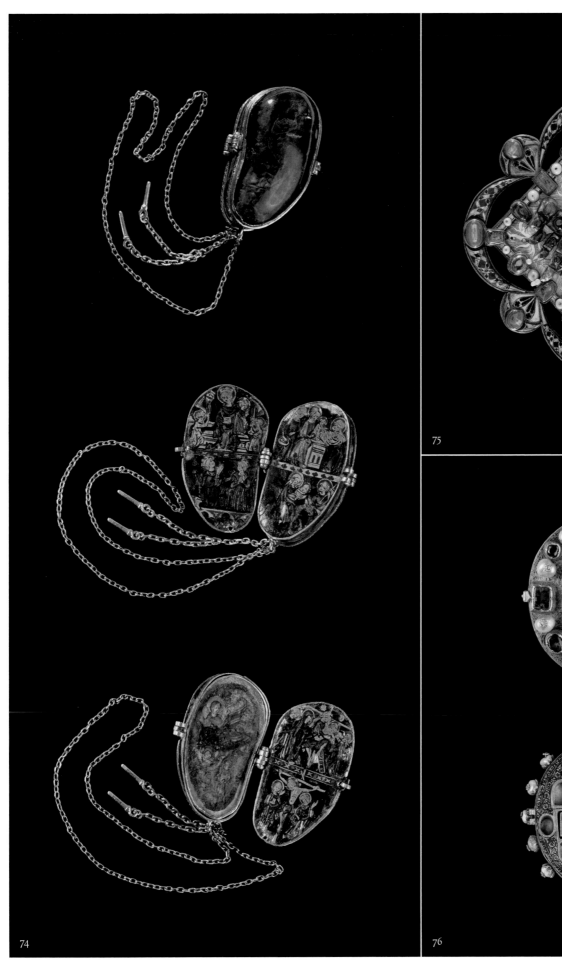

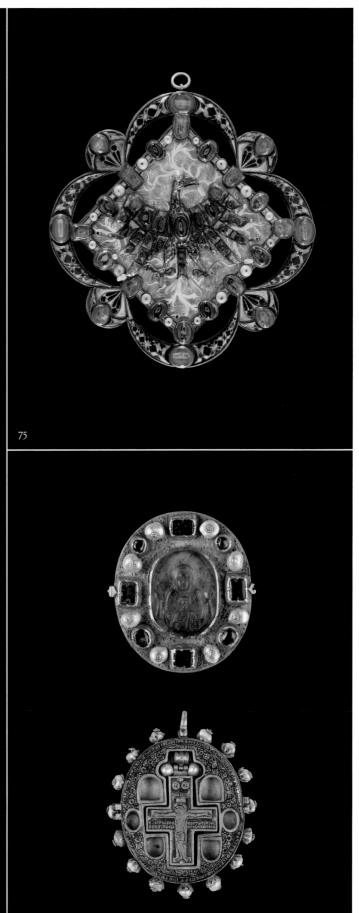

75

76

MATTER OF FAITH

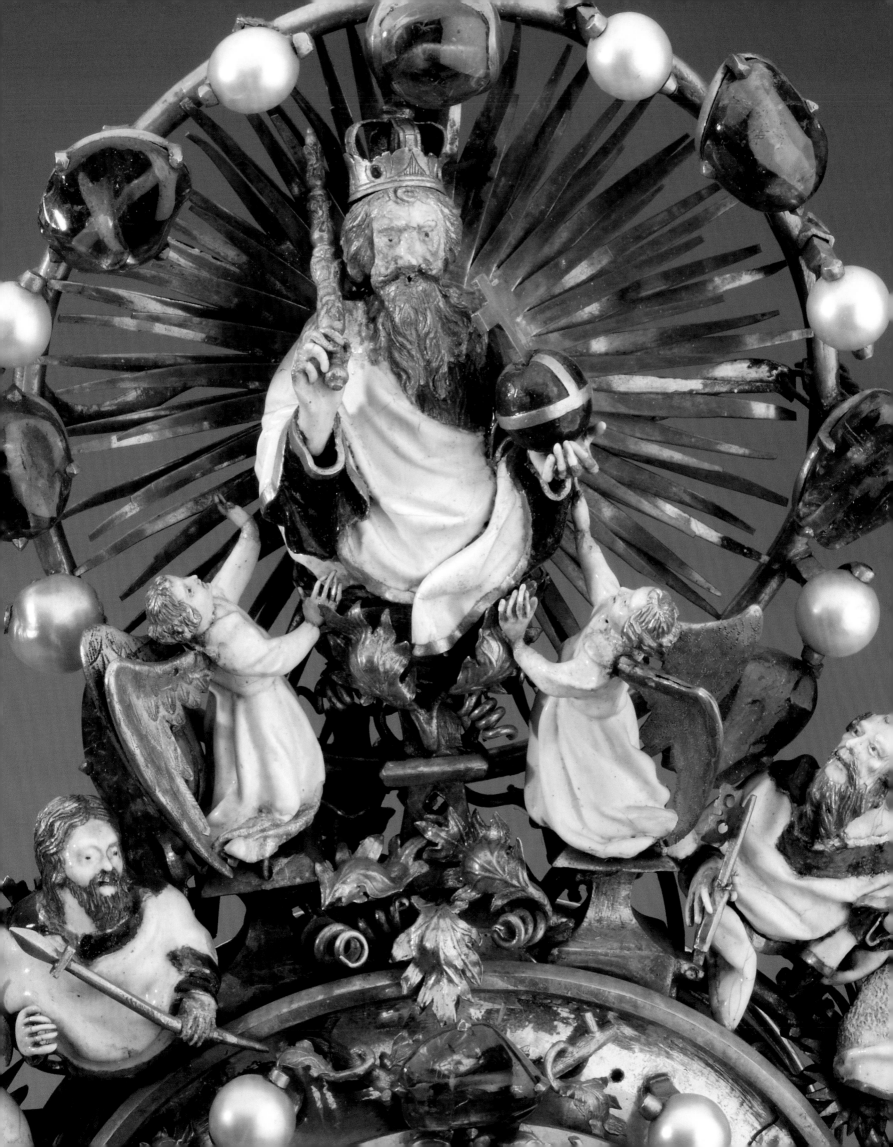

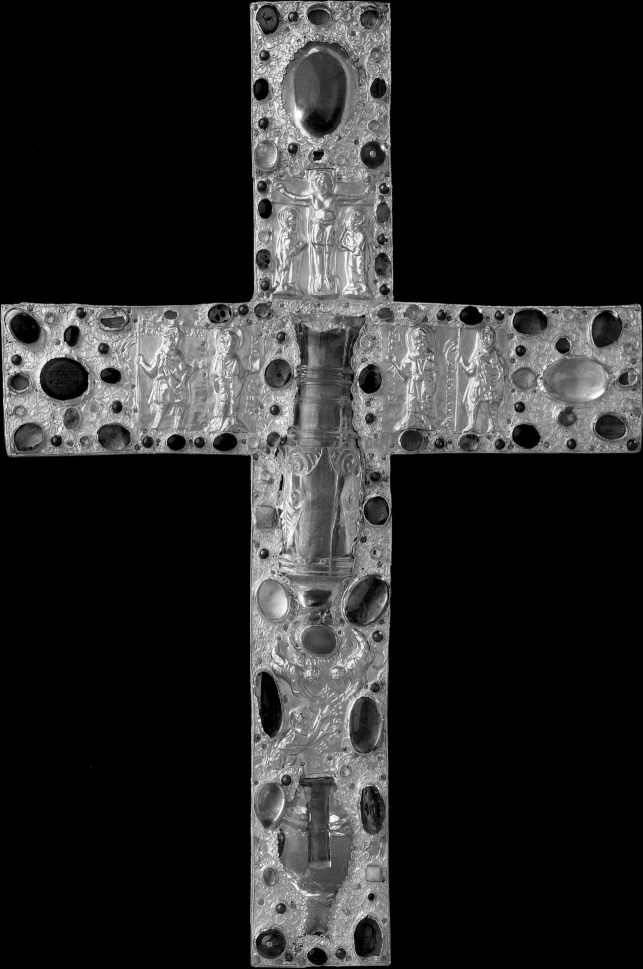

The Stuff of Heaven
Materials and Craftsmanship in Medieval Reliquaries

MARTINA BAGNOLI

In an address given at the twentieth World Youth Day in 2005, Pope Benedict XVI observed: "By inviting us to venerate the mortal remains of the martyrs and saints, the Church does not forget that, in the end, these are indeed just human bones, but they are bones that belonged to individuals touched by the living power of God. The relics of the saints are traces of that invisible but real presence which sheds light upon the shadows of the world and reveals the kingdom of heaven in our midst." Pope Benedict's statement touches on an important aspect of the cult of relics that has preoccupied theologians since Late Antiquity: how can human remains transmit the power of God, who is not matter but spirit? This paradox worried both critics and supporters of the cult of relics, which emerged periodically as a matter of controversy provoked by unregulated popular devotion. In the fourth century, Jerome denounced a priest who disparaged the cult of relics as superstition.[1] Five centuries later, Claudius, bishop of Turin from 817 to 827, argued that saints' relics were no more important or holy than animal bones, a claim attacked as heresy by Jonas, bishop of Orleans (r. 818–843/44).[2] In the twelfth century the debate flared up again with the appearance of two theological treatises on the veneration of relics: one in favor, by Thiofrid of Echternach (d. 1110), and one against, by Guibert of Nogent (1055–1124).[3] In his often quoted *Flores epytaphii sanctorum* (Flowers Strewn over the Tombs of the Saints), Thiofrid associates the veneration of relics with the Incarnation of Christ, which made matter an instrument of salvation. He interprets relics as a means of commemorating saints who had achieved spiritual purity. To justify the Church's lavish expenditures on saints' tombs, and to answer critics who faulted the veneration of relics as materialistic, Thiofrid observes that relics are objects that need to be apprehended by the senses; reliquaries were thus necessary tools to reveal the spiritual power of their contents. In that respect, reliquaries served the same purpose as the bread and wine of the Eucharist: to show the nature of Christ's presence in a way that ordinary people would find palatable: "Knowing that man cannot see and touch rotten flesh without being nauseated, he hid his body and his blood in the bread and wine, to which men are accustomed. Similarly, he has persuaded the sons of the Church to conceal and shelter the relics of the saint's happy flesh in gold and in the most precious of natural materials so that they will not be horrified by looking at a cruel and bloody thing."[4]

Material Splendor

Thiofrid's statement validated a long-standing custom in church practice: the fashioning of reliquaries out of precious materials. Since the origins of the cult of relics, reliquaries had been conceived as precious containers. The riches of the reliquaries' exteriors embodied the spiritual value of the

bits of bone and dust they contained: their material worth was equated with spiritual merit. It is not surprising, therefore, that medieval sources often describe liturgical objects, including reliquaries, in terms of their cost. For the donor, commissioning a costly reliquary was considered a sign of pious homage, but reliquaries were also conceived as capital to be used in time of trouble; veneration did not stand in the way of breaking cult images apart in order to raise capital. The Benna Cross in Mainz, for example, was cast from six hundred pounds of gold in about 983; in 1153 a foot was removed to pay for the army of Bishop Arnold. A few years later, an arm was taken by another bishop, Rudolph, to fund a trip to Rome. The remainder was melted down in 1161.[5] The treasury of the Basilica of Saint-Denis was above all a monetary reserve to be used for the care of the poor or for maintaining the monastery in the event of severe financial need.[6] Sometimes, the saint in question was said to have appeared in visions, commanding the guardian of his or her remains to detach parts of the relics' container to advance a particular cause.

The magnificence of precious containers awed worshipers, augmenting the appeal of the relics. Even in a secular museum setting, the sheer density of precious materials that cover many medieval reliquaries is beguiling; in their original religious and ritual context, the lure must have been irresistible. A letter written in 1125 by Bernard, abbot of Clairvaux (r. 1113–28), to his fellow monk William of Saint-Thierry, attests the ways in which precious materials could enhance the sacred quality of relics and illustrates the effect of glittering beauty on the laity: "The thoroughly beautiful image of some male or female saint is exhibited, and that saint is believed to be more holy the more highly colored the image is."[7] "Colored" in medieval terminology refers the material riches of a variegated surface.

It follows that the appeal of glitter was also invoked to dispel any doubts about the authenticity of relics. Guibert of Nogent's treatise, *De sanctis et eorum pigneribus* (On the Saints and Their Relics) is a passionate attack on unscrupulous clerics. The text is filled with examples of fraudulent relics foisted on the credulous by means of spurious or misleading inscriptions and elaborate shrines.[8] The use of precious materials was certainly part of the process of marketing relics: the opulent display of gold reliquaries studded with gems effectively proclaimed the relic's "real" worth. This principle worked in both directions, and lack of a proper setting cast doubt on the authenticity of the relics. The chronicle of the monastery of Prüm, near Trier in Germany, records that in the ninth century a woman came to the monastery to venerate the newly translated relics of Sts. Daria and Chrysantus. Loaded with gifts, she rushed toward their tomb, but seeing that it "did not shine with gold and silver, she scorned the place" and turned around, taking her gifts with her.[9]

Medieval craftsmen exploited the rich symbolism associated with specific materials in making reliquaries to signal the sacred. Precious metals were selected not only because they were expensive and rare but also because they were thought to be pure; the smelting process used in their refinement was seen as akin to purification by fire. Precious metals were incorruptible,

moreover, like the flesh of the saints.[10] Accounts of saints' lives and their miracles are filled with stories of saintly bodies being found uncorrupted, even centuries after their death; invariably these bodies gave out the sweet smell of flowers, not the stench of rotten flesh.[11] In the second-century account of the martyrdom of Polycarp, bishop of Smyrna, the saint's body appears to the bystanders as a shining vision in "gold or silver" as it is consumed by flames.[12]

Gems as well partook of a rich symbolic tradition. Medieval lapidaries—that is, treatises on minerals—built upon the tradition established by ancient authors such as Theophrastus and Pliny.[13] Precious stones, which were defined to include organic materials such as coral and pearls, were thought to be the result of processes influenced by the stars and the astrological signs. Gems were thus considered to be alive and to contain the power associated with the cosmic events that led to their creation. From this power they drew their magical, medical, and for Christian authors, spiritual qualities. Christian lapidaries usually concentrated on the stones mentioned in the Bible, which were often compared to virtues. The English monk and historian Bede (d. 735), for example, associated jasper with the strength of the incorruptible faith, while sapphire, thought to be found in the Red Sea, signified that those who were inspired by faith could rise, intellectually at least, to celestial heights.[14] Garnet was traditionally associated with compassion, while rock crystal, understood as petrified water because of its transparency, symbolized purity from sin and was often associated with Christ.

Because of the costs and labor involved in finding, mining, and processing precious stones, gems from cultures distant in both time and space were frequently reused. Sometimes, the use of Antique gems was a sign of the patron's political aspiration, but, more often, these reused objects, or *spolia,* were considered valuable for the quality of their finish and intrinsic geological characteristics.[15] The Dominican friar and philosopher Albertus Magnus (d. 1280), for example, describes the marvelous designs on the cameo of the Ptolemies set into the Shrine of the Three Kings in Cologne as the result of astrological forces at work during its formation and thus a sign of the gem's power.[16] Two rock crystal vessels, containing relics of the Passion of Christ and of several saints, were incorporated into the vertical shaft of the Borghorst Cross (cat. no. 77), one at the center and one at the bottom.[17] The presence of the relics visible inside the transparent vessels underscores the idea of Christ's sacrifice as a source of salvation, dispensed through the water of Baptism (symbolized by the rock crystal). Moreover, the Fatimid flask's Near Eastern origin corroborated the supposed provenance of these relics, thus validating their authenticity.

One specific aspect of the symbolism of gems that was important in the creation of reliquaries was their association with saints, a common theme in exegetical literature. The sacred nature of precious stones is described in Scripture, particularly in Exodus 28:17, which enumerates the jewels on Aaron's breastplate and compares the twelve tribes of Israel to precious stones, and in Revelation 21, describing the vision of the heavenly Jerusalem,

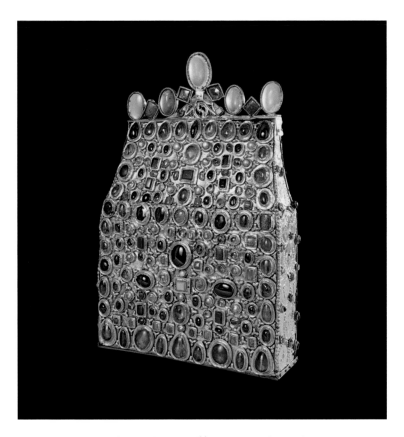

Fig. 46. Purse reliquary of St. Stephen. Reims(?), ca. 830, Kunsthistorisches Museum, Vienna, Schatzkammer (SK XIII 26)

Fig. 47. Reliquary pouch. Trier, ca. 993. Germanisches Nationalmuseum, Nuremberg (KG 562)

the walls of which were made of gems. In the second-century account of St. Polycarp's martyrdom, the bones of the martyr are collected and treated as if they were precious stones.[18] In an eleventh-century allegorical account of the Heavenly Jerusalem, the Italian theologian Bruno of Segni (d. 1123) compares precious stones to the apostles and martyrs, as does Thiofrid of Echternach in his *Flores* and Honorius of Autun (d. after 1135), a philosopher and encyclopedic writer, in his *Gemma animae*.[19]

These ideas informed the appearance of reliquaries. The remains of saints, considered to be "exalted and distinguished vessels of gold" *(vasa auri excelsa et eminentia)* were placed in reliquaries covered with stones, which "represented" the relics contained within.[20] A bejeweled purse-shaped reliquary in the Kunsthistorisches Museum, Vienna (fig. 46) enshrines earth soaked with the blood of St. Stephen, while completely hiding that relic from view. At the same time it transforms a portable textile pouch, of the sort that would have been used to carry relics, like that still extant in the Germanisches Nationalmuseum in Nuremberg (fig. 47) into a glittering impenetrable box, neither portable nor accessible. Brigitte Buettner and Cynthia Hahn have discussed the complex web of paradoxes at work in this object: blood and dust were covered in gold and gems so as to advertise their "real" value, yet to the faithful the contents of the reliquary remained infinitely more precious. Indeed, they were asked to believe without seeing; perhaps, as Buettner has proposed, the precious reliquary overcame the problem of disbelief that seeing naked earth would have entailed.[21]

In addition, the cluster of stones assembled on the surface of the reliquary would have sparkled with rays of light considered to be powerful instruments of healing, possessing powers that were similar and complementary to those of saints' relics.[22]

As this example makes clear, materials mediated, and even facilitated, the fusion of relics and the art-objects called upon to enshrine them. This process reached its apex at the end of the Middle Ages, and it is best illustrated in a 1487 book describing the annual exhibition of relics of the Holy Roman Empire in Nuremberg (cat. no. 125). The text accompanying the illustration of the first such exhibition gives a detailed description of their "form und gestalt" (form and appearance) and refers to the adjoining woodcut, which shows clerics holding reliquaries to the admiring gaze of the crowd, to confirm the information.[23] During the annual exhibition, the relics were not taken out of their containers but were instead shown inside their reliquaries. For the Nuremberg pilgrim, relic and reliquary were one and the same. Notwithstanding the importance of craftsmanship, to which I shall return later, the complex web of allusion established by the materials used to store relics elicited the absorption of content by the container.

Ultimately, materials contributed to the transformation of reliquaries into sculpted images like the reliquary bust of St. Baudime (cat. no. 105). Fleshed in gold and clothed in gems, the reliquary statue was a visualization of the saint as the immortal dweller in paradise, to whom the faithful directed their prayers for intercession. The understanding of this sculpture

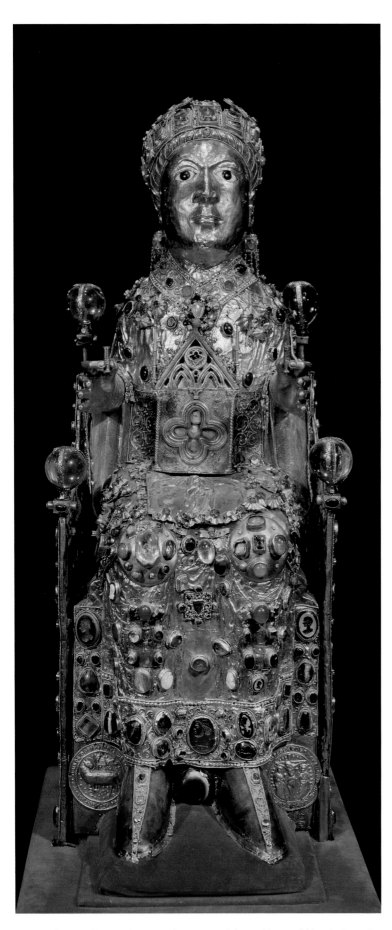

Fig. 48. Reliquary of St. Foy. Conques, 9th century, with later additions. L'abbatiale Sainte-Foy de Conques

as a living presence was underscored by liturgical processions, in which the bust of St. Baudime like many other such reliquary busts would be paraded through town to be venerated and to dispense protection. We know from documentary sources that in the eleventh century numerous reliquary statues of saints represented their churches at the Synod of Rodez, where the famous reliquary of St. Foy also held court (fig. 48).[24] The precious stones that once clothed the figure of Baudime would have satisfied the requirement of variety. As an aesthetic concept, variety—in colors, material, and techniques—was an important tenet of medieval art and should be understood as a metaphor for the myriad virtues of Christ and the Holy Church.[25] This is also true, in the context of a saint's *Life*, where as we have seen, the virtues were often compared to gems. In his *Life*, the virtues of St. Marculph are described as "gold distinguished by diverse rows of gems,"[26] and the radiance that the gems emit is a metaphor for the saint's enlightened status. Thiofrid explains the saints' luminosity as "heavenly clarity," resulting from their closeness to God in paradise.[27]

Nevertheless, all this glitter on three-dimensional sculptures left many clerics uneasy about the perils of idolatry. In the twelfth century, Church authorities sent a cleric from Chartres, Bernard of Angers, to Conques to report on the popular devotion surrounding the reliquary of St. Foy. Bernard, a skeptic at first, later acknowledged the sculpture's miraculous properties and described it as the "pious memory of the holy virgin [St. Foy]" and the emissary of the power of God as attested by the miracles that it performed.[28] Here, relics and materials worked together to justify an image that for all intents and purposes looked and worked like an idol.

How could this be, given Christendom's condemnation of false images? Beyond the symbolic reference to the bones of the saints, precious materials subverted the relationship between the container and its contents. The relics themselves were removed from view and reinterpreted through material associations presented by the reliquaries. For medieval Christians, unable to see the Divine with their eyes, the precious materials of reliquaries activated the *mind's* eye by presenting a vision of the sacred rather than an image of the saint. Thiofrid's characterization of reliquaries as a way to disguise the horror of actual remains should be interpreted as the dichotomy between carnal and spiritual sight, precisely as demanded by the mystery of the Eucharist, which Thiofrid adduces as an example.

Not all Christians, however, recoiled from the stark sight of holy remains. In the Byzantine East, relics were routinely displayed, and the bones themselves were adorned but not hidden from view.[29] The relic of the skull of St. James the Younger (fig. 49), now in the treasury of the cathedral of Halberstadt, was brought to Germany from Constantinople by its bishop, who participated in the Crusaders' sack of the Byzantine capital in 1204. The skull is adorned by silver bands that join the bones and by a plaque nailed onto the top that depicts a holy figure. Half of this plaque is unfortunately missing, but presumably it would have carried the

identification of the relics, as is the case for the skull of St. Akindinos now in the Church of Saint-Just in Arbois, France.[30] Such skulls would have been kept in reliquary boxes like that of St. Praxedes in the Sancta Sanctorum in Rome (see p. 73, fig. 33), which could easily be opened to reveal the bones and enable them to be retrieved.[31] The difference between the treatment of relics in East and West is perhaps best exemplified by the arm of St. George in the treasury of San Marco, brought to Venice by Doge Enrico Dandolo (r. 1195–1205) after the conquest of Constantinople. The relic arrived in Venice with its original decoration, a silver shell wrapped around the bone and open at the top with an inscription identifying the relic. In the fourteenth century, the Byzantine relic was housed in a new precious setting (cat. no. 51), which transformed the silver-clad bone into an ornate vessel, resplendent with gems, translucent enamels, and precious metals. Although the bone was still visible at the top, the Western reliquary removed the actual relic from the tactile immediacy of the Byzantine original.

The influx of relics from Byzantium into Western Europe as a result of the sack of Constantinople had a profound effect on how these valuable commodities were traded, venerated, and displayed. Reliquaries routinely began to open up to the enquiring gaze of the faithful, showing the relics contained within. The comparison between the twelfth-century arm reliquary of the apostles now at the Cleveland Museum of Art (cat. no. 41) and that made in fourteenth-century Naples and containing relics of St. Luke, now in the Musée du Louvre (cat. no. 109) is representative of this development. In the Cleveland reliquary the incorruptible bones of the saints are fleshed in gold, intended to be understood as visual manifestations of the powerful arm of the Church and as a "dispenser of power."[32]

Fig. 49. Skull relic of St. James the Younger. Byzantine (Constantinople), before 1204. Domschatzverwaltung, Halberstadt (19)

By contrast, the Louvre arm reliquary reduces the writer of the Gospel to his most significant feature, a hand holding a pen. Luke's bones are not covered in gold, but they would have been visible through the transparent rock crystal chamber that constitutes his arm. In a companion piece, also at the Louvre, containing the relic of St. Louis of Toulouse, the rock crystal is set into an architectural structure that resembles the pier of a church (fig. 50). Medieval discussions of the symbolism of church buildings often compared the saints and the apostles to pillars supporting the Church; this idea was literally embodied by burying relics within the churches' architectural structures. The Neapolitan reliquary, therefore, presents the bones of the saint as an integral support of the institution of the Church.[33]

The proliferation of rock crystal reliquaries in the thirteenth century has been studied by Christof Dietrich, who compares the visible placement of actual relics inside small transparent reliquaries (see cat. nos. 77–80) to the substitution of large expanses of stained glass windows for walls in Gothic cathedrals. The transparent chambers allowed for the presentation of the relics without disturbing the saints' peace, as no manipulation was necessary. In addition, transparency permitted a higher degree of intimacy with the relics for a greater number of people. In the early Middle Ages only a handful of important people were allowed to examine the relics concealed inside reliquaries; transparent reliquaries popularized that form of engagement at a time when a more human approach to divinity was actively sought. The Gothic period saw an increased reliance on sight as a sensory perception through which God's grace could be achieved. At this time, the emergence of the science of optics stimulated discussion about the nature and the workings of man's sight. According to the Aristotelian theory of intromission, which became popular in the thirteenth century, in order to be seen, an object emitted rays that converged in the beholder's eyes.[34] Perception had to be processed in the brain so that knowledge could be attained: vision led to knowledge. In the earlier Middle Ages, vision implied a superimposition of archetypal images onto the world. Beginning in the thirteenth century, external reality was instead conceived as providing factual information to be processed by the subject's brain. This change meant the passage from a supernatural to a natural understanding of the world and changed the dynamic between the thing seen and the person looking at it. Late medieval optics, as Michael Camille has observed, "objectified the thing seen and 'personalized' the subject looking at it."[35] The increased visibility of relics, partaking in these scientific developments, demonstrates a desire to apprehend divinity by looking at the relics. It subverts the attitude common in the early Middle Ages of mistrusting physical sight to privilege the mind's eye.

The shift between these different paradigms of devotion, one that hides and one that reveals, is evident in the reliquary of St. Oda in the Walters Art Museum (cat. no. 81). The presence of holes and cropped wooden pins on the backs of the Walters' reliquary and a similar panel at the British Museum (cat. no. 82) might suggest that the objects were originally the gable-ends of a twelfth-century architectural chasse containing the remains

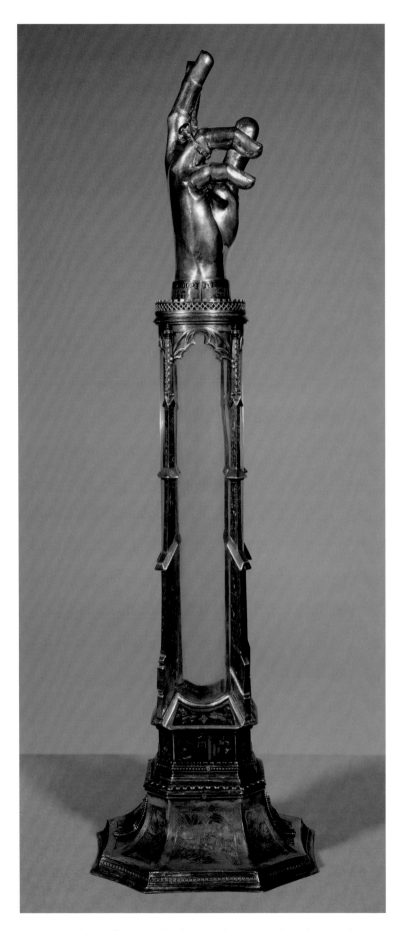

Fig. 50. Arm reliquary of St. Louis of Toulouse. Naples, 1336–38. Musée du Louvre, Paris (OA 3254)

of Oda, a seventh-century widow from Amay (in present-day Belgium) renowned for her piety. These two ends were subsequently adapted for use as independent reliquaries in the thirteenth century. Physical evidence suggests that the relic chambers in the inner border of the Baltimore panel were added sometime after it was first fashioned into a separate reliquary.[36] The relic chambers are set as if they were gems; they are in fact framed in a way similar to the cabochon crystals alongside them. The cabochon settings exemplify the common practice of setting precious stones surrounded by four pearls at the corners followed by an enameled plaque. In the London and Baltimore panels, though, the pearls have been replaced by gilt silver bosses interspersed with *couvettes,* or gouged cavities, that create the illusion of a gem-studded surface.

The movement of relics from the hidden core of the reliquary to the periphery, where they take the place once occupied by gems, attests to the shift from materiality to visuality that occurred in thirteenth-century art. Where the gems had once stood metaphorically for the bones of the saints, they now yielded to the actual remains of those saints. In the Oda reliquaries, the relics are visible through thin sheets of horn, identified by red inscriptions on parchment strips, known as *authentiques.* The presence of the authentiques encouraged worshipers to look and thus gain knowledge of sacred presence. The evocation of the saints' names was itself a powerful intercessory mechanism, as attested by the litanies invoked during the Mass, when long lists of saints were appealed to with a series of repetitive and formulaic prayers. Thiofrid discusses the power of uttering saints' names as equal to that of the relics themselves. In the Oda shrine, then, the material of the reliquary is somewhat displaced by sight and sound. With the gems and their false settings relegated to the outer frame, the relics are hierarchically situated in relation to the central picture of Christ, serving as the real measure of the image's validity; to a certain extant, the relics authenticate the truthfulness of the image. In the later Middle Ages, relics are frequently used to frame images in painted reliquaries in which precious materials were simulated (see cat. nos. 117–120).[37] The Baltimore shrine, to which relics were added on the frame, shares with painted reliquaries the dependence on relics to justify "valueless" man-made image. In Christendom relics and images shared many of the same properties, and, despite protestations to the contrary in the early medieval period, they both served as a way to facilitate meditation of God.[38] Indeed, sometimes images were themselves relics, as is the case of the *acheiropoieton* (not made by human hands) icons of Christ (see cat. no. 113). The image of the *mandylion* was the result of an impression of Christ's face on a towel, and was thus a contact relic of Christ.[39] Another famous *acheiropoieton*, the celebrated icon of the Sancta Sanctorum at the Lateran, was reputed to have been painted in part by St. Luke and finished by angels.[40] But not all painted images could claim such lofty origins, and in order to justify their base materiality and human origins relics were often buried deep inside them or inserted around them. The faithful turned their prayers not only to the saints enshrined in the paintings but also to those portrayed on them. Thus the

relics served a double function: they were the object of veneration, but they also validated the painter's craft. If at the beginning, then, art was enlisted in the service of relics, later relics became the handmaids of art. A fourteenth-century ostensorium in the Cleveland Museum of Art (cat. no. 44) presents an interesting case of a work of art authenticated by the presence of relics. The Cleveland reliquary includes at its center a twelfth-century paten, a dish used for the bread during the celebration of the Eucharist. The ostensorium was created to display several relics, including a piece of the True Cross, visible at the top. Constructed as a miniature building, the ostensorium frames the paten as if it were the rose window of a Gothic cathedral. The center of the paten is decorated with the figure of Christ the Redeemer sitting on a rainbow and displaying the stigmata. An inscription around him confirms his role as Savior—"Be witness, I have redeemed you with my death"—and he is surrounded by symbols of the four Evangelists and personifications of the four cardinal virtues. An inscription on the outer rim refers to the transubstantiation of Christ's body into the bread of the Eucharist: "The bread which is broken in me is the body of Christ itself. He who receives it in good faith shall live in eternity." The paten was probably incorporated because of its associations with Bishop Bernward of Hildesheim (d. 1022, canonized in 1192/93), who is named as the artist on a strip of parchment visible on the back of the ostensorium (this same strip of parchment also identifies all of the relics enshrined in the reliquary) (fig. 51). In the Cleveland ostensorium, Bernward's creation not only proclaims God's mystery but is itself a relic of the saint, and this is in turn validated by the myriad relics that surround it. Indeed, due to the nature of the liturgical object, Bernward is here venerated as a *sacerdos*, a priest, who through the Holy Spirit participates in the transformation of the bread and wine into the body and blood of Christ, but he is also celebrated as an artist. As a servant of Christ, Bernward both creates and uses the paten.

Divine Craftsmanship

The comparison implicit in the Cleveland paten between the artist and the priest marks the conclusion of a process that had begun two centuries earlier. From the ninth through the twelfth century, theologians debated the nature of the transubstantiation of the bread and wine into the flesh and body of Christ. Medieval commentators conceived of the priest as a participant with the Holy Spirit in that process of transformation, and the priest came to be seen as a stand-in for the Virgin Mary, a vital participant in the incarnation of Christ.[41] This insistence on the role of the priest in the Eucharistic miracle led twelfth-century artists to imitate the priestly model and interpret their creative process as similar to the actions of the priest during Mass. This intellectual trend is reflected in the increasing importance of fabricated images in the liturgy and the abundance of artists' signatures on works from this period.[42]

The presence of the Holy Spirit at the moment of artistic creation and its role as the direct cause of the artist's work are discussed by the monk Theophilus in the only extant twelfth-century manual dedicated to the making of art: *On the Various Arts*. Theophilus's treatise is unique in that it is not confined to instructions for making tools and mixing paint, but also gives significant attention to the role and mission of the craftsman. Indeed, Theophilus's book is an invitation to his fellow monks to exercise their manual skills, through which they could exercise their right to knowledge. Theophilus understands artistic talent as an "inherited right," which man maintained despite his fall from grace. Man could regain his likeness to God only if this right was studiously exercised. According to Theophilus, the craftsman who sets out to decorate the house of God is filled with the sevenfold spirit.[43] As John van Engen has noted, according to Theophilus, the ideal craftsman possesses all seven gifts of the spirit, as did, according to other theologians, Christ himself.

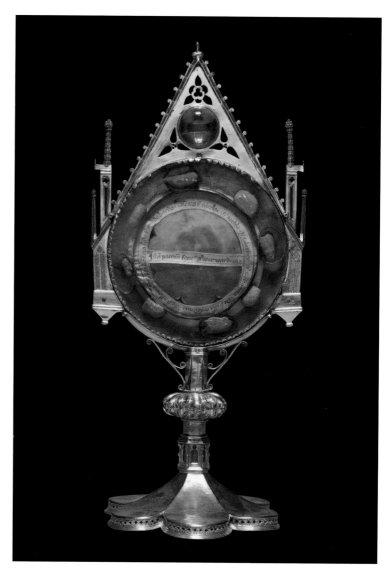

Fig. 51. Reverse of ostensorium with "Paten of St. Bernward" (cat. no. 44). German (Lower Saxony), 12th/14th century. The Cleveland Museum of Art, purchase from the J.H. Wade Fund with additional gift from Mrs. R. Henry Norweb (1930.505)

Theophilus classifies the craftsman's knowledge as his capacity to arrange his creation according to order, variety, and measure. This characterization is borrowed from Scripture, where God "ordered all things by measure, number and weight" (Wisdom 11:21) and implicitly compares the work of the craftsman with that of God. The idea is steeped in twelfth-century commentaries on Genesis. Theologians such as William of Conches (ca. 1090–after 1154), Abelard (1079–1142), and Thierry of Chartres (d. ca. 1150) sought to understand the mystery of Creation through reason rather than solely through the weight of received authority. According to Anselm of Bec, archbishop of Canterbury (d. 1109), God's Creation is supremely rational and hence it is open to man's rational understanding, since man was created in God's own image. This climate of "intellectual confidence," to use R.W. Hanning's term, fostered an appreciation of human creativity as a microcosm of God's creation and led to the widespread use of the metaphor of God as artist.[44] William of Conches in his gloss on Plato's *Timaeus* writes: "for as a craftsman wishing to make something first arranges it in his mind and afterward, having procured material, forms it according to his idea, so the creator before he was to create anything, had an idea of it in his mind and thereafter performed it if by his act."[45] The comparison of the artist and God elevated the value of the craftsman in intellectual circles by giving philosophical and rational dignity to the process through which artifacts were created. Indeed the *artifex* had to proceed with "the confidence of a full mind" as Theophilus so elegantly proclaimed.

This is particularly true in the writings of Hugh of Saint-Victor (1096–1141) and Rupert of Deutz (d. 1135), both of whom, like Theophilus, recognized the value of the mechanical arts as gifts proceedings from the Holy Spirit and as instruments in the combat against vice. In his guide to the arts, titled *Didascalicon*, Hugh discusses the works of God, of Nature, and of the artist/craftsman imitating Nature; he argues that the role of man as maker is to overcome his fallen state by turning the work of nature to his use. So does Rupert of Deutz in his work dedicated to the Trinity.[46] Hugh, Rupert, and Theophilus elevate the mechanical arts to the level of other intellectual faculties engaged in achieving wisdom. Furthermore these authors emphasize the capacity of craftsmanship to inspire awe. Hugh discusses how, driven by need, man had to find "all that is most excellent in the occupation of man: "from this [want] the infinite varieties of painting, weaving, carving, and founding have arisen, so that we look with wonder not at nature alone but at the artificer as well."[47] This idea is clearly expressed by Theophilus too, when he claims that the work of craftsmen can lift the soul toward God, causing the faithful: "to praise God the creator in this creation and to proclaim him marvelous in his works."

The above discussion provides the background for the creation of the Cleveland ostensorium. In the fourteenth century, Bernward's holiness was celebrated through his art, and his work was enshrined as a relic. The resulting reliquary draws attention to an important shift beginning in the twelfth century, in the understanding of the making of art, and in particular of the nature of craftsmanship as a source of wonder and awe.

Workmanship now partook of some of the same wondrous qualities that were previously associated with precious material. Ovid's remark that craftsmanship sometimes surpassed material worth *(materiam superabat opus)* was often invoked in medieval descriptions of works of art not only to justify extravagance but also to record genuine wonderment at precious craftsmanship.

That the value of artistry was considered to be equal to that of the material is attested by numerous instances of metalworkers offering the labor of their craft to God, as a patron would offer to underwrite the expenses required to carry out their commissions. In a marvelous example of book binding, Hugo of Oignies portrays himself accompanied by an inscription that compares his work as a goldsmith with his labor as a scribe offering both as prayers to God: "The book is written outside and inside. Hugo wrote it inside painfully and outside with his hands, pray for him, some sing the praise of God with the voice, Hugo sings it with his craft as a goldsmith painfully laboring over his work" (fig. 52).[48]

The meaning of Hugo's inscription has been the subject of debate, particularly in regard to the extent of Hugo's active participation as a scribe.[49] But what is clear is the value placed on the goldsmith's skill as a gesture of veneration and as a means of praising God, precisely as Theophilus would have in his manual.

Hugo left many signed works. One of these is the reliquary of the rib of St. Peter, now in the treasury of Oignies in the Convent of the Sisters of Notre Dame in Namur (cat. no. 112). A strip of parchment inserted in the vessel containing the relics records that the reliquary was made by brother Hugo in 1238. The rock crystal tube containing the relics is mounted onto an arch of metal shaped like a rib and adorned with silver filigree in the form of an inhabited scroll. The rib-shaped support is itself elevated on a foot similar to the foot of a chalice or cross. The little crystal vessel contains a sliver of a bone that cannot be immediately identified as any specific part of a body. Instead, the nature of this fragment is identified by Hugo's rib-shaped flowering silver creation. The immediacy of Hugo's interpretation is at odds with the appearance of the actual relic yet it illustrates the whole relic, interpreting the fragment for the viewer. The incorruptibility of St. Peter's flesh is symbolized by the flowering nature of Hugo's imagined bone. Borrowing a parallel from twelfth-century literature, it is possible to understand Hugo's creation as an *integumentum*, a rhetorical device used by twelfth-century humanists to justify pagan literature. It is best explained as a fictional narrative intended as an ornate covering for hidden truths. The poet Bernard Silvestris (ca. 1085–1178) explained in his *Cosmographia*: "the integumentum is a type of exposition that wraps the apprehension of the truth in a fictional narrative and thus it is also called a cover."[50] In the same way, Hugo's rib reliquary disguises the real relic and presents a visionary image of that poor bit of bone. Just as the poet is the purposeful creator of the literary *integumentum*, charged with leading readers to discover hidden truths, so here Hugo constructs an image of the sacred, which simultaneously hides and reveals the truth.[51]

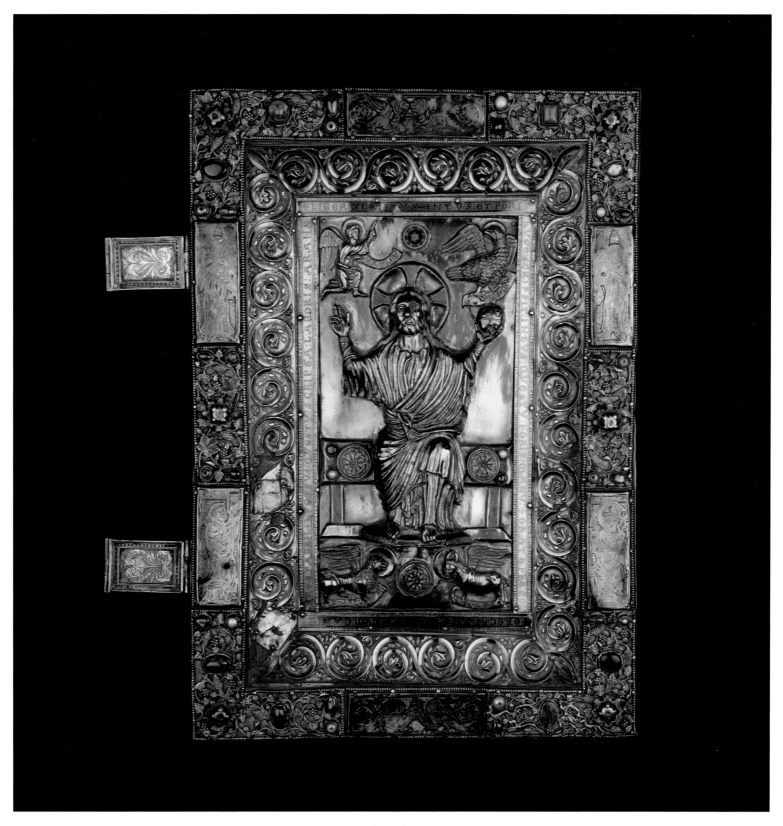

Fig. 52. Gospel Book with Christ in Majesty. Binding by Hugo of Oignies, ca. 1230. Trésor d'Hugo d'Oignies, Couvent des Soeurs de Notre-Dame, Namur

From the beginnings of Christianity the makers of reliquaries were charged with shaping the sacred. In so doing they slowly discovered that their art could rival nature. With this in mind, it is worth pondering whether the explosion of new forms of reliquaries, particularly body-part reliquaries that became so popular in the twelfth century, should not perhaps be attributed in part to a renewed confidence in the value of craftsmanship to reveal God's presence.

Notes

1. Saint Jerome, *Against Vigilantius*, in *Saint Jerome: Letters and Selected Works*, Selected Library of Nicene and Post-Nicene Fathers, trans. H. Fremantle, G. Lewis, and W.G. Martley, 2nd series, vol. 6 (New York, 1895), 417–23.

2. "Surely if men are to be adored, it is the living rather than the dead who should be so adored. In the living there is God's likeness, not the likeness of cattle, or what is worse, of rocks or wood, which are deprived of life, sense, and reason." Claudius of Turin, *Apologeticum atque rescriptum Claudii episcopi adversus Theutmirum abbatem*, PL 105:459–64. A translation of Claudius's full text may be found in G. McCracken and A. Cabaniss, ed. and trans., *Early Medieval Theology* (Philadelphia, 1957). On Claudius's opposition to the cult of relics, see D. F. Appleby, "Holy Relic and Holy Image: Saints' Relics in the Western Controversy over Images in the Eight and Ninth Centuries," *Word and Image* 8 (1992), 333–43; Jonas of Orléans, *De Cultu Imaginum*, PL 106:305–88, esp. 311.

3. Thiofridus Epternacensis (Thiofrid of Echternach), *Flores Epytaphii Sanctorum*, ed. M.C. Ferrari, CCCM 133 (Turnhout 1996); Guibert of Nogent, *De sanctis et eorum pigneribus*, in *Opera varia*, ed. R.B. Huygens, CCCM 127 (Turnhout, 1993).

4. Thiofrid of Echternach, *Flores Epytaphii Sanctorum*, 2.3.84–92, CCCM 133:39.

5. C. Claussen, "Materia und Opus: Mittelalterliche Kunst auf der Goldwaage," in *Ars Naturam Adiuvans: Festschrift für Matthias Winner*, ed. V. von Flemming and S. Schütze (Mainz, 1996), 40–49.

6. D.G. Chopin, *Le trésor de Saint Denis*, exh. cat., Musée du Louvre (Paris, 1991), 24.

7. The letter is known as the *Apologia ad Wilhelmum*. On this, see C. Rudolph, *The "Things of Greater Importance": Bernard of Clairvaux's Apologia and the Controversy over Monastic Art* (Los Angeles, 1985).

8. Guibert de Nogent, *De sanctis et eorum pigneribus*, in *Opera varia*, ed. Huygens, CCCM, 127, 79–175, esp. 85–109; see also *Medieval Hagiography: An Anthology*, ed. T. Head (London, 2000), 402–22.

9. *Historia translationis reliquiarum Chrysanti et Dariæ ex urbe Roma in Galliam*, PL 121:673–82, esp. 676. This episode is mentioned by Rudolph, *The "Things of Greater Importance"* (1985, cited in n. 7), 72

10. On the symbolism of various materials in medieval art, see the comprehensive survey by T. Raff, *Die Sprache der Materialien: Anleitung zu einer Ikonologie der Werkstoffe* (Munich, 1994).

11. See Angenedt herein, p. 22; *The Martyrdom of St. Polycarp*, ed. and trans. H. Musurillo, *The Acts of the Christian Martyrs* (Oxford, 1972), 2–21; Thiodfrid, *Flores epytaphii sanctorum*, 1.5–6, CCCM 133:21–27.

12. Eusebius, *Historia Ecclesiastica*, 4.15.53, in *Die greichischen christlichen Schriftsteller* 2.1 (Leipzig, 1903), 353; *The Martyrdom of St. Polycarp*, in Musurillo, *The Acts of the Christian Martyrs* (1972, cited in n. 11), 15.

13. For a history of the symbolism of precious stones, see C. Meier, *Gemma Spiritalis: Methode und Gebrauch der Edelsteinallegorese vom frühen Christentum bis ins 18. Jahrhundert* (Munich, 1977); G. Jüttner, "Edelsteine" in *LMA*.

14. Beda Venerabilis, *Bedae presbyteri Expositio Apocalypsis*, 3.37, ed. R. Gryson. CCSL 121A (Turnhout, 2001), 533

15. For the state of the question of spolia in medieval art and for further bibliography, see D.E. Kinney, "The Concept of Spolia," in *A Companion to Medieval Art*, ed. C. Rudolph (Oxford, 2006), 233–52

16. Albertus Magnus, *Book of Minerals*, trans. D. Wickoff (Oxford, 1967), 131.

17. C. Garcia de Castro Valdés, ed., "*Signum Salutis*": *Cruces de Orfebreria de los siglos V al XII*, exh. cat., Asturias: Consejería de Cultura y Turismo (Oviedo, 2008), 247–49.

18. *Martyrdom of Polycarp*, in Musurillo, *The Acts of the Christian Martyrs* (1972, cited in n. 11), 17.

19. Brunonis Segnensis (Bruno of Segni), *Libri Sententiarum*, PL 165:891; Thiofrid, *Flores Epytaphii Sanctorum*, 2.138–40, CCCM 133:32; Honorius Augustodunensis, *Gemma Animae*, PL 172:594.

20. Thiofrid of Echternach, *Flores Epytaphii Sanctorum*, 2.1.33, CCCM 133:32.

21. C. Hahn, "Metaphor and Meaning in Early Medieval Reliquaries," in *Seeing the Invisible in Late Antiquity and the Early Middle Ages*, ed. G. de Nie, K.F. Morrison, and M. Mostert (Turnhout, 2005), 239–63; B. Buettner, "From Bones to Stones," in *Reliquiare im Mittelalter*, ed. B. Reudenbach and G. Toussaint (Berlin, 2005), 43–60.

22. G. Toussaint, "Heiliges Gebein und edler Stein: Der Eldelsteinschmuck von Reliquiaren im Spiegel mittealtterlicher Wahrnehmung," *Das Mittelater* 8 (2003): 2, 41–66.

23. "Das ist dy form und gestalt diser yetzgenanten heiligen stücke und mitsampt dem heitligthumstuel wy ir do sehet" (This is the form and shape of these aforementioned holy objects together with the sacred throne as you see it here). *Heiltumsweisung in Nuremberg* (1487), Library of Congress, Washington, DC, Rosenwald Collection 120, fol. 3v.

24. The early eleventh-century Synod of Rodez is reported by Bernard of Angers. See *The Book of Sainte Foy*, 1.1.28, 2.2.11, trans. P. Sherington (Philadelphia, 1995), 98, 136.

25. For a discussion of *varietas* in the context of Carolingian art, see W.J. Diebold, "Medium as Message in Carolingian Writing about Art," in *Word and Image* 22, no. 3 (2006): 196–201.

26. *Vita I* (*sancti Marculphi Abbatis*), AASS, May 1, p. 73.

27. Thiofrid of Echternach, *Flores Epytaphii Sanctorum*, 2.7.133–39, CCCM 133: 53. On the concept of light and holy relics, see Angendent herein, p. 20.

28. *The Book of Sainte Foy* 1.13, trans. Sherington (1995, cited in n. 34), 79.

29. C.L. Diedrichs, *Von Glauben zum Sehen: Die Sichbarkeit der Reliquie in Reliquiar. Ein Beitrag zur Geschichte des Sehens* (Berlin, 2007), 34.

30. G. Toussaint, "Die Sichtbarkeit des Gebeins im Reliquiar— Eine folge der Plünderung Konstaninopels?" in Reudenbach and Toussaint, eds., *Reliquiare im Mittelalter* (2005, cited in n. 21), 89–106.

31. On the Sancta Sanctorum and its reliquaries, see Cornini herein, pp. 69–78.

32. C. Hahn, "The Voices of the Saints: Speaking Reliquaries," *Gesta* 36, no. 1 (1997): 20–31; B. Bessard and G. Mariotti, "Dispensers of Power," *FMR* 42 (1990): 138

33. On church symbolism, see Palazzo herein, p. 99.

34. D.C. Lindberg, *Theories of Vision from al-Kindi to Kepler* (Chicago, 1981), esp. 87–147

35. M. Camille, "Before the Gaze: The Internal Senses and Late Medieval Practices of Seeing," in *Visuality before and beyond the Renaissance: Seeing as Others Saw*, ed. R. Nelson (Cambridge, 2000), 197–223; id., *Gothic Art: Glorious Visions* (New York, 1996), 24–25.

36. The enameled plaques visible along the outer edge of the London panel were replaced on the Baltimore panel with a strip of gilt copper decorated with inhabited scrollwork, itself recycled from some other object. The plaque of the outer frame is pierced so as to accommodate the large cabochon crystals, which match those in the London example and thus seem to be contemporary with the earlier chasse or to date to an early phase in the history of these two paired reliquaries. On the Baltimore panel, the gilt brass repair at the top of the outer border appears to be contemporary with the gilt brass frame of the relics chambers in the inner border.

37. For the importance of relics in authenticating painted images, see C.G. Mann, "Relics, Reliquaries, and the Limitations of Trecento Painting: Naddo Ceccarelli's Reliquary Tabernacle in the Walters Art Musuem," *Word and Image* 22, no. 3 (2006), 251–59

38. For the debate regarding images and relics, see the comprehensive study by Hans Belting, *Likeness and Presence: A History of the Image before the Era of Art* (Chicago, 1994). See also J.-C. Schmitt, *Le corps des images: Essais sur la culture visuelle au Moyen Âge* (Paris, 2002), 273–94.

39. See cat. no. 113 for further bibliography.

40. On the Lateran icon and its liturgical importance, see Cornini herein, pp. 72–74.

41. P.A. Mariaux, "'Faire Dieux?': Quelques refléxions sur les relations entre confection eucharistique et création d'images (IXe–XIe siècles)," in D. Ganz and T. Lentes, eds., *Aesthetik des Unsichtbaren: Bildtheorien und Bildgebrauch in der Vormoderne* (Berlin, 2004), 95–112.

42. J. Wirth, *L'image à l'époque romane* (Paris, 1999), 308.

43. Theophilus, *On Divers Arts*, trans. J.G. Hawthorne and C.S. Smith (Toronto, 1979), 78: "Through the spirit of wisdom you know that created things proceed from God and without him nothing is. Through the spirit of understanding, you have received the capacity for practical knowledge of the order, the variety, and the measure that you apply to your various kind of work. Through the spirit of counsel you do not hide away the talent given you by God, but working and teaching openly and with humility you faithfully reveal it to those who desire to learn. Through the spirit of fortitude you shake off all the apathy of the sloth, and whatever you commence with quick enthusiasm you carry through to completion and vigor. Through the spirit of knowledge that is given to you, you are the master by virtue of your practical knowledge and you use in public the perfect abundance of your abounding heart with the confidence of a full mind. Through the spirit of piety you set limits to pious consideration on what the work is to be and for whom, as well as on the

time, the amount and the quality of work, and, lest the vice of greed of cupidity should steal in, on the amount of the recompense. Through the spirit of the fear of the Lord you bear in mind that of yourself you are nothing able and you ponder on the fact that you possess and desire nothing that Is not given to you by God, but in faith, trust and thankfulness you ascribe to divine compassion whatever you know are or can be."

44. R. W. Hanning, "'Ut Enim Faber . . . Sic Creator': Divine Creation as Context for Human Creativity in the Twelfth Century," in *Word, Picture and Spectacle,* ed. C. Davidson (Kalamazoo, 1984), 95–149.

45. Guillelmi de Conchis, *Opera Omnia,* ed. É. Jeauneau, CCCM 203 (Turnhout, 2007); Hanning, "'Ut Enim Faber . . . Sic Creator'" (1984, cited in n. 44), 115.

46. Rupert of Deutz, *De Sancta Trinitate et operiis eius,* 2.3, ed. R. Haacke, CCCM 21, (Turnhout, 1971), 187.

47. J. Taylor, ed. and trans., *Didascalicon of Hugh of Saint Victor: A Medieval Guide to the Arts* (New York, 1991), 56. On this, see Hanning, "'Ut Enim Faber . . . Sic Creator'" (1984, cited in n. 44), 114–16.

48. "liber scriptus intus et foris hugo scripsit intus questu foris manu orate pro eo ore canunt alii cristum canit fabrili hugo sui quaestu scripta labris arans."

49. On the debate surrounding this inscription and its various interpretations, see G. J. M. Bartelik, "Questus dans une inscription médiévale," *ALMA: Bulletin du Cange* 39 (1973–74), 103–5; J. Leclercq-Marx, "Les inscriptions dans l'oeuvre de frère Hugo," in *Autour de Hugo d'Oignies,* ed. R. Didier, exh. cat., Musée des arts anciens du Namurois, 2003 (Namur, 2003), 133–52.

50. "Integumentum vero est genus demonstrationis sub fabulosa narratione veritatis involvens intellectum unde et involucrum dicitur." Quoted in E. Jeauneau. "L'usage de la notion de 'integumentum' à travers la glose de Guillaume de Conches," in *Archives d'Histoire Doctrinale et Literaire du Moyen Age* 14 (1957): 35–100, repr. in Jeauneau, *Lectio Philosophorum: Recherches sur l'école de Chartres* (Amsterdam, 1973), 130.

51. Hanning, "'Ut Enim Faber . . . Sic Creator'" (1984, cited in n. 44), 108; Jeauneau, "L'usage de la notion de integumentum" (1957/1973, cited in n. 50).

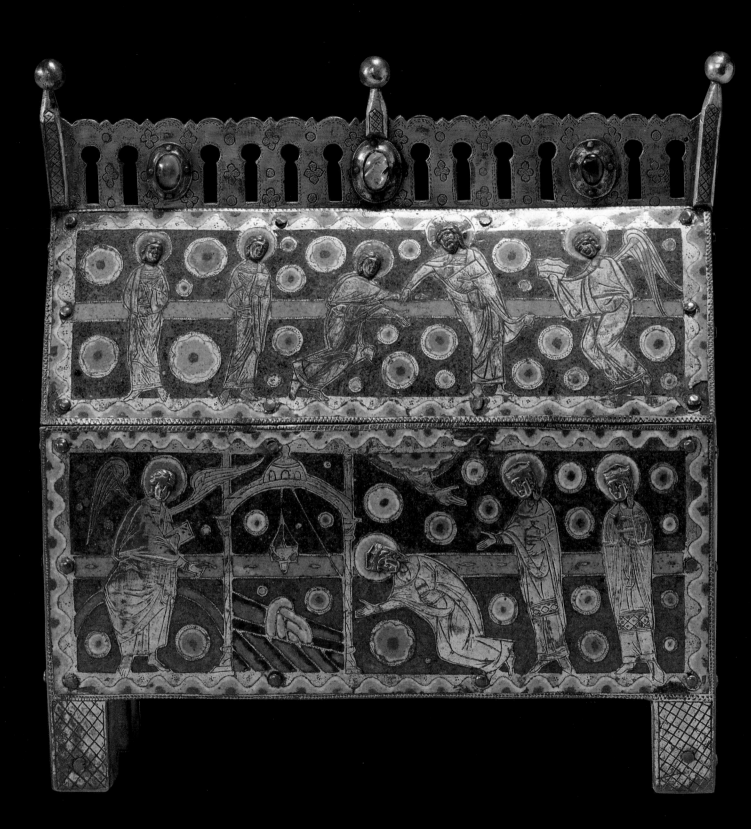

"A Brilliant Resurrection"
Enamel Shrines for Relics in Limoges and Cologne, 1100–1230

BARBARA DRAKE BOEHM

To account for the proliferation of churches built after the millennium, historians of the Middle Ages frequently invoke a poetic passage by the Cluniac monk Rodulfus Glaber (985–1087) that refers to a "white mantle of new churches" covering Europe. Less well known is the text that immediately follows it, in which the same chronicler refers to the extraordinary number of saints' relics that came to light in the same period:

> [i]n the eighth year after the millennium of the Saviour's Incarnation, the relics of many saints were revealed by various signs where they had long lain hidden. It was as though they had been waiting for a brilliant resurrection and were now by God's permission revealed to the gaze of the faithful; certainly they brought much comfort to men's minds.[1]

Perhaps because the vicissitudes of history have been less kind to precious medieval reliquaries created to enshrine saints' remains than to the monumental stone edifices built to house them, scholarly attention has traditionally focused more on the still ubiquitous architecture than on scattered surviving examples of goldsmiths' work.[2] Nonetheless, the combined testimony of extant works of art and contemporary chronicles attests to a flurry of activity in the creation of reliquaries that runs in tandem with the frenetic pace of church building after the millennium.

Medieval reliquaries often survive in near isolation from other works of art that would have clarified the larger artistic context in which they were created. An important exception, however, exists in the twelfth century, when goldsmiths in two principal urban centers, Limoges and Cologne, produced reliquaries that survive in sufficient quantity today to provide a compelling picture of the artistic response to the challenge of suitably honoring saints' relics. These were, after all, not merely bones, but sacred matter deemed "more valuable than precious stones and finer than refined gold,"[3] which therefore merited the finest work of the medieval artist.

It is not surprising that the cities of Limoges and Cologne were vibrant centers of goldsmithing in the Middle Ages. Both cities were set at crossroads of commerce: Cologne, more obviously so, given its commanding position on the Rhine, and Limoges at the intersection of principal roads bisecting France from north to south and from east to west.[4] Moreover, each was a city in a region possessed of an established tradition of metalwork. The importance of Limoges as a center for goldsmithing is enshrined in the legend of St. Eligius, celebrated across Europe as patron of goldsmiths. Born in Chaptelat, just north of Limoges, at the end of the sixth century, he trained at the mint in Limoges, becoming so adept at his trade that he reputedly created two gold thrones set with gems for King Clothair from the materials provided for a single throne! Early in his career, as abbot of Solignac, St. Eligius had secured the right of the monastery to mint

Fig. 53a. The tomb of Bishop Ulger, Cathedral of Saint-Maurice, Angers. Drawing (before 1711), possibly by Louis Boudan (French, 1687–1709), from the compilation by Francois-Roger de Gaignières (1642–1715). Bodleian Library, Oxford, MS Gough 18359, Drw. Gaignieres 14, fol. 190r

Fig. 53b. Enamel plaque from the tomb of Bishop Ulger, Cathedral of Saint-Maurice, Angers. Drawing (before 1711), possibly by Louis Boudan (French, 1687–1709), from the compilation by François-Roger de Gaignières (1642–1715). Bodleian Library, Oxford, MS Gough 18359, fol. 191r

coin.[5] Gold was mined near Solignac, silver near Limoges, which was active as a mint in the Merovingian period, and in the tenth and first half of the eleventh centuries.[6] Cologne was a focal point of goldsmithing activity that flourished along both the Meuse and Rhine rivers. The seat of an archbishop, the city was particularly rich in churches: eleven collegiate churches, twelve monasteries, ten convents, nineteen parishes, and more than one hundred chapels according to a tally in a sixteenth-century account.[7] It was also a major center of trade within the Holy Roman Empire, linked by the river to neighboring cities and ecclesiastical centers, as well as to mineral wealth.[8] Cologne seems to have been a center for the copper trade as early as the beginning of the fourth century and to have continued to be a locus for this activity, without interruption, through the Middle Ages.[9]

While we know very little about how goldsmiths' ateliers functioned in either medieval Cologne or Limoges, we can nonetheless trace the results of their adept, artistic manipulation of the technique of champlevé enameling at a time of increased demand for reliquaries, to which Rodulfus

Glaber had alluded in the late eleventh century. Commissions realized in each center were initially approached similarly, but over the course of the twelfth century, the way that goldsmiths used enameling evolved in distinct ways, with visibly different results. Enamelers in Cologne exploited the gem-like quality of colorful enamel, while their counterparts in Limoges increasingly focused on the potential of enameling to present legible images of Christian belief. As a result, before the mid-thirteenth century, Limoges' reputation as a center of enameling had eclipsed that not only of Cologne but of the greater Rhine and Meuse valleys—to such an extent that, across Europe, *opus lemovicense* (Limoges work) was virtually synonymous with the art of champlevé enamel.

Enameling, which developed outside the Roman tradition, allows the shining, sleek surfaces of metal to be enriched with color. Set alongside gems and pearls, it enhances the rich, decorative quality of precious objects. The mid-twelfth-century treatise *On the Various Arts,* written under the pen name "Theophilus" probably by the German monk Roger of Helmarshausen

(located near Hannover in Lower Saxony), calls for the use of small enamel plaques on a chalice and outlines the steps in making gold cloisonné enamel.[10] Theophilus indicates that enamels should alternate with gems and pearls on the rim. He mentions that enamel can be used to make "whatever work you want . . . whether circles or scrollwork or little flowers or birds or animals or figures,"[11] leaving the choice to the goldsmith's whim. Importantly, and unlike his instructions for fabricating censers, in which individual figurative elements with the symbols of the Evangelists, the Rivers of Paradise, apostles, and angels are specified, Theophilus does not prescribe any particular subjects or symbolism appropriate to enamel; the designs he mentions are purely decorative, not narrative, and are listed in an offhand manner.

Theophilus focuses his attention on the setting and placement, rather than the appearance, of the enamels; in effect, he presents them as the equivalent of gems. Theophilus's text reflects established practice for using enamels on liturgical objects, from the mid-tenth-century Chalice of Gauzelin in the cathedral treasury at Nancy, to the Helmarshausen Gospel Book in the Trier Cathedral treasury, and it likewise conforms to the manner in which enamels had been employed on precious monumental works, such as the Golden Altar of Sant' Ambrogio in Milan of about 850.[12]

In the late eleventh century—more than a generation before Theophilus—the artist of the reliquary of St. Front set enamels and gems side by side on a shrine to house relics of the saint.[13] Made for the church dedicated to him in the city of Périgueux in the Dordogne region, between Limoges and Bordeaux, this was a far more ambitious use of enamel than a chalice, however precious. A review of the documentation concerning this shrine offers a point of departure for a consideration of the use of enamels on saints' shrines that would develop in the Limousin.

According to the saint's legend (recorded by Gauzbert, a cleric of Limoges, apparently in the mid-tenth century), St. Front had been sent by St. Peter to evangelize Périgueux and served as the city's first bishop. The memory of this local saint therefore underscored the legitimacy of the Christian community at Périgueux and was vital to it. Consequently, the large shrine served as a tangible public testament to the saint's, and by extension the community's, history.

The "sculpting" of the shrine was entrusted to Guinamundus, himself a monk of La Chaise-Dieu, between 1077 and 1082.[14] Although it was destroyed in 1577, a description recorded two years earlier provides key information regarding the use of enameling as an integral element of a monumental reliquary. The shrine was round, with a pyramidal roof,[15] and covered with intaglios of characters from Antiquity, monsters, wild animals, and various figures, "such that there was no stone that was not enriched." Their number and variety are indicative of the importance and expense of the commission, which was financed by Canon Étienne Itier, the "cellerier" responsible for the provisions of the collegiate church and overseer of its finances. In addition to "glass stones of different colors," early accounts mention "sheets of gilded copper and enamels";[16] another

chronicler refers to its having "mosaic work" (opera musivo, or opus musivum),[17] reflecting the adoption of the term for mosaic work to describe enameling. There is, alas, no surviving record of the appearance of these enamels.[18] It is not clear whether the precious sepulcher of St. Front illustrated his story. In the absence of any specific description, we should probably infer that enameling on the sepulcher of St. Front was being used decoratively, in the manner of gems.

Indeed, surviving French enamels of the eleventh century, created at roughly the same time as the shrine of St. Front, generally consist of quite small medallions, only an inch or two in diameter. The designs echo Theophilus's range of choices, including simple stylized flowers, the occasional bird, or, exceptionally, a medallion of a man on horseback.[19] Nearly a hundred years would pass after the creation of the sepulcher of St. Front before there is any record of the use of figurative enameling as a central design element of a monumental saint's shrine (to say nothing of its use in depicting a saint's legend), either in the Rhineland or in France.

The first clear example of figurative enamel as a key element in the decoration of a holy figure's precious sepulcher is the tomb of Bishop Ulger (figs. 53a and b).[20] Created soon after his death in October 1148 for his cathedral at Angers, near the juncture of the Loire and the Maine rivers, the shrine still included, as late as the seventeenth century, a plaque with the bishop's image rendered in enamel as well as fifty-three other enamel plaques. Most of the tomb's medieval decoration, which included copper repoussé work, *email brun*,[21] and rock crystal, was destroyed during the Protestant Reformation in 1562. The wood core survives today as testament to the ambitiousness of this funerary monument in metal, nearly two meters long and three quarters of a meter high (fig. 54).

Fig. 54. Wood core of the tomb of Bishop Ulger. French (Angers), after 1148. Cathedral of Saint-Maurice, Angers

The Angers tomb presented a standard image of Christ in Majesty, surrounded by symbols of the four Evangelists, as well as paired prophets and evangelists. Rather exceptionally, on the lower left, flanking Ulger's own image, were officials of the chapter of Angers, each named in inscriptions, among them a certain Payen Engelé, and Geoffroy Bégule. The figures were set under arcades; sixteen of forty-eight such "statues" still survived in 1623.

The tomb was apparently created in hopeful anticipation of the future canonization of this local holy man.[22] As in the case of the sepulcher of St. Front, the Angers tomb enshrined the body of a distinguished member of the community responsible for its foundation. In this case, we know definitively that the image of the saint was portrayed in enamel. In addition, enamel was also used to present images of members of the chapter— no doubt at their own initiative rather than the artist's—in the company of Christ and his apostles, making the monument a celebration of the community itself and its importance.

A decade later, Bishop Gerard II of Limoges (r. 1139–77) commissioned a metal chasse for the body of St. Loup. He too was a saint whose veneration was regional—in this case restricted to the Limousin. The successor of St. Martial, first bishop of Limoges, he was, equally importantly,

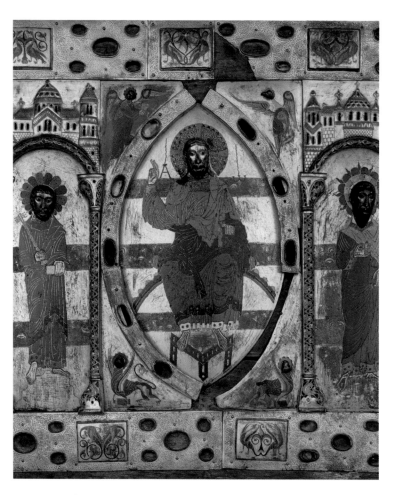

Fig. 55. Detail of Christ in Majesty from the urna of St Dominic of Silos. Spanish (Burgos or Silos), ca. 1150–70. Museo de Burgos (190)

a celebrated predecessor of the man who commissioned the reliquary.[23] According to the Limousin twelfth-century chronicler Geoffroy de Vigeois, the body of St. Loup was exhumed by Bishop Gerard II around 1158, when Henry II and Eleanor of Aquitaine ruled the region, and coincident with work on the great abbey of Saint-Martial in Limoges.[24] Geoffroy de Vigeois points to the needs of the faithful as the motivating factor in the creation of the new gilded tomb: originally entombed in a stone sarcophagus, the relics were now placed, instead, in "a gilded chasse to be exposed to the veneration of the people."[25] Bonaventure de Saint-Amable, in the seventeenth century, further specifies that the chasse was copper, and another source specifies that it was enameled.[26] The size of the new chasse can only be inferred from its being described as a replacement for the stone sepulcher.[27]

Between 1160 and 1174, while Gerard II was still bishop, a chasse for the body of another holy man of Limoges, St. Alpinian, was created at the initiative of Isembert Escoblart, a former monk of Saint-Martial of Limoges who had become prior of Ruffec, one of its dependencies in the diocese of Bourges. Ruffec possessed the relics of Alpinian,[28] a saint who legendarily had come to evangelize the Limousin in the company of St. Martial and St. Austriclinian, and whose illustrious history had been recorded by Gregory of Tours. Before 1790, the great chasse was poised above the altar, and was described as "4 pieds" in length, and "1 pied et demy" in height—making it apparently the largest recorded Limoges reliquary. It had, moreover, been characterized by Geoffroy de Vigeois as *opere mirabilis:* "of admirable workmanship."[29] A sixteenth-century inventory described the chasse as of "leston [*étain*, or tin] figuré et émaillé."[30] The wood core was covered with copper plaques, and a crest ran across the top. A number of enamel figures decorated the shrine, most important among them St. Alpinian himself, identified by inscription. It is self-evident that the patron would have reasons both spiritual and political to honor the saint who, like himself, was linked both to St. Martial and to Ruffec. It also seems that Isembert Escoblart had spiritual gifts and, apparently, ambitions of his own: he subsequently returned to Saint-Martial in Limoges, as its abbot.[31] Whatever talents the goldsmith brought to bear in the realization of the chasse are lost with his creation. Nonetheless, the description of the chasse provides some indication of its being technically, if not iconographically, innovative: some figures were represented with their heads rendered in relief. That choice at such an early date presages a practice that would become widespread in Limoges work within a decade.

Not one of these early monumental enameled shrines survives in France. Their importance, consequently, is neglected by comparison with the great shrines that still grace the restored Romanesque churches of Cologne. Something of their lost heritage can nonetheless be sensed from a contemporary enamel shrine at Silos in northern Spain, whose abbey was linked to the Limousin both through exchange of monastic personnel and through the patronage of the Plantagenets in the late twelfth century. At Silos, an enamel revetment for the body of St. Dominic, founder of

Fig. 56. Drawing (1661) of the St. Remaclus retable (ca. 1158) of the Abbey of Stavelot. Archives de l'Etat, Liège

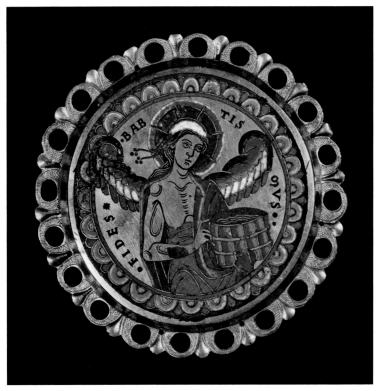

Fig. 57. Enamel medallion of *Fides Baptismus* from the St. Remaclus retable of the Abbey of Stavelot. Frankfurt, Museum für Angewandte Kunst (6710)

the monastery and its patron saint, was created about 1150–70 (fig. 55). After 1076 and before the beginning of the thirteenth century, the body of St. Dominic had been moved to a new tomb set below the altar of the new chapel. A thirteenth-century chronicler specifies that it had an image of Christ in Majesty and the twelve Apostles. Moreover, it was created in such a way that it was still possible to see the stone of the underlying sarcophagus. Resembling an altar frontal set over an arcade, it represents perhaps the purest surviving example of these sacred enamel sepulchers. In terms of structure and program, this shrine, known as the Urna of St. Dominic of Silos, provides a useful comparison to the lost tomb of Ulger of Angers. It is significant, too, that it includes images with the heads rendered in relief.[32]

Monumental shrines in the Rhineland created about the same time as the Ulger shrine at Angers offer interesting points of comparison with the way that enameling was evolving in French territories. The silver and copper-alloy shrine of St. Hadelin, created between 1130 and 1150 for the Abbey of Celles near Dinant, which the saint had founded,[33] and thus later than the shrine at Périgueux and roughly contemporary with the 1148 shrine at Angers, had no enamel decoration. But its repoussé plaques, rather than presenting a series of standing holy figures, told the history of the saint. The famously ambitious shrine of St. Remaclus, a masterpiece made for the Abbey of Stavelot under Abbot Wibald (d. 1158),[34] is known from a drawing of 1661 (fig. 56). The shrine was set in the niche of a massive retable featuring an elaborate narrative cycle that recounted the life of

the saint. Repoussé bas-relief friezes of shining metal provided legible chapters in the story of Remaclus. The reliquary for his body, however, was largely obscured; only the shorter end-panel with a relief of Christ flanked by St. Peter and Remaclus was visible. In both cases the complexity of the narrative is surely indicative of the patron's direct involvement in the program (see Hahn herein, pp. 164–65). Enamel was incorporated into the ensemble not in narrative scenes but in colorful accents, as seen in the two surviving medallions, half-length personifications identifiable by their accompanying inscriptions *Fides Baptismus* (fig. 57) and *Operatio*. The presentation of the half-length figure is straightforward; it is rather the artist's exceptionally fine enameling that distinguishes it. With few exceptions, the most notable of which is the Stavelot Triptych (see p. 168, fig. 67), the tradition of figurative enameling in the Rhineland and the Meuse valleys would develop in the direction of emblematic figures or biblical typology, not toward hagiography.

Only once among the great shrines of Cologne was enameling chosen as an effective means of telling the story of a saint, on one of the earliest from the region: the shrine of St. Heribert, archbishop of Cologne from 970 to 1002, and founder of the Benedictine abbey of Deutz, near Cologne, for which it was made about 1165–75 (fig. 58).[35] The shrine is long and narrow— 153 cm long, nearly 70 cm high, and a narrow 42 cm deep—consistent with its function as a precious sarcophagus and as insistent reminder of the foundation of the community. Around the body of the chasse are standing figures of prophets, each named in an inscription set over his halo, and

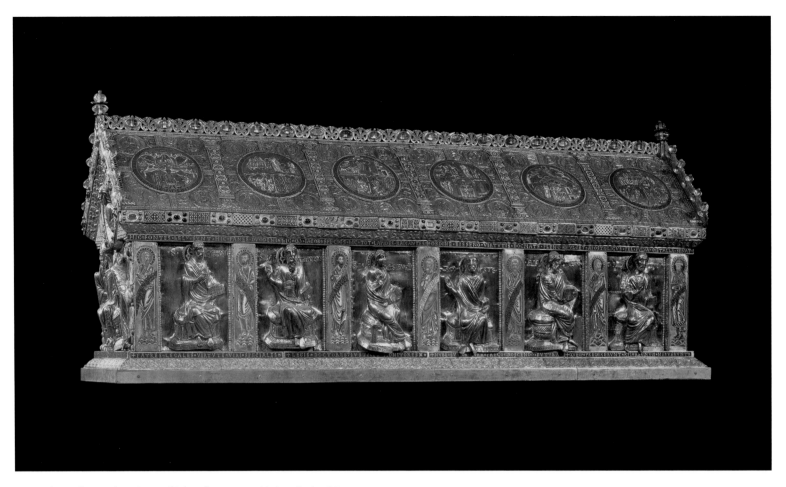

Fig. 58. Shrine of St. Heribert. German (Cologne), ca. 1165–75. Heribert Kirche, Cologne

each bearing in his hand a quotation from his own writings. The saint's own story, which depends on the legend recorded by Rupert of Deutz, is told in enameled roundels on the roof of the shrine.³⁶ Following long-established tradition, seen in many different media, an inscription explains each subject, as if the story on each enamel was ultimately inseparable from the manuscript tradition on whose authority it—and the community responsible for the chasse's creation—depended.

This monumental chasse stands alone for the early date of its complex narrative told in enamel. Only one example of Limoges enameling even begins to compete with it in scale, ambition, and complexity of narrative: the chasse of St. Calminius, created more than a generation later at Mozac. Commissioned by an abbot of Mozac named Peter, it measures 45 cm high by 81 cm long by 24 cm deep; one of the largest surviving chasses of Limoges work, it is still notably smaller than the shrine of St. Heribert. Its front face, rather predictably, presents the Crucifixion and Christ in Majesty, flanked by standing figures of the apostles, similar to what we can see at Silos and infer from the lost shrines discussed above. The reverse of the Mozac chasse, however, presents the legend of St. Calminius (fig. 59). The saint's story does not conform to the pattern we have seen of a local saintly ecclesiastic; indeed, this legend of a seventh-century duke of Aquitaine and count of Auvergne might at first glance seem anomalous. But

the inscriptions identifying each scene—which are exceptional in Limoges work—place the subjects squarely in the familiar context of chasses that celebrate the foundation of the churches for which they were made and the community's vital links to particular saints. In this case, the link between St. Calminius and Mozac is presented as the culmination of a career of distinguished beneficence. The inscriptions read like chapter titles in a book about the saint: "St. Calminius builds an abbey in the diocese of Puy in honor of St. Theofrede the Martyr"; "St. Calminius, Roman senator, builds a second abbey, named Tulle, in the diocese of Limoges"; "St. Calminius builds a third abbey, named Mozac, in the diocese of Auvergne in honor of St. Caprasius the martyr and St. Peter . . ."; "Here St. Calminius, confessor of Christ, is buried in the monastery"; "Here the blessed Namadia [his wife] is buried. Here she is led by the angels to the monastery of Mozac"; "Peter, abbot of Mozac, has a [precious?] chasse made." The scenes, and their accompanying inscriptions—presumably supplied by the patron—lend luster to Mozac and the abbot patron of the chasse. They connect Mozac to other important abbeys—one in the diocese of Puy, the second in the diocese of Limoges—and they also make clear that among all these, Mozac was the place chosen by the saint, and moreover by God's angel messengers, as the resting place for the saint and "blessed Namadia," his wife.

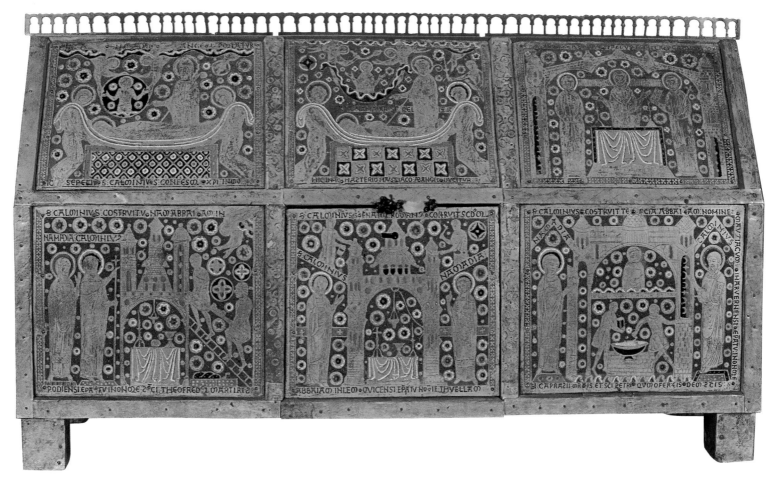

Fig. 59. Chasse of St. Calminius. French (Limoges), 12th century. L'abbaye Saint-Pierre et Saint-Caprais de Mozac

Certain formulaic elements found in the scenes of the Heribert chasse also appear here: the representation of an altar set with a chalice and candlestick or chalice and paten (which one finds on at least two different Heribert roundels); or placing the figures "indoors" by setting them in front of a kind of stage set created by an arcade surmounted by stylized building elements (in at least three roundels).

But whereas the roundels of the Heribert chasse tell the story in enamel against a gilded ground, at Mozac, the system is reversed. The actors in the story are engraved in the reserved, gilded metal, while the background and certain "props," like the bowl of mortar held by the mason, are enameled. This is almost certainly a more efficient, less time-consuming means of enameling than was required to fill the small cavities defining drapery or limbs or faces on the roundels of the Heribert shrine.

Three plaques at Mozac present artisans at work, and it is here that we can sense the goldsmith's creativity at work. The images of the saints, whether at the altar, overseeing the construction, or being laid to rest, are sober and hieratic; by contrast, the images of the artists have a wonderful animated quality. In one, workmen climbing a ladder are set opposite the images of the saints supervising the work; God's angel hovers in the air above the workmen, not above the haloed saints. In another, masons work high in the air on the roof of the Abbey of Tulle, apparently putting

on the final touches, for the altar is already set with a chalice and cross. In the scene of the building of the Abbey of Mozac itself, the masons themselves take center stage, as the saints watch over them through an open door and window. The goldsmith has portrayed them with a dance-like grace that the other characters in the story do not possess. At left, the mason assistant bends forward under the weight of the mortar that he carries gently in his arms. At right, the master mason sets a brick in place with his left hand, while deftly turning to put mortar on his trowel with his right.

On both Cologne's Heribert shrine and Limoges' Calminius shrine, the inscriptions reinforced the visual narrative for members of the community for which they were made, but, within that community, the scenes would surely still have been comprehensible without them. After the Heribert shrine, whether there were inscriptions or not, enamel was not used to convey narrative on saints' shrines in the Rhineland.[37] Instead, most Rhenish examples of enameling on reliquaries perpetuate its use for its gem-like colors, a means of enriching the metal surface, rather than telling a story. This is likewise true in the nearby Meuse Valley, and can be seen on the ends of the shrine of St. Oda, divided between the Walters and the British Museum (cat. nos. 81, 82). Where enameled figures are included, they are usually static images; where figures appear, there appears to be little

Fig. 60. Capital from the reliquary shrine of St. Anno, German (Cologne), ca. 1175–1200, The Metropolitan Museum of Art, New York, gift of J. Pierpont Morgan, 1917 (17.190.441)

confidence in the capacity of images alone to tell the story—images are consistently identified by inscription. Most figural images and indeed most narrative is conveyed without color, usually through repoussé images on various shrines, often with accompanying inscriptions in enamel.[38] Two of the most celebrated shrines may serve as representative examples.

The Anno shrine, begun 1183, originally had images of saints, notably bishops of Cologne and those whose relics were at the church, set under an arcade on the lower level, identified by gilded inscriptions in reserve. On the upper level, the story of Bishop Anno was represented in repoussé. The sophistication of the goldsmiths' work is apparent on individual decorative elements that were removed during the course of restorations, including the charming goat's head in the Metropolitan Museum of Art that forms a miniature capital from the shrine (fig. 60). The range of goldsmithing techniques on each shrine is remarkable, almost surely a testament to a cooperative effort among individuals and/or ateliers; the overall effect is dazzling. The use of enameling is highly decorative and highly accomplished but does not exploit the narrative possibilities inherent in the technique.

The shrine of the Three Kings in Cologne Cathedral attributed to Nicholas of Verdun, with the cooperation of a number of artists, and created over a period of several decades, exceeds all others in the richness of its materials, as well as in sheer size (fig. 61).[39] The Magi, whose relics were

enshrined within, appear as gilded repoussé figures on one end. As they approach the central figure of the enthroned Virgin and Child from the left, the key moment of their story—recognizing the King of Kings—is conveyed. Significantly, they are accompanied by the standing figure of Emperor Otto IV, who, as a ruler himself, follows their example in recognizing the sovereignty of Jesus. But the scene is not simply a narrative of the Epiphany or a statement about imperial devotion. Otto's appearance is rather linked to contemporary politics: his claim to the imperial crown, which he received in 1209, had been endorsed by Archbishop Adolph of Cologne. Otto and Reinald von Dassel (archbishop of Cologne from 1159 to 1167, coincident with the acquisition of the relics), who appears in a medallion on the opposite end, are the only other nonbiblical figures on the shrine. In the rich panoply of imagery, additional moments in the narrative of the Magi, such as their journey, their appearance before Pilate, the angel warning them in a dream to return by a different road, are neglected. The choices instead represent mainstream Christian subjects: the Baptism of Christ is set at the right of the Virgin; Christ is enthroned above; prophets and apostles fill the niches on the upper and lower stories of each side; Christ crowns Sts. Nabor and Felix on the opposite end. Missing from the sloping sides of the upper roof are scenes from the Apocalypse, lost in 1794, and scenes from the life of Christ. Enamels on the shrine are entirely decorative, consisting of rectangular plaques, column shafts, apple finials at either end,[40] and saints' haloes. Faces rendered in reserve against blue enamel punctuate the decorative bands of the roof level (recalling contemporary Limoges work in the articulation of strands of hair, exaggerated brow and wrinkle lines). The quality of the enameling of decorative elements is exceptionally high, a fact that can scarcely be appreciated from the way the massive shrine was displayed in the cathedral, but which is readily perceptible at closer hand on individual elements preserved today in museum collections (fig. 62)

Such a lavish, expensive commission as this shrine for the archiepiscopal, imperial city of Cologne is simply without peer. Perhaps because there were fewer extravagant projects at hand in Limoges, enamelers began to diversify their work in the final decades of the twelfth century. While still creating great sepulchral shrines, as well as altar frontals—whose decorative programs often paralleled that of the large shrines—for places like the Cathedral of St. Martin at Orense, probably completed by 1188,[41] or San Miguel in Excelsis (near Pamplona),[42] they also turned their attention increasingly to smaller-scale chasses. A few such portable chasses had already been created in the Limousin just before the mid-twelfth century as special, sometimes site-specific, commissions, notably the chasse with St. Martial for his church at Champagnat, in the Metropolitan Museum of Art; the chasse of St. Stephen at Gimel, created for the church dedicated to him at Braguse in the Corrèze.[43] While the small-scale Limousin examples from about 1150 seem to have fallen into abeyance between about 1160 and 1180,[44] when the large-scale commissions were created, high-quality, small-scale reliquaries came into prominence around 1180. For Toulouse,

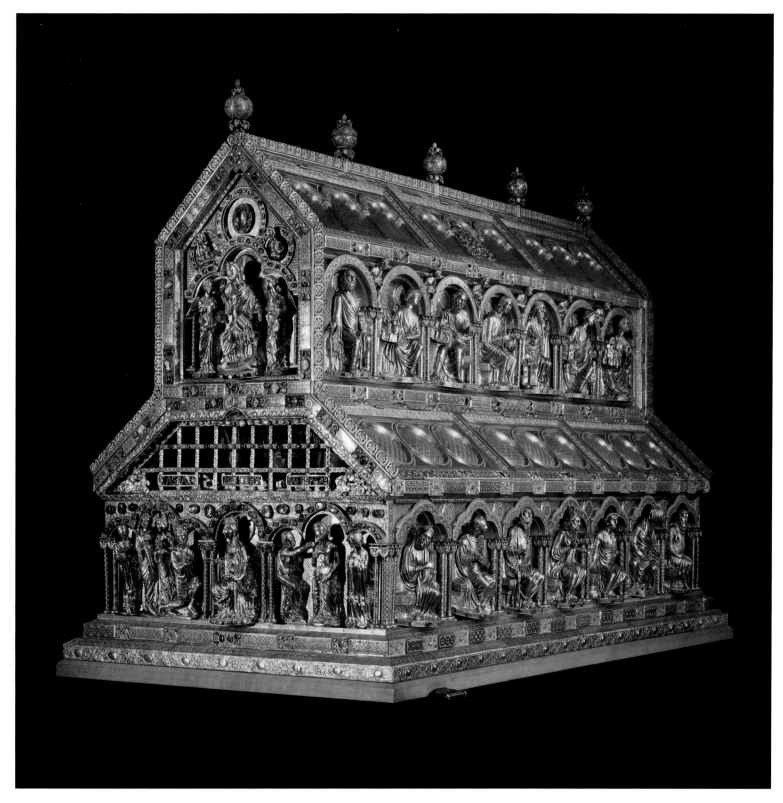

Fig. 61. Nicholas of Verdun and Cologne followers, The Shrine of the Three Kings, ca. 1170(?)–1230, and later additions. Cologne Cathedral

a distinctive chasse depicting the acquisition of relics of the True Cross, created between 1178 and 1198, represents a specific commission, dependent, like Mozac, on inscriptions to clarify the narrative (cat. no. 62). But more frequent were smaller chasses representing universally comprehensible subjects, such as Christ in Majesty, mimicking the established example of tomb-size shrines. Unlike stories like that of St. Calminius of Mozac, such generic themes were to prove exportable across Europe, to places like Pisa, Agrigento, and Uppsala.[45] At the same time, mimicking the example of a special commission like Mozac on a more modest scale, local saints' narratives also began to appear in the Limousin on small chasses—

exceptionally like Martial, or more commonly, Valerie (cat. nos. 43, 91). Some regional iconography persisted well into the thirteenth century, on substantial chasses made for local communities such as Saint-Viance, in the southern Limousin,⁴⁶ or local saints like Fausta (Cluny [inv. Cl. 2827], 1240–60). For these, the enamelers of Limoges developed a highly legible, narrative style that did not depend on inscriptions to ensure legibility, or for that matter on a specific patron or community to initiate the artistic process. There is no indication that goldsmiths in the Rhineland created reliquaries of this kind.⁴⁷ Small-scale enamel chasses of Limoges enamel-work increasingly depicted the widely told stories current in the twelfth century, both biblical and hagiographic.

The martyrdom of Stephen offers one case in point. The first Christian martyr, whose story appears in the Acts of the Apostles (6–7), was a universally recognized subject. Two early chasses depicting the saint were created for churches dedicated to Stephen at Braguse and Malval, the latter, exceptionally, bearing inscriptions identifying both Saul and Stephen. Subsequently the subject appears on chasses that do not have such clear histories. Is the continuing choice of the story of Stephen as a subject in Limoges work related to the fact that so many French churches at the time—and according to legend those in the Limousin founded by St. Martial—were dedicated to St. Stephen?⁴⁸ For any community, the subject was emblematic of the glory of martyrdom; moreover, its story could have had particular resonance for a significant number of churches.

Perhaps most remarkable among the small-scale chasses of Limoges work that began to be created in the final decades of the twelfth century are those representing the journey of the Magi, enshrined in the Gospels but particularly celebrated following the acquisition of their relics for the cathedral of Cologne in 1164. One might even suggest a certain audacity on the part of Limoges' enamelers in appropriating Cologne's story for their own use (see cat. nos. 24, 26). But it is not clear that the Limoges reliquaries representing the Magi were intended for relics of the Three Kings. Their relics seem to have been jealously guarded in Cologne and not widely disseminated before the fourteenth century, when church and altar dedications to the kings became widespread. Moreover, there is no record of relics of the Magi having been introduced into the Limousin, even though a delegation of monks from the Abbey of Grandmont, just outside Limoges, traveled to Cologne in the twelfth century and procured a number of other relics.⁴⁹ One of the chasses with images of the Magi, preserved in the parish church at Beaulieu in the southern Limousin, contains a thirteenth-century authentication of the relic contents, indicating relics of the Cross and of Sts. Peter, Paul, and/or Hilary, but not of the Magi.⁵⁰ The enamelers of Limoges, their names and reputations lost to us, created a winning formula to enshrine not the relics of the Three Kings but the story of the Epiphany. If the materials they had at hand were infinitely more modest than those afforded by the patronage of Cologne Cathedral for its great shrine, the freedom of the goldsmiths in Limoges

Fig. 62. Nicholas of Verdun and Cologne followers, trilobed arch from a reliquary shrine. German (Cologne), ca. 1200. The Metropolitan Museum of Art, New York, gift of George Blumenthal, 1941 (41.100.148)

to tell the story was far richer. It will suffice to recount what we can read on the chasse from the Church of Saint-Martin, Linard, in the Walters Art Museum (cat. no. 94) and the related example from the British Museum (cat. no. 95): on the roof panel, three crowned figures on horseback, gallop on fine, dappled horses toward an unseen destination. The kings gesture confidently, but the artist conveys a sense of urgency in their journey: the reins fly up, and the horses' movement is made emphatic by the placement of their legs and their flying tails. On the lower panel, the same three kings appear, now dismounted. Contrasting with the movement above, each now appears as if stopped in his tracks, approaching the enthroned figure of the Virgin Mary and the Christ Child almost tentatively, each holding a gift.

Given Plantagenet sovereignty over the Limousin, it was perhaps to be expected that goldsmiths in the city of Limoges would also produce reliquaries of Thomas Becket, the strident and brave archbishop of Canterbury who challenged the authority of Henry II. But the story of Becket attained almost universal appeal, and it is not necessary to ascribe the creation of reliquaries of the saint to particular regional circumstances. Some fifty Limoges chasses or chasse fragments dedicated to the subject survive (see cat. nos. 99–101).[51] Like chasses of the Three Magi, very few among the surviving Becket chasses house, or are ever recorded as having housed, relics of the saint.[52]

The appearance of chasses depicting the Magi or the martyrdom of Becket was coincident with development of their cults as international pilgrimage destinations.[53] Therefore, it seems that the decoration of small-scale Limoges reliquaries was intended to portray the most compelling stories of Christianity, whether biblical or hagiographic, and not necessarily to reveal the contents of the box. Perhaps this offers a simple explanation of the otherwise surprising juxtaposition of the Crucifixion and the martyrdom of Becket on a plaque from a chasse in the Cleveland Museum of Art (cat. no. 101).

Very occasionally the effort of the enamelers to communicate the stories they wished to tell, however successful in the thirteenth century, does not translate to the present. Such is notably the case of the Walters chasse representing the Holy Women at the Tomb and a scene variously identified on its roof (cat. no. 93). But most of these Christian stories were so widely disseminated that virtually any audience across Europe could be presumed, in the first place, to be interested in them and, in the second, to be able to read them. Unlike their counterparts in the Rhineland, the enamelers of Limoges could not, it would appear, and did not, consequently, depend so exclusively on large-scale, regional, lavish reliquary commissions. Spectacular as they are still today, such commissions were necessarily more limited in number, depending on important patrons and significant resources. Except in the isolated cases of works for Stavelot, where the narrative seems to have been prescribed, the enamelers' contribution to the great shrines of Cologne is in a minor key—these are small, quiet masterpieces characterized by refinement of technique. Their counterparts in

Limoges turned their very considerable talents to the attention of a wider market and found a European audience that appreciated their abilities to communicate the dramatic narrative stories of Christianity—both biblical and hagiographic. In so doing, they ultimately passed on to us a legacy that is rich, not in material, but in artistry.

Notes

1. Rodulfus Glaber, *Historiarum*, 3.19, in Rodulfus Glaber, *The Five Books of the Histories*, ed. and trans. J. France (Oxford, 1989), 126–27, quoted in R. Landes, "The White Mantle of Churches: Millennial Dynamics and the Written and Architectural Record," in *The White Mantle of Churches: Architecture, Liturgy, and Art around the Millennium*, ed. N. Hiscock (Turnhout, 2003), 249–64.

2. This is especially true in the United States and Great Britain, the latter probably because of the dearth of material that survived the Reformation, combined with a certain Protestant squeamishness about the subject. On Protestant attitudes toward the cult of relics, see the brief discussion in B.D. Boehm, "Body-Part Reliquaries: The State of Research," *Gesta* 36, no. 1 (1997): 11–15. The tradition among historians from Roman Catholic lands is distinct. See especially J. Braun, *Die Reliquiäre des christlichen Kultes und ihre Entwicklung* (Freiburg, 1940). Those today whose aesthetic tastes favor goldsmiths' work may find the French connoisseur Balthasar de Monconys's account of a visit to Cologne in 1663 surprising and amusing: he proclaimed that the churches of the city were dark and ugly, and that the only thing of beauty in the cathedral was the relics. See I. Bosch, "Sacrarium Agrippinae," in *Ornamenta Ecclesiae: Kunst und Künstler der Romanik in Köln*, 3 vols., exh. cat., Cologne: Schnuitgen-Museum (Cologne, 1985), 2:175.

3. This is the description in the second-century account, recorded by Eusebius, of recouping the relics of St. Polycarp after his martyrdom. *The Martyrdom of Polycarp* 18.2–3; trans. in *The Apostolic Fathers*, ed. J.B. Lightfoot and J.R. Harmer, 2nd ed. M.W. Holmes (Grand Rapids, 1992).

4. See recently R.W. Mathisen, ed. and trans., *Ruricius of Limoges and Friends: A Collection of Letters from Visigothic Gaul* (Liverpool, 1999), 8; also B. Barrière, "The Limousin and Limoges in the Twelfth and Thirteenth Centuries," *Enamels of Limoges, 1100–1350*, exh. cat., Paris: Musée du Louvre; New York: Metropolitan Museum of Art (New York, 1996), 22–28.

5. The legend of St. Eligius famously recounts the story of his creating two gold thrones set with gems from the materials provided for only one by King Clothair II. During Dagobert's reign, Saint Eligius fabricated the tomb of St. Denis.

6. See J. Nouaillac, *Histoire du Limousin et de la Marche* (Paris, 1931), 79; P.H. Sevensma, *Les gisements d'or de la région de Saint-Yrieix (Haute-Vienne, France)* (Geneva, 1941), 7, 9; M. Bloch, "The Problem of Gold in the Middle Ages," in idem, *Land and Work in Medieval Europe* (London, 1967), 191; J. Lafaurie, "Les monnaies épiscopales de Limoges aux VIIe et VIIIe siècles," *Bulletin de la société française de numismatique*, 30 (1975): 778–82; P. Spufford, *Money and Its Use in Medieval Europe* (Cambridge, 1988), 33.

7. The account of 1531 is cited in Bosch, "Sacrarium Agrippinae" (1985, cited in n. 2) 2:157–78.

8. The geographical and historical importance is elucidated in N. Stratford, *Catalogue of Medieval Enamels in the British Museum, 2: Northern Romanesque Enamel* (London, 1993), 11–15.

9. Stratford, *Northern Romanesque Enamel* (1993, cited in n. 8), 20.

10. J.G. Hawthorne and C.S. Smith, ed. and trans., *On Divers Arts: The Treatise of Theophilus*, (Chicago, 1963), 125–26.

11. The technique he prescribes is cloisonné on gold. It is most easily realized using gold; probably because of its inherent expense, cloisonné did not become the prevailing method in Western Europe, where champlevé enamel on copper was preferred. Though it could not be drawn into such fine wire as gold, copper was sturdier and less expensive; plaques of copper could be gouged out and filled to cover larger areas, making it better suited to use on large-scale objects. Hawthorne and Smith, *On Divers Arts* (1963, cited in n. 10), 126.

12. See the summary in P. Lasko, *Ars Sacra: 800–1200* (Harmondsworth, 1972), 50–54.

13. There are numerous descriptions of precious metal chasses set with gems created in south central France in the tenth and eleventh centuries; most of these accounts, however, do not specifically mention enamels. Often these were reliquaries for the bodies of saints, with the skulls enshrined separately. See B.D. Boehm, "Medieval Head Reliquaries of the Massif Central," Ph.D. diss., Institute of Fine Arts, New York University, 1990, appendix. The earliest account does not specify particular relics. The skull of St. Front "and numerous other relics" are specifically mentioned in the transcription of a text of about 1583 recorded by Comte W. de Taillefer, *Antiquités de Vésone*, vol. 2 (Périgueux, 1826), 507 n. 1.

14. The text is recorded by Labbe, *Rerum Aquitanicarum collection: Nova Bibliotheca manuscriptorum librorum*, 2:738, and transcribed by E. Rupin, *L'oeuvre de Limoges*, (Paris and Brive, 1890), 107 n 5. A plaque representing a priest and bearing the inscription F(RATE)R GVINAMVNDVS ME FECIT was in the collection of the Limousin priest and scholar Abbé Texier in the nineteenth century, who believed it to be from the tomb of St. Front. This is also noted in Rupin, *L'oeuvre de Limoges* (1890, cited in n. 14) 107, and F. de Verneilh, "Emaux français," *Bulletin monumental*, 3rd ser., vol. 9 (1863): 137. According to M.-M. Gauthier (*Emaux méridionaux: Catalogue international de l'oeuvre de Limoges*, vol. 1: *L'époque romane* [Paris, 1987], 52), that plaque must date from the thirteenth century.

15. No metalwork shrines of such an early date in this form, mimicking the Holy Sepulcher, survive. A late twelfth-century enamel reliquary in Darmstadt, more modest in scale and in materials, is one of several that assume similar form. See *Ornamenta Ecclesiae* (1985, cited in n. 2), 2:412–13 (F53).

16. Taillefer, *Antiquités de Vésone* (1826, cited in n. 13), 509.

17. C. Guigue, "Guinamundus, architecte et sculpteur du onzième siècle," *Archives de l'art français* 5 (1857–58): 30.

18. One that is said to have been in a private collection in Paris in the late nineteenth century is cited by Rupin, *L'oeuvre de Limoges* (1890, cited in n. 14), 107–8 n. 5, without mention of its appearance.

19. London, British Museum, MLA 87-5-24,2. See Gauthier, *Emaux méridionaux* (1987 cited in n. 14), 1:49 (cat. no. 15), pl. VII, fig. 66. A lozenge-shaped cloisonné enamel with Christ in Majesty in the Metropolitan Museum of Art (17.190.696), ascribed to Limoges at the end of the eleventh century, is altogether exceptional at nearly thirteen centimeters long. See Gauthier, *Emaux méridionaux*, 1:51 (cat. no. 19), pl. VIII, fig. 68.

20. Gauthier, *Emaux méridionaux* (1987, cited in n. 14), 1:106–8 (cat. no. 103), pls. D 6a–c, E, 8, LXXXIV, 329; LXXXV, 332.

21. The French term to describe this technique is misleading, as it has nothing to do with enamel. Rather it creates a design on copper by baking linseed oil to darken the metal's surface. Commonly associated with metalwork in the Meuse and Rhine valleys, the technique was also employed in French goldsmiths' work, as this example demonstrates.

22. Gauthier, *Emaux méridionaux* (1987, cited in n. 14), 1:106–8 (cat. no. 103), pls. D 6a–c, E, 8, LXXXIV, 329; LXXXV, 332. Gauthier notes the parallel function of the monuments at Silos and Deutz, discussed below.

23. See Dom J. Becquet, "Les évêques de Limoges aux X, XI et XII siècles," *Bulletin de la société archéologique et historique du Limousin* 107 (1980): 109–41.

24. *Légende dorée du Limousin: Les saints de la Haute-Vienne*, exh. cat., Paris: Musée du Luxembourg (Limoges, 1993) 134–35. The chasse was in the church of Saint-Michel-des-Lions, Limoges, at the end of the twelfth century, then Saint-André, then Saint-Pierre-du-Queyroix.

25. "une châsse dorée pour être exposée à la vénération des peuples."

26. For these accounts, see Gauthier, *Emaux méridionaux* (1987, cited in n. 14), 1:83–84 (cat. no. 75).

27. It was adapted and readapted to use for other saints' relics over time. See Gauthier, *Emaux méridionaux* (1987, cited in n. 14), 1:83–84 (cat. no. 75).

28. Geoffroy de Vigeois notes the presence of relics of St. Alpinian, along with those of Austriclinian, at the Abbey of Saint-Martial at the end of the twelfth century.

29. Cited in *Légende dorée du Limousin: Les saints de la Haute-Vienne*, exh. cat., Paris: Musée du Luxembourg (Paris 1993), 124.

30. Last inventoried in 1790, it was apparently destroyed during the French Revolution. See *Légende dorée du Limousin* (1993, cited in n. 29), 124.

31. Noted by M.-M. Gauthier. See C. de Lasteyrie, *L'Abbaye de Saint-Martial de Limoges: Étude historique, économique, et archéologique* (Paris, 1901), 6, 10, 11, 20, 104, 112.

32. There appears likewise to have been a similar twelfth-century shrine, now lost, at the Church of St. Isidore, Leon. At the end of the nineteenth century, it was described as being six feet wide, and three feet high, with gold, and enamels of Christ and the apostles. Mentioned in *The Art of Medieval Spain, A.D. 500–1200*, exh. cat., New York: Metropolitan Museum of Art (1993), 239–44 (cat. no. 110).

33. *Rhein und Maas, Kunst und Kultur, 800–1400*, exh. cat., Cologne: Kunsthalle; Brussels: Musées royaux d'art et d'histoire (Cologne, 1972), 242 (G4)

34. Concerning the improbability of an earlier date, see ibid., 249.

35. Ibid., 77–78 (H17).

36. The circular form is surely more challenging for storytelling than the usual stagelike rectangle.

37. Curiously, it continues on other special commissions, notably those not intended for public view, such as the Stavelot triptych, or the Klosterneuburg retable. Neil Stratford (*Northern Romanesque Enamel* [1993, cited in n. 8]) has linked this choice to the growing interest in classicism in the Rhineland.

38. See for example the arch fragments with inscriptions in the British Museum, M&LA 78,11-1,13-14 published by Stratford, *Northern Romanesque Enamel* (1993, cited n. 8), 103–4, nos. 20, 21.

39. The best summary of the monument in English remains Lasko, *Ars Sacra* (1972, cited in n. 12), 243–45.

40. The replacement and copying of such elements as these remains an issue. Recent visual and technical examination of an "apple" finial exhibited for decades at the Metropolitan Museum of Art (17.190.347) has shown it to be of nineteenth-century manufacture.

41. See *Enamels of Limoges* (1996, cited in n. 3), 188–89, cat. no. 51.

42. Gauthier, *Emaux méridionaux* (1987, cited in n. 14), 1:126–38, cat. no. 135.

43. See *Enamels of Limoges* (1996, cited in n. 3), 90–92, 106–8, cat. nos. 10, 16.

44. The lacuna was noted by E. Taburet-Delahaye in "Beginnings and Evolution of the *Oeuvre de Limoges*," in *Enamels of Limoges* (1996, cited in n. 3), 34.

45. See M.-M. Gauthier, *Emaux du moyen age occidental* (Fribourg, 1972), 335–36 (nos. 60–61); B.D. Boehm, "*Opus Lemovicense*: The Taste for and Diffusion of Limousin Enamels," in *Enamels of Limoges* (1996, cited in n. 3), 40–47.

46. *Enamels of Limoges* (1996, cited in n. 3), 347–50, cat. no. 118.

47. There, apart from the great commissions for shrines, goldsmiths using enamel seem to have focused on a limited range of liturgical objects, such as portable altars, on which symbol rather than narrative was more likely to be an integral component. These little-studied objects seem to have been created for a small, priestly clientele within rather closely defined geographic boundaries. There is no exhaustive treatment of the subject; see, however, Gauthier, *Emaux du moyen age occidental* (1972, cited in n. 44), Stratford, *Northern Romanesque Enamel* (1993, cited in n. 8)

48. See Gauthier, *Emaux méridionaux* (1987, cited in n. 14), 1:109.

49. Was there an affront to the sensibilities, if not the prerogative, of Cologne in the creation of a Limoges chasse of St. Ursula, arguably Cologne's most famous holy celebrity? Those relics, with those of her companions, provided Cologne an apparently endless supply of sacred and diplomatic currency. See *Enamels of Limoges* (1996, cited in n. 3), 332–33, cat. no. 114

50. I have discussed this previously in *Enamels of Limoges* (1996, cited in n. 3), 124, cat. no. 22. On chasses of the Magi, see recently E. Taburet-Delahaye, "A propos d'une acquisition du musée de Cluny: Les chasses limousines consacrées à l'Adoration des Mages," *Lemouzi*, no. 187, (July 2008): 135–41.

51. See *Valérie et Thomas Becket: De l'influence des princes Plantagenêt dans l'oeuvre de Limoges*, ed. V. Notin, exh. cat., Limoges: Musée municipal de l'Evêche (Limoges, 1999).

52. One in Anagni contains relics of the Holy Innocents, though these seem to replace relics of Becket mentioned in the cathedral as early as 1325; the chasse in Lucca now contains relics of St. James and St. Simon, as attested by an inscription on the crest, but an inventory of 1239 mentions relics of Becket; most important, the chasse in the Victoria and Albert Museum (66.1997) was ordered by Abbot Benedict of Peterborough for relics of Becket. Another chasse in the Burrell Collection, Glasgow, in the collection of an archdeacon of Canterbury at the end of the eighteenth century, contained relics of numerous saints. I am grateful to Simone Caudron of the Corpus des émaux méridionaux team for each of these citations.

53. The question of why chasses of St. Valerie were distributed to churches in present-day Germany and Spain remains a mystery.

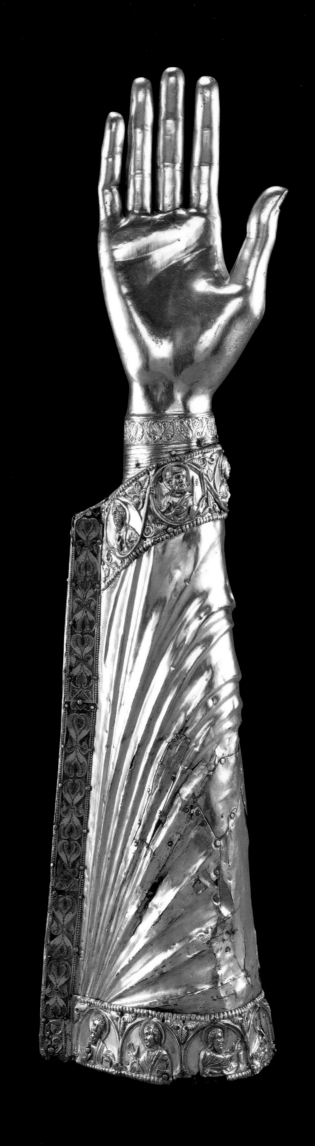

The Spectacle of the Charismatic Body
Patrons, Artists, and Body-Part Reliquaries

CYNTHIA HAHN

We long to be perfectly carved and sculpted in the image of good men, and when excellent and sublime qualities stand out in them, which arouse astonishment and admiration in men's minds, then they shine forth in them like the beauty of statues, and we strive to recreate those qualities in ourselves.[1]

These words, written by Hugh, the famous twelfth-century scholar and teacher at the royal abbey and school of Saint-Victor in Paris in his manual for young novices, refer to the importance of shaping one's character after the example of saintly mentors—a crucial component of a spiritual education. Medieval writers made little distinction between the living body of a spiritual leader and the relic remains of a holy man or woman, and Hugh's characterization of the bodies of holy men as potential triggers for spiritual awakening offers a means to conceptualize the function of reliquaries. In particular, body-part reliquaries might exemplify the excellent and sublime qualities that stimulate imitation. Thus, along with their functions as containers for relics, as objects intended to inspire veneration, and as sites of miraculous intervention, reliquaries could also serve to teach spiritual lessons.

Body parts have consistently provided metaphors for the relationship of the saints to Christ and the Church. In Colossians 1:18, Paul wrote of Christ, "And he is the head of the body, the church." 1 Corinthians 12 speaks of the "members" joined with Christ; Jerome, the early Church Father, expanded the metaphor, describing the faithful as "one body of Christ, the head of which is God, and we are the members," and comparing the prophets to eyes, the apostles to teeth (who have chewed the nourishment of the Gospels), and calling others bellies, hands, and feet, concluding "would that I might be worthy to be His heel!"[2] Relic fragments of such body parts—teeth, hands, and limbs—were always important in relic collections, but at a certain moment of artistic inspiration, reliquaries themselves began to be shaped as body parts. Rather than the literal representation of a relic, however, the impulse for the creation of these striking objects seems to have originated in spiritual motivations.

Such motivations accord with medieval ideas about art. Medieval commentators consistently speak of the shaping of character and virtue in terms of a sort of artistic creativity; the spiritual disciples of holy men are said to be "formed . . . from wet and malleable clay into vessels of glory."[3] In like manner, it seems clear that medieval patrons and artists created reliquaries with the hope of shaping the souls of their viewers. In other words, the form of the reliquary had more to do with its impact on the viewer than its presentation of information about its contents.

I focus here not only on artistic creativity but on the productive relationship between patron and artist. There is no doubt that patrons were always important to the making of medieval reliquaries. They brought artist and

means together: at times sponsoring the foundation of new workshops, at times convincing aristocrats and kings of the potential prestige of a project in order to elicit funds. But even more than managing such practical concerns, patrons were moved to create effective art works. Reliquaries had to, at the least, honor the saint with a beautiful product; at the most, produce a spectacular effect that would, with surpassing and wondrous beauty, bedazzle pilgrims, visitors, and congregations. Believing that they might rouse the ardor of the faithful through the ambitious presentation of relics, bishops, abbots, and abbesses were active in seeking new, striking, and significant designs.

In this essay, I will consider a particular sort of object with a very specific audience. Although there is no denying that they were spectacular, pleasing to crowds, and beautifully suited to the liturgy, what I would like to term "charismatic" body-part reliquaries were perhaps first imagined as tools for meditation and inspiration for an elite audience of monks and schoolmen in the eleventh and twelfth centuries. These were some of the earliest and most important of body-part reliquaries. Their production, as objects with the potential to have an arresting and decisive impact upon the senses and thereby to open a pathway of access to the soul, represents an act of remarkable creativity. The training of the body and the senses, the acquisition of sensory *knowledge* or "aesthetics," is one of the primary motives of education in the high Middle Ages.[4] Can we say that the patrons who first imagined these objects consciously engaged with such "aesthetics," in order to produce the effects they desired? Indeed, were such patrons closer to what we today call artists?[5] Some of them may deserve that label.

Patron and Artist

During much of the Middle Ages, making art was not a matter of a patron simply placing an order for an art work. In many cases, ambitious patrons had to find artists and establish workshops that could work in special media in order to have their ideas realized. The emperor Charlemagne sponsored the first bronze-casting workshop since Antiquity at Aachen. In the tenth century, bishops Bernward of Hildesheim and Egbert of Trier each founded renowned metal-working workshops. Abbot Suger of Saint-Denis gathered artists from all over France for the production of his innovative sculpture and stained glass. With such involvement, it is not surprising that some bishops were lauded in the Middle Ages as "artists" themselves.[6]

It is at least certain that the relationship between patron and artist in the Middle Ages was one based on close mutual cooperation and understanding.[7] The unique surviving correspondence between the great patron of the arts Wibald, eleventh-century abbot of Stavelot, and the goldsmith master G is a case in point. Wibald takes a very intimate tone in the letter he writes to the artist G, promising advice on the management of G's

household and wife. Such intimacy encourages us to think that the two men are genuine collaborators. At the same time, Wibald also addresses loftier issues, complimenting G on his "elevated spirit" and his able and "illustrious" hands. He declares faith in the artist, saying "your work is inspired by truth." G's reply, in turn, praises Wibald's "profound wisdom" and reveals a certain pride in receiving a letter from the great man. He uses language similar to that of the abbot, reinforcing the idea that they have discussed the project at length: "I have engraved in my memory that . . . my art is distinguished by your faith and my work marked by truth and that my promises are crowned by success."[8]

The idea that art is inspired by truth and faith—repeated in both letters—has its origin in the Bible and occurs in several medieval sources. Theophilus, the anonymous author of *De diversis artibus*, a twelfth-century handbook on the arts, argues that in the Book of Exodus craftsmen were "chosen by name" by the Lord and, although he does not use the word "truth," states that artists are "filled . . . with the spirits of wisdom, of understanding, and of knowledge."[9] He explicates the "grace of the sevenfold spirit," including the spirit of counsel, the spirit of piety, and even the spirit of fortitude that allows for the completion of artistic projects— a rather more humble concern but one touched on in both letters preserved by Wibald.

Inscriptions also often celebrate the collaboration between patron and artist, as well as mentioning the saint in honor of whom the work was made. The inscription on a portable altar given by a countess to Braunschweig Cathedral (cat. no. 42)—"Gertrude offers to Christ, to live joyfully in him, this stone that glistens with gems and gold"—clarifies that such objects are a gift from patron (and artist) to God. Such inscriptions suggest that the effectiveness of the reliquary is the joint venture of a spiritual community that stretches across heaven and earth, encompassing secular and sacred powers.[10]

From the very beginning of the cult of the saints, collaborations of artist and patron, patron and saint produced reliquaries that served spiritual needs through material products. Already in the fourth century AD, Bishop Paulinus of Nola advised a friend who was building a church not to conceal all the available relics in an altar; instead, he encouraged his friend to save out the True Cross relic, so that he would have it "available for [his] daily protection and healing," presumably in a reliquary.[11] Paulinus himself apparently venerated a Cross relic that he had encapsulated in a gold reliquary—imitating a faith that, as he said, was "like gold tried in the fire." He describes becoming lost in contemplation of the relic, the "invulnerable sign."[12] The reliquary may have looked something like surviving examples (see cat. no. 26).

Reliquary boxes like that used by Paulinus undeniably did the job. Ornament and precious materials both enclosed and showed respect for the relic. Figural or symbolic decoration like the little crosses that often appear on such boxes specified something about the contents or its meaning. Small size allowed manipulation and effective veneration. Given the

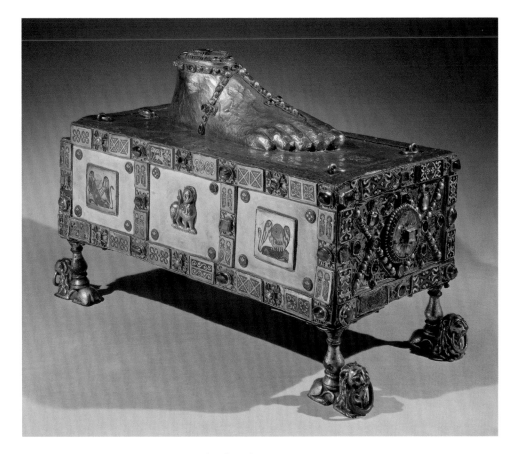

Fig. 63. Portable altar of St. Andrew. German (Trier), 977/93. Trierer Domschatz

Fig. 64. Reliquary of the staff of St. Peter. Trier, Egbert-Werkstatt, ca. 980. Domschatz und Diözesanmuseum, Limburg (D 2/2)

adequacy of these basic elements of their design, we might ultimately ask why reliquaries ever took on new shapes and forms? In general, of course, in the central Middle Ages, portable reliquaries moved from the sphere of private devotion to a more public arena of usage in liturgy and pastoral care (only later to move back again).[13] In particular, however, one might ask why reliquaries came to be figured as body parts, those uncanny representations of feet, arm, fingers and heads that are so memorable and striking.

Body-Part Reliquaries—Patron and Artist

Body-part reliquaries, while certainly serving as dramatic liturgical implements also, as intimated above, coincide with the body's new importance in religious literature of the period. Descriptions speak of the shining faces, eyes, and limbs of saintly bodies, emphasizing the perfection of gesture, of gait, of expression, and of speech. These descriptions of inspiring teachers, originating in the most renowned of medieval schools, are profoundly humanistic and grow out of the cult of spiritual friendship, but nonetheless seem to have inspired somewhat disturbing images of dismembered bodies. A close look at a few examples may help us understand the artistic choice.

Egbert, archbishop of Trier (977–93) commissioned the first known surviving body-part reliquary that is not a head: the portable altar dedicated to St. Andrew (fig. 63). He also was the patron of a few other shaped reliquaries—the reliquary from Limburg an der Lahn containing St. Peter's staff (fig. 64) and a nail reliquary (cat. no. 38), purportedly containing one of the nails of the Crucifixion (perhaps Carolingian in date). These reliquaries are stunning and beautiful objects that brought great glory to Egbert's episcopal home and, in general, look like the relics they contain. The impressive staff reliquary identified Trier as an apostolic center that possessed the very staff of St. Peter.[14] The nail, because of its association with the Cross and contact with Christ's body and blood, was one of the premier relics of Christendom, and its reliquary communicates its physical shape while glorifying the object with gold and gems. Notwithstanding the striking qualities of these objects, it is the portable altar, featuring a lifelike representation of a foot, that impresses the modern viewer as most remarkable.

The portable altar of St. Andrew, however, does not contain a foot as is often claimed. Among a large number of various relics, including the nail which was customarily stored in the altar, it encloses the *sandal* of the Apostle Andrew.[15] Thus, the foot sculpture on the exterior refers not to a foot *relic* but, ultimately, to a more abstract idea. Scholars have appropriately associated the reliquary with the biblical verse in Romans that itself refers

to a text from Isaiah: "How beautiful upon the mountains are the feet of him that bringeth good tidings, and that preacheth peace"(Is. 52:7, Rom. 10:15). The foot thus references the mission of the apostles, a message reinforced by the shaping of the reliquary as an "arca" with rings, recalling the Ark of the Covenant and its association with "teachers" and missionaries in the Middle Ages.[16]

In his commentary on Psalm 91, Augustine asks, "Who are our Lord's feet?" and answers, "The Apostles sent throughout the whole world . . . the Evangelists, in whom our Lord travels over all nations."[17] Christ's presence is represented by those who "walked" the earth spreading his word. Similarly, by the eleventh century, the actual sandals of a bishop were likened to those of the apostles, signifying that bishops should follow the apostolic model of preaching and "prepar[ation] of the Gospel of Peace."[18] Not only are the Evangelists represented on the Trier reliquary in enamels of the evangelical beasts on the sides, but one also sees an apostolic foot. The image of the shining golden foot girded about with a sandal made of straps composed of gems, each strap taking the shape of an elongated cross, makes reference to the perfection of the saints, the possibility of perfection of the body, and ultimately the living, "charismatic" body to which Egbert himself aspired.

At the time that Egbert served the bishopric of Trier, the city was known as one of the great cathedral schools, one that taught both "letters and manners." Such schools featured renowned individual teachers who served as models of perfection in their manners, but also in their *bodies*. As noted by C. Stephen Jaeger, the cult of charisma began with the body and the countenance and posture of a living person and was the most immediate means to register that person's spiritual beauty.[19] Medieval commentators catalogued the different possible gaits of a holy man, agreeing that even his walk revealed his character.[20] Such attention to the perfecting of the body must have influenced Egbert's artistic choice. We should imagine that in processions Egbert matched his step to the imagined gait of Andrew, following the altar reliquary and literally walking in the footsteps of the apostle and therefore Christ.

Arm Reliquaries and the Spectacle of the Liturgy

Although Egbert's reliquary in the form of a foot is a compelling example, shaped reliquaries in the form of arms were much more common: hundreds survive in museums and church treasuries (see cat. nos. 41, 51, 109). They may have become popular because they are superbly suited to dramatic use in the liturgy, but examples also testify to the importance of sacred and imitable gesture as an aspect of body-part reliquaries.

Reliquaries in the shape of an arm do not necessarily contain arm or hand relics; indeed most often they hold a collection of relics. Rather than reflecting their contents, as is often claimed, the significance of the arm itself as an active part of the human body is the reason these objects were

produced: patrons made them in order to use them theatrically, to extend and magnify their own gestures through the gestures of the saints. Thus, an arm reliquary could reproduce the perfect gesture of the saint and exemplary teacher as well as auspiciously extend the "reach" of the bishop or clergyman who commissioned it.

As golden images of limbs, reliquary arms are caught in a moment of performance, realizing their potential as instruments of divine action accomplished on earth. Many make a "blessing" gesture with the fingers; others stretch out the palm, ready to provide a reassuring, efficacious, or healing touch (see cat. no. 91).[21] The reliquary of St. Luke (cat. no. 109) diverges from the more typical pastoral or liturgical reference but refers to the saint's divine work of writing the Gospels. These are indeed *parts* of bodies, cut off from a metaphorical whole, working as limbs of the "Church" (1 Cor. 12:12 and Jerome above).

One of the earliest texts concerning an arm reliquary, the eleventh-century *Vita Gauzlini*, describes "a relic of the burial shroud of . . . Christ, . . . [in] a container resembling a right arm made of gold and precious gems."[22] The text specifies that during a procession on Ascension Day, the abbot "strengthened [the crowd] by a benediction made by the relics." Similarly, a series of Ordinaries, records of a church's liturgical practice, attests to the custom of priests lifting and using arm reliquaries to bless the people. Ad hoc uses are also recorded. In the early twelfth century, Guibert of Nogent describes the healing of his noble cousin by the bejeweled golden arm reliquary of St. Arnoul: only after the "touch of the holy arm pressed [a swelling] hard," did the disease vanish.[23]

Another text, however, takes us beyond function to indicate something of the larger meaning of saintly "hands" and their golden coverings. In verses written about a lost sixth-century fresco, the poet Venantius Fortunatus describes a miracle during the celebration of Mass by Martin, bishop of Tours. In a miraculous revelation, the saint's hand began to sparkle "with heavenly beauty, corruscating with the varied splendor of noble jewels, scattering rays of light in all directions as a wheel . . . vibrating like lightning"[24] Fortunatus describes the jewels as a "new mantle" and a "tunic," and asks who the artist might be, finally calling the whole a "mystery" of grace.[25] Indeed, reliquary arms as they begin to appear at a much later date are clothed, wearing beautiful sleeves, sometimes gloves, or even rings. But in some sense the reliquary itself always serves as a "vestment" for the relic, revealing the beauty of the holy body as it acts on earth and will be resurrected in heaven.

Indeed, as Jaeger has so eloquently argued, in the eleventh century the polished and shining bodies of living holy men and women were said to be the "envy of angels;" angels who might be perfect but had no corporeal existence, no lovely bodies, no arms and legs with which to act. In an effort to attain to such perfection, the student aspirant studied his teacher— a saint, a bishop, an abbot—as a model in order to "seek to be reformed through the example of good men," and especially to "perceive in them the traces of actions, . . . sublime and eminent."[26] Such perception was applied

to one's own bodily movement, especially the refinement of gesture and virtuous action. The gorgeous arm reliquary embodied such perfection and even allowed its "action" to originate in the living celebrant, extending the sacred power of the priest who lifted and used it.

Head Reliquaries and Wibald of Stavelot

Head reliquaries, perhaps the most striking, familiar, but ultimately also at times the most unsettling of the body-part reliquaries, are also the earliest to be clearly documented. The oldest example that was known to take the shape of a head was the late Carolingian reliquary of Maurice in Vienne, attested by seventeenth-century drawings. Surprisingly, this head, minimalist and abruptly cut off at the neck, seems little more than a support for crowns, a glorified mannequin of precious materials. More than one crown was donated to the figure of Maurice and available to be placed on the head (fig. 65). Similar head reliquaries, with large glaring eyes but little else that seems responsively human, have a limited expressive quality. Somewhat later "majesties" such as the magnificent examples of Baudime and Césaire (cat. nos. 105, 106) are more appealing, perhaps because the addition of the arms allows a more human interaction; an exchange of prayers and gifts. Nevertheless, even these examples present a masklike and abstract presence. Not at all like portraits, these early "majesties" are disquieting, they transfix us with their large, staring eyes.[27] These examples were created in the south of France where, as Bernard of Angers attests in the eleventh century, similar reliquaries were a common and powerful type of intercessory image.

The development of the head reliquary, however, was given a particular and significant new direction by one of the great patrons of reliquary art, Abbot Wibald of Stavelot (1098–1158), discussed above for his correspondence with an artist. Wibald was a prolific patron. In addition to the head reliquary of Pope Alexander (fig. 66), Wibald was responsible for a beautiful portable altar, an elaborate reliquary and shrine setting for his patron saint Remaclus, and among many other objects, the innovative reliquary, now in the Pierpont Morgan Library in New York called the Stavelot Triptych (fig. 67), which may be the first significant Western use of the triptych form.[28] The wings of the triptych open to display an inner panel in which are embedded two additional, diminutive triptychs that simulate Byzantine reliquaries. (Wibald served as ambassador to Constantinople and was using the prestige of Byzantine art to make a statement of the importance of these relics.) Thus, three pairs of doors supply multiple possibilities of display, and the reliquary becomes an active center of ceremony and movement.

It is within this context of innovative reliquary design that we should position the head of Alexander. The gilded silver reliquary head with its classical profile, suave surfaces, and engaging golden eyes, concretizes much of the discourse of the charismatic model of the human body, making

Fig. 65. Sketches (ca. 1612) by Nicolas Fabri de Peiresc of the reliquary head of St. Maurice, showing the crown commissioned by Boson, king of Burgundy (879–87), left, and the crown commissioned by Hughes of Arles, king of Italy (926–47), right. Nicolas Fabri de Peiresc, *Miscellanea*, Bibliothèque nationale de France, Paris, MS lat. 17558, fols. 28r and 28v (details)

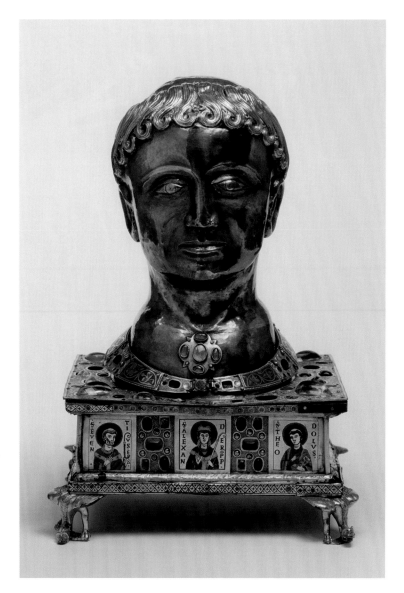

Fig. 66. Reliquary head of Pope Alexander, Mosan, ca. 1145. Musées royaux d'Art et d'Histoire, Brussels (1031)

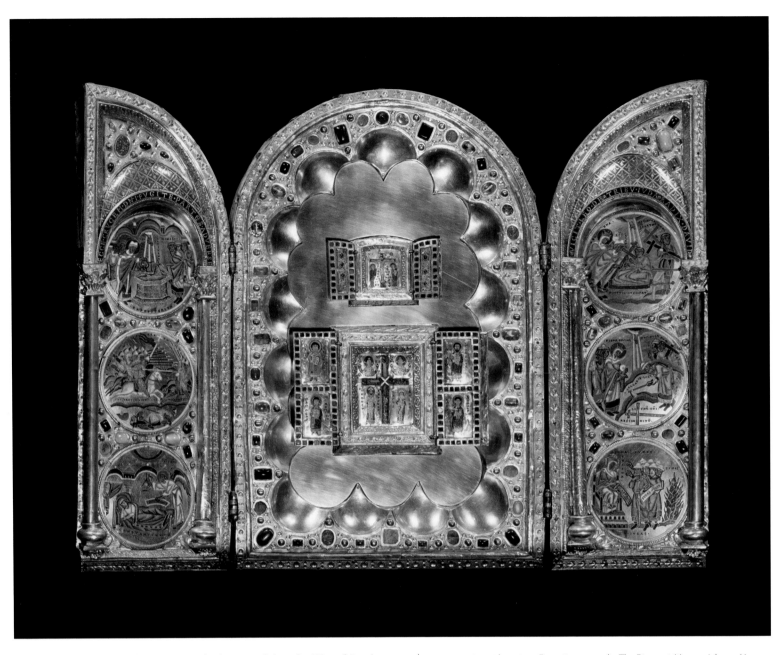

Fig. 67. Scenes from the Life of Constantine and Helen. Triptych from the Abbey of Stavelot, ca. 1156/58, incorporating 11th-century Byzantine enamels. The Pierpont Morgan Library, New York (AZ 001)

the idea much more human and personal than did the examples of reliquary arms and feet.

In art historical discussions, the Alexander reliquary has been the subject of heated debate. The strikingly classicizing style of the head has led scholars to propose a number of rather fantastic theories: that the head and the more typically bejeweled and enameled base are the product of two different workshops—one more stylistically advanced than the other; that the head is actually from southern France, collected by Wibald at some time in his travels and affixed to a new base with the awkward "collar" of gems; or even that the head was an ancient artifact like that of St. Foy in Conques (see p. 25, fig. 17).²⁹ More recent scrutiny of the piece discourages such theories, clarifying similarities between the head and

the base. Despite a technical resolution to the problem, however, the classicizing style of the head still calls for explanation.

A somewhat later text may give us some insight into Wibald's strategy concerning his reliquary for Alexander. At Weingarten in 1215, after dedicating altars to Michael, Gregory, and Martin, Abbot Berthold decided to use some reserved relics of Martin to make a silver-gilt head reliquary "in order to encourage the faith and piety [of the people]"³⁰ (Here we might compare this action to the similar use of a skull removed from a tomb and placed in a spectacular head reliquary, represented in a later manuscript illustration [fig. 68]—again St. Martin.)³¹ The abbot expected his reliquary to be the object of quite special attention and an inscription on the now-lost head specified: "This head, like God, is judge and witness. / It exhibits

in its vestments [the golden covering of the image] pious and pleasing gifts, / while with outstretched arms the saint prays with concern to the Father. . . . / Of these honors Martin was worthy, / because he clothed the naked Christ with the vestment of his chlamys."[32] The head reliquary allows the saint to act as "judge and witness" and then to intercede with prayers for the devotee. It is intended to encourage the "faith" of the audience. Perhaps of some surprise is that in the short inscription, clothing is mentioned twice, and both times is referred to as "vestment" and as a gift. The second reference is to the chlamys or cloak given by Martin to the poor man in his famous miracle story: the saint gave his cloak and was granted a vision of God. The first reference to a vestment, "as a pious and pleasing gift," must concern the golden sheath of the reliquary, perhaps an ex-voto of which the saint was "worthy." Vestments, whether legendary, figurative, reliquary, or actual attire are manifestly essential in establishing the virtue and status of a holy figure.

And indeed, when we turn from the Weingarten text to the Stavelot head, we are struck by a sumptuous vestment—in this case a jeweled collar—that adorns the neck of the figure. It ties the head to the base, to the secondary imagery of the pope and his saintly cohort, and to a field of gems that further symbolically illustrates Alexander's virtue.[33] Additionally, and somewhat out of place, a small gemmed quatrefoil adorns the saint's neck (or rather what is likely meant to be his "breast"). This ornament may represent a medieval version of the Old Testament Rationale, an adornment made of jewels and symbolizing the virtues of the bishop.[34]

I would argue that Wibald commissioned this head, in its sumptuous beauty, as the essential representation of the saint's charismatic body: a "portrait" of a man who is to be studied and emulated. In another of his many preserved letters, this one to a student, Wibald tells us how such study should work. He looks to his contemporary Bernard of Clairvaux as a living exemplar: "For that good man, . . . *persuaded* [those he encountered] *by sight before hearing*. He was given by God the best of natures, the highest learning, . . . and bodily gestures perfectly suited to every mode of expression Merely *to see him is to be taught*; to hear him is to be instructed; to follow him is to be perfected."[35] Wibald's description is highly reminiscent of Bernard's own sentiments about the possibilities of body, sight, and charisma. Bernard describes the potential beauty of the body:

> When the luminosity of this beauty fills the inner depths of the heart, it overflows and surges outward. . . . It makes the body into the very image of the mind; [the body] catches up this light glowing and bursting forth like the rays of the sun. All its senses and all its members are suffused with it, until its glow is seen in every act, in speech, in appearance, the way of walking and laughing. . . . When the motions, the gestures and the habits of the body and the senses show forth their gravity, purity, modesty . . . then beauty of the soul becomes outwardly visible.[36]

The two descriptions of bodies are in some sense two sides to a coin. In Bernard's the body shows forth its inner secrets spontaneously, figuratively, in a burst of light—perhaps something we can take as analogous to the golden covers and "vestments" of the reliquaries.[37] Wibald's description, on the other hand, involves turning toward the person as an object of contemplation, looking and studying. The observer is affected before Bernard even speaks, merely by *sight*.

Furthermore, as described by Wibald, Bernard's is not a robust beauty but is characterized as "pale from fasting, reduced to the meager form of a spiritual being." In a similar comment in a *vita*, another saint is said to be "strong in his emaciation, ornate in his pallor," an oxymoronic description that forces us to look, not at the conventional beauty of the surface but towards the inner man.[38] And finally, Wibald asserts that the sight of Bernard could "awaken those who are asleep," even raise the dead—an exemplar sufficient to rouse anyone from spiritual torpor. Wibald is urging his student to study the saintly man, not only to improve comportment but to better his soul. Similarly, as teacher of his flock, Wibald created a new kind of head reliquary, a type that would eventually lead to the concept of portraiture, but that in this instance, presents the ideal, the humane, the beloved face of a teacher, "clothed" in virtue, and ever ready for spiritual exchange and prayer. This is a reliquary that Wibald must have hoped would "encourage the faith and piety" of his charges, and perhaps have led them to a new level of spiritual perfection.

Fig. 68. The translation of the head of St. Martin / The royal family at prayer. *De translatione capitis S. Martini.* Tours(?), ca. 1340–50. Bibliothèque municipale de Tours, MS 1023, fol. 101

Aesthetics and the Working of the Reliquary

Perhaps we can ask more specifically how such an exchange worked? Can we imagine how head or arm reliquaries (or reliquaries in general for that matter) were meant to interact with viewers? Here it will help to return to the possibility of aesthetics, or sensory knowledge, as it was discussed in the twelfth and thirteenth centuries.

The ability of art to act as spiritual guide is not an obvious or easy concept. Umberto Eco argues that for the medieval philosopher Thomas Aquinas (1225–74) "human productions [i.e., art] are beautiful only in a superficial sense; their aesthetic value is deficient" and secondary to the natural divine creation. He adds that "intellectual travail is a necessary pathway to the knowledge of beauty."[39] Nevertheless, Thomas admits that the aesthetics of the man-made and its formal structure is more easily grasped by man's intellect than is that of nature, and beauty had the ability to provoke attraction and pleasure, drawing the gaze of the spectator. As a historical prelude to these possibilities as put forward by Thomas, Richard of Saint-Victor proposed that contemplation could be aestheticized as "a state of clear insight and detached admiration at the spectacle of wisdom" [*Benjamin Major* 1.4], in which the "soul expands and is uplifted by the beauty it perceives; it loses itself in the object." These comments are very like those of Abbot Suger of Saint-Denis and others, for whom the possibilities of the beauty of art is perceived both affectively and cognitively, that is, with love, through the use of "interior seeing."[40] However, it is another medieval philosopher, Witelo, who specifies some of the work that is done in such contemplation: one must use not only the senses but also "memory, imagination, and reason."[41]

Given that medieval aesthetic theory puts a premium on unity and the perception of wholeness, one might imagine that parts of bodies would have been inappropriate, even repulsive to such contemplative endeavors, but Thomas Aquinas specifically informs us otherwise: "The soul is the form of the whole body in such fashion as to be also the form of each part" and "if the members of the body, such as the hand [which he calls the *organum organorum*] and foot, are in a state which accords with nature, we have the disposition of beauty."[42] He specifies that the parts—the hand, the outward-looking eye and upright head—distinguish the nobility of man (versus animal).

Perhaps it is no coincidence that the three parts of the body singled out for attention by Thomas Aquinas—hand or arm, foot, and head—are the parts that occur with by far the most frequency in body-part reliquaries. It is tempting to say that in their mediating status between the natural (the relic) and the artificial (the "artfulness" of the sheath and its gems), such reliquaries take a medial location in aesthetic contemplation. Aided and abetted by their uncanny naturalism and the glowing beauty of their numinous materials, reliquaries start the viewer on a path toward the contemplation of beauty in nature.

Indeed, rather than the old theory which proposed that the presence of a relic sanctioned the development of monumental sculpture through

reliquaries, perhaps we should imagine that a quest for beauty in its full intellectual possibility pushed patrons and artists to create this uncanny hybrid between the natural and the artificial. Along the way, three-dimensional sculpture came into prominence in a new and significant way.

The head of Eustace (ca. 1210, cat. no. 104) might serve as an example. In looking at the reliquary, one is almost overwhelmed by the gleaming golden surface, the saint's "vestment" shining so brilliantly. It is as if one sees, as in the tropes quoted above, the human figure giving off light, a stunning and oversaturated sensory experience. Given the chorus of companions represented on the altarlike platform that supports the head, one understands this holy person's place as a saint; his fashionably cut "courtier's" hair and beautiful crown reminds us that he is part of the court of heaven. Ultimately, however, the viewer must persist in gazing into the saint's gentle eyes, pushing past the gorgeous surface, seeking a deeper significance and making use of "imagination" and "memory" to recall the saint's life and its significance.

How, in fact, would the viewer press him or herself to engage more fully in the "spectacle of wisdom"? Perhaps a very specific means of "enquir[ing] after God" could be imagined—one that is parallel to the three stages of productive Christian reading as described by Mary Carruthers.[43] There is no doubt such reading is hard work. The stages begin with "affliction," move on to reading scripture and ruminating upon it, and finally advance to "composing prayers of compunction and desire, 'which raises the spirit to God,' the object of knowledge." In other words, in a first stage, lifting the soul toward God while reading originates in the body and the senses, and begins with pain and tears. In particular, tears allow a softening of the soul to ready it for the salutary effect of the contemplative process. In place of the reading of scripture of the second stage, one could imagine the contemplation of beauty in a man-made object of great significance and aesthetic value.

However, a danger presents itself. As Bernard of Clairvaux complained, "[Pilgrims] are shown a most comely image of some saint, whom they think all the more saintly that he is the more gaudily painted."[44] In contrast to such superficial appreciation, the monk or contemplative would avoid the superficial beauty to seek instead the saint's virtue, not with physical sight, but with the "gaze of the inner eye."[45] Instead of the golden sheath, the contemplative would see that the figure "glow[s] and burst[s] forth like the rays of the sun . . . all its members . . . suffused with [divine light]."[46]

Hugh of Saint-Victor describes something like this process in the training of his novices through a sort of softening and then "pressure": "In them [i.e. good men] the form of the likeness of God is engraved, and when through the process of imitation we are pressed against that likeness, we too are moulded according to the image of that likeness. But you must know that unless the wax is first softened, it cannot receive the form. . . ."[47]

After opening oneself to such effects, through long arduous prayers or the tears of compunction, the contemplative's mind is ready to be imprinted: "When [saintly men] act in such a way as to arouse the admiration of

human minds, then they appear as exquisite sculptures. What stands out [is outstanding: *eminet*] should be recreated inwardly in us." The metaphor is like the impress of a seal in wax. The process is contemplative, multifaceted, arduous, and literally impressive but not superficial. In the actions of spiritual imitation, prayers are effected and the soul is lifted toward divine knowledge. This is aesthetic in the medieval sense, and all the more powerful for that.

Hugo, the Priory of Oignies, and the Unification of the Saintly Body

Although we have focused on the meaning of fragmentation in the understanding and contemplation of body-part reliquaries, collections of reliquaries and a goal of "reunification" of the body also seem to have been important in some cases and perhaps just as powerful as a spiritual image. Hugo of Oignies, the renowned metalworker and canon after 1230 at the priory founded by his clerical brothers, Saint-Nicolas d'Oignies in the diocese of Liège, created an extraordinary group of reliquaries that even today continues to elicit rapt admiration.

From its early years, the priory was a spiritual center, attracting committed and devout leaders including both Marie, a founder of the Beguines, the important spiritual movement for women, and Jacques de Vitry, who wrote Marie's *vita* and celebrated her spiritual achievements. Jacques, also a cleric renowned for his preaching of sermons and involvement in the Crusades, eventually became a bishop and finally a cardinal, donated relics to the priory, and was ultimately buried there.

Two of the objects in the treasury of the priory represent body-part reliquaries that can be seen in this exhibition: a right foot of St. Blaise and a rib of St. Peter (cat. nos. 111, 112). However, the treasury also contained other body-part reliquaries: a matching *left* foot of St. James made perhaps a decade earlier and a reliquary with the jaw of Barnabas. Some of the same apostolic ideas associated with the St. Andrew altar at Trier as discussed above apply to these reliquaries, especially the foot of the Apostle James. These apostolic relics would have presumably been particularly inspiration to canons who sought to live in apostolic perfection. But at Oignies, the grouping of a right and left foot along with a rib and jaw must have corresponded to an even more ambitious imaginative contemplation of reliquaries: a devotion that, in effect, re-created a whole charismatic spiritual body, not that of any individual saint, but of the saints and Church as a collective entity.[48] The imagery returns us to where we began—in the descriptions of Paul and Jerome of saints as parts of the body, as members of a community of the Church. In a priory dedicated to spiritual contemplation, one imagines that such objects would have inspired intense devotional prayer and "spiritual shaping."

In this essay I have described a series of extraordinary objects; objects of unusual shape and striking beauty that took the shape of parts of the human body. Although we have focused on their potential for spiritual inspiration and as models of perfection, these reliquaries served many other purposes. At their most basic, they protected and glorified the relics they contained. They also inspired devotion with their beauty, and as portable objects, allowed that devotion to flourish in dramatic liturgical spectacles. Sometimes they were the instruments of miracles.

Although these objects are and were extraordinary, I would not like to leave the reader imagining that reliquaries of the more "common" sort did not have a stake in this same aesthetic territory. Indeed, the saturation of light and the accumulation of precious substances in any group of reliquaries and service objects surrounding the celebrant and his sacred actions at the altar evoked similar response. If patrons of the high Middle Ages strove to heighten the force of the aesthetic (or sensory) process by creating ever more beautiful and wondrous objects, they labored in service to the "beauty of [God's] house" (Ps. 26:8). In so doing, they both elevated the status of their institutions as possessors of precious objects and used beauty to open a spiritual and educational pathway for the congregations in their care. In the end, are patrons who acted in this way not in some sense great artists?

Notes

1. Hugh of Saint-Victor, *De institutione novitiorum* 8, quoted in C.S. Jaeger, *The Envy of Angels: Cathedral Schools and Social Ideals in Medieval Europe, 950–1200* (Philadelphia, 1994), 347.

2. Ambrose, Letter 41, in *St. Jerome: Letters and Selected Works*, Library of Nicene and Post-Nicene Fathers of the Christian Church, 2nd ser., 10, ed. Philip Schaff (Grand Rapids: 1983–86), 447.

3. Goswin of Mainz, *Letter to Walcher* 27, quoted in Jaeger, *Envy of Angels* (1994, cited in n. 1), 349 ff.

4. Jaeger, *Envy of Angels* (1994, cited in n. 1).

5. Certainly the categories were not clearly delineated in the Middle Ages. The Carolingian cleric Einhard was praised as a new Bezaleel (the artist of the Temple in Jerusalem) for his ornamentation of the church, as was Rodolfus at Saint-Benoît sur Loire in the eleventh century. For Einhard, see V.H. Elbern, "Liturgisches Gerät und Reliquiare," in *799: Kunst und Kultur der Karolingerzeit*, ed. C. Steigemann and M. Wemhoff (Mainz, 1999), 3:694–710, at 694; for Rodulfus, Andreas de Fleury, *Vie de Gauzlin, abbé de Fleury*, ed. R.H. Bautier and G. Labory (Paris, 1969); and an artist who worked for Benedict of Aniane: E. Lesne, *L'inventaire de la propriété: Églises et trésors des églises du commencement du VIIIe à la fin du XIe siècle* (Lille, 1936), 183, 219.

6. Adelelmus of Clermont-Ferrand visited his artist's workshops, giving suggestions. (I.H. Forsyth, *The Throne of Wisdom: Wood Sculptures of the Madonna in Romanesque France* (Princeton, 1972), 95–97, 106. See also Martina Bagnoli's observation herein (p. 143) that Bernward is cast as the "artist" of a paten because his acts as priest are essentially creative.

7. Forsyth, *Throne of Wisdom* (1972, cited in n. 6), 95–97 and 106.

8. The letter is reproduced and translated into German in J. Stiennon and R. Lejeune *Rhin-Meuse: Art et civilisation, 800–1400* (Cologne, 1972), 17.

9. C.R. Dodwell, *The Various Arts / De Diversis Artibus* (Oxford, 1986), 77.

10. See P.E. Michelli, "The Inscriptions on Pre-Norman Irish Reliquaries," *Proceedings of the Royal Irish Academy* 96 (1996): 1–48, at 11.

11. Paulinus, Ep. 32, in P.G. Walsh, *Letters of St. Paulinus of Nola* (New York, 1967), 142.

12. Walsh, *Poems of Paulinus* (1967, cited in n. 11), 291, 152–54.

13. See Robinson herein, p. 112.

14. T. Head, "Art and Artifice in Ottonian Trier." *Gesta* 36 (1997): 65–82.

15. H. Westermann-Angerhausen, "Die Goldschmiedearbeiten der Egbertwerkstatt," *Münster* 26 (1973): 72–74; "Spolie und Umfeld in Egberts Trier," *Zeitschrift für Kunstgeschichte* 50 (1970): 305–36; "Das Nagelreliquiar im Trierer Egbertschrein: Das 'künstlerisch edelste Werk der Egbertwerkstätte," in *Festschrift für Peter Bloch*, ed. H. Krohm and C. Theuerkauff (Mainz, 1990), 9–23.

16. Gregory the Great, *Liber Regulae Pastoralis*, 2.11.88, PL 77: 49A–B; Bede, *In Pentateuchum Commentarii* 2. 25, PL 91:322C. See further discussion in Hahn, *Strange Beauty* (forthcoming).

17. P. Schaff, ed, and trans, *Augustine: Expositions on the Book of Psalms* (New York, 1988 [repr. 1995]), Ps. 91, 451. My thanks to Susannah Fisher for sharing her work on this reliquary.

18. T. Dale, "The Individual, The Resurrected Body, and Romanesque Portraiture: The Tomb of Rudolf von Schwaben in Merseberg," *Speculum* 77 (2002): 707–43, at 724, citing Bruno of Segni. My thanks to Susannah Fisher for sharing her work on this reliquary.

19. Jaeger, *Envy of Angels* (1994, cited in n. 1), 8, 10.

20. Hugh of Saint-Victor, as cited by Jaeger, *Envy of Angels* (1994, cited in n. 1), 261.

21. Hahn, "The Voices of the Saints: Speaking Reliquaries," *Gesta* 36 (1997): 20–31.

22. Andreas de Fleury, *Vie de Gauzlin*, trans. Bautier (1969, cited in n. 5), 60–63. See also Hahn, "Voices of the Saints" (1997, cited in n. 21).

23. J.F. Benton, *Self and Society in Medieval France: The Memoirs of Abbot Guibert of Nogent (1064–ca. 1125)* (Toronto, 1984), 226. For the liturgical texts, see Hahn, "Voices of the Saints" (1997, cited in n. 21).

24. H.L. Kessler, "Pictorial Narrative and Church Mission in Sixth-Century Gaul," *Studies in the History of Art* 16 (1985): 75–91.

25. *Vita Martini*, 4.305–30 (*MGH AA*, IV, 357–58), trans. Giselle de Nie, for a talk at Kalamazoo in 1994, "Gregory and His Poetic Spokesman Venantius Fortunatus: 'Simple' and 'Jeweled' Representations of Divine Actions for Different Occasions."

26. Jaeger, *Envy of Angels* (1994, cited, in n. 1), 259, discussing the Victorine rule as in Hugh, *De institutione novitiorum*, 7, 933. There are six columns on gesture in the *Patrologia Latina* edition.

27. B.D. Boehm, "Reliquary Busts, 'A Certain Aristocratic Eminence,'" in *Set in Stone: The Face in Medieval Sculpture*, ed. C.T. Little, exh. cat., New York: The Metropolitan Museum of Art (New York, 1990), 168–73. For a recent discussion of these issues, see B. Fricke, *Ecce Fides: Die Statue von Conques, Götzendienst und Bildkultur im Westen* (Munich, 2007).

28. K.M. Holbert, *Mosan Reliquary Triptychs and the Cult of the True Cross in the Twelfth Century* (New Haven, 1995), 184; W. Voelkle, *The Stavelot Triptych: Mosan Art and the Legend of the True Cross* (New York, 1980).

29. S. Wittekind, *Altar–Reliquiar–Retabel: Kunst und Liturgie bei Wibald von Stablo* (Cologne, 2003), 175–77.

30. H. Swarzenski, *The Berthold Missal and the Scriptorium of Weingarten Abbey* (New York, 1943), 18-20.

31. Boehm, "Reliquary Busts" (1990, cited in n. 27), 171–72.

32. Swarzenski, *Berthold Missal* (1943, cited in n. 30), 117–18.

33. See Bagnoli herein, pp. 138–39.

34. See Hahn, *Portable Altars*, in press.

35. Epistle 147, PL 189:1255 (emphasis added).

36. Sermon 85 on Song of Songs, 85.11, in *S. Bernardi opera*, ed. J. Leclerq, C.H. Talbot, and H.M. Rochais, 8 vols. (Rome, 1957–77), 2:314.

37. Dale, "The Individual, The Resurrected Body, and Romanesque Portraiture" (2002, cited in n. 18), 728.

38. *Vita Odilonis* 5, PL 142:900D–901A; Jaeger, *Envy of Angels* (1994, cited in n. 1), 110.

39. Quotation and the following material from U. Eco, *The Aesthetics of Thomas Aquinas* (Cambridge, Mass., 1988), 51–53, 127–130, and 201–4. In addition to Thomas Aquinas, Eco cites Witelo.

40. *De administratione* 33, in E. Panofsky, ed. and trans., *Abbot Suger on the Abbey Church of St.-Denis and Its Art Treasures* (Princeton 1946).

41. Eco, *Aesthetics of Thomas Aquinas* (1998, cited in n. 40), 52–53.

42. *Summa contra Gentiles* 2.723.3 and 4; and *Summa Theologiae*, 1-II, 54, Ic, in Eco, *Aesthetics of Thomas Aquinas* (1998, cited in n. 40), 127.

43. Peter of Celle, *De afflictione et lectione*, in M. Carruthers, "On Affliction and Reading, Weeping and Argument: Chaucer's Lachrymose Troilus in Context." *Representations* 93 (2006): 1–21, at 2–3; see also ibid., 7, 9.

44. Eco, *Aesthetics of Thomas Aquinas* (1988, cited in n. 40), quoting Bernard of Clairvaux's *Apologia*, 8.

45. Jotsald's *Life of Odilo of Cluny* (ca. 1051), talking of Maiolus, in Jaeger, *Envy of Angels* (1994, cited in n. 1), 109.

46. Bernard of Clairvaux, *Sermons on the Song of Songs*, 85.11, in *S. Bernardi opera*, ed. Leclerq et al. (1955–77, cited in n. 36), 2:314.

47. *De institutione novitiorum* 7, PL176: 932D–933A, quoted in Jaeger, *Envy of Angels* (1994, cited in n. 1), 258.

48. A fifteenth-century inventory from Lens recorded three shaped reliquaries; a left and right foot and a rib. See J. Braun, *Die Reliquiare des christlichen Kultes und ihre Entwicklung* (Freiburg im Breisgau, 1940), 386–87. Caroline Walker Bynum (*The Resurrection of the Body in Western Christianity, 200–1336* [New York, 1995]) discusses the reconstitution of the Church through shaped reliquaries (202) and the miraculous concern with body parts at Oignies (207–8). At Langres in the twelfth century, the body of Mamas was "reconstituted" through the collection of parts: *Canonicus Lingonensis*, in *Exuviae Sacrae Constantinopolitanae*, ed. Count Riant, 3 vols. (Geneva, 1877–98), 1:33–34. I thank Susannah Fisher for sharing her work on this material.

77
Cross of St. Nikomedes of Borghorst

German (Essen?), ca. 1050
Gold (filigree and repoussé), and copper gilt over a wood core, precious stones, rock crystal, pearls (silver mounts); 41.1 × 28.4 cm
Pfarrgemeinde St. Nikomedes, Steinfurt-Borghorst, Germany
London only

INSCRIBED: obverse: left arm: S. COSMAS / S. PETRUS; right arm: S. PAULUS / S. DAMIANUS; lower arm: ANG[E]LI / C[AESAR] HEINRIC[US] I[M]P[E]R[ATOR]; reverse: HEC SUNT NOMINA ISTORUM SANCTORUM DE LINGO DNI DI SPONDIA DNI DE LECTO MARIE MATRIS DNI DE CORPORE SCI PETRI APL S ANDREE APL SCI BARTHOLOMEI APL S STEPHANI M S NICOMEDIS S MAURICII S PANCRACII S LAURENTII S CRISTOFORI S CLEMENTIS S NIICOLAI DE SCAPULA S SIMEONI S MARIA MAGDAL S AGATHE V ISTI ET OMNES SCI INERCEDANT PRO ME PECCATRICE ET PRO OMNIBUS ILLIS QUI ALIQUID BONI AD HOC SIGNACULO FECERUNT. BERTHA ABBA. (These are the names of those saints of the Wood of the Lord; of the sponge of the Lord; of the bed of Mary, Mother of God; of the body of St. Peter the Apostle; St. Andrew the Apostle; St. Bartholomew the Apostle; St. Stephen martyr; St. Nikomedes; St. Mauritius; St. Pancratius; St. Lawrence; St. Christopher; St. Clement; St. Nicholas; of the shoulder of St. Symeon; St. Mary Magdalene; St. Agatha. May these and all the saints intercede for me, a sinner, and for all who did anything good for this sign [i.e., the Cross] Abbess Bertha)

PROVENANCE: Collegiate Church of St. Nikomedes, Steinfurt-Borghorst

BIBLIOGRAPHY: Cologne 1985, 3:106; Forsyth 1995; Paderborn 2006, 2:255–57, no. 362; Asturias 2008, 247, no. 45 (with further bibliography)

A wood core covered by gold sheet (on the front) and gilded copper (on the back) forms this reliquary cross. The relics are wrapped in red silk and contained in two Fatimid rock crystal flasks inset at the center and bottom of the cross and visible from both sides. The front of the cross is studded with numerous gems, including a large cabochon rock crystal inset at the top, presumably to balance the flasks on the vertical axis. Gold filigree and repoussé images complete the decoration: the Crucifixion, at the top between the cabochon and the central flask; four figures of saints on the horizontal arm; and a kneeling man, between the central and bottom flasks. The latter is depicted raising his arms toward two angels swooping down from the sky; an inscription identifies him as "Emperor Henry." Inscriptions also identify the saints: from left to right, Cosmas, Peter, Paul, and Damian. The back of the cross is decorated with an engraved vegetal scroll and a long inscription running along the border that lists the relics contained in the reliquary.

The image of a woman in prayer, corresponding to the figure of the emperor on the obverse, is engraved on the cross's reverse between the two flasks.

Above her, the hand of God bestows a blessing from the clouds; an inscription directly below identifies her as "Abbess Bertha"—the cross's donor. Bertha was the abbess of the convent at Borghorst, which in the eleventh century enjoyed good relations with the Holy Roman Emperors, especially Henry III, who was generous in his endowment of the collegiate church. The figure of "Henricus" therefore must be Henry III (1017–56), and the date of his accession to the throne, 1046, is the *terminus post quem* for the cross.

In Christian art, the gemmed cross is a symbol of Christ's triumphant victory over death. The salvific meaning of the Borghorst example is accentuated by the presence of numerous relics inside. The red cloth used to protect the relics and visible through the transparent flasks establishes a parallel with the blood spilled by Christ and his martyrs. The position of the central flask below the image of the Crucifixion takes this comparison further by equating the flask with the chalice used to collect Christ's blood, which often appears in Romanesque images of the Crucifixion. The theatrical display of relics at the center of the cross, framed and enlarged by the optical distortions created by the rock crystal, sets up a comparison between the relics and the precious stones around them, advertising the relics, humble pieces of wood and bone, as more valuable than the gems surrounding them. / MB

78
Fatimid Flask Reliquary

Mount: European, 14th century
Flask: Fatimid (Egypt), 11th–14th century
Silver gilt, rock crystal, niello; height 8.9 cm, internal diameter 0.9 cm
The British Museum, London (PE AF.3129)

INSCRIBED: in Arabic (Kufic script) around the body of the vessel: Baraka li sahibihi (Blessing to its owner); in Latin (Lombardic letters) in niello on the top: +CPL; BAT; MRE (+ Capillus beate Marie: the hair of the blessed Mary)

PROVENANCE: Given by Sir Augustus Wollaston Franks

BIBLIOGRAPHY: Read and Tonnochy 1928, 18

The modest dimensions of this Fatimid rock crystal vessel suggest that it was probably crafted originally as a perfume flask. At some point in the fourteenth century, it was converted to use as a Christian reliquary for suspension. A Latin inscription on the gilded silver cap that seals it implies that the flask once contained "the hair of the blessed Mary." The transparency of rock crystal and its somewhat

lenticular quality made it an appropriate choice of material for relics that might be difficult to see. The nail clippings of St. Clare may still be found at Assisi in the Fatimid crystal flask that first contained them in the fourteenth century when it was embellished with gilded silver mounts. Other relics known to have been held by crystal containers include the tears, breath, and blood of Christ.

The suitability of rock crystal for use in reliquary manufacture was enhanced by a symbolism recognized by both Christian and Muslim authorities on the nature of materials. The Muslim scholar al-Bīrūnī (973–1050) regarded rock crystal as the most precious of stones, arguing that it combined the elements of air and water. Classical and subsequently Christian theorists took a similar view and saw the crystal as petrified water, an interpretation reinforced by scriptural allusion. The Book of Revelation (22:1) recounts: "And he showed me a pure river of water of life, clear as crystal, pro-ceeding out of the throne of God and of the Lamb." A shared understanding of the symbolic quality of rock crystal accounts for the conversion of this perfume bottle into a reliquary. What is less clear is whether the Arabic inscription carved in relief around the body of the flask was equally understood by its Christian audience. The sentiment "Blessing to its owner" is, of course, entirely appropriate to its Christian use as a repository for a sacred relic. / JR

79
Reliquary Casket

French, ca. 1200
Plaques: Fatimid (Egypt), 10th century
Silver gilt on a wood core, rock crystal (carved and engraved), sapphires, garnets, turquoise, emeralds, rubies, cornelian intaglios, cameos, mother of pearl, pearls, colored glass; 11.3 × 14.8 × 9.7 cm
Musée de Cluny—musée national du Moyen Âge, Paris (Cl. 11661)
Cleveland and Baltimore

PROVENANCE: Treasury of the cathedral of Moûtiers-en-Tarentaise; Musée de Cluny; acquired in 1887 from the chapter of the cathedral

BIBLIOGRAPHY: Barbier de Montault 1879, 545–62; Champeaux 1888–98, 1: pl. 81 ; Lamm 1930, no. 10; Rice 1956, 11; Paris 1971, no. 270; Paris 1977, no. 272; Paris 1984, no. 30E; Berlin 1989, no. 4/9; Taburet-Delahaye 1989, 35–37; Paris 1998, no. 206; Shalem 1996, 224; Vienna 1998, no. 240; Amsterdam 2000, 115–17

This casket, formerly in the treasury of the cathedral of Moûtiers-en-Tarentaise (Savoie) was very likely used as a reliquary. The rock crystal plaques

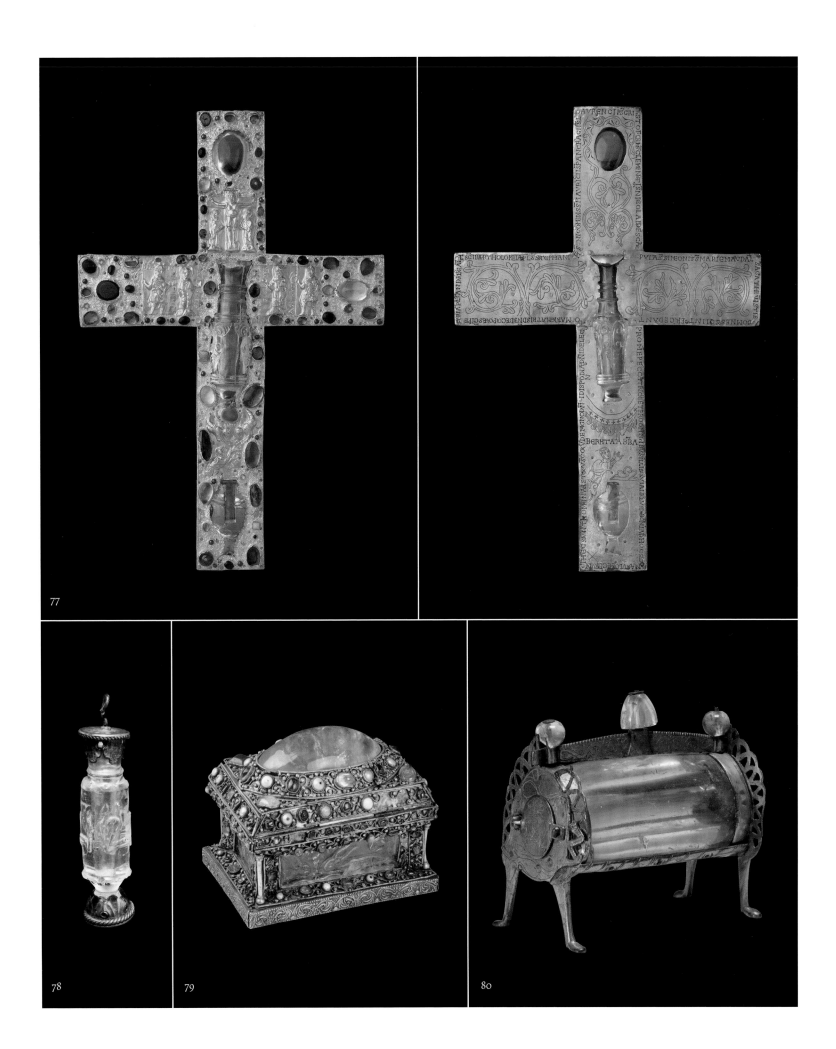

77

78

79

80

that compose the casket's four sides, engraved with figures of ibexes—alone and flanking a palmette—a stag, and a hound, were formerly part of another (tenth-century) secular casket from Fatimid Egypt, where the working of rock crystal, a rare and precious material, was a specialty. The reuse of Islamic objects in the Western Christian world attests to commercial, diplomatic, and artistic exchanges between East and West during the Middle Ages, as well as to hostile confrontations such as the Crusades. The reuse was often the occasion for changing the object's secular purpose to sacred use. In this instance, the Christian goldsmith removed four plaques from the original casket to form the sides of the reliquary. They were mounted on a wooden core covered with leaves of silver decorated with filigree, gems, and pearls, graced by four cast-silver columns on each of the corners. The nearly transparent plaques would have allowed the faithful to see the precious relics contained in the casket. The curved oval crystal that forms the lid is a later addition. The reliquary was probably made (on the evidence of the style of filigree) in northern France. / CD

80
Crystal Reliquary

Rhenish, ca. 1200
Copper gilt on rock crystal; 14.5 × 16.8 × 9.5 cm
The Walters Art Museum, Baltimore (53.8)
Cleveland and Baltimore

PROVENANCE: Tycon and Smith, Paris, by purchase; Henry Walters, Baltimore, 1929, by purchase; Walters Art Museum, 1931, by bequest

BIBLIOGRAPHY: Cologne 1985, 3: nos. H51 and H52; Diedrichs 2001, 115–18

This barrel-shaped reliquary consists of a large, cylindrical piece of crystal bored down the middle to create a narrow compartment for a relic. According to medieval lapidaries, rock crystal was a symbol of spiritual purity. Hence the mineral was frequently used to adorn saints' reliquaries from the early Middle Ages onward. In the Walters' reliquary, however, rock crystal is not merely decorative but is used as a chamber. In this way, the relic is revealed for veneration rather than hidden from view as in earlier reliquaries. The rock crystal chamber magnified the relics contained inside, establishing the real presence of the saint. The emergence of this new type of transparent reliquary is to be linked with a renewed interest in visibility during the early Gothic period. Transparent reliquaries satisfied the believers'

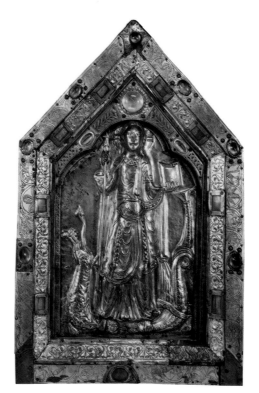

81

desire to see the relics without having to handle them. The removal of relics from their containers was prohibited by the Fourth Lateran Council (1215), which sought to reduce the danger of fraudulent exchanges and commerce in relics. During the twelfth century, improvements in techniques for hollowing rock crystal made possible the production of these "roll" reliquaries. The Baltimore example belongs to a group produced in the Rhine region of Germany around 1200. Two other reliquaries of this group are in Geseke (Church of St. Peter) and in the Schnütgen-Museum, Cologne (G.17). / MB

81
Reliquary from the Shrine of St. Oda

Mosan (Belgium), late 11th/12th and 13th century
Silver, silver gilt, copper, copper gilt, enamel (champlevé), rock crystal, horn; 58.5 × 38 × 5.6 cm
The Walters Art Museum, Baltimore (57.519)

PROVENANCE: Hollingworth Magniac, Colworth, Bedford, prior to 1862, by purchase; Charles Magniac, Colworth, 1867, by inheritance; sale, Christie's, London, 4 July 1892, no. 494; A. Tollin, Paris (date of acquisition unknown), by purchase; sale, Hotel Drouot, Paris, 20 May 1897, no. 93; Jacques Seligmann, Paris (date of acquisition unknown), by purchase; Henry Walters, Baltimore, ca. 1900, by purchase; Walters Art Museum, 1931, by bequest

BIBLIOGRAPHY: Verdier 1981; Lemeunier 1989, 81–89; Stratford 1993, 90–97

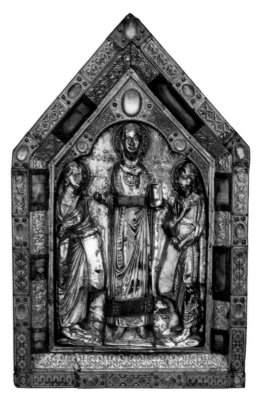

82

82
Reliquary from the Shrine of St. Oda

Mosan (Belgium), 12th and 13th century
Silver, silver gilt, copper, copper gilt, enamel (champlevé), rock crystal, horn; 58.3 × 38 × 6.5 cm
The British Museum, London (PE 1978,0502.7)

INSCRIBED: S[AN]C[T]A ODA (St Oda); RELIGIO (Religion); ELEMOSINA (Alms-giving)

PROVENANCE: Hollingworth Magniac, Colworth, Bedford, prior to 1862, by purchase; Charles Magniac, Colworth, 1867, by inheritance; sale, Colworth Collection, Christie's, London, 4 July 1892, no. 494; A. Tollin, Paris (date of acquisition unknown), by purchase; sale, Hotel Drouot, Paris, 20 May 1897, no. 93; Jacques Seligmann, Paris (date of acquisition unknown), by purchase; Sir Julius Wernher, 1912, by purchase; The British Museum, London, 1978, bequest from the estate of Sir Harold Wernher

BIBLIOGRAPHY: Verdier 1981; Lemeunier 1989, 81–89; Stratford 1993, 90–97

Like many surviving works of medieval art, these gable-shaped reliquaries are the product of a number of medieval and modern alterations. The repoussé panel showing Christ treading on the lion and the serpent was originally part of an eleventh- or early twelfth-century work, perhaps a reliquary or an altar frontal. Later in the twelfth century, this panel was probably reused on a gabled reliquary chasse made for St. Oda of Amay, in present-day Belgium, with St. Oda herself shown on another panel from

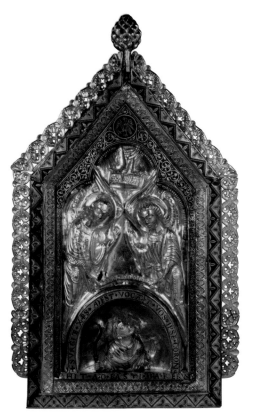

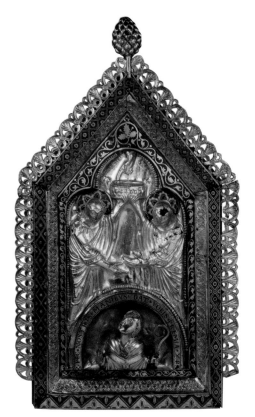

83

84

that shrine. In the thirteenth century, when a new shrine was made for St. Oda, these two panels from the older shrine were preserved and modified to serve as reliquaries in their own right, with small cavities for relics added to the frames. These small cavities were covered with pieces of translucent horn, allowing the relics inside to be seen, and their contents were labeled with small pieces of parchment. The two reliquaries were kept together as a pair until the turn of the twentieth century, when the panel with Christ, which had been repaired in the nineteenth century, was sold to Henry Walters, and the reliquary depicting St. Oda was sold to Sir Julius Wernher, eventually entering the collection of the British Museum. The depiction of Christ trampling beasts is taken from Psalm 91(90):13: "You will tread on the asp and basilisk, the young lion and the serpent you will trample underfoot." Christ's triumph over death was depicted on many shrines and altar frontals in the Middle Ages, and the image would have been appropriate for the cult of any saint, as saints were understood to enter heaven immediately upon dying, thus conquering death in the manner of Christ. The Oda panel shows the saint herself flanked by female figures personifying religion and alms-giving, notable characteristics of the pious widow Oda. / KBG

83
Reliquary of St. Gondulph

Mosan (Maastricht), ca. 1180–1200
Copper gilt (cast, engraved, and embossed) over wood, *vernis brun*, enamel (champlevé); 56 × 33 cm
Musées royaux d'Art et d'Histoire, Brussels (1036)
London only

INSCRIBED: SURGITE XRISTUS ADEST VOCAT VOS IPSE CORONAT (Arise! Behold, Christ is calling you and he himself is crowning you)

BIBLIOGRAPHY: Cologne 1972, G9 (with previous bibliography); Kroos 1985, 252–56; Musées Royaux d'Art d'Histoire 1999, no. 11

84
Reliquary of St. Monulph

Mosan (Maastricht), ca. 1180–1200
Copper gilt (cast, engraved, and embossed) over wood, *vernis brun*, enamel (champlevé); 56 × 33 cm
Musées royaux d'Art et d'Histoire, Brussels (1037)
London only

INSCRIBED: HEC NOSTRIS MANIBUS DAT VOBIS PREMIA CHRISTUS (Through our hands Christ gives you this reward)

PROVENANCE: Church of St. Servaas, Maastricht, until 1847; acquired by Mr. Horn; Soltykoff collection until 1861, when they were acquired by the Musées royaux d'Art et d'Histoire.

BIBLIOGRAPHY: Cologne 1972, G9 (with previous bibliography); Kroos 1985, 252–56; Musées Royaux d'Art d'Histoire 1999, no. 11

These gable reliquaries are part of a set of four, which until 1811 were placed on each side of the chasse of St. Servais in the saint's eponymous church in Maastricht. The four reliquaries celebrate early holy bishops of Tongres (Tongeren, in present-day Belgium): St. Candidus and St. Valentine complete the series. It is unclear whether the four reliquaries were originally part of two disassembled chasses, as might have been the case for the St. Oda reliquaries (cat. nos. 81, 82) or whether they were intended originally to serve as independent reliquaries.

While the reliquaries of St. Candidus and St. Valentine differ substantially in their presentation, those of Sts. Gondulph and Monulph are very similar. Each shows the bust of the holy bishop inside an arched structure that resembles an *arcosolium*, twisting energetically as if ready to leap from his tomb. Above each bishop, two standing angels await the saint's resurrection. In the reliquary of Gondulph, the angels gesture to the saint while holding a crown (symbol of eternal life in heaven) blessed by the hand of God above. In the reliquary of Monulph, the hand of God, holding the crown, emerges from the sky. In both examples, the inscriptions around the *arcosolia* clarify the scene, drawing attention to the saints' resurrection.

The resemblance of the two reliquaries is perhaps a reflection of the entangled identities of the two bishops, who were both commemorated on the same day (16 July) and are celebrated as the secondary patrons of the city of Maastricht. Monulph transferred the seat of the bishopric from Tongres to Maastricht and beautifully restored the Church of St. Servais. Gondulph succeeded Monulph to the bishopric. Both were buried at St. Servais and exhumed together in 1039.

Stylistically, the reliquaries present many affinities with the chasse of St. Servais, and they are probably by the same workshop that produced the larger chasse. The busts of Monulph and Gondulph, for example, closely resemble the figures of Paul and Bartholomew on one of the long sides of the St. Servais chasse. Differences in execution in the chasse and the four gable reliquaries attest to the presence of different craftsmen at work on the same object. At the same time, stylistic similarities between the Brussels reliquaries and metalwork from the Rhine region, such as the Anno chasse from Siegburg, point to the fertile artistic exchanges that occurred in the region between the Meuse and Rhine rivers during the last decade of the twelfth century. / MB

85
Reliquary of the True Cross

Mosan (Belgium), ca. 1150–75
Copper gilt, enamel (champlevé and cloisonné), 28.9 × 18.5 × 4 cm
The Walters Art Museum, Baltimore (44.98)
Cleveland and Baltimore

INSCRIBED: upper arm: SPES (Hope); right cross arm: FIDES
(Faith); left cross arm: INOCEN/TIA (Innocence); foot: OBEDI/ENTIA
(Obedience)

PROVENANCE: Charles Stein, Paris, 1899, by purchase; Sir T.D.
Gibson-Carmichael, London, 1902, by purchase; Basilewsky (?)
(date and mode of acquisition unknown); Arnold Seligmann,
Paris (date of acquisition unknown), by purchase; Henry
Walters, Baltimore (date of acquisition unknown), by purchase;
Walters Art Museum, 1931, by bequest

BIBLIOGRAPHY: Verdier 1961; Holbert 2005, 355–57

Purported fragments of the True Cross were
brought to western Europe from the Holy Land
and the Byzantine Empire throughout the Middle Ages,
and their popularity appears to have increased
with the greater contact between these regions during
the Crusades. Reliquaries of the True Cross were
sometimes made in the shape of a cross, and in this
example, which is missing its back plate, a cavity near
the base of the cross held the relic, accessible through
a small cruciform opening. In the twelfth century,
enamel work flourished in the monastic workshops
of the Meuse River valley, and these Mosan enamels
have a distinct style, differing from Limoges works
in many details. One compositional feature common
to many Mosan works is the use of figures arranged

in groups of four—for example, the four Evange-
lists or personifications of the four cardinal virtues.
This cross features a rare, if not unique, group of
four virtues: Hope is shown at the top of the cross
with a chalice and communion wafer; Faith is on
the right cross arm, with a baptismal font; Obedience
is at the base, holding a cross through which the
relic would have been visible; and Innocence is on the
left arm, holding the sacrificial lamb associated
with Christ. The cross itself is green, a reference to
the tree of life, against a background of colorful
stars. Here, the Cross of the Crucifixion is presented
as both a cosmological metaphor for the universe, as
it was understood by many of the early Greek Fathers
of the Church, and also as a moral instrument,
demonstrating the virtues of Christ, an interpretation
favored by the early Latin Fathers. These two ways
of understanding the cross, here brought together
visually, were also intermingled in the writings of
many medieval theologians. / KBG

86
Reliquary Cross Front

Mosan (Belgium), 1160–70
Copper alloy (gilded), enamel (champlevé and cloisonné),
rock crystal on silver backing, lapis lazuli, garnet, amethyst;
37.4 × 25.6 cm
The British Museum, London (PE 1856,0718.1)

INSCRIBED: center panel: IACOB/EFRA/IM. MANASSE; top terminal:
MOYSES; AARON; left terminal: VIDVA; HELYAS; right terminal
SIG/NU.TAV; bottom terminal: .IOSU/E; CALEPH; .BOTRUS

PROVENANCE: M. Bouvier, Amiens; William Maskell, Bristol, 1855,
by purchase; The British Museum, London, 1856, by purchase

BIBLIOGRAPHY: Mitchell 1919, 85–89; Stratford 1993, 68–77;
Madrid 2001, 55–58; Robinson 2008, 66–67; Baert 2004, 102ff

87
Reliquary Cross Back

Mosan (Belgium) 1160–70
Copper alloy (gilded), enamel (champlevé and cloisonné),
rock crystal on silver backing, lapis lazuli, garnet, amethyst;
37.5 × 26 cm
Kunstgewerbemuseum, Staatliche Museen zu Berlin
(1973,187–189)
London only

INSCRIBED: center panel: HEL(ENA) MOR/TU(U)/SV/S C(RUX); top
terminal: HEL(ENA) S(ANCTA) CRUX; left terminal: HEL(ENA); right
terminal: HEL(ENA); bottom terminal: HEL(ENA); I(N)VE(NV)TIO
S(ANCTA) CRUCIS

PROVENANCE: Peter Beuth (1781–1853); acquired by the Prussian
State in 1853; Beuth-Schinkel Museum, Berlin, until 1945;
Staatliche Museen zu Berlin

BIBLIOGRAPHY: Stratford 1993, 70–77 (with previous bibliogra-
phy); Baert 2004, 120ff

These objects constitute the long-separated front and
back of a Mosan cross reliquary. The London cross
is composed of champlevé enamel plaques with cloi-
sonné details, decorated with gem stones. Five Old
Testament scenes interpreted as prefiguring Christ's
Crucifixion are interspersed with decorative plaques
of four-leafed flowers within lozenges, edged with
colored stones. At top: Moses and Aaron flank a
serpent raised on a column (Exod. 7:9–10); left: Elijah
and the widow of Sarepta, who makes a cross with
her two sticks (1 Kings 17:12); center: Jacob, who forms
a cross with his arms, blesses Joseph's sons Ephraim
and Manasseh (Gen. 48:13–14); right: the slaugh-
tered lamb of the Passover lies in a doorway marked
above the frame with a *Tau* (T, which symbolizes
the cross) (Exod. 12:12); bottom: Caleph and Joshua
share the load of a bunch of grapes from the Prom-
ised Land (Num. 13:24; 14:6).

The back of the cross, in the Kunstgewerbe-
museum, Berlin, shows five scenes from the account
(in the *Golden Legend*) of St. Helena's discovery
of the True Cross. The left terminal, lost in 1945 (the
photograph is a montage), shows Helena crowned
and seated and holding a scepter, questioning Judas
Cyriacus on the whereabouts of the True Cross;
right: Helena orders Judas to be subjected to trial by
fire; bottom: Helena oversees four men (Judas is
the bearded figure) digging three crosses from the
ground with spades; center: St. Helena and four men
identify which of the three is the True Cross by res-
urrecting a man from the dead; top: the True Cross
stands on an altar as Helena prostrates herself
before it. Joined, the pieces may have been intended
to hold a relic of the True Cross.

The twelfth century was the high point of gold-
smithing in the Meuse region of Belgium. The
London and Berlin crosses have been attributed to the
workshop of Godefroid of Huy, a goldsmith who was
attached to the court of the emperors Lothair II
(r. 1125–37) and Conrad III (r. 1138–52) (see cat. no. 89).
A similar style of enameling can be found in plaques
showing Helena and the finding of the True Cross
on the Stavelot Triptych in the Pierpont Morgan
Library (see p. 168, fig. 67). / NCS

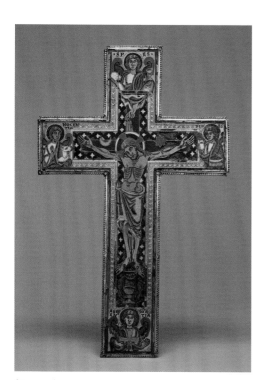

85

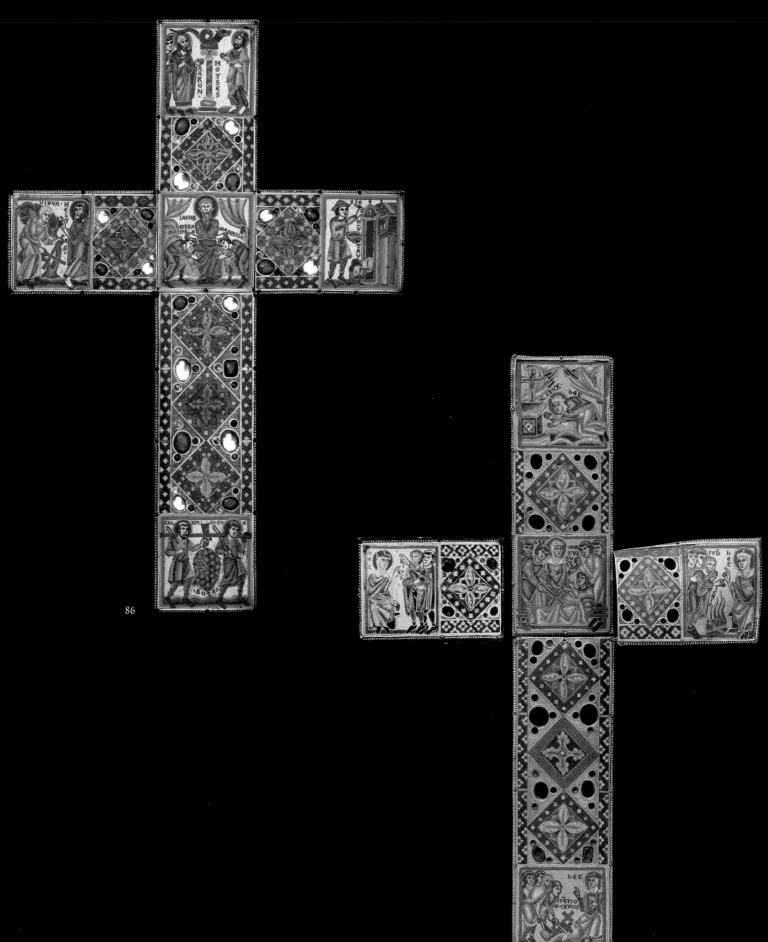

86

87

88
Phylactery

Mosan (Belgium), ca. 1160
Copper gilt, *vernis brun*, enamel (champlevé), gems, and rock crystal; 22.5 × 22 × 3 cm
Private Collection, London (0653)

INSCRIBED: left plaque: ELENA REGINA IUDEI CU IUDA (Queen Helena asks the advice of the Jews and Judas); right plaque: IUDAS TERRIT IGNIS (Judas is frightened by the fire); bottom plaque: IUDAS CRUX INVENTA (Judas discovers the cross); SCA CRUX DEFUNCTUS SUSCITATUS (The holy cross raises the dead)

PROVENANCE: Possibly the Abbey of Lobbes, thereafter the Priory of Sart-les-Moines, Courcelles, until the suppression of the monasteries in 1796; Mme Hembise-Bomal, who sold it to Monseigneur Dumont, bishop of Tournai, in 1875; thereafter Dumont family and private collection

BIBLIOGRAPHY: Van Bastelaer 1880; Bertrand 1993, 14–30; Baert 2004, 97–103

Connections have been made between the style, narrative, and technique of this phylactery, the Stavelot triptych at the Pierpont Morgan Library, New York (p. 168, fig. 67), and the panels from the reverse of a cross at the Kunstgewerbemuseum, Berlin (cat. no. 87). In terms of construction, two other phylacteries bear some relevance to our understanding of this piece, one at the Cleveland Museum of Art and the other at the State Hermitage Museum, Saint Petersburg. In both instances, the central component is an enclosed unit rendering the relic invisible. Due to later adjustments, the cavity for the relics here is exposed by a vitrine of crystal on the front while the corresponding part on the reverse contains a gold repoussé panel showing the hand of God, wrongly aligned horizontally. The back of the relic cavity may have originally held a plaque decorated in *vernis brun* (as at Cleveland) or one with an inscription in enamel (as at Saint Petersburg). On the front, instead of the crystal cover, a plaque showing a scene in keeping with the narrative scheme would have concealed the relics. The narrative panels on the front potentially suggest the nature of the relic once contained by the phylactery. They depict the discovery of the True Cross by the empress Helena. On the left, she interrogates the Jewish doctors on the whereabouts of the Cross. On the right, Judas Cyriacus refuses to reveal its location and is threatened with death in a furnace. The bottom plaque shows the discovery of the True Cross with the two crosses used to execute the thieves crucified with Christ. At the top, the True Cross is distinguished from the others by its miracle-working powers, which raise a man from the dead. The deployment of these scenes has led to the not unreasonable suggestion that the reliquary was made to contain a piece of the True Cross. However, the judgment that narrative necessarily reflects relic should perhaps be qualified. Many reliquaries were used to store multiple relics that might be replenished or removed without any regard for narrative cohesion. The publication of the phylactery by M.D.A. van Bastelaer in 1880 describes the relics at that time as: "two specks of dirty white stone, a speck of brownish wood and two small splinters of black wood." There is, however, no supporting evidence to suggest that these were the original contents. / JR

89
Triptych Reliquary of the True Cross

Mosan (probably diocese of Liège), ca. 1160–70
Copper gilt over wood, *vernis brun*, enamel (champlevé), rock crystal; open: 26.9 × 29.2 cm
Private Collection, London

PROVENANCE: Guennol Collection; Alastair B. Martin Collection; Private Collection, London

BIBLIOGRAPHY: Hoving 1969, 54; Gauthier 1972, 135, no. 93; Verdier 1973b; Bober 1975; Cologne 1985, 3:121, no. H39 ; Monroe 1992; Holbert 1995, 157–86, 259–61; Klein 2004, 217–19

The Guennol Triptych, named after one of its former owners, was made by a leading goldsmith's workshop in the Mosan region, the area between the Meuse and Rhine rivers where wealthy monasteries and readily available natural resources such as copper and tin created a fertile ground for the production of fine metalwork. While the identity of the master and the exact location of the workshop responsible for the triptych's execution cannot be determined with certainty—Stavelot, Maastricht, and Liège have all been suggested as possible locations—it has generally been associated with Godefroid of Huy, one of the most important artistic personalities of the region during the second half of the twelfth century (see also cat. nos. 86, 87).

The triptych's elaborate iconographic program is intimately tied to the relic of the True Cross—and possibly other relics of Christ's Passion—once

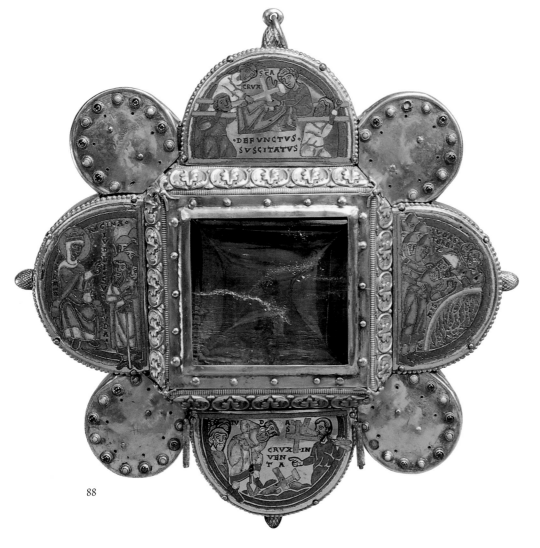

88

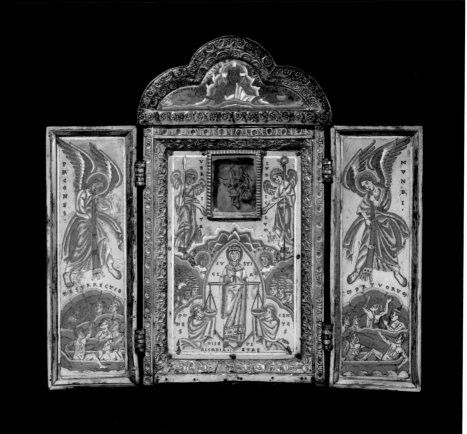

89

displayed behind rock crystal in the cavity at its center. As the main instrument of Christ's Passion and vehicle for mankind's salvation, the Cross of Christ played an essential role in medieval eschatology: it was interpreted as "the sign of the Son of Man in Heaven" (Matt. 24:30), heralding Christ's Second Coming. The triptych's iconography needs to be understood in those eschatological terms: the wings portray two trumpet-blowing angels, awaking the dead to the Last Judgment. Accompanying inscriptions identify them as "heralds of the world" (*praecones mundi*) and the scene below as the "resurrection of the dead" (*resurrectio mortuorum*). The triptych's center panel depicts in its lower half the figure of Justice (*iustitia*). Flanked by personifications of Prayer (*oratio*) and Alms-giving (*elemosyna*), she is surrounded by "all nations" (*omnes gentes*) awaiting Christ's judgment. The scales of judgment are held in balance by the kneeling personifications of Mercy (*misericordia*) and Piety (*pietas*) at her feet. Above, two angels carry the Holy Lance and Holy Sponge. With their free hands, they support the rock crystal at their center, thus presenting to the beholder the relic(s) contained in it. Two accompanying inscriptions further label the angels as Truth (*veritas*) and Judgment (*iudicium*), making them witnesses to Christ's Passion and heralds of his Second Coming.

Completing the triptych's program, Christ appears in half-figure in the lunette above the central panel as the Son of Man (*filius hominis*). He is flanked by images of the Crown of Thorns (*corona spinea*) and the jar of vinegar (*vas aceti*), thus completing the display of instruments of Christ's Passion.

The back of each of the triptych's wings features a gilded copper plate exquisitely worked in *vernis brun*, a decorating technique for which Mosan artists were widely known and admired throughout the Middle Ages. / HAK

90
Reliquary Triptych from St. Maria ad Gradus

Byzantine (Constantinople), 12th century; German (Cologne), ca. 1230/40s
Gold, silver, silver gilt, enamel, gems; 37.5 × 27.5 cm
Hohe Domkirche, Schatzkammer, Cologne, Germany (L 20)
London only

INSCRIBED: on the reverse of the reliquary cross: ΕΞΕΙϹ ΜΕ ΦΡΟΥΡΟΝ ΤΟΝ ΠΑΓΕΝΤΑ ΤΩ ΞΥΛΩ – ΚΟΝϹ(ΤΑΝΤΙΝΕ) ΕΓΓΟΝΕ (ΑΛΕΞΙΟΥ Δ) ΕϹΠΟΤΟΥ (You will have me, who was nailed to the Cross, as your protector – Constantine, grandson of Emperor Alexios)

PROVENANCE: From the Church of St. Maria ad Gradus, Cologne; bequest of the last canon of St. Maria ad Gradus, 1837; Archiepiscopal Palace, Cologne.

BIBLIOGRAPHY: Eickolt 1867; Maciejczyk 1913; Hübener 1983; Cologne 1975, 164, no. D 2; Cologne 1985, 118–20, no. H 37; Becks and Lauer 2000; Klein 2004, 266–69

Likely made in a workshop at Cologne, this reliquary of the True Cross is a pastiche, composed of various Western elements and fragments of a twelfth-century Byzantine cross reliquary, or *staurotheke*, which probably arrived in the region after the sack of Constantinople in 1204. Whether the dismemberment and remodeling of the Byzantine work was the result of functional or general aesthetic considerations or whether it was prompted by the fact that the Byzantine work was already damaged is difficult to assess. What is interesting, however, is that the workshop responsible for the project chose a reliquary format—namely, the triptych—that was well established in the Mosan region since the second half of the twelfth century (see cat. no. 89). In fact, the way the triptych's wings fold into the central panel follows a number of earlier triptychs, most prominently a reliquary from the Church of the Holy Cross in Liège (present-day Belgium).

The most important part preserved from the Byzantine *staurotheke* is undoubtedly the double-arm reliquary cross, prominently placed at the center of the triptych and framed by a band of elegant local gold-filigree work. An inscription on the cross's reverse identifies a certain Constantine, grandson of Emperor Alexios, as the relic's previous owner and the Byzantine *staurotheke*'s likely patron. Surrounding the True Cross are four angels swinging censers, a delicate work of local craftsmanship executed in gold repoussé. Further flanking the relic on the interior of the triptych's wings are two Byzantine repoussé figures of Emperor Constantine the Great (r. 306–37) and his mother, Helena, who are considered co-founders of the cult of the True Cross in the Orthodox world. Remounted on the exterior of the triptych's wings are two more Byzantine figures: the mourning Virgin and St. John. They were taken from a Crucifixion scene that likely decorated the sliding lid of a panel-shaped Byzantine *staurotheke*. Completing the figural composition, the triptych's back features once again a work of purely Western craftsmanship, namely, a representation of Christ in Majesty *(Majestas Domini)* surrounded by the symbols of the Evangelists and the Lamb of God *(Agnus Dei)*, executed in *vernis brun*. / HAK

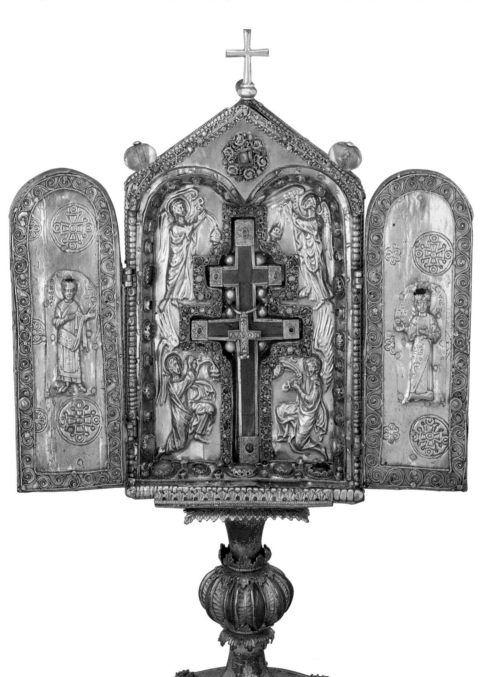

90

91
Reliquary Chasse with St. Valerie

French (Limoges), ca. 1170–72
Copper, gold, enamel (champlevé); 16.5 × 29.2 cm
The British Museum, London, The Waddesdon Bequest (PE WB.19)
London only

PROVENANCE: Baron Anselm de Rothschild; Baron Ferdinand de Rothschild, by inheritance, 1874; The British Museum, London, 1892, by bequest

BIBLIOGRAPHY: Read 1902, 19; Dalton 1927, X, 4, 5; Gauthier 1987, 97–98, no. 91; Limoges 1999, 71; Robinson 2008, 97

The scenes on the front and lid of this chasse are episodes from the martyrdom of St. Valerie, the patron saint of Limoges. When Valerie, the daughter of the Roman governor of Aquitaine, was executed, her head fell into her lap; miraculously, she presented it to St. Martial (who had previously converted her to Christianity). On the left, the proconsul Junius Silanus condemns Valerie to death as Hortarius the executioner holds the saint by the arm. Her execution takes place on the right, witnessed by a group of spectators clustered in a doorway. On the lid above, the decapitated saint walks, aided by an angel; kneeling at the altar, she offers St. Martial her head. Each of the side panels depicts a brightly enameled angel, hovering above the ground while holding a censer. The back and corresponding roof panels show birds, lions, and human-headed beasts within medallions.

It is possible that this casket is linked with the Plantagenets, who were devotees of the saint. In 1172 Richard the Lionheart is known to have worn a ring of St. Valerie at his installation as duke of Aquitaine. The prominence of St. Valerie in the decoration suggests that the chasse might originally have contained her remains, although reliquaries with representations of St. Valerie often contained relics of other saints. / NCS

92
Reliquary Chasse with the Virgin and Child

French (Limoges), 1175–80
Copper alloy, gold, enamel (champlevé), rock crystal;
15.5 × 18.8 × 7.8 cm
The British Museum, London (PE 1851,0715.2)

PROVENANCE: C.K. Sharpe, Edinburgh (mode and date of acquisition unknown); Augustus Wollaston Franks, London, 1851, by purchase; The British Museum, London, 1851, by purchase

BIBLIOGRAPHY: Marquet de Vasselot 1906, 15; Hildburgh 1936, 81; Manchester 1959, 48; Gauthier 1987, 148–49; Victoria [British Columbia] 2009, 57

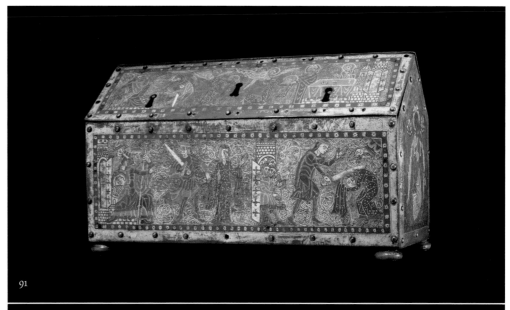

91

We do not know what this casket once held, but the large image of the Virgin and Child that dominates the front of the chasse may hint at the type of relics it contained. The front of this box also shows two saints flanking the Virgin and Child, possibly St. Philip and St. Andrew. The back, roof, and left side of the casket show various saints and apostles, including St. Peter, standing under arcades. The heads on the front were separately manufactured and then attached to the chasse. Limoges chasses often incorporate appliqué relief figures such as these, probably cast, with details such as hair and beards subsequently chased or inscribed. Limoges was a minting town, and as such it would have had the capacity to manufacture molds and dies. The side of the roof, which is glass, the ornamental panel on the right side, which holds a cabochon crystal, and the brass nails are modern additions. The addition of the glass panel enabled this reliquary to display the relics within. / NCS

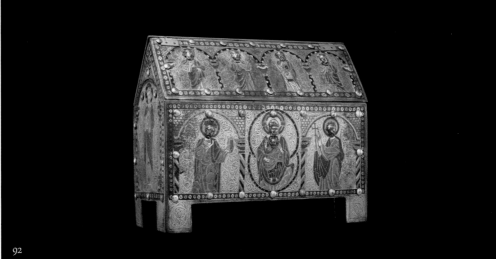

92

93
Reliquary Chasse with the Holy Women at the Tomb

French (Limoges), ca. 1200–1210
Copper gilt over wood, enamel (champlevé), glass;
22.9 × 23 × 9.2 cm
The Walters Art Museum, Baltimore (44.119)
Cleveland and Baltimore

PROVENANCE: Ottile Goldschmidt-Przibram, Brussels, by purchase; sale, Frederik Muller & Cie., Amsterdam, 19 June 1924, no. 132; Brimo de Laroussilhe, Paris (date of acquisition unknown), by purchase; Henri Daguerre, Paris (date of acquisition unknown), by purchase; Henry Walters, Baltimore, 1928, by purchase; Walters Art Museum, 1931, by bequest

BIBLIOGRAPHY: Bertrand 1995, 28; Holbert 1996, 2–3; Baltimore 2002, 63

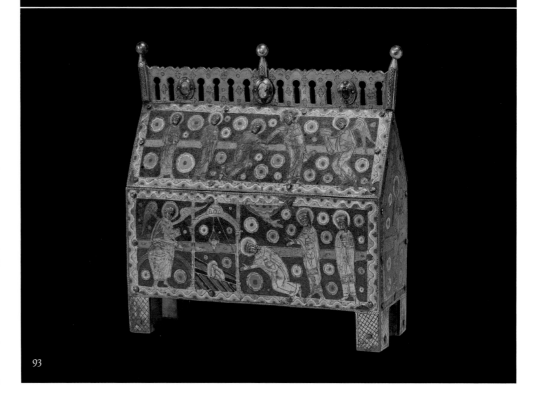

93

Many medieval reliquaries are not securely tied to any particular saint. The three figures with Christ on the upper panel of this chasse lack inscriptions or any identifying characteristics. Scholars have linked this object with several saints, including St. Martial, the first bishop of Limoges. The Abbey of St. Martial in Limoges, founded in 848, was a popular pilgrimage destination throughout the Middle Ages, and a number of works of art produced in the region have been associated with Martial. It has been suggested that the figure whose arm Christ grasps in the upper panel is Martial, accompanied by his two companions, Alpinian and Austriclinian. Martial was reputed to have raised the dead and also to have had visions of Christ, episodes that complement the lower panel, where the Holy Women are shown discovering that Christ has risen from his tomb. However, it has also been proposed that the upper scene depicts the Harrowing of Hell, when, following his Resurrection, Christ rescued from Hell the worthy people who had died before the Incarnation. Many reliquaries depict scenes related to Christ rather than to any particular saint, so the scenes on the casket are not necessarily directly related to the relics that it originally contained. As with a number of other reliquary caskets made in this region (see cat. nos. 92, 94, 96), the gable-ends

of this work feature single standing figures of saints, and the back is decorated with colorful geometric patterns in enamel. / KBG

94
Reliquary Chasse with the Adoration of the Magi

French (Limoges), ca. 1220
Copper gilt, enamel (champlevé); 22.5 × 20.5 × 8.5 cm
The Walters Art Museum, Baltimore (44.288)
Cleveland and Baltimore

PROVENANCE: Joanny Benoît Peytel (1844–1924), Paris, by purchase; Brimo de Laroussilhe, Paris, by purchase; Henri Daguerre, Paris, by purchase; Henry Walters, Baltimore, 1927, by purchase; Walters Art Museum, 1931, by bequest

BIBLIOGRAPHY: New York 1970, 1:157; Bertrand 1995, 22; Baltimore 2002, 196, no. 40

The journey of the Magi is shown on the roof of this casket; on the front panel the three Wise Men present their gifts to the Christ Child, held in his mother's arms. The relics originally contained in this casket are lost, and the identities of the saints in question are not known. Depictions of the three Wise

Men are found on a number of Limoges caskets, ranking with St. Thomas Becket and St. Valerie among the most popular subjects.

In viewing Christ, acknowledging him as the Messiah, and presenting gifts to him, the three Magi provided a model of behavior for faithful Christians. The gifts carried by the Magi would have reminded viewers of the sacred vessels used in the Mass, and the appearance of these crowned kings, mounted on horses, might also have resonated with members of the nobility. As with many other reliquaries of this type (see cats. nos. 92, 93, 96), the standing figures on the end panels are not identified as particular individuals, and should perhaps be understood as generic saints. Many enameled caskets from Limoges have small doors that give access to the relics contained within, sometimes placed on the end panels, underneath the casket, or, as here, on the back panel. In this example, the door is complete with lock and key. The visibility of the door conveyed to pilgrims and other viewers that there was something inside worth protecting. Many medieval reliquaries have undergone significant repairs and refurbishments over the centuries, but this example appears to be unusually close to its original state, with only minor repairs made to the structural elements of the roof. / KBG

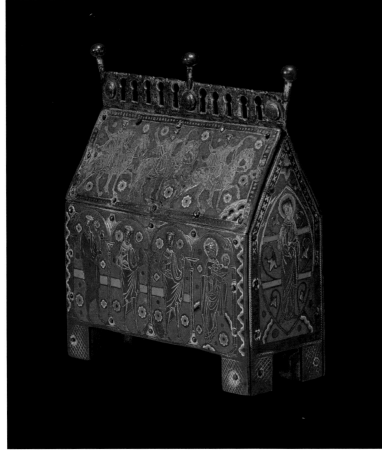

94

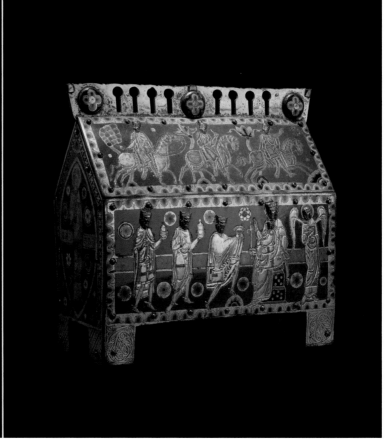

95

95
Reliquary Chasse with the Adoration of the Magi

French (Limoges), ca. 1200–30
Copper gilt, enamel (champlevé); 18.3 × 20.1 × 8.9 cm
The British Museum, London (PE 1855,1201.8)

PROVENANCE: Mr. Isaacs (mode of acquisition unknown),
early 1800s; Ralph Bernal, by purchase (date of acquisition
unknown); John Webb, 1855, by purchase; British Museum,
London, 1855, by purchase

BIBLIOGRAPHY: Bohn and Bernal 1857, 132–33; Gauthier 1950,
39; Stratford 1993, 14, 18, 23, 108–15; Aylesbury 1995, 21; Tokyo
2003, 124

The roof of this chasse's front shows the three Magi,
bearded and crowned, riding on horseback toward
Bethlehem. The holy star, clearly visible in the top
right corner, resembles a flower. The main panel
below shows the kings humbled before the newborn
Christ, who, sitting on the Virgin's lap, raises his
hand in a two-fingered blessing. An angel stands on
the right, behind the scene, witnessing the blessing
and gift-giving. The visitation of the Magi was often
used on religious items for public display such as
reliquaries. In addition to their role as historical wit-
nesses to the Nativity, the three Magi are symbolically
important to Christian doctrine: they are icons of
true faith and belief in the divinity of Christ.

On either side of the reliquary is a saint within
a mandorla. The bright blue background is typical
of Limoges enamel of this time, as are the stylized
rosettes in a rainbow of colors. While we do not know
what relics this chasse originally contained, the
1855 catalogue of Bernal's auction of this casket states
that the "celebrated reliquaire of the kings" once
held "relics found in the Chartreuse [de Champmol],
at Dijon." / NCS

96
Reliquary Chasse with Scenes from the Life of Christ

French (Limoges), ca. 1230–50
Copper gilt over wood, enamel (champlevé); 39.7 × 46.7 × 14.6 cm
The Walters Art Museum, Baltimore (44.247)
Cleveland and Baltimore

INSCRIBED: broad side, front: above figure of Christ: IHS (Jesus);
back: MA/TEUS SI/MON MA/RCIAL/BARN/ABA PHI/LIP BA/RTOLOMS
(Matthew, Simon, Martial, Barnabas, Philip, Bartholomew);
MATI/AS SIOAN/NES SPA/UL'/SPE/TRU SAN/DREAS IA/COB'; Matthias,
St. John, St. Paul, St. Peter, St. Andrew, James; narrow side
(Annunciation scene): AVE M/ARIA (Hail Mary)

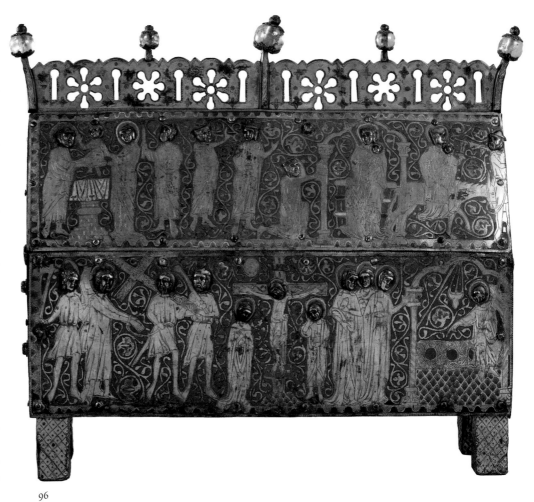

96

PROVENANCE: Collège de Jésuites, Billom, France, before 1789;
Municipality of Billom Sale, Hôtel des Ventes, Paris, 26 March
1886; Charles Mannheim (1833–1910), Paris, March 26, 1886;
Comte Gaston Chandon de Briailles (1852–1914), Beaune (Côte
d'Or), before 1900; Hector Economos, Paris, before 1913; Brimo
de Laroussilhe, Paris (date and mode of acquisition unknown);
Arnold Seligmann, Rey and Co., New York (date and mode
of acquisition unknown); Henry Walters, Baltimore, 1922, by
purchase; Walters Art Museum, 1931, by bequest

BIBLIOGRAPHY: Bertrand 1995, 28; Reinburg 1995, 21–22; Gauthier
1972, 188, 347

This reliquary chasse has much in common with
other enameled Limoges chasses in this exhibition,
but it is significantly larger and includes a number
of inscriptions. In its present state, the front of the
casket features several scenes from the life of Christ:
along the top are the Presentation in the Temple,
the Adoration of the Magi, and the Flight into Egypt,
and on the lower panel, Christ carrying the Cross,
the Crucifixion, and the Holy Women at the Tomb.
On the back of the reliquary Christ and the Virgin
are each depicted with a group of standing apostles,
including St. Martial, the patron saint of Limoges
who, in the Middle Ages, was thought to be an
apostolic saint. However, photographs of this piece
taken before it was sold in 1886 show that the panels

have been rearranged: before 1886, the scenes from
the life of Christ were positioned on the top of
the reliquary, and the panels showing Christ and the
Virgin surrounded by apostles were each positioned
on the main faces of the casket. The earlier photo-
graphs show that the crest and legs have also been
changed, and testing of the enamels has indicated
some areas of post-medieval repairs. Given the ease
with which enamel panels can be repositioned on
a wood core, it is possible that such changes could
have occurred several times over the centuries. On
the shorter ends of the casket, Christ and the Virgin
are presented again: the Annunciation to the
Virgin is shown on one end, and Christ in Majesty
is shown on the other, where a small door allows
access to the reliquary chamber. / KBG

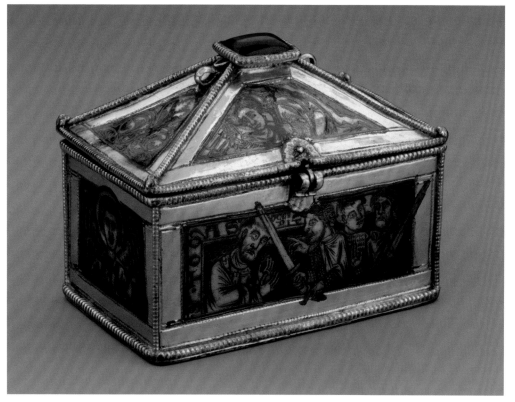

97

of the compromised, abbreviated inscription and impossible to confirm due to the lack of documentary evidence about the treasury of Chartres in the Middle Ages.

Contemporary works in niello survive in small number but with considerable geographic range; the most compelling argument for an English attribution in this case is its early date to a time when relics of the sainted archbishop had not been dispersed. / BDB

97
Reliquary Chasse with Scenes of the Martyrdom of Thomas Becket

English, ca. 1173–80
Silver gilt, niello, glass; 5.7 × 7 × 3.4 cm
The Metropolitan Museum of Art, New York, gift of J. Pierpont Morgan, 1917 (17.190.520a, b)
London only

INSCRIBED: front: S(ANCTUS) TOMAS OCCIDIT (St. Thomas dies); back: [. . .]T()SANGUIS.E(ST) S(ANCTI) TOME (. . . is the blood of St. Thomas)

PROVENANCE: Albert Germeau, Limoges, France (by 1865); Louis Germeau (sold Paris, 1905, lot 931); J. Pierpont Morgan, London and New York

BIBLIOGRAPHY: Darcel 1865; Williamson 1910, 134, no. 89; Breck 1918; Borenius 1932, 78; Swarzenski 1967, fig. 490; New York 1970, 78–79, no. 85; London 1984, 282, no. 302; Little 2002, 205

As chancellor of England, Thomas Becket had been a favorite of King Henry II, but after Becket became archbishop of Canterbury in 1162, his relationship with the king grew contentious. On 29 December 1170, Becket was brutally murdered in the cathedral at Canterbury, by four knights who may have been acting on the king's orders. So notorious was the crime and so great Becket's celebrity, that he was canonized within three years. This is undoubtedly

one of the earliest reliquaries associated with the sainted archbishop of Canterbury; its dramatic use of niello lends a cold, graphic immediacy to the scenes. On the front, three of the four knights responsible for Becket's murder—Reginald FitzUrse, William de Tracy, Richard le Bret, and Hugh de Moreville— attack the archbishop. The first strikes a blow to Thomas's head. His hand, his sword, and the sword of one of his accomplices cross over the frame of the scene, pushing the action into our realm. The horror of the scene notwithstanding, an angel set in the lid of the casket (the lid representing the heavenly realm) watches over Becket's martyrdom. On the back, two monks hold Thomas's body, while on the roof an angel receives his soul in the form of a small naked body only partially covered by a cloth.

The inscription of the reverse is marred by damage, but Neil Stratford's suggestion that it might be interpreted as including the word "Intus" (within), referring to relics of Thomas's blood, is appealing. The interior of the casket is divided into two equal halves, which may be inferred as compartments for two relics. (A similar arrangement, with uneven compartments, is used on a small Limoges casket of about 1200 in the Metropolitan Museum of Art's collection, 14.40.703, as well as on pieces preserved in Boston and Limoges. See New York 1996, no. 43.) J. B. Breck theorized that these would have been two phials of Becket's blood given to Chartres Cathedral, a hypothesis difficult to sustain on the basis

98
Reliquary Pendant with Queen Margaret of Sicily and Bishop Reginald of Bath

English, after 1174; perhaps by 1177
Gold; 5.1 × 3.2 cm
The Metropolitan Museum of Art, New York, purchase, Joseph Pulitzer Bequest, 1961 (63.160)
London only

INSCRIBED: obverse, inner ring: DE SANGUINE S(AN)C (T)I.THOME. M(ARTY)RIS.DE VESTIBU(S) SUIS SANGUINE SUO TINCTIS; outer ring: DE PELLICIA. DE CILITIO. DE CUCULLA. DE CALCIAMENTO. ET CAMISIA (Of the blood of St. Thomas Martyr. Of his vestments stained with his blood; of the cloak, the belt, the hood, the shoe, the shirt); reverse: ISTUD REGINE MARGARETE SICULOR(UM) TRA(N)SMITTIT PRESUL RAINAUD(US) BATONIOR(UM) (Bishop Reginald of Bath hands this over to Queen Margaret of Sicily)

PROVENANCE: Pierro Tozzi Galleries, Inc., New York

BIBLIOGRAPHY: Hoving 1965; Little 2002, 209

98

Reginald Fitz-Jocelyn, who was consecrated as bishop of Bath in 1174, presented this pendant to Margaret of Navarre, queen of Sicily (1138–83). For both Queen Margaret and Bishop Reginald, the recent martyrdom of Thomas Becket had particular immediacy. Margaret of Navarre had corresponded with and sought Becket's assistance, and supported him in his struggles with Henry II prior to his murder in 1170. Reginald had served both Becket and the king, and was excoriated by Becket when he attempted to reconcile the archbishop with the king. After the murder, Reginald helped ensure that Henry II was not excommunicated; later, at his own consecration as bishop, he was obliged to swear that he had no role in the murder.

Reginald of Bath was in Canterbury soon after his consecration; it has been proposed that he received the relics at that time and that he subsequently gave this pendant to Queen Margaret in 1177, when her son William married Joan of England, a daughter of Henry II. In any event, it must have been given before 1183, the year of Margaret's death. Reginald of Bath died within a month of his own election as archbishop of Canterbury in 1191. The inscription on the front lists the relics once contained under a crystal or other gem. / BDB

99
Reliquary Chasse with Scenes of the Martyrdom of Thomas Becket

French (Limoges), ca. 1210
Copper alloy (gilded), enamel (champlevé); 16 × 14.2 × 6.9 cm
The British Museum, London (PE 1878,1101.3)

PROVENANCE: Colonel Smith, London, on or before 1812 (mode of acquisition unknown); Joseph W. Dinsdale, 1812, by purchase; Francis Douce, London, by gift, 1828; Sir Samuel Rush Meyrick, 1834, by bequest; Augustus Meyrick, 1848, by inheritance; The British Museum, London, 1878, by donation

BIBLIOGRAPHY: Meyrick 1836, 159; Borenius 1932, 84–91; Hoving 1965, 28–29; Caudron 1977, 9–33; London 1987, 225

After Becket's canonization in 1173, Canterbury was transformed into a center for pilgrims, and Becket became a widely admired and venerated figure. The pilgrimage that Chaucer's characters make in his *Canterbury Tales* shows that some two hundred years later the cult of Thomas Becket and the draw of Canterbury were still thriving. Scenes of Becket's martyrdom were a common subject in Limoges enamelwork during the first half of the thirteenth century; some fifty chasses or chasse fragments depicting the saint have survived. With one exception (owned by the Society of Antiquaries, London), only two or three attackers are depicted in the murder scene.

A very similar chasse is in the Musée du Louvre, Paris (OA 7745). The front panels of both show the

scene of Becket's murder: as he stands by an altar his neck is struck by the sword of one of two knights who advance upon him. In the British Museum chasse Becket stands upright, facing the two knights, with his arms outstretched, as if trying to reason with his attackers; in the Louvre example Becket is facing the altar and he falls onto it with his head turned to the right, looking at the viewer. The front roof sections of both chasses show the saint rising to heaven as he emerges from a cloud, flanked by angels. / NCS

100
Reliquary Chasse with Scenes of the Martyrdom of Thomas Becket

French (Limoges), ca. 1210
Copper alloy (gilded) over wood core, enamel (champlevé); 18.1 × 21.1 × 8.3 cm
Allen Memorial Art Museum, Oberlin College, Oberlin, Ohio, gift of Baroness René de Kerchove, 1952 (1952.20)
Cleveland only

PROVENANCE: Possibly from the Couvent de Pont-à-Mousson, Meurthe-et-Moselle, France; Henri Daguerre, Paris; Collection Michael Dreicer, New York (1918), bequeathed by him to the Metropolitan Museum of Art, New York, 1921 (22.60.18); returned to the donor's family, 1933; collection Baroness René de Kerchove (widow of Michael Dreicer); Allen Memorial Art Museum, 1952, by bequest

BIBLIOGRAPHY: Breck 1918, 220–24; Parkhurst 1952, 96–105; Caudron 1993; Los Angeles 2007, 159

99

100

The murder of the illustrious archbishop Thomas Becket in front of the altar of Canterbury Cathedral is vividly depicted on the main plaque of this chasse. Two of the four historical knights are shown here: one directly confronts the unarmed Becket to deliver the fatal slash; the other steps away holding sheath and axe. Becket's burial in the crypt of Canterbury Cathedral on the morning after his murder is presented on the roof panel: kneeling attendants lower Becket's body into his tomb as an archbishop holding a crozier stands behind to bestow a blessing. The gable end plaques depict mourning female saints. The one on the proper left holds a book, and the one on the right grasps her right wrist with her left hand in a gesture of sorrow commonly found in Crucifixion scenes, thus perhaps connecting Becket's martyrdom to that of Christ. These mourning saints resemble those on the Cleveland enamel plaque (cat. no. 101), where scenes of Becket's martyrdom and Christ's Crucifixion are presented together. The general iconography of the Oberlin piece is typical of Limoges chasses that depict the martyrdom of Thomas Becket. This chasse, dated to 1210, shows the stylistic transition that occured between 1195 and 1220 from the linear, dynamically agitated figural depictions to graceful figures with more rounded forms and more fluid drapery. / TD

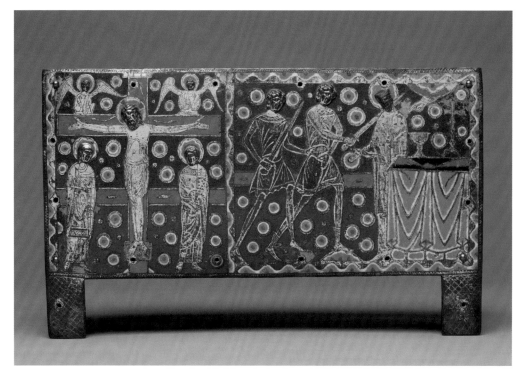

101

101
Plaque from a Reliquary Chasse

French (Limoges), ca. 1220–25
Copper gilt (engraved), enamel (champlevé); 16.9 × 28.5 cm
The Cleveland Museum of Art, purchase from the J. H. Wade Fund (1951.449)
Cleveland and Baltimore

PROVENANCE: By 1905, Georges Chalandon, Paris; Adolph Loewi, Los Angeles

BIBLIOGRAPHY: Migeon 1905, 19, 28; Milliken 1952a; Cleveland 1967, 116–17, 359, no. III–36; Caudron 1993, 62; Caudron 1999, 60–61; Limoges 1999; Los Angeles 2007, 158–59, no. 54

This fine enamel plaque once formed the principal face of a chasse. It is decorated with two narrative scenes depicting Christ's Crucifixion on the left and the martyrdom of Thomas Becket on the right. While both scenes follow standard iconographic formulas, their pairing on this plaque is a rare occurrence that equates the martyrdom of Thomas Becket with the Passion of Christ (see cat. no. 100).

While chasses decorated with scenes of the martyrdom of Thomas Becket are likely to have contained relics of the saint, their actual relic content rarely survives. Apart from the blood of the martyr, which the monks of Christ Church had carefully gathered after the archbishop's murder, and parts of his skull, which became one of Canterbury's proudest possessions, both primary and secondary (textile) relics were distributed throughout England and Europe, as church inventories and surviving artifacts attest. / HAK

102
The Butler Hours

English, ca. 1350
Ink, paint, and gold on parchment; 66 leaves, each approximately 21 × 14.5 cm
The Walters Art Museum, Baltimore (w.105)
Illustrated: fol. 14r: The Martyrdom of Thomas Becket
Cleveland and Baltimore

PROVENANCE: Boteler family, Shropshire, Diocese of Lichfield; John Boykett Jarman, England, by 1846 (date and mode of acquisition unknown); T. Taylor, Wakefield (date and mode of acquisition unknown, but exhibited in 1878); Leon Gruel, Paris; Henry Walters, by purchase; Walters Art Museum, 1931, by bequest; five additional leaves: Jean-Marie Le Fell, Paris (date and mode of acquisition unknown); Sam Fogg, London, by purchase; Walters Art Museum, Baltimore, 1994, by purchase.

BIBLIOGRAPHY: Sandler 1986, 130–31; Baltimore 1988, 222; Quandt 1992, 4–5

Books of Hours were personal prayer books made for the laity, based on the daily prayer cycles or "hours" observed by monks. This leaf is from a Book of Hours made for the Boteler (Butler) family, whose coat of arms appears in the manuscript. The manuscript has been dated as early as 1340, but considering that one of the miniatures depicts the lord with his wife and daughter at Mass, it was likely made for William le Boteler, the 3rd Lord of Wem (d. 1369), who had a daughter but no male heir; for that reason, a date in the 1350s or even 1360s should not be ruled out. Books of Hours were sometimes lavishly illustrated, and although they centered on prayers to the Virgin Mary, they often included prayers, or "suffrages," to other saints as well. Among those in the Butler Hours is a suffrage to Thomas Becket. This picture shows the moment of Becket's martyrdom, a common choice in depictions of the saint in reliquaries as well as illuminated manuscripts. Scenes of his death often included grisly details, and in this example blood can be seen pouring from the sword wound in the saint's head. Many depictions of Becket were purposefully defaced during the Reformation, but this example appears to have escaped such treatment. However, as several other areas of this manuscript have been retouched by a skilled nineteenth-century artist (and other parts, including the face of Thomas's companion, by less skilled artists), it is possible that Thomas's face was damaged and has been repaired. The manuscript has clearly fallen prey to other dangers: the Butler Hours suffered heavy water damage, probably when the owner's London house was flooded in 1846. / KBG

Hic cū magna reuerencia ꝫ deuoce relique scē Hedwigis tollunt̄ de sepulchꝛ ꝫ ex pūenerabiles
patres dūm wlodizlaū sale̱bꝛurgesem archiepm duce̱ slesie nycolau abbate̱ Hlubense· ꝫ mauriaū
abbate camē̄ necēsem uenabilē

reportatur· pūnlib Con rado duce̱ glogonie· cū filiis suis ꝫ sorore agnere ꝫ aliis mltis nobilibꝰ pūsois
cūc accederūt oīa
miracla que in hoc
libro cōtinetur·

103
Life of the Blessed Hedwig

Silesian (court workshop of Duke Ludwig I of Liegnitz and Brieg), 1353
Tempera, colored washes, and ink on parchment bound between wood boards covered with red-stained pigskin; 34.1 × 24.8 cm
The J. Paul Getty Museum, Los Angeles (MS Ludwig XI 7 [83.MN.126])
Illustrated: fol. 137v: The Opening of St. Hedwig's Tomb; The Translation of St. Hedwig's Relics
Cleveland and Baltimore

PROVENANCE: Duke Ludwig I of Liegnitz and Brieg (1364–98); bequeathed to the convent of St. Hedwig, Brieg, or possibly given to this convent by Duke Ludwig when he founded it in 1369; following the suppression of the convent in 1534, to the Bibliothek des Fürstlichen Gymnasiums, established in the convent buildings; given to J. Breuner by Duke Johann Christian of Brieg, 1630; to Franz Gottfried von Troilo, Lassoth; to Duke Julius Heinrich of Saxe-Lauenburg (d. 1665), Schlackenwerth, near Karlsbad, middle seventeenth century; by descent to Maria Benigna (d. 1701), wife of Ottavio Piccolomini; to the Piarist monastery, Schlackenwerth, 1701; following the suppression of the monastery in 1876, to the Stadtbibliothek Schlackenwerth; (Gilhofer and Ranschburg, Catalogue 100 [Vienna, 1910]); Rudolf Ritter von Guttmann, Vienna; confiscated from him in 1938 and placed in Österreichische Nationalbibliothek, Vienna, ser. nov. 2741; returned to Guttmann, 1947, with him in Royal Oak, Canada, until 1964; H.P. Kraus; Peter and Irene Ludwig

BIBLIOGRAPHY: Gottschalk 1967; Braunfels 1972; Euw and Plotzek 1982, 3: 74–81; Kren et al. 1997, 58–59 (A.S. Cohen); Hamburger 2009, figs. 1–3, 6, 8–9, 23–32

The noblewoman Hedwig of Silesia (1174–1243), wife of Henry I, duke of Silesia, was revered during her lifetime for her prayerful life, acts of charity, and mortification of the flesh, leading to her canonization in 1267, very shortly after her death. She and her husband founded a convent at Trebnitz, the first in Silesia. After bearing seven children, both Hedwig and her husband took vows of celibacy, and Hedwig resided at the Trebnitz nunnery after Henry's death. The Getty *Life of Hedwig* is the earliest surviving illuminated copy of the text that details her life. Hedwig's descendant, Duke Ludwig I, commissioned this manuscript and bequeathed it to the convent of St. Hedwig in Brieg (Brzeg), which he founded in his ancestor's honor in 1369.

While primarily an account of her various good deeds and largesse, the *Life of the Blessed Hedwig* also describes the afterlife of the saint's remains. One of the final images in the manuscript (fol. 137v) depicts the translation of her relics to the church of the Trebnitz monastery for permanent installation in the choir. Above, Archbishop Wladislaus of Salzburg, Abbot Nikolaus of Leubus, and Abbot Mauritius of Kamenz oversee the opening of Hedwig's tomb by Duke Konrad of Glogau. Hedwig's *Life*

recounts that when her body was exhumed, it was found completely decayed, with the exception of the three fingers with which she had held her beloved statuette of the Virgin and Child. In the lower register, the procession of clergy and nobles bears the saint's haloed skull in cloth-covered hands, as well as Hedwig's ivory statue, and finally the bones of Hedwig's arm, with the flesh of her hand still preserved. This miniature therefore provides explicit evidence of the translation of her body, visually establishing Trebnitz as a locus for devotion to St. Hedwig and pilgrimage to venerate her relics. / CS

104
Reliquary Head of St. Eustace

Upper Rhenish (possibly Basel), ca. 1210
Silver gilt over wood, rock crystal, chalcedony, amethyst, cornelian, pearl, and glass, wooden core with gesso; 35 × 16.6 × 18.4 cm
The British Museum, London (PE 1850,1127.1)

PROVENANCE: Basel Cathedral, Switzerland, 1477–1834; allocated to Basel-Country, 1834; Johann Friedrich Burckhardt-Huber, Liestal, 12 April 1836, by purchase; William Forest; Isaacs sale, Puttick and Simpson, London, 12 November 1850, lot 152; purchased by The British Museum, London

BIBLIOGRAPHY: Paris 1968, 239; New Delhi 1997, no. 205; London 2000, 18; New York 2001, no. 9; Robinson 2008, 74

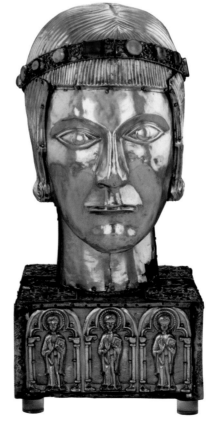

104

This head reliquary has been associated since 1477 with St. Eustace, a Roman general who, having seen a stag with an image of the Crucifixion between its antlers, converted to Christianity and was martyred for his faith; it was part of the cathedral treasury of Basel until it was sold in 1836.

Body-part reliquaries became popular in the central Middle Ages (twelfth–thirteenth centuries; see Hahn herein, pp. 163–72). Although the shape of these reliquaries might give an indication of their content, they sometimes enshrined a number of different relics. Such is case with the Eustace head-reliquary, which contained numerous relics, including those of Eucharius, first bishop of Trier; Nicolas, bishop of Myra; Benedict, abbot of Monte Cassino, and the Holy Virgins. In 1955 the reliquary was opened and the relics were returned to Basel. The St. Eustace head is composed of a wooden (sycamore maple) core and a silver-gilt repoussé shell composed of eleven gilded silver sheets that cover the neck and head. A brow band decorated with sixteen colored stones encircles the figure's neatly parted and combed hair. The head is mounted on a base clad with silver-gilt sheets and decorated with figures of the twelve apostles standing under arches. The wooden core is also head-shaped, and has been hollowed out with a lathe. The relics were originally wrapped in precious textiles and stored in three layers. Those at the bottom comprise nine unlabeled fragments of skull, presumably the relics of St. Eustace. / NCS

105
Reliquary Bust of St. Baudime

French (Auvergne), mid-12th century (1146–78)
Copper gilt over walnut core, ivory, and horn; 73 × 43 × 46 cm
Mairie de Saint-Nectaire, France (MH 1897/0127)

PROVENANCE: Probably in the church since its manufacture; first recorded in 1462

BIBLIOGRAPHY: d'Auvergne 1859; Paris 1966, 262–63, 67; Lasko 1994, 105, fig. 144; Boehm 1990, 285–94; Paris 2005, 380, no. 292

According to legend, St. Baudime, St. Nectaire, and St. Auditeur were sent to Gaul from Rome by St. Peter, and they were instructed to evangelize the Auvergne by St. Austremonius, the first bishop of Clermont-Ferrand. They established themselves on Mont Cornadore, where they were ultimately interred. The twelfth-century church dedicated to St. Nectaire is built on the site, and the reliquary of St. Baudime is first recorded in an inventory dated 1462, which mentions that the bust contained a vial

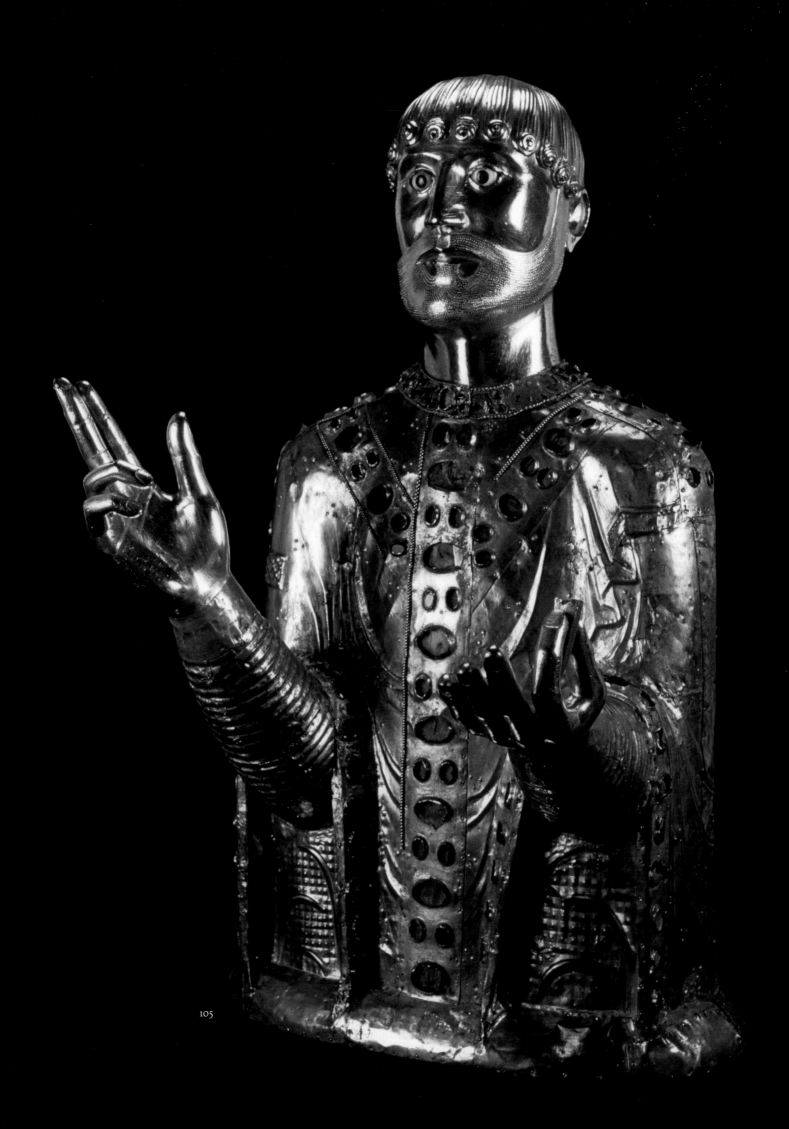

of the saint's blood. A cavity for relics protected by a door was found during restoration of the bust in 1957, but no relics have been recorded in the bust since at least 1871. There is no record of the bust having contained the skull of the saint; among documented and surviving examples from south central France, it is exceptional for an image reliquary not to contain the skull of the saint.

A radiant image intended to evoke the heavenly appearance of the saint, the bust is particularly animated by the black and white eyes and the suspended gesture of Baudime's raised arms and elegant hands. The goldsmith's work is distinguished technically by the stippling of the beard, the beautifully rhythmic curls of hair, and the elegant patterning of his vestments.

The core of the reliquary of St. Baudime is made of walnut, like the images of the Virgin and Child in Majesty for which the Auvergne region is renowned. The placement of the head directly onto the cylindrical, plug-like neck of the core is comparable to the construction of the reliquary of St. Foy at Conques (see Bagnoli herein, p. 140), but the tenth-century date proposed for the St. Baudime reliquary by Peter Lasko is untenable both on historical grounds (the community at Saint-Nectaire did not yet exist, so one would have to presuppose a different original provenance) and on visual evidence. The forked-cross form of the orphrey that decorates the front and back of the saint's chasuble was common from the twelfth to the fourteenth century; the cap-like hair of St. Baudime bears comparison to sculpted stone images of St. Nectaire and St. Baudime in the carved capitals of the nave of the church, datable to between 1146, when Saint-Nectaire is not included in a papal listing of Auvergnat monasteries, and 1178, when it is. The priory at Saint-Nectaire was established as a dependency of the monks of La Chaise-Dieu, following a gift from Guillaume VII, count of Auvergne.

The record of a parish visit in 1652 identified three images on the high altar: Saint Baudime; an image of the Virgin, perhaps the painted one still in the church today; and an effigy of St. Peter. Prior to the French Revolution, the church at Saint-Nectaire also possessed a fifteenth-century image of its patron, containing the saint's skull, part of a suite of reliquaries of the patron in a hierarchy of different materials, the most precious, of silver, for the skull.

The gems of the bust of St. Baudime were already missing in 1859, when Anatole d'Auvergne painted a watercolor of the reliquary; it is possible that they were removed during the French Revolution. The terms of a law of 1791 could explain both the gems'

disappearance and the bust's survival: according to a proclamation of March of that year, works of art dating before 1300 were to be preserved, but precious stones and intaglios should be removed from them for examination in Paris. The bust of St. Baudime was stolen from the church at the beginning of the twentieth century but recovered soon thereafter by the police. / BDB

106
Reliquary Bust of St. Césaire

French (Massif Central), third quarter of the 12th-century, with 13th-century and later additions
Silver and copper gilt over wood core, cabochons, paint; 91 × 43 cm
L'abbatiale Saint-Césaire, Maurs

INSCRIBED: on the inside of the silver-gilt door: HIC EST CAPVT: S(AN)C(T)I CESARII ARELATENCIS: EPI(SCOPUS); in inverted letters on the 13th-century door for viewing the relic: FIG (perhaps for Figeac)

BIBLIOGRAPHY: F.C. 1886, 675–80; Rupin 1890, 455–58, figs. 508–14; Rochemonteix 1902

During restoration in 1951, the wood plaque covering the hollowed-out back of this bust reliquary was removed to reveal a skull, a wood cross, and two parchment identification tags, dated 1272, noting that the sculpture contained the head of St. Césaire. This is the basis of the identification of the bust today. St. Césaire, whose legend is recorded by Gregory of Tours, was a monk on the island of Lérins near Cannes. In 502, he became bishop of Arles, a post that he held until his death in 543. He is the author of numerous writings, including a rule for monastic life. How the relic of his skull came to the Benedictine abbey church at Maurs is not known. It has been suggested that Césaire's relics were removed from Arles prior to the sack of the city by Muslims in the tenth century.

Like the image of St. Baudime at Saint-Nectaire, the figure of St. Césaire is one of the earliest surviving bust-length images of a saint in France, an example of a type amply documented throughout the Massif Central. In this instance, painted wood is used in combination with revetment in gilded metal. Given the stylistic rapport with an image of St. Peter from Saint-Pierre-de-Bredons, local manufacture can be inferred.

As in the case of St. Baudime, St. Césaire raises his hands in greeting and blessing, a pose in keeping with the importance of such reliquaries as abiding emblems of authority. This was especially meaning-

ful for the community to which they belonged, but also for visiting pilgrims and neighboring territories or dependencies to which such reliquaries were sometimes taken.

A seal impression of the consuls of Maurs on a document of 1284 bears a half-length image of St. Césaire that appears to correspond to the bust reliquary. Under an agreement of 1281, the bishop of Rodez and the abbot of Maurs alternately exercised the right to confirm the consuls of Maurs, to maintain the keys of the city, impose taxes, create public officers, as well as to benefit from taxes paid by the Jews of the city and other taxes and revenues (Déribier-du-Chatelet 1856, 4:310). The door set in the chest of the image of St. Césaire is a later addition to afford visibility, like the fourteenth-century quatrefoil opening in the belly of the image of St. Foy at Conques (see p. 140, fig. 48). / BDB

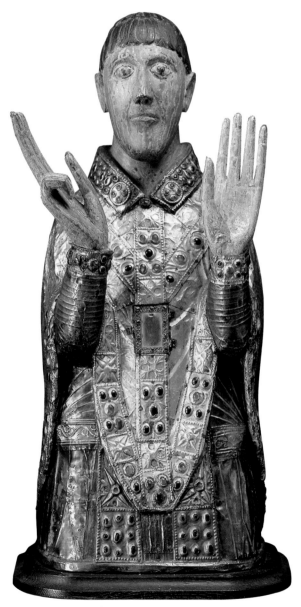

106

107
Reliquary Bust of St. Balbina

South Netherlandish (Brussels?), ca. 1520–30
Painted and gilded oak; height 44.5 cm
The Metropolitan Museum of Art, New York, bequest of Susan
Vanderpoel Clark, 1967 (67.155.23)
Cleveland and Baltimore

PROVENANCE: Louis Mohl, Paris, sold 1912; Susan Vanderpoel
Clark, New York

BIBLIOGRAPHY: New York 2006, 188–90, no. 77 (with earlier
literature)

A hinged rectangular lid at the crown of the head of this reliquary opens to expose the relics of a skull still nestled tightly inside. A paper tag attached to the inside of the lid bears an inscription identifying the saint as Balbina. The name is associated with an early virgin martyr of Rome; some of her relics, along with those of her father, Quirinus, were reputed to have been found at Neuss, near Cologne, in the Middle Ages, and St. Balbina's name is occasionally linked to that of St. Ursula.

Not surprisingly, therefore, this reliquary conforms in type to the ubiquitous busts of Ursula and her companions. Religious pilgrims who were, according to their legend, martyred by the Huns,

their celebrity developed after the discovery of a large cemetery in Cologne in 1106. The lavish painted and gilded costume and jewels, along with the richly plaited hair and delicate complexions painted on reliquaries of virgin maidens such as this poignantly underscore the price of martyrdom. So successful was this type of reliquary that entire ensembles can be found still today in the Golden Room of the Church of St. Ursula in Cologne; the cathedral of Avila, Spain; the high altar at Ubeda (Jaén), Spain; as well as in museum collections.

Comparisons of this bust with other sculpture suggest that it may have been carved in Brussels. / BDB

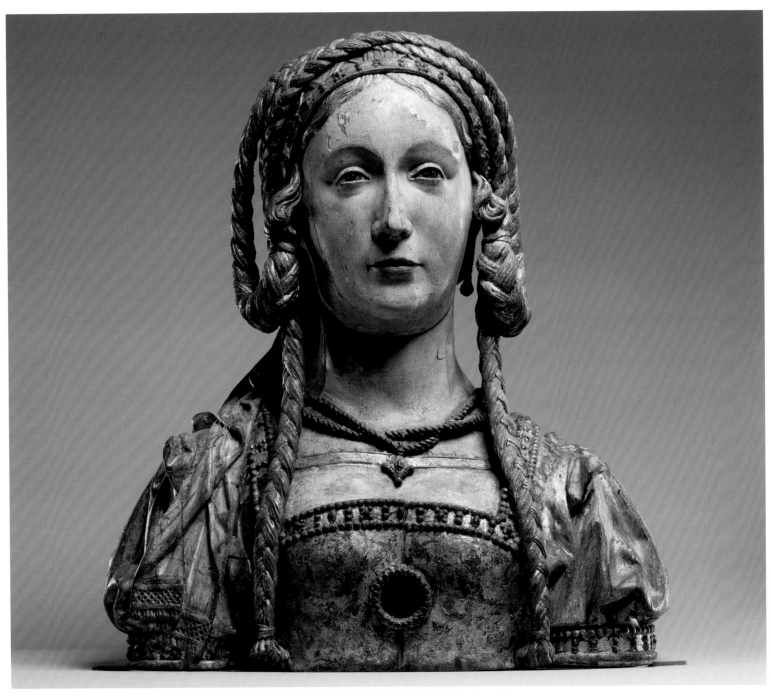

107

108

Reliquary Bust of an Unknown Female Saint, Probably a Companion of St. Ursula

South Netherlandish (Brussels?), ca. 1520–30
Painted and gilded oak; height 42.4 cm
The Metropolitan Museum of Art, New York, The Cloisters
Collection (59.70)
Cleveland and Baltimore

PROVENANCE: Henry Hirsch, London (sold 1931); Henri
Heilbronner, Lucerne

BIBLIOGRAPHY: New York 2006, 188–90, no. 77 (with earlier
literature)

By the late Middle Ages, bust reliquaries for the
skulls of saints were often assembled in large num-
bers in church sanctuaries, on or surrounding
altars. This was especially the case with reliquaries
of the companions of St. Ursula, legendarily
reputed to number 11,000. This bust and the bust
of St. Balbina (cat. no. 107) are particularly close
to examples preserved in the Chapel of San Salvador
in Ubeda in Spain, which controlled the Low-
lands at this time. The chapel in Ubeda was conceived
as the funerary chapel for a secretary of Emperor
Charles V, Francisco de los Cobos, who brought an
Italian architect, and apparently sculpture from
Brussels, to his native city.

This example, like the bust of St. Balbina,
originally contained a skull associated with a saint,
tightly sandwiched between the front and back
halves. At some point the relic was removed, and

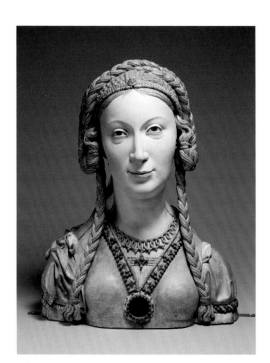

108

the paper tag identifying it, formerly attached
to the inside of the lid, torn away. The small glazed
medallion resembling a brooch set at the chest
displayed additional relics. / BDB

109

Reliquary Arm of St. Luke

Naples, before 1338
Silver gilt, enamel (champlevé), rock crystal; height 48 cm,
diameter at the base 26 cm
Musée du Louvre, Paris, Département des Objets d'art
(OA 10944)
Cleveland and Baltimore

INSCRIBED: HIC EST OS BRACHII BEATI LUCE EVANGELISTE (This is
the arm bone of the blessed Evangelist Luke)

PROVENANCE: Made for Sancha of Majorca, second wife of
Robert II of Anjou, king of Naples; probably transferred to
Eleanor of Aragon, queen of Castille (d. 1382), and subsequently
to her daughter-in-law Eleanor of Alburquerque, queen of
Aragon, who bequeathed it to the Dominican convent at Medina
del Campo; sold in 1890; acquired in 1891 by Frédéric Spitzer;
Heckscher collection (sale, London, Christie's, 4 May 1898,
no. 258); coll. Davis. Lord Astor [Gavin Astor, 2nd Baron of Hever];
acquired at the Astor sale, London, Sotheby's, 6 May 1983

BIBLIOGRAPHY: Bertaux 1898; Catello 1975, 15; Leone de Castris
1980; Gaborit-Chopin 1985; Cioni 1998, 296–301; Fontevraud
2001, 315

On the basis of Neapolitan archives, Émile Bertaux
established that this reliquary, in the treasury of
the Angevin kings of Naples, and the arm reliquary
of St. Louis of Toulouse (p. 142, fig. 50) were made
between 1336 and 1338 for Queen Sancha of Majorca,
second wife of Robert II of Anjou.

The reliquary takes the form of the Evangelist's
right forearm, the hand still holding the quill that
recorded the life of Christ and the Holy Word. The
goldsmith sought a somewhat naturalistic treatment
in the rendering of the garment, decorated with
two bands of armorial ophreys, and in the remarkably
plastic modeling of the hand. The most striking
aspects of this reliquary are the beauty of the silver-
gilt hand and the profusion of heraldic decoration.
On the bands of orphreys at the two ends of the
monstrance as well as on the enamel fillets that sup-
port the monstrance, lozenges with the arms of the
House of Anjou stand out clearly superimposed
on the pallets of the arms of Majorca, marking their
ownership by their first beneficiary, Queen Sancha.
By one of several ties of kinship that united the
houses of Anjou, Majorca, and Aragon at that time,
the two reliquaries came into the possession of
Queen Eleanor of Alburquerque, who deeded them
in 1435 to the Dominican convent of Medina del

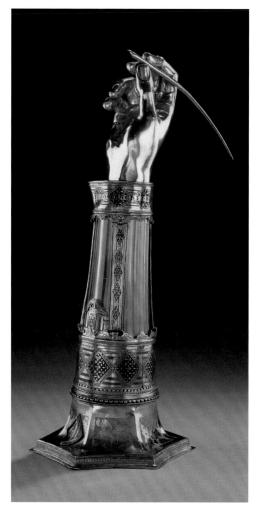

109

Campo. Her arms appear on the two enameled
lozenges at the base of the reliquary, probably substi-
tuted for those of Sancha. Finally, two enameled
fillets, later additions, carry the arms of the convent
of Medina del Campo, as well as an enameled blazon
that masks damage to the rock crystal which likely
occurred in the fifteenth century.

Thus, with the exception of the hand holding
the quill, the reliquary's decoration illustrates
neither the life of Luke nor that of Christ; rather it
calls to mind its successive owners. Pierluigi Leone
de Castris (followed by Elisabetta Cioni in 1998)
attributed the two reliquary arms made for Sancha
of Majorca to the Sienese goldsmith Lando di Pietro
(d. 1340), but it has since been established that his
residence in Naples postdates the making of these
reliquaries. They should for that reason be attrib-
uted to a goldsmith trained in the Sienese tradition
working for the Angevin court. / EA

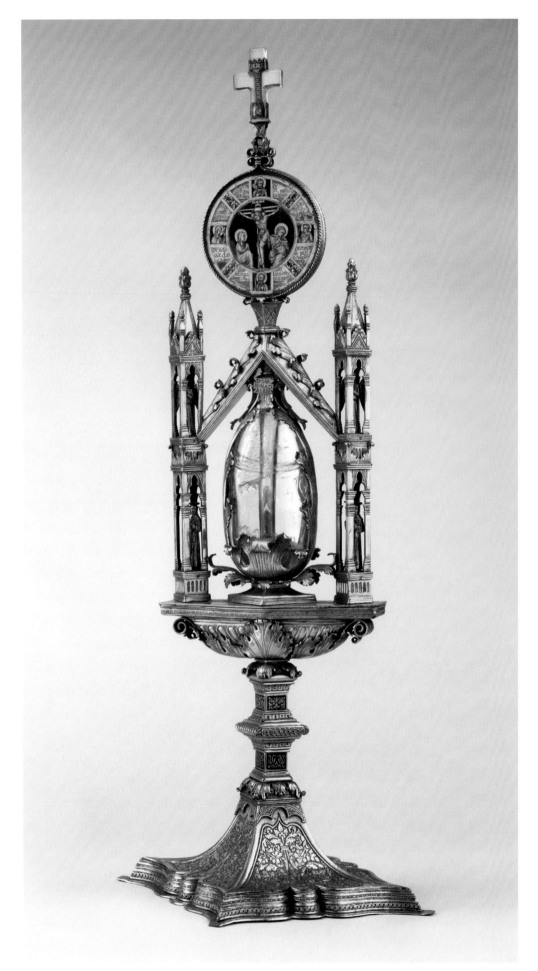

110
Reliquary of the Tooth of Mary Magdalene

Tuscan; *verre églomisé*: 14th century, goldsmith's work:
15th century
Silver gilt, copper gilt, niello, *verre églomisé*, rock crystal
55.9 × 23.8 × 20.2 cm
The Metropolitan Museum of Art, New York, gift of J. Pierpont
Morgan, 1917 (17.190.504)
Cleveland and Baltimore

INSCRIBED: In niello on a silver plaquette above the rock crystal:
D(E).S(ANTA).M(A)RI(A)E.MADALENE

PROVENANCE: J. C. Robinson, London; J. Pierpont Morgan,
London and New York

BIBLIOGRAPHY: Amsterdam 2000, 152–55; Carboni 2001, 36

The large, egg-shaped rock crystal that forms the
centerpiece of this reliquary enshrines and magni-
fies a tooth set at its center, identified as a relic of
St. Mary Magdalene. Over the course of the Middle
Ages, the Magdalene became a highly venerated saint.
Her relics were particularly venerated in France: at
Vézelay, reputedly as early as the eighth century, and
in Provence from the late thirteenth century. Gospel
accounts attest to her central role in witnessing the
Crucifixion and Resurrection of Jesus. Her notoriety
as a prostitute who repented of her sinful ways
to follow Jesus's teachings appears to stem from an
erroneous, sixth-century assertion by Gregory the
Great. In some Orthodox communities, the Mag-
dalene is linked to a legend about eggs, but the date
of the association is obscure; it appears to have no
bearing on the present example.

It was in her reputed role as a penitent that Mary
Magdelene's legend, and therefore her relics, were
embraced by the Dominicans and the Franciscans.
This reliquary must have been made for a Francis-
can community. On one side of the disk that crowns
the reliquary, half-length images of St. Francis and
St. Clare witness the Crucifixion of Jesus, in the
company of, and on a par with, images of St. Peter
and St. Paul. The two saints who stand under the
arcades on either side of the rock crystal wear robes
secured with the knotted cord of the Franciscan
order. They may represent St. Francis himself, and
St. Bernardino, with the sunburst, in reference to
the design of the monogram of Christ that he typi-
cally held while preaching. St. Francis exhorted
brothers living in hermitages to follow the example
of the Magdalene (see the citation from the *Opuscoli di
S. Francesco* in De Selincourt 1905, 175), and St. Ber-
nardino invoked the Magdalene repeatedly in his

sermons. If St. Bernardino is intended, then the goldsmith's work must date after 1450, the year he was canonized.

In *Il Libro dell'Arte (The Craftsman's Handbook)*, written about 1390, the Florentine artist Cennino Cennini outlines the "individual attractive, fine and unusual" process of gilding glass "for the embellishment of holy reliquaries." Franciscan communities frequently chose reverse-glass painting (known in art historical literature as *verre églomisé*), as a means of decorating their reliquaries, but seldom are they as lavish as this example. Here, small relics with identifying inscriptions are enclosed behind the decorated glass panels. Although the palette of the glass medallion that crowns the reliquary is limited to shades of gray, with delicate touches of red and green, the overall effect of crystal and gilded metal is sumptuous, and the drawing of the figures highly sophisticated.

This *verre églomisé* medallion appears to date from the second half of the fourteenth century and to have been incorporated into this fifteenth-century shrine. Similarly, the quartz crystal appears originally to have been created for a different context: the carved ridge across the middle and the protrusions at one side do not play any role, either functional or decorative, on the reliquary. A material prized for its clarity, rock crystal was frequently reused over the centuries (see cat. nos. 77–80). / BDB

111
Reliquary of the Rib of St. Peter

Hugo of Oignies (Mosan), 1238
Silver gilt (filigree, repoussé), bronze gilt, niello, gems, topaz, garnet, beryl, pearls, rock crystal; 50.5 × 35 cm
Tresor d'Oignies, Sœurs de Notre-Dame, Namur
London only

INSCRIBED: IN HOC VASE HABETUR COSTA PETRI APP (this vessel contains the rib of St. Peter)

PROVENANCE: Priory of St. Nicholas, Oignies, until 1818; thereafter in the Convent of the Sœurs de Notre-Dame de Namur

BIBLIOGRAPHY: Namur 2003, 204–10 (with earlier bibliography)

Jacques de Vitry (1160–1240), bishop of Acre (capital of the Kingdom of Jerusalem between 1192 and 1291) and later cardinal of Tusculum, acquired a number of important relics during his extensive travels in the Holy Land and Italy. He donated much of his collection to the priory of Oignies (in France's northern Calais region), with which he had maintained

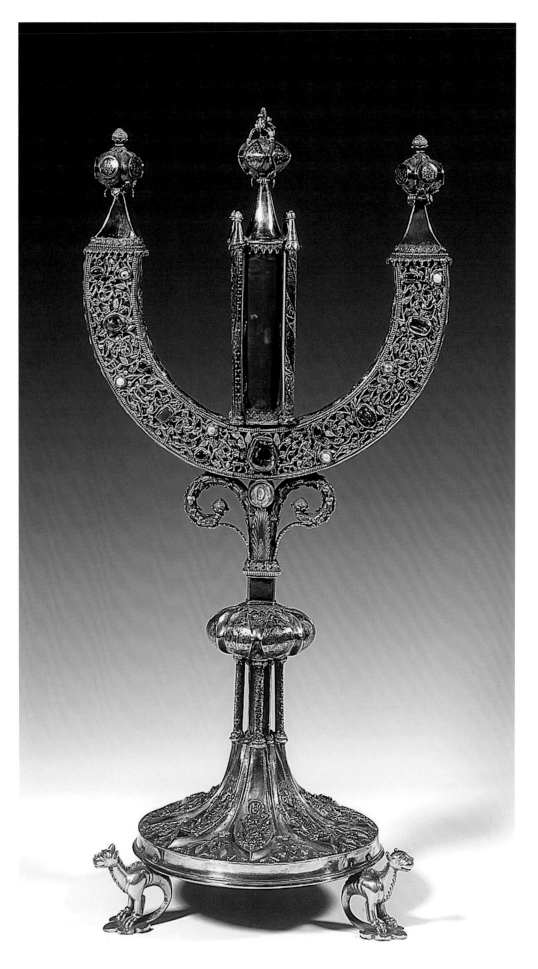

111

strong ties since the beginning of his religious life. The relic of the rib of the apostle Peter was one of these gifts. The unusual shape of the reliquary re-creates the form of a human rib, even though the actual relic is contained in the rock crystal chamber emerging from the center of the metal rib. A folded strip of parchment inside the relic vessel names Hugo of Oignies as the maker of the reliquary and dates the enshrining of the relics to 1238: RELIQ[UI]E ISTE FUERU[N]T HIC RECO[N]DITE ANNO D[OMI]NI M°. CC°. XXX° OCT[AVO]. FRAT[ER] HUGO VAS ISTUD OP[ERA]T[US] EST. ORATE PRO EO.

Hugo was one of the foremost Mosan goldsmiths of the thirteenth century. The sophistication of his artistry is evident in the delicacy of the filigree that transforms the rib into a foliate scroll inhabited by birds, fruit, and a lively hunting scene. Hugo's mastery is also attested by the multiple techniques he used. In addition to filigree, the reliquary—a tour de force of goldsmithing—incorporates niello, repoussée work, and casting. The foot of the pedestal is decorated with enthroned images of the Virgin Mary and holy bishops important to the Oignies community: Lambert (patron saint of the dioceses of Liège), Nicholas (patron saint of the priory), Augustin (whose rule was followed by the canons of the priory), and Servatius (Servais), first bishop of Tongres and a popular saint in the Mosan region). / MB

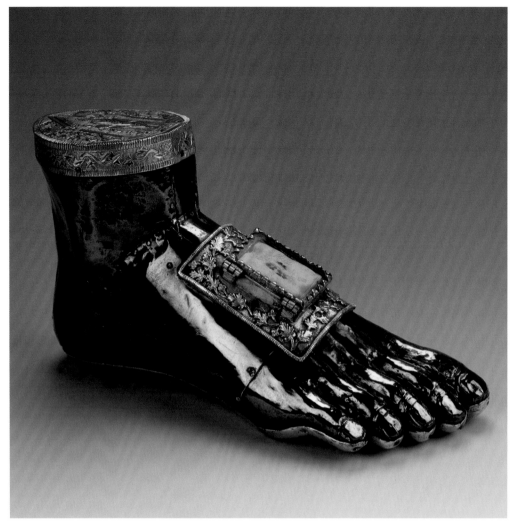

112

112
Reliquary of the Foot of St. Blaise

Workshop of Hugo of Oignies, ca. 1260
Silver gilt, copper gilt over wood, rock crystal; 25 × 25 cm
Tresor d'Oignies, Sœurs de Notre-Dame, Namur
London only

PROVENANCE: Priory of St. Nicholas, Oignies, until 1818; thereafter in the Convent of the Sœurs de Notre-Dame de Namur

BIBLIOGRAPHY: Westermann-Angerhausen 1996, 326–27; Saint-Riquier 2000, 326–27; Namur 2003, 247–48

At the time of his death in 1240 Jacques de Vitry bequeathed his collection of relics to the priory of St. Nicholas at Oignies to which he had already given many relics over the years. It is supposed that the relic of St. Blaise, a fourth-century bishop from Sebaste in Armenia, was part of this estate. The cult of St. Blaise became widespread in Europe in the twelfth and thirteenth centuries. Reliquaries shaped to "speak" their contents, such as this foot reliquary, often contained the relics of multiple saints.

Indeed, the inventory of the treasury of Oignies, executed in 1648, records "a reliquary shaped like a foot containing many relics." It is unclear whether it refers to the reliquary of St. Blaise or that of St. James of Compostela also in the treasury. The reliquary of St. Blaise consists of a wood core covered with sheets of silver. The sole of the foot is made of gilded copper. A window covered with rock crystal on the front would have enabled the faithful to peer inside to see the relics. The foot is cut at the ankle and is topped by a plaque of gilded copper incised with the image of a bishop, possibly Blaise, standing underneath a gabled baldachin. The elongated silhouette of the saint, his small head, and the deep angular drapery recall the style of Parisian goldsmiths of the second half of the thirteenth century, but the repetition of forms and models used by Hugo of Oignies in earlier works indicates that this reliquary is probably the work of his workshop, which continued production long after the death of the master. / MB

113
Mandylion

Mandylion: unknown date and place of origin
Frame: Grancesco Corni, 1623
Mandylion: painted cloth; 28 × 19 cm
Frame: silver gilt, enamel; 65 × 45 cm
Ufficio delle Celebrazione Liturgiche del Sommo Pontefice, Vatican City

BIBLIOGRAPHY: Rome 2001, 67–76; Genoa 2004, passim; Kessler 2007; Guscin 2009

The elaborate seventeenth-century mount that frames and crowns the likeness of Christ's face provides a brilliant contrast for the dark, almost invisible portrait and, simultaneously, establishes its aspect as a relic within a reliquary. The painting seems to have been made as a replacement for a nearly identical icon in Genoa (San Bartlomeo degli Armeni), most likely when the latter was enclosed in its fourteenth-century frame. The Vatican and Genoa faces both replicate Byzantium's most venerated icon, the *Mandylion*, claimed to have been created

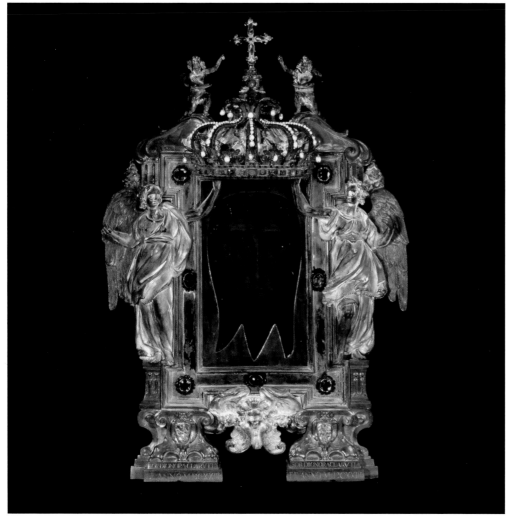

113

Pendant Icon with the Virgin
Dexiokratousa

Icon: Byzantine, 12th century; frame: German, mid-14th century
Icon: steatite, 5.3 × 4 cm
Frame: silver gilt, pearls, 6.7 × 5.3 cm
The Cleveland Museum of Art, purchase from the J. H. Wade Fund (1951.445.1, 1954.445.2)

INSCRIBED: on the frame: HA[N]C · YMAGINE[M] · FEC[IT] · S[ANCTUS] · LUCAS · EV[ANGELISTA] · AD · SI[MI]LITUDINEM · B[EA]T[AE] · MARI[A]E (This image was made by St. Luke the Evangelist according to the likeness of the Blessed [Virgin] Mary)

PROVENANCE: Treasury of the Cathedral of Aachen; bequeathed in 1804 to the Empress Joséphine of France (1763–1814), Paris; by inheritance to her son Eugène Rose de Beauharnais, prince of Venice and duke of Leuchtenberg (1781–1824), Paris; Henri Daguerre, Paris; César de Hauke, Paris; museum purchase, 1951

BIBLIOGRAPHY: Montesquiou-Fezensac 1962, 74; Aachen 1965, 494–95, no. 674; Grimme 1965, 48–53; Aachen 1972, 48–50; Kalavrezou-Maxeiner 1985, 124, no. 32; Athens 2000, 189, no. 125; New York 2004, 500, no. 303; Los Angeles 2007, 76–77, no. 20

Consisting of a Byzantine steatite icon of the Virgin and Child mounted in a Gothic ogee-shaped frame, this small pendant belonged to the treasury of Aachen Cathedral until 1804, when it was given to Empress Joséphine of France as a gift. By then, it was cherished for its association with Emperor Charlemagne (r. 800–814), who was believed to have worn it in battle. A related tradition, first attested during the early seventeenth century, claims that the pendant was one of three reliquaries found around

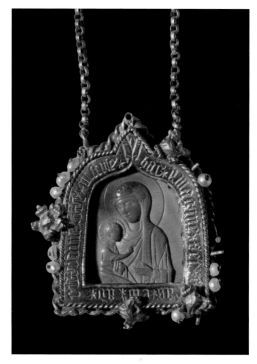

when a painter dispatched to the Holy Land by King Abgar of Edessa (Urfa in modern Turkey) was unable to capture Christ's visage using traditional artistic means because of the radiance emanating from the divine face; washing his face and drying it on a towel, the Lord effected the portrait's miraculous transfer onto the cloth. When the *Mandylion* was brought back to Edessa, it cured Abgar of leprosy, acting as if it were Christ himself, who had left few actual relics behind when he ascended to heaven.

Engaging a tradition in which pilgrims captured the aura of relics by touching them with cloths *(brandea)*, the *Mandylion* was, then, no ordinary painting. An *acheiropoieton*, that is, an image "not made by human hands," it hovered between being a picture and touch-relic, an aspect captured by the portrait, which seems to be dyed into the cloth without clear contours except those made by the gold mat superimposed on it. Like a shadow, the *Mandylion* reminds viewers that Christ was once present and visible on earth but has returned to his Father; in so doing, it conjures up both the human Jesus and his ineffable divinity.

Although the *Mandylion* was believed to be capable of replicating itself when cloths or other substances were laid atop it, the miraculously made image continued to attract pilgrims to Edessa until it was rescued from the Moslem-controlled city by the Emperor Constantine VII (r. 905–59) and installed with ten relics of Christ's Passion in the imperial palace in Constantinople. It was displayed in the Pharos Chapel with the tablets given Moses on Mt. Sinai once treasured in the Ark of the Covenant, which the tenth-century account of the *Mandylion*'s transfer refers to as "the other, less elevated ark"; indeed, the Baroque angel-frame may have been intended to evoke the cherubim that watched over the great Jewish reliquary chest. In the medieval setting, the association with the tablet of the law containing a prohibition of images, the *Mandylion* realized the fundamental theological argument that God's covenant with the Jews, proffered in words, had been superseded by the incarnate Christ whose dual nature enabled both relics and images. / HLK

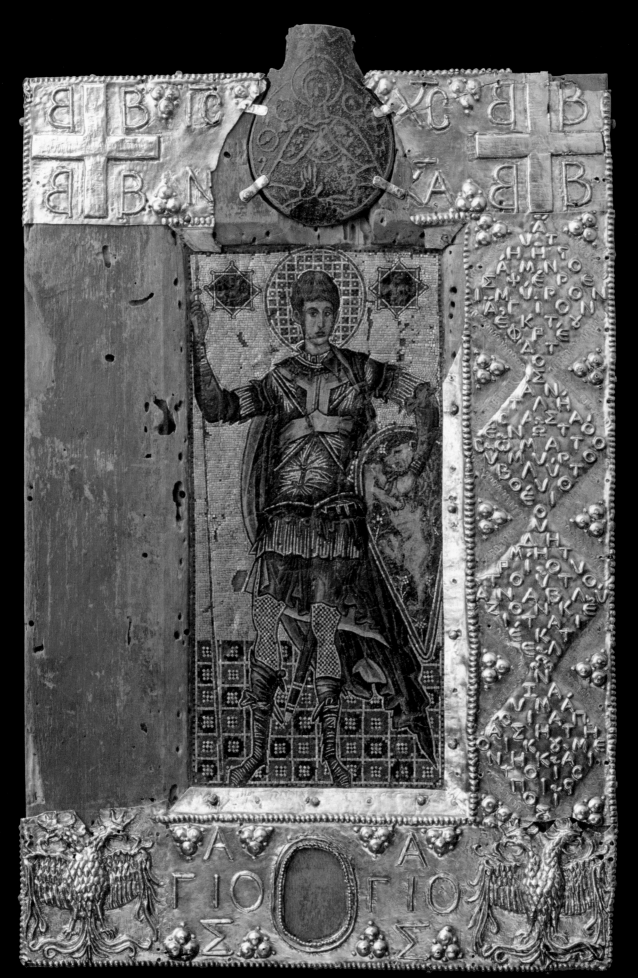

Charlemagne's neck when the emperor's body was exhumed in 1166 following his canonization. The object, however, tells a different story.

Dated to the twelfth century on the basis of its style and iconography, the pendant's steatite icon depicts the half-length figure of the Virgin holding the Christ Child on her right arm while pointing toward him with her left. Known as the Virgin *Dexiokratousa*—literally, "the one who holds with her right"—this icon type is a mirror image of the Virgin *Hodegetria*, the most famous miracle-working icon of Constantinople. Allegedly painted by St. Luke the Evangelist in Jerusalem, the *Hodegetria* icon was considered an authentic portrait of the Virgin and Child, and thus became one of the most widely copied icons of the Orthodox world. While it is unknown how the *Dexiokratousa* icon emerged, it is likely that it was through direct contact with the miracle-working prototype that this image type first gained currency in the Byzantine Empire.

While the steatite icon's purported association with Charlemagne and its discovery in his tomb must be considered a later invention, the pendant's status as a relic is confirmed by the framing inscription and engraved image of an ox—the symbol of St. Luke—on its silver-gilt frame. When the steatite icon was mounted, presumably during the mid-fourteenth century, the image was understood in its significance as an authentic portrait of the Virgin and Child painted by St. Luke, an image-relic of the highest order. / HAK

115
Mosaic Icon of St. Demetrios with Reliquary Flask

Flask: Byzantine, 13th or 14th century; mosaic: 14th or 15th century; frame: mid-15th century
Wax, wood, paint, silver gilt, lead
Overall: 24.3 × 16 cm, mosaic: 12.5 × 5.5 cm, lead flask: height 5.2 cm
Museo Civico, Sassoferrato

INSCRIBED: (after Durand in New York 2004): on the mosaic icon: O ΑΓΙΟC [ΔH]MH[?]ΤΡΙΟ[C] (St. Demetrios); on the flask: O A ΔM (St. Demetrios) (recto); H ΑΓΙΑ ΘΕΟΔΡΑ (St. Theodora)' (verso); on the frame: upper panel: two crosses, each containing the letter B (for *Basileus* [emperor]), and ICXC N[I]KA (Jesus Christ conquers); lower panel: ΑΓΙΟC (saint; repeated twice); on the left vertical panel, now missing (trans. Durand): O Great Martyr Demetrios, intercede with the Lord that he may help me, I, your faithful servant, the basileus of the Romans, Justinian, to conquer my enemies and subjugate them beneath my feet; on the right vertical panel (trans Durand): This ampulla bears the holy oil drawn from the well in which the body of the divine Demetrios reposes, which gushes forth here and accomplishes miracles for the entire universe and for the faithful; on the metal plaque covering the flask, now missing: the holy Myrrh.

PROVENANCE: In the collection of Niccolò Perotti (1429/30–80); given by him to the city of Sassoferrato, 1472; kept at the monastery of Sta. Chiara de Sassoferrato until 1861 when it was confiscated by the municipality; stolen in 1894; recovered and returned to Sassoferrato in 1895

BIBLIOGRAPHY: Barucca 1992; Cutler 1995, 253–54; New York 2004, 231–33, no. 139, 209–12

A thirteenth- or fourteenth-century lead pilgrimage flask from Thessalonike, two carved gemstones, at least one of which might have been produced in Antiquity, and a mosaic icon from Constantinople, probably made in the fourteenth century, were brought together within a single frame in the mid-fifteenth century, creating a powerful testament to the long-standing authority and power of St. Demetrios. Although the icon and the flask are Byzantine, they were owned by the Italian humanist Niccolò Perotti (1429/30–80)—a noted poet, grammarian, secretary to Cardinal Bessarion and Pope Calixtus III, and eventually archbishop of Siponto (r. 1458–80). Like many educated Italians in the fifteenth century,

Perotti was interested in Byzantine relics and reliquaries, and he owned a number of works of art from the Byzantine Empire. The inscriptions on the frame are in Greek, but the frame itself, and probably the conglomeration of the mosaic icon, the pilgrimage flask, and the gemstones (now lost), were conceived by an Italian, possibly Perotti himself. The inscriptions and images on the frame contain references to the spiritual power of St. Demetrios, the Byzantine emperor Justinian I (r. 527–65), and the last imperial dynasty of Byzantium, the Palaiologoi. These references, placed around an icon of Demetrios and a container of the holy oil from the saint's shrine, encapsulate the entire span of Byzantine imperial history and unite Constantinople, the imperial capital, with Thessalonike, the second city of the Byzantine Empire and the center of the cult of St. Demetrios. The icon was stolen in 1894 and although it was quickly recovered, the frame had been significantly damaged; fortunately the frame had been described and recorded in a photograph taken before the theft. / KBG

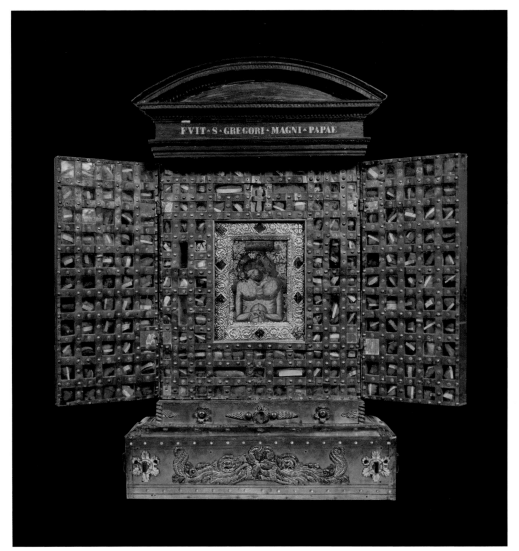

116

116
Imago pietatis (Man of Sorrows)

Icon: Byzantine, ca. 1300; case with relics: Italian, ca. 1380
Icon: multicolored stones, gold and silver, on wood; 23 × 28 cm
Case with relics: wood and metal; 98.7 × 97.1 cm
Basilica di Santa Croce in Gerusalemme, Rome

PROVENANCE: Icon: Mt. Sinai, St. Catherine's Monastery

BIBLIOGRAPHY: Belting 1990; New York 2004, 221–22, no. 131

A precious icon of the *Man of Sorrows* made of minute stones (micromosaic) in Byzantium at the end of the thirteenth century or the beginning of the fourteenth was treated as a relic only after it was brought to Rome by Raimondello Orsini del Balzo, count of Lecce, around 1380. The image type itself— Christ shown half-length dead and displaying his wounds before the Cross, but propped up to convey his supernatural aspect—had been developed in

Byzantium to engage the viewer in contemplation of the Lord's human suffering and was already dispersed in the Latin West. In this case, however, the meticulous fitting of tiny pieces of stone embedded in wax to form a startlingly beautiful image of the suffering Christ must itself have struck viewers as miraculous; and it may not be going too far to connect the tesserae that form Christ's body with the bones of saints that, in the surrounding frame, constitute an image of the Heavenly Jerusalem.

As the label on the case attests, "This was [the vision] of St. Gregory the Pope." The imported icon came to be identified with the vision that St. Gregory (r. 590–604) was said to have had while celebrating Good Friday Mass in the Church of Sta. Croce. An ancient version of the story, recorded in Jacobus de Voragine's popular *Golden Legend* of ca. 1260, reports that a woman had scoffed when Gregory declared the sacramental bread to be the "the Body of our Lord Jesus Christ" but was restored to faith when she saw

a "particle of bread changed into flesh in the shape of a finger" (trans. Ryan 1993, vol. 1, p. 179). Raimondello's gift of the Byzantine micromosaic seems to have prompted a modification of this legend, in which an icon of the dead Christ replaced the small fragment of his hand, i.e., an image came to substitute for a body part. The change was effective, and during the fifteenth and sixteenth centuries, pilgrims streamed to Sta. Croce to venerate the *Imago pietatis* and were rewarded with indulgences; at the same time, pictures of the *Mass of St. Gregory* in which the icon is quoted became a favorite theme in art. / HLK

117
Reliquary Frame

Sienese, 1347
Gilded wood, *pastiglia*, *verre églomisé*, glass cabochons, and relics; 63.5 × 50.8 × 25.3 cm
The Cleveland Museum of Art, gift of Ruth Blumka in memory of Leopold Blumka (1978.26)
Cleveland only

INSCRIBED: On the base of the reliquary frame: Obverse: HOC/OPUS : FACTUM . FUIT . SUB . ANNO . DO/MINI; Reverse: [small loss] /CCC . XLVII . TEMPORE . DOMINI . MINI/CINI. [This/work : has . been . made . under . year . of . the . Lord [small loss] /300 47 . in . the . time . of the Lord . Mini/Cini.]
On the obverse and reverse of the supporting base: LUCAS ME FECIT. [Luke has made me.]

PROVENANCE: Listed in a 1719 inventory of the Ospedale della Scala, Siena; Blumka Gallery, New York

BIBLIOGRAPHY: Moran 1979; Wixom 1979; Gordon 1981; Gauthier 1983, 173, no. 100; Preising 1995–97, 19–25, 58; Los Angeles 2007, 264–65

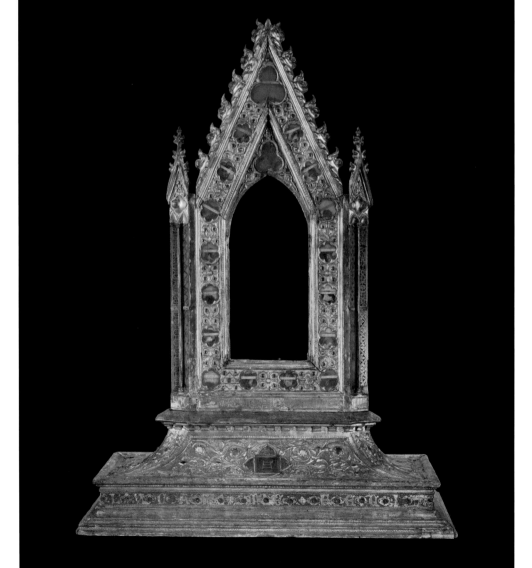

117

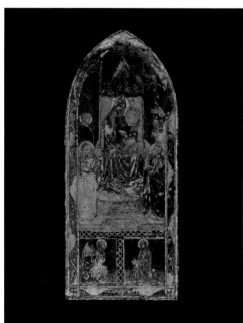

117 FIG.

The present reliquary, which is double-sided, rests upon a gilded rectangular base decorated with foliate *pastiglia* designs, glass cabochons, punching, and four *verre eglomisé* heraldic panels. This supports a gabled rectangular frame adorned with *pastiglia* and inset with glass rosettes protecting seventeen labeled relics.

One inscription dates the object to 1347. Another, along with two heraldic panels on the base, identifies the patron: Mino di Cino of the aristocratic Sienese Cinughi family. Two further heraldic panels belong to the Ospedale di Sta. Maria della Scala, Siena's foremost hospital, orphanage, and charitable institution. Mino di Cino Cinughi was the Osepedale's rector from 1340 until 1351; rectors typically commissioned gifts for the foundation emblazoned with their family's and the Ospedale's arms. The frame once enclosed a *verre eglomisé* depicting the Virgin and Child Enthroned with Saints above the Annunciation (fig., Cambridge, Fitzwilliam Museum, m.56 & a–1904). Documentary evidence records that another now-lost glass showing the Crucifixion sat back to back with this one.

Two inscriptions state that an artist named "Lucas" made this reliquary. These might refer to St. Luke, who legendarily painted the Virgin from life, thus constituting a claim for the authenticity for the object, the central image of the Virgin, and the surrounding relics. More convincing, however, is the idea that they are the "signature" of a documented artist called Lucas, brother of the accomplished Sienese goldsmith and enameler Ugolino di Vieri. Lucas seems to have been a highly versatile craftsman specialized in translating the visual idioms of luxury metalwork into other, less precious, media. Indeed, the present ensemble makes strong allusions to metalwork, in particular the *verre eglomisé*, which simulates the appearance of enamel.

Detachable from its base, the upper part could have been mounted on a pole and carried aloft in processions. Otherwise, the object likely resided upon the altar of a small chapel. The reliquary celebrates Siena's principal patron saint, the Virgin, and reiterates the Ospedale's devotion to her. The relics seem to have been chosen for their relationship to the Ospedale's activities, including the housing of pilgrims and care of the sick. For example, pieces of the True Cross are the ultimate pilgrimage relic; Sts. Juliana and Elizabeth of Hungary were healers whose relics are also included. Relics of the Holy Innocents may refer to the Ospedale's rescue of children, while several others belonging to mothers, such as Felicitas, a Roman matron martyred with her sons, evoke the foundlings' absent mothers and the Ospedale's own parental role. / vb

118
Wing of a Reliquary Diptych with the Crucifixion and Saints

Italian, ca. 1355–70
Tempera and gold leaf on panel with marble, ceramic, and *verre eglomisé* insets on a gilded wood frame;
45.6 × 21 × 2.2 cm
The Walters Art Museum, Baltimore (37.1686)
Baltimore only

PROVENANCE: Private collection, Rome [date and mode of acquisition unknown]; sale, Villa Borghese, Rome, March 17, 1893, lot 385 [Padiglione dell' Orologio a Villa Borghese, Pl. XIII]; Marquess Filippo Marignoli, Rome and Spoleto, prior to 1898 (mode of acquisition unknown); Marquess Francesco Marignoli, 1898 (mode of acquisition unknown); Don Marcello Massarenti Collection, Rome, 1899 (mode of acquisition unknown) (1900 catalogue supplement: no. 51, as Taddeo Gaddi); Henry Walters, Baltimore, 1902, by purchase; Walters Art Museum, 1931, by bequest

BIBLIOGRAPHY: Zeri 1976, 1:63–65, pls. 32, 33; Zafran 1988, 22; Preising 1995–97, 28–29, 56–57; Steen Hansen and Spicer 2005, 32–35; Travi 2007, 103

This work, probably the right wing of a diptych, brings together an unusual range of media, combining painted surfaces with inset plaques of *verre eglomisé*, as well as inlaid fragments of marble and ceramic. The Crucifixion at center and the Virgin at the top are on reverse-painted glass by an unknown artist, while the images of numerous saints around them are panel paintings by Tommaso da Modena (1325/29–before 1379). The panel at the top represents the Virgin Annunciate and would have faced an image of the Archangel Gabriel on the left wing. The image of the Crucifixion in the central panel is surrounded by encased relics identified by labels written in red. These are the wood of the True Cross and a stone from the Holy Sepulcher (top), the bones of the 11,000 Virgins and of one of the Magi (right), the bones of St. James the Apostle (bottom), the Apostle Andrew, the Evangelist Luke, and St. Peter and St. Paul (left).

The technique of *verre eglomisé* flourished in Assisi in the fourteenth century, where it was used in the mass production of reliquaries of Franciscan devotion. The Baltimore panel shows a marked Franciscan association by virtue of the presence of three friars among the saints portrayed: St. Francis, St. Anthony Abbot, and St. Anthony of Padua. The widespread use of reverse-painted glass for reliquaries at this time might be the basis for the mention of this technique in *The Craftsman's Handbook* by Cennino Cennini (ca. 1370–ca. 1440) as especially suitable for making containers of sacred matter. / cv

119
Reliquary with Virgin and Child with Saints

Lippo Vanni (active 1344–76), 1350–59
Tempera and gold leaf on wood, paper; open: 49.4 × 45.4 × 6.2 cm
The Walters Art Museum, Baltimore (37.750)

INSCRIBED: on central panel, below left saint: s[AN]c[T]A AURA (St. Aurea); on central panel below right saint: s[AN]c[TU]s IOH[N]ES BATTI[ST] (St. John the Baptist); on left wing under left saint in black paint: MAR . . . (?); on left wing under right saint in black paint: s DOMINI; s[ANCTUS] DOMINI[CUS] (St. Dominic); on left wing in upper register on scroll: SPI[RITUS SANCTUS] ET VENIET [IN TE] ET VIRTUS ALTIS[S]IMI OB[UMBRABIT TIBI], (the Holy Ghost shall come upon thee and the power of the Almighty shall overshadow thee)

PROVENANCE: Don Marcello Massarenti Collection, Rome [date of acquisition unknown], by purchase [1900 catalogue supplement: no. 49, as School of Fra Angelico]; Henry Walters, Baltimore, 1902, by purchase; Walters Art Museum, 1931, by bequest

BIBLIOGRAPHY: Baltimore 1962, 38–39, pl. 6; Zeri 1976, 44–46, pl. 22

This triptych is both a painting and a reliquary; it once contained relics in the circular holes of the central section. St. Aurea and John the Baptist flank the central image of the enthroned Virgin and Child. The Annunciation is painted on the top portion of the wings, where Gabriel holds a scroll with the words from the antiphon sung at the Feast of the Annunciation. In 1358 Lippo Vanni painted a monumental triptych for the female Dominican community of St. Aurea (now in the Church of SS. Domenico and Sisto) in Rome that featured Aurea, a Christian virgin martyred at Ostia in the third century, as the primary saint. It is possible that the owners of this triptych, whose coat of arms are visible but no longer identifiable at the feet of St. Dominic and an apostle on the left and right wings, were affiliated in some way with the community that commissioned the Roman triptych. The production of small devotional panels surrounded by relic chambers began to flourish in Siena in the second half of the fourteenth century. This phenomenon may be ascribed to the widespread circulation of relics and the desire to adapt monumental retables in smaller size for private devotion. The development of gold-ground painting techniques allowed painters to reproduce the preciousness of metalwork. In this painting, the gold is tooled and punched, while some of the decoration is in *sgraffito*. The different treatments allowed the gold background to react differently to light, creating a sense of depth and movement. Lippo Vanni was a Sienese painter much influenced by the art of the Lorenzetti brothers (Pietro and Ambrogio) and that of Simone Martini.

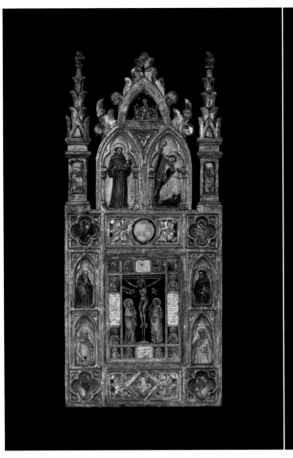

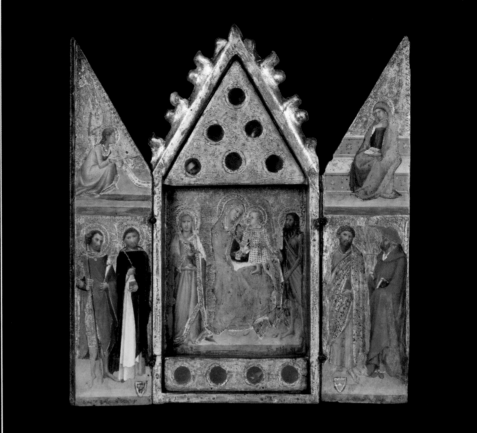

His gentle and elegant figure style was particularly well suited to this category of precious object. / MB

120
Reliquary Tabernacle with Virgin and Child

Naddo Ceccarelli (active ca. 1330–60), ca. 1350
Tempera, gold, and glass on panel; 62.1 × 43.2 × 9.4 cm
The Walters Art Museum, Baltimore (37.1159)
Baltimore only

PROVENANCE: Arnold Seligmann, Rey and Co., New York (date and mode of acquisition unknown); Henry Walters, Baltimore, 1920, by purchase; Walters Art Museum, 1931, by bequest.

BIBLIOGRAPHY: Meiss 1951, 42, no. 119; De Benedictis 1974, 140–41; Zeri 1976, 1:43–44; Wixom 1979, 128; Rowlands 1979, 122–38; Preising 1995–97, 22–24; Steen Hansen and Spicer 2005, 24–27

Throughout the Middle Ages, reliquaries were typically the special domain of the goldsmith, the artisan whose work was three-dimensional, architectural, and precious. By the fourteenth century, however, the development of gold-ground painting in Italy and the widespread circulation of relics in Europe gave rise to new categories of sacred containers.

Particularly in Siena, renowned for its goldsmiths, enamelers, and painters, a variety of novel reliquary forms emerged. The incorporation of sacred relics into panel paintings, particularly those featuring Marian imagery, responded to the devotional requirements of both private and institutional patrons. The producers of these objects relied on materials traditionally associated with panel painting, but borrowed their forms and their visual language from works in other media.

Naddo Ceccarelli, a talented follower of Simone Martini (ca. 1284–1344), was one of a handful of Sienese painters to create reliquaries that emulated the work produced by goldsmiths. Their work combined the display functions of reliquaries with the devotional imagery associated with sculpture and painting. In this object, Ceccarelli has set a delicately tooled image of the standing Virgin and Child within an armature punctuated by thirty-four clear glass relic chambers. The glimmering gold-ground painting at the core of the object constitutes one of the few surviving examples of a full-length, standing Virgin and Child in fourteenth-century painting. This particular genre of Marian iconography is more commonly found in freestanding sculpture. Standing on a faux-marble platform, Ceccarelli's Virgin recalls the placement of Marian statues above

altar tables. The presence of the rectangular relic chamber below the painted marble surface enhances this association with an altar table, which was required by canon law to contain relics. By combining these elements in his painted tabernacle, Ceccarelli presented worshipers with the miniature equivalents of the furnishings of a funerary chapel complete with statuary, altar, and relics. / CGM

121
Reliquary Triptych with the Annunciation, St. Ansanus, the Adoration of the Magi, and the Crucifixion

Triptych: Bartolo di Fredi (active 1353–1410), ca. 1370
Ivory: French, 13th century
Tempera and gold leaf on wood with gold and polychromed ivory; open: 35.5 × 46 cm
Private Collection, London (0442)

PROVENANCE: English private collection; Important Old Master Pictures, Christie's, London, 22 April 1994, lot 57; English private collection

BIBLIOGRAPHY: Freuler 1994, 506–7, no. 100; Torquat 2007

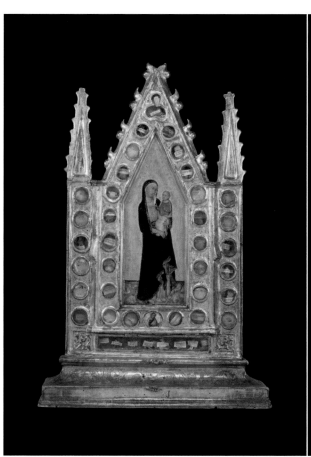

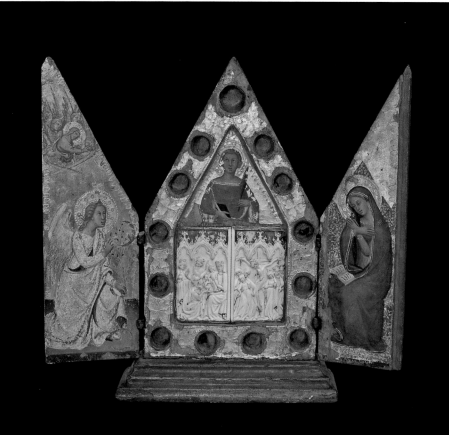

120

121

In *The Craftsman's Handbook*, Cennino Cennini described the adornment of reliquaries as "a branch of great piety." Cennini's statement clearly indicates the special status he accorded painted wooden reliquaries, which made their first appearance in Siena in the first half of the fourteenth century. Inventories of the period listed "reliquiere di legno 'lavorate a oro'" (reliquaries of wood worked with gold) among the contents of Sienese treasuries. With its reference to fashioned gold, this terminology evokes the precious surface effects achieved by painters, who used gold-ground techniques in emulation of goldsmith and enamel work.

Although related to a devotional format established by the mid-fourteenth century, this winged tabernacle uniquely incorporates an ivory diptych into its central panel. The ivory depicts the Adoration of the Magi and the Crucifixion, and was likely imported into Siena from France. The iconography of the wings, which feature the Annunciation, draws upon the visual language of Simone Martini's San Ansano altarpiece (ca. 1333), created for Siena's Duomo. Scholars have identified the male saint in the pinnacle of the central panel as St. Ansanus, one of the city's primary civic saints.

The thirteen compartments around the central panel once contained relics sealed behind glass disks.

While it is possible that the relics related to the events represented in the triptych's decorative program, it was more likely that they were secondary relics associated with the Holy Land, or possibly with St. Ansanus. The program takes its point of departure from the wings, which introduce the theme of spirit's entry into matter. Combined with episodes from the beginning and the end of Christ's earthly life, the relics extended the theme of the Incarnation into the core of the object. Moreover, the move from painted to sculpted decoration reinforced the shift from spiritual to physical presence. Charged with the power of its sacred contents, this object was likely housed within a private chapel. / CGM

122
Reliquary with the Man of Sorrows

Bohemian, 1347–49
Silver gilt, enamel (champlevé), semiprecious stones;
29.5 × 21.3 × 12.7 cm
The Walters Art Museum, Baltimore (57.700)

INSCRIBED: HANC MONSTANCIAM CUM SPINA CHORONE DOMINI DNS IHOANNIS OLOMUCZENSIS EPICOPUS PREPARARI FECIT (John, the bishop of Olmütz, commissioned this monstrance with the thorn of the crown of Christ)

PROVENANCE: Jacques Seligmann, Paris; Henry Walters, Baltimore, 1903, by purchase; Walters Art Museum, 1931, by bequest

BIBLIOGRAPHY: Verdier 1973a; Fritz 1982, 223; New York 2005, 140–41

Contact relics of Christ, such as pieces of his shroud or the wood of the True Cross, were among the most precious of medieval possessions. Many relics in this important category, including the Crown of Thorns, were brought to Paris from Constantinople by Louis IX in the thirteenth century. Thorns from the Crown began to circulate in Europe thereafter as important gifts. According to an inscription on the base, this reliquary was commissioned by John Volek (1334–51), the bishop of Olmütz in Moravia to house a Holy Thorn. Probably he received the relic as part of the estate of his half-sister, Elisabeth Přemysl, mother of Emperor Charles IV. The coats of arms of Moravia, Bohemia, and Olmütz are on the base, indicating that the reliquary was probably intended as a gift to Charles IV. As Charles reigned over both Bohemia and Moravia only from 1347 to 1349, the piece must date to this time.

Charles IV was an avid collector of relics (see Klein herein, p. 61), and he owned two more thorns from Christ's Crown gifted to him by Charles, the dauphin of France. The image of the Man of Sorrows is a distillation of the events of Christ's Passion. Christ contemplates with sorrow the instruments of his suffering: the Cross and hammer, whips, nails, the column of the Flagellation, and the dice thrown by the soldiers for his garments. The gabled container held by an angel once housed the Thorn, while the hinged cross and column probably held pieces of the relic of the True Cross and the column against which Christ was whipped. The theatrical staging of the composition contributes to the devotional aspect of this reliquary, which was intended to help the viewer visualize and experience the Passion of Christ. The Walters' Man of Sorrows is one of the few surviving pieces that attest to the sophistication of Bohemian goldsmiths working for the emperor. / MB

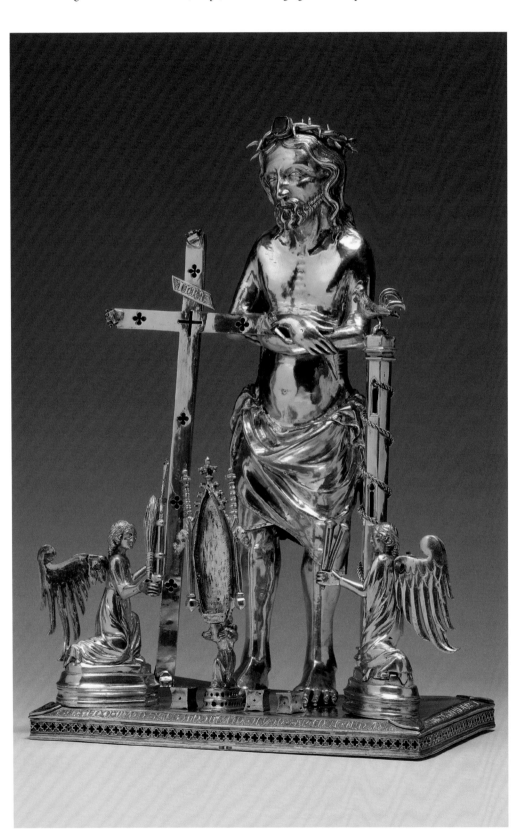

123
Reliquary Statuette of St. George

German, ca. 1480–90
Silver, partially gilded; height 30.5 cm
Kunstgewerbemuseum, Staatliche Museen zu Berlin (1878.618)
Cleveland only

PROVENANCE: Brotherhood of St. George, Elbing (eastern Prussia; now Elbag, Poland) since at least 1564 until 1652; Church of the St. George Hospital, Elbing; Church of the Holy Magi, Elbing; C.G. Wulff (superintendent of the latter church), 1773, by purchase; [unrecorded owners]; Kaminiski, 1876 (mode of acquisition unknown); Albert Katz, Gorlitz (date and mode of acquisition unknown); Staten Museen zu Berlin, by gift, 1878

BIBLIOGRAPHY: Pieper 1959; Lüdke 1983, 2:316–17, no. 12; Amsterdam 2000, 127, 131, 133

George was an extremely popular saint across Europe and the Mediterranean region throughout the Middle Ages, and from at least the eleventh century he was renowned in legend as a dragon slayer. The Berlin reliquary is remarkable for its fanciful details and theatrical composition. The dragon, accompanied by smaller dragons and other beasts, crouches on a mound enclosed by a miniature fence. The saint has broken his lance in the dragon's neck, and the dragon bites at George's shield as the saint raises his sword for the final blow. This refined and courtly work of art incorporates a small window through which the relics inside could be viewed, but this seems almost secondary to the elegantly portrayed action of the figural group. The design for this statuette has been attributed to the sculptor Bernt Notke (ca. 1435–1508/9), but this attribution remains highly speculative. The work is remarkably similar to another statuette of St. George now in Hamburg (Museum für Kunst und Gewerbe, 1950.31), and both pieces were likely based on an earlier engraving attributed to Israhel van Meckenem (ca. 1445–1503). Several chivalric orders and brotherhoods were dedicated to St. George in the fifteenth century, and it is possible that this reliquary was made for one of these groups, or perhaps commissioned by an individual member. / KBG

122

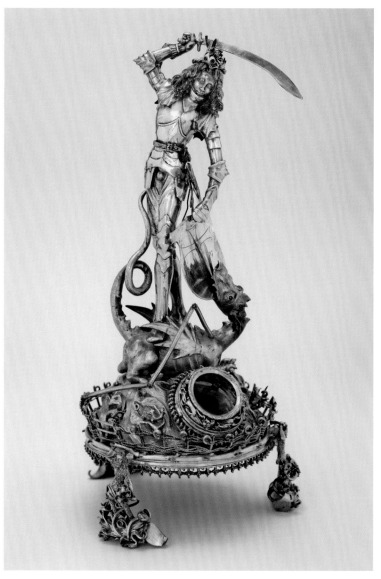

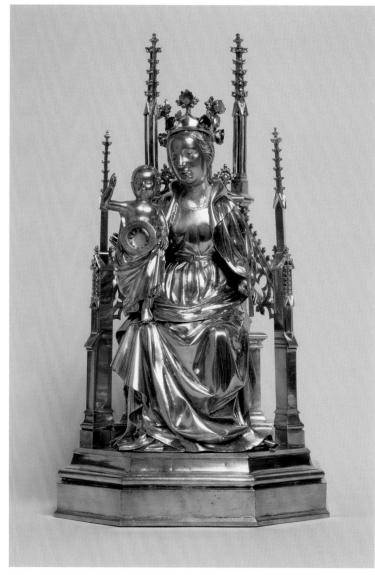

123

124

124
Virgin with the Christ Child

French (Paris), 1407
Silver gilt, colored glass; 33.4 × 18.9 × 17.2 cm
Musée de Cluny–musée national du Moyen Âge, Paris (Cl. 3307)
London only

INSCRIBED: around the relic chamber: DE UMBILICO DOMINI JESU CHRISTI (from the umbilicus of Lord Jesus Christ)

PROVENANCE: Treasury of Notre-Dame-en-Vaux (Châlons-en-Champagne); François Clément, merchant and former church warden of Notre-Dame-en-Vaux, 1728, purchased from the vestry of Notre-Dame-en-Vaux; Prince Petr Soltykoff, Paris (sale, 8 April–1 May 1861, no. 171); acquired by the Musée de Cluny at the Soltykoff sale

BIBLIOGRAPHY: Du Sommerard 1838–46, 5:339; Labarte 1864–66, 2:339; Didron 1869, 414; Falke 1908, 872; Paris 1947, no. 428; Müller and Steingräber 1954, 43; Müller 1966, 199; Lüdke 1983, no. 163; Taburet-Delahaye 1989, 140–45; Munich 1995, no. 11; Amsterdam 2000, 38–40; Paris 2004, no. 207

This delicate statuette of the Virgin with the Christ Child formerly contained a relic of the Holy Umbilicus, or umbilical cord, placed in a small chamber on Christ's body. (The chamber that contains the inscription is modern, as is most of the glass.) This reliquary is particularly rare given that only one fragment of the Holy Umbilicus is known to have been preserved in France. It reveals an unusual characteristic of medieval piety, which venerated the physical remains of Christ (the umbilical cord, the foreskin) and the Virgin (her milk) although they themselves ascended to Heaven. The relic, purportedly given by the Byzantine emperor to Charlemagne, and by Charlemagne to the pope, is said to have been given to the church of Châlons (Champagne) by Pope Clement V (r. 1305–14) at the beginning of the fourteenth century. First kept in a simple silver box, it was placed in this reliquary statuette by Charles de Poitiers, bishop of Châlons, as attested by the transcript of the proceedings dated 8 December

1407. This document also specifies that the reliquary was commissioned by the executors of Thibaut des Abbés, a citizen of Châlons, probably for the chapel dedicated to Notre-Dame-du-Puits that they founded in the Church of Notre-Dame-en-Vaux in Châlons. An inventory (drawn up in 1603) of the church's treasury mentions "an image of gilded silver called the Holy Umbilicus of Our Savior" ("une ymage d'argent doré appelée le saint nombril de Nostre-Seigneur"). The relic itself was destroyed by the bishop of Châlons at the beginning of the eighteenth century. The Virgin, wearing a crown and seated on an architectural throne with a lily in her left hand, holds the Child upright, like a Christ Victorious, on her right knee. The refinement of this reliquary statuette, whose modeling is exceptionally fine (note in particular the elegant fluidity of the drapery and the Virgin's gentle expression), calls to mind Parisian artistic circles of around 1400. / CD

BEYOND THE MIDDLE AGES

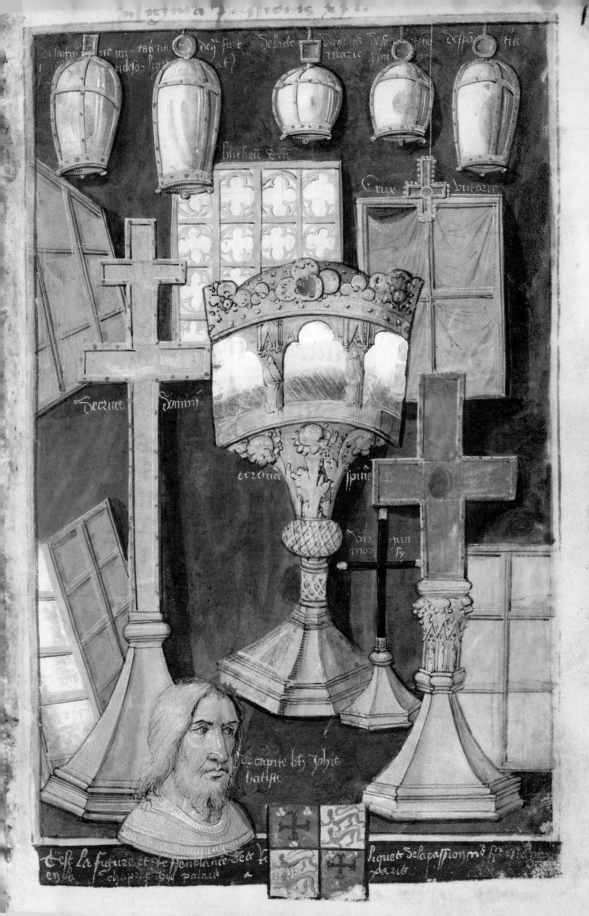

The Afterlife of the Reliquary

ALEXANDER NAGEL

The Relic as *Vanitas*

The early sixteenth-century Dutch reformer Erasmus found the cult of relics highly distasteful, but being a naturally moderate man he counseled against orgies of destruction. He wanted Christians to see the piece of bone and the fragment of clothing not as magical talismans but rather as remnants of a life, prompts to remember the exemplary virtues of a model Christian. For Erasmus, the most important relics were the writings left behind by the Evangelists and apostles.[1] A physical artifact was, by contrast, little more than a *memento mori*, a form of *vanitas*. Indeed, *any* mortal remains, not necessarily those of a saint, could serve as a reminder that the life of the body is brief and as a powerful incentive to concentrate on concerns of the spirit while we are alive. One need only think of the anonymous skull contemplated by St. Jerome, Erasmus's hero, in so many paintings of the saint.

Such a conceptual reorientation was one way to allay the concerns about deception that always surrounded the cult of relics.[2] John Calvin, less patient than Erasmus, put the matter bluntly: "How do we know that we are venerating the bone of a saint and not the bone of some thief, or of an ass, or of a dog, or of a horse? How do we know that we are venerating the ring and the comb of the Virgin Mary rather than the baubles of some harlot?"[3] To worship a mere ordinary thing was to succumb to the worst idolatrous delusion. Calvin saw the reliquary, which dressed the relic up in jewels and gold, often shielding it from view, as a device designed precisely

to suppress these questions: dazzled by these ritual objects, Calvin says, the devotees do not consider what is truly at the basis of the cult and even close their eyes in the presence of the reliquary "out of superstition," not daring to gaze upon what is there. Apparently a festival for the eyes, the cult of relics, all elaborate housings and pompous ritual, in fact imposes and promotes blind patterns of behavior.[4]

Catholic theologians countered that the reliquary was a form of protection—protection against mishandling and theft of the relics that it contained but also protection against misidentification. But now, in the face of the Protestant challenge, Catholic authorities were prolific in laying out guidelines. Carlo Borromeo, the prominent late sixteenth-century bishop of Milan, gave some of the most thorough instructions on how relics should be securely labeled: an engraved or parchment inscription should document the names and bodies of the saints, the date when they were deposited, and the places from which they had been translated. Relics should be hermetically sealed in reliquaries and kept safe from tampering.[5] These affirmations are in fact the corollary of Calvin's critique. The relic, indistinguishable from ordinary detritus, cannot speak for itself, and thus requires the reliquary, which is really a label expanded into a more elaborate physical form. The reliquary provides authentication and thus a guarantee that one is not mistakenly venerating a thief, or a prostitute.

Both the Reformist critic and the Counter-Reformation apologist were clear-eyed about the interdependence of the relic and the reliquary. If the compound of sacred substance and precious container are prised apart,

as happened with increasing frequency under the impact of the Reformation, each element undergoes a fundamental change. Unprotected, the relic became indistinct matter; emptied, the reliquary became a work of human art to be appreciated on its own or repurposed as material of some monetary value. In 1545, Heinrich von Pflummern, an unreformed and unhappy clergyman of the reformed city of Biberach, tallied the destruction wrought by the reformers: church funds appropriated by the city amounted to 49,600 pounds, the objects appropriated for secular use equaled 5,915 pounds, and the objects destroyed came to 7,275 pounds. Grand total: 62,790 pounds.[6]

The distribution is interesting. Almost as many objects were saved and repurposed as were destroyed. Without further information it is impossible to know what protocols governed the triage, but it is likely that the objects with inherent material value, those composed of precious metals and gems, were slated for preservation, while paintings and sculptures not in precious metal were discarded or destroyed. Often precious metal reliquaries were simply melted down and their jewels pilfered.[7] When works of religious painting or sculpture were salvaged, they were recontextualized and thus assigned a new function as cabinet or gallery pieces (see cat. no. 132).[8]

When were the reliquaries that are now museum pieces emptied of their contents and reclassified as works of art? How many were saved in this way by the reformers of the sixteenth century?[9] Certainly the great majority that we now have were the ones that were kept safe in Catholic hands through the storm of the Reformation and entered museums only later, when Catholic foundations were suppressed in the period around 1800. Museological commemoration was thus layered over the cult of relics, sometimes even on the very sites of religious foundations. During the French invasion of Italy, the Venetian priest Guglielmo Wambel scrambled to save the sacred objects in Venice, amassing a collection of close to ten thousand items, including thousands of reliquaries, which shortly after his death were installed in a newly built rotunda attached to the Church of San Tomà.[10] Although still in a cult setting, this new construction was just as importantly a proto-museum of religious art. In Paris, the connoisseur Alexandre du Sommerard took over the late-Gothic townhouse of the abbots of Cluny in 1832 and turned it into a historical museum, known as the Musée de Cluny after it became the responsibility of the French state in 1843. Classes of objects were arrayed in period-specific ensembles: the salle François I contained Renaissance furniture; the "chapel" contained liturgical books and reliquaries of various kinds (cat. nos. 75, 79, 124, and 137).[11]

Relic and Reliquary

Reformation and Enlightenment iconoclasm certainly exerted acute pressure, but fairly radical shifts in the relationship between relic and reliquary were already part of the dynamic of the cult of relics. A relic is, in principle, a meaningful object characterized by its irreplaceability. As we have seen, it was not acceptable to replace a saint's bone with a pig's bone, or to replace a saint's bone with the bone of an ordinary, non-saintly mortal. An image or any work of human art was, by contrast, eminently replaceable. Even the most revered images (indeed, those in particular) were copied in different media, propagating their power through replication.[12] The relic thus marks a limit point in the system of signs used in medieval religious culture. It was defined as the unsubstitutable sign, a sign whose physical relationship to its origin was a necessary part of its meaning. Reliquaries, on the other hand, were secondary fabrications. Their *raison d'être* was the relic.

And yet this also meant that reliquaries often shared in the aura of the relic. Although often made centuries after the time of the reputed relic they contained, reliquaries were commonly assumed to be of more ancient date, especially when the packages arrived from exotic lands. More than one True Cross relic from Constantinople turned up in Italy in the thirteenth and fourteenth centuries already encased in their gold settings. It was only logical to imagine that these mountings were contemporaneous with the fourth-century emperor Constantine, the first Christian emperor; Constantine's mother, Helena, had reputedly found the True Cross, after all. In 1359, the Ospedale Sta. Maria della Scala purchased a True Cross relic contained in a small gold reliquary executed in the thirteenth or fourteenth century in Constantinople. Despite its relatively recent manufacture, a 1359 document in the Ospedale's archives describes the reliquary and not merely the relic as "anticam" and as having belonged to Constantine. In the Louvre, a reliquary of the True Cross of Byzantine provenance is held up by two angels of French manufacture: the Greek reliquary is handled like a relic in its own right; it has become fused with the relic and partakes in its venerability.[14]

The display of relics typically assumed a nested structure: reliquaries were kept inside larger housings, and these were placed in structures that functioned both as buildings and as macro-reliquaries. The governing model for these nested encasings is the Jewish Ark of the Covenant, a box for relics eventually enshrined in the Holy of Holies of the Jewish Temple (Exodus 25).[15] When King Louis IX (r. 1226–70) assembled signal relics from Constantinople in the thirteenth century, he put them in the Grande Châsse—a container in turn housed in the great oversized reliquary that is the Sainte-Chapelle in Paris. This embedded arrangement was itself a sort of reconstruction of the Pharos Chapel, an architectural reliquary that had housed these relics (and reliquaries) in the imperial palace in Constantinople.[16] Such framings are the pre-condition for depictions of the Grande Châsse, such as a miniature from the Morgan Library (cat. no. 138), which offers us a view of the assembly of reliquaries inside the Grande Châsse, almost as if the limits of the picture corresponded to the limits of the container. The Sancta Sanctorum in Rome, as the name itself suggests, also had a nested structure. It began as a Carolingian relic-chest, containing, among other things, a box of stones from the Holy Land (cat. no. 13 and fig. 74). The collection was then housed in the

macro-reliquary of Nicholas III's thirteenth-century chapel near the Basilica of St. John Lateran.[17]

The Morgan miniature and others like it made the contents of the Grande Châsse available "virtually" to a wider public, but they are really portraits of the reliquaries rather than documentation of the relics themselves. If a reliquary on its own directs our attention to its contents, in embedded structures such as these, the emphasis is shifted one level up, with the reliquaries now becoming the object of focus. Varied in shape and each with its own personality, the reliquaries become protagonists in their own right. That attention after the sixteenth century drifted from the relic to the reliquary was not so much a symptom of secularization as an extension of an established pattern of installation and display, where containers become displays in larger containers.

There were other good reasons why it was natural for reliquaries to acquire something like the status of relics. Christian relics were never strictly separated from curiosities of various kinds, including impressive works of human art, and features of out-and-out tourism were never absent from the cult of relics.[18] The renowned treasury of Saint-Denis in France contained the relics of Christian saints, but also an array of precious liturgical objects, coronation regalia, and insignia of the kings of France, as well as various other secular marvels, such as the horn of Roland, a griffin's claw (see cat. no. 132), and the abbey's famous unicorn horn.[19] In Erasmus's dialogue "A Pilgrimage for Religion's Sake," written in the early 1520s, one of the interlocutors suggests that his friend is going on pilgrimage simply "out of curiosity, I dare say." But the friend insists that he is going "on the contrary, out of devotion."[20] This alternative, out of curiosity/out of devotion, already internal to the relic cult, was to structure larger patterns of collecting objects in the centuries following the Reformation.[21] The line between the potent relic, the miraculous natural object, and the wondrous artifact was never a strict one.

The Gualdo collection, assembled in Venice in the sixteenth and seventeenth centuries, contained an impressive collection of relics, including a piece of the True Cross, saints' body parts, fragments of the tombs of Lazarus, Jesus, and the Virgin Mary, as well as stones from Mount Sinai and from the spring of Cedron—a collection of stones presumably like those in the box from the Sancta Sanctorum. These mingled with "profane" relics such as the turtle from the Vendramin collection and the claw of a great beast given by the king of Poland, and also with examples of ancient epigraphy, paintings, and antiquities.[22] Sometimes the reliquary itself consisted of natural marvels, such as ostrich eggs or nautilus shells, which were duly adorned with settings in silver and gold.[23] More than simple containers for the sacred, reliquaries were multiple structures worthy of attention as *curiosa* in their own right.

The culture of curiosity that arose in the sixteenth and seventeenth centuries was, therefore, not merely the successor to the cult of relics but an adapted version of it.[24] Certain collections played a key transitional role, such as the famous and vast assembly of relics and curiosities amassed in

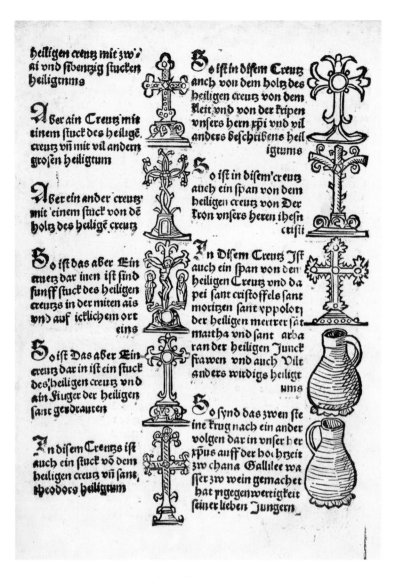

Fig. 69. Bamberg Relic-book, 1493. Library of Congress, Washington, DC, Rare Book and Special Collections Division (Incun. 1498.H46 Rosenwald Coll. no. 162), fol. 11v

Wittenberg by the Elector Frederick of Saxony (1463–1525), who became the protector of Martin Luther at the end of his life.[25] The catalogues describing and illustrating these objects were called *Heiltumsbücher*. Examples, such as the *Hallesches Heiltumsbuch* describing the relic collection of Frederick's greatest competitor, Cardinal Albrecht of Brandenburg, or the *Heiltumsbücher* from Bamberg and Nuremberg (fig. 69 and cat. nos. 125, 126), lavish attention on the features of the reliquary itself, its materials, and its workmanship. Once again, the reliquary seems as much the object of attention as the relic, even before the Reformation forced the issue.

"Reliques," Antiques, and Works of Art

"Now one reason I tender so little Devotion unto Reliques is, I think, the slender and doubtful respect I have always held unto Antiquities."[26] This offhand critique of relics offered by the English doctor and amateur

metaphysician Thomas Browne around 1635 comes from a new seventeenth-century position. Added to the now-traditional Reformist view of relics is a new impatience with the antiquarian enthusiasms that had grown up in the preceding century. From Browne's vantage, it was clear that relic hounds and antiquarians were really members of the same species, preoccupied with material things and overly attached to a literalist conception of history.

As relics were demoted, works of art were raised to relic-status. In the thirteenth, fourteenth, and fifteenth centuries, in part due to the importation of precious images with hoary Eastern provenances, it became increasingly common to treat works of sacred art with the same reverence as relics. That is, they were valued as the result of a specific production history, and their value was bound up with their status as originals. Icons reputed to have been made by the hand of St. Luke were nothing less than contact relics of the Evangelist.[27] The Mandylion, the towel on which Christ reputedly impressed his own features (see cat no. 113), was a contact relic of Christ, free even of the agency of an artist. The Man of Sorrows mosaic in the Church of Sta. Croce in Gerusalemme (cat. no. 116) was presented as the very work of art that was commissioned by Gregory the Great in the sixth century in commemoration of the miraculous appearance of Christ to him while he said Mass. Nonetheless, the arrival of works with such reputations did not prevent them from being copied hundreds of times over. The idea that powerful originals were somehow effective through their copies never died away.[28]

Yet the idea of the relic-image established by St. Luke icons and Mandylion/Veronica images took hold, becoming nothing less than an alternative model for thinking about works of art of all kinds, both antiquities and modern productions. Alongside the substitutable image now appeared the relic-image, which was not to be restored or repainted.[29] After the fourteenth century especially, the norm of overpainting or simply replacing older works was countered by a new commitment to preserving the work of art in a condition as close as possible to that of the time of its production. With increasing frequency, old works were preserved as they were, despite the fact that they violated current aesthetic norms; the modern additions were confined to new frameworks that were built up around the artifact-image.[30] The notion of conservation espoused by every modern museum is an adapted version of the novel approaches to conservation developed in the later Middle Ages, and in particular for images that made claim to being relics. Museum pictures in their frames are not only the modern descendants of religious cult images; they are, more precisely, one consequence of the momentous application of a relic status to images, a status that became widespread in the early modern period.

This was no simple application, for often enough, as we have seen, relics became reliquaries and reliquaries acquired the status of relics. Evidence is mounting that many paintings and sculptures of the thirteenth and fourteenth centuries also served as containers for relics. Often this function is patently visible, as in the case of the panel by Naddo Ceccarelli (active

Fig. 70. A lock of Albrecht Dürer's hair (1528) and "reliquary" box (1871). Akademie der bildenden Künste, Vienna

ca. 1347) in the Walters Art Museum (cat no. 120), where the central image is surrounded by relic cavities. But often relics were embedded in images in an unadvertised way and have been discovered only much later, as in the case of the Virgin by Coppo di Marcovaldo (ca. 1220–after 1276) in Sta. Maria Maggiore in Florence.[31] In cases such as this, preserving the panel intact was a continuation and not a transposition of values associated with relics and reliquaries.

The new forms of preservation developed for old artifacts and venerable icons also came to be applied to the productions of living artists. Pietro Aretino expressed a fairly widespread sensibility among art lovers of his time when, writing to Michelangelo in 1544, he asked for "a relic from among those sheets of paper that are least important to you;" indeed, he would value even "two chalk marks on a piece of paper" more highly than the most precious cups and necklaces he has received from princes."[32] Aretino also was for some time in possession of Parmigianino's *Self-Portrait in a Convex Mirror*, now in Vienna, which he kept in his home, according to Vasari, "as if it were a relic."[33] Only infrequently did Vasari use the word "reliquia" in this way to refer to a work of art; when he did, it was in cases involving extraordinary works kept by extraordinary people. When given a small painting of Christ praying in the garden by Raphael, the Venetian noblemen and Camaldolese monks Paolo Giustinian and Pietro Querini, kept it, according to Vasari, "like a relic and a most rare thing."[34] In 1515, Albrecht

Dürer received from Raphael a drawing, on which he, Dürer, wrote that it had been sent to him by Raphael as evidence of his hand ("sein Hand zw weisen").[35]

From collecting examples of the artist's work (now understood as an artistic *corpus*) it was a short step to collecting nonartistic traces or samples of the artist's body, in exactly the fashion formerly applied to saints. We learn from a sixteenth-century annotation of Vasari's *Lives* that the hands of the Florentine monk-painter Lorenzo Monaco were kept "as relics" by the members of his religious order.[36] A lock of Dürer's hair, reportedly snipped from the artist's head by his pupil Hans Baldung, survives to this day in Vienna (fig. 70).[37] Secular reliquaries had become an established category by the eighteenth century. A fifteenth-century West African ivory salt cellar, the sort of object kept in European curiosity cabinets in the sixteenth and seventeenth centuries (Dürer, in fact, owned more than one, believing them to be of Indian origin), was converted into a reliquary of the poet Jean-Baptiste Rousseau after his death in 1741; upended, its concave base was filled with bits of the skull and its body inscribed with the poet's name.[38] Dominique Vivant Denon, director of French museums under Napoleon, made a reliquary that included the beard of Henry IV, a tooth of Voltaire's, and a lock of Napoleon's hair.[39] The entire mode of the secular reliquary came in for commentary in Alexander Pope's *Rape of the Lock*, in which the fateful lock of hair, around which much drama and scandal arises, fails ever to make an appearance. In a hostile response to the poem by one Esdras Barnivelt (in fact Pope himself), a "key" is provided to the *Lock*, imputing to the poem a "Papist" subtext and pointing out the various allusions to "Romish worship" and to the invocation of saints throughout the poem. A parody of overinterpretation, *A Key to the Lock* makes a point of the obvious parallel between this fetishized (and never seen) lady's lock and the prehistory of Christian relic worship.

Fig. 71. Piero Manzoni (Italian, 1933–63), *Merda d'artista*, 1961

If the Dürer reliquary stands at the beginning of a history of sanctifying artists, Piero Manzoni's series *Merda d'artista*, sealed cans of the artist's feces now kept in many major museum collections around the world, is the highly successful ironic commentary from the other end, as it were, of that history (fig. 71). The work makes the point emphatically that the cult of the artist is a version of the saint's cult, which involved the veneration of even the most abject remains of the holy man. Like those of the saints, Manzoni's product relics are housed in hermetically sealed containers that carry labels identifying and guaranteeing the authenticity, even the date of production, of the contents. The protocols of relic worship are restaged, but now under the management of the artist.

Presentations of the Ordinary and the Abject

Manzoni's provocations return us to a basic feature of the relic cult that had been lost during the early modern afterlife of the reliquary. Curiosities, natural marvels, antiquities, works of art—all of these in some sense substituted for the relic in the new world of the curiosity cabinets and proto-museums, attracting similar kinds of awed attention. But these were all notable items: samples of precious materials, works finely wrought, and, in the case of natural specimens, instructive anomalies or singularities or samples of things rarely seen in parts of the world familiar to Europeans. This interest in the unusual, the curious, and the remarkable presents a fundamental difference from the attitude at work in the cult of relics. The saint's relic acquires its value not because it is intrinsically precious, or interesting for its physical qualities, or because it is a rare example of its kind, or because it belongs to no kind yet known. Relics, whether pieces of bodies or the results of human manufacture, such as clothing, are typically unremarkable in and of themselves. One man's bones are very much like another's, and one monk's habit is in principle indistinguishable from another's. What makes the relic unique and valuable is its provenance: one keeps it and reveres it because it is the index or sample of a specific history, of an individual's life. This is the basis of its efficacy, real or perceived.

The stones in the sixth-century Palestine box (fig. 74 and cat. no. 13), for example, were not collected and wondered at for their beauty or curiosity, but because they were samples of very important places, places that had become the object of a topographical cult after the building of architectural commemorations on those sites by Constantine in the fourth century.[40] It is possible that their unremarkable appearance served as tacit confirmation of the unimpeachable authenticity of their provenance. The Veronese nobleman Ludovico Moscardo (1611–81), dedicated a chapter of a description of his collection to the stones brought from various places in the Holy Land, carefully correlating the traditional designation with exact topographical location. There is the stone from the place of the Virgin's sepulcher, "which is outside the city of Jerusalem in the valley of Josaphat;" there is the stone from the place where St. Stephen was

Fig. 72. Kurt Schwitters (German, 1887–1948), Untitled (*Inlaid wooden box, SK or P for Sophie and Paul Erich Küppers*), 1921, fabricated by Albert Schulze. Wood inlaid with ivory and mother of pearl, Museum August Kestner, Hannover (L 1996,001)

stoned, which is "just outside of the gate of the city near the river Cedron;" there is the stone from Calvary, "which is a rocky mount of middling height . . . , and close to the city;" and so on.[41] In a separate part of the book he treated the other minerals in his collection, which were intrinsically valuable either for their rarity, or because of their magical/medicinal virtues, or because of certain remarkable properties such as their seeming capacity to carry depictions of trees, houses, and landscapes, instances of nature parodying human art.[42]

Something closer to the principles of the relic cult appeared toward the end of the eighteenth century, when works of medieval art were collected because they were deemed worthy documents of their time, and despite the

fact that they were acknowledged to be of inferior quality. The eighteenth-century Friulian numismatist Giangiuseppe Liruti collected coins from the Lombard period that he acknowledged to be of extreme "grossness and barbarity," yet he saw in them distinct historical value.[43]

But it was with the stagings of the found object proposed throughout twentieth-century art that the logic of the relic returned with real force. Duchamp's readymades were a revival of the relic idea and a logical extension of his effort to set himself "as far as possible from 'pleasing' and 'attractive' physical paintings"—that is, from the art of the bourgeois era. Before this period, he said, art "had been literary or religious: it had all been at the service of the mind."[44] In the case of the readymade, as in that

of the relic, an ordinary object, indistinguishable from many others like it, is consecrated as something extraordinary. Of course, the system of consecration was now different, no longer provided by religious ritual but instead by a culture of art. If the medieval relic drew its significance from its link to sanctity and from its provenance, as argued above, both categories established by the Church, Duchamp used the art system as a readily available (in fact readymade) consecrating mechanism. The process of consecration is thus accelerated: the object does not live through a history linked to a saint, but is arbitrarily designated, as it were, retroactively, by the artist and consecrated by the art gallery. Of course, this willful manipulation of a prevailing system carried different consequences; here the primary effect is to prompt reflection on the mechanisms of consecration themselves. This kind of critical reflection was not, typically, what reliquaries were designed to promote. But they were subjected to this kind of critique during periods of iconoclasm. Thus, if there is a parallel to Duchamp's gesture it is not the medieval relic cult as a whole but those moments when its modalities came under scrutiny. The Reformation dismantling of the relic cult is the mirror image of the Duchampian intervention.

A more redemptive approach to the found object was proposed by Kurt Schwitters, who abandoned painting in 1919 and thereafter (with the exception of a return to landscape painting at the end of his life) worked with found materials, photographs, and typography. "What the material signified before its use in the work of art is a matter of indifference," he said, "so long as it is properly evaluated and given meaning in the work of art. And so I began to construct pictures out of materials I happened to have at hand, such as streetcar tickets, cloakroom checks, bits of wood, wire, twine, bent wheels, tissue paper, tin cans, chips of glass, etc." But in their reconfiguration in the work of art they are transformed, losing their individual character and even becoming dematerialized (entmaterialisiert).[45] As novel as Schwitters's methods were, he was acutely aware of the relic cult as a primary model for his practice. Schwitters collaborated with a Hannover craftsman to produce a series of inlaid wood boxes based on his collages. Various woods with different colors and grains approximate the pasted scraps of paper. Made to safeguard souvenirs and mementos, the boxes bear a similarity in shape to reliquary chasses—now empty and dedicated to significant people in his life. The initials inlaid into the box illustrated here (fig. 72) are those of Paul Erich Küppers, president of a progressive Hannover art association, and his wife, Sophie. After Paul's death in 1922, Sophie married the artist El Lissitzky and moved to his native Russia, where she eventually was imprisoned in a gulag, carrying with her the treasured box filled with mementos.[46]

The process of installing and consecrating relics was a guiding principle of the work that became Schwitters's primary preoccupation in the 1920s and early 1930s, and in various iterations throughout his life: the Kathedrale des erotischen Elends (Cathedral of Erotic Misery) or what he later called the Merzbau. The work began with a three-dimensional collage and then

grew into an architectural web of grottoes, shrines, treasures, commemorations, reliquaries, and so on. Here is part of Schwitters's 1931 description of the Merzbau:

> There is the Nibelungen hoard with its gleaming treasure; the Kyffhäuser mountain range with the stone table; the Goethe grotto with one of Goethe's legs as a relic with the many pencils worn to their stubs by poetry; . . . the sadistic murder cavern with the sorely mutilated body of a pitiful young girl stained with tomatoes and many Christmas gifts; the Ruhr region with genuine anthracite and genuine coke; the art-exhibition with paintings and sculptures by Michelangelo and myself, the only visitor to which is a dog with a bride's train[47]

The display of found materials in reliquary-like boxes is a powerful strain in twentieth-century art. One need only think of Joseph Cornell's and Lucas Samaras's boxes, Robert Rauschenberg's early Feticci and Scatole Personali, Paul Thek's Technological reliquaries, Daniel Spoerri's Trap Paintings, and Joseph Beuys's and Jeff Koons's vitrines, to name a few instances. To conclude, I will concentrate on one case.

Robert Smithson and the Logic of the Medieval Reliquary

On 14 June 1968, Robert Smithson, together with his wife Nancy Holt and his friend Michael Heizer, took a trip to Franklin, New Jersey, to collect mineral deposits and bring them back to New York City, where Smithson would display them in bins in the now-famous Earthworks show at the Dwan Gallery in October 1968.[48] The installation (now reinstalled in the Chicago Museum of Contemporary Art) involves bins occupying the space of the gallery and, on the walls, visual documentation of the site in the form of aerial photographs (fig. 73). Smithson referred to this type of installation as a Non-site. In other "Non-sites" Smithson exhibited maps pinpointing the exact locations from which the minerals were drawn.

"If one visits the site," Smithson wrote, "he will see nothing resembling a 'pure object.'"[49] It is matter that has been scattered, as he puts it, in heaps, lava flows, ash pits, etc. by unknown agents. The delimited Non-site, putting the samples into bins, brings the entropic site into artificial focus, and yet neither one stands independent of the other: the Non-site is determined but displaced, whereas the so called real site is undifferentiated but now designated and determined by the portion of earth that it has lost to the Non-site. As Smithson put it, in an unpublished note from 1968, "both sides are present and absent at the same time."[50]

The Franklin site is still a magnet for geology enthusiasts because of its exceptionally rich array of ore deposits. In his 1968 notes, Smithson took great delight in describing the enthusiasms and paraphernalia of this

Fig. 73. Robert Smithson (American, 1938–73), *A Non-Site, Franklin, New Jersey*. Museum of Contemporary Art, Chicago. Photo courtesy James Cohan Gallery, New York / Art © Estate of Robert Smithson/Licensed by VAGA, New York

world of rock hounds. He was not the only one carting away large quantities of material from the site for display elsewhere; as Smithson mirthfully noted, at the end of the day "the caretaker said he had seen the springs break before on other cars" loaded with rocks.[51]

In fact, taking rocks away as souvenirs and samples of a place has been going on for a long time, as we have seen. The Palestine box discussed above was assembled in the sixth century (fig. 74). Measuring 28 by 18 centimeters, it contains rocks and some splinters of wood. These are materials from different locations within the general region of Palestine. Rather than texts on the wall in the mode of Smithson, these stones and the wood bear inscriptions on their surfaces. Some stones have fallen out, leaving their impress in the plaster holding the assemblage together. The Greek inscriptions tell us that the piece of wood comes from Bethlehem, that the rock just above it comes from Mount of Olives, that the rock in the center of the box comes from the place of the Resurrection (the Holy Sepulcher),

and that the one just underneath the piece of wood comes from Zion, which may mean Jerusalem as a whole but probably refers to the citadel of Mount Zion, where, among other things, the room of the Last Supper is located.

Rather than suggest that Smithson's work was influenced or informed by the tradition of the topographical reliquary, this comparison instead challenges us to understand one in terms of the other. The logic of the pilgrim's box corresponds fairly precisely to the logic of the Smithson Non-site, and Smithson's writings on the Non-sites are helpful in coming to terms with the reliquary. The Palestine box collects stone samples from different, clearly designated locations, assembled here and displayed at a distance from their original site. The box lid carries paintings that are more famous than the contents of the box, since art historians have traditionally given more importance to paintings than to rocks. From a "Smithsonian" perspective, however, it is not the paintings alone but their relation to the "logical picture" of assembled rocks beneath that matters.

The shape and slotted structure of the lid and the box's inner edges indicate that the lid fits into the box with the paintings facing down, almost touching the stones. The paintings are, one might say, the graphic transcriptions of the inscriptions on the stones. Stones are mute, and thus, as Smithson understood, once they are displaced and made to function as signs they require an extra apparatus of text and images. Smithson, in 1968, used photographs and maps. In the sixth century, the preferred means was to use paint to represent scenes set in important Holy Land sites—memory images of sorts. At the bottom left is the *Nativity of Christ*, which occurred in Bethlehem. To its right we have the *Baptism*, in the River Jordan. The centrally positioned *Crucifixion* happened outside the walls of Jerusalem, and nearby was the tomb, which is represented at upper left. Christ finally ascended to heaven, not far from the Jerusalem, shown in the upper right.

Abbreviated as they are, the paintings pay particular attention to site. Beyond the topographical markers indicated by the iconography, there is a structural movement upward, corresponding to the narrative progression. In the bottom register's *Nativity*, we are underground in a cave, and in the *Baptism* we are underwater, sunk between two land masses. In the middle register we are in the landscape, the horizon just at the level of the crosses. At the bottom of the cross is a conspicuous mound of earth (more on that later). In the top register there is almost no landscape at all: we have the empty tomb, and in the *Ascension* Christ leaves the earth behind. Thus, the lid paintings figure, in compressed form, the passage from birth to ascension, which is also an allegory of pilgrimage, travel, and conversion. That which was of the earth gets taken up and carried away.

To return to the box's interior, here in their new location the stones are displaced, but their real connection to their sites is proclaimed by a system of inscriptions and pictures. We thus have one site existing in two different locations. We might call this an effect of topographical destabilization, which Smithson described in terms of metaphor. "Between the

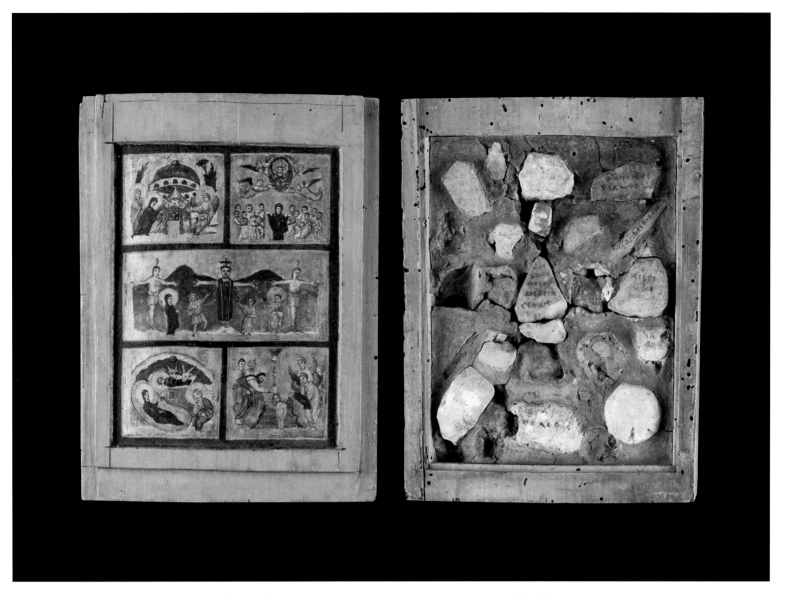

Fig. 6. Reliquary box with stones from the Holy Land (cat. no. 13), Syria or Palestine, 6th century. Museo Sacro, Musei Vaticani (61883)

actual site in the Pine Barrens and *The Non-Site* itself," Smithson wrote, "exists a space of metaphoric significance. It could be that 'travel' in this space is a vast metaphor. . . . Let us say that one goes on a fictitious trip, if one decides to go to the site of the *Non-Site*. The 'trip' becomes invented, devised, artificial; therefore, one might call it a non-trip to a site from a Non-site."[52]

In Smithson's rethinking of the conditions of exhibition and viewing, the work of art is an occasion for radical displacement—a displacement of the art work, which is both here and elsewhere, but also a displacement of the viewer, who is here but confronted with an elsewhere, and with the fact that implied travel (or fictitious travel, or as he also called it, anti-travel) to that other place is built into the work. In this effort, Smithson was returning to premodern modalities for thinking about art in its relation to space and time. A primary alternative to the modern art gallery was the Christian chapel, whose spatio-temporal logic was much more amenable to Smithson's thinking.[53]

Throughout the Middle Ages there was a site that was popularly known as "Jerusalem" despite the fact that it was located in Rome. It is a chapel in the Church of Sta. Croce in Gerusalemme to which one accedes by descending a ramp off the right aisle of the church. A long ceramic inscription along the wall of this ramp, installed in about 1510, informs us that this was the chapel where St. Helena placed the relics she had brought back from the Holy Land in the early fourth century: two thorns from the Crown of Thorns, a nail from the Crucifixion, pieces of the True Cross, and the tablet of the *titulus* from the Cross. (In the fourteenth century the recently imported mosaic panel Man of Sorrows [cat. no. 116], was installed in this chapel.)

These relics came very close to Christ's body, but the ground at the foot of the Cross, soaked with the blood of Christ, was also sacred. According to legend, this too was transported, in enormous quantities, and installed in the flooring of this chapel.[54] An ancient "earthworks" project, this site was a piece of transplanted territory, a bit of Jerusalem reinstalled in Rome.

Fig. 75. View of glass flooring covering the earth of Golgotha. Jerusalem Chapel, Church of Sta. Croce in Gerusalemme, Rome. Photo Alexander Nagel

The effect is somewhat hard to appreciate now. The relics on display in this chapel during the Middle Ages are now on view in a chapel/display room built in 1930 on the other side of the church. The only relic remaining in the Jerusalem chapel is the earth from Golgotha, some of which can still be seen under glass, embedded in the floor (fig. 75). However, there was once much more earth there: one sixteenth-century commentator claimed that originally the earth reached the springing of the vaults![55]

Smithson visited Rome in 1961, at a time when he was making overtly Christian paintings. He said on several occasions that he much preferred the medieval objects to the works of Renaissance art he had seen there. He later remembered that when he was in Rome he was "exposed to all the church architecture and enjoyed all the labyrinthine passageways."[58] We will probably never know whether Smithson saw the Jerusalem chapel and admired its earthwork. But I find it interesting that at some unknown date he felt it necessary to excerpt and carefully transcribe onto a piece of paper a few lines from Beckett's *Waiting for Godot*, which read:

Vladimir: Do you remember the Gospels?
Estragon: I remember the maps of the Holy Land. Coloured they were. Very pretty. The Dead Sea was pale blue. The very look of it made me thirsty. That's where we'll go, I used to say, that's where we'll go for our honeymoon. We'll swim. We'll be happy.[57]

Notes

I would like to thank Martina Bagnoli, Charles Dibble, Cynthia Hahn, Herbert Kessler, Holger Klein, and C. Griffith Mann for their many helpful suggestions and criticisms during the writing of this essay.

1. Some of Erasmus's most trenchant comments appear in his spiritual handbook of 1503, the *Enchiridion Militis Christiani* [Handbook of a Christian Soldier], especially the fourth and fifth rules (chaps. 12 and 13).

2. For the longstanding concerns about questions of authenticity, see Bagnoli herein, pp. 142–43.

3. John Calvin, *Traité des reliques*, ed. A. Autin (Paris, 1921), 196.

4. Calvin, *Traité des reliques*, 97: "Car plusieurs, en regardant un reliquaire, ferment les yeux par superstition ; afin, en voyant, de ne voir goutte, c'est-à-dire qu'ils n'osent pas jeter l'œil à bon escient pour considérer ce que c'est. Ainsi que plusieurs qui se vantent d'avoir vu le corps de saint Claude tout entier, ou d'un autre saint, n'ont jamais eu cette hardiesse de lever la vue pour regarder que c'était." Beyond the question of whether reliquaries allowed for the visibility of their relics, Calvin's observation introduces a behavioral dimension that is much more difficult to trace. On the problem in general, see C. Diedrichs, *Die Sichtbarkeit der Reliquie im Reliquiar: Ein Beitrag zur Geschichte des Sehens* (Berlin, 2001).

5. E. C. Voelker, *Charles Borromeo's* Instructiones fabricae et supellectilis ecclesiatica, 1577: *A Translation with Commentary and Analysis*, Ph.D. diss., Syracuse University, 1977 (Ann Arbor: University Microfilms International, 1977), chap. 16.

6. C. S. Wood, "In Defense of Images: Two Local Rejoinders to the Zwinglian Iconoclasm," *Sixteenth-Century Journal* 19 (1988), 25–44. The Pfund Heller was equivalent to 1.25 or 1.5 Gulden.

7. Claude de Sainctes, bishop of Évreux, describes how the Protestants who took over the city of Orléans in 1562 destroyed everything in the Church of Saint-Euverte—books, images, tombs, glassware, furniture, even much of the church masonry—with the exception of the reliquaries. Those they commandeered, though "without the sacred bones, which they burned." Whether the reliquaries were kept or simply melted down is not certain. Claude de Sainctes, *Discours sur le saccagement des Églises Catholiques par les Hérétiques anciens, et nouveaux calvinistes, en l'an 1562* (Paris, 1563), in *Archives curieuses de l'histoire de France depuis Louis XI jusqu'à Louis XVIII*, ed. L. Cimber and F. Danjou, series 1, vol. 4 (Paris, 1835), 357–400, esp. 381.

8. See M. Warnke, "Durchbrochene Geschichte? Die Bilderstürme der Wiedertäufer in Münster 1534/35," in *Bildersturm: Die Zerstörung des Kunstwerks*, ed. M. Warnke (Munich, 1973), 73; and H. Belting, *Likeness and Presence: A History of the Image in the Era before Art* (Chicago, 1994), chap. 20.

9. Some examples are discussed in Johann Michael Fritz, *Die bewahrende Kraft des Luthertums. Mittelalterliche Kunstwerke in evangelischen Kirchen* (Regensburg: Schnell & Steiner, 1997). My thanks to Hoger Klein for this reference.

10. P. Selvatico and V. Lazari, *Guida artistica e storica di Venezia e delle isole circonvicine* (Venice: Carpano, 1852), 191; *Menzioni onorifiche de' defunti scritte nel nostro secolo, parte seconda*, ed. G.B. Contarini (Venice: Ancora, 1846), 46–47; and R. Gallo, "Reliquie e reliquiari veneziani," *Rivista mensile della città di Venezia* 13 (1934): 187–214, at 193.

11. See S. Bann, *The Clothing of Clio: A Study of the Representation of History in Nineteenth-Century Britain and France* (Cambridge, 1984), 86.

12. H. Bredekamp, "Der simulierte Benjamin: Mittelalterliche Bemerkungen zu seiner Aktualität," in A. Berndt et al., eds. *Frankfurter Schule und Kunstgeschichte* (Berlin, 1992), 125–33.

13. The 1359 letter documenting the sale of the reliquaries to the Ospedale describes the gold reliquary of the True Cross as "unam crucem auri incassatam anticam plenam de ligno vere crucis fuit sancti Constantini" (G. Derenzini, "Le reliquie da Costantinopoli a Siena," in *L'oro di Siena: il tesoro di Santa Maria della Scala*, ed. L. Bellosi (Milan, 1996), 67–78, at 75). Since *lignum* is not feminine, it must be the *crucem auri incassatam* that is qualified as *anticam* and as having belonged to Constantine. (A research paper by my student Melissa Greenberg on reliquaries as antiquities greatly clarified these matters for me.) None of this is unreasonable as early Church histories and pilgrims' accounts speak of a fragment of the True Cross in a reliquary of precious metal in the Church of the Holy Sepulcher in Jerusalem from the fourth century on: Theoderet, the early fifth-century bishop of Cyrrhus (*Historia Ecclesiastica*, 1.17), mentions a silver casement for the relic ordered by Helena and left in the care of the bishop of Jerusalem, and the fourth-century pilgrim Egeria (*Peregrinatio*, chap. 37), describes it as a silver-gilt casket. It would have been natural to think that these Byzantine True Cross reliquaries, too, dated to these times.

14. The Byzantine work, known as the Jaucourt reliquary, dates to the eleventh or twelfth century, and the angels and external mounting date from ca. 1340. See K.M. Holbert, "Relics and Reliquaries of the True Cross," in *Art and Architecture of Late Medieval Pilgrimage in Northern Europe and the British Isles*, ed. S. Blick and R. Tekippe, 2 vols. (Leiden, 2005), 1:337–64, at 360.

15. This point is made by Cynthia Hahn, in the introduction to her forthcoming study *Strange Beauty: Issues in the Making of Reliquaries from the Fourth Century to 1204*. My thanks to Professor Hahn for her helpful comments on this and other topics.

16. See Krueger and Klein herein, pp. 13 and 59.

17. See Cornini herein, pp. 69–78. My thanks to Herbert Kessler for sharing his thoughts on this and related matters.

18. Sarah Benson, "Reproduction, Fragmentation, and Collection: Rome and the Origin of Souvenirs," in *Architecture and Tourism: Perception, Performance, Place*, ed. D.M. Lasanki (New York, 2004), 15-36. Maria Macioti, "Pilgrimages of Yesterday, Jubilees of Today," in *From Medieval Pilgrimage to Religious Tourism*, ed. W.H. Swatos (Westport, 2002), 75–91.

19. Although it is true that the unicorn horn is first mentioned only in 1505. See *Le trésor de Saint-Denis*, exh. cat., Paris: Musée du Louvre (Paris, 1991), 310–11, and see also the discussion in L. Daston and K. Park, *Wonders and the Order of Nature* (New York, 2001), chap. 2. See also P.A. Mariaux, "Collecting (and Display)," in *A Companion to Medieval Art: Romanesque and Gothic in Northern Europe*, ed. C. Rudolph (Oxford, 2006), 213–32, esp. 219–20, who offers resistance to the idea that the medieval treasury is a *Wunderkammer* in nuce.

20. Erasmus, "A Pilgrimage for Religion's Sake" (1526), in *Collected Works of Erasmus* vol. 40, *Colloquies*, ed. C.R. Thompson (Toronto, 1997), 623.

21. A point made by S. Bann, "Shrines, Curiosities, and the Rhetoric of Display," in *Visual Display: Culture Beyond Appearances*, ed. L. Cooke and P. Wallen (New York, 1998), 15–29.

22. K. Pomian, *Collectionneurs, amateurs et curieux: Paris-Venise, XVIe–XVIIe siècles* (Paris, 1987), 90–91.

23. J. Braun discusses some examples in *Die Reliquiare des christlichen Kultes und ihre Entwicklung* (Freiburg, 1940), 227–29.

24. Bann, "Shrines, Curiosities, and the Rhetoric of Display" (1998, cited in n. 23), proposes that what had been lost as a result of Reformation iconoclasm—lost not only materially but conceptually—was recuperated in the curiosity cabinets of Europe in the early modern period.

25. S. Laube, "Zwischen Hybris und Hybridität: Kurfürst Friedrich der Weise und seine Reliquiensammlung," in *"Ich armer sundiger mensch": Heiligen- und Reliquienkult am Übergang zum konfessionellen Zeitalter*, ed. A. Tacke (Göttingen, 2006), 170–207.

26. Sir Thomas Browne, *Religio Medici*, part 1, section 28.

27. The Venetian chronicler Marin Sanudo (1466–1536) noted about two hundred relics of supreme importance in Venice—arms, hands, heads, whole bodies, and True Cross fragments; among them was listed one image, presumably because it was an image that was also a relic, the handiwork of St. Luke: "La imagine della Beata Verzene, di musaico, fatta per man di San Luca." See Marin Sanudo il Giovane, *De origine, situ et magistratibus urbis Venetiae ovvero la città di Venetia (1493–1530)*, ed. A. Caracciolo Aricò (Milan, 1980), 157–65, at 164. On St. Luke as portraitist of the Virgin see above all M. Bacci, *Il Pennello dell'Evangelista: storia delle immagini sacre attribuite a san Luca* (Pisa, 1998).

28. For one signal example, see K. Noreen, "Replicating the Icon of Santa Maria Maggiore: The *Mater ter admirabilis* and the Jesuits of Ingolstadt," *Visual Resources* 24 (2008): 19–37. My thanks to Holger Klein for bringing this article to my attention.

29. The trend is clearly illustrated by the reception history of the famous Virgin icons of Rome. Most scholars agree that the latest interventions on the St. Luke icon in Sta. Maria Maggiore date to the thirteenth century. Gerhard Wolf convincingly disproved Joseph Wilpert's dating of the panel to ca. 1250, arguing that the original painting was done in the sixth century, shortly after the founding of the church. See G. Wolf, *Salus Populi Romani: Die Geschichte römischer Kultbilder im Mittelalter* (Weinheim, 1990), 24–28. The early eighth-century Madonna della Clemenza in Sta. Maria in Trastevere was also not overpainted after the thirteenth century; see C. Bertelli, *La Madonna di Santa Maria in Trastevere: Storia, iconografia, stile di un dipinto romano del ottavo secolo* (Rome, 1961). The Madonna of San Sisto in Sta. Maria del Rosario, too, was apparently also last retouched in the thirteenth century, to judge from the prerestoration photos. Unfortunately, the main study on the work does not consider this question; see C. Bertelli, "L'immagine del 'Monasterium Templi' dopo il Restauro," *Archivum Fratrum Praedicatorum* 31 (1961): 82–111. Besides some nineteenth-century overpainting removed in 1950, the latest layer of repainting on the seventh-century icon from Sta. Maria Antiqua, now in Sta. Francesca Romana, was a layer of tempera paint dating to the thirteenth century; see E. Kitzinger, "On Some Icons of the Seventh Century," in *Late Classical and Medieval Studies in Honor of Albert Mathias Friend*, Jr., ed. K. Weitzmann, (Princeton, 1955), 132–50. In this case, the thirteenth-century restoration also involved the preservation and insertion of the faces of the Virgin and Child in their original state, as relics, thus signaling a move

toward a more modern approach to restoration already at that stage; see P. Cellini, "Una Madonna molto antica," *Proporzioni* 3 (1950): 1–6. The Madonna of the Pantheon is the exception, as it was repainted several times up to the eighteenth century; see C. Bertelli, "La Madonna del Pantheon," *Bollettino d'Arte* 46 (1961): 24–32 and 30 n. 3.

30. M. Warnke, "Italienische Bildtabernakel bis zum Frühbarock," *Münchner Jahrbuch der bildenden Kunst* 19 (1968): 61–102

32. A silk bag of relics was recently found in the Virgin's head and a little packet of red silk in the child's head, containing Christ's blood in a tin seal, a piece of the True Cross, some fragments of thread, possibly belonging to a Virgin's veil. See M. Ciatti, "The Typology, Meaning, and Use of Some Panel Paintings of the Duecento and Trecento," in *Italian Panel Paintings of the Duecento and Trecento*, Center for Advanced Study in the Visual Arts, Studies in the History of Art, Symposium Papers 28, ed. V.M. Schmidt (Washington, DC, 2002), 15–29, at 26.

32. *Il carteggio di Michelangelo*, ed. G. Poggi, P. Barocchi, and R. Ristori, 5 vols. (Florence, 1965–83), 4:181.

33. Giorgio Vasari, *Le vite*, ed. R. Bettarini, 8 vols. (Florence, 1966–84), 4:535–36.

34. Ibid., 4:161.

35. See J. Shearman, *Raphael in Early Modern Sources (1483–1602)*, 2 vols. (New Haven, 2003), 1: 216–20; and C. Wood, "Eine Nachricht von Raffael," in *Öffnungen: Zur Theorie und Geschichte der Zeichnung*, ed. F. T. Bach and W. Pichler, (Munich, 2009), 109–37.

36. M. Ruffini, "Sixteenth-century Paduan Annotations to the First Edition of Vasari's Lives," *Renaissance Quarterly* 62 (2009): 748–808, at 793: "Mani di fra' Lorenzo tenute commo reliquie."

37. See J. Koerner, *The Moment of Self-Portraiture in German Renaissance Art* (Chicago, 1993), 249–51; and L. Schmitt, "Dürers Locke," *Zeitschrift für Kunstgeschichte* 66 (2003): 261–72.

38. See S. P. Blier, "Capricious Arts: Idols in Renaissance-era Africa and Europe (The Case of Sapi and Kongo)," in *The Idol in the Age of Art*, ed. M.W. Cole and R. Zorach (Aldershot: Ashgate, 2008), 11–29, at 11–13, with further references.

39. B. Foulon, ed., *Dominique-Vivant Denon: L'oeil de Napoléon*, exh. cat., Paris: Musée du Louvre (Paris, 2000), 480.

40. See B. Breudenbach, "Reliquien von Orten. Ein frühchristliches Reliquiar als Gedächtnisort," in *Reliquiare im Mittelalter*, ed. B. Breudenbach and G. Toussaint (Berlin, 2005), 21–41. See also J. Elsner, "Replicating Palestine and Reversing the Reformation: Pilgrimage and Collecting at Bobbio, Monza, and Walsinghan," *Journal of the History of Collections* 9 (1997): 117-30.

41. Ludovico Moscardo, *Note ovvero memorie del Museo Lodovico Moscardo, Nobile Veronese Accademico Filharmonico* (Padua, 1656), part 2, 445–48.

42. Ibid., part 1, 148.

43. Giangiuseppe Liruti, *Della moneta propria, e forastiera ch' ebbe corso nel ducato di Friuli dalla decadenza dell' imperio romano sino al secolo XV* (Venice, 1749), 137 (quoted in Pomian, *Collectionneurs, Amateurs, et Curieux*, 287).

44. M. Duchamp, interview with James Johnson Sweeney, in "Eleven Europeans in America," *Bulletin of the Museum of Modern Art* 13 (1946): 19–21.

45. K. Schwitters, "Die Bedeutung des Merzgedankens in der Welt," in *Das literarische Werk*, 5 vols. (Cologne, 1973–81) 4:134; translation from W. Schmalenbach, *Kurt Schwitters* (New York, 1967), 84.

46. My thanks to Leah Dickerman for providing information and confirming facts about Schwitters's boxes. Paul Erich Küppers was an art historian who, apart from championing modern artists, was also a scholar of earlier art and the author of a monograph on the Renaissance artist Domenico Ghirlandaio.

47. K. Schwitters, "Ich und meine Ziele," in *Das literarische Werk*, 5:344.

48. Smithsonian Institution, Washington, DC, Archives of American Art, Robert Smithson and Nancy Holt Papers, reel 3834, frame 176.

49. Ibid., frame 405.

50. Ibid., frame 407.

51. Ibid., frame 177.

52. Robert Smithson, *The Collected Writings*, ed. J. Flam (Berkeley, 1996), 364.

53. In this connection it is interesting that the Dia Art Foundation, founded by Heiner Friedrich in 1974 precisely to respond to the challenges of the new art of Smithson's generation, was inspired in no small part by the experience of Christian chapels. Giotto's Arena Chapel in Padua was an especially powerful model; for Friedrich, it yielded "the true insight for the unfolding and development of Dia." Quoted in an interview with M. Kimmelman, "The Dia Generation," *New York Times Magazine*, April 6, 2003, 34-35.

54. The majolica inscription mentioned above speaks of "terraque sancti montis Calvariae navi inde advecta supra quam Christi sanguis effusus fuit." See I. Toesca, "A Majolica Inscription in Santa Croce in Gerusalemme," in *Essays in the History of Art Presented to Rudolf Wittkower*, eds. Douglas Fraser, Howard Hibbard, and Milton J. Lewine (London, 1967), 102–105, at 105. The Spanish traveller Pero Tafur, visiting Rome in 1436, heard a somewhat different story: "All this church, with the floor and the walls and everything else, was made from earth of Jerusalem brought as ballast in ships, when St. Helena sent the holy relics to Rome." P. Tafur, *Travels and Adventures, 1435–1439* (London, 1926), 41.

55. Onofrio Panvinio, *Le sette chiese Romane* ... trans. Da Marco Antonio Lanfranchi (Rome, 1570), 274.

56. Robert Smithson, interview with Paul Cummings, in *Collected Writings*, 286. Earlier in the interview, 282, he says, "I was very interested in the Byzantine. As a result I remember wandering around through these old baroque churches and going through these labyrinthine vaults."

57. Archives of American Art, Robert Smithson and Nancy Holt Papers, reel 3834, frame 165.

125
Nuremberg Relic-Book

Peter Vischer (German, ca. 1460–1529), 1487
Printer's ink on parchment, hand-colored; 21 × 14 cm
Library of Congress, Washington, DC, Rare Book and Special
Collections Division (Incun. 1487.H4 Rosenwald Coll. no. 120)
Illustrated: fols. 3v–4r (top), 5v–6r (bottom)
Cleveland and Baltimore

PROVENANCE: From the Liechtenstein Collection

BIBLIOGRAPHY: Nuremberg 1986, 57–68; Kühne 2000, 144–52;
Cordez 2004, 54–58

With the introduction of movable type in Europe
during the second half of the fifteenth century,
a new kind of devotional object emerged: the *Heil-
tumsbuch*, or relic-book. Pilgrims' accounts report
that relic-books could be purchased at the annual
display of relics, or *Heiltumsweisung*, which became
a regular feature of the church calendar in the
fourteenth century. This suggests that relic-books
served as mementos for those who traveled great
distances to view the remains of a particular saint
and as advertisements for those who had yet to
make the journey. Relic-books were also powerful
aids to devotion, offering the believer a carefully
orchestrated program for venerating the saints
through text and image. The practice of extending
the indulgences associated with many relics to
images of those relics and their containers further
accounts for the popularity of relic-books.

Prepared under the direction of the Nuremberg
sculptor Peter Vischer, the Nuremberg relic-book
is the first of its kind. Printed on parchment, it
contains six folios, including three hand-colored
woodblocks, one of which shows the *Heiltumsstuhl*.
This was a temporary wooden platform erected
in the central square of Nuremberg each year for the
purpose of displaying the city's most important
relics. These relics included the Holy Lance, pieces
of the True Cross, and the imperial insignia of Char-
lemagne (r. 768–814), the first Holy Roman Emperor
(see Klein herein, p. 61). The phalanx of soldiers
that separates the crowd gathered below from the
relics held in precious reliquaries presented by local
clerics and city elders in the upper register of the
platform provides some idea of how carefully these
objects were guarded. While somewhat exagger-
ated by the designer of the woodblock, the distance
between the pilgrims and the relics underscores
the extent to which relic-books provided a more
intimate access to the remains of saints than what
one experienced in ceremonies like the *Heiltums-
weisung*. / GS

125

Bamberg Relic-Book

Hans Mair (German, d. 1520), 1493
Printer's ink on paper; 19.8 × 13.3 cm
Library of Congress, Washington, DC, Rare Book and Special
Collections Division (Incun. 1498.H46 Rosenwald Coll. no. 162)
Illustrated: fols. 7v–8r (top), 10v–11r (bottom)
Cleveland and Baltimore

PROVENANCE: From the Sylvain S. Brunschwig Collection

BIBLIOGRAPHY: Machilek 1987; Kühne 2000, 275–93; Cárdenas
2002, 25–33

In 1493, the impressive collection of relics housed
in the cathedral of Bamberg inspired not one but two
relic-books. Additional volumes followed in 1495
and 1508/09. These books all attest to the growing
popularity of the display of relics, or *Heiltums-
weisung*. Unlike in most pilgrimage centers, where
the display of relics took place each year, the *Heil-
tumsweisung* in Bamberg occurred only once every
seven years. This extended cycle was a condition
of the Council of Basel (1444), which decided to
grant all those who saw the relics in Bamberg up to
five years and two hundred days of freedom from
purgatory. While this was not the first indulgence
awarded to the cathedral, it demonstrates how
indulgences provided the Church with a means of
institutionalizing the cult of saints.

The woodcuts that accompany the relic-book
printed by Hans Mair in 1493 involve a similar effort
at codification. On the first folio, the viewer encoun-
ters a portrait of the Holy Roman Emperor Heinrich
[Henry] II (973–1024) and his wife, Cunigunde
(d. 1039), holding a model of Bamberg Cathedral. Not
only were Heinrich and Cunigunde instrumental in
founding the cathedral in 1021, but they also became
two of the most important saints associated with
it. The so-called *Heinrichshrein*, a reliquary casket
containing remains of Heinrich II, occupies a central
role in the procession pictured in the following
woodcut. After these images, which became standard
"types" in later relic-books, the Bamberg relic-book
shows the various relics housed in the cathedral
arranged into groups. These groups reflect the pres-
entation of the relics at the *Heiltumsweisung*. They
also reveal a certain interest on the part of the designer
of the woodcuts in the reliquaries, which despite
their schematized appearance retained an aspect
of their individual ornamental characteristics. This
suggests that relic-books were more than just
"catalogs" of relics, playing an important role in the
history of early printmaking. / GS

126

127

127
Broadside of Relics from Kloster Andechs

German, 1496
Printer's ink on paper, hand-colored; 26.5 × 75 cm
The British Museum, London (PD 1895,0122.188–89)

PROVENANCE: The British Museum, 1895, by donation

BIBLIOGRAPHY: Munich 1967; Andechs 1993, 165–85, 249–50;
Kühne 2000, 348–78

Printed from four separate woodblocks on a single
sheet of paper, this relic-broadside, or *Heiltumsbrief*,
shows the relics once owned by the Benedictine
monastery at Andechs. Founded on 17 March 1455 by
Duke Albrecht III of Bavaria (r. 1438–1460), the
Andechs monastery occupies the site of an earlier
chapel where a wondrous event reportedly took
place in 1388. While celebrating Mass, a priest had
a vision that beneath the altar there were a number
of precious relics. Indeed, there were several relics
related to the Passion of Christ as well as three hosts
with wonder-working properties. Pictured in a mon-
strance at the center of the broadside, these hosts
became an important political tool in the hands of the
dukes of Bavaria, who had them transferred to
Munich in 1389 in hopes of attracting more pilgrims
to the city.

 After the hosts were returned to Andechs in
the early decades of the fifteenth century, the dukes
continued to claim ownership of them, as can be
seen by the inclusion of their coat of arms in the lower
left-hand corner of the broadside. On the right, we
find the coat of arms of the Andechs monastery
alongside the abbot Johann Schattenbach (1492–1521),
who kneels in adoration before a display of reli-
quaries. This display, however, does not offer the
abbot direct access to these sacred objects, but
instead mediates his relationship to them through
another image, a relic-altarpiece. Such altarpieces
offered the faithful a means of focusing their
devotion during those parts of the year when the
reliquaries themselves were stored in the church
treasury. Painted two years before the publication
of the broadside, the altarpiece at Andechs under-
scored the role of the saints as intercessors by placing
representations of the reliquaries that contained
their remains against a blue background symbol-
izing Heaven. / GS

128
Print of the Relics of the Holy Roman Empire

Hans Spoerer (?) (German, fl. last quarter of the 15th century),
1480/1496
Printer's ink on paper, hand-colored; 43.4 × 29.8 cm
The British Museum, London (PD 1933,0102.1)
London only

PROVENANCE: Duke of Gotha; presented to the British Museum
in 1923 by a body of subscribers as a tribute to Campbell
Dodgson, Keeper of Prints and Drawings, 1912–32

BIBLIOGRAPHY: Schnelbögl 1962, 106–29; Bühler 1963, 99–101;
Schier and Schlief 2004

129
Print of the Relics of the Holy Roman Empire

Hans Spoerer (?) (German, fl. last quarter of the 15th century),
1480/1496
Printer's ink on paper; 43.4 × 29.8 cm
The British Museum, London (PD 1916, 0913.1)
Not illustrated
Cleveland and Baltimore

PROVENANCE: Guiseppe Storck (1766–1836), Milan, by 1797
(mode of acquisition unknown); G. de V. Kelsch (date and mode
of acquisition unknown); donated to the British Museum, 1916

BIBLIOGRAPHY: Schnelbögl 1962, 106–29; Bühler 1963, 99–101;
Schier and Schlief 2004

Besides relic-books, pilgrims could purchase single-
leaf woodcut reproductions of relics associated
with a particular church or shrine. Scholars often refer
to these woodcuts, or *Heiltumsblätter*, as cheaper
versions of relic-books, since the high cost of parch-
ment and even paper prevented many people from
purchasing the latter. While this was generally the
case, the single-leaf woodcut illustrating the relics
of the Holy Roman Empire first printed around 1480
and then again in 1496 came in a hand-colored ver-
sion. What really differentiated *Heiltumsblätter* from
relic-books was that their large scale allowed them
to be displayed in public places like churches, where
they performed a similar function to indulgence
announcements. Of course, this did not preclude their
use in private devotion; it simply draws attention
to how different kinds of objects encourage different
viewing practices.

This difference is apparent in the *Heiltumsblatt* illustrating the relics of the Holy Roman Empire, including pieces of the True Cross, thorns from Christ's crown, along with the sword, robe and scepter of Charlemagne (r. 768–814). The imperial collection also featured the Holy Lance that tradition states was used by Longinus to pierce Christ's side after his death; this was a highly prized possession, since it was one of the few contact relics associated with Christ, who was said to have left behind no bodily relics. In 1423, Emperor Sigismund (r. 1368–1437) bequeathed the Lance to Nuremberg for safekeeping, where it became the centerpiece of the *Heiltums-weisung*. The Holy Lance's size in the woodcut is one indication of its importance, although this was not a mere effect of representation, for its makers claimed that this was a "true copy" of the Lance, which measures 50.8 cm in height and 7.9 cm in width. / GS

130
Christ Designating a Child

Ottonian (Milan?), ca. 968
Elephant ivory, traces of polychromy; 12.8 × 11.8 × 0.8 cm
Musée du Louvre, Paris, Département des Objets d'art (OA 11372)
Cleveland and Baltimore

PROVENANCE: from the cathedral of Magdeburg; then in the treasury at Halle; before 1909 on the antiquarian market in Bonn; collection of V. Martin le Roy in Neuilly sur Seine before 1909; collection of Jean-Joseph Marquet de Vasselot; purchased pursuant to order of 27 January 1993

BIBLIOGRAPHY: Hildesheim 1993, no. II–14; Musée du Louvre 1995, no. 17; Filitz 2001, fig. 7.9; Magdeburg 2001, no. v.35j and l; Gaborit-Chopin 2003, no. 47

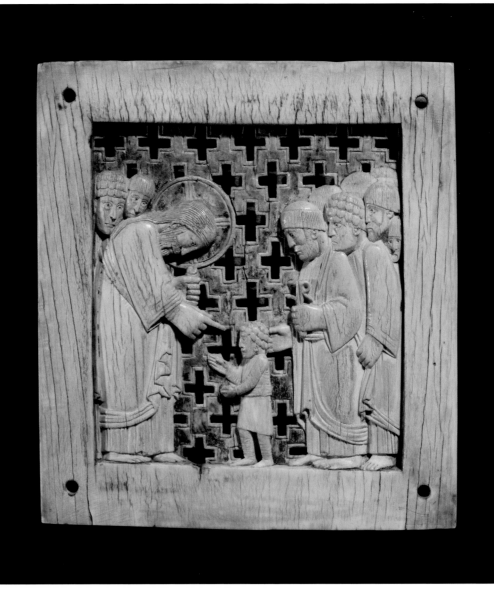

130

This ivory plaque is part of a set of ivories that once adorned a monument in the Church of St. Mauritius in Magdeburg. The monument's form, whether a throne, chancel doors, or an antependium, is uncertain, but we know that it was erected by Emperor Otto I (936–973) on the occasion of the elevation of Magdeburg to an archbishopric. The monument was dismantled soon thereafter, probably as a consequence of the fires that ravaged the cathedral in the first half of the eleventh century, but sixteen plaques are still extant. That illustrated here portrays the episode of the Gospels in which Jesus associates children with spiritual purity (Matt. 18:1–6; Luke 9:47–48). The central figure of a child flanked by two groups of people forms the axis of a symmetrical composition: Jesus on the left points to the child, while Peter, holding the keys, heads a group of apostles on the right. The carving has a monumental

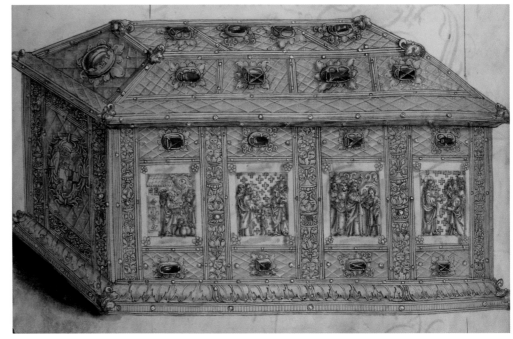

130 FIG.

quality enhanced by the geometrical simplification of forms: the drapery folds are few and straight, the figures' heads are big and round with large eyes and straight noses. The surviving plaques differ in style, suggesting that more than one artist worked on the monument. The workshop responsible for the Ottonian ensemble might have been located in Milan.

Because of their quality and their important historical associations, many of the ivories from the Magdeburg monument were reused during the Middle Ages to decorate other objects. Eight of them, including this one, decorated a reliquary chasse in the collection of Cardinal Albrecht of Brandenburg (r. 1490–1545), documented in several publications, including a lavish manuscript (fig., Aschaffenburg, Hefbibliothek, MS.14). Cardinal Brandenburg's collection was dispersed during his lifetime, and many of the objects disappeared, including the chasse with the ivory of Christ designating the child (see also cat. no. 131). / MB

131

131
Appliqué with Saint George Slaying the Dragon

German, ca. 1500
Mother of pearl; 4.5 × 5.2 × 0.8 cm
The Walters Art Museum, Baltimore (72.21)
Cleveland and Baltimore

PROVENANCE: Miss Dorothy Miner (date and mode of acquisition unknown); Walters Art Museum, 1942, by gift

BIBLIOGRAPHY: Ross 1944/45; Büttner 2000, 89

This fragment is all that remains of a circular relief that was once attached to a pax, a tablet with a sacred image kissed by the celebrant and the faithful during Mass. The pax was in the collection of liturgical vessels and reliquaries established in Halle, Germany, by Cardinal Albrecht of Brandenburg (r. 1490–1545), archbishop of Mainz and an important patron of the arts. In addition to extensive building campaigns to remodel the collegiate church at Halle, his primary residence, and the cathedral in Mainz, Albert collected an impressive number of relics housed in precious reliquaries. Once a year the reliquaries were exhibited to the public in organized "rounds." Those who saw the collection, known as the *Hallesches Heiltum* (the sacred objects of Halle), gained numerous indulgences, and thus the cardinal's collection at Halle became an

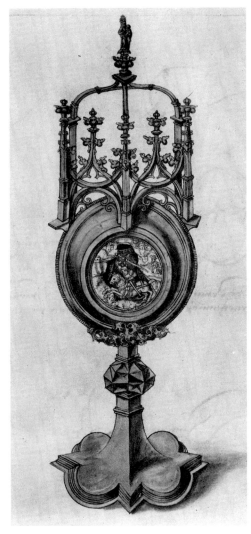

131 FIG.

important site of pilgrimage. In 1520, Albrecht had each of his reliquaries illustrated in a printed book that served as a guide to the pilgrims but also as memory of the event to be used for further meditation. Later, his collection was the subject of a lavish hand-painted book. One of the pages of this book (fig., reproduced from Moritz and Magdalena 1931,

pl. 153) shows the pax before its destruction with the mother-of-pearl relief of St. George killing the dragon. Originally, a princess appeared on the right side of the relief and is now lost as well as the saint's right arm wielding the sword. The damage might have occurred during the tumultuous events that followed the Reformation. However, Cardinal Albrecht's collection was dispersed during his own lifetime, as he sold or pawned his precious reliquaries to raise capital.

The luminescence of mother of pearl is evident in this delicate appliqué carving. Mother of pearl is very brittle and hard and it is difficult to carve. Only the flat central portion of a shell can be used for figurative reliefs such as this one. The medium became popular during the sixteenth century as a decorative element in liturgical furnishings, probably as a result of the availability of large shells from tropical seas. / MB

132
"Griffin's Claw" of St. Cuthbert

English (Durham); mount: 1575–1625
Ibex horn, silver; length: 71.1 cm
The British Museum, London (PE OA 24)

INSCRIBED: GRYPHI UNGUIS DIVO CUTHBERTO DUNELMENSI SACER (The claw of a griffin sacred to the blessed Cuthbert of Durham)

PROVENANCE: Robert Bruce Cotton (1571–1631); Sir Thomas Cotton (d. 1662), by inheritance; Sir John Cotton (d. 1702), by inheritance; 1701, English Parliament, by donation; The British Museum, London, 1753, by transfer

BIBLIOGRAPHY: Fowler 1899, 425–39; Vinycomb 1906, 151; Jones 1990, 85; Bede, trans. Sherley-Price 1990, IV, 27–32

This horn is associated with the popular Anglo-Saxon saint Cuthbert (634–87), who was a hermit and the bishop of Lindisfarne, in the north of England. St. Cuthbert's remains were venerated at Durham Cathedral, where this horn was discovered. Although claimed to be the claw of a griffin, a mythical half-eagle half-lion, it is the horn of an Alpine goat, the ibex. The mount, bearing an inscription, is thought to be of a later date than the horn itself: an inventory of the shrine of St. Cuthbert in Durham Cathedral, compiled in 1383, lists two griffins' claws and griffins' eggs. The claw would have been part of a collection of fantastic objects displayed at the shrine, most likely given as a donation. The griffin was a magical creature in the medieval consciousness; its claws could only be acquired from the beast

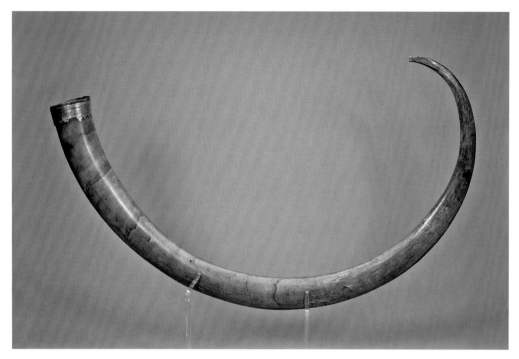

132

in return for medicinal aid from a holy person. These items were often associated with powerful or popular figures. Vinycomb, in 1906, noted that Braunschweig Cathedral still held a griffin's claw brought from the Holy Land by Henry the Lion (1129–95).

There is no firm documentary evidence that this is one of the claws described at the shrine of St. Cuthbert in 1383. However, its emergence in the collection of Sir Robert Cotton (1571–1631) in the years after the Reformation might support the suggestion that it was indeed a survival from the despoliation of the shrine. The Cotton Collection was dedicated to the nation by an Act of Parliament in 1701 by Sir John Cotton and formed part of the first collection of the British Museum on its formation in 1753. The three generations of collectors in the Cotton family, Sir Robert, Sir Thomas, and Sir John, all reflect the gentlemanly trend for forming "cabinets of curiosities," which became popular from the sixteenth century through much of the eighteenth. This griffin claw may have moved from its venerated position among the wonders of St. Cuthbert's shrine to a gentleman's collection of exotic material. In both positions the claw would have been an object of wonder, drawing pilgrims in a spiritual and secular sense, pre- and post-Reformation. / NCS

133
Kneeling Prophet

Jean de Clichy, Gautier du Four, and Guillaume Bouyn, goldsmiths (French [Paris]), 1409
Cast and gilded bronze; 13.8 × 8.7 × 7.8 cm
Musée du Louvre, Paris, Département des Objets d'art (OA 5917)
Cleveland and Baltimore

PROVENANCE: Collection of Jules Maciet (1846–1911), Paris; gift of J. Maciet, 1903

BIBLIOGRAPHY: Migeon 1904, no. 666; Krautheimer 1947, 33 and fig. 14; Wixom 1966, 350–55; Egbert 1970; Gaborit-Chopin 1970; Erlande-Brandenburg 1972; Paris 2004, 310–11, no. 190C; Altötting 2006, 34–35

134
Kneeling Prophet

Jean de Clichy, Gautier du Four, and Guillaume Bouyn, goldsmiths (French [Paris]), 1409
Cast and gilded bronze; 13.8 × 9.3 × 9.7 cm
The Cleveland Museum of Art, Leonard C. Hanna Jr. Fund (1964.360)

PROVENANCE: Sestieri, Rome, Herbert Bier, London

BIBLIOGRAPHY: Cleveland 1967, 254–55, 376, no. VI-20; Egbert 1970; Cleveland 1975, no. 3; Ultee 1981, fig. 11; Paris 2004, 310–11, no. 190d; Los Angeles 2007, 212–13, no. 77

135
Reliquary Chasse of St. Germain, Bishop of Paris

Jean Chaufourier (1679–1757), ca. 1724
Ink on paper; unframed: 32.3 × 21.3 cm
Musee Carnavalet–Histoire de Paris, Cabinet des estampes (G 30505)

The prophet statuettes of the Musée du Louvre and the Cleveland Museum of Art were identified in 1970 by Virginia Egbert as supports for the great chasse of St. Germain (Germanus, ca. 496–576), bishop of Paris, melted down in 1792 and known through an eighteenth-century engraving. The contract for the chasse's manufacture, signed in 1409 by Guillaume, the abbot of Saint-Germain-des-Prés, and three Parisian goldsmiths (Jean de Clichy, Gautier du Four, and Guillaume Bouyn) has survived. The chasse took the form of a double-story Gothic chapel. The lower level contained twelve statuettes of apostles beneath arches; on one of the gable-ends were the Holy Trinity, flanked by Abbot Guillaume and King Odo (Eudes I, r. 888–98), who had commissioned a chasse in the ninth century; on the other, St. Germain, seated between St. Vincent and St. Stephen. The gilded silver chasse was studded with 260 gems and 197 pearls re-used from the earlier chasse. Six statuettes of kneeling prophets, holding phylacteries, supported it. These two statuettes, which escaped the depredations of the Revolution, were probably removed from the chasse when it was altered for the construction of a new altar at the beginning of the eighteenth century.

The two prophets, with heads of noble elders, are typical examples of the Gothic International style of about 1400: the drapery is voluminous and supple, the headdresses elaborately draped, and the faces depicted with an expressive naturalism. The square faces, knitted brows, and prominent cheekbones of the Louvre statuette call to mind contemporary depictions of St. Joseph. The period was in fact marked by a veritable "invasion" of prophets; the type of the prophetic elder, widely taken up by the European courts, appears both in monumental art (the brackets of the Tour du Village and of the Sainte-Chapelle at Vincennes) and in the minor arts (the prophets of André Beauneveu in the Psalter of Jean de Berry). Before Egbert's identification, these two lovely statuettes were attributed variously to Beauneveu, Sluter, or Ghiberti. Though the makers are barely known, these elegant figures nonetheless attest to the consummate skill of Parisian artists at the beginning of the fifteenth century. / EA

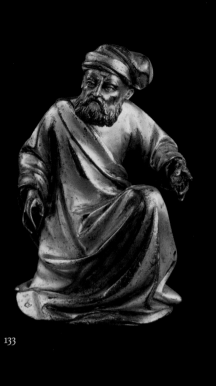

133

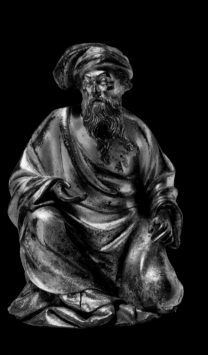

134

CHASSE DE S. GERMAIN ÉVÊQUE DE PARIS.

135

consilio 7 penitens se maluisse c̃ eos q̃
suos i marte ludo triumphasse⸱ expeditissim̃
nuc eni⸱ s⸱ frem⸱ j⸱ templariu elemosinariu̅ suu̅
ad eos destinauit⸱ ut infausto torneamc̃tu
ill̃ iam p̃ ota usq⸱ ad cōgressiōm hostile sparatu̅
tariu̅⸱ regiis litis prohibet⸱ Eodemq⸱ anno⸱
pdc̃s G⸱ Basset dum equu suu̅ c̃ nemore cu uenit
tu uerr̃ aucupno⸱ sttpte offendic̃tim facienteci
corruit⸱ 7 dissipatis ossib; 7 niuis dissolutis pro
tractis paucis dieb; atam exalauit⸱ 7 cito p̃
fili⸱ eide G⸱ unic̃ 7 heres paruis⸱ 7 occ̃ assioc̃s
s̃ agarie iustuione uoci griis doloie⸱ migt̃
ab hoc seculo⸱ hereditate ad ficaone basset decanu
eboracuse frem dc̃ G⸱ consequitur deuoluta⸱
Et eodem tr̃e⸱ s⸱ uns occ̃ assupc̃oi be ugii⸱ Joh̃s
Biser suns anglie forestarii de q̃ mentiōn p̃dua̅
uimus⸱ uia̅ uniuse carnis est ingressus⸱

C̃ Dquidã
magnates anglie iter ierosolimitanũ
ide aute tempis arrdentc̃ arripueru̅t⸱
serenutate⸱ comes de alba axarla⸱ Willi⸱ s⸱ de for
tib; miles strenuissmi⸱ Pec̃ de ayalo lacu nasco
ne pictauensis diucq⸱ 7 clientela regis Joh̃is edu
catus 7 ditatus⸱ Ebelui de Rocheford frauensis⸱
Joh̃s Ansard⸱ Alexã de histauia⸱ Gaffris de chan
delers⸱ 7 alui muisi nobilef de regno Anglie⸱ ualedi
centes amicis suis⸱ 7 oto ̃rib; religiosoz se come
dantes⸱ it ierosolimitanũ cu magno apparatu
arripueru̅t⸱ Qu eca tps̃ autispnale naues i
mari meditaneo ascendentes⸱ transfretaueru̅t⸱

De tribus beneficiis regno francoz celit̃ his
duob; annis⸱ collatis⸱ uidelicet corona⸱ 7 cruce

E odem Anno⸱ Crux sc̃a dn̄i⸱ 7 corpe sc̃i Admu
que post tempora Saladi⸱ di⸱ cc̃nt arch̄iepi⸱
m̃ reposita fuerat apud Damiata usq⸱ ad guet̃
tu infelicet p̃ quã ipa ciuitas pmo adsista⸱ et
pea flebiliter amissa⸱ cessit i ptate sarraceno
riu̅⸱ est i regniu frãcoz delata⸱ rege frã⸱ 7 mre eī
.B⸱ id prudent penuantib; 7 ptati eoz c̃ exptant
te 7 p̃o eade cruce multa data pecua⸱ 7 felici
mancipata⸱ Die siqdem ueneris q̃ proxia die pas
che pcedit⸱ ci⸱ s⸱ dn̄i nr̃i ih̃u⸱ x̃p̃i mũdi redepc̃one
uiuifice cc̃is⸱ astruis patibus⸱ apportabat̃ eade
erux partisus⸱ s⸱ ab ecca sc̃i Antonii⸱ uitra eĩm
gposita fuit edam stac̃onis machina⸱ i qã rex
ipe ascendet cu uirc⸱ regina⸱ s⸱ mre sua .B⸱ 7 uxo
re sua oz⸱ cu frib; eidem regis⸱ psentib; archi
episc⸱ epis⸱ abbib;⸱ 7 aluis uiris religiosis⸱ siuo 7 uo
bilib; francoz magnatib; cu innuabili popta
c̃cu̅stante cu cordis iubilo tã gloriosu spectaculu
erptante⸱ cruce ipam i altu eleuauit lacrui
sbortis⸱ incipientib;⸱ ei psentes erãt pta̅is uoce
altissima⸱ tecce eruce dn̄i⸱ be cu oms ueniam ac
deuote ipam adorassent⸱ rex nud pedes i lauce

discenedus⸱ capite discoogto⸱ 7 duano ieiunio An
tiapato⸱ edoctus exemplo nobilissimi triuphatonis
eraclii augusti⸱ uersus parisiacem urbe⸱ 7 usq⸱
ad eccam be ugiis cachedrale baiulauit⸱ Et cu cõ
simili denoc̃oe⸱ cõfessionib; ieiunus ̃roioib; exp̃a
ati fiet dña regis⸱ cu frãcie cũ regiis supdc̃is⸱ pedetentim
seqbantur⸱ Portaiont̃ 7 ipi coronam spinea⸱ eãm
simul secmatis 7 parso eleuantes⸱ iþ̃ ostribus
psentaru̅t⸱ eãm diuina regno frãcoz anno p̃ito
mia gc̃uleat⸱ prout iþ̃ enarrat̃⸱ Supportabant
au nobiles qda̅ bc̃ha regis 7 fratrū eius⸱ tã pii
onus baiulantu̅⸱ ne forte ̃ritigati cu assidue i
celu̅ brachia eleuata c̃ iþ̃ impreabili ̃cdea̅m dice
ret̃ sustenarur⸱ be si ̃cc̃uise iþ̃ platis sic uolen
tib;⸱ ̃rcũ ut ipi epu prudencia tanta gla fuer
uit adc̃sista⸱ eet 7 ̃cc̃ustante iþ̃ ad uistar eraclii
de q̃ fecuit mentiōn alio nu̅ ueniant arc̃ecaea⸱
cũ q̃ pueniti eet ad eccam cathedie⸱ pulsatu̅ oib;
7 ciuitate signis odōrib;⸱ ep̃ specialib; sollep̃nit plẽs
reuisus⸱ rex ad mai p̃latuu suu ep̃ i media ur
be deferens eccm sua gloriose frib;⸱ eq; ei corona
consequte platoz ordinata processione⸱ q̃ nũeq̃ui
uisa fuit in regno francoz sollep̃noz au̅ iocun
dioz⸱ Uniuisi 7 singli dn̄ q̃ regniu frãcoz pre
onib; alius speciali ostenetur dilec̃e⸱ 7 solatui
7 tuet⸱ iunctis manib; glorificate⸱ Sicq⸱ dñs nr̃
ih̃e q̃ rex regis 7 dn̄is d̃sanc̃uit cui iudicia abissu̅ ̃mlta
i au̅ manu cœda fiit regii dan̅i salute iþ̃⸱ uist ip
su̅ regnu̅ franc huis eb; dotatu̅ 7 ditauit i breui
tr̃e b̃ic̃eius pc̃osit⸱ uidelz corona pda̅⸱ 7 ece dn̄i de
qua iam dc̃m⸱ 7 corpe b̃i Admundi cant archi
epi 7 ̃cfessoris⸱ tan̅dinis miratlis euidentr̃ choui
cant⸱ Rex q̃ frã⸱ s̃ n procul a palac̃o suo capllam
mirifici decoris dc̃o thesauro regio ̃cuenienc̃
uisit fabricari⸱ In q̃ ipam honore odigno postea
collocauit⸱

De morte Regis dacie⸱ 7 filii sui⸱ s⸱ hedi

A̅no q̃ eodem⸱ Waldemar̃ Rex dacie postqm
xl⸱ annis regnauit⸱ qui ausu temario cõ
minac̃ est anglie fines inuade⸱ 7 hostilit̃ ipugn
nare⸱ inþ̃ltiplicans loq̃ sublimia glorando⸱ sb
latus est de medio⸱ Et ut efficaces sentiret bani
Admuardi pc̃es quas dñ fudat i anglioz ptecc̃oni
q̃ danos tyrannide⸱ fili⸱ eiusde regis dacie uni
cus 7 heres uniuisoz⸱ uia̅ uniuise carnis ingre
diens⸱ regniu dacoz totu̅ reddidit desolatu̅⸱

Eodemq⸱ Anno⸱ Walterus de lasci uir ner
omnis nobiles hybnie eminentissmi⸱ post uis
su̅ piuac̃oem⸱ 7 multas alias ecpornis siu̅ af
fliccōnes⸱ er huis seculi transiuit incolatu⸱

De quada̅ uisione cõ pibro frc̃i londoniis mu̅ibt
Arca dies illos cuida̅ pibro uiro scō 7 ̃pi Ai
denti inocturna uisione reuelatu est q̃
quida̅ archipsul pontificalib; ornat̃ crucemq⸱

136
Chronica Majora

Matthew Paris (English, ca. 1200–1259), ca. 1250
Ink and paint on parchment; 35.8 × 24.4 cm
Corpus Christi College, Cambridge (MS 16)
Illustrated: fol. 142v: Louis IX with the relics of the Passion
London only

PROVENANCE: Given by Matthew Paris to the monastery
of St Albans [inscription, fol. 1r]; Robert Talbot, prebendary
of Norwich (1547–58) [inscription, fol. 245v]; Sir Henry Sidney
(1529–86); Matthew Parker (1504–75), archbishop of Canter-
bury; Cambridge, Corpus Christi College, bequest of Matthew
Parker, 1575

BIBLIOGRAPHY: Vaughan 1958; Morgan 1982, 136–39, no. 88,
figs. 295–96, 302, 307; Lewis 1987; Vaughan 1993

Matthew Paris was a monk and historian at the
Benedictine monastery of St. Albans, about twenty
miles north of London. He composed a number
of historical works, and a few of these survive in what
appear to be at least in part copied and illustrated
by his own hand. One of these is the *Chronica Majora*,
or Greater Chronicle, which begins at the Creation
and continues into Matthew's lifetime. Two volumes
of this work, substantially copied and illuminated by
Matthew himself, are now at the Parker Library in
Cambridge (Corpus Christi College, MSS 26 and 16).

The arrival of the relics of the Passion in Paris
was an important event in thirteenth-century Europe
(see cat. no. 137, 138). Matthew drew two pictures
of the Crown of Thorns itself (fol. 140v), and also
a depiction of King Louis IX of France (r. 1226–70)
displaying the relics in Paris (fol. 142v). Standing on
a wooden platform, Louis raises a reliquary of the
True Cross and speaks the words *Ecce crucem domini*
(Behold the Cross of the Lord), while one of his
brothers holds up the Crown of Thorns and another
brother raises his arms in prayer. The inscription
in the box above the king's head recounts how the
relics came into his possession, and how much
he paid for them. Another public display of a relic
of the Passion is also shown in this same manu-
script: King Henry III of England (r. 1216–72) had
acquired a vial of the blood shed by Christ on the
Cross, and Matthew has portrayed the English king
carrying this precious container in a procession in
London in 1247 (fol. 216r). / KBG

137
Reliquary of Sts. Lucian, Maximian, and Julian

French (Paris), ca. 1261
Silver gilt (engraved, chiseled); 19.6 × 13.5 × 2.9 cm
Musée de Cluny–musée national du Moyen Âge, Paris (Cl. 10746)
Cleveland and Baltimore

INSCRIBED: obverse: DE BRACHIO S(AN)C(T)I MAXIANI (From the arm
of St. Maximian); DE COSTA S(AN)C(T)I LUCIANI (From the rib of
Saint Lucian); DE COSTA S(AN)C(T)I IULIANI (From the rib of Saint
Julian); reverse: S(ANCTUS) MAXIANUS (St. Maximian); S(ANCTUS)
LUCIANUS (St. Lucian); S(ANCTUS) IULIANUS (St. Julian)

PROVENANCE: Treasury of la Sainte-Chapelle de Paris; deposited
at Saint-Denis, 12 March 1791; Toussaint Grille, Angers (sale,
28 April 1851); Perré; Prince Petr Soltykoff, Paris; (sale, Paris,
8 April–1 May 1861, no. 169); Charles Timbal, before 1865; gift
of his widow, 1881

BIBLIOGRAPHY: Morand 1790, 48; *Magasin pittoresque* 33 (1865),
307–8; Renet 1892–94, 1: 271–72; Vidier 1911; Souchal 1960; Paris
1960, no. 221; Salet 1961, 70–72; Paris 1962, no. 165; Hertlein
1965, 62–64; Paris 1970, no. 88; Branner 1971, 18, 42; Ottawa
1972, no. 40; Montesquiou-Fezensac and Gaborit-Chopin
1973–77, 42; Morel 1982, 13; Taburet-Delahaye 1989, 83–86; Paris
1991, 74; Cologne 1995, no. 16; Amsterdam 2000, 41–44; Paris
2001, no. 38; Barcelona 2004, no. 32; Paris 2010, 18, fig. 14

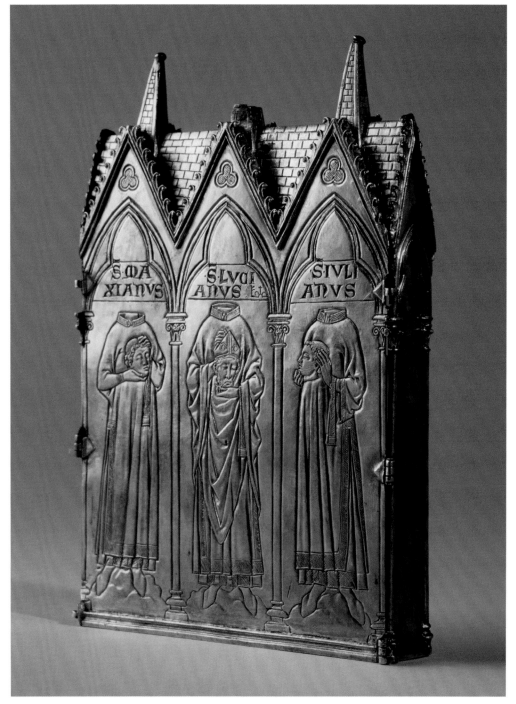

137

This small reliquary, in the form of a church, is the only reliquary made for the Sainte-Chapelle under Louis IX (r. 1226–70, the future St. Louis) to have survived the French Revolution. It was part of the chapel's treasury, built by the king between 1243 and 1248 to house relics of the Passion, and appears in all of the treasury's inventories between 1336 and 1793. It once held relics of the three evangelizing saints associated with the town and the area of Beauvais in northern France: Lucian, Maximian, and Julian, decapitated at the command of the Roman emperor around 290. On 1 May 1261, their relics, preserved in the Abbey of St. Lucian of Beauvais were transferred to new chasses in the presence of Louis IX; it was probably on this occasion that Louis received fragments of one of Maximian's arm and relics from the ribs of the two other martyrs. He commissioned this reliquary, which takes the form of a building. Its architectural structure, often compared to that of the Sainte-Chapelle, rather calls to mind the baldachin above the large relics chasse in the chapel's center.

The front of the reliquary is pierced with three rectangular openings (see p. 209); they were formerly plugged with rock-crystal plaques, which made it possible to see the relics, identified by engraved inscriptions. On the back are the three headless saints, who, according to the *Golden Legend*, miraculously carried their heads after their decollation. This work, solemn and monumental despite its small size, is remarkable for the power and the level of detail of its engravings, the strength of its modeling, and the delicacy of its chasing (even down to the stippling of the tonsure and the stubble on the saints' cheeks). The stylistic similarities with the statues of the southern portal of the Cathedral of Notre-Dame in Paris associate the reliquary with Parisian artistic circles of around 1260. / CD

138
Psalter Hours

French; manuscript: ca. 1460; miniature on folio 1r: ca. 1500(?)
Ink, paint, and gold on parchment; 330 folios, 15.2 × 11 cm
The Pierpont Morgan Library, New York, Gift of J.P. Morgan (1867–1943), 1924 (MS M.67)
Illustrated: fol. 1r: Reliquaries in the Sainte-Chapelle
Cleveland and Baltimore

PROVENANCE: Remodeled for Étienne II Petit, ca. 1500, his arms; owned (18th century) by Françoise Elizabeth Danse (of Beauvais); Beauvais exhibition, 1869, no. 1083; E. Rahir (no. 30399); purchased by J. Pierpont Morgan (1837–1913) from Gruel in 1905; J.P. Morgan (1867–1943)

BIBLIOGRAPHY: New York 1982, 47–48, no. 63; Paris 2001, no. 28; Sauerländer 2007, 121, fig. 10

This private prayer book was made in about 1460, and when it changed hands in about 1500, new material was added at the beginning of the book, including the miniature shown here and the Office, or ceremonial rite, of the relics of the Sainte-Chapelle. These relics, including the Crown of Thorns, pieces of the True Cross, and the sponge and lance, had long been in the possession of the Byzantine emperors. Constantinople, the Byzantine capital, fell to European Crusaders in 1204, and it was ruled by Western

aristocrats until 1261. In the 1230s, the Latin Empire of Constantinople was in dire financial straits, and the emperor, Baldwin II (r. 1236–1261), pawned some of the relics to the Venetians. Louis IX was able to purchase these in 1238, and later he acquired others directly from Baldwin. These relics had been the property of the Byzantine emperors for centuries, and the transfer of their ownership to France signaled, to the French at least, a transfer of political authority and status. Furthermore, bringing

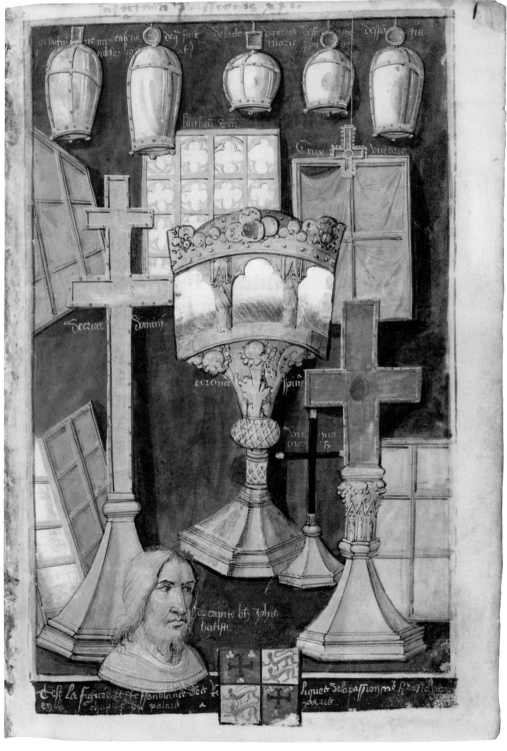

138

the Passion relics to Paris presented that city as a new Jerusalem, and the people of France as God's chosen people. This miniature depicts individual reliquaries, each labeled, including the Holy Blood, a chain from the flagellation of Christ, the Virgin Mary's milk, the sponge from the Crucifixion, the Crown of Thorns, wood from the True Cross, Moses's rod, and the head of John the Baptist. / KBG

battle in the Ashmolean Museum, Oxford (Wilson 2003, 12–13) shows two pennants, one blue with fleur de lis, carried by armored riders around the king as he is surrounded by imperial forces. Is this the "the royal flag (drapeau royale *[sic]*), taken from Francis I at the battle of Pavia," described as "blue, with the arms of France," noted in the Brussels royal armory in 1682, but by 1897, not to be found (Van Duyse 1897, 7–9, 233)? Unspecified trophies from Pavia were deposited into Charles's armory

at Valladolid but are no longer traceable (Crooke y Navarrot 1898, 353–63).

The silk pennant, a secular relic, was accompanied by sacred relics, surely booty from the French camp. Princes often took relics on military campaigns, hoping that their presence would influence events (see the inventory of relics taken from Charles the Bold's camp by the Swiss at Grandson in 1476 [Deuchler 1963]). The coats of arms on the exterior and interior remain unidentified. / JS

139
Box for a French Pennant Taken at the Battle of Pavia

Spanish, 1525
Leather (molded and incised), silver (partially gilded and enameled), paper, gold paint, glass cameos; 6 × 14 × 9.6 cm
The Walters Art Museum, Baltimore (73.1)
Cleveland and Baltimore

INSCRIBED: interior lid, engraved on two plaques of silver (apparently cut from another object), subscripted letters are inscribed in the letter preceding: [?] . LVPᵢ * QᵤIXADA / Dₑ CᵣETₒ² DₒCᵗᵒʳ PₒSVᵢT ([uan] Lopez Quixada, Doctor of Law . . .), with two unidentified coats of arms; interior, in gold paint, with the holes in the paper indicated here by · : D · IUAN. LOPᴱᶻ · QUIXADA · DₒC /TOR EN DₑCᵣETO YCHANTRE DE. / SCALAS * ZQ [?]GANO EL ESTÃDARTE, Q[?] ESTA /A QVĪ, YESTAS', SANCTI SIMAS, RELIQVIAS * / QVANDO EL REY DE FRANCIA PERDIO LA. / BATALLA DE PAVIA.Y.FVE. PRESO.DE SPAÑO / LEˢ A.XX.V.DE FEI RO ANNO D [?]/ · M · D XXV · (Don Juan Lopez Quixada, doctor of canon law and choir master, won the standard that lies here and these very saint relics when the King of France lost the Battle of Pavia and was made prisoner by the Spaniards the 25th of February of the year 1525)

PROVENANCE: Charles Stein (1840–99), Paris; Henry Walters, Baltimore, by purchase [date unknown]; Walters Art Museum, 1931, by bequest

BIBLIOGRAPHY: Gabhart 1971, 36; Miller 1991, 48; Miller 2009, 60

This leather box is unremarkable for its artistry— the foliage pattern engraved in the leather and the glass cameos imitating ancient and modern banded onyx with busts, the Adoration of the Shepherds, and saints are ordinary—but noteworthy for its former contents. The inscription declares that this box held a French pennant taken on 25 February 1525 (actually 24 February), at the Battle of Pavia in Italy, when the French army under Francis I was defeated by that of Emperor Charles V. Juan Lopez Quixada did not capture the king (as earlier references to the box claimed) but may be the "Casada" noted by the Italian historian Paolo Giovio (1561, 231–33) as a man of "singular ardor" and captain of the Spanish harquebusiers, who were devastating to the heavily armored French nobility and critical to the assault on Francis himself. A painting of the

139

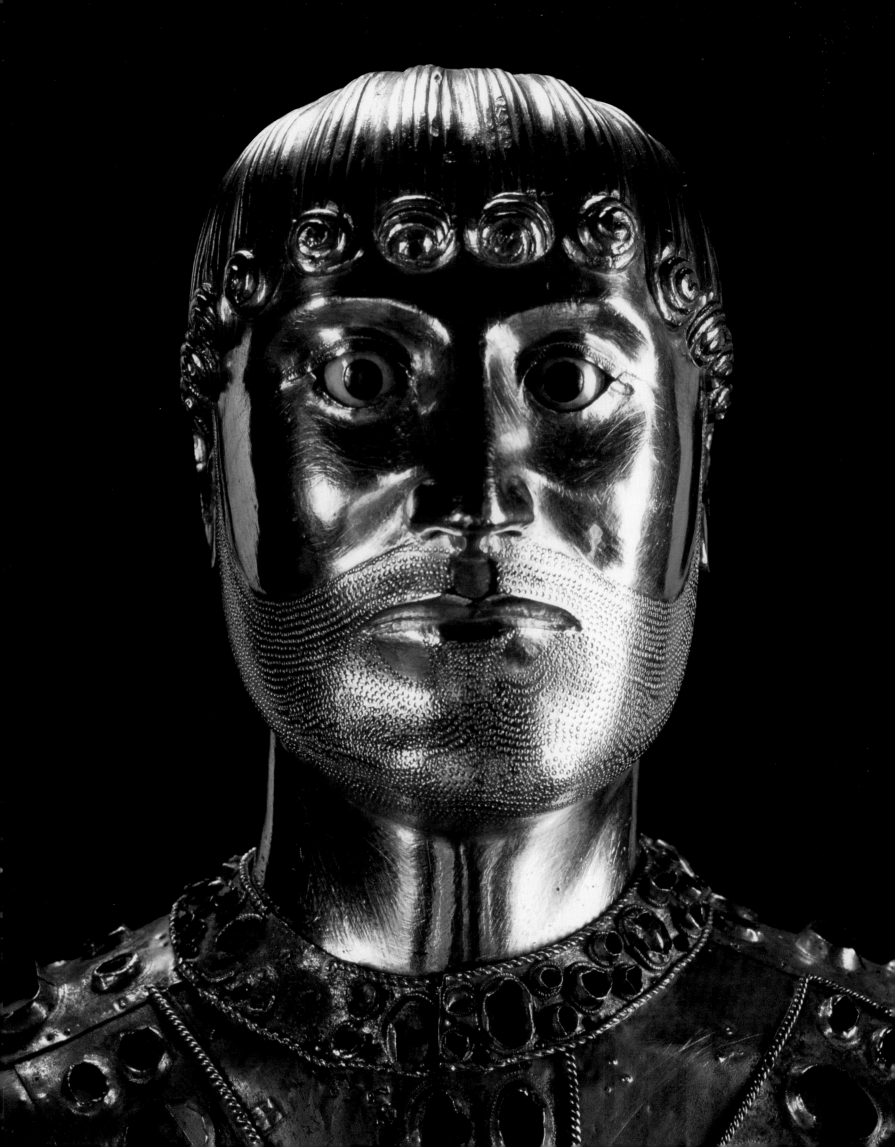

Abbreviations

AASS	*Acta Sanctorum* (Paris, 1863–1940)
Arch. Bibl.	Biblioteca Apostolica Vaticana, fondo *Archivio Biblioteca*
BullMon	*Bulletin monumental*
BWAG	*Bulletin of the Walters Art Gallery*
CCCM	Corpus christianorum, Continuatio mediaevalis
CCSG	Corpus christianorum, Series graeca
CCSL	Corpus christianorum, Series latina
CMA Bulletin	*Bulletin of the Cleveland Museum of Art*
CSEL	Corpus scriptorum ecclesiasticorum latinorum
DOP	*Dumbarton Oaks Papers*
ICUR	*Inscriptiones Christianae Urbis Romae* (Rome, 1857–61, 1888)
JAC	*Jahrbuch für Antike und Christentum*
JWAG	*Journal of the Walters Art Gallery*
JWAM	*Journal of the Walters Art Museum*
LCI	*Lexikon der christlichen Ikonographie,* 8 vols. (Rome, 1968–76)
LMA	*Lexikon des Mittelalters,* 9 vols. (Munich and Zurich, 1977–95)
LThK	*Lexikon für Theologie und Kirche,* 10 vols. (Freiburg im Breisgau, 1957–65)
MGH Ep	Monumenta Germaniae historica, Epistolae
MGH ScriptRerMerov	Monumenta Germaniae historica, Scriptores rerum Merovingicarum
MGH SS	Monumenta Germaniae historica, Scriptores
MMAB	*The Metropolitan Museum of Art Bulletin*
PG	Patrologiae cursus completus, Series graeca, ed. J.-P. Migne (Paris, 1857–66)
PL	Patrologiae cursus completus, Series latina, ed. J.-P. Migne (Paris, 1844–80)
RAC	*Reallexikon für Antike und Christentum*
RACr	*Rivista di Archeologia Cristiana*
RQ	*Römische Quartalschrift für christliche Altertumskunde und Kirchengeschichte*

Abbreviated References

Aachen 1965. *Karl der Große: Werk und Wirkung*. Exh. cat., Rathaus zu Aachen und Kreuzgang des Domes.

Aachen 1972. E. G. Grimme. *Der Aachener Domschatz*. Exh. cat., Museumsverein Aachen. Aachener Kunstblätter 42. Düsseldorf.

Abou-el-Haj 1983. B. Abou-el-Haj. "Bury St Edmunds Abbey between 1070 and 1124: A History of Property, Privilege, and Monastic Art Production." *Art History* 6:1–29.

Ackerman 1936. P. Ackerman. "A Gold-Woven Byzantine Silk of the Tenth Century." *Revue des arts asiatiques* 10:86–91.

Adolph Hess AG and William Schwab 1957. *Bedeutende Kunstwerke aus dem Nachlaß Dr. Jacob Hirsch*. Auction cat., Lucerne: Adolph Hess AG and William Schwab.

Albersmeier 2005. S. Albersmeier. *Bedazzled: 5000 Years of Jewelry*. Baltimore.

Altötting 2006. R. Eikelmann. *Von Paris nach Bayern: Das Goldene Rossl und Meisterwerk der französischen Hofkunst 1400*. Exh. cat., Stadtgalerie Altötting.

Amsterdam 2000. H. van Os, ed. *The Way to Heaven: Relic Veneration in the Middle Ages*. Exh. cat., Amsterdam: Nieuwe Kerk. Baarn.

Andechs 1993. J. Kirmeier and E. Brockhoff, eds. *Herzöge und Heilige: Das Geschlecht der Andechs-Meranier im europäischen Hochmittelater*. Veröffentlichungen zur bayerischen Geschichte und Kultur 24. Exh. cat., Kloster Andechs. Regensburg.

Angiolini 1970. A. Angiolini. *La capsella eburnea di Pola*. Studi di Antiquità Cristiane 7. Bologna.

Archaeological Institute of Great Britain and Ireland 1848. "Archaeological Intelligence." *The Archaeological Journal* 5:154–67.

Asturias 2008. C. Garcia de Castro Valdés, ed. *Signum Salutis: Cruces de orfebrería de los siglos V al XII*. Exh. cat., Asturias: Consejería de Cultura y Turismo. Oviedo.

Athens 2000. M. Vassilaki, ed. *The Mother of God: Representations of the Virgin in Byzantine Art*. Exh. cat., Athens: Benaki Museum. Milan.

Athens 2002. D. Papanikola-Bakirtzi, ed. *Everyday Life in Byzantium*. Exh. cat., Athens: Museum of Byzantine Culture.

Aylesbury 1995. T. Raison and R. Shepherd, eds. *We Three Kings: The Magi in Art and Legend*. Exh. cat., Aylesbury: Buckinghamshire County Museum.

Baert 2004. B. Baert. *A Heritage of Holy Wood: The Legend of the True Cross in Text and Image*, trans. L. Preedy. Leiden.

Baltimore 1962. P. Verdier, ed. *The International Style: The Arts in Europe around 1400*. Exh. cat., Baltimore: The Walters Art Gallery.

Baltimore 1986. M. M. Mango, ed. *Silver from Early Byzantium: the Kaper Koraon and Related Treasures*. Exh. cat., Baltimore: The Walters Art Gallery.

Baltimore 1988. R. Wieck, ed. *Time Sanctified: The Book of Hours in Medieval Art and Life*. Exh. cat., Baltimore: The Walters Art Gallery. New York.

Baltimore 2002. W. Noel and D. Weiss, eds. *The Book of Kings: Art, War, and the Morgan Library's Medieval Picture Bible*. Exh. cat., Baltimore: The Walters Art Museum.

Barbier de Montault 1879. X. Barbier de Montault. "Le trésor de la cathédrale de Moûtiers." *BullMon* 45:545–62.

Barcelona 2004. *Objecte i memoria*. Exh. cat., Barcelona: Museu Frederic Mares.

Barucca 1992. G. Barucca. "I reliquiari donate da Niccolò Perotti a Sassoferrato." *Studi Umanistici Piceni* 12:9–46.

Becks and Lauer 2000. L. Becks and R. Lauer. *Die Schatzkammer des Kölner Domes*. Meisterwerke des Kölner Domes 6. Cologne.

Bede, trans. Sherley-Price 1990. *Bede: Ecclesiastical History of the English People: With Bede's Letter to Egbert and Cuthbert's Letter on the Death of Bede*, trans. L. Sherley-Price, rev. trans. R. E. Latham. London.

Beissel 1902. S. Beissel. *Die Aachenfahrt. Verehrung der Aachener Heiligtümer seit den Tagen Karls des Großen bis in unsere Zeit*. Ergänzungsheft zu den Stimmen aus Maria Laach 82. Freiburg im Breisgau.

Beliaev 1929. N. M. Beliaev. "Khersonesskaia moshchekhranitel'nitsa." *Seminarium Kondakovianum* 3:115–32

Belting 1990. H. Belting. *The Image and Its Public in the Middle Ages: Form and Function of Early Paintings of the Passion*, trans. M. Bartusis and R. Meyer. New Rochelle, N.Y.

Bentz 1997/98. K. M. Bentz. "Rediscovering the Licinian Tomb." *JWAG* 55/56:63–88.

Berlin 1989. *Europa und der Orient, 800–1900*. Exh. cat., Berliner Festspiele.

Bertaux 1898. E. Bertaux. "Le bras-reliquaire de saint Louis de Toulouse." *Chronique des Arts et de la curiosité* 1898:45–46

Bertrand 1993. E. Bertrand. *Brimo de Laroussilhe: Sculptures et objets d'art précieux du XIIe au XVIe siècle*.

Bertrand 1995. E. Bertrand. *Émaux limousins du Moyen Âge*. Paris.

Bianchini 1752. F. Bianchini. *Demonstratio historiae ecclesiasticae quadripartitae comprobatae monumentis pertinentibus ad fidem temporum et gestorum*, 3 vols. Rome.

Biehl 1919–32. W. Biehl. "Die Staurothek von Vicopisano." *Mitteilungen des kunsthistorisches Instituts in Florenz* 3:183–85.

Bisconti 1997. F. Bisconti. "Il luceranrio di S. Cecilia: Recenti restauri e nuove acquisizioni nella cripta callistiana di S. Cecilia." *RACr* 73:307–39.

Bisconti 1998. F. Bisconti. "L'evoluzione delle strutture iconografiche alle soglie del VI secolo in Occidente. Il ruolo delle decorazioni pittoriche e musive nelle catacombe romane e napoletane." In *Acta XIII Congressus Internationalis Archaeologiae Christianae, Split-Poreč 1994*, 253–82. Vatican.

Bober 1975. H. Bober. "Mosan Reliquary Triptych." In *The Guennol Collection*, ed. I. E. Rubin, 151–64. New York.

Bock 1896. F. Bock. *Die byzantinischen Zellenschmelze der Sammlung Dr. Alex. von Swenigorodskoï und das darüber veröffentlichte Prachtwerk*. Aachen.

Boehm 1990. B. D. Boehm. "Head Reliquaries of the Massif Central." Ph.D. diss., New York University.

Boehm 2006. B. D. Boehm. "Une croix-reliquaire limousine au musée du Berry." *Revue des musées de France/Revue du Louvre* 56, no. 4: 28–37.

Bohn and Bernal 1857. H. G. Bohn and R. Bernal. *A Guide to the Knowledge of Pottery, Porcelain, and Other Objects of Vertu*. London.

Boldetti 1720. M. A. Boldetti. *Osservazioni sopra i Cimiteri de' Santi martiri ed antichi cristiani di Roma*. Rome.

Bonn 2010. F. Daim, ed. *Byzanz: Pracht und Alltag*. Exh. cat., Bonn: Kunst- und Ausstellungshalle der Bundesrepublik Deutschland. Munich.

Borenius 1932. T. Borenius. *St. Thomas Becket in Art*. London.

Boskovits and Brown 2003. M. Boskovits and D. A. Brown, eds. *Italian Paintings of the Fifteenth Century*. Systematic Catalogue of the National Gallery of Art. Washington, D.C., and Oxford

Boston 1995. N. Netzer and V. Reinburg, eds. *Memory and the Middle Ages*. Exh. cat., Boston College Museum of Art. Chestnut Hill, Mass.

Bouillart 1724. J. Bouillart. *Histoire de l'église de Saint-Germain des Prez*. Paris.

Bourke 1980. C. Bourke. "Early Irish Hand-Bells." *Journal of the Royal Society of Antiquaries of Ireland* 110:52–66.

Brandenburg 1972. H. Brandenburg. "Ein frühchristliches Relief in Berlin." *Mitteilungen des Deutschen Archäologischen Instituts, Römische Abteilung* 79:123–54.

Brandt 1985. K. Brandt. "Die früh- und hochmittelalterliche Entwicklung von Emden." In *Stadt im Wandel: Kunst und Kultur des Bürgertums in Norddeutschland 1150–1650*, vol. 3, ed. C. Meckseper, 151–66. Stuttgart-Bad Cannstatt.

Brandt 1998. K. Brandt. "Aus dem Kunstkreis Heinrichs des Löwen? Anmerkungen zu Laurentius- und Apostelarm aus dem Welfenschatz." In Ehlers and Kötzsche 1998, 353–68.

Branner 1971. R. Branner. "The Grande Châsse of the Sainte-Chapelle." *Gazette des Beaux-Arts* 113:5–18.

Braunfels 1972. W. Braunfels, ed. *Der Hedwigs-Codex von 1353: Sammlung Ludwig*. 2 vols. Berlin.

Braunschweig 1995. J. Luckhardt and F. Neihoff, eds. *Heinrich der Löwe und die Kunst seiner Zeit*. 4 vols. Exh. cat., Braunschweig: Herzog Anton Ulrich-Museum. Munich.

Breck 1918. J. B. Breck. "A Reliquary of Saint Thomas Beckett Made for John of Salisbury." *MMAB* 13, no. 10: 220–24.

Bregenz 2008. T. G. Natter, ed. *Gold. Schatzkunst zwischen Bodensee und Chur*. Exh. cat., Bregenz: Vorarlberger Landesmuseum. Ostfildern.

Brisbane 1988. *The Holy See: Vatican Collections*. Exh. cat., Brisbane: World Expo.

Brubaker 1999. L. Brubaker. "The Chalke Gate, the Construction of the Past, and the Trier Ivory." *Byzantine and Modern Greek Studies* 23:258–85.

Brussels 1982. J. Lafontaine-Dosogne. *Splendeur de Byzance*. Exh. cat., Brussels: Musées Royaux d'Art et d'Histoire.

Buckton 1994a. D. Buckton, "'All that glisters . . .' Byzantine Enamel on Copper." In *Thymiama: Ste mneme tes Laskarinas Boura*, vol. 1: *Keimena,* ed. L. Boura, 47–49. Athens.

Buckton 1994b. D. Buckton. *Byzantium: Treasures of Byzantine Art and Culture from British Collections*. London.

Buddensieg 1959. T. Buddensieg. "Le Coffret en ivoire de Pola, Saint-Pierre et le Lateran." *Cahiers Archéologiques* 10:157–200.

Bühl 2008. G. Bühl, ed. *Dumbarton Oaks: The Collections*. Washington, D.C.

Bühler 1963. A. Bühler. "Die heiliger Lanze: Ein ikonographischer Beitrag zur Geschichte der deutschen Reichskleinodien." *Das Münster* 16:85–116.

Buonarroti 1716. F. Buonarroti. *Osservazioni sopra alcuni frammenti di vasi antichi, di vetro ornati di figure trovati ne' cimiteri di Roma*. Florence.

Buschhausen 1971. H. Buschhausen. *Die spätrömischen Metallscrinia und frühchristlichen Reliquiare*, vol. 1: *Katalog*. Wien Byzantinische Studien 9. Vienna.

Büttner 2000. A. Büttner. *Perlmutt: Von der Faszination eines Goettlichen Materials*. Petersberg.

Calcagnini 1988. D. Calcagnini. "Nota iconografica: la stella e il vaticinio del Vecchio Testamento nell'iconografia funeraria del III e IV secolo." *RACr* 64:65–87.

Camber, La Neice, and Webster forthcoming. R. Camber et al. *"A Newly Discovered Anglo-Saxon Chrismatory c. AD 800."*

Cappi 1846. A. Cappi, *Prose artistiche e letterarie*. Rimini.

Carboni 2001. S. Carboni, ed. *"Ars Vitraria:* Glass in the Metropolitan Museum of Art." *MMAB* 59, no. 1.

Cárdenas 2002. L. Cárdenas. *Friedrich der Weise und das Wittenberg Heiltumsbuch: Mediale Repräsentation zwischen Mittelalter und Neuzeit*. Berlin.

Catania 2008. *Agata santa: Storia, arte, devozione*. Exh. cat., Catania: Museo Diocesano, Florence.

Catello 1975. E. and C. Catello. *L'oreficeria a Napoli nel XV secolo*. Naples.

Caudron 1977. S. Caudron. "Connoisseurs of Champlevé Limoges Enamels in Eighteenth-Century England." *British Museum Yearbook* 2:9–33.

Caudron 1993. S. Caudron. "Les châsses reliquaires de Thomas Becket émaillé à Limoges: Leur géographique historique." *Bulletin de la Société Archéologique et Historique du Limousin* 121:55–83.

Caudron 1999. S. Caudron. "Thomas Becket et l'oeuvre de Limoges." In Limoges 1999, 56–68.

Champeaux 1888–98. A. de Champeaux. *Portefeuille des arts décoratifs*. 10 vols. Paris.

Cherry forthcoming. J. Cherry. *The Holy Thorn Reliquary*. London.

Cioni 1998. E. Cioni. *Scultura e smalto nell'oreficeria senese dei secoli XIII e XIV*. Florence.

Clayhil and Cherry1997. M. Clayhil and J. Cherry, eds. *A. W. Franks: Nineteenth-Century Collecting and the British Museum*. London.

Cleveland 1967. W. D. Wixom, ed. *Treasures from Medieval France*. Exh. cat., Cleveland Museum of Art.

Cleveland 1975. W. D. Wixom. *Renaissance Bronzes from Ohio Collections*. Exh. cat., Cleveland Museum of Art

Cleveland 1998. R. Bergman, ed. *Vatican Treasures: Early Christian, Renaissance, and Baroque Art from the Papal Collections*. Exh. cat., Cleveland Museum of Art.

Cologne 1972. A. Legner, ed. *Rhein und Mass: Kunst und Kultur, 800–1400*. Exh. cat., Cologne: Schnütgen-Museum.

Cologne 1975. A. Legner, ed. *Monumenta Annonis—Köln und Siegburg: Weltbild und Kunst im hohen Mittelalter*. Exh. cat., Cologne: Schnütgen Museum.

Cologne 1985. A. Legner. *Ornamenta Ecclesiae. Kunst und Künstler der Romanik*. 3 vols. Exh. cat., Cologne: Schnütgen Museum.

Cologne 1995. *Un trésor gothique: La châsse de Nivelles*. Exh. cat., Cologne: Schnütgen Museum. Paris.

Cooke 1825. T. L. Cooke. "Description of the Barnaan Cuilawn, and Some Conjectures upon the Original Use Thereof." *Transactions of the Royal Irish Academy* 14 (Antiquity): 31–46.

Cooke 1853. T. L.Cooke. "On Ancient Irish Bells." *Transactions of the Kilkenny Archaeological Society for the Year 1852*, vol. 2, no. 1: 7.

Corblet 1868. "Précis de l'histoire de l'art chrétien en France et en Belgique." *Revue de l'art chrétien* 12:499–501.

Cordez 2004. P. Cordez. "Wallfahrt und Medienwettbewerb: Serialität und Formenwandel der Heiltumsverzeichnisse mit Reliquienbildern im Heiligen Römischen Reich (1460–1520)." In *"Ich armer sundiger mensch": Heiligen- und Reliquienkult am Übergang zum konfesionellen Zeitalter*, ed. A. Tacke, 37–73. Göttingen.

Cormack 2007. R. Cormack. *Icons*. London.

Cornaro 1749. F. Cornaro. *Ecclesiae venetae antiquis monumentis nunc etiam primum editis illustratae ac in decades distributae*.13 vols. Venice.

Cornaro 1758. F. Cornaro. *Notizie storiche delle chiese e monasteri die Venezia e di Torcello*. Padua.

Crawford 1922. H. S. Crawford. "Notes on the Irish Bell-Shrines in the British Museum and the Wallace Collection." *Journal of the Royal Society of Antiquaries of Ireland* 52:1–9.

Crooke y Navarrot 1898. J. B. Crooke y Navarrot. *Catalogo historico-descriptivo de la real Armeria de Madrid*. Madrid.

Cutler 1995. A. Cutler. "From Loot to Scholarship: Changing Modes in the Italian Response to Byzantine Artifacts, ca. 1200–1750." *DOP* 49:237–67.

d'Auvergne 1859. A. d'Auvergne. "Notice sur le buste de saint Baudime conservé dans l'église de Saint-Nectaire (Puy-de-Dôme)." *Revue des sociétés savantes*, ser. 2, 1:1–4.

Dalton 1901. O. M. Dalton. *Catalogue of Early Christian Antiquities and Objects from the Christian East in the Department of British and Mediaeval Antiquities and Ethnography of the British Museum*. London.

Dalton 1909. O. M. Dalton. *Catalogue of the Ivory Carvings of the Christian Era with Examples of Mohammedan Art and Carvings in Bone in the Department of British and Mediaeval Antiquities and Ethnography of the British Museum*. London.

Dalton 1926. O. M. Dalton. "An Enamelled Gold Reliquary of the Twelfth Century." *The British Museum Quarterly* 1:33–35.

Dalton 1927. O. M. Dalton. *The Waddesdon Bequest: Jewels, Plate, and Other Works of Art Bequeathed by Baron Ferdinand Rothschild*. London.

Darcel 1865. A. Darcel. "Musée retrospectif: Les nielles—Les emaux." *Gazette des Beaux-Arts* 1865:508–10.

De Benedictis 1974. C. De Benedictis. "Naddo Ceccarelli." *Commentari* 25, no. 29: 139–54.

De Selincourt 1905. B. D. de Selincourt *Homes of the First Franciscans in Umbria: The Borders of Tuscany and the Northern Marches*. London.

De Winter 1985. P. M. de Winter. "The Sacral Treasures of the Guelphs." *CMA Bulletin* 72, no. 1: 2–160.

Deichmann 1989. F. W. Deichmann. *Ravenna, Hauptstadt des spätantiken Abendlandes*, vol. 2: *Kommentar*, part 3: *Teil*. Stuttgart.

Deichmann, Bovini, and Brandenburg 1967. F. W. Deichmann, G. Bovini, and H. Brandenburg, eds. *Repertorium der christlich-antiken Sarkophage*, vol. 1: *Rom und Ostia*. Wiesbaden 1967.

Delbrueck 1929. R. Delbrueck. *Die Konsulardiptychen und verwandte Denkmäler*. Studien zur spätantiken Kunstgeschichte 2. Berlin.

Deuchler 1963. F. Deuchler, ed. *De Burgunderbeute: Inventar der Beutestücke aus den Schlchten von Grandson, Murten und Nancy 1476/77*. Bern.

Di Stefano Manzell 1997. I. Di Stefano Manzella, ed. *Le iscrizioni dei Cristiani in Vaticano: Materiali e contributi per una mostra epigrafica*. Vatican.

Didron 1869. A. Didron. "Les images ouvrantes." *Annales archéologiques* 26:410–21.

Diedrichs 2001. C. L. Diedrichs. *Von Glauben zum Sehen: die Sichtbarkeit der Reliquie im Reliquiar: ein Beitrag zur Geschichte des Sehens*. Berin.

Dončeva-Petkova 1979: L. Dončeva-Petkova. "Croix d'or–reliquaire de Pliska." *Izvestiia na Arkheologicheskiia institut* 35:74–91.

Dončeva-Petkova 1992: L. Dončeva-Petkova, "Sgradi pri iuzhniia sektor na zapadnata krepostna stena na Pliska." *Pliska-Preslav* 5:123–45.

Donnelly and Smith 1961. M. C. Donnely and C. S. Smith. "Notes on a Romanesque Reliquary." *Gazette des Beaux-Arts* 58:109–19.

Du Sommerard 1838–46. A. Du Sommerard. *Les arts au Moyen Âge*. 5 vols. Paris.

Durliat 1986. M. Durliat. *St-Sernin de Toulouse à l'époque romane*. Toulouse.

Effenberger 1983. A. Effenberger. "Ein byzantinisches Emailkreuz mit Besitzerinschrift." *Cahiers archéologiques* 31:114–27.

Egbert 1970. V. W. Egbert. "The Reliquary of Saint Germain." *The Burlington Magazine* 112:359–69.

Eickolt 1867. E. Eickolt. "Über ein Kreuzreliquiar des vormaligen Mariengradenstifts zu Köln." *Kölner Domblatt* 263:10–12.

Engemann 1972. J. Engemann. "Anmerkungen zu spätantiken Geräten des Alltagslebens mit christlichen Bildern, Symbolen und Inschriften." *JAR* 15:154–73.

Engemann 1973. J. Engemann. "Palästinensische Pilger-ampullen im F. J. Dölger-Institut in Bonn." *JAC* 16:5–27.

Engemann 2001. J. Engemann. "Pilgerwesen und Pilgerkunst." In *Byzanz. Das Licht aus dem Osten. Kunst und Alltag im Byzantinischen Reich vom 4. bis zum 15. Jahrhundert*, ed. C. Stiegmann, 45–52. Exh. cat., Paderborn: Erzbischöfliches Diözesanmuseum. Mainz.

Engemann 2002. J. Engemann. "Palästinensische Pilger-ampullen: Erstveröffentlichungen und Berichtigungen." *JAC* 45:153–69.

Erlande-Brandenburg 1972. A. Erlande-Brandenburg. "Aspects méconnus du mécénat de Charles V. La sculpture decorative." *BullMon* 130:338–39.

Euw and Plotzek 1982. A. von Euw and J. M. Plotzek. *Die Handschriften der Sammlung Ludwig*. 4 vols. Cologne.

Evans 1953. J. Evans. *A History of Jewellery*, London, 1953.

F. C. 1886. F. C. "Buste de Saint Césaire à Maurs." *Bulletin de la société scientifique, historique et archéologique de la Corrèze* 8:675–80.

Faedo 1978. L. Faedo. "Per una classificazione preliminare dei vetri dorati tardoromani." *Annali della Scuola normale superiore di Pisa* 8:1025–70.

Falke 1908. O. von Falke. "L'orfèvrerie et l'émaillerie au XVe siècle." In *Histoire de l'art*, vol. 3, part 2, ed. A. Michel, 865–96. Paris.

Falke 1936. O. von Falke. *Kunstgeschichte der Seidenweberei*, 3rd ed. Berlin.

Falke, Schmidt, and Swarzenski 1930. O. von Falke, R. Schmidt, and G. Swarzenski, eds. *The Guelph Treasure*. Frankfurt.

Ficker 1890. J. Ficker. *Die altchristlichen Bildwerke im Christlichen Museum des Laterans*. Leipzig.

Fillitz 2001. H. Fillitz. *Die gruppe der Magdeburger Elfenbeintafeln*. Mainz.

Fillitz and Pippal 1987. H. Fillitz and M. Pippal. *Schatzkunst: Die Goldschmiede- und Elfenbeinarbeiten aus österreichischen Schatzkammern des Hochmittelalters*. Salzburg and Vienna.

Fischer 1969. B. Fischer. "Die Elfenbeintafel des Trierer Domschatzes: Zu ihrer jüngsten Deutung durch Stylianos Pelikades 1952." *Kurtrierisches Jahrbuch* 9:5–19.

Folda 1995. J. Folda. *The Art of the Crusaders in the Holy Land: 1098–1187*. New York.

Fontevraud 2001. *L'Europe des Anjou: Aventure des princes angevins du XIIIe au XVe siècle*. Exh. cat., Fontevraud: Abbaye royale de Fontevraud.

Forsyth 1995. E. H. Forsyth. "Art with History: The Role of Spolia in the Cumulative Work of Art." In *Byzantine East, Latin West: Art Historical Studies in honor of Kurt Weitzmann*, ed. C. Moss and K. Kiefer, 153–62. Princeton.

Franks 1856. A. W. Franks. "Antiquities and Works of Art Exhibited." *Archaeological Journal* 13:87–89.

Frend 1996. W. C. H. Frend. *The Archaeology of Early Christianity: A History*. London.

Freuler 1994. G. Freuler. *Bartolo di Fredi Cini: Ein Beitrag zur sienesischen Malerei des 14. Jahrhunderts*. Disentis.

Fritz 1982. J. M. Fritz. *Goldschmiedekunst der Gotik in Mitteleuropa*. Munich.

Frolow 1961a. A. Frolow. *La relique de la vraie croix: Recherches sur le développement d'un culte*. Archives de l'Orient Chrétien 7. Paris.

Frolow 1961b. A. Frolow. «Le culte de la relique de la vraie croix.» *Byzantinoslavica* 22:320–27.

Frolow 1965. A. Frolow. *La relique de la vraie croix*. Archives de l'Orient Chrétien 8. Paris.

Frolow 1966. A. Frolow. "Le médaillon byzantin de Charroux." *Cahiers Archéologiques* 16:39–50.

Frolow 1971. A. Frolow. "Reliquie orientali e reliquiari bizantini." In *Il Tesoro e il Museo* [Il Tesoro di San Marco 2], ed. H. R. Hahnloser, 31–41. Florence.

Fowler 1899. C. Fowler, ed. "Liber de Reliquiis, 1383." In *Extracts from the Account Rolls of the Abbey of Durham: From the Original Mss.* [Surtees Society 100], 425–40.

Gabhart 1971. A. Gabhart. *Treasures and Rarities: Renaissance, Mannerist and Baroque.*

Gaborit-Chopin 1970. D. Gaborit-Chopin. "Chronique." *BullMon* 128:247–48.

Gaborit-Chopin 1985. D. Gaborit-Chopin. "Le bras-reliquaire de saint Luc au musée du Louvre." *Antologia di Belle Arti* 27–28:5–18.

Gaborit-Chopin 2003. D. Gaborit-Chopin. *Département des Objets d'art du Musée du Louvre, Catalogue: Ivoires médiévaux*. Paris.

Gallo 1967. R. Gallo. *Il Tesoro di San Marco e la sua storia*. Florence.

Garrucci 1858. R. Garrucci. *Vetri ornati di figure in oro trovati nei cimiteri cristiani di Roma*. Rome.

Garrucci 1864. R. Garrucci. *Vetri ornati di figure in oro trovati nei cimiteri cristiani di Roma*, 2nd ed. Rome.

Garrucci 1872–80. R. Garrucci. *Storia dell'Arte Cristiana nei primi otto secoli della chiesa*. 6 vols. Prato.

Gauthier 1950. M.-M. Gauthier. *Emaux limousins champlevés des XIIe, XIIIe et XIV siècles*. Paris.

Gauthier 1972. M.-M. Gauthier. *Émaux du Moyen Âge occidental*. Fribourg.

Gauthier 1983. M.-M. Gauthier. *Les routes de la foi: Reliques et reliquaires de Jerusalem à Compostelle*. Paris.

Gauthier 1987. M.-M. Gauthier. *Emaux méridionaux: Catalogue international de l'oeuvre de Limoges*, vol. 1. Paris.

Genoa 2004. G. Wolf, C. Dufour Bozzo, and A. R. Calderoni Masetti, eds. *Mandylion: Intorno al Sacro Volto, da Bisanzio a Genova*. Exh. cat., Genoa: Museo diocesano. Milan.

Georgiev 2006: P. Georgiev. "Odessos-Theodoriada: A Centre of Monophysitism during the Sixth Century (The Djanavara Church and Its Syro-Mesopotamian Features)." In *Early Christian Martyrs and Relics and Their Veneration in East and West* [Acta Musei Varnaensis 4], ed. A. Michev and V. Iotov, 291–308. Varna.

Geroulanou 1999. A. Geroulanou. *Diatrita: Gold Pierced-work Jewellery from the 3rd to the 7th Century*. Athens.

Giovio 1561. P. Giovio. *Le Vite di dicenove huomini illustri, descritte da monsignor Paolo Giovio, et in diversi tempi et luoghi stampate.* Venice.

Gnirs 1908. A. Gnirs. "La basilica e il reliquiario d'avorio di Samagher presso Pola." *Atti e Memorie della Società Istriana di Archeologia e Storia Patria* 24, no. 2: 5–48.

Gordon 1981. D. Gordon. "A Sienese Verre Églomisé and Its Setting." *The Burlington Magazine* 122:148–53.

Gose 1958. E. Gose. *Katalog der frühchristlichen Inschriften in Trier.* Trierer Grabungen und Forschungen Band 3. Berlin.

Gosebruch 1979. M. Gosebruch. "Die Braunschweiger gertrudiswerkstatt. Zur spätottonischen Goldschmiedekunst in Sachsen." *Niederdeutsche Beiträge zur Kunstgeschichte* 18:9–42.

Gottschalk 1967. J. Gottschalk. "Die älteste Bilderhandschrift mit den Quellen zum Leben der hl. Hedwig, im Auftrag des Herzogs Ludwig I. von Liegnitz und Brieg im Jahre 1353 vollendet." *Aachener Kunstblätter* 34:61–161.

Goy 1909. M. de Goy. "Au musée de Bourges." *Mémoires de la société des Antiquaires du Centre* 32:3–10.

Grabar 1950. A. Grabar. "Quelques reliquaires de saint Démétrios et le martyrium du saint à Salonique." *DOP* 5:3–28.

Grabar 1954. A. Grabar. "Un nouveau reliquaire de saint Démétrios." *DOP* 8:307–13.

Grabar 1957. A. Grabar. "Le reliquaire byzantin de la cathédrale d'Aix-la-Chapelle." In *Karolingische und Ottonische Kunst. Werden, Wesen, Wirkung*, 282–97. Wiesbaden. Reprinted in *L'art de la fin de l'antiquité et du Moyen Âge*, 1:427–33. Paris, 1968.

Grabar 1958. A. Grabar. *Ampoules de Terre Sainte (Monza–Bobbio).* Paris.

Grimme 1965. E. G. Grimme. "'Die Lukasmadona' und das 'Bustkreuz Karls des Großen'." In *Miscellanea Pro Arte; Hermann Schnitzler zur Vollendung des 60. Lebensjahres am 13. Januar 1965*, ed. P. Bloch and J. Hoster, 48–54. Düsseldorf.

Grisar 1908. H. Grisar. *Die römische Kapelle Sancta Sanctorum und ihr Schatz.* Freiburg.

Guarducci 1978. M. Guarducci. *La capsella eburnea di Samagher: Un cimelio di arte paleochristiana nella storia del tardo Impero.* Trieste.

Guillou 1996. A. Guillou, ed. *Recueil des inscription grecques médiévales d'Italie.* Rome.

Guscin 2009. M. Guscin. *The Image of Edessa.* Leiden.

Hahn 1991. C. Hahn. "'Peregrinatio et natio' The Illustrated Life of Edmund, King and Martyr." *Gesta* 30:119–39.

Hahnloser 1971. H. R. Hahnloser. "Reliquiario del braccio di San Giorgio." In *Il Tesoro e il Museo* [Il Tesoro di San Marco 2], ed. H. R. Hahnloser, 162–63. Firenze.

Halkin 1985. F. Halkin. *Le ménologe imperial de Baltimore: Textes grecs publiés et traduits.* Brussels.

Hamburger 2009. J. S. Hamburger. «Representations of Reading—Reading Representations: The Female Reader from the 'Hedwig Codex' to Châtillon's 'Léopoldine au Livre d'Heures'.» In *Die lesende Frau*, ed. G. Signori, 177–236. Wiesbaden.

Hayward 1974. J. F. Hayward. "Salomon Weininger, Master Faker." *The Connoisseur* 187:170–79.

Hayward 2003. J. Hayward. *English and French Medieval Stained Glass in the Collection of the Metropolitan Museum of Art*, vol. 1. Corpus Vitrearum, United States of America, part 1. New York.

Heinen 1996. H. Heinen, *Frühchristliches Trier. Von den Anfängen bis zur Völkerwanderung.* Trier.

Henning 2007. J. Henning. "Katalog archäologischer Funde aus Pliska." In *Post-Roman Towns, Trade and Settlement in Europe and Byzantium*, vol. 2: *Byzantium, Pliska and the Balkans*, ed. J. Henning. Berlin and New York.

Hertlein 1965. E. Hertlein. "Capolavori francesi in San Francesco d'Assisi." *Antichità viva* 4, no. 4:54–70.

Hess 2002. K. M. Hess. "The Saint's Presence and the Power of Representation: A Reliquary Box Depicting the Life of St. John Prodromos." MA thesis, Pennsylvania State University.

Hildburgh 1936. W. L. Hildburgh. *Medieval Spanish Enamels and Their Relation to the Origin and the Development of Copper Champlevé Enamels of the Twelfth and Thirteenth Centuries.* London.

Hildesheim 1993. M. Brandt and A. Eggebrecht, eds. *Bernward von Hildesheim und das Zeitalter der ottonen.* Exh. cat., Hildesheim: Dom- und Diözesanmuseum.

Hildesheim 1998. M. Brandt and A. Effenberger, eds. *Byzanz: Die Macht der Bilder.* Exh. cat., Hildesheim: Dom-Museums. Berlin.

Hildesheim 2001. M. Brandt, ed. *Abglanz des Himmels: Romanik in Hildesheim.* Exh. cat., Hildesheim: Dom-Museums. Regensburg.

Holbert 1995. K. Holbert. "Mosan Reliquary Triptychs and the Cult of the True Cross in the Twelfth Century." Ph.D. diss., Yale University.

Holbert 1996. K. Holbert. "Solving the Mystery of a Limoges Enamel Shrine" *BWAG* 49 (October): 2–3

Holbert 2005. K. Holbert. "Relics and Reliquaries of the True Cross." In *Art and Architecture of Late Medieval Pilgrimage in Northern Europe and the British Isles*, ed. S. Blick and R. Tekippe, 337–63. Lieden.

Holum and Vikan 1979. K. Holum and G. Vikan. "The Trier Ivory, Adventus Ceremonial and the Relics of St. Stephen." *DOP* 33:115–33.

Hoving 1965. T. P. F. Hoving. "A Newly Discovered Reliquary of St. Thomas Becket" *Gesta* 4 (Spring): 28–30.

Hoving 1969. T. P. F. Hoving. "Valuables and Ornamental Items. The Collection of Mr. and Mrs. Alastair Bradley Martin." *MMAB* 28, no. 3: 147–60.

Hübener 1983. S. Hübener. "Das Kreuzreliquiar aus Mariengraden im Kölner Domschatz." *Kölner Domblatt* 48:231–74.

Jacob 1848–51. P. L. Jacob. *Le Moyen Âge et la Renaissance: Histoire et description des mœurs et usages, du commerce et de l'industrie, des sciences, des arts, des littératures, et des beaux-arts en Europe.* 5 vols. Paris.

Jalabert and Mourterde 1959. L. Jalabert and R. Mourterde, eds. *Inscriptions grecques et latines de la Syrie*, vol. 5: *Émésène.* Paris.

Johnston 1984. W. Johnston, ed. *The Taste of Maryland: Art Collecting in Maryland, 1800–1934.* Baltimore.

Jones 1990. M. Jones, ed. *Fake? The Art of Deception.* London.

Kalavrezou-Maxeiner 1985. I. Kalaverezou-Maxeiner. *Byzantine Icons in Steatite.* 2 vols. Vienna.

Kartsonis 1986. A. Kartsonis. *Anastasis: The Making of an Image.* Princeton.

Kauffmann 1975. C. M. Kauffmann. *Romanesque Manuscripts 1066–1190.* London.

Kenny 1944. M. Kenny. *Glankeen of Borrisoleigh, Tipperary Parish.* Dublin.

Kessler 2006. H. L. Kessler. "The Mondsee Gospels." In *In the Beginning: Bibles Before the Year 1000*, ed. M. Brown, 309–10. Exh. cat., Washington, DC: The Freer Gallery of Art and the Arthur M. Sackler Gallery.

Kessler 2007. H. L. Kessler. "Christ's Dazzling Dark Face." In *Intorno al Sacro Volto: Genova, Bisanzio e il Mediterraneo (secoli XI–XIV)*, ed. A. R. Calderoni Masetti, C. Dufour Bozzo, and G. Wolf, 231–46. Venice.

Kirschbaum 1954. E. Kirschbaum. "Der Prophet Balaam und die Anbetung der Weisen." *RQ* 49:129–71.

Kitzinger 1988. E. Kitzinger. "Reflections on the Feast Cycle in Byzantine Art." *Cahiers archéologiques* 36:51–73.

Klein 2004. H. A. Klein. *Byzanz, der Westen und das 'wahre' Kreuz: Die Geschichte einer Reliquie und ihrer künstlerischen Fassung in Byzanz und im Abendland.* Wiesbaden.

Koch 2000. G. Koch. *Frühlistiche Sarkophage.* Munich.

Kollwitz and Herdejürgen 1979. J. Kollwitz and H. Herdejürgen, eds. *Die Ravennatischen Sarkophage.* Die Sarkophage der westlichen Gebiete des Imperium Romanum 2: Die antiken Sarkophagereliefs 8, 2. Berlin, 1979.

Kötzsche 1994. D. Kötzsche. "Die Quedlinburger Reliquientafel." In *Studies in Medieval Art and Architecture Presented to Peter Lasko*, ed. D. Buckton and T. A. Heslop, 70–79. London.

Kötzsche-Breitenbruch 1984. L. Kötzsche-Breitenbruch. "Pilgerandenken aus dem Heiligen Land. Drei Neuerwerbungen des Württembergischen Landesmuseums in Stuttgart." In *Vivarium: Festschrift Theodor Klauser zum 90. Geburtstag*, ed. E. Dassmann and K. Thraede, 229–46. JAC, Ergänzungsband 11. Münster.

Kötzsche-Breitenbruch 1991. L. Kötzsche-Breitenbruch, "Zum Ring des Gregor von Nyssa." In *Tesserae: Festschrift für Josef Engemann*, ed. J. Engemann and E. Dassmann, 291–98 JAC, Ergänzungsband 18. Münster.

Kourkoutidou-Nikolaïdou 1981. E. Kourkoutidou-Nikolaïdou. "To egkainio basilikes sto anatoliko nekrotapheio Thessalonikes." *Archaiologike ephemeris* 1981:70–81.

Kraft 1971. K. Kraft. "Ein Reliquienkreuz des Trecento." *Pantheon* 29:102–13.

Kraus 1868. F. X. Kraus. *Der heilige Nagel in der Domkirche zu Trier*. Beiträge zur Trierischen Archaeologie und Geschichte. Trier.

Krautheimer 1947. R. Krautheimer. "Ghiberti and Master Gusmin." *Art Bulletin* 29, no. 1: 25–35.

Kren et al. 1997. T. Kren et al. *Masterpieces of the J. Paul Getty Museum: Illuminated Manuscripts*. Los Angeles.

Kroos 1985. R. Kroos. *Der Schrein des Heiligen Servatius in Maastricht*. Munich.

Kühne 2000. H. Kühne. *Ostensio Reliquiarum*. Berlin.

Künzle 1976. P. Künzle. "Das Petrusreliquiar von Samagher." *RQ* 71:22–41.

Labarte 1847. J. Labarte. *Description des objets d'art qui composent la collection Debruge-Duménil, précédée d'une introduction historique*. Paris.

Labarte 1864–66. J. Labarte. *Histoire des arts industriels au Moyen Âge et à l'époque de la Renaissance*. 6 vols. Paris.

Lamm 1930. C. J. Lamm. *Mittelalterliche Glaser und Steinschnittarbeiten aus dem nahen Osten*. 2 vols. Berlin.

Lang 1999. J. Lang. "The Imagery of the Franks Casket: Another Approach." In *Northumbria's Golden Age*, ed. J. Hawkes and S. Mills, 247–55. Stroud.

Lasko 1994. P. Lasko. *Ars Sacra, 800–1200*, 2nd ed. New Haven.

Lasko 2003. P. Lasko. "Roger of Helmarshausen, Author and Craftsman: Life, Sources of Style, and Iconography." In *Objects, Images, and the Word*, ed. C. Hourihane, 180–201. Princeton.

Lassus 1958. J. Lassus. *Les reliquaires du Musée Stéphane Gsell: Les conférences visités du Musée Stéphane Gsell, 1956–1957*. Alger.

Lauer 1906. P. Lauer. *Le Trésor du Sancta Sanctorum*. Paris.

Lawrence 1954. M. Lawrence. "Two Ravennate Monuments." In *Studies in Art and Literature for Belle da Costa Greene*, ed. D. Miner, 132–42. Princeton.

Leader-Newby 2004. R. E. Leader-Newby. *Silver and Society in Late Antiquity: Functions and Meanings of Silver Plate in the Fourth to Seventh Centuries*. Aldershot and Burlington.

Leclercq 1907–53. H. Leclercq. *Dictionnaire d'Archéologie Chrétienne et de Liturgie*. 15 vols. Paris.

Lehmann-Hartleben and Olsen 1942. K. E. Lehmann-Hartleben and C. Olsen. *Dionysiac Sarcophagi in Baltimore*. Baltimore.

Lemeunier 1989. A. Lemeunier. "L'ancienne châsse de Sainte Ode (XIIe s.)." In *Trésors de la collégiale d'Amay*, 81–89.

Leningrad 1990. *Medieval Art from The Metropolitan Museum of Art and The Art Institute of Chicago*. Exh. cat., Leningrad: State Hermitage Museum.

Leone de Castris 1980. P. Leone de Castris. "Une attribution à Lando di Pietro, le bras-reliquaire de saint Louis de Toulouse." *Revue du Louvre et des musées de France* 1980:74–75.

Lewis 1987. S. Lewis. *The Art of Matthew Paris in the "Chronica Majora."* Berkeley.

Liebaert 1913. P. Liebaert. "Le reliquaire du chef de Saint Sébastien." *Mélanges de l'école Française de Rome* 33:179–492.

Lightbown 1992. R. W. Lightbown. *Medieval European Jewellery; with a Catalogue of the Collection in the Victoria and Albert Museum*. London.

Limoges 1999. V. Notin, ed. *Valérie et Thomas Becket: De l'influence des princes Plantagenêt dans l'Oeuvre de Limoges*. Exh. cat., Limoges: Musée Municipal de l'Evêché.

Little 2002. C. T. Little. "The Road to Glory: New Early Images of Thomas Becket's Life." In *Reading Medieval Images: The Art Historian and the Objects*, ed. E. Sears and T. K. Thomas, 205. Ann Arbor.

Liverani 1999. P. Liverani. *La topografia antica del Vaticano*. Vatican.

London 1984. G. Zarnecki, J. Holt, and T. Holland, eds. *English Romanesque Art, 1066–1200*. Exh. cat., London: Hayward Gallery.

London 1987. J. Alexander and P. Binski, eds. *Age of Chivalry: Art in Plantagenet England 1200–1400*. Exh. cat., London: Royal Academy of Arts.

London 2000. J. C. H. King, ed. *Human Image*. Exh. cat., London: British Museum.

London 2007. J. Reeve. *Sacred: Books of the Three Faiths: Judaism, Christianity, Islam*. Exh. cat., London: British Library.

London 2008. R. Cormack and M. Vassilaki, eds. *Byzantium 330–1453*. Exh. cat., London: Royal Academy.

Longhi 1997. D. Longhi. "Il lato sinistro della capsella di Samangher e la memoria costantiniana di S. Lorenzo." *Felix Ravenna* 141/144:95–128.

Los Angeles 2007. H. A. Klein, ed. *Sacred Gifts and Worldly Treasures*. Exh. cat., Los Angeles: The J. Paul Getty Museum. Cleveland.

Lüdke 1983. D. Lüdke. *Die Statuetten der gotischen Goldschmiede: Studien zu den 'autonomen' und vollrunden Bildwerken der Goldschmiedeplastik und den Statuettenreliquiaren in Europa zwischen 1230 und 1530*. 2 vols. Munich.

Machilek 1987. F. Machilek. "Die Bamberger Heiltümerschätze und ihre Weisungen." In *Dieses große Fest aus Stein*, ed. H.-G. Röhrig, 217–56. Bamberg.

Maciejczyk 1913. A. Maciejczyk. "Das byzantinische Kreuz in der Schatzkammer des Kölner Domes." *Zeitschrift für christliche Kunst* 26:178–84.

MacLachlan 1965 [1986]. E. P. MacLachlan. *The Scriptorium of Bury St. Edmunds in the Twelfth Century*. New York.

Madrid 2001. B. D. Boehm, ed. *De Limoges a Silos*. Exh. cat., Madrid: Biblioteca Nacional.

Magdeburg 2001. M. Puhle, ed. *Otto der Große. Magdeburg und Europa*. 2 vols. Exh. cat., Magdeburg: Kulturhistorischen Museum. Mainz.

Mainz 2004. H.-J. Kotzur, ed. *Die Kreuzzüge. Kein Krieg ist heilig*. Exh. cat., Mainz: Bischöfliches Dom- und Diözesanmuseum.

Manchester 1959. C. M. Kauffman. *Romanesque Art c. 1050–1200 from Collections in Great Britain and Ireland*. Exh. cat., City of Manchester Art Gallery.

Mango 1994. C. Mango. "On the Cult of Saints Cosmas and Damian at Constantinople." In *Thymiama: Ste mneme tes Laskarinas Boura*, vol. 1: *Keimena*, ed. L. Boura, 47–49. Athens.

Marquardt 1961. H. Marquardt. *Bibliographie der Runen nach Fundorten*, vol. 1: *Runenschriften der Britischen Inseln*. Göttingen.

Marquet de Vasselot 1906. J.-J. Marquet de Vasselot. *Les émaux limousins à fond vermiculé*. Paris.

Marucchi 1910. O. Marucchi. *I monumenti del Museo Cristiano Pio Lateranense*. Milan.

Matt 1969. L. von Matt, G. Daltrop, and P. Adriano. *Die Kunstsammlungen der Biblioteca Apostolica Vaticana Rom*. Cologne.

Matt, Daltrop, and Prandi n.d. [1970]. L. von Matt, G. Daltrop, and A. Prandi. *Art Treasures of the Vatican Library*. New York.

Meiss 1951. M. Meiss. *Painting in Florence and Siena after the Black Death*. Princeton.

Meurer 1985. H. Meurer. "Zu den Staurotheken der Kreuzfahrer." *Zeitschrift für Kunstgeschichte* 48:65–76.

Meyrick 1836. S. R. Meyrick. "Catalogue of the Doucean Museum." *The Gentleman's Magazine* 4 (issues of March–December)

Michael 1994. M. Michael. "The Iconography of Kingship in the Walter of Milemete Treatise." *Journal of Courtauld and Warburg Institute* 57:35–47.

Mietke 1998. G. Mietke. "Wundertätige Pilgerandenken, Reliquien und ihr Bildschmuck." In Hildesheim 1998, 40–55.

Mietke 2006. G. Mietke, ed. *Das Museum für Byzantinische Kunst im Bode-Museum*. Munich.

Migeon 1904. *Musée national du Louvre: Catalogue des bronzes et cuivres du Moyen Âge, de la Renaissance et des temps modernes*. Paris.

Migeon 1905. G. Migeon. "La Collection de M. G. Chalandon." *Les Arts* 42:17–29.

Milan 2003. P. Pasini, ed. *387 d.C.: Ambrogio e Agostino le sorgenti dell'Europa*. Exh. cat., Milan: Museo diocesano.

Miller 1991. A. M. Miller. *Cameos Old and New*, 1st ed. New York.

Miller 2009. A. M. Miller. *Cameos Old and New*, 4th ed. New York.

Milliken 1930. W. M. Milliken. "The Acquisition of Six Objects from the Guelph Treasure for the Cleveland Museum of Art." *CMA Bulletin* 17, no. 9: 163–77.

Milliken 1931. W. M. Milliken. "The Gertrudis Altar and Two Crosses." *CMA Bulletin* 18, no. 2: 23–26.

Milliken 1952a. W. M. Milliken. "A Champlevé Enamel Plaque." *CMA Bulletin* 39, no. 1: 7–13.

Milliken 1952b. W. M. Milliken. "Reliquary of the True Cross." *CMA Bulletin* 39, no. 8: 203–5.

Milliken 1954. W. M. Milliken. "Byzantine Goldsmith Work." *CMA Bulletin* 41, no. 8: 190–92.

Minchev 2001. A. Minchev. "Dve rannokhristianski mozaiki s iztochni motivi ot Varnenska oblast." In *Khristiianskata ideiia v istoriiata i kulturata na Evropa*, ed. D. Ovcharov, 44–64. Sofia.

Minchev 2003. A. Minchev. *Early Christian Reliquaries from Bulgaria, 4th–6th Century AD*. Varna.

Mitchell 1919. H. P. Mitchell. "Some Enamels from the School of Godefroid de Claire." *The Burlington Magazine* 35:34–40.

Molanus 1697. G. W. Molanus. *Lipsanographia sive Thesaurus sanctarum Reliquiarum Electoralis Brunsvico-Luneburgicus*. Hannover.

Monroe 1992. W. S. Monroe. "The Guennol Triptych and the Twelfth-Century Revival of Jurisprudence." In *The Cloisters: Studies in Honor of the Fiftieth Anniversary*, ed. E. C. Parker, 167–77. New York.

Montesquiou-Fezensac 1962. B. de Montesquiou-Fezensac. "Le talisman de Charlemagne." *Art de France* 2:66–76.

Montesquiou-Fezensac and Gaborit-Chopin 1973–77. B. de Montesquiou-Fezensac and D. Gaborit-Chopin. *Le trésor de Saint-Denis*. 3 vols. Paris.

Moran 1979. G. Moran. "A Fourteenth-Century Sienese Reliquary from the Spedale della Scala." Unpublished paper in curatorial files, acc. no. 1978.26. The Cleveland Museum of Art.

Morand 1790. S.-J. Morand. *Histoire de la Sainte-Chapelle royale du Palais, enrichie de planches, par M. Sauveur-Jérôme Morand*. Paris.

Morel 1982. B. Morel. "Le trésor de la Sainte-Chapelle du Palais royal de Paris." *Revue de gemmologie* 73 (December): 2–6.

Morello 1991. G. Morello. "Il Tesoro del Sancta Sanctorum." In *Il Palazzo Apostolico Lateranense*, ed. C. Pietrangeli, 90–105. Florence.

Morey 1926. C. R. Morey. "The Painted Panel from Sancta Sanctorum." In *Festschrift zum sechzigsten Geburtstag von Paul Clemen, 31. Oktober 1926*, ed. W. Worringer, H. Reiners, and L. Seligmann, 151ff. Bonn-Düsseldorf.

Morey 1937. C. M. Morey "The Inscription on the Enameled Cross of Paschal I." *Art Bulletin* 19, no. 4 (1937): 595–96.

Morey and Ferrari 1959. C. F. Morey and G. Ferrari. *The Gold Glass Collection of the Vatican Library*. Vatican City

Morgan 1982. N. Morgan. *Early Gothic Manuscripts*, vol. 1: 1190–1250. London.

Moritz and Magdalena 1931. K.S. Moritz and M. Magdalena, eds. *Das hallesche heiltum: Man. Aschaffenb. 14*, ed. Philipp Maria Halm und Rudolf Berliner. Berlin.

Müller 1966. T. Müller. *Sculpture in Netherlands, Germany, France and Spain*. London, 1966.

Müller and Steingräber 1954. T. Müller and E. Steingräber. "Die französische Goldemailplastik um 1400." *Münchner Jahrbuch der Bildenden Kunst* 5:29–79.

Müller-Christensen 1973. S. Müller-Christensen. "Zwei Seidengewebe als Zeugnisse der Wechselwirkung von Byzanz und Islam." In *Artes Minores: Dank an Werner Abegg*, ed. M. Stettler and M. Lemberg, 9–25. Bern.

Munich 1967. R. Rückert, ed. *Der Schatz vom Heiligen Berg Andechs*. Exh. cat., Munich: Bayerischen Nationalmuseum München.

Munich 1995. R. Baumstark, ed. *Das goldene Rössl. Ein Meisterwerk der Pariser Hofkunst um 1400*. Exh. cat., Munich: Bayerisches Nationalmuseum.

Muñoz 1913 A. Muñoz, "La cripta e la tribuna della Chiesa dei SS. III Coronati, la teca argentea del capo di S. Sebastiano." *Studi Romani* 1:196ff.

Musée du Louvre 1995. Musée du Louvre. *Nouvelles acquisitions du département des Objets d'art, 1990–1994*. Paris.

Musées Royaux d'Art et d'Histoire 1999. S. Balace *La salle aux trésors: Chefs d'oeuvre de l'art*. Turnhout.

Namur 2003. R. Didier, ed. *Autour de Hugo d'Oignies*. Exh. cat., Namur: Musée des Arts anciens du Namurois

Napier 1900. A. S. Napier. "The Franks Casket." In *An English Miscellany Presented to Dr. Furnivall*. Oxford.

Naples 2000. B. Ulianich, ed. *La Croce: Dalle origini agli inizi del secolo XVI*. Exh. cat., Naples: Castel nuovo.

Nesbitt 2008. J. Nesbitt. "Sigillography." In *The Oxford Handbook of Byzantine Studies*, ed. E. Jeffreys, J. Haldon, and R. Cormack, 150–56. Oxford.

Neumann 1891. W. A. Neumann. *Der Reliquienschatz des Hauses Braunschweig-Lüneburg*. Vienna.

Neumann de Vegvar 2008. C. Neumann de Vegvar. "Reading the Franks Casket: Context and Audiences." In *Intertexts: Studies in Anglo-Saxon Culture Presented to Paul E. Szarmach*, ed. V. Blanton and H. Scheck, 141–59. Tempe.

New Delhi 1997. R. Blurton, ed. *The Enduring Image: Treasures from the British Museum*. Exh. cat., New Delhi: National Museum. London.

New York 1970. K. Hoffman, ed. *The Year 1200*. Exh. cat., New York: The Metropolitan Museum of Art.

New York 1979 [1977]. K. Weitzmann, ed. *Age of Spirituality: Late Antique and Early Christian Art, Third to Seventh Century*. 2 vols. Exh. cat., New York: The Metropolitan Museum of Art.

New York 1982. J. Plummer. *The Last Flowering; French Painting in Manuscripts, 1420–1530, from American Collections*. Exh. cat., New York: The Pierpont Morgan Library.

New York 1983. *The Vatican Collections: The Papacy and Art*. Exh. cat., New York: The Metropolitan Museum of Art.

New York 1993. *The Art of Medieval Spain, A.D. 500–1200*. Exh. cat., New York: The Metropolitan Museum of Art.

New York 1996. B. D. Boehm and E. Taburet, eds. *Enamels of Limoges 1100–1350*. Exh. cat., Paris: Musée du Louvre; New York: The Metropolitan Museum of Art.

New York 1997. H. Evans and W. Wixom, eds. *The Glory of Byzantium: Art and Culture of the Middle Byzantine Era, AD 843–1261*. Exh. cat., New York: The Metropolitan Museum of Art.

New York 2001. T. Husband, ed. *The Treasury of Basel Cathedral*. Exh. cat., New York: The Metropolitan Museum of Art.

New York 2004. H. C. Evans, ed. *Byzantium: Faith and Power (1261–1557)*. Exh. cat., New York: The Metropolitan Museum of Art.

New York 2005. B. D. Boehm and J. Fajt, eds. *Prague: The Crown of Bohemia 1347–1437*. Exh. cat., New York: The Metropolitan Museum of Art.

New York 2006. C. T. Little, ed. *Set in Stone: The Face in Medieval Sculpture*. Exh. cat., New York: The Metropolitan Museum of Art.

New York 2007. S. Fogg. *Art of the Middle Ages*. Exh. cat., New York: Alexander Gallery.

Nielsen 2004. C. Nielsen, ed. *Devotion and Splendor: Medieval Art at the Art Institute of Chicago, Art Institute of Chicago*. Museum Studies 30, no. 2. Chicago.

Noga-Banai 2008. G. Noga-Banai. *The Trophies of the Martyrs: An Art Historical Study of Early Christian Silver Reliquaries*. Oxford.

Norwich 2006. N. Larkin and A. Moore, eds. *At the Rockface: The Fascination of Stone*. Exh. cat., Norwich Castle Museum and Art Gallery. London.

Nuremberg 1978. F. Seibt, ed. *Kaiser Karl IV: Staatsmann und Mäzen*. Exh. cat., Nuremberg: Kaiserburg Nürnberg. Munich.

Nuremberg 1986. G. Schuhmann, ed. *Nürnberg, Kaiser und Reich*. Ausstellungskataloge der Staatlichen Archive Bayerns 20. Exh. cat., Nuremberg: Staatsarchivs Nürnberg. Munich.

O'Flanagan 1927. M. O'Flanagan, ed. *Letters Containing Information Relative to the Antiquities of the County of Donegal during the Progress of the Ordnance Survey in 1835*. Bray.

Ó Floinn 1994. R. Ó Floinn. *Irish Shrines and Reliquaries of the Middle Ages*. Dublin.

Ottawa 1972. *L'art et la cour/Art and the Courts: France and England from 1259 to 1328.* Exh. cat., Otawa: National Gallery of Canada.

Paderborn 1999. C. Stiegemann and M. Wemhoff, eds. *799: Kunst und Kultur der Karolingerzeit. Karl der Grosse und Papst Leo III.* Exh. cat., Paderborn: Museum in der Kaiserpfalz. Mainz.

Paderborn 2006. C. Stiegemann and M. Wemhoff, eds. *Canossa 1077: Erschütterung der Welt. Geschichte, Kunst und Kultur am Aufgang der Romanik,* 2 vols. Exh. cat., Paderborn: Museum in der Kaiserpfalz. Munich.

Palli 1962. E. L. Palli. "Der syrisch Palästinische Darstellungstypus der Hollelfahrt Christi.» *RQ* 57:250–67.

Paris 1947. *Le siège français du Moyen Âge à nos jours.* Exh. cat., Paris: Musée des Arts décoratifs.

Paris 1960. *Saint Louis à la Sainte-Chapelle.* Exh. cat., Paris: Sainte-Chapelle.

Paris 1962. *Cathédrales; sculptures, vitraux, objects d'art, manuscrits des XIIe et XIIIe siècles.* Exh. cat., Paris: Musée du Louvre.

Paris 1966. J. Taralon. *Trésors des églises de France,* 2nd ed. Exh. cat., Paris: Musée des arts décoratifs.

Paris 1968. *L'Europe gothique, XIIe–XIVe siécles.* Exh. cat., Paris: Musée du Louvre.

Paris 1970. *La France de Saint Louis.* Exh. cat., Paris: Conciergerie.

Paris 1971. *Arts de l'Islam des origines à 1700 dans les collections publiques françaises.* Exh. cat., Paris: Orangerie des Tuileries.

Paris 1977. *L'Islam dans les collections nationales.* Exh. cat., Paris: Grand-Palais.

Paris 1981. F. Baron. *Les fastes du Gothique: Le siècle de Charles V.* Exh. cat., Paris: Galeries nationales du Grand Palais.

Paris 1984. *Le trésor de Saint-Marc de Venise.* Exh. cat., Paris: Galeries nationales du Grand Palais. Milan.

Paris 1991. *Le trésor de Saint-Denis.* Exh. cat., Paris: Musée du Louvre.

Paris 1992. E. Roesdahl and D. M. Wilson, eds. *From Viking to Crusader: Scandinavians and Europe, 800–1200 (Les Vikings: Les Scandinaves et l'Europe, 800–1200)* Exh. cat., Paris: Grand Palais. New York

Paris 1998. *Trésors fatimides du Caire.* Exh. cat., Paris: Institut du monde arabe.

Paris 2001. J. Durand and M.-P. Laffitte, eds. *Le trésor de la Sainte-Chapelle.* Exh. cat., Paris: Musée du Louvre.

Paris 2004. E. Taburet-Delahaye, ed. *Paris 1400: Les arts sous Charles VI.* Exh. cat., Paris: Musée du Louvre.

Paris 2005. *La France romane au temps des premiers capétiens, 987–1152.* Exh. cat., Paris: Musée du Louvre.

Paris 2010. *Paris, ville rayonnante.* Exh. cat. Paris: Musée de Cluny—musée national du Moyen Age.

Parkhurst 1952. C. Parkhurst. "Preliminary Notes on Three Early Limoges Enamels at Oberlin." *Allen Memorial Art Museum Bulletin* 9, no. 3: 96–105.

Parpulov 2004. G. Parpulov. "A Catalogue of the Greek Manuscripts at the Walters Art Museum." *JWAM* 62:71–183

Pasini 1886. A. Pasini. *Il tesoro di San Marco in Venezia.* Venezia.

Pastorello 1938. E. Pastorello, ed. *Andrea Dandolo Chronica per extensum descripta.* Rerum Italicarum Scriptores 12, part 1. Bologna.

Perret 1851–55. L. Perret. *Catacombes de Rom.* 6 vols. Paris.

Peschlow 2006. U. Peschlow. "Altar und Reliquie. Form und Nutzung des frühbyzantinischen Reliquienaltars in Konstantinopel." In *Architektur und Liturgie. Akten des Kolloquiums vom 25. bis 27. Juli in Greifswald,* ed. M. Altripp and C. Nauerth, 175–202. Wiesbaden.

Peter 2001. M. Peter. *Der Gertrudistragaltar aus dem Welfenschatz: Eine stilgeschichtliche Untersuchung.* Schriften des Dom-Museums Hildesheim 2. Mainz.

Piatnitsky 2006. Y. A. Piatnitsky. "Early Christian Reliquary from the Peter the Great Collection in Saint Petersburg." *Mitteilungen zur christlichen Archäologie* 12:73–82.

Pieper 1959. P. Pieper. "Die silbernen St. Georgsfiguren aus Elbing." In *Festschrift für Erich Meyer zum sechzigsten Geburtstag, 29. Oktober 1957: Studien zu Werken in den Sammlungen des Museums für Kunst und Gewerbe, Hamburg,* ed. W. Gramberg, 93–105. Hamburg.

Pitarakis 2006. B. Pitarakis. *Les croix-reliquaires pectorales byzantines en bronze.* Paris.

Preising 1995–97. D. Preising. "Bild und Reliquie: Gestalt und Funktion gotischer Reliquientafeln und altärchen." *Aachener Kunstblätter* 61:13–84.

Quandt 1992. A. Quandt. "The Conservation of the Butler Hours." *BWAG* 45 (October): 4–5.

Radford 1955. C. A. R. Radford. "Two Reliquaries Connected with South-West Scotland." *Transactions of the Dumfriesshire and Galloway Natural History and Antiquarian Society for 1953–54,* 3rd series, no. 32: 119–23.

Ravenna 1990. G. Morello, ed. *Splendori di Bisanzio. Testimonianze e riflessi d'arte e cultura bizantina nelle chiese d'Italia.* Exh. cat., Ravenna: Museo nazionale. Milan.

Ravenna 2001. A. Donati and G. Gentili, eds. *Deomene: L'immagine dell'orante fra Oriente e Occidente.* Exh. cat., Ravenna: Museo nazionale. Milan.

Read 1902. C. H. Read. *The Waddesdon Bequest: Catalogue of the Works of Art bequesthed to the British Museum by Baron Ferdinand Rothschild, M.P., 1898.* London.

Read and Tonnochy 1928. H. Read and A. B. Tonnochy. *Catalogue of the Silver Plate, Mediaeval and Later, Bequeathed to the British Museum by Sir Augustus Wollaston Franks.* London.

Reinburg 1995. V. Reinburg. "Remembering the Saints." In Boston 1995.

Renet 1892–94. Abbé Renet. *Saint Lucien et les autres saints du Beauvaisis.* 3 vols. Beauvais.

Riant 1875. P. Riant. *Des dépouilles religieuses enlevées à Constantinople au XIIIe siècle et des documents historiques nés de leur transport en occident.* Paris.

Riant 1877–78. P. Riant *Exuviae Sacrae Constantinopolitanae.* 2 vols. Geneva. Reprint, Paris, 2008.

Riant 1879. P. Riant. "Trois inscriptions relatives à des reliques rapportées de Constantinople par des croisés Allemands." *Mémoires de la société nationale des Antiquaires de France* 40:128–45.

Ricci 1909. C. Ricci. "Marmi Ravennati erratici." *Ausonia* 4:247–89.

Rice 1956. D. S. Rice. "A Datable Islamic Rock Crystal." *Oriental Art* 11, no. 3: 85–93.

Rimini 1996. A. Donati, ed. *Dalla terra alle genti: La diffusione del cristianesimo nei primi secoli.* Exh. cat., Rimini: Palazzo dell'Arengo e del Podestà. Milan.

Robinson 2008. J. Robinson. *Masterpieces: Medieval Art.* London.

Rochemonteix 1902. A. de Chalvet de Rochemonteix. *Les églises romanes de la Haute-Auvergne.* Paris.

Rogers and Goetz 1945. M. R. Rogers and O. Goetz. *Handbook to the Lucy Maud Buckingham Medieval Collection.* Chicago.

Rome 1999. M. D'Onofrio, ed. *Romei e Giubilei. Il pellegrinaggio medievale a San Pietro (350–1350).* Exh. cat., Rome: Palazzo Venezia.

Rome 2000a. A. Donati, ed. *Pietro e Paolo. La storia, il culto, la memoria nei primi secoli.* Exh. cat., Rome: Palazzo della Cancelleria. Milan.

Rome 2000b: V. Pace, ed. *Treasure of Christian Art from Bulgaria.* Exh. cat., Rome: Markets of Trajan.

Rome 2001. H. L. Kessler. "Il mandylion." In *Il volto di Cristo,* ed. G. Morello, 66–76. Exh. cat., Rome: Palazzo delle esposizioni. Milan.

Ronig 1993. F. Ronig. *Egbert, Erzbischof von Trier, 977–993. Gedenkschrift der Diözese Trier zum 1000. Todestag.* 2 vols. Trierer Zeitschrift für Geschichte und Kunst des Trierer Landes und seiner Nachbargebiete, Beiheft 18. Trier.

Rosenberg 1921. M. Rosenberg. *Geschichte der Goldschmiedekunst,* vol. 3: *Zellenschmelz.* Frankfurt.

Ross 1936. M. C. Ross. "The Reliquary of Saint Amandus." *Art Bulletin* 18, no. 2: 186–97.

Ross 1944/45. M. C. Ross. "A Late Fifteenth-Century Mother of-Pearl Carving." *JWAG* 7/8:125–26.

Ross 1965 [2005]. M. C. Ross. *Catalogue of the Byzantine and Early Medieval Antiquities in the Dumbarton Oaks Collection,* vol. 2: *Jewelry, Enamels, and Art of the Migration Period.* 2nd ed., 2005, addendum by S. A. Boyd and S. R. Zwirn. Washington, DC

Ross and Downey 1962. M. C. Ross and G. Downey. "A Reliquary of St. Marina." *Byzantinoslavica* 23:41–44.

Ross and Laourdas 1951. M. Ross and B. Laourdas. "The Pendant Jewel of the Metropolitan Arsenius." In *Essays in Honor of George Swarzenski*, ed. O. Goetz, 181–84. Chicago.

Rossi 1878–94. G. B. de Rossi. *Catalogo del Museo Sacro Vaticano*. Biblioteca Apostolica Vaticana 66A.

Rossi 1887. G. B. de Rossi "Capsella argentea africana." *Nuovo Bullettino di Archeologia Cristiana* 5:118–29.

Rowlands 1979. E. W. Rowlands. "Sienese Painted Reliquaries of the Trecento:Their Format and Meaning." *Konsthistorisk Tidskrift* 48:122–38.

Ruggieri 1988. V. Ruggieri. "Consacrazione e dedicazione di chiesa, secondo il Barberinianus graecus 336." *Orientalia Christiana Periodica* 54 (1988), 79–118.

Rupin 1890. E. Rupin. *L'oeuvre de Limoges*. Brive and Paris, 1890.

Saint-Riquier 2000. *Reliques et reliquaires du XIIème au XVIème siècle*. Exh. cat., Saint-Riquier: Musée Départmental de l'Abbaye de Saint-Riquier.

Salet 1961. F. Salet. "Un reliquaire de la Sainte-Chapelle au musée de Cluny." *BullMon* 119:70–72.

Salzburg 1982. *St. Peter in Salzburg: Das älteste Kloster im deutschen Sprachraum*. Exh. cat., Salzburg: Dommusuems zu Salzburg.

Sandler 1986. L. F. Sandler. *Gothic Manuscripts, 1285–1385*, vol. 2: *Catalogue*. London.

Sankt Pölten 2001. F. Daim and T. Kühtreiber, eds. *Sein und Sinn, Burg und Mensch*. Exh. cat., Sankt Pölten: Niederösterreichisches Landesmuseum.

Sauerländer 2007. W. Sauerländer. "Architecture gothique et mise en scène des reliques: L'exemple de la Sainte-Chapelle." In *La Sainte-Chapelle de Paris: Royaume de France ou Jérusalem céleste? Actes du colloque (Paris, Collège de France 2001)*, ed. C. Hediger, 113–36. Turnhout.

Saunders 1982. W. B. R. Saunders. "The Aachen Reliquary of Eusthatius Maleinus, 969–70." *DOP* 36:211–19.

Schestag 1872–74. F. Schestag. "Anhang." In *Katalog der Kunstsammlung des Freihern Anselm von Rothschild in Wien*. Vienna.

Schier and Schlief 2004. V. Schier and C. Schlief. "Seeing and Singing, Touching and Tasting the Holy Lance: The Power and Politics of Embodied Religious Experiences in Nuremberg, 1424–1524." In *Signs of Change: Transformations of Christian Tradition and Their Representation in the Arts, 1000–2000*, ed. N. H. Petersen and N. Bell, 401–26. Amsterdam.

Schlumberger 1905. G. Schlumberger. "L'inscription du reliquaire byzantin en forme d'église du trésor de la cathédrale d'Aix-la-Chapelle." *Monuments et Mémoires: Académie des Inscriptions de Belles-Lettres, Fondation Eugène Piot* 12:201–06.

Schnelbögl 1962. J. Schnelbögl. "Die Reichskleinodien in Nürnberg, 1424–1524." *Mittheilungen des Vereins für Geschichte der Stadt Nürnberg* 51:78–159.

Schorta 1998. R. Schorta. "Reliquienhüllen und textile Reliquien im Welfenschatz." In Ehlers and Kötzsche 1998, 139–76.

Ševčenko 1993. N. P. Ševčenko. "The Walters 'Imperial' Menologion." *JWAG* 51:43–64.

Sevrugian et al. 2001. P. Sevrugian, et al. *Kostbarkeiten aus dem Domschatz zu Halberstadt*. Halle.

Shalem 1996. A. Shalem. *Islam Christianized: Islamic Portable Objects in the Medieval Church Treasuries of the Latin West*, 1st ed. Frankfurt and New York.

Shaw 1843. H. Shaw. *Dresses and Decorations of the Middle Ages*, vol. 2. London.

Shepard 1998. M. Shepard. "The Relics Window of Saint Vincent of Saragossa at Saint-Germain-des-Prés." *Gesta* 37:258–65.

Shepherd 1950. D. G. Shepherd. "A Medieval Brocade." *CMA Bulletin* 37, no. 9: 195–96

Silvagni et al. 1922. A. Silvagni et al. *Inscriptiones Christianæ Urbis Romae septimo saeculo antiquiores*. 10 vols. Rome.

Singapore 2005. U. Utro et al., eds. *Journey of Faith: Art and History from the Vatican Collections*. Exh. cat. Singapore: Asian Civilisations Museum. Vatican City.

Sitte 1901. A. Sitte. "Die kaiserlich-geistliche Schatzkammer in Wien," part 3. *Mittheilungen der K.K. Central Commission für Erforschung und Erhaltung der Kunst und Historischen Denkmale* 27:138–45.

Skedros 2006. J. C. Skedros. "Shrines, Festivals, and the 'Undistinguished Mob'." In *Byzantine Christianity*, ed. D. Krueger, 81–101. Minneapolis.

Škorpil 1921. H. Škorpil and K. Škorpil. "Dvaisetgodishnata deinost na Varnenskoto Arkheologichesko Druzhestvo, 1901–1921." *Izvestiia na Varnenskoto arkheologichesko druzhestvo* 7:3–84.

Smith 1854. C. R. Smith. *Catalogue of the Museum of London Antiquities*. London.

Sotheby Parke Bernet and Co. 1983. *The Thomas F. Flannery, Jr. Collection: Medieval and Later Works of Art*. Auction cat., London: Sotheby Parke Bernet and Co.

Souchal 1960. G. Souchal. "Un reliquaire de la Sainte-Chapelle au musée de Cluny" *La Revue des arts* 10, nos. 4–5: 179–94.

Spain 1977. S. Spain. "The Translation of Relics Ivory, Trier." *DOP* 31:279–304.

Speck 1987. P. Speck. "Das Trierer Elfenbein und andere Unklarheiten." In *Varia II*, ed. P. Speck, 275–83. Bonn.

Spilling 1992. H. Spilling. *Sanctarum Reliquiarum Pignera Gloriosa: Quellen zur Geschichte des Reliquienschatzes der Benediktinerabtei Zwiefalten*. Bad Buchau.

Steen Hansen and Spicer 2005. M. Steen Hansen and J. A. Spicer, eds. *Masterpieces of Italian Painting: The Walters Art Museum*. Baltimore.

Stohlmann 1939. F. Stohlmann. *Gli smalti del Museo Sacro Vaticano*. Vatican.

Stratford 1993. N. Stratford. *Catalogue of Medieval Enamels in the British Museum*, vol. 2: *Northern Romanesque Enamels*. London.

Stuttgart 1977. R. Haussherr, ed. *Die Zeit der Staufer*. 5 vols. Exh. cat., Stuttgart: Württembergisches Landesmuseum.

Swarzenski 1918 [1978]. G. Swarzenski. "Die Sammlung Harry Fuld in Frankfurt." *Das Kunstblatt* 2:85ff (repr. 1978).

Swarzenski 1967. G. Swarzenski. *Monuments of Romanesque Art*, 2nd ed. Chicago.

Taburet-Delahaye 1989. É. Taburet-Delahaye. *L'orfèvrerie gothique au musée de Cluny (XIIIe–début XVe siècle)*. Paris.

Tait 1986a. H. Tait. *Catalogue of The Waddesdon Bequest in the British Museum*, vol. 1: *The Jewels*. London.

Tait 1986b. H. Tait. *Seven Thousand Years of Jewellery*. London.

Tanner 1990. N. P. Tanner, ed. *Decrees of the Ecumenical Councils*. 2 vols. Washington, D.C.

Taylor et al. 2009. J. Taylor, ed. *Encyclopedia of Medieval Pilgrimage*. Leiden.

Testini 1972. P. Testini. "Alle origini dell'iconografia di Giuseppe di Nazareth." *RACr* 48:271–347.

Thunø 2002. E. Thunø. *Image and Relic. Mediating the Sacred in Early Medieval Rome*. Analecta Romana Instituti Danici, Supplementum 32. Rome.

Tiepolo 1617. G. Tiepolo. *Trattato delle santissime reliquie*. Venice.

Tietze 1913. H. Tietze. "Ein Passionszyklus im Stift Schlägl." *Jahrbuch des kunsthistorischen Instituts der Zentralkommission für Denkmalpflege* 7:173–88.

Tokyo 2003. *Treasures from the World's Cultures: The British Museum after 250 Years*. Exh. cat., Tokyo: Metropolitan Art Museum. London.

Tonnochy 1952. B. Tonnochy. "The Ninian Reliquary." *British Museum Quarterly* 15:77.

Torquat 2007. Torquat, Alix de. "A Fourteenth-Century Painted Reliquary Attributed to Bartolo di Fredi with Two Inserted Ivories." M.A. thesis, Courtauldt Institute of Art.

Travi 2007. C. Travi. "Su Alcuni Reliquiari Dipinti Trecenteschi di Ambito Emiliano." *Arte Cristiana* 95:100–10.

Trempelas 1950–1955. P. N. Trempelas, ed. *Mikron Euchologion*. 2 vols. Athens.

Trier 2007. J. Engmann and A. Demandt. *Konstantin der Große*. Exh. cat., Trier: Rheinisches Landesmuseum.

Ultee 1981. *The Abbey of Saint Germain des Prés in the Seventeenth Century*. New Haven and London.

Van Bastelaer 1880. M. D. A. Van Bastelaer. "Étude sur un reliquaire phylactère du XIIe siècle." *Annales de l'Académie d'Archéologie de Belgique*, 3rd series, 36:2–52. Brussels.

Van Dyse 1897. H. Van Dyse. *Catalogue des Armes et Armures du Musée de la Porte de Hal*. Brussels.

Van Keuren 2002. F. Van Keuren. "Late-Nineteenth-Century Restorations of Sarcophagi from the Licinian Tomb, Rome." In *Interdisciplinary Studies on Ancient Stone*, ed. L. Lazzarini, 117–26. ASMOSIA 6. London.

Vatican 1998. G. Morello, A. M. Piazzoni, and P. Vian, eds. *Diventare santo*. Exh. cat., Vatican City: Biblioteca Apostolica Vaticana. Calgliari.

Vatican 2006. M. C. Carlo-Stella, P. Liverani, and M. L. Polichetti eds. *Petros eni—Pietro è qui*. Exh. cat., Vatican City: Braccio di Carlo Magno. Rome.

Vatican 2009. U. Utro, ed. *San Paolo in Vaticano: La figura e la parola dell'Apostolo delle Genti nelle raccolte pontificie*. Exh. cat., Vatican City: Musei Vaticani. Todi.

Vaughan 1958. R. Vaughan. *Matthew Paris*. Cambridge.

Vaughan 1993. R. Vaughan. *The Illustrated Chronicles of Matthew Paris: Observations of Thirteenth-Century Life*. Dover, N.H.

Venice 1974. I. Furlan and G. Mariacher, ed. *Venezia e Bisanzio*. Exh. cat., Venice: Palazzo Ducale.

Venice 1994. G. Fiaccadori, ed. *Bessarione e l'Umanesimo*. Exh. cat., Venice: Biblioteca Nazionale Marciana. Naples.

Venice 2008. J.-J. Aillagon, ed. *Rome and the Barbarians: The Birth of a New World*. Exh. cat., Venice: Palazzo Grassi. Milan.

Verdier 1961. P. Verdier. "Un monument inédit de l'art mosan du XIIe siècle: La crucifixion symbolique de Walters Art Gallery." *Revue belge d'archéologie et d'histoire de l'art* 30:115–75.

Verdier 1973a. P. Verdier. "Le Reliquaire de la Sainte Epine de Jean de Streda." In *Intuition und Kunstwissenschaft: Festschrift fur Hanns Swarzenski*, ed. P. Bloch, 319–44. Berlin.

Verdier 1973b. P. Verdier "Les staurothèques mosanes et leurs iconographie du Jugement Dernier." *Cahiers de civilization médiévale* 16:97–121 and 199–213.

Verdier 1981. P. Verdier. "The Twelfth-Century Chasse of St. Ode from Amay." *Wallraf-Richartz Jahrbuch* 42:7–94.

Verdier 1982. P. Verdier. "A Thirteenth-Century Reliquary of the True Cross." *CMA Bulletin* 69, no. 3: 95–110.

Vicenza 2004. *Restituzioni 2004: Tesori d'arte restaurati*. Exh. cat., Vicenza: Gallerie di Palazzo Leoni Montanari.

Vicenza 2008. C. Bertelli, ed. *Restituzioni 2008: Tesori d'arte restaurati*. Exh. cat., Vicenza: Gallerie di Palazzo Leoni Montanari.

Victoria [British Columbia] 2009. British Museum, ed. *Treasures: The World's Cultures from the British Museum*. Exh. cat., Victoria: Royal British Colombia Museum. London.

Vidier 1911. A. Vidier. *Le Trésor de la Sainte-Chapelle: Inventaires et documents*. Paris, 1911.

Vienna 1860. *Katalog der von dem Wiener Alterthums-Verein veranstalteten Ausstellung von Kunst-gegenständen aus dem Mittelalter und der Renaissance*. Exh. cat., Vienna: Wiener Alterthums-Verein.

Vienna 1998. *Schätze der Kalifen. Islamische Kunst zur Fatim-idenzeit*. Exh. cat., Vienna: Kunsthistorischen Museums.

Vikan 1982. G. Vikan. *Byzantine Pilgrimage Art*, Dumbarton Oaks Byzantine Collection 5. Washington, D.C. (rev. ed. forthcoming).

Vikan 1998. G. Vikan. "Byzantine Pilgrim's Art." In *Heaven and Earth: Art and Church in Byzantium*, ed. L. Safran, 229–66. University Park, Penn. Repr. in G. Vikan, *Sacred Images and Sacred Power in Byzantium,* Aldershot, 2003.

Vinycomb 1906. J. Vinycomb. *Fictitious and Symbolic Creatures in Art; with Special Reference to British Heraldry*. London.

Viollet-le-Duc 1871–75. E.-E. Viollet-le-Duc. *Dictionnaire raisonné du mobilier français de l'époque carolingienne à la Renaissance*. 6 vols. Paris.

Volbach 1937. W. F. Volbach. "Relique e reliquari orientali in Roma." *Bollettino d'arte* 30:337–50.

Volbach 1941. W. F. Volbach. *Il tesoro della Cappella Sancta Sanctorum*. Vatican City

Vopel 1899. H. Vopel. *Die altchristlichen Gold-gläser*. Archaeologische Studien zum christlischen Altertum und Mittelalter 5. Freiburg.

Wallach, König, and Müller 1978. L. Wallach, E. König, and K. O. Müller. *Die Zwiefalter Chroniken Ortliebs und Bertholds*, 2nd ed. Schwäbische Chroniken der Stauferzeit 2. Sigmaringen.

Walters Art Gallery 1985. R. Randall, ed. *Masterpieces of Ivory from the Walters Art Gallery*. New York.

Ward-Perkins 1975/76. J. B. Ward-Perkins. "Workshops and Clients: the Dionysiac Sarcophagi in Baltimore." *Rendiconti della Pontificia Accademia Romana di Archeologia* 48:191–238.

Webster 1982. L. Webster. "Stylistic Aspects of the Franks Casket." In *The Vikings*, ed. R. T. Farrell, 20–32. London.

Webster 1999. L. Webster. "The Iconographic Programme of the Franks Casket." In *Northumbria's Golden Age*, ed. J. Hawkes and S. Mills, 227–46. Stroud.

Webster 2010. L. Webster. *The Franks Casket*. London.

Weitzmann 1974. K. Weitzmann. "Loca Sancta end the Representational arts of Palestine." *DOP* 28:35–55.

Wessel 1967a. K. Wessel. *Byzantine Enamels from the 5th to the 13th Century*, trans. I. R. Gibbons. Greenwich, Conn.

Wessel 1967b. K. Wessel. *Die Byzantinische Emailkunst vom 5. bis 13 Jahrhundert*. Recklinghausen.

Westermann-Angerhausen 1973. H. Westermann-Angerhausen. *Die Goldschmiedearbeiten der Trierer Egbert-werkstatt*. Trier.

Westermann-Angerhausen 1990. H. Westermann-Angerhausen. "Das Nagelreliquiar im Trierer Egbertschrein: das 'künstlerisch edelste Werk der Egbertwerkstätte'?" In *Festschrift für Peter Bloch zum 11. Juli 1990*, ed. H. Krohn and C. Theuerkauff, 8–23. Mainz.

Westermann-Angerhausen 1996. H. Westermann-Angerhausen, ed. *Schatz aus den Trümmern. Dar Silbershrein von Nivelles und die Europäisch Hochgotik, Schnütgen Museum Köln*. Cologne.

Westermann-Angerhausen 1998. H. Westermann-Angerhausen. "Die Stiftungen der Gräfin Gertrud. Anspruch un Rang." In Ehlers and Kötzsche 1998, 51–76.

Wilckens 1987. L. von Wilckens. "Zur Kunstgeschichtli-chen Einordnung der Bamberger Grabfunde" In *Textile Grabfunde aus der Sepultur des Bamberger Domkapitels* [Bayerisches Landesamt für Denkmalpflege, Arbeitsheft 33], ed. H. Herrmann and Y. Langenstein, 62–79. Munich.

Williamson 1910. G. C. Williamson. *Catalogue of the Collection of Jewels and Precious Works of Art: The Property of J. Pierpont Morgan*. London.

Wilpert 1929. G. Wilpert. *I sarcofagi cristiani antichi*, vol. 1. Rome.

Wilson 1984. L. Wilson. "The Trier Procession Ivory. A New Interpretation." *Byzantion* 54:602–14.

Wilson 2003. T. Wilson. *The Battle of Pavia*. Oxford.

Wixom 1966. W. Wixom. "Three Gothic Sculptures." *CMA Bulletin* 53, no. 9: 350–55.

Wixom 1979. W. Wixom. "Eleven Additions to the Medieval Collection." *CMA Bulletin* 66, no. 3: 128–32.

Wood 1990. I. N. Wood. "Ripon, Francia and the Franks Casket in the Early Middle Ages." *Northern History* 26:1–19.

Woodfin 2006. W. Woodfin. "An Officer and a Gentleman: Transformations in the Iconography of a Warrior Saint." *DOP* 60:111–43.

Wortley 1980. J. Wortley. "The Trier Ivory Reconsidered." *Greek, Roman and Byzantine Studies* 21:381–94.

Yasin 2009. A. M. Yasin. *Saints and Church Space in the Late Antique Mediterranean: Architecture, Cult, and Community*. Cambridge

Zafran 1988. E. M. Zafran, ed. *Fifty Old Master Paintings from the Walters Art Gallery*. Baltimore.

Zanchi Roppo 1969. F. Zanchi Roppo. *Vetri paleocristiani a figure d'oro conservati in Italia*. Studi di Antichità Cristiane 5. Bologna.

Zeri 1976. F. Zeri. *Italian Paintings in the Walters Art Museum*. 2 vols. Baltimore.

Ziemann 2007. D. Ziemann. *Vom Wandervolk zur Grossmacht: Die Entstehung Bulgariens im frühen Mittelalter, 7.–9. Jh.* Cologne.

Index

Italicized numbers designate text figures.

A

Aachen, Germany
 cathedral, 199
 palatine chapel, 60
 as pilgrimage destination, 23
 relics and reliquaries in, 23, 61, 113, 118 (no. 55)
Aaron the Levite (brother of Moses), 138, 178
Abdinghof Altar, 126 (no. 65)
Abel (Genesis), 30, 32
Abelard, 144
Abgar, king of Edessa, 10, 199. *See also* Mandylion
Acclamatio sedis, 40
acheiropoeiton, 72–74, 77n47, 142, 199
Acre, 197
Adam (Genesis), 46, 50
Adelelmus of Clermont-Ferrand, 172n6
Adelheid, St., empress, 85
Adolph, archbishop of Cologne, 156
Adoration of the Cross, 71, 85
Adoration of the Magi, 6, *11,* 33 (no. 6), 50 (no. 33), 81
 (no. 37), 120, 156, 158, 159, 184 (no. 94), 185 (nos. 95, 96),
 203, 203–4 (no. 121). *See also* Cologne, Shrine of the Three
 Kings
Adoration of the Shepherds, 235
Adrian of Nicomedia, St., 125
Adrianople, 90
adventus ceremonies, 13, 38, 58–59
Ælfeah, bishop of Winchester, 104–5
Ælred of Rievaulx, 22
Æthelwold, bishop of Winchester, 104–5
Æthethryth, abbess, 22
Agatha, St., 90, 127
Agilulf, king of the Lombards, 57
Agnes, Roman martyr-saint, 34, 35, 70, 76n20
Agnus Dei (Lamb of God), 32, 88, 114–15, 131, 182
Agricola, St., 56
Agrigento, 157
Aistulf, Lombard king, 74
Akindinos, St., 141
Albertus Magnus (d. 1280), Dominican friar 138
Albrecht, cardinal of Brandenburg, 23, 63–64, 213, 229
Albrecht III, duke of Bavaria, 226
Alburquerque, convent of Medina del Campo, 195
Alcuin of York, 24
Alexander, St. (Pope Alexander I), head reliquary of,
 167–68, *168*
Alexander III, pope (r. 1159–81), 74, 75n8
Alexandria, 6, 9, 10, 42
Alexis, St., 87
Algeria, 41
Alpinian, St., 152, 160n28, 184
altars
 altar frontal, 40–41 (no. 17)
 Golden Altar of Sant'Ambrogio (Milan), 151
 portable altars, 85–86 (no. 42), 99, 112, 126–27 (nos. 65,
 66), 161n47, 165–66, 167
 relics and consecration of, 10, 21, 39, 40–41, 56, 85, 127,
 153, 164, 204, 226
 See also sepulchra (altar tombs)

altarpieces
 Kloster Andechs, 226
 San Ansano, 205
Amandus of Maastricht, St., 128, 129
Amandus of Worms, St., 22–23, 128–29
Amay (Belgium), 142, 176
Ambazac (Haute-Vienne, Limousin, France), chasse of, 90
Ambrose (Aurelius Ambrosius, d. 397), bishop of Milan,
 St., 21–22, 24, 56
amethyst, 92, 114, 132
ampullae, 9, 11, 43–44 (nos. 21–24), 57, 94, 113, 115, 201
amulets, 44, 50, 111, 114-15, 131. *See also* pendant reliquaries;
 portable reliquaries
anargyroi, 50
Anastasios, bishop saint, 82
Anastasios the Persian, St., 61, 118
Anastasis (Harrowing of Hell), 30, 32, 82, 184
Anastasis, Shrine of the (Jerusalem), 11
ancestor worship, 19
Ancyra (Asia Minor), 82
Andechs (Bavaria), abbey of, 226
Andrew of the Moors, St., 131
Andrew the Apostle, 13, 56, 65n16, 82, 127, 183, 203; portable
 altar of (Trier Cathedral treasury), *165*–66, 171
Angers, Cathedral of Saint-Maurice, 104, 151, 152, 155
Angevin kings of Naples, 195
Anjou, duchy of 195
Anne, St., 67n72
Anno, St.
 shrine of, Cologne, 156
 chasse of, Sieburg, 177
Annunciation to Mary, 12, 49, 71, 81, 82, 122, 185, 203, 204–5
Annunciation to the Shepherds, 132
Ansanus (Ansano), St., 204–5
Anselm of Bec, archbishop of Canterbury, 144
Anthony, St. (father of monasticism), 7
Anthony Abbot, St., 203
Anthony of Novgorod, 13, 118
Anthony of Padua, St., 203
Antioch on the Orontes (Syrian Antioch), 7, 8, 118
Apamea, Syria, 9
Aphrahat, ascetic, 8
Apocalpyse (Revelation), 156. *See also* Last Judgment
Apocrypha, 81
apostles, arm reliquary of, 83–84 (no. 40), 141
Apostles, Twelve (apostolic college), 11, 30, 40, 41, 83–84,
 85, 87, 153, 191
Appian Way. *See* Rome, streets
Aquila, St., martyr-saint of Trebizond, 94
Aquitaine, 152, 154, 182
Arabic inscriptions, 174
Arbois (Jura, Franche-Compté), Church of Saint-Juste, 141
Arciconfraternita of the Lateran Palace, 69
arcosolia (funerary or architectural niches), 6, 177
Ardo Smaragdus (d. 843), hagiographer, 104
Aretino, Pietro (d. 1556), 214
Ark of the Covenant, 58, 71, 75n16, 166, 199
Arma Christi. See Flagellation of Christ; Holy Lance;
 Passion relics; True Cross
arm relics and reliquaries, 165, 166–67, 170
 of the apostles, 83–84 (no. 40), 87, 141
 of St. Eustace, 84
 of St. George, 59, 92 (no. 51), 141

 of St. Hedwig, 191
 of St. Innocence, 84
 of St. John the Baptist, 59, 93
 of St. Louis of Toulouse, 141, *142*
 of St. Luke, 195 (no. 109)
 of St. Maximian, 234
 of St. Martin, 84
 of St. Theodora, 84
Arno (d. 821), archbishop of Salzburg, 128
Arnoul, St., arm reliquary of, 166
Arsenios, metropolitan of Serres (Greece), 132
Artemios, St., 9
artophorion (tabernacle), 118
Ascension of Christ, 11, 36, 43, 49, 88, 121, 123, 166, 218.
 See also Christ in Majesty
Aschaffenburg, 64
Ashmolean Museum, Oxford, *Battle of Pavia,* 235
Athanasios, patriarch of Alexandria, 42
Aubert, Étienne. *See* Innocent VI, pope
Auctor, St., 87
Auditeur, St., 191
Augusta Treverorum (Trier), 34
Augustine of Hippo, St., 22, 23, 69, 166
Aurea, St., 203
Austremonius, St., 191
Austriclinian, St., 152, 160n28, 184
authenticity and authentication of relics, 23, 118, 138,
 142–43, 146n37, 158, 201, 203, 211, 215. *See also cedulae;*
 labeling of relics
authentiques, 142
Auvergne, 191, 193
Auvergne, Anatole d', 193
Auxerre (Bourgogne), France, Abbey of Saint-Germain, 101
Avila, Spain, cathedral, 194

B

Bagawat (Kharga Oasis), Egypt, 6
Bakchos, St., 15, 44; reliquary pendant with 46–47 (no. 29)
Balaam the Prophet, 33
Balbina, St., 194
Balderich, abbot of church of St. Peter, Salzburg, 129
Baldung, Hans, 215
Baldwin II, Latin emperor of Constantinople, 59, 132, 234
Baltimore, Walters Art Museum
 Butler Hours, 188 (no. 102)
 crystal reliquary, 176 (no. 80)
 garland sarcophagus, 30 (no. 1)
 Regensburg Gospels, 121–22 (no. 61)
 Limoges chasses, 183–84 (nos. 93, 94)
 Man of Sorrows reliquary, 205–6 (no. 122)
 menologion, 47 (no. 31)
 mother-of-pearl pax appliqué, 229 (no. 131),
 painted reliquaries, 203–4 (nos. 118–20)
 pennant box, 235 (no. 139)
 pilgrim flasks, 43 (no. 21), 44 (no. 24)
 reliquary pendant, 132 (no. 76)
 shrine of St. Amandus, 129 (no. 69)
 shrine of St. Oda, 176–77 (no. 81)
 stained-glass panels, 130 (nos. 70, 71)
 True Cross reliquary, 178 (no. 85)
 votive plaques, 36 (nos. 11, 12).

martyrs, orgins of cult of, 5–8, 19–23

Mary Magdalene, 74, 90, 127, 174; tooth reliquary of, 196–97 (no. 110). *See also* Holy Women

Mary of Cleophas. *See* Holy Women.

Mary, mother of James and John. *See* Holy Women

Mary, Mother of Jesus. *See* Virgin Mary

Mass. *See* Eucharist

Master G (goldsmith), 164

Matthew of Edessa, 66n45

Matthew the Evangelist, 30, 82, 102, 185,

Maurice, Byzantine emperor, 57, 73

Maurille, St., 104

Mauritius, abbot of Kamenz, 191

Mauritius (Maurice), St., 83, 167

Maurs, l'abbatiale Saint-Césaire, 193 (no. 106)

Maximian, St., 233

Maximus of Turin, 34

Meinwerk, bishop of Paderborn, 126

Melania the Elder, 12

Menas, St., 9, 42–43

menologia, 10, 47 (no. 31)

Mercurios, St., 82

Merzbau (Kurt Schwitters), 217

Michael III, Byzantine emperor, 115

Michael IV, Byzantine emperor, 47

Michael the Archangel, 85, 94, 102, 104, 120, 168

Michael Keroularios, patriarch of Constantinople, 47

Michelangelo. *See* Buonarroti, Michelangelo.

Middleham Jewel (Yorkshire Museum), 114, *115*

Milan

 churches, 56, 151

 Concilium Sanctorum, 56

military saints, 15, 47, 82. *See also* Demetrios, St.; Eustathios, St.; George, St.

Miner, Dorothy, 229

Moissac Abbey, France, 118

Monconys, Balthasar de, 160n2

Monopoli (Italy), cathedral of, 12, *13*

Monreale (Sicily), cathedral, 112

Monulph, St., 177

Monymusk, 118

Monza (Lombardy)

 cathedral, 11

 Church of St. John the Baptist, 57

More, Thomas, 26

Moreville, Hugh de, 186

Mortain casket, 118

mosaics, 7, 112, 201–3, 151

Mosan enamels and goldsmithing, 167, 176–81 (nos. 81–90), 197, 198

Moscardo, Ludovico, 215

Moses the Prophet, 58, 178, 199, 235

mother of pearl, 229

Mount of Olives, 218

Mount Sinai, 199, 213

Mount Tabor, 20

Mount Zion, 43, 218

Moûtiers en-Tarentaise (Savoie, France), 174

Mozac (Auvergne, France), abbey of, 154, 155, 157

Mudazio, Angelo, 92

Mudejar textiles, 86–87

mummification, 7, 21

Munich, Staatliche Graphische Sammlung, *20*

Myra (Asia Minor), 128

myron (oil), 14, 15, 47

N

Nabor, St., 156

Namadia, wife of St. Calminius, 154

Namur (Belgium), Couvent des Soeurs de Notre-Dame, 144, *145,* 197–98 (nos. 111, 112)

Nancy (France), cathedral treasury, 151

Naples

 catacomb of San Gennaro, *6,* 41

 goldsmiths' workshops, 141

Napoleon Bonaparte, 113, 215

Natalia, St., 125

Nativity of Christ, 11, *12* 36, 49, 50, 71, 81, 82, 88, 114, 132, 218

Nazarius, St., 56

Near Eastern art, 71, 81, 85–87, 129

Nectaire, St., 191

Nestor of Thessalonike, St., 46

Neuss (Germany), 194

Neustadt, 62

New York

 Dia Art Foundation, 222n46

 Metropolitan Museum of Art

 gold glass medallion, 35 (no. 10)

 reliquary busts, 194–95 (nos. 107, 108),

 reliquary chasse, 186 (no. 97)

 reliquary cross, 89–90 (no. 48)

 reliquary pendant, 186–87 (no. 98)

 tooth reliquary, 196 (no. 110)

 True Cross reliquary, 81–82 (no. 37)

 Pierpont Morgan Library

 German Gospel book (M.651), 122

 Life and Miracles of St. Edmund (M.736), 125 (no. 63)

 Lindau Gospels (M.1), 122

 Psalter Hours (M.67), 212–13, 234–35 (no. 138)

 Stavelot Triptych, 12, 62, 153, 160n37, 167, *168,* 178, 180,

Nicaea, Seventh Ecumenical Council of, 85, 112

Nicholas, St., 82., 87, 198

Nicholas III (Giovanni Gaetano Orsini), pope, 70, 213

Nicholas of Myra (d. 346), St., 49, 128, 191

Nicholas of Verdun, goldsmith, 156, *158*

Nicolaus of Leubus, abbot, 191

niello, 42, 46, 49, 50,71, 82, 87, 91, 92, 94, 186, 198

Nikephoros, patriarch of Constantinople, 49, 73

Nikomedes of Borghorst, 174

Ninian, St., 131

Noli me tangere, 121

Norbert of Xanten, St., 131

Notke, Bernt, 206

Numidia (Algeria), 41

Nuremberg

 relic collections in, 61, 139, 213, 224, 228

 Germanisches Nationalmuseum, reliquary pouch, *139*

Oberlin (Ohio) Allen Memorial Art Museum, reliquary chasse, 187–88 (no. 100)

Oda, St., reliquary shrine of, 141–42, 155, 176–77 (nos. 81, 82)

Odessos (Varna), 39

Odilon, abbot of Cluny, 107

Odo (Eudes I), duke of Burgundy, 230

odor of relics, 22. *See also myron*

Ognies, priory of Saint-Nicholas, 171, 197–98

Olaf, St., 24

Olmütz, Moravia, 205

omophorion (ecclesiastical vestment), 82

opus interrasile, 44

opus lemovicense, 150. *See also* Limoges, enamelwork

opus musivum ('mosaic work'), 151

orans posture, 24, 34, 35, 36, 42, 46

ordinaries *(ordines),* 71, 105, 166

Orense (Ourense, Spain)

 Cathedral of Saint-Martin, 156

 Church of Saint-Euverte, 221n7

Orsini, Giovanni Gaetano (Pope Nicholas III), 70

ossuaries, 7

ostensoria, 87 (no. 44), 143, 144

Ostia, 203

Oswald, king of Northumbria, 83

Otto I the Great, Holy Roman Emperor, 60–61, 108n3, 113, 228

Otto III, Holy Roman Emperor, 23, 87, 113

Otto IV of Braunschweig, Holy Roman Emperor, 62, 156

Otto the Mild, duke of Braunschweig–Lüneburg, 62

Ovid (Publius Ovidius Naso), 144

Oxford, Ashmolean Museum

 reliquary ring from Thame hoard, 114, *115*

 Battle of Pavia, 235

P

Paderborn, Franziskanerkloster / Diozesanmuseum, Abdinghof Altar, 126 (no. 65)

Padua, Arena Chapel *(Cappella degli Scrovegni),* 222n53

Palaiologan emperors, 201

Palatinate (Germany), Trifels Castle, 61

pallae and *pallia* (cloaks), 30, 32, 34, 35, 41

palliolum contact relics, 40

palm trees, 40, 41

Pamplona, Sanctuary of San Miguel in Excelsis, 156

Panteleimon, St., 82

Paradise, 35, 41, 139, 151

Paris

 Abbey of Saint-Germain-des Prés, 130

 Bibliothèque nationale de France, MS lat 17558, 167

 Cathedral of Notre-Dame, 234

 Musée Carnavalet–Histoire de Paris, print of chasse of St. Germain, 230 (no. 135)

 Musée de Cluny

 Bohemian reliquary jewel, 132 (no. 75)

 reliquary casket, 174–76 (no. 79)

 reliquary of Sts Lucian, Maximian, and Julian, 233 (no. 137)

 Virgin and Child reliquary statuette, 207 (no. 124)

 Musée du Louvre

 arm reliquaries,141, *142* 195 (no. 109)

 chasse with St. Thomas Becket, 187

 ivory plaque, 228–29 (no. 130)

 Jaucourt reliquary, 212, 221n14

 prophet figure, 230 (no. 133)

 reliquary of St. Henry, 83 (no. 39)

 True Cross reliquary, 88–89 (no. 46)

 Sainte-Chapelle, 13, 59, 61, 94, 130, 132, 212, 213, 234

 Saint-Germain-des Prés, 130, 230

Paris, Matthew, 233 (no. 136)

Parmigianino, *Self-Portrait in a Convex Mirror,* 214

Paschal I, pope, 51, 71, 72, 81

Passion relics, 13, 43, 59, 60, 61, 138, 89. *See also* Crown of Thorns; Crucifixion of Christ; Flagellation; Holy Blood; Holy Lance; *sudarium,* True Cross

pastiglia, 203

Pater noster, 106

Patriarchum (popes' palace), 69, 71

Thek, Paul, 217
Thekla, St., 10
Themonianos, St., 13
Theodelinda, queen of the Lombards, 11, 57, 58
Theodora, St., 14, 15, 47
Theodore, St., 82, 84, 90, 92
Theodore the Recruit, 5
Theodoret of Cyrrhus, 8, 32, 93, 221n13
Theodosius I, emperor, 35, 93
Theofrede, St., 154
Theophilus (pseud.), *De diversis artibus,* 143–44, 150–51, 164. *See also* Roger of Helmarshausen
Thessalonike (Greece), 14–15, 46, 47, 50, 201
Thibaut des Abbés, 207
Thierry of Chartres, 144
Thietmar of Merseburg, 108n3
Thiofrid of Echternach, 20, 22, 25, 103, 130, 137, 139, 140, 142
Thomas Aquinas, St., 20, 170
Thomas de Cantilupe, 24
Thomas, St., 82, 102
Three Kings Shrine. *See* Cologne, Shrine of the Three Kings
Three Marys. *See* Holy Women.
Timothy the Apostle, 13, 47, 56, 65n16
Tomasso da Modena, 203
Tongres (Tongeren), 177, 198
tooth relics and reliquaries, 19, 22, 23, 163, 215
 of John the Baptist, 84 (no. 41)
 of Mary Magdalene, 196 (no. 110)
 of St. Patrick, 120
touch relics. *See* contact relics
Toulouse, Abbey of Saint-Sernin, 122–23, 156–57
tourism, and cult of relics, 213
Tours (France), 9
Tracy, William de, 186
Traditio legis, 40, 107
Transfiguration of Christ, 49
translation (relocation) of saints' relics, 7, 10, 14, 21, 22, 23, 26, 38, 42, 47, 55, 56, 58–59, 91, 112, 138, 169, 191, 211
transparency in reliquaries, 138, 141, 174–76, 197. *See also* rock crystal
Transubstantiation of Christ, 143
Traut, Wolf, 64
treasure bindings, 121–22, *145*, 151
Trebizond, 15, 93, 94
Trebnitz (Silesia), 191
Trent, Council of, 26
Trier. *See also* Egbert, bishop of Trier
 as apostolic center, 165–66
 cathedral treasury, 58, 151
 Holy Nail reliquary, 82 (no. 38),
 portable altar of St. Andrew, 165
 'Trier Ivory', 38 (no. 14)
 Church of St. Paulinus, 34, 82
 Rhenisches Landesmuseum, Frankish funerary
 epitaph, 34 (no. 7)
Trifels Castle, 61
triptych reliquaries, 12–13, *158*, 180–82 (nos. 89, 90), 203–5 (nos. 119–21). *See also* Stavelot Triptych
tropaia (victory monuments), 55

True Cross
 adoration of, 86
 discovery of, 11–12, 115, *168*, 178, 180
 in Exaltation of the Cross ceremony, 12, 56
 fragments as diplomatic gifts, 57, 58, 59, 61, 87
 oaths sworn on, 60
 relics and reliquaries, 43, 44, 46, 57, 58, 71, 72, 87, 113, 114, 131, 143, 156–57, 164, 203, 212, 213, 221n13, 224, 228, 233, 234, 235
 Bohemian Man of Sorrows (Baltimore), 205–6 (no. 122)
 Byzantine cross pendants, Dumbarton Oaks, 47 (no. 27), 50–51 (no. 34); British Museum, 51 (no. 35)
 Byzantine pectoral cross ('Pliska Cross'), 49 (no. 42)
 Cross of Paschal I (Vatican), 81 (nos. 36)
 crux vaticana (Cross of Justin II), 58
 double-arm cross (Cleveland), 89 (no. 47)
 Fieschi Morgan Staurotheke (New York), 81–82 (no. 37)
 Grandmont Cross (New York), 89 (no. 48)
 in German Gospel binding (Baltimore), 121–22 (no. 61)
 Limoges reliquary chasse (Saint-Sernin, Toulouse), 122 (no. 61)
 Latin/Italo-Byzantine reliquary (Paris, Louvre), 88 (no. 46)
 Mosan reliquary (Baltimore), 178 (no. 85), panel reliquary (Cleveland), 90–91 (no. 49)
 in triptych reliquaries, 181–82 (no. 90), 180–81 (no. 89)
 Zweifalten reliquary, 88 (no. 45)
Tuscany, 196, 197

U

Ubeda (Jaén, Spain), cathedral of, 194, 195
Ugolino di Vieri, 203
Ulger, bishop of Angers, tomb of, *150, 151,* 151–52, 155
umbilicus (umbilical cord) of Christ, 23, 207
unicorn horns, 213
Uppsala, 157
Urfa (Turkey), 199
urna of St. Dominic of Silos, *152–53*
Ursula of Cologne, St., 21, 23, 112, 161n49, 194

V

Valentine, St., 177
Valerian, St., 94
Valerie, St., reliquaries of, 157, 161n53, 182 (no. 91), 184
Valerius of Saragossa, bishop, 130
Valois court, 94
vanitas objects, 211
Varna, Bulgaria, reliquary boxes, 10, 38–39 (no. 15)
Vasari, Giorgio, *Lives of the Painters,* 214–15
Vatican
 Basilica of St. John Lateran, 213
 Basilica of St. Peter, 21, 40, 42, 58
 Lateran Palace, 69–70. *See also* Sancta Santorum
 museums
 Museo Cristiano, 30 (no. 2), 30–32 (no. 3), 32 (no. 5), 34–35 (no. 8), 35 (no. 9), 41 (no. 18)
 Museo Lapidario Cristiano, 33 (no. 6)
 Museo Sacro, 36 (no. 13), 42 (no. 19), 71, 81 (no. 36)
 Patriarchum (popes' palace), 69, 71
 Ufficio delle Celebrazione Liturgiche del Sommo Pontifiche, 198–99 (no. 113)

Venantius Fortunatus, 105, 166
Vendramin collection, Venice, 213
Venice
 basilicas and churches
 San Liberale, 91
 San Marco, 49, 59, 92 (no. 51), 94 (no. 53), 141
 Sta. Marina, 91
 San Tomà, 212
 museums
 Museo Archeologico Nazionale, 40 (no. 16)
 Museo Correr, 91 (no. 50)
 patron saints of, 92
 Vendramin collection, 213
vernis brun, 151, 180, 181, 182
Veronica, veil of, 72, 77n50, 122, 214. *See also* Mandylion
verre églomisé, 196, 197, 202, 203
Vézelay (France), 196
Vienna
 Akademie der bildenen Kunst, Dürer hair relic, *214*
 Kunsthistorisches Museum, 60, purse reliquary of St. Stephen, *139*
 treasure chapel of the Holy Roman Emperors, 94
Vigeois, Geoffroy de, 152, 160n28
Vigilantius of Calagurris, 64
Vincennes, Sainte-Chapelle, 230
Vincent, St., 85, 90, 107, 230
Vincent of Saragossa, St., 130–31
Virgin Mary
 in Adoration scenes, 6, 11, 33, 50, 185
 in Annunciation scenes, 185, 203
 in Ascension scenes, 11
 and Christ Child, 114, 127, 132, 156, 159, 183, 191, 203, 204, 207
 and Christ in Majesty, 122, 128
 in Crucifixion scenes, 12, 46, 50, 89, 115, 119, 182
 dedication of altars and chapels to, 50, 102, 103, 130
 Dormition of, 66n60, 74
 enthroned, 11, 159, 198
 Feast of the Nativity of, 64
 on gold glass medallions, 35
 icons of
 Dexiokratousa, 199–200
 Hodegetria, 78n61, 200, 201, 221n27, 221n29
 Salus populi Romani, 74, 78n61, 221n29
 in Nativity scenes, 11, 12, 36, 49, 50, 81, 82, 114, 132, 185, 218
 relics of, 13, 19, 23, 90, 91, 94, 113, 174, 211, 213, 222n32, 235
 Theotokos (Mother of God), 46, 49, 174
 tomb of, 213, 215–16
 Visitation of, 81, 93
Visher, Peter, 224
vitae (saints' lives), 69, 104, 105, 125, 140, 166, 169, 171
Vitalis, St., 56
Vivan Denon, Dominique, 215
Volek, John, bishop of Olmütz, 205
vollschmelz enamels, 82
Voragine, Jacobus, 202. *See also* Golden Legend
votives, 24, 36 (nos. 11, 12)

W

Y

Z

Illustration Credits

Allen Memorial Art Museum, Oberlin College, Oberlin, Ohio: no. 100

Archivio Fotografico Soprintendenza Speciale per il Patrimonio Storico Artistico ed Etnoantropologico e per il Polo Museale della città di Roma: no. 116

The Ashmolean Museum, University of Oxford: fig. 43

© Biblioteca Apostolica Vaticana, MS Vaticanus gr. 1613, by permission of the Biblioteca Apostolica Vaticana, all rights reserved: fig. 6

© Biblioteca nacional de España: fig. 13

Bibliothèque nationale de France: fig. 65

Bildarchiv Preussischer Kulturbesitz / Art Resource, NY: figs. 5, 58, nos. 4, 87, 123; photo Félicien Faillet: fig. 63, no. 38

© The Bodleian Library, University of Oxford, 2010: fig. 53

Courtesy of Elizabeth Bolman: figs. 1, 4

The Bridgeman Art Library: fig. 2

© Trustees of the British Museum: figs. 27, 45, 69; nos. 20, 30, 33, 35, 54, 57–60, 66, 72–74, 78, 82, 86, 91, 92, 95, 99, 104, 127–29, 132; courtesy of Private Colleciton, London: nos. 56, 88, 121

© British School at Athens: fig. 11

Capitolo di S. Pietro in Vaticano: fig. 20

Centre d'études médiévales d'Auxerre, G. Fèvre, 1997: fig. 35; 2002: fig. 40

The Cleveland Museum of Art: fig. 51; nos. 17, 22, 23, 26, 40, 42–44, 47, 49, 52, 68, 101, 114, 117, 134

Photo CNAC/MNAM/Dist. Réunion des Musées Nationaux / Art Resource, NY, photo Philippe Migeat; Art © 2010 Artists Rights Society (ARS), New York / SIAE, Rome: fig. 71

Conseil Regional d'Auvergne, Inventaire general, ADAGP, photo R. Choplain, Ra. Maston: fig. 59

The Master and Fellows of Corpus Christi College, Cambridge: no. 136

© Francis Debaisieux, France: nos. 105, 106

Diözesanmuseum, Paderborn, photo Ansgar Hoffmann: no. 65

© Dombauarchiv Köln, Matz und Schenk: fig. 18, no. 90

© Domkapitel Aachen, photo Ann Münchow: no. 55

Domschatzverwaltung, Halberstadt: fig. 49

© Dumbarton Oaks, Byzantine Collection, Washington, DC: nos. 25, 27–29, 34

Copyright © Éditions Zodiaque, 1958: fig. 38

Fitzwilliam Museum, Cambridge: no. 117 figure

Courtesy of Fondazione Musei Civici Venezia: no. 50

Germanisches National Museum: fig. 47

The J. Paul Getty Museum, Los Angeles: no. 103

© Rose Hajdu: no. 45

Photography by Robert Hashimoto; reproduction courtesy of The Art Institute of Chicago: nos. 41, 64

Herzog August Bibliothek, Wolfenbüttel: fig. 28

Hofbibliothek Aschaffenburg: no. 130 figure

Hohe Domkirche, Domschatz, Trier (Ann Muenchow): no. 14

© IRHT-CNRS: fig. 68

Photo courtesy James Cohan Gallery, New York; Art © Estate of Robert Smithson/Licensed by VAGA, New York: fig. 73

© KIK-IRPA, Brussels: fig. 56, no. 111

© Stehan Kube: no. 77

© Kunsthistorisches Museum Vienna: figs. 22, 23, 46

Kunstsammlungen der Veste Coburg: fig. 29

Kupferstichkabinett der Akademie der bildenden Künste, Vienna: fig. 70

Courtesy of La Procuratoria della Basilica di San Marco: nos. 51, 53

Courtesy of Anton Legner: fig. 19

Erich Lessing / Art Resource, NY: figs. 17, 24, 25, 42, 48, 61; no. 130

Library of Congress, Washington, DC: fig. 69; nos. 125, 126

© Libreria Editrice Vaticana: fig. 14

© Paul Maeyaert / The Bridgeman Art Library: fig. 64

Courtesy Carolyn Malone: fig. 37

The Menil Collection, Houston: fig. 10

Image © Samuel Merrin, The Merrin Gallery, Inc: no. 89

Image © The Metropolitan Museum of Art / Art Resource, NY: figs. 60, 62; nos. 10, 37, 48, 97, 98, 107, 108, 110

Image © The Metropolitan Museum of Art, courtesy of the Museo de Burgos, Spain: fig. 55

Image © The Metropolitan Museum of Art, photo Bruce White, courtesy of the Cathedral Treasury Esztergom, Hungary: fig. 8; courtesy of the Comune di Sassoferrato, Italy: no. 115; courtesy of the Museo Diocesano di Monopoli (Bari), Italy: fig. 9

© Ministère de la Culture / Médiathèque du Patrimoine, Dist. RMN / Art Resource, NY, photo Emmanuel-Louis Mas: fig. 39; photo Jean Gourbeix: fig. 54

© Museo e Tesoro del Duomo di Monza: fig. 7

Photo courtesy of Museum August Kestner; Art © 2010 Artists Rights Society (ARS), New York / VG Bild-Kunst, Bonn: fig. 72

Museum für Angewandte Kunst: fig. 57

Museum Kloster Bentlage, photo Roman Mensing: fig. 16

Museum of Archaeology, Varna: nos. 15a–c

Couresty of Alexander Nagel: fig. 75

Image courtesy of the Board of Trustees, National Gallery of Art, Washington, DC: no. 67

National Institute of Archaeology and Museum—Bulgarian Academy of Sciences, photo Krassimir Georgiev: no. 32

Parisienne de Photographie / Musée Carnavalet—Histoire de Paris: no. 135

© Jean-François Peiré—DRAC Midi-Pyrénées: no. 62

The Pierpont Morgan Library, New York: no. 63, 138; photo Joseph Zehavi, 2007: fig. 67

Courtesy of Regierungspräsidium Freiburg, Ref. 26—Denkmalpflege: fig. 36

Design and typesetting:
Studio A
Alexandria, Virginia

Printing and binding:
EBS–Editoriale Bortolazzi-Stei s.r.l.
Verona, Italy

Paper:
GardaMatt Art 150gsm

Type:
Maiola, TypeTogether
Gloriola, Suitcase Type Foundry
Daxline Greek, FontFont